THE BRITISH MUSEUM BOOK OF
CHINESE
ART

THE BRITISH MUSEUM BOOK OF
CHINESE ART

Jessica Rawson, Anne Farrer, Jane Portal,
Shelagh Vainker and Carol Michaelson

Edited by Jessica Rawson

Published for the Trustees of the British Museum
by British Museum Press

front cover Detail of a large cloisonné enamel jar with domed cover (see fig. 139).
Ming dynasty, Xuande mark and period (AD 1426–35). HT: 62 cm.

back cover Attributed to the Northern Song Emperor Huizong (r. 1101–25),
Gardenia and Lichi with Birds (detail). Handscroll, ink and colours on silk.
HT: 26 cm, W (complete painting): 281 cm.

Quotations are reprinted (on the pages noted) by courtesy of Foreign
Languages Press, Beijing (pp. 10, 140, 163); Reed Publishing (p. 13);
Oxford University Press (pp. 39, 63); HarperCollins Publishers (pp. 44, 204);
Bulletin of the Museum of Far Eastern Antiquities (p. 59); Chinese
University of Hong Kong (pp. 74, 242); Harvard University Press (pp. 75–6);
Indiana University Press (p. 84); A & C Black (pp. 99–100); Columbia
University Press (pp. 134, 256); Penguin Books (p. 168); New York State
Institute for Glaze Research (pp. 213–14); E. J. Brill (p. 261); University
of California Press (p. 262); Princeton University Press (p. 266). For
consistency, pinyin romanisation has been used where appropriate.

© 1992 The Trustees of the British Museum

Published by British Museum Press
A division of The British Museum Company Ltd
46 Bloomsbury Street, London WC1B 3QQ
First published 1992
Reprinted 1996

A catalogue record for this book is available from the British Library

ISBN 0-7141-1453-7

Designed by Behram Kapadia

Set in Garamond by Rowland Phototypesetting Ltd, Bury St Edmunds, Suffolk
Printed in Italy by Arnoldo Mondadori Editore, Verona

Contents

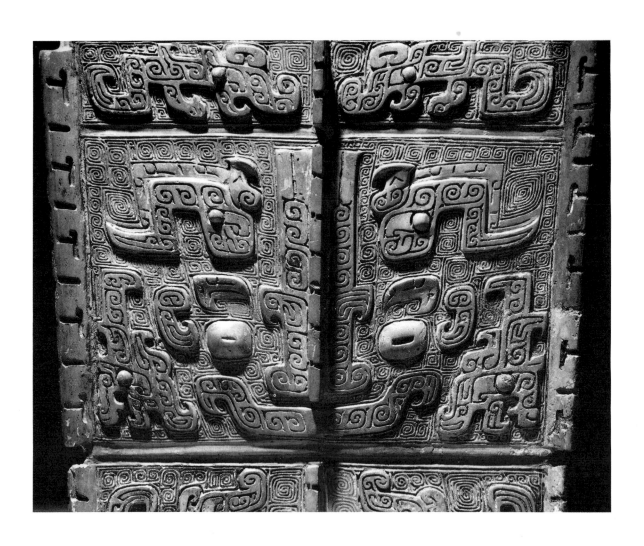

Detail of a *taotie* face decorating a *fang yi*, a bronze ritual vessel used for wine. Shang dynasty, 12th century BC (fig. 32).

Preface

This book is written to accompany and to celebrate the opening of the Joseph E. Hotung Gallery of Oriental Antiquities at the British Museum in the autumn of 1992. The complete redisplay of the collections from China, South and Southeast Asia has made it possible to look anew at the whole Asian collection, and this book on China is one result of this reassessment.

For centuries China has fascinated the West with its exquisite luxuries and its philosophies and beliefs. Great collections of porcelains, bronzes and jades first decorated European palaces and later filled Western museums. The values of Chinese society have intrigued and perplexed Western missionaries and philosophers from Voltaire to Marx. Although this book describes the material culture, it is also concerned with the broader context. The objects of daily life and the works of art of any society are made with care and intent: they result from its needs and aspirations. The subjects of this book are ancient bronzes, paintings and porcelains, but through them we may perceive some of the values of the ancient Chinese who created them.

The project within which this reassessment has taken place is one of the largest the British Museum has undertaken, involving almost all parts of the Museum. The Museum, its Director and Trustees owe profound thanks to Mr Hotung for making possible the complete redisplay of these important collections. Installed in the main gallery on the north side of the building, now known as the Joseph E. Hotung Gallery, the Chinese collections are at last given their full due.

Constructed in the early part of the century after a design by Sir John Burnett, the gallery was opened by His Majesty King George V in 1914. The monumental classical room has been restored to its former dignity, with all the accretions of the intervening decades removed. Its length of 110 metres makes it the largest single gallery in the British Museum (and possibly the largest in Britain). In the new display the original architecture and the mahogany cases which were designed to match have both been retained. The new colour scheme also reflects the classical gold and white chosen by the architect. Indeed, gold harmonises with the objects themselves, so many of which came from temples and palaces that were probably originally adorned with gold.

The organisation of the book complements, but does not duplicate, the displays in the gallery, in the sense that both are intended to show objects which have been made and used in China within the kinds of groups to which they would have belonged, thus revealing both their original contexts and their aesthetic qualities. Of course, many – indeed most – of the items displayed are either works of art or of great craftsmanship, but they are also products of a particular society at a particular time; their technologies, functions and designs illustrate aspects of that society. The great numbers and the high quality, in brilliant colours and fine surfaces, of the objects produced in China are recurring themes in the chapters following, which describe religious objects and the utensils of daily life. The arts of calligraphy and literati painting, on the other hand, exhibit different qualities, such as spontaneity of individual expression, through the simple means of ink on paper.

The text has been written in collaboration with my colleagues, Anne Farrer, Jane Portal and Shelagh Vainker. I am especially grateful for the contributions of Shelagh Vainker after her departure from the British Museum to take up the position of curator

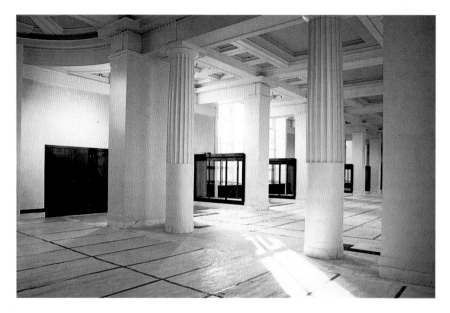

View of the new Joseph E. Hotung Gallery of Oriental Antiquities during refurbishment in 1992.

opposite Detail of the large imperial seal ('Treasure of the Most Exalted Emperor') of the Qianlong emperor (1736–95), one of several inscriptions and colophons (fig. 57) on the handscroll *The Admonitions of the Court Instructress* (fig. 65) attributed to Gu Kaizhi (c. 344–c. 406).

of Chinese art in the Ashmolean Museum, Oxford. The second section of the book provides essential supplementary information, ranging from chronologies of Chinese history and glossaries of terms to technical details, bibliographies and brief identifications of painters and archaeological sites. This mass of material has been very ably compiled by Carol Michaelson and I thank her for her dedication. Many others have contributed and in particular I am grateful to Hero Granger-Taylor, Roderick Whitfield and Nigel Wood for sharing their substantial expertise in the textile glossary, the list of painters and the ceramics glossary respectively.

For checking this information and adding details, I would like to thank Michael Loewe, Andrew Lo, Jessica Harrison-Hall, Rosemary Scott, Celia Withycombe, Jacqueline Simcox and Wang Tao. I am also grateful to my colleagues Jerry Losty and Frances Wood in the British Library for their help. The maps and drawings are by Ann Searight, and I thank her for her enthusiasm in interpreting our sketches. At all stages our editor, Nina Shandloff, has offered her warm support of our endeavours and has coped valiantly with the large size of this project. Susan Leiper is also thanked for her work on the text and the proofs, Susanne Atkin for the index, and Behram Kapadia for his ingenious design. Carol White and Lay Leng Goh typed large sections of the book and we all thank them for their patience. Photographs have come from many quarters and are acknowledged on pp. 384–6. I thank all those who have been so generous with photographs, which are difficult to obtain for many aspects of Chinese art. We are especially grateful for the many excellent photographs of pieces in the collection taken by David Gowers, Jim Rossiter and John Williams.

All of us who study China are deeply in the debt of our Chinese colleagues and I would like to thank all the many Chinese scholars who have visited the British Museum over the last decade and given us the benefit of their views. From them we have all learned a lot; China is a country whose long history and dense culture remain a perpetual challenge and delight, and we are grateful for their guidance across the difficult terrain. My most heartfelt thanks go to Joe Hotung, without whose generosity neither I nor the other members of the Department of Oriental Antiquities could have embarked upon this exploration of the past of the great country we know today as China.

Jessica Rawson
KEEPER OF ORIENTAL ANTIQUITIES, BRITISH MUSEUM

8

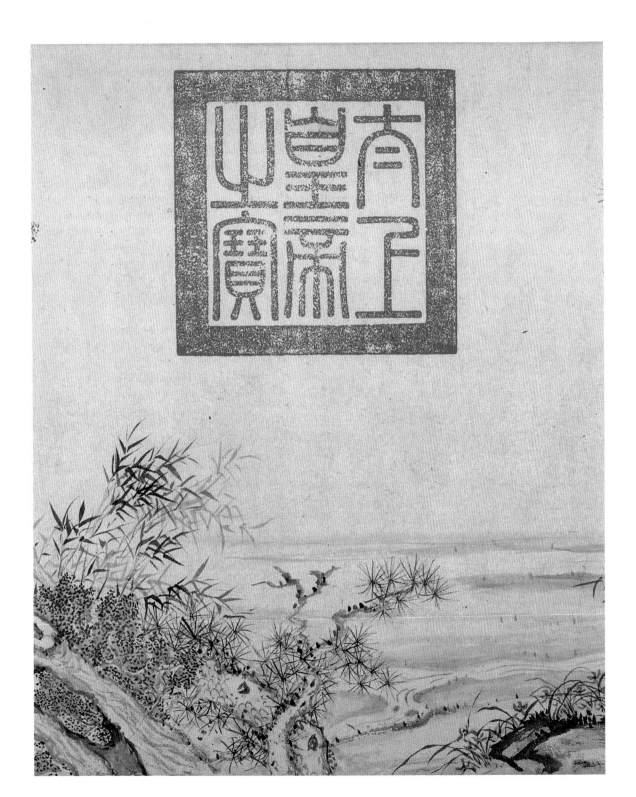

Proclamation of the First Emperor

China was unified in 221 BC under the rule of the first emperor, Qin Shi
Huangdi, who set up stone stelae in various parts of his empire which were
carved with inscriptions proclaiming his achievements and his ultimate goals.
As compiled in 104–91 BC by Sima Qian, the Han dynasty court historian, the
inscription on the tower at Mt Langya read:

> In the twenty-eighth year of his reign
> A new age is inaugurated by the Emperor;
> Rules and measures are rectified,
> The myriad things set in order,
> Human affairs are made clear
> And there is harmony between fathers and sons.
> The Emperor in his sagacity, benevolence and justice
> Has made all laws and principles manifest.
> He set forth to pacify the east,
> To inspect officers and men;
> This great task accomplished
> He visited the coast.
> Great are the Emperor's achievements,
> Men attend diligently to basic tasks,
> Farming is encouraged, secondary pursuits discouraged,
> All the common people prosper;
> All men under the sky
> Toil with a single purpose;
> Tools and measures are made uniform,
> The written script is standardized;
> Wherever the sun and moon shine.
> Wherever one can go by boat or by carriage,
> Men carry out their orders
> And satisfy their desires;
> For our Emperor in accordance with the time
> Has regulated local customs,
> Made waterways and divided up the land.
> Caring for the common people,
> He works day and night without rest;
> He defines the laws, leaving nothing in doubt,
> Making known what is forbidden.
> The local officials have their duties,
> Administration is smoothly carried out,
> All is done correctly, all according to plan.
> The Emperor in his wisdom
> Inspects all four quarters of his realm;
> High and low, noble and humble,
> None dare overshoot the mark;
> No evil or impropriety is allowed,
> All strive to be good men and true,

And exert themselves in tasks great and small;
None dares to idle or ignore his duties,
But in far-off, remote places
Serious and decorous administrators
Work steadily, just and loyal.
Great is the virtue of our Emperor
Who pacifies all four corners of the earth,
Who punishes traitors, roots out evil men,
And with profitable measures brings prosperity.
Tasks are done at the proper season,
All things flourish and grow;
The common people know peace
And have laid aside weapons and armour;
Kinsmen care for each other,
There are no robbers or thieves;
Men delight in his rule,
All understanding the law and discipline.
The universe entire
Is our Emperor's realm,
Extending west to the Desert,
South to where the houses face north,
East to the East Ocean,
North to beyond Tahsia;
Wherever human life is found,
All acknowledge his suzerainty,
His achievements surpass those of the Five Emperors,
His kindness reaches even the beasts of the field;
All creatures benefit from his virtue,
All live in peace at home.*

*from Selections from Records of the Historian,
Yang Hsien-yi and G. Yang (trans.), Beijing, 1979, pp. 170–2

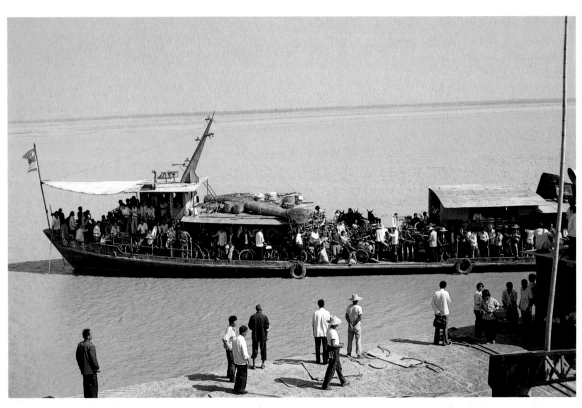

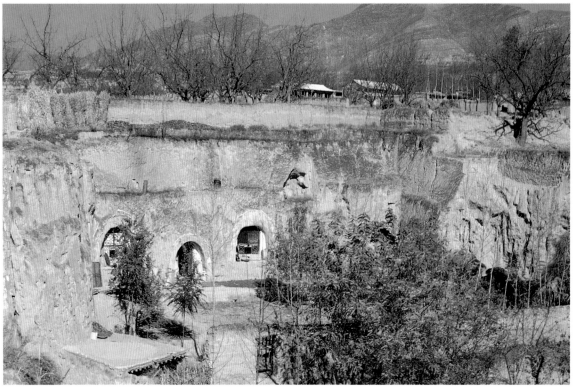

Introduction

*The universe is a lodging house for the myriad things, and time
itself is a traveling guest of the centuries. This floating life is like
a dream. How often can one enjoy oneself? It is for this reason that
the ancient people held candles to celebrate the night.**

Europe and China stand at the two ends of the world's largest continent:
Europe, centred on the Mediterranean, faces west across the Atlantic
to America; China, bordering the China Sea, faces east towards Japan
and the Pacific. While the Atlantic in the west and the Pacific in the east
feed rain to the great rivers flowing into them, the centre of the continent
is dry, harsh and unyielding; deserts, frozen wastes and great mountains
make difficult terrain, and the Indian subcontinent is further barricaded by
the Himalayas. The responses of the Chinese to their land and to their
inheritance have been relatively unaffected by contact with the Middle East
and Europe, and even the Indian subcontinent has contributed very little.
China has, therefore, developed completely different solutions to the univer-
sal search for a good life from those to which we are accustomed. Not only do
religious beliefs and social and political organisation contrast with Western
institutions; all aspects of material life differ also. From the everyday to the
rare and beautiful, almost everything the Chinese have chosen to make and
to use is quite unlike any European counterpart. Instead of our flat plates
and cutlery, the Chinese have for millennia used bowls and chopsticks.
Where Westerners have prized the brilliant colours of paintings in oils, the
Chinese have revered calligraphy in black ink on silk or paper.

Occasionally, as we shall see, there has been contact across Asia, and more
recently ships have taken the long route around Africa and India. With the
opening of the sea routes, trade flourished, and day-to-day life in the West
was transformed by the introduction of Chinese silks, teas, spices and por-
celains. Indeed, so desirable were these luxuries that they were widely
imitated. In addition, Chinese technology – printing, the making of gun-
powder, iron casting and methods of mass-production – altered the West
beyond recognition.[1] By contrast, Western products, techniques and ideas
had very little impact on China before the twentieth century.

*from 'A Night Feast' by Li Bai, in Lin Yutang, *The Importance of Understanding*, London,
1961, p. 100

1 (*opposite above*) Ferry boat on
the Yellow River near
Kaifeng in Henan province.
The silt washed down from
the loess lands of the
northwest colours the river
yellow most of the year.
Deposits of this silt across the
flood plains of eastern China
not only made the land fertile
but also made early farming
life hazardous.

2 (*opposite below*) The loess
area. Thick layers of fine sand
blown from the Gobi Desert
over millennia cover
northwest and north central
China. The soft fertile earth
was easy to till and
contributed to the success of
early Chinese agriculture. It
still provides fertile farmland
today, but it can also be
hollowed out into cave houses
and fired as bricks, tiles and
other ceramics, such as
moulds.

The land

The Yellow River is the dominant feature of northern central China. Rising on the northern edge of the Tibetan plateau, it runs in a great bend through the Mongolian steppe before turning southwards along the boundary of the province of Shanxi. East of Xi'an it is joined by its tributary, the Wei, and bends east. Along this stretch to the sea, the river and its tributaries watered the early cities of ancient China (map 1, opposite).

The Yellow River flows through the loess deposits, one of the world's most extraordinary geological features, and takes its name from the yellow, sandy silt it carries for most of the year (fig. 1). This silt, or loess, is a very fine sand, blown by the prevailing winds from the Gobi Desert, which over millennia has formed deposits hundreds of metres thick across northern China (fig. 2). Through this layer, the Yellow River and its tributaries have cut deep ravines and carried the loess hundreds of miles eastwards, depositing it across the immense central plain of northern China. The Yellow River has sometimes broken its banks with devastating effect and it has changed course several times, on each occasion depositing yet further silt across the plains. As the loess is blown by the wind, its primary deposits have not been leached by water, so where it lies in thick layers the ground is very fertile. The present-day provinces of Hebei, Henan and Shandong, as well as Shaanxi and Shanxi, benefit from these rich soils. In earlier times the loess areas were covered with trees, but these have long since been felled for buildings and fuel. The whole area is now densely cultivated with the principal crops: wheat, millet and vegetables.

The Yangzi is a quite separate and equally extensive river system. In the west, the watershed between the Yellow and Yangzi rivers is provided by the steep Qinling mountains and the eastern edge of the huge Tibetan ranges. Through the densely forested and swampy areas of southern China, rivers were essential routes for travel and conquest. Running north-south from these high mountains to the Yangzi are long tributaries, such as the Jialing Jiang and the Min, which water Sichuan province, and the Han Shui which runs west to east to join the Yangzi near the present-day city of Wuhan. Either side of the Yangzi at this point are networks of lakes, the largest of which is the Dongting Hu, through which the Xiang River flows from the south to join the Yangzi. In the east, the Huai River joins further lakes north of the estuary of the Yangzi at Shanghai. In ancient times this region was heavily forested, but these areas took much longer to clear for agriculture than the uplands of the loess country. It was along the coasts, however, that rice cultivation was initiated – no later than 5000 BC, and most probably earlier – and the Yangzi basin is today still the heart of China's rice growing (fig. 3).

The southern tributaries of the Yangzi, flowing northwards, are divided from a further river system – that of the Red River and the Xi River, running to a large estuary at Canton – by mountain ranges called the Nanling, part of the Dongnan Qiuling mountains. This subtropical area has always been extremely fertile. The Dongnan Qiuling also continue through Fujian province, where they are known as the Wuyishan, and cut off the fertile coastal area from the rest of the country. To the west lie the southern edges

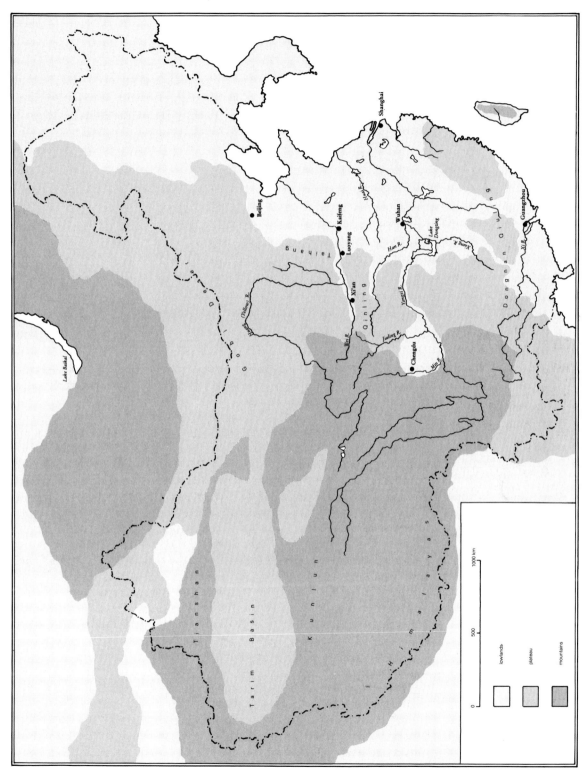

MAP 1 Physical map of China.

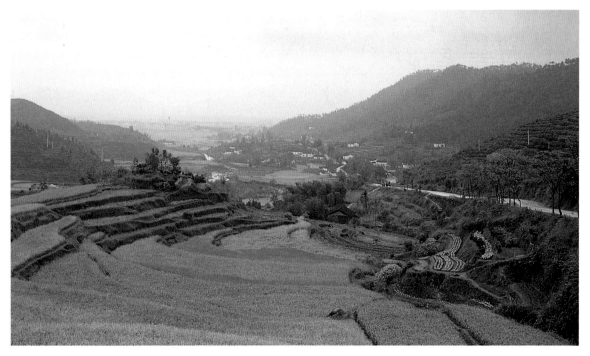

3 Rice growing in the foothills of Jiuhuashan, Anhui province, about 30 km south of the Yangzi River. Southern China is dominated by the Yangzi and its tributaries, and rice is the principal crop. It is planted in fields that can be flooded and drained to suit the growing cycle.

of the Tibetan mountains, which taper into Yunnan province and Burma.

The western mountainous regions and the steppes and deserts of the north and northeast form a ring of lands, all bordering central China, whose different physical characteristics gave rise to styles of life that were quite distinct from those of the areas along the great rivers.[2] In the extreme north and northeast the steppe lands touching the edge of China provided a route into Mongolia. A more secure route lay through a corridor between high mountain ranges in Gansu province into the deserts of the Taklamakan basin, between the Tianshan and the Kunlun mountains which border Tibet. A string of oases along the fringes of this desert made possible the famous trade routes, known collectively as the Silk Route (fig. 4). The massive mountain ranges of Tibet, south of the Silk Route, were almost impassable, although a few roads linked the high plateau with the present-day province of Sichuan.

History

Control of a single, stable, prosperous state has been the aim of all Chinese rulers.[3] Two forces have continually threatened this goal: unrest within China's huge territory, and pressure from without. Moreover, the geographical diversity already described fostered political divisions at many periods.

The development of settled farming supported many related but quite clearly separate cultures, distinguished by their pottery and tools as well as by their houses and ways of life. This wealth of diverse lifestyles might well have given birth to many separate political entities. However, from this background one ruling house or dynasty, the Shang, emerged pre-eminent before 1500 BC as users of bronze, the most advanced technology of their day. The march towards the goal of a single state or empire was made explicit

by the successors to the Shang, the Zhou (*c.*1050 BC), who claimed to be the legitimate heirs of the Shang. By not acknowledging any other of the many peoples by whom they were surrounded as either predecessors or competitors, the Zhou established what was probably at best a much over-simplified view: that Chinese history had only a single possible route, a single succession of rulers, and a single goal – a unified state.[4] The sense, if not the reality, of a single line of progression has been proclaimed continuously up to the present day.

The Zhou were in practice unable to maintain their supremacy in the face of onslaughts from semi-nomadic peoples to the north and west. In 771 BC they were driven eastwards from their capital at Xi'an and their lands separated into a number of petty states, the most powerful of which were Jin in Shanxi, Chu in Hubei and, the eventual conqueror of the whole area, Qin. The Qin state, situated in western China, provided the name (pronounced to sound like 'chin') which was eventually adopted by foreigners as the name for the whole of China. Although his reign was short lived, Qin Shi Huangdi, the first emperor, not only unified the country by military force in 221 BC, but also created the Great Wall by joining together earlier sections of wall along the northern and western defenses. He prescribed forms of script and weights and measures and established laws and institutions, all of which laid a firm basis for future development of the whole area into a single state.[5] The succeeding Han dynasty (206 BC–AD 220) benefited from this unification and extended China's rule into Central Asia, Korea and Vietnam. Had they pressed further west, the Han might have come into contact with the other great empire of their day, that of the Romans.[6]

The Han empire was the outcome of China's first major territorial expansion, an expansion that was to recur as China's rulers attempted to check

4 The deserts near Bezeklik at Turfan, Xinjiang province. The Tang dynasty monk Xuanzang, who passed through this area in the 7th century AD, described these fiery-coloured mountains.

the incursions of the peoples on her borders by fighting back or even by anticipating their attacks. For her great wealth, combined with economic and political instability on her borders, often drew the peoples on the northern periphery to invade China. The collapse of the Han in the early third century AD precipitated the first of several major disruptions, with a number of non-Chinese rulers taking over the north. Several centuries of foreign rule gave impetus to a foreign religion, Buddhism, and led to a complete transformation in many areas of the arts and decorative arts, including religious architecture and image making, metalwork, ceramics and textiles.

A *coup d'état* by a general, Yang Jian, established a short-lived but powerful ruling house that took the title Sui (AD 589–617). The country was reunified; large public works were undertaken, of which the building of the Grand Canal is the best known; and the central and local bureaucracies were reorganised. The Tang (AD 618–906), succeeding the Sui, rather as the Han had followed the Qin, built on the reforms instituted by the Sui. Indeed, as with the Han, the Tang expanded into Central Asia, but that expansion too brought economic problems and collapse, with a massive rebellion in AD 755. Although the Tang dynasty survived, it never regained its former political or economic strength, and in the tenth century the country disintegrated into a series of smaller kingdoms.

The restoration of unified rule under the Song (AD 960–1279) reinforced and extended changes that had begun under the latter part of the Tang dynasty. Wide-ranging reforms of central government were proposed and instituted under the guise of a return to ancient political practices. Great advances were made in economic development, particularly in the areas of iron and coal mining and in the expansion of sea trade. The northern borders were, however, weak points, and the Song were constantly under threat from these areas, ruled in succession by two foreign dynasties, the Liao (907–1125) and the Jin (1115–1234). In 1127 the Jin drove the Song from their northern capital at Bianliang (present-day Kaifeng), forcing them to set up a southern capital at Lin'an (present-day Hangzhou). This move reinforced a long-prevailing tendency of the population to move south and eastwards towards the coast. Ironically, as the area controlled by the Song diminished, the central government fostered sea trade to generate revenue lost from the conquered regions, which led to economic expansion.

The political constraints on the Song, which forced them to govern from Hangzhou, a city remote from the earlier centres of power at Xi'an or Luoyang and Kaifeng, encouraged a further review of the past as a source of inspiration for new political solutions. Interest in the arts of the past was also stimulated by this search for renewed political programmes. The artist Ma Hezhi was commissioned by the court to produce illustrated scrolls of the ancient Zhou text, the *Book of Songs*, compiled in the late Western Zhou period, an indication of the Song search for models in what they perceived as a Golden Age, models which they wished to propagate through the medium of texts and illustrations (ch. 2, fig. 66).[7]

The relative political weakness of the Song, especially in foreign policy matters, was exacerbated by the distance of their capital from the main threats in the extreme north. The Song had sought help against the Jin from the Mongols, but once unified by Genghis Khan the Mongols were them-

selves a much greater danger, and they took over territories from both the Jin and the Song, establishing the Yuan dynasty (1279–1368), which ruled over the whole of China. Because the other lands under Mongol control lay to the north and west of China proper, the capital was moved north to Beijing. During the relatively short period of Mongol domination of much of Asia, Chinese products, including textiles, ceramics, lacquers and metalwork, were taken westwards in the wake of the Mongol armies, influencing Iran and Turkey in particular.

Although a long way from the traditional centres on the Yellow River, the capital was to remain at Beijing, except for a short period after the fall of the Mongols – an acknowledgement of the continuing political dangers posed by northern neighbours. A Chinese dynasty was restored under the title of the Ming (1368–1644), which saw the construction of both the Forbidden City and the Ming tombs. The early Ming emperors supported the sea trade developed under the Song, and between 1405 and 1433 the admiral Zheng He took seven fleets, consisting of as many as sixty-two ships each, to India, Ceylon, Sumatra and even to Africa (ch. 6, fig. 202). The Ming, however, ruled a larger territory than had the Song and took less interest in sea trade as a source of revenue. Further dangers threatened from the north and west, and in 1433 the emperor banned Chinese merchants from going abroad, with the result that trade passed to foreign merchants. China thereby lost an essential stimulus, while the Europeans moved into the vacuum.

China's economic and political difficulties in the seventeenth century had their counterparts on the other side of the globe, in the turmoil in Europe which resulted in such upheavals as the beheading of Charles I and the creation of a Commonwealth in Britain under Oliver Cromwell and the Thirty Years War in Germany and Central Europe. In the seventeenth century the Ming collapsed in the face of the invading Manchus, who then founded the Qing dynasty (1644–1911). This was another period of great territorial expansion, with the Kangxi (1662–1722) and Qianlong (1736–95) emperors exercising their vast powers across a large territory embracing parts of Central Asia, Tibet and Southeast Asia (map IV, p. 289). At the same time as the great Chinese rulers achieved political and military success in East Asia, the Europeans came knocking at their door, first as missionaries and later as traders. Although marvelling at the wealth of China, the Europeans little understood the social and political system that supported it.

Language and government

China's quite extraordinary achievements in the quality of material life, in the arts and in technological invention, all of which the Europeans admired, were the product of a highly organised, coherent and tightly knit society, which was held together by its language and institutions of government.

The language has one advantage denied to many others, in that when written it is not closely linked to the vagaries of pronunciation.[8] It is constructed of single-syllable words, each expressed by a written character. This character carries a meaning rather than a sound, with the result that the same character can be pronounced in different ways in the different

regions of China, but still retain the same meaning. While learning the two to five thousand characters necessary for literacy places a great burden on the young, once learned it is accessible to all educated people, regardless of dialect or period.

This written language has been in use, with only some rather limited changes in grammatical structure and vocabulary, since at least the middle period of the Shang dynasty (c. 1300 BC). The effect of this continuity cannot be overestimated. Ancient texts have been continuously accessible to the educated, and as a result writings of all periods have been compiled and treated as current. The literate have thus always shared a common culture, uniting past and present through the educated people of all periods.

Writing was the essential tool of the governing élite, but it was much more than a tool. It was a source of a shared view of the world, binding together all who could share the wealth of Chinese literary and historical writing. This shared view was particularly powerful because China, unlike the West, shifted from a military élite to an educated one at a very early stage. Of course, fighting and winning battles were always important qualifications for ruling, but from early times the military was subordinated to administrators trained in the written literature of their culture.

As early as the Anyang period (c. 1300 BC), kings employed literate diviners to consult the spiritual powers about matters of government, using bones to which they applied hot brands. The resulting cracks in the bones or shells indicated the outcome of the issue, and the questions posed were inscribed on the bones (fig. 6). These diviners or scribes, involved as they were in the most serious matters of the kingdom, were almost certainly powerful men. The Zhou (c. 1050 BC), too, though military conquerors *par excellence*, recorded their achievements in writing, both in inscriptions on bronze vessels and in longer texts that have been handed down through the generations. They clearly felt that such records were essential to their political legitimacy. The collapse of the Zhou probably speeded up the growth of an all-powerful educated official class. As incessant warfare between petty states demanded both the mobilisation of huge numbers of men and the production of weapons on a large scale, the organisation of these activities by literate managers became essential.[9]

The Qin state especially fostered the growth of the bureaucracy.[10] The state, occupying the relatively backward area of the Wei valley, supported fewer powerful landed families than did the territory of its neighbours to the east. Advisers to the dukes of Qin, especially the philosopher known by the name of Shang Yang (c. 390–338 BC), were able to reorganise the state on administrative lines without giving undue attention to the power of great families. Legalism, the philosophy propounded by Shang Yang, extolled the moral and political power of a centralised state and its ruler, using the sanctions of punishment and war to deter dissent. Groups of five and ten families were made mutually responsible for one another's good conduct. The power of noble families was controlled and the government organised in the hands of men promoted on the basis of merit rather than land or wealth. From the Han period (206 BC–AD 220) Chinese government was divided into three separate hierarchies: the general administrative hierarchy responsible for ritual, taxation, justice and diplomatic relations; the military

hierarchy; and a branch of government that commented on and criticised actions of the other sections, known as the censorate.[11]

All subsequent dynasties adopted a comparable bureaucratic organisation, staffing it with highly educated men selected on the basis of their own personal merit. This merit was judged in relation to their knowledge of the great writings of literature and philosophy of the past. From the Tang dynasty (AD 618–906) a system of examinations was developed for the selection of all members of the central and local bureaucracies. This system codified access to élite positions, ensuring that a common education in classical texts was the principal avenue to advancement. An élite that shared a common set of literary and moral tenets gave China its compelling unity in philosophical attitudes and in government. The vehicle of administration was, of course, the written language, in which directives were conveyed and reports made. Furthermore, a written language which was accessible to all generations and not tied to a particular pronunciation system, and which thus did not become outdated as spoken language changed, meant that all past decisions and practices could be studied by all generations of officials. China early developed systems of compiling documents and indexing them so that they could be readily used. Political upheavals only rarely affected this body of knowledge; they merely intensified the sense that in the past things had been better managed and that a full consideration of past examples would help to solve present difficulties.

Religion and philosophy

China was as intensely religious as any other country. However, both its earliest and most fundamental beliefs and those propounded by the famous Confucian and Daoist philosophers differ from the search for individual salvation, often in another world, that has dominated the major religions of the Mediterranean, the Middle East and the Indian subcontinent: Judaism, Christianity, Islam, and Buddhism and Hinduism. China's primary religions define man's relationship to his society, this social group being first of all the family and secondly the state, whose structure was modelled on the family. Society crosses the boundary between this world and the next, as it embraces the ancestors of both individuals and rulers. Even Daoism, which is concerned with the individual's relationship with nature, is involved by implication with society, as it presupposes a highly organised society from which freedom must be sought.[12]

Cults of the family are generally known as ancestor worship. This term is somewhat misleading, however, as it emphasises the ancestors rather than the deities. Gods and spirits were always important elements in Chinese beliefs, and their appeasement was an essential goal in all Chinese religion. One avenue to these spirits lay through the good offices of the ancestors. It was hoped that, if accorded proper respect, the dead would intercede with the spirits on behalf of the living. Thus rituals that paid respect to ancestors were a constant element of religious practice from at least the Shang dynasty and probably earlier. Such rites are still practised today, particularly in Taiwan, Hong Kong and Singapore. At the state level, similar rites were enacted in which the emperor sacrificed to his ancestors and interceded with

the spirits on behalf of his subjects. These rites, which continued up to the Qing dynasty, became subsumed under the general description of Confucianism and will be mentioned again below.

Closely tied to the cult of the ancestors were Chinese burial practices, which had two major components: tombs and their contents, which were to enable the continued existence of the deceased; and ceremonies to honour the dead, carried out in temples and offering halls by their relatives. Complex structures were developed for both elements. Because the deceased were seen as continuing their lives after death, they were provided with everything they might need. At different times, different aspects of life were given more or less emphasis. In the Shang and Zhou periods (c.1500–c.350 BC) the dead were buried with the sets of bronze vessels required for offering sacrifices to the ancestors, a practice they were deemed to continue after death. In the late Zhou and Han (fourth–first century BC), the fine bronzes, lacquers and jades of court life were buried, and ritual vessels declined in significance. In the later Han (first–second century AD), the emphasis was on replicas of buildings, while the Tang (AD 618–906) seem to have wished to preserve their retinues of servants, ladies-in-waiting and military escorts, all of whom were depicted in ceramic models. Despite these differences in detail, attempts to recreate the world show that the idea of life continuing after death was a constant in the Chinese perspective of the universe, right up to the end of the Qing dynasty in the early twentieth century.

The great philosophies of Confucianism and Daoism for which China is renowned existed alongside these fundamental beliefs about the world. Understanding China's several religious beliefs and practices is complicated by the different levels at which all of them were carried out.

Confucianism is a good example. It was initially a philosophical school propounded by Confucius (trad. dates c.551–479 BC) and his followers, among whom Mencius living in the fourth century BC and Xunzi in the third were the most significant.[13] Confucian writings discussed the role of the ruler and of the subject and proposed moral values to direct them both. The principal concepts concerned the nature of the good man, the *junzi*, who would exhibit warm and considerate behaviour, *ren*. Such behaviour could only be achieved through a lifetime of practice, the control of all aspects of personal conduct and the observation and proper performance of all social rules, which include *li*, the conduct of ritual in all its formal and informal manifestations.[14] Rituals embraced all aspects of family life, including ceremonies to show respect to ancestors and the preparation of burials. In this way Confucianism subsumed the earlier ancestor cults. Texts which described this approach to life and the proper conduct of it remained almost continually available to all generations of scholars and officials.

Confucianism took on a wider aspect when linked to the rituals of the state and city. Here the observance of rituals for the family, past and present, was extended to embrace the family and predecessors of the rulers. Sacrifices to the ancestors of the emperor were of course important state ceremonies, as were offerings to imperial predecessors and to great statesmen and warriors.[15] In addition, the harmony of the natural world was seen as responding to the moral conduct of the sovereign and his people, and the cosmos was thus drawn into the ritual practices of the state. All aspects of

nature that might affect the conduct of life, such as the seasons, the weather and natural disasters, were included in ritual observance. The principal state offerings were made at altars on large platforms raised in several tiers and situated in the suburbs of the capital. On the altars of highest rank it was not customary to depict figures as objects of worship.

Slightly lower down the hierarchical scale were sacrifices to emperors of previous dynasties and those to Confucius and his disciples held at similar altars, in both the imperial capitals and important regional capitals.[16] All major cities held rites in which sacrifices were made to gods, such as Guandi – a historical general who was worshipped as the god of military affairs – and the deities established in legends: Huangdi, Fuxi and Shennong, the fire god Huoshen, the dragon god and gods of water, and the city god, Chenghuang. At this level, official or Confucian practices were closely linked to popular religion and local gods, including important local figures who could be worshipped in temples alongside or adjacent to more generally revered figures. Daoism and Buddhism developed parallel popular branches.

Daoism was the converse of Confucianism, stressing non-action (*wuwei*), as opposed to the busy round of official and social rituals and practices, in order to allow nature free rein. In common with Confucianism, Daoism exhibited several distinct strands, which over time were wound together, principally a philosophical strand and a religious strand emphasising various personal disciplines. The philosophical texts are the famous *Daodejing*, attributed to a figure known as Laozi; the *Zhuangzi*, by the brilliant writer Zhuang Zhou (*c*. 399–295 BC), and the *Liezi*, which may have been compiled in imitation of the *Zhuangzi*.

These philosophical texts stressed the need to retire from the world and master the *dao*, or way. Only away from the constraints of morality, ritual and politics was a free, happy and independent life to be achieved. All distinctions, the life of the Confucian social hierarchy, were seen as arbitrary, and language and especially the written word, so essential to the social and political life of China, were castigated as illusory. The saints would instruct their disciples without uttering words. The recluse would also practise dietary, respiratory, sexual and physical exercises designed to nourish the vital principle. Daoists probably appropriated these exercises from much earlier magical rituals, and these continued over centuries in a prolonged series of experiments in the search for immortality. While emperors and their courts also followed these rituals and exercises, the loftier aims of Daoism had to be sought in retirement to remote areas (fig. 5), following the teachings of Daoist saints, who became themselves the focus of worship. Such cults were then emulated by the Buddhists and assimilated into their cults of saints.

The third major religion, Buddhism, was foreign, probably reaching China from the Indian subcontinent and Central Asia as early as the Han dynasty (206 BC–AD 220), but it did not become properly established until patronised by the Northern Wei (AD 386–535) and other non-Chinese dynastic houses who ruled north China after the third century AD.[17] The tenets of Buddhism, which taught that the release from suffering came through subjugating the desires of the world, were concerned primarily with individual salvation. In addition, Buddhism supported large religious communities divorced from the main structures of social life. As a result, funds and

5 Huangshan, Anhui province. The mountain range has at least seventy-two peaks, and the area has been a famous scenic spot since the Tang dynasty (AD 618–906), providing the inspiration for poetry and paintings.

lands were accumulated by monasteries in rivalry to state institutions, and such enclaves became the prey of aggressive emperors during periods of economic or political difficulty.

All three religions developed scriptural texts, rituals, temples in which to practise these rituals, and images to represent their deities. Some aspects of these are discussed in chapter 3.

Objects and society

It is a general characteristic of all civilisations, as highly stratified societies are often described, that many objects, buildings and texts are employed in the activities of religion, politics and daily life. However, it is also true that neither everyday objects, such as eating dishes and drinking glasses, nor the higher arts, such as painting or sculpture, are common to all peoples around the world. Although some constant factors can be found, such as some sort of building for shelter and some sort of ceramic or other containers for food, in most other details the diversity is astonishing. Every society develops its own objects, its own apparatus for living. In considering the abundant Chinese objects that survive today, three questions can help to illuminate the particular features of the society that made them: What were they used for? How were they made? And how did they serve and advance the well-being of society? For just as individuals seek survival and prosperity, so too do collections of individuals, whether in a village, city or state.

Chinese objects, particularly those amassed and preserved in museums,

are probably best discussed in terms of their functions. Therefore, consideration will here be given to the objects according to their use. First, writing and the arts related to the Chinese scripts are discussed, as writing was essential to the whole conduct of Chinese social life; next come the utensils related to religion and daily life; and last is a brief survey of the settings in which these utensils were used – palaces, temples and tombs.

One of the major features of the high arts (calligraphy and painting), of the utensils related to religion, ceremonies and daily life, and of architecture was their powerful role in cementing social and political relations. All societies use many different devices to ensure that their members do not resort to violence but follow some sort of code of conduct that ensures peace, at least most of the time. Very complicated societies such as that of ancient China had developed a long way beyond the use of direct force, constructing a hierarchy of central and local officials to maintain order, both by administering law and by enacting ceremonies of many kinds to proclaim publicly and privately the ordering of society. Moreover, as we have seen from the description of Confucianism, notions of morality and correct conduct as well as direct restrictions and ceremony were employed to manage society. The written word was another such tool. Not only were philosophical texts and administrative decisions written down, but so too were commentaries and letters, for example. By establishing and expressing social bonds in writing, both within a generation and between different generations, scholar-officials made explicit their allegiances to one another.[18] As these individuals constituted the ruling élite, their allegiances helped to achieve and maintain order in society.

From as early as the Anyang period of the Shang dynasty (c. 1300 BC), writing was intimately linked to the religious and political structure of the state. The earliest surviving bulk of Chinese characters, recording the divinations made from about 1300 BC on behalf of the Shang kings, are cut into the ox scapulae and turtle shells which were employed in divination (fig. 6). Thereafter, the practice of writing with a soft flexible brush developed, and several character types became standardised over a period of about a thousand years (ch. 2).[19] In addition to being written with a brush, texts were often cut into stone, which meant both that they could be made publicly visible and that they would endure. The first texts so recorded were the seven tablets announcing the conquests of the first emperor, Qin Shi Huangdi (fig. 7).[20] Although stone cutting was often the work of artisans, the individual style of the writer of the text was retained and transferred to the stone. In addition there developed the art of carving seals.

An essential characteristic of writing with a flexible brush is the ability of the brush to convey the subtle movements of the writer's hand and so preserve a sense of the person's individuality in the final work. From this effect developed the art of calligraphy, in which the styles of particular scholars could be recognised, admired and in due course emulated. The same brush techniques were employed for a type of painting, particularly from the Song dynasty (AD 960–1279), which was executed by scholar-officials and known as literati painting. Links between official writing and the arts of calligraphy and literati painting were forged through their common features: the brush itself, and the scholar-officials who wielded it. These

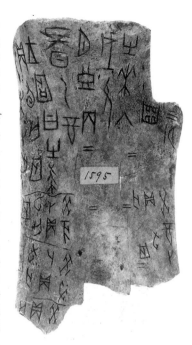

6 An inscribed oracle bone. Shang dynasty, 12th century BC. This ox scapula has the remains of six drilled depressions on the rear to which hot brands were applied, causing the cracks from which the divination was read. The characters, read vertically, ask whether there will be a disaster in the next ten-day week. The question is then repeated, and finally it is noted that there was indeed an invasion. L: 13 cm.

7 Rubbing of the Yishan tablet (*bei*). This stone inscription was one of seven set up by Qin Shi Huangdi following his conquest of the various states into which China had been divided (see pp. 10–11). The stone has not survived and the rubbing is made from a copy dated AD 993. The text is written in seal script, the script devised by the Qin state to unify the Chinese writing system. It proclaims the majesty and greatness of the first emperor in making his conquests.

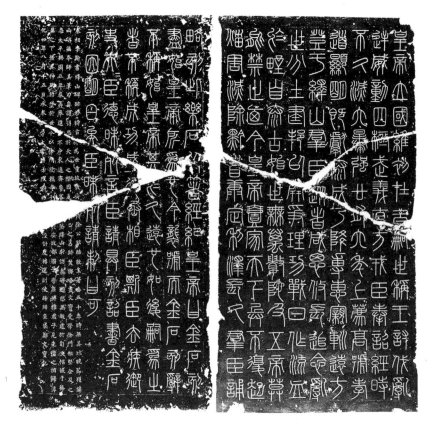

arts then accrued some of the other qualities inherent in official writing.

Scholar-officials looking at official documents would obviously assume that they contained something of value. Turning their attention to arts which employed the same techniques and aesthetic vocabulary – the same brushstrokes and ink tones on the same backgrounds of paper or silk – they were likely to view them in the same way. Thus the features shared by official texts and works of art meant that, despite their different functions, they were accorded a similar response and, indeed, respect. As many of the most important official writings were Confucian texts, from which the reader would expect to gain moral and spiritual insights, so the scholar-officials expected to gain the same understandings from calligraphy and painting.

Only calligraphy or painting undertaken by scholar-officials was accorded this respect. Fairly restricted in subject matter (mainly landscapes, though flowers and bamboo were also occasionally depicted), such painting differed in both content and technique from religious and decorative paintings, which were the work of artisans. Rather than emphasising the scholars' expressive calligraphic lines, professional painters employed rich colours and strong representational forms. Their religious and decorative paintings were not considered art at all (ch. 2, figs 68–9; ch. 3, fig. 110; ch.6, fig. 198).[21]

Writing, calligraphy and literati painting functioned at two different levels: the public and the private. Official documents and all texts carved on stone were for public consumption. Indeed, texts engraved on stone could be known and appreciated even more widely once rubbing copies were made

and circulated. But letters, poems, journals and paintings were more intimate exchanges between individuals. However, as all were done by members of a fairly restricted class, boundaries between the public and the private were blurred. Ancient texts, public and private, were collected by later officials and scholars, both in their original forms and in rubbing copies. Further comments, inscriptions (known as colophons) and seals were added to these earlier works by their later owners, often by people who saw such works only briefly. The same practices developed in the case of paintings, to which long inscriptions and seals were also appended.

Not only were writing and calligraphy direct means of communication, simple links between the most important members of society, but they also had a more subtle influence. Collecting contemporary calligraphy and painting, as well as the works of old masters, expressed an official's political and social affiliations. On those occasions when groups of scholars met to study and enjoy pieces of calligraphy or painting and to record their gathering, their links and bonds were made concrete in the inscriptions appended to the works. In addition, paintings were commissioned by officials to record appointments and other important occasions in their careers, and to these paintings were added inscriptions of comment and praise by contemporaries and admirers. Thus again the media of painting and calligraphy were used to forge social and political relationships.[22]

Objects played a similar role in bonding Chinese society and probably do so in most other societies. They were important not only in the public display of political power but also in private life. We all make judgements about what is going on around us from what we can see at a glance.[23] A person's dress and the furnishings in their home tell us far more quickly what we need to know about their age and status, social class and interests than a potted biography, written or spoken, could ever do.

These judgements rely on our understanding of the ways in which the hierarchies of society are linked to the hierarchy of arts and of goods in that society. Different societies rank materials and artefacts differently in their order of value or esteem. Among the artefacts we use in the West, buildings are considered especially important, and there is a very clear hierarchy among buildings in any city, with the residences of kings, religious buildings and civic meeting-places at the top.[24] We also rank our materials, starting with the precious metals – gold and silver – and followed by high-quality stones, right down to cotton and earthenware near the bottom.

In China, architecture was employed as a marker of status and position, but objects such as dress, furnishings and utensils were comparatively more important. In the first place, they were made in enormous numbers and could, therefore, be very widely distributed. In addition, their very high technical and aesthetic levels meant that a wide range of quality, from the very best to the most rudimentary, could be established within any material. Moreover, as we shall see, the skill with which these materials could be worked and designed led to the development of a large number of very small variations. This wide range in quality and multitude of variations enabled the complexity of goods to match the complexity of the official and social hierarchy developed over the centuries in China. Further, as many of the items were produced in state factories, their distribution was basically deter-

mined from the top and followed the lines of officialdom. In this way objects and dress, both for official occasions and for daily life, were closely correlated with the ranks in society. At a glance, therefore, a person's exact status and social links would be evident from his dress and possessions.[25] These gave information to onlookers, thus enabling them to adjust their manners appropriately. As much as the laws of society and the Confucian rules of conduct, objects of all sorts became a component of the adhesive that held together the Chinese élite.

The goods which dominate any society depend upon what objects and what materials the élite chooses to use for religious and political ceremonies. As already mentioned, in the West gold, silver and precious stones were selected for sceptres, crowns and Christian chalices. These objects and materials thus occupied the highest levels in the hierarchy of goods. They set standards of design and of visual quality that were admired and emulated. Polished and glittering surfaces still retain a high position in our visual world, and many people wear gold chains and silver bracelets.

China is unusual in having developed for this high level in the hierarchy two different ranges of materials and therefore two distinct aesthetic worlds: the first was that of bronze and jade, and the second that of gold and silver. In ancient China, bronze and jade were employed for ritual implements. These ritual objects were really everyday objects, such as stone tools and cooking pots, made in particularly prized materials. The simple use of fine materials marked jade sceptres and bronze cauldrons as more potent than everyday tools and pots. Furthermore, changes to shape and decoration increased the gulf: jade sceptres were ground thinner than ordinary stone tools, and bronze cauldrons were sometimes made in rectangular forms that were less common in ceramic. Chinese religious paraphernalia, and thus the hierarchy of utensils, dramatically changed from the fourth and fifth centuries AD as a result of the introduction of foreign images and utensils along with Buddhism, and gold and silver vessels and images became the norm.

For technical reasons, both jade and bronze were fashioned into heavy, rounded shapes: jade was laborious to work and unsuitable for slender, sharply angled forms; bronze was cast and therefore made into thick-walled, rounded vessels (ch. 1, figs 23 and 30). Ceramic copies reproduced these solid heavy forms and their subtle dense colours. Although ancient ritual jades and bronzes went out of use for a time after the Han dynasty (206 BC–AD 220), they were revived from the Song period (AD 960–1279), as were ceramics based upon them (fig. 8).

Gold and silver, by contrast, can be hammered into sheets from which vessels are worked. As a result, sharply angled, crisp, thin-walled vessels were developed. When potters imitated these in porcelain they made very thin fluted bowls and ewers with long stems and bent handles (fig. 9).[26] In this way, two separate and distinct visual standards were developed: the subtle colours and heavy shapes of the jades and bronzes, and the much more delicate forms of the silver and gold vessels, with narrow stems and fluted bodies.

These two distinct hierarchies established two visual traditions linked implicitly to the functions of bronze and silver. Thus the green-glazed wares in figure 8, imitating jade and bronze, are late descendants of the ancient

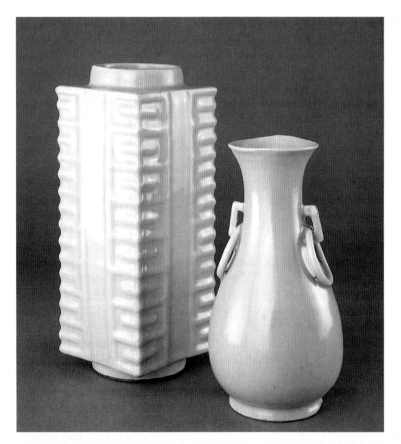

8 Two flower vases in green-glazed ceramic from Longquan, Zhejiang province. Song dynasty, 13th century AD. The one on the left is in the shape of an ancient jade *cong*, the other that of a bronze flask with ring handles. Both the green glazes and the shapes refer self-consciously to ancient jade and bronze forms. Such items would have been used on household altars or on desks in scholars' studies.
HT: 26 cm; 20.9 cm.

9 (*below*) A porcelain ewer and cup on a stand, both decorated with *qingbai* glaze. Song dynasty, 12th–13th century AD. The fragile thinness of the pieces and the indented lobes, narrow spout and small ring on the bent handle are all features borrowed from silver. The pieces were used for drinking wine or tea and thus imitate more expensive sets in silver.
HT: 16.5 cm; 5.2 and 3.8 cm.

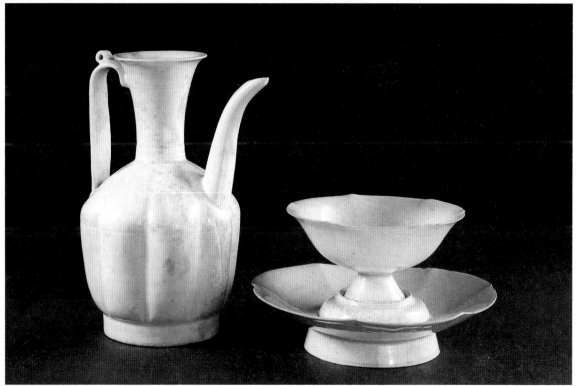

ritual tradition; their appearance tells us that they are appropriate for use on household altars as flower vases or on writing tables in the scholar's study. The white porcelains (fig. 9), on the other hand, imitate gold and silver and can immediately be recognised as belonging to the tradition of high-quality eating utensils rather than to the set of objects for altars or studies. Such sequences of interrelated shapes across several different materials make evident the degree to which we all rely on visual clues to tell us not only what we are looking at, but also to what sort of tradition or function the objects belong. These two different lineages or traditions added greatly to the variety and interest of the Chinese world.

In addition to these two quite distinct aesthetic standards, Chinese ceramics, lacquers and other decorative arts are remarkable for their very fine surfaces and wonderful colours. These were achieved by sophisticated techniques in firing ceramics or in producing and dying silk. Such wonderful tactile and visual qualities made for a beguiling material world, to which the Chinese élite became accustomed. Moreover, these items were not rare, but were made in very large quantities to meet the demands of a large population.

In the West we now take the supply of large quantities of highly finished goods for granted because we have learned techniques and methods of production from the Chinese: Western porcelain and silk-weaving are both derived from China. But China's most remarkable contribution was the creation of the first large-scale factories in which bronzes, lacquers, textiles and ceramics were mass-produced, not using machines as in modern factories, but using workers among whom the required processes were subdivided.

The simple fact that large numbers of bronzes and ceramics survive indicates that the workshops were not small enterprises with a master and some assistants, but that large numbers of workers were involved. In the Shang period c. 1250 BC, members of the élite might own over two hundred bronze ritual vessels. The Marquis of Zeng was buried in about 433 BC with ten tons of bronze (ch. 1, figs 42–3; Bronze glossary). More than two thousand years later Dutch ships would carry 150,000 pieces of Chinese porcelain in a single load. In addition, the difficulty of the processes and the many small variations in technique and design suggest that the work was subdivided between a number of different workers. A few surviving inscriptions give specific information on the way this was done.

An inscription on a Han dynasty lacquer cup (fig. 10) in the British Museum reads:

> In the fourth year of the reign period Yuan Shi [AD 4], the Western Factory workshop of the Shu prefecture manufactured this lacquered, polished and painted, wooden-cored cup with yellow [i.e. gilt bronze] ear-handles for imperial use. Capacity one *sheng* 16 *yue*. Manufactured by: the wooden core by Yi, lacquering by Li, top-coat lacquering by Dang, gilding of the ear-handles by Gu, painting by Ding, final polishing by Feng, product inspection by Ping, supervisor-foreman Zong. In charge were [Government] Head Supervisor Zhang, Chief Administrator Liang, his deputy Feng, [their subordinate] Executive Officer Long and Chief Clerk Bao.[27]

There are a number of very similar inscriptions on several lacquer pieces of

the same period, and from them we learn that the different stages in the process of lacquering a single cup were carried out by different individuals. Indeed, every piece made would pass through the hands of several workers, who might move about and undertake different tasks within the sequence. Even more important, we learn that there were nearly as many organisers or managers as workers. These men presumably structured the tasks and arranged the receipt and delivery of orders, materials and finished goods. Indeed, the structure for governing the country by officials was paralleled in the manufacturing industry.

Finally, and perhaps most important of all, the factory belonged to the state and so was part of government. Very large numbers of factories were run either by the central state or by local officials, and the objects they produced were part of an extensive command economy. This system had started simply: the princes and kings of early China controlled raw materials and set up workshops to supply their palaces with all their needs, from religious utensils (the bronzes and jades already mentioned) to furnishings and dress, weapons and tools. Such factories filled orders from the courts and probably made further items for use as gifts, for gifts were as important as trade in the distribution of luxury goods.[28] Private workshops, foundries and kilns always existed, and markets in their products developed. The degree to which they flourished depended upon the economy of the time.[29] However, it is probably the case that all the items most central to the religious, political and social hierarchies were produced in state-run factories, and that these factories probably always supplied goods of a higher quality than those available from private ones.

Although here we are only concerned with factories making luxuries, we can imagine the role of government in controlling all such operations by considering the iron industry, which produced both tools and weapons. China was the first country in the world to develop the casting of iron. Very high temperatures are required to smelt it from its ore, and in the West these temperatures were only achieved in the late Middle Ages. But the Chinese, from probably at least the sixth century BC, could smelt and cast iron into weapons, chariot parts and tools. Foundry remains show that the industry was large, and that mass-production methods were standard. For example, groups of moulds used for casting identical parts, such as chariot axle-caps, were replicated from a master pattern, stacked one upon the other and linked by small channels (fig. 11), so that with a single pour of hot metal many identical axle-caps could be produced.[30]

The iron industry never ceased to be a major factor in the Chinese economy, and from time to time it must have dominated all other forms of production.[31] In AD 806 China was producing 13,500 tons of iron a year and by the Song period this had risen to 125,000 tons. This dramatic rise was due to major economic expansion under the Song, and the need to equip a large army against the peoples on the northern borders of China, as discussed on p. 18. The scale of this effort was enormous: in 1040 the regular army comprised 1.25 million men and by 1160 the output of the armaments office reached 3.24 million weapons a year. As a minor by-product of this large armaments industry, iron was cast into religious images and guardian figures for temples (fig. 12).

10 Lacquer cup. Han dynasty, dated AD 4. The long inscription on this cup gives the names of the workers involved in its making. It is one of a number of similarly inscribed lacquer pieces made in the same period, which document the widespread and early use of division of labour in manufacturing in China. L: 17.6 cm.

At all these periods the equipment of the army was of major importance to the state, and the state would obviously have wished to retain overall control. But all other factory enterprises can also be seen in the same light, as supplying the needs of the state. In the case of ritual objects, dress and furnishings, we see the distribution not of weapons of war but of materials that enhanced and maintained the religious, political and social structure that the emperor deemed essential for a stable and prosperous state. The court and local officialdom directed the factories to supply goods of appropriate categories to officials and workers. Luxuries of the very highest quality can only have been available to the imperial household and the top officials.

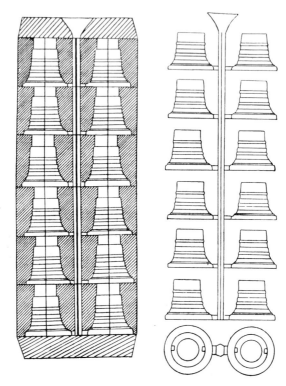

11 Moulds for iron axle-caps, from the Wen xian foundry site in Henan province. Han dynasty (206 BC–AD 220). (left) The moulds stacked, ready for the molten metal to be poured in. (right) The chariot fittings, still linked together after the moulds have been removed. Stacked moulds for both bronze and iron casting were invented in the Eastern Zhou period (770–221 BC) and enabled huge numbers of weapons, chariot parts and coins to be manufactured, using a single model to produce the multiple moulds.

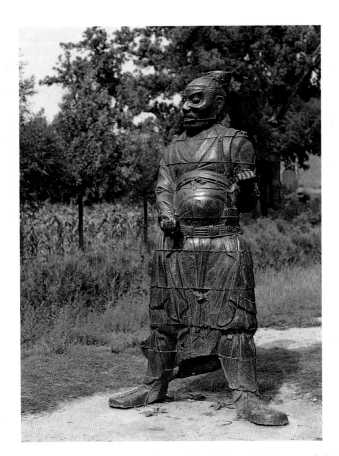

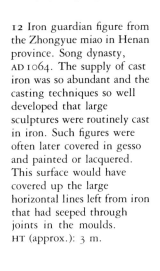

12 Iron guardian figure from the Zhongyue miao in Henan province. Song dynasty, AD 1064. The supply of cast iron was so abundant and the casting techniques so well developed that large sculptures were routinely cast in iron. Such figures were often later covered in gesso and painted or lacquered. This surface would have covered up the large horizontal lines left from iron that had seeped through joints in the moulds. HT (approx.): 3 m.

Indeed, the very finest and most beautiful objects in terms of design and finish were owned in the largest sizes and in the greatest numbers by the emperor and, below him, by the highest-ranking members of the court.

We can demonstrate this by looking first at some early products, the ritual bronzes, and then at later ones, such as court dress. The bronzes owned by Fu Hao (c.1250 BC), a consort of a Shang king, can for example be compared with the bronzes owned by a much lower-ranking member of the élite of the same date, the occupant of a contemporary tomb known as tomb 18 at Anyang Xiaotun (Tombs appendix). While Fu Hao had over two hundred ritual bronzes, the noble had twenty-four. Those of Fu Hao were large, often fifty or sixty centimetres high, while those of the noble were between twenty and thirty centimetres high. Figure 13 shows a wine container on three pointed legs, known as a *jia*, which belonged to Fu Hao; it towers over the vessel of the same type belonging to the noble. Its thicker casting makes it immediately obvious to the onlooker that it is made of a precious resource, bronze. It is also much more elaborately decorated than the *jia* from tomb 18. In other words, higher aesthetic qualities as well as larger size and greater numbers were available to the very powerful.[32]

As bronze was at the time the material used for weapons, it is likely that all bronze casting was ultimately controlled by the court. Indeed, we know from bronze inscriptions of about 1020 BC that bronze was often given as a gift by the king to his nobles, enabling them then to have bronze ritual vessels cast. By controlling the supplies of metal, the king probably controlled the number and size of bronze ritual vessels any particular noble

13 Two bronze ritual vessels of the type *jia*, from tombs at Anyang Xiaotun. Shang dynasty, 13th century BC: (*left*) from the tomb of Fu Hao; (*right*) from tomb 18. The size and complex decoration of the piece from Fu Hao's tomb indicate her power and wealth. In this way differences in the social hierarchy were made visible. HT: 65.7 cm; 28.2 cm.

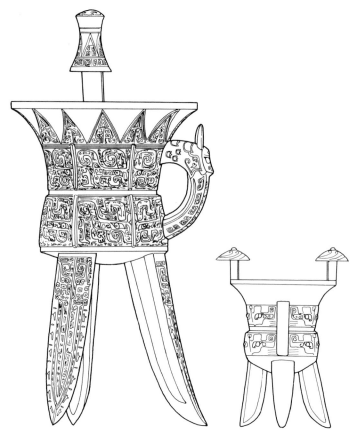

might own. From the number, size and decoration of their ritual bronzes, members of the élite must have been able to assess the status of their fellows. What is more, it is probable that the royal family and the élite believed that their ancestors and the spirits could make similar judgements about the status of their families as they received the offerings made in the vessels.

Just as the Shang rituals were moments when the status of members of the court was made visible through the size and above all the aesthetic qualities of their ritual bronzes, all later court and other official ceremonies performed the same function, often through the medium of official dress (ch. 4, p. 194). For all periods for which records survive, official texts prescribe this dress. A section on ritual in the Song history gives the following information:

> Official clothes . . . The Song, following Tang regulations, [state] that the third rank and above wear purple, the fifth rank and above wear cinnabar, the seventh rank and above wear green and the ninth rank and above wear dark blue. As for these regulations, from royal dukes down to the lowest rank of officials, all wear the curved collar, large sleeves, the horizontal band at the hem, tied with a leather belt, the *putuo* [official hat], and black leather boots.
>
> *Song shi, Zhonghua shuju* edition, vol. II, *quan* 153, p. 3561

Very little early dress survives, but many examples of the eighteenth and nineteenth centuries are in the palace collections in Beijing and Taipei as well

as in Western museums. While the brilliance of the colours is immediately striking, what is also apparent is that, although their shapes are all remarkably standard, very small differences distinguish one robe from another. Variations might occur in embroidery, fringes and borders and, in the Qing dynasty, in the badges of different ranks (fig. 14). These practices were very different from those of Western court life. Although there were sumptuary laws in the West, courtiers by and large manifested their positions at court by the variations in their embroidery and jewellery, which tended to change with the whim of fashion. In China, as these displays of official position were prescribed from above and not subject to personal choice, very minute variations in colour or detail of embroidered design could be used to signify rank.[33]

Although there is less detailed knowledge about the control and supply of other materials, it is clear from surviving lacquers, textiles and ceramics that something of the same regulation applied to the highest levels of utensils, furnishings and dress.[34] Wealth alone could not purchase the most highly desired objects, for China was a society in which goods were supplied from the top downwards. Within the very dense population of China all scrambled for position, but it was in the interest of those higher up to make sure that those lower down did not exceed their prescribed privileges. In this way the possession and use of goods followed and sustained the structure of society.

The settings in which these goods were used – the palaces, tombs and temples – were equally standardised. The principal architectural features were relatively simple and changed little over three thousand years. Structures made of wood stood on solid compressed earth or brick platforms and had roofs of ceramic tiles. The frameworks consisted of wooden columns bound together by horizontal beams and supported on stone bases. The beams were so arranged as to carry a heavy curved roof, whose overhang protected the building from the elements. The regular grid of columns and beams meant that the buildings were made up of a number of repeated units, which could be increased or decreased as required. Over time, wooden brackets were developed for the junction of the column and beam in order to spread the load (fig. 15). All these parts were made in a limited number of forms and were employed in buildings of many functions (Architecture appendix). Although these parts were standardised in shape, they were varied in size for buildings of differing importance. We know from an official manual on building construction, *Yingzao fashi*, compiled by the Song official Li Jie (d. AD 1110), that there were eight ranks of building defined by the sizes of their wooden structural members.[35]

Ground plan as well as structure defined the hierarchical position of a building. Early buildings consisted of one main hall surrounded by smaller buildings within the outer wall of the compound. For larger and more prestigious buildings, the halls could be increased in size by adding a bay, or additional halls could be placed one behind another. The palace of the Forbidden City in Beijing exhibits such variation in the sizes of its halls and in the sequences of the different buildings in the different sections.[36] The principal building, the Hall of Supreme Harmony (fig. 16), lies at the centre of the complex (fig. 17). Its importance is emphasised by its high platform,

14 Embroidered badge of rank, with a phoenix among clouds above an island in the sea. Early Qing dynasty, 17th century AD. The wearing of embroidered badges of rank first became compulsory in AD 1652. 32 x 32 cm.

elevating it above all the surrounding buildings, as seen from the south, the direction in which courtiers and ambassadors would have approached. Here the main ceremonies on the accession of an emperor were performed, and here too the ceremonies for honouring empress dowagers, for the New Year, for the Imperial Birthday and for the Winter Solstice Prayers to Heaven took place. Behind the ceremonial halls lay the Inner Court, where the emperor and empress had their living quarters. The buildings were not only implicitly ranked according to the status of their owners or of their uses, but access was also decided by rank. Office and position determined who could enter the different parts of the palace, and the same was true on a lesser scale for all buildings of any significance. Such buildings were the stages on which Chinese society performed its religious, political and social rituals, and the buildings were designed to fill this role (ch. 4, fig. 145).

The buildings of the dead were equally well attuned to the hierarchical structure. Tombs were replicas of the outside world and, as in the world, the proper rank and degree of the deceased had to be shown. Early tombs consisted simply of coffins in which the burial goods were the possessions of the dead, thus implicitly reflecting the owner's rank. Over time, however, tomb structures started to recreate more fully the shapes of buildings. In the tomb of the Marquis of Zeng, buried in about 433 BC, for example, different rooms in the outer coffin represented the hall of a palace, the retiring

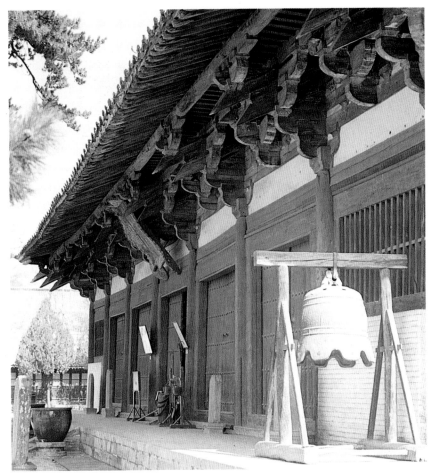

15 View of the main hall of the Foguangsi Buddhist temple in the Wutai mountains, Shanxi province. Tang dynasty, 9th century AD. The view illustrates the bracketing system by which the heavy overhanging roof was supported. Such roofs protected the wooden structure and gave it stability in high winds. (For a plan and cross-section of the building see Architecture appendix, figs 218–19.)

16 (*below*) The Hall of Supreme Harmony in the Forbidden City, Beijing. First built in the 15th century, the hall has been restored many times. It is raised on a double terrace, with two other audience halls behind it (see fig. 17). The outer pillars are over 60 metres apart, and the hall is over 35 metres high. It has the most complicated roof system available, being double-eaved, hipped and having one horizontal and four sloping ridges.

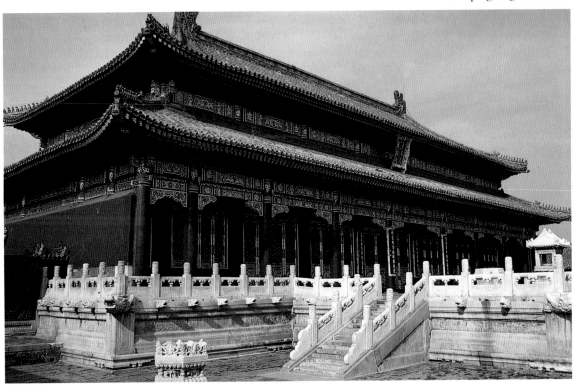

17 Plan of the Forbidden
City at the centre of Beijing,
first built in the Ming
dynasty but extended and
restored many times. The
plan indicates the hierarchical
arrangement of the
buildings: at the centre are
three main audience halls
(see fig. 16), and behind are
the living quarters of the
emperor and his empress.
Many of the lower side
buildings were government
offices. At the rear is a
theatre and a garden.

KEY

 1 Noon Gate
 2 Gate of Supreme Harmony
 3 Hall of Supreme Harmony
 4 Hall of Central Harmony
 5 Hall of Protecting
 Harmony
 6 Gate of Heavenly Purity
 7 Hall of Cultivating Mind
 8 Palace of Heavenly Purity
 9 Hall of Mutual Ease
10 Palace of Earthly Repose
11 Six West Palaces
12 Gate of Earthly Repose
13 Imperial Garden
14 Hall of Imperial
 Tranquility
15 Gate of Martial Spirit

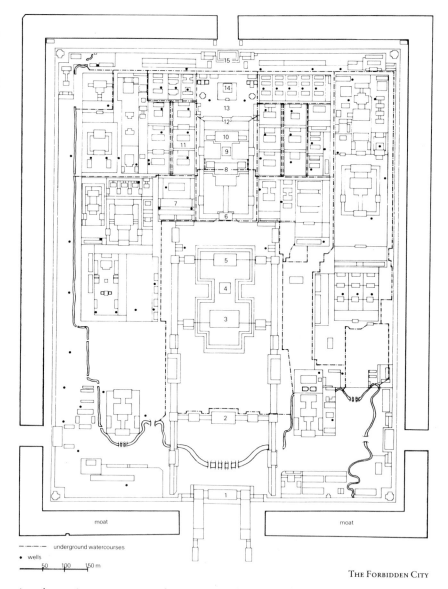

THE FORBIDDEN CITY

chamber, the armoury and the room for servants or concubines (Tombs
appendix).

Tomb goods also reproduced aspects of life. Thus the pottery models of
figures and buildings, which started with the spectacular army of the first
emperor (ch. 3, fig. 91), were intended to supply the dead with all the
necessities for life after death. So keen were the living to make sure that life
after death would be of the same standard as the present one that vast
treasures were buried, often impoverishing families and ultimately the state.
Many rulers therefore imposed regulations to prevent quantities of precious
material and labour being wasted, particularly at times of economic
difficulties.[37] The buildings and sculptures above ground were also intended
to provide for all aspects of the life of the deceased.

Many religious sculptures should be understood in the same way.

Temples, like palaces and great houses, provided the stage settings for ritual. As mentioned above in connection with the sacrifices of the official state rituals, altars of varying sizes were prescribed for the different sacrifices carried out in the different cities of the empire. In addition, the future life promised by the religions was modelled on the aspirations of the present. In the afterworld the ranks and hierarchies of this world would be reproduced, as would no doubt the physical settings and objects of the living. Buddhism also took the present as a model for paradise. Large paintings from the Buddhist cave temples at Dunhuang in Gansu province show the heavenly world as a magnificent Chinese court, complete with the wooden buildings of the day (ch. 3, fig. 110). In Hell, likewise, the ranks and positions of the officials would be reproduced (ch. 3, fig. 114).

A complete contrast was provided by Daoism, which viewed the natural world, especially mountains, as the home of immortals (fig. 18). Counterbalancing the Confucian life of the court and the ordered society, there always remained one option to the Chinese: a return to nature and the spontaneity associated with the natural world. Thus, as well as the cultivated official, there emerged the stereotype of the wild or mad recluse or artist. These hermits would retreat to the countryside to be near the mountainous peaks, the gateway to immortality.[38] Here, amid the rocks, a slit or crevice was to be found which led into another world. But the paradise beyond is not an otherworldly paradise filled with angels, as described in the Western world; it is a land with a calmer, better life, a more archaic version of the life of the present.[39]

A famous description of such a place is found in the writings of the poet Tao Yuanming in the 'Peach Blossom Spring'. He tells of a fisherman who goes upstream for some considerable distance until he reaches a peach grove. At the far end of the grove he finds the base of a mountain, and here he follows a stream through a crevice and enters a cave. Then he emerges from the cave into a new world:

> . . . after a few dozen steps [the cave] suddenly opened out into a broad and level plain where well-built houses were surrounded by rich fields and pretty ponds. Mulberry, and bamboo and other trees and plants grew there, and the criss-cross paths skirted the fields. The sounds of cocks crowing and dogs barking could be heard from one courtyard to the next. Men and women were coming and going about their work in the fields. The clothes they wore were like those of ordinary people. Old men and boys were carefree and happy.
>
> J. R. Hightower, *The Poetry of T'ao Ch'ien*, Oxford, 1970, pp. 254–5

Thus paradise mirrored the calm, everyday life that the Chinese hoped to achieve by means of their complex hierarchical social and political structures. As mentioned, images of the Buddhist paradise and of Hell likewise based themselves on the world. Paradises and hells would have shared the objects and arts of the world itself, and the objects would have had similar functions of marking position and of creating social bonds.

The complex structures of Chinese social and political life embraced the whole country in one over-arching pattern, and within that wide sphere – across a vast land with an extraordinarily dense population – smaller struc-

18 Four miniature mountains: (*left to right*) turquoise, Qing dynasty, 18th century, HT: 14 cm; bamboo, Qing dynasty, 17th century, HT: 25 cm; porcelain, 20th century, HT: 5.8 cm; jade, Qing dynasty, 18th century, HT: 15.5 cm. Small representations of mountains signified the retreat of the scholar from official life and offered the alternatives of a hermit's existence or of individual expression in the face of strong government bureaucracy. Such mountains were also seen as a route to paradise (see ch. 4, fig. 129).

tures mirrored larger ones; these structures were perpetuated in descriptions of other worlds beyond the crack amid the rocks and across the boundary of death. No other people has built such an ordered, coherent society spread across such an immense area, and maintained it over such a length of time. Also, few peoples, if indeed any before modern times, have matched the extraordinary visual and technical virtuosity of Chinese calligraphy and of the bronzes, jades, dress, lacquers and ceramics which helped to bind this society together. Indeed, objects seem essential elements in the order and coherence so much valued by the Chinese.

Notes

1. For topics on Chinese science and technology see J. Needham, *Science and Civilisation in China*, Cambridge, 1965. The transfer of Chinese technology requires further study, but for a general overview see J. Merson, *The Genius that was China: East and West in the Making of the Modern World*, New York, 1990.

2. Tong Enzheng, 'Shi lun wo guo cong dongbei zhi xinan de biandi banyuexing wenhua zhuanbodai', in *Wenwu Chubanshe chengli sanshi zhounian jinian: wenwu yu kaogu lunji*, Beijing, 1987, pp. 17–43.

3. For further information the reader is referred to the chronologies in the appendix and to general surveys of Chinese history, including J. Gernet, *A History of Chinese Civilization*, Cambridge, 1982. Published volumes of *The Cambridge History of China* listed in the General bibliography should also be consulted.

4. For translations of parts of the Zhou text, the *Shujing*, and selected bronze inscriptions see W. A. C. H. Dobson, *Early Archaic Chinese, A Descriptive Grammar*, Toronto, 1962.

5. A. F. P. Hulsewé, *Remnants of Ch'in Law, An Annotated Translation of the Ch'in Legal and Administrative Rules of the 3rd Century B.C. Discovered in Yün-meng Prefecture, Hu-pei Province, in 1975*, Leiden, 1985.

6. A. F. P. Hulsewé, *China in Central Asia, The Early Stage: 125 B.C.–A.D. 23, An Annotated Translation of Chapters 61 and 96 of the History of the Former Han Dynasty*, Leiden, 1979.

7. For a discussion of the role of imperial patronage of the arts for political purposes see J. K. Murray, 'Sung Kao-tsung as Artist and Patron: The Theme of Dynastic Revival', in Chu-tsing Li (ed.), *Artists and Patrons, Some Social and Economic Aspects of Chinese Painting*, Kansas, 1989, pp. 27–36; and J. K. Murray, *Ma Hezhi and the Book of Odes*, Cambridge, forthcoming.

8. In this and succeeding sections, I am indebted to L. Ledderose, 'Chinese Calligraphy: Its Aesthetic Dimension and Social Function', *Orientations*, October 1986, pp. 35–50. His University of Cambridge Slade Lectures, Lent Term 1992, *Module and Mass Production in Chinese Art* (forthcoming publication),

have contributed many of the ideas expressed in this introduction.

9. For discussions on changes in the structure of politics in the Warring States see M. E. Lewis, *Sanctioned Violence in Early China*, New York, 1990.

10. For a review of recent work on the Qin, with special reference to archaeological finds see L. Ledderose and A. Schlombs, *Jenseits der Grossen Mauer, der Erste Kaiser von China und Seine Terrakotta Armee*, Munich, 1990.

11. Full information on Chinese official ranks and titles is given in C. O. Hucker, *A Dictionary of Official Titles in Imperial China*, Stanford, 1985.

12. Surveys of Chinese religious belief and practice are rather limited in number. The following should be consulted: 'The Mind and Senses of China, Beliefs, Customs and Folklore', in B. Hook (ed.), *The Cambridge Encyclopedia of China*, Cambridge, 1982, pp. 304–38; J. L. Watson and E. S. Rawski (eds), *Death Ritual in Late Imperial and Modern China*, Berkeley, Los Angeles, London, 1988; S. Feuchtwang, *The Imperial Metaphor: Popular Religion in China*, London and New York, 1992; A. P. Wolf, *Studies in Chinese Society*, Stanford, 1978; S. Teiser, *The Ghost Festival in Medieval China*, Princeton, 1988.

13. For a discussion of the major philosophical schools, including Confucianism, Daoism and Legalism, see B. I. Schwartz, *The World of Thought in Ancient China*, Cambridge, Mass. and London, 1985.

14. For the nature of Confucian ritual, see R. Eno, *The Confucian Creation of Heaven, Philosophy and the Defense of Ritual Mastery*, New York, 1990. The principal ancient texts on aspects of ritual are found in the *Zhou li*, the *Liji* and the *Yili*. For Neo-Confucian interpretations of ritual see P. Ebrey, *Chu Hsi's 'Family Rituals'*, Princeton, 1991; P. Ebrey, *Confucianism and Family Rituals in Imperial China*, Princeton, 1991; R. L. Taylor, *Iconographies of Chinese Religion*, XII, 3: *The Way of Heaven*, Leiden, 1986.

15. Ritual was an essential element of Chinese religious practice. See R. Eno, 1990, op. cit.; H. J. Wechsler, *Offerings of Jade and Silk, Ritual and Symbol in the*

Legitimization of the T'ang Dynasty, New Haven and London, 1985; D. McMullen, *State and Scholars in T'ang China*, Cambridge, 1988.

16. Described in S. Feuchtwang, 'School-Temple and City God', A. P. Wolf, 1978, op. cit., pp. 103–30.

17. K. K. S. Ch'en, *Buddhism in China: A Historical Survey*, Princeton, 1964.

18. See references to the writings of L. Ledderose mentioned in footnote 8 above. See also L. Ledderose, *Mi Fu and the Classical Tradition of Chinese Calligraphy*, Princeton, 1979.

19. For a description and discussion of these texts see L. Ledderose and A. Schlombs, 1990, op. cit., no. 57.

20. It is evident from Chinese art historical criticism from the Song period (S. Bush, *The Chinese Literati on Painting: Su Shih (1037–1101) to Tung Ch'i-ch'ang (1555–1636)*, Cambridge, Mass., 1971) that Chinese categories of what they considered art were arbitrary, in the sense that they were defined by the society. Sculpture, for example, was not regarded as an art. Western categories can therefore be regarded as constructed in a similarly 'arbitrary' way.

21. Consider the discussion of the Tang dynasty rituals in H. J. Wechsler, 1985, op. cit., chapter 1.

22. L. Ledderose, 1986, op. cit., pp. 35–50; C. Clunas, *Superfluous Things, Material Culture and Social Status in Early Modern China*, Cambridge, 1991, p. 119; A. De Coursey Clapp, *The Paintings of T'ang Yin*, 1991, chapter 3.

23. The word glance is used here to stress the rapid assessments made by a quick scan of the eyes. I have found it useful to consider perceptual studies in explaining how judgements about objects are made (see reference in footnote 32 below). An understanding of cognition is an essential precondition of an explanation of how we all use objects in our daily lives, both as utilitarian items and as indicators of status.

24. For a discussion of the notion of hierarchy in the arts see P. O. Kristeller, 'The Modern System of the Arts: A Study in the History of Aesthetics', *Journal of the History of Ideas*, vol. 12, pp. 496–527; vol. 13, pp. 17–46.

25. T'ung-Tsu Ch'u, *Law and Society in Traditional China*, Paris, 1961, p. 135.

26. For a discussion of hierarchies of materials and of the imitation of gold and silver in porcelain see J. Rawson, 'Chinese Silver and Its Influence on Porcelain Development', in P. E. McGovern and M. D. Notis (eds), *Ceramics and Civilization*, vol. IV: *Cross-Craft and Cross-Cultural Interactions in Ceramics*, Westerville, Ohio, 1989. For a wider consideration of this phenomenon see M. Vickers (ed.), *Pots and Pans, A Colloquium on Precious Metals and Ceramics in the Muslim, Chinese and Graeco-Roman Worlds, Oxford 1985*, Oxford, 1986.

27. I am indebted for this translation (as well as for that below from the *Song shi*) to Carol Michaelson, who has followed W. Willets, *Chinese Art*, London, 1965, p. 135. Other lacquer items with similar inscriptions are discussed in Wang Zhongshu, *Han Civilization*, New Haven and London, 1982, chapter 4. For a general discussion of the import of this inscription see L. Ledderose in the Slade Lectures cited (in footnote 8).

28. The relative importance of distribution, gift and purchase is difficult to assess at present, as little or no work has been done on the subject. Many forms of distribution, including, for example, the so-called tribute system, were described as gifts, but should probably be understood at least as barter if not as trade. For a brief account of the tribute system (mentioned in ch. 6) see M. Rossabi (ed.), *China among Equals, The Middle Kingdom and Its Neighbours, 10th–14th Centuries*, Berkeley and Los Angeles, 1983, pp. 3–4.

29. C. Clunas has examined China's consumption of goods, most of which were presumably available for purchase during the late Ming period, in C. Clunas, 1991, op. cit.

30. For reports on complex iron foundry techniques see *Kaogu xuebao* 1978.1, pp. 1–24; *Zhongguo yezhushi lunji*, Beijing, 1986, pp. 248–78.

31. For a discussion of the role of the iron industry, see R. Hartwell, 'Markets, Technology and the Structure of Enterprise in the Development of the Eleventh-Century Chinese Iron and Steel Industry', *Journal of Economic History* 26, 1966, pp. 29–58; 'A Cycle of Economic Change in Imperial China: Coal and Iron

in Northeast China, 750–1350', *Journal of Economic and Social History of the Orient*, vol. 10, 1967, pp. 103–59; and W. H. McNeill, *The Pursuit of Power*, Chicago, 1982, chapter 2.

32. Discussed by J. Rawson in 'Late Shang Bronze Design: Meaning and Purpose', a paper presented to a colloquy held at the School of Oriental and African Studies, London University, in June 1990, to be published in the proceedings.

33. For references to the sumptuary laws controlling dress see Ch'u, 1961, op. cit., p. 137.

34. C. Clunas, 'The Art of Social Climbing in Sixteenth-Century China', *The Burlington Magazine*, June 1991, pp. 368–75, mentions Ming sumptuary laws while also describing the purchase of objects to increase status. See also C. Clunas, 1991, op. cit., p. 149.

35. For illustrations of the components of buildings see Architecture appendix, where drawings are shown based upon *Zhongguo gudai jianzhushi*, Beijing, 1980. Good illustrations and drawings of the construction of a wooden building are found in *Ying Xian muta*, Beijing, 1980. For discussion of the *Yingzao fashi* and the grading of buildings according to the sizes of their structural components see E. Glahn, 'Unfolding the Chinese Building Standards: Research on the Yingzao Fashi', in N. Schatzman Steinhardt et al., *Chinese Traditional Architecture*, New York, 1984.

36. The Forbidden City and palace life are illustrated in Yu Zhuoyun, *Palaces of the Forbidden City*, Harmondsworth, 1984, reprinted 1987; and Wan Yi, Wang Shuqing and Lu Yanzhen, *Daily Life in the Forbidden City*, Harmondsworth, 1988.

37. See, for example, P. Ebrey, *Chu Hsi's 'Family Rituals'*, Princeton, 1991, pp. 109–10.

38. For artefacts associated with this view see Kiyohiko Munakata, *Sacred Mountains in Chinese Art*, Urbana and Chicago, 1991.

39. L. Ledderose, 'The Earthly Paradise: Religious Elements in Chinese Landscape Art', in S. Bush and C. Murck (eds), *Theories in the Arts of China*, Princeton, 1983, pp. 165–83.

I

Jades and bronzes for ritual

'I bestow upon you a jade sceptre and a jade goblet,
And a bowl of black mead.
Announce it to the Mighty Ones
That I give you hills, lands and fields;
That the charge which you receive from the house of Zhou
*Is as that which your ancestor received.'**

Jade and bronze are placed first in this book because they were chosen early in China's history as the materials for society's most precious objects. The main reason for this is very straightforward. Both materials are beautiful to the eye and, in the case of jade, also to the touch. Jade is a dense stone which can be ground to smooth, soft surfaces and glows in subtle greens, greys and browns. Bronze, an alloy of tin and copper, is a light, bright gold colour when polished.

Jade was employed (c.4500 BC) for exceptionally elegant versions of utilitarian stone tools (fig. 19); bronze was the choice (c.1650 BC) for the highest quality cooking pots (fig. 20). Made in jade, the tools were not for daily use but for displays of status and power, and the bronze cooking pots were not for ordinary meals but were reserved for offerings of food and wine to ancestors. Jade and bronze were thus used for special ritual or ceremonial versions of standard everyday items.

The materials themselves were scarcer and required more labour to work them than ordinary stone and ceramic. That this was the case must have been as clear in the past as it is today and must have marked the objects into which they were made as in some way exceptional. Not only the materials, but also the ways in which they were worked demonstrated their exalted functions. Jade sceptres were ground more thinly than the stone tools they copied. Had they been used to chop down a tree, they would have fractured. Bronze cooking pots were made in complicated forms, with extra knobs and handles and dense decoration, all of which would have been impracticable on everyday ceramics. Details of shape and design – in other words, aesthetic qualities – were chosen to show off the distinctions between the jade sceptre and the stone axe, the bronze ritual vessel and the ceramic cooking pot.

There would be no point in using these scarce and labour-intensive materials in place of common ones if they could not be immediately

*after A. Waley (trans.), *The Book of Songs*, London, 1937, p. 132

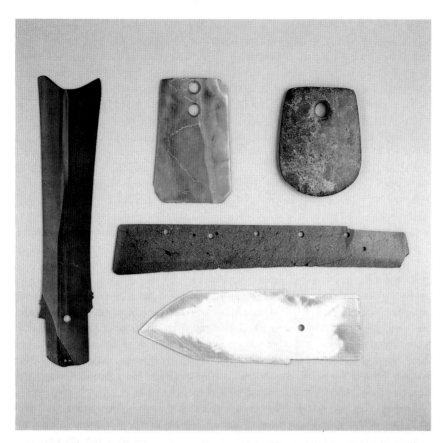

19 A group of Neolithic stone weapons and Shang sceptres based upon stone and bronze tools: (*left to right, top to bottom*) black jade sceptre, Shang period, 13th–11th century BC, L: 36 cm; jade axe, Neolithic period, *c*.2500 BC, L: 15.5 cm; stone axe, Neolithic period, *c*.4000 BC, L: 14 cm; jade sceptre based upon the shape of a stone reaping knife, Shang period, 13th–12th century BC, L: 37.5 cm; jade sceptre imitating a bronze halberd blade, *ge*, Shang period, 13th–12th century BC, L: 28.6 cm. Weapons and tools are used in many societies as emblems of rank.

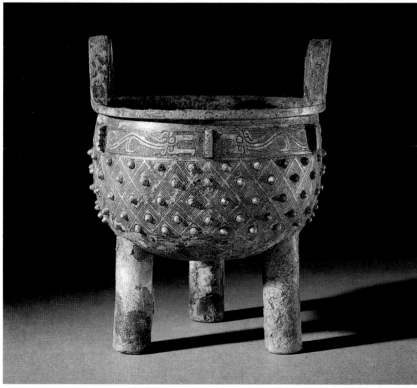

20 Bronze ritual vessel *ding*. Shang dynasty, 12th century BC. This standard food vessel illustrates the mould sections employed for casting, as shown in the drawing in fig. 21. HT: 20.3 cm.

recognised as outstanding. Craftsmanship was, therefore, directed to exploiting and displaying the particular qualities of jade and bronze that make them recognisably different from ordinary stones and ceramic. These qualities had to be made visually noticeable: they had to be seen. Other qualities, such as weight or texture, can only be appreciated by holding the object, and fewer people will have the opportunity to pick it up and feel its features with their hands than will be able to glance at it quickly.

Visual distinctions deployed to separate the ceremonial from the everyday can also be used to refer to smaller differences in the ranking of ritual items, separating those owned by the kings from those owned by nobles, as illustrated in the Introduction (fig. 13). Such differences can be in size or mass – one piece being larger or thicker than another – or in skill: one is better crafted than another. We make such judgements when looking at ancient objects today, and it seems likely that some sort of similar assessment was made at the time.

Two hierarchies, both visible to the eye, were thus achieved. First and most fundamental was a hierarchy of function, the ritual object standing above the everyday. Second was the hierarchy within each category, with the more elaborately worked and often the larger object higher up the scale. The rich and powerful owned the jade sceptres and the bronzes. What is more, these sceptres and vessels not only expressed or reflected the status of their owners, they probably also reinforced it. In this way jades and bronzes became bound up with the religious and political structures of the early Chinese state, and they remained so linked up to the twentieth century.

This type of hierarchy, created in this kind of way, is found in other parts of the world, including Europe. In any society, from ancient China to twentieth-century Europe, the scarcest and most beautiful materials will be restricted to the uses deemed most important by that society. Thus today gold is highly regarded because it is bright and does not tarnish; it is also in short supply. It is therefore used for wedding rings, which have religious and socially significant purposes, but not for key rings.

As in China, everyday objects have in Europe also become the models for ritual and ceremonial ones. The mace carried in the British House of Commons is a highly decorated form of a medieval weapon; the chalice and plate used in Christian worship are elaborate forms of everyday eating and drinking vessels. Tools, weapons and eating and drinking vessels seem, indeed, frequent choices as the forms for ceremony and ritual. In all these cases, the ritual objects are made of more precious materials than the utilitarian ones and, within the category of ritual pieces, there is a hierarchy of value which reflects not just function but also status within a social, political or religious structure. Further, once made in ritual forms in precious materials, the ritual objects are restricted in their use. Just as the European chalice is not taken out of the church and used in drinking parties, so it is unlikely that the Chinese bronze vessels were used to cook household meals. There is a further common element: the chalice, which is based upon gold and silver wine goblets that are no longer employed, is still in use today; likewise the shapes of ritual jades and bronzes survived long after the everyday items of similar shape had gone out of fashion. Piety and conservatism kept the ancient shapes alive.

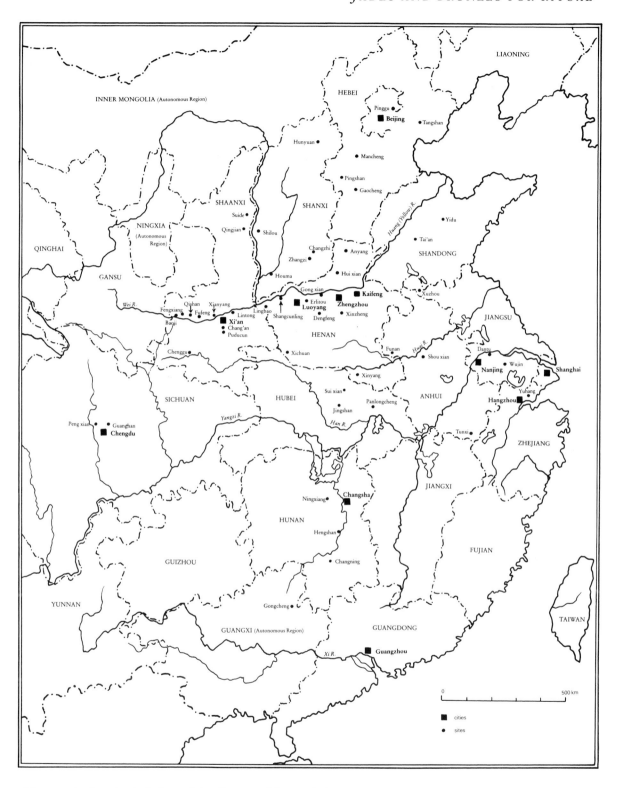

MAP II Archaeological sites of the Shang to Han periods (*c.* 1500 BC–AD 220).

Ritual objects thus seem to share the following features: their forms are modelled on everyday utilitarian items, but they are made in precious materials; the ways in which these materials are employed are devised specifically to display both the materials and the distinctions between ritual and everyday use. These features serve to advertise the wealth of the patron who can command supplies of both material and skilled labour. Certain characteristics – quantity, size and aesthetic quality – are still today linked to status.

It is therefore not surprising that at times when rulers and their courts wished to assert their authority, they commissioned large numbers of conspicuous bronzes. Further, when they wished to distract attention from weakness in society, they emphasised their power even more by increasing expenditure on ritual objects.[1] This chapter charts the changes in aesthetic qualities of jades and bronzes and tries to suggest what they can tell us about the society which produced them.

Later generations of Chinese scholars of the Song dynasty (AD 960–1279) quickly recognised the link between the bronzes and jades and political power. In their search for political legitimacy, they collected and studied ancient artefacts, pursuits which in themselves reinforced the high status of jade and bronze in society. From the idea that political power resided in ancient objects, including calligraphy and painting (ch. 2), grew the first art collections.

Materials and techniques

Jade is the word we use in English to translate the Chinese word *yu*. However, while the word *yu* can be used to embrace several types of grey, green, brown and black hardstones, jade has a more restricted use. It is the name given to two minerals, nephrite and jadeite. Jadeite, found in Burma, was unknown in China before the eighteenth century and so does not come into this discussion. Nephrite is today found in Chinese Central Asia, in the province of Xinjiang, but in ancient times it may have come from more sites, now worked out or lost. Both nephrite and jadeite are particularly hard to work. Because both are metamorphosed forms of crystalline rocks, which means that their crystals have been crushed together over many millions of years to make a matted or felted conglomeration, they do not split or fracture easily, and the stones have to be ground with a hard abrasive sand. While most of the pieces illustrated in this chapter are made of nephrite, a few are of serpentine or other softer stones.

Nephrite is found in large or small lumps or seams within larger bodies of non-precious rocks. Such pieces are usually split by weathering from the main bulk of rock in which they occur, with the result that small and large boulders of jade are often washed down in rivers. These pebbles or boulders are cut into slices with a cord and an abrasive sand and then shaped. Many of the main early jade forms were, therefore, carved from flat slabs (fig. 19). Their silhouettes are often freely curved and give an impression of ease, although such grace belies the labour with which all jades are worked. It would have taken many months to make any of the pieces illustrated. Given

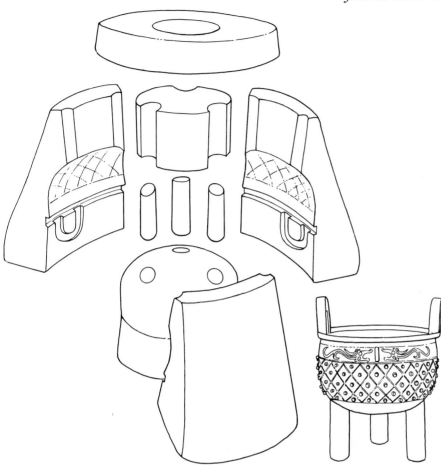

21 The ceramic mould sections required for casting a bronze ritual food vessel *ding*, such as the one illustrated in fig. 20. The mould consists of three principal outer sections and a piece for the base, a core for the inside, three cores for the legs, a section between them, and a lid and base to contain the hot metal when poured.

the huge effort required to produce a single piece, one of the astonishing features of Chinese jade carving is the large scale of production.

Chinese bronzes were also made in huge numbers. All surviving ancient Chinese bronzes were cast – that is, alloys of copper and tin, and sometimes also lead, were heated to a liquid state and then poured into ceramic moulds in the shape of the piece required. For the making of bronze weapons this was a commonplace technique; weapon moulds are comparatively simple and need only consist of two outer sections and a core. What was unusual was that the Chinese extended their weapon-casting technology to vessels.[2] Tripod vessels, such as the *ding* illustrated in figure 20, were made in closely fitting ceramic moulds in a configuration of the type shown in figure 21. Moulds had to be generated from a model of the object to be made. The model was probably of clay; when this model had hardened, more clay was packed around it to make the moulds; to remove these moulds from the model, the clay wrapper had to be carefully cut into sections. The mould sections were fired and then reassembled around a core, so that when the hot metal was poured into them, a hollow vessel would result (fig. 21). Exactly the right clays had to be chosen so that the model and moulds would separate cleanly and the moulds would not shrink in the firing. Indeed, the very detailed decoration of the bronzes could only have been achieved with

material of very fine consistency, namely loess (Introduction, p. 14). Copper and tin were necessary to make the bronze. Ores were probably mined a long way from the foundry and smelted, and the bars of metal would then have been transported to the foundry.

Cast bronzes are much thicker than their hammered counterparts and consume great quantities of metal. The number of bronze vessels produced in ancient China is truly amazing. Thousands of bronzes survive today, and intact tombs of the rich and powerful, such as that of Fu Hao, consort of the Shang king Wu Ding, who was buried late in the thirteenth century BC, have revealed that as many as two hundred ritual vessels (Introduction, fig. 13) might be interred with a single member of the royal family.[3] Willingness to tie up such large quantities of metal is very surprising, as bronze was essential for weapons and warfare, and the early Chinese were always at war. Viewed in this perspective, the Chinese must have considered the ritual vessels essential to the well-being of their state, ranking them in importance alongside or even above weapons.

The very abundance of large, heavy and skilfully made bronze vessels testifies to the densely organised population of China. Hundreds of men would have been employed in mining and smelting and in the transport of metal from mining areas to the capital and the workshops. The large quantities of material required and the many stages in the casting process depended upon subdividing the tasks among a large number of workmen. No single craftsman contributed to every stage in the production of a particular vessel. Workshops were therefore large; and many men with different skills – model makers, mould makers, casters, finishers – were required to make the vessels.

The Neolithic, the Shang and the Western Zhou periods (c.4500–771 BC)

Jade

By definition the Neolithic is the time when people used tools of stone, and metal working had not yet been invented. The working of jade was an extension of a large stone industry. Jade was used for beautifully coloured and textured prestigious versions of utilitarian stone tools. Many areas of the east coast employed fine polished stone axes and knives from about 4500 BC.[4] In Shandong and Jiangsu, areas occupied at this time by peoples of the Dawenkou Neolithic cultures, some exceptional pieces were of nephrite.[5] Figure 19 illustrates fine stone and jade implements, including two Neolithic axes. On the extreme right is a heavy rounded one of a dense brown-grey stone, which could have been used for chopping; to the left is a much thinner ceremonial axe made of yellowish nephrite. Other stone tools, including reaping tools, were also made in ceremonial forms. The original knives were relatively heavy, horizontal blades, with rows of holes by which they were attached to wooden shafts. At the centre of figure 19 is a ceremonial sceptre based upon such a knife. A slender, dark stone blade has a row of holes along the straight edge; the right-hand end has been shaped not as part of the blade but as the grip of a sceptre. It is too fragile to have been used as a tool, and it is also very elegant.

Jade was used not only to make ceremonial weapons and tools, but was also carved by some Neolithic peoples into ornaments and small animals. Recent discoveries in northeast China have demonstrated that peoples in Liaoning province, belonging to what is known today as the Hongshan culture (c. 3500 BC), carved animal figures and other ornaments from jade (fig. 22). The small, unusual stone and jade sculptures found near buildings and in tombs include realistic depictions of turtles, birds and much stranger creatures shaped like coiled insects or reptiles. These pieces, of which the Museum has only a half, are described as 'pig-dragons' (fig. 22 *right*). The other major form known from this area is a hair ornament. An example illustrated in figure 22 is shaped as an oval-sectioned tube. Similar pieces have been found beneath the heads of the dead in Hongshan graves and may once have had hair threaded through them.[6]

Another group of Neolithic peoples living further south, in Jiangsu province, and belonging to what is today known as the Liangzhu culture dating from about 2500 BC, used jade for ceremonial purposes. The Liangzhu people inherited skills and traditions from the Dawenkou and Hongshan peoples already mentioned.[7] Their graves were furnished with pottery made in complicated shapes and with fine stone tools, both in the Dawenkou tradition. The ceramics are so complex that we can infer that they stood high in the hierarchy of cooking pots and serving dishes and that they are likely to have had ceremonial or religious functions. Axes, flat blades with a single hole, were complemented by small fittings to embellish their wooden shafts. These small and obviously decorative carvings demonstrate that such axes too were not mere tools but were in fact emblems of status or power.

The Liangzhu peoples also used, in large numbers, two other distinct types of ritual jade: a disc later known as a *bi* and a tube of square cross-section pierced with a circular hole, later known as a *cong* (fig. 23). In a tomb at Sidun in Jiangsu province (fig. 24), for example, were twenty-five *bi* and thirty-three *cong*.[8] In some cases they were made of serpentine.

The corners of *cong* are decorated with faces, indicated by eyes and parallel bars suggesting hair and a nose. Two types of face are found: one with rounded human eyes and the other with large oval eyes. Creatures with these two types of eyes appear on other jades, including axes, where they are often shown in much greater detail. The rounded human eyes belong to a priest-like figure wearing a feathered headdress, often shown mounted on or grasping a monster with large oval eyes (fig. 25). This second creature may have been a new interpretation of the Hongshan type of coiled dragon, which also had large oval eyes.

Jades were less in evidence once bronze casting developed. However, although their original purposes were probably forgotten, *bi* and *cong* survived throughout the Bronze Age. Later *cong* were often small and plain; when they appear in the tomb of Fu Hao, *cong* seem to be relics of an almost forgotten age.[9] By the Han period (206 BC–AD 220), they had become antiquities to be collected. In a Han tomb in Jiangsu province excavators found a *cong* mounted in inlaid bronze, suggesting that it was a precious heirloom or a highly venerated antique object.[10] *Bi* had a more extensive life under the Shang, Zhou and Han dynasties, though they were never again used in the same profusion as in the Neolithic period. They continued to be

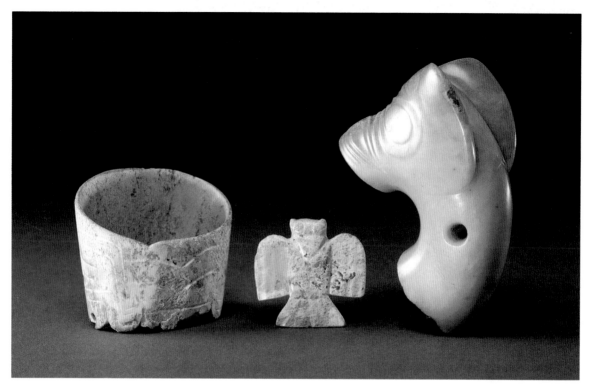

22 (*above*) Three jade carvings of Neolithic Hongshan type, *c*.3500 BC: (*left to right*) hair ornament, HT: 7 cm; bird pendant, W: 5.2 cm; part of a coiled pig-dragon, L: 10.4 cm.

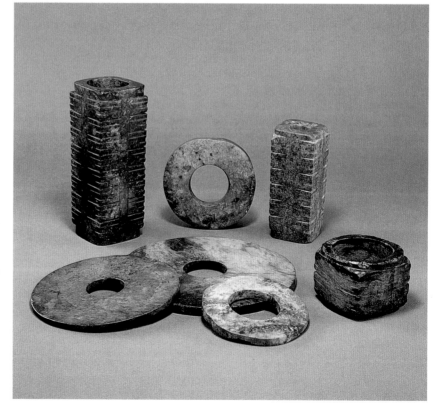

23 A group of *cong* and *bi* in jade and other hard stones. Neolithic, mainly Liangzhu type, *c*.2500 BC: (*back row*) two *cong* and a *bi*, HT: 20.3 cm; DIAM: 12.5 cm; HT: 15 cm; (*front row*) three *bi* and a *cong*, DIAM: 17 cm; 21.5 cm; 11.7 cm; HT: 6.7 cm. The purposes of these jade carvings are unknown, although they are thought to have had a ceremonial and possibly also a protective function. They have been found in large numbers in burials of the Liangzhu period (*c*.2500 BC), as illustrated in fig. 24.

24 (*left*) A burial of the Neolithic, Liangzhu type, *c.*2500 BC, tomb 3 at Sidun in Wujin county, Jiangsu province. The body lay beneath a long row of *cong*. In addition to *cong*, there were *bi* discs and also several other jade types, among which axe blades are conspicuous at the top left of the picture. The burial of such large numbers of very valuable jades suggests that they were highly important to ceremonies concerned with death.

buried in tombs and were presumably still essential ritual items, while smaller rings, also derived from Neolithic jades, were incorporated into pendant sets to be hung around the neck or from belts.[11]

Ancient ritual jade sceptres survived long after stone tools had been replaced by bronze ones. New sceptre forms were also invented in imitation of bronze weapons. Such jades were particularly well carved during the early Bronze Age of the Erlitou (*c.*1650−1500 BC) and the early Shang, or Erligang (*c.*1500−1400 BC) period, but they also survived into the late Shang and even the early Western Zhou.[12] A sceptre with a splayed end on the left in figure 19 is a type popular in the early Shang period.[13] Jade copies of bronze halberds, *ge*, continued into the Western Zhou, and simple Western Zhou *ge* were the models for Han and even much later Ming (AD 1368−1644) sceptres, which were carried at court by officials and the emperor as emblems of rank. Late forms of these weapons were highly stylised and remote from their origins. None the less, the very antiquity of the forms probably ensured their veneration.

Animal-shaped carvings were a much less stable element of the Chinese jade repertoire. Indeed, as so many jade carvings were worked from thin slabs, the three-dimensional forms of animals probably did not occur readily to jade workers. Carvings of creatures had been made in the Neolithic cultures of the northeast and the southeast, the Hongshan (fig. 22) and the Liangzhu, but they do not seem to have been known or sought after by the early Shang peoples inhabiting Henan. When animal carvings appear in some profusion at the late Shang city of Anyang (fig. 26), it seems likely that they were inspired by examples from outside the main Shang area.[14]

25 (*above*) Drawing of the fine carving of a figure wearing feathers, standing behind and grasping the eyes of a monster with a large jaw, on a *cong* found in the Neolithic Liangzhu burials at Fanshan in Yuhang county in Zhejiang province. Neolithic, Liangzhu type, *c.*2500 BC. This complex decoration is the source of the much-abbreviated face patterns on the corners of *cong*, such as those seen in fig. 23.

26 Drawings of jade carvings in the shapes of animals and faces, and a marble carving of a buffalo, from the tomb of Fu Hao at Xiaotun near Anyang in Henan province. Shang dynasty, 13th century BC.

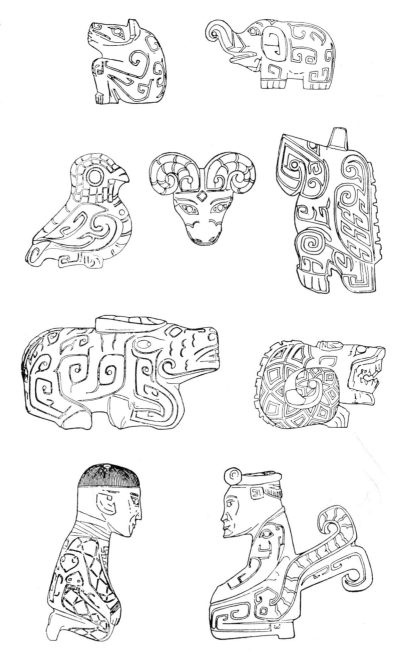

They are all rather small, although there are more substantial ones in marble from the same date.[15] All the creatures were shown more or less realistically. As they were carved in three dimensions, they were worked from small blocks rather than thin slabs and have neat, compact shapes (fig. 26). Such animal pendants were also used in the Western Zhou.

Bronze
First and foremost, the Shang employed bronze for weapons (fig. 27). Bronze weapons are relatively easy to cast and much more effective than their stone

counterparts. They do not seem to have been prized primarily as ceremonial items. When they appear in burials, they represent the fighting power of their owners and were, presumably, the weapons they had used in daily life. The principal types found in Shang tombs were the halberd and the spear. The halberd, a dagger-shaped blade, was mounted horizontally; the spear was mounted vertically (fig. 27). All such weapons, being comparatively flat, were cast in simple, two-part moulds.

Because we know that the halberd and the spear were the principal Shang weapons, when other types appear in Shang tombs, we can surmise that they were imported from non-Shang areas. Small curved knives with animal heads were popular on the northern and northwestern periphery of China, but from time to time they appear in Shang burials at Anyang (fig. 28). The small knife in figure 27 is an example of the form used in Shaanxi province; Anyang examples were slightly more delicate.[16] Axes and halberds with tubular hafts were also foreign. A tubular fitting for wooden shafts was popular all over the Iranian area and may have reached China by way of Central Asia or the Mongolian steppes. Examples of Chinese halberds with a tubular haft were developed at Anyang, probably in response to such foreign weapons.

While both the Shang rulers and their neighbours cast weapons, bronze vessels were at first a speciality of the cities of Henan province, and the very earliest vessels have come from Erlitou, near the present-day city of Luoyang.

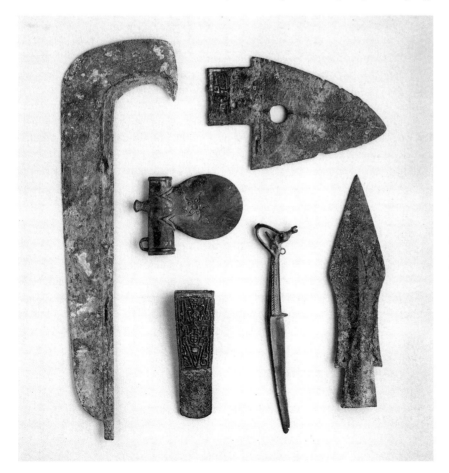

27 Bronze weapons of types current in different regions of central, north and western China at the time of the Shang and early Zhou dynasties, 12th–11th century BC. Curved blade, Shaanxi province, L: 46.8 cm; halberd blade, Henan province, L: 21.1 cm; circular axe with tubular haft, of a type found in northwestern China, L: 13 cm; socketed axe, Henan province, L: 15.2 cm; knife decorated with animal head, Shaanxi province, L: 25.1 cm; spearhead, Henan province, L: 27.4 cm.

28 Tomb 1001 at the site of the burials of the Shang kings at Wuguancun near Anyang in Henan province. The overall length of this tomb is more than 100 metres; such tombs were over 20 metres below the ground, and huge quantities of earth had to be shifted to create these impressive burials. The king's body was interred in a wooden coffin at the centre of the tomb, burial goods were arranged around it, and servants and soldiers were buried on the access ramps. This and the other adjacent royal tombs were probably robbed when the Zhou seized the Shang state in about 1050 BC.

Bronzes gradually replaced the ceramic vessels previously buried in tombs. While almost all later bronze vessel shapes were based on Neolithic ceramics, the source of the earliest type of all, the *jue* (fig. 29), is something of a mystery. It has a narrow spout, a sharply angled body and small posts on the lip; the *jue* survived in this shape for two thousand years. But where did it come from? At present we do not know.

The forms of bronze vessels changed gradually as casting techniques developed in China. Although the basic ceramic forms copied in bronze were tripods, lobed vessels, platters on stands and jars with lids (ch. 5, fig. 168), the use of metal permitted many detailed changes to be made. Sharp edges, fine handles and small projections were now possible. Rounded ceramic shapes could be made in versions with rectangular cross-sections, for example, and the legs on which bowls stood were turned into long pointed knife-shaped supports (fig. 30). These changes distanced the bronzes from the ceramics of everyday use, making their highly valued ritual status explicit to the eye. Starting with one or two bronze vessels in the Erlitou period, the number of types cast in bronze increased steadily throughout the Erligang and Anyang phases of the Shang period.

These many differently shaped vessels must have been essential to their users, otherwise the bronze casters would not have gone to such lengths to make them all. The vessels were clearly food and wine containers, the different varieties probably being intended for particular foods and wines. Groups of bronzes found in graves demonstrate that sets, which included a large number of shapes, were used (Bronze glossary, figs 229–32). There were as many as twenty different types, although only a much smaller number was essential. A group of vessels of the types most commonly found in Shang tombs is illustrated in figure 30, and the vessels from a single tomb of a high-ranking Shang noble, from the tomb known as tomb 18 at Anyang Xiaotun, are illustrated in the Bronze glossary.[17] Wine vessels dominated

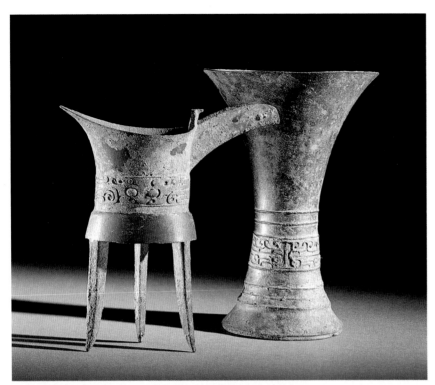

29 Two bronze ritual wine vessels, *jue* and *gu*. Early Shang period, 15th–14th century BC. Early bronze vessels such as these are often relatively small and thinly cast. On the *gu (right)* an early design in thread relief is abstract and lacks the eyes which could turn it into a *taotie* motif. The *jue* carries a *taotie* design in relief. HT: 14.5 cm; 16.8 cm.

30 (*below*) A group of bronze ritual food and wine vessels illustrating the range of possible types in use together in the late Shang dynasty, 12th century BC. As a group, they would have created a striking visual effect. Golden in colour when first made, they would rapidly have turned black in the humid summer climate of north central China. HT (of *zun*): 30 cm.

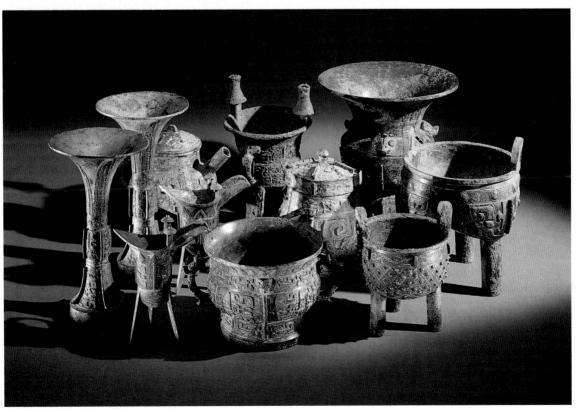

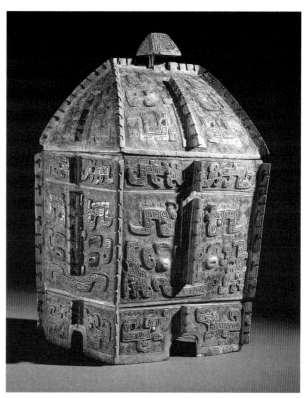

31 (*above*) Rubbings of *taotie* decoration from bronze vessels, illustrating the progression from simple thread relief lines to dense patterns of scrolls. The top example shows a small *taotie* face from a *jue* vessel, with simple eye patterns adjacent to it, from either side of the handle. Below it, a thread relief pattern with much longer scrolls fills out a unit of decoration from a vessel of wider circumference. A slightly later type of design in the third row illustrates the use of bands rather than thread relief. The bottom example is the most advanced; the casters have made use of additional lines and scrolls to create a denser design of greater height, and an additional creature in profile appears on either side of the main face.

the sets – in numbers, complexity of shape and elaboration of decoration. Food containers were less complicated, and only in the Western Zhou did they come to be pre-eminent in the ritual vessel set (Bronze glossary). Therefore we can assume that wine-drinking was a central practice.

The principal decorative motif on most Shang ritual vessels was the *taotie*, a face that resembles but never captures the likeness of an animal (figs 31–2). It has the features of a creature: eyes, ears, mouth, horns and claws. But the forms of these horns or claws differ from example to example, and they do not seem to belong to a specific real animal. The motif has perplexed scholars for centuries. Whether the *taotie* has a meaning – that is, whether it refers to a system of beliefs independent of the bronzes – is not clear. It is more straightforward to describe its development as an ornament than to consider its possible iconography.[18] Changes made to the face seem to have had the purpose of decorating ritual vessels ever more effectively, in the sense of densely covering the whole of their surfaces. The changes do not appear to have been intended to extend or elaborate religious symbolism.

The earliest designs consisted simply of eyes (fig. 31). Eyes are extremely compelling, as from birth human beings recognise and respond to them; for our own well-being we must learn to pay attention to them. Scrolls and cusps surrounded the eyes, making a symmetrical motif to fill a narrow horizontal border. As the centuries passed, the borders were deepened and the number of scrolls increased and refined to make ever more interesting patterns, but none of these early designs resembled a creature very closely. During the second half of the Shang, more explicit patterns were achieved

by separating the features of the face from the background and then by showing the features in relief (fig. 32).[19] It is these very explicit faces that have excited most speculation as to their meaning. But at present there are no contemporary Shang written records describing the significance of the *taotie*, and it is impossible to speculate what, if anything, that meaning might have been. If there were a meaning, it seems possible, though not certain, that it was expressed as easily by the early design of a pair of eyes (fig. 31 *top*) as by the more complicated face (fig. 32 and front cover). Both simple and complex patterns were used on ritual bronzes, and all presumably had the same function, whatever that was.

More important than any meaning was the versatility of the decoration. There were, after all, many vessels, all of different shapes, to be decorated. The *taotie* was sufficiently flexible to be used on rounded vessels, such as the *hu* on the front cover, or on rectangular flat-sided vessels, such as the *fang yi* in figure 32. It could fill long horizontal borders or taller square panels. To fill out long spaces it might be given bodies; to make a dense pattern its features were sunk in a sea of spirals.[20] This flexibility enabled shape and decoration to be carefully bonded. The Shang seem also to have pursued an intricacy that could be endlessly varied.[21]

Both early inscriptions and later poems tell us that the vessels were used in banquets at which food and wine were offered to the ancestors. It is impossible to reconstruct exactly what went on, but an early poem (*c*.600 BC) gives an impression of such a gathering:

> They manage the furnaces with attentive movements; there are food-stands that are very grand; some roast, some broil; the noble wives are reverently quiet; there are *dou* vessels that are very numerous; there are visitors, there are guests, they pledge each other in all directions; the rites and ceremonies are entirely according to rule; the laughter and talk are entirely to the point; the divine protectors arrive, they will requite us with increased felicity; by a longevity of a myriad [years] we are rewarded.
>
> *The Book of Odes*, trans. B. Karlgren, *Bulletin of the Museum of Far Eastern Antiquities*, vol. 16, 1944, p. 246

These were essentially family ceremonies in which both the dead and the living took part. The dead remained an integral part of everyday society, requiring the kind of attention also given to living members of the family. The banquets or rituals were a show of respect to the dead so as to ensure that they would help their descendants by interceding on their behalf with the gods or spirits. Without help from the dead, and a proper acknowledgement of their role, human affairs might fail and their descendants suffer.

The ancestors of the kings had to be served in the same way. However, as the prosperity of the king and his family was synonymous with the welfare of the state, in the case of the king a family ritual assumed state proportions. In this way ancient Chinese state rituals were identified with those of the family.

Although the vessels were made for use in family temples, they were also buried in tombs (fig. 28), presumably so that the dead could continue to

32 (*opposite right*) Bronze ritual vessel of the type *fang yi*, used for wine. Shang dynasty, 12th century BC. This covered container is a rectangular version of a ceramic covered jar. Most of the bronze ritual vessel shapes were ultimately based upon ceramic forms, but by making some bronzes with flat sides, the casters created immediately visible distinctions between the two. The features of the *taotie* faces in the four panels are separated by a background pattern of spirals known as *leiwen*. HT: 27 cm.

33 Bronze ritual wine vessel in the shape of a pair of rams supporting a jar, possibly from Hunan province. Shang period, 13th–12th century BC. Southern China borrowed the Shang form of bronze casting and also the practice of making wine vessels. However, the forms and styles of decoration were often quite distinct from the metropolitan types, and realistic creatures such as these are an example of provincial tastes and skills. HT: 43.2 cm.

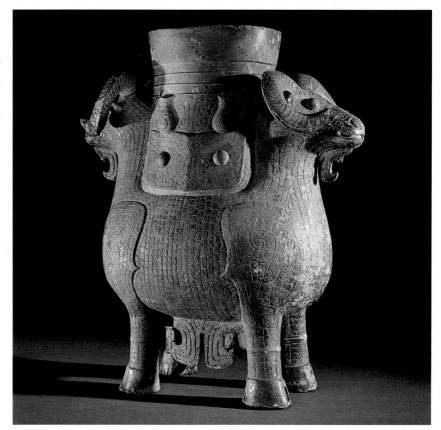

offer sacrifices to their ancestors after death. Recent excavations, which have revealed large groups, make it clear that bronzes should be seen in sets, as this was how they were used in their time. By comparing sets of vessels found in different tombs in terms of their numbers, sizes and the degree and quality of their decoration, we can today make some assessment of the relative standing of their owners (Bronze glossary, figs 229–32).

Social hierarchy was reflected in the hierarchy of materials used for the vessels, and in their shapes and decoration. Thus at the bottom of the social scale were people who were buried with undecorated ceramics. Next came those who could afford bronzes in relatively simple ceramic-related forms with little decoration. Above these came the higher levels of the élite and the royal family, whose bronzes were distanced from the ceramic prototypes by the use of angular and often rectangular-sectioned vessels decorated all over with densely arranged motifs (fig. 32). The richest and most powerful members of the Shang owned the largest and most highly decorated examples available (Introduction, fig. 13).[22]

Careful observation of the ritual vessels reveals other features of Shang life: for example, at times patrons and priests were sufficiently confident to make changes to shape and decoration by borrowing ideas from their neighbours. At other times, as we shall see, they were much more restrained, shunning exotic features in favour of reworking ancient designs.

The time of the burial of Fu Hao (c. 1250 BC) was a particularly lively moment: both the shapes and decoration of bronze vessels were radically changed by the introduction of real animal forms. We know such represen-

tations of animals were typical of southern China from bronzes found there. A famous wine vessel in the Museum, in the shape of a pair of rams, belongs to this southern tradition (fig. 33).[23] The two rams are shown with eyes, mouths, horns and beards, just like real rams. They are quite unlike the *taotie* designs (fig. 31), on which the features continually vary and whose elements never convincingly depict particular beasts. In contrast, all motifs and vessel shapes which can be described as representational display an accurate reference to real creatures. For a brief time around the lifetime of Fu Hao, animal-shaped bronzes and realistic animal motifs appeared on bronzes made at Anyang, although the interest in real creatures seems not to have been very far reaching. In the first place, vessels in the shapes of animals were confined to the very richest tombs – in other words, only those who could afford luxuries bothered with them. They were not used lower down the social scale and cannot, therefore, have been indispensable to the ritual practice. Secondly, the vessels with designs of real creatures are not among the most important types, namely the wine cups such as the *jue* and the *gu*, or the shouldered *zun*. Finally, these realistic animal shapes and motifs were abandoned long before the end of the Shang period. Adventurous representational or semi-representational motifs were replaced by revivals of much earlier *taotie* patterns. The Shang, therefore, seem to have prized bronzes that belonged to a long-established tradition, rather than vessels which introduced new creatures.

The Shang retreated into ancient traditions in the generation or so before they were defeated at the hands of a western confederation of peoples under their king, Wu Wang, who then founded the Zhou dynasty (*c.* 1050 BC). We know about the Zhou from one of the earliest surviving Chinese texts, the *Shujing*, which describes the Zhou conquest and their subsequent reor-

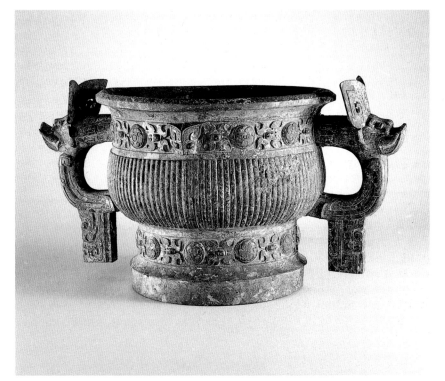

34 Bronze ritual food vessel of the type *gui*. Western Zhou period, 11th century BC. This vessel is known as the Kang Hou *gui*, after the brother of the Zhou King Wu, known as the Duke of Kang or Kang Hou, who is named in the long inscription inside the vessel (fig. 35). The Zhou developed the Shang practice of inscribing vessels to record family achievements and honours, and inscribed vessels are still very highly prized. HT: 21 cm, W: 42 cm.

61

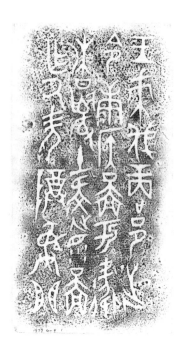

35 Rubbing of the inscription inside the Kang Hou *gui* (fig. 34). The inscription describes a gift of territory to the Mei Situ, an associate of the Kang Hou (also mentioned in the inscription), after the successful defeat of a rebellion by the Shang.

ganisation of the conquered state. In addition, long inscriptions inside Zhou ritual vessels both confirm and expand this early account (fig. 35). The ideas propounded by the Zhou were to have a lasting impact on all later Chinese political thinking. The Zhou are renowned for their justifications of their success: Heaven, they claimed, had granted them victory because they were righteous. The self-evident justice of all successful rulers was to remain a basic tenet of political faith for all later ruling houses.

Inscriptions cast inside bronze ritual vessels are not merely vital historical documents; they are evidence of a new function, that of communicating the political and social achievements of their owners. Under the Shang this function may have been implicit. Because only the rich and powerful could own large numbers of high-quality bronzes, their display alone was sufficient to proclaim the power of both kings and nobles. Ownership of Shang bronzes was sometimes indicated by a single character, the name of the owner, but the decoration rather than the inscription always seems to have been more important. Only towards the end of the Shang period were long inscriptions occasionally cast in bronzes.

The Zhou suddenly expanded this practice. In long inscriptions they told of their prowess, dating honours and gifts which acknowledged those successes by references to political events of their time. Thus one of the most illustrious bronzes in the Museum, the *gui* of the Duke of Kang (figs 34–5), tells that the duke, a brother of Wu Wang, and one Mei Situ gained territory in Wei in recognition of their contributions; it mentions the defeat of a Shang rebellion as a way of establishing the time when the events took place. The fact that the Mei Situ wished to announce this gift probably meant that he felt he had made great advances in the eyes of the king, which he wanted to make publicly known.[24]

While these inscriptions bring the politics of the Zhou state to life, their main significance is in the account they give of the personal success of those who had them cast. The Zhou seem to have felt the need to proclaim their honours, not just among the contemporary members of their families, but in a wider context of past and future members of their clans. They were, after all, placing these inscriptions within ritual vessels in which food was offered to ancestors. Thus the ancestors could be expected to see the inscriptions as they accepted the food. Such inscriptions would also remain for all future generations to see, as the vessels were retained in temples. Fame achieved by their descendants would reflect on the dead, too. If the living had become more influential in the world of the living, their ancestors might also gain influence in the world of the dead.

Vessels with long inscriptions were rarely buried in tombs, presumably because they were important historical documents. It seems likely that the Zhou were relative outsiders to the world of the Shang. They may, therefore, have felt under a particular compulsion to make their achievements widely known. Further, once long inscriptions were used in bronzes, those bronzes presumably became particularly important. This development made it necessary to continue to cast inscriptions in vessels. Under the Zhou, inscriptions were to become better cast and thus presumably of more significance than the decoration of the ritual bronzes. For the Shang, decoration expressed the rank and prestige of the owner, while for the Zhou the inscription fulfilled

this role. Whereas the vessels of the Shang were bearers of decoration, those of the Zhou were bearers of inscriptions.

The long-term effect of these inscriptions was immeasurable. They are the single most striking feature of the Zhou bronzes and were assiduously studied by later generations. The characters employed by the Zhou are essentially the same as those used in later centuries right up to the present day, and with a little experience all later educated Chinese could learn to read them. So the Zhou remained at the forefront of people's minds; indeed, later writers on ritual noted the usefulness of bronze inscriptions:

> The *Ding*-cauldrons had inscriptions on them . . . The inscriber discourses about and extols the virtues and goodness of his ancestors, their merits and their zeal, their services and their toils, the congratulations and rewards [given to them], their fame recognised by all under Heaven; and in the discussion of these things on his spiritual vessels he makes himself famous; and thus he sacrifices to his ancestors. In the celebration of his ancestors he exalts his filial piety. That he himself appears after them is natural. And in the clear showing of all this to future generations, he is giving instruction.
>
> *Liji*, trans. J. Legge, *The Sacred Books of the East:*
> *The Texts of Confucianism, Part IV*, Oxford, 1885, p. 251

Just as Shang bronzes reveal something about Shang society, the Zhou bronzes illustrate aspects of Zhou society and politics. Both the choice of shapes and motifs and the development of their aesthetic qualities demonstrate Zhou ritual and aesthetic priorities. The Zhou did not perpetuate the qualities of bronzes that the Shang evidently admired – restrained shapes and *taotie* designs (fig. 31). Had they been true inheritors of Shang traditions, they would have been dedicated to Shang ritual vessel types. Instead, they introduced many new variant shapes and decorative styles.

Zhou vessels are often boldly formed, with rounded bodies contrasting with angled footrings and sculptural handles, as seen on the Duke of Kang's *gui* (fig. 34). A group of such heavy bronzes with relatively simple if eye-catching designs must have had a very different visual effect from the more intricate surfaces of a group of Shang vessels. It seems likely that those who saw the bronzes recognised the contrast between Shang and Zhou vessels.

The motifs preferred by the Zhou were often explicit but bizarre, such as strange coiled dragons and slightly unnatural elephants.[25] The carefully balanced *taotie* beloved of the Shang were in the main abandoned. New creatures such as coiled dragons and elephants were almost certainly derived from the west and the south, and show the Zhou to have had contacts with peoples other than the Shang. Such contacts were, however, never admitted to or recorded in the main Zhou texts; we can trace them only by noting the sharing of strange motifs, for example, on bronzes used at the Zhou capital near Xi'an and on those employed in areas to the west and southwest.[26]

Contact between Xi'an and the south seems to have been made westwards along the Wei River by way of Baoji in western Shaanxi and thence along tributaries of the Yangzi, which passed through Sichuan province (map II, p. 47). In the south lay regions inhabited by peoples who had adopted

36 Bronze ritual wine vessel of the type *you*, decorated with birds with long plumes. Middle Western Zhou period, 10th century BC. This vessel was formerly in the collection of the Emperor Qianlong (1736–95) and is recorded in the catalogue of that collection illustrated in fig. 37. The bird pattern is typical of the middle Western Zhou and can be compared with similar designs on jades of the same or slightly earlier date (fig. 38). HT (to handles): 24.8 cm.

37 (*below*) Two pages from *Xi Qing gujian*, the catalogue of the bronzes in the collection of the Emperor Qianlong. The illustrations show the *you* (*right*) in fig. 36 and its inscription. Bronzes were assiduously collected and recorded by the Qianlong emperor to establish and reinforce the legitimacy of his rule.

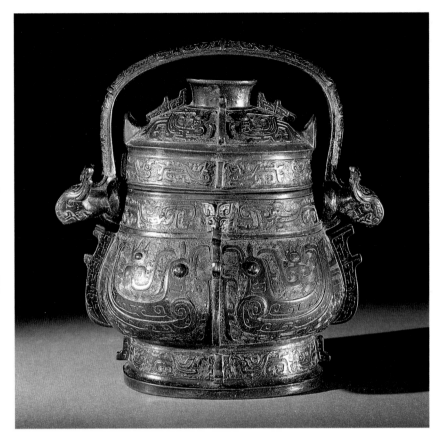

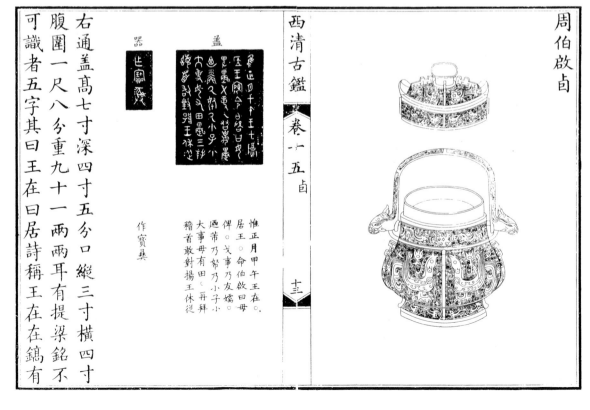

Chinese methods of bronze casting, but who had exploited them for purposes quite different from those of the Chinese living in Shaanxi and Henan. As already noted, animal figures appeared both as vessel shapes (fig. 33), and as ornament on bronzes. Bells were also southern products.[27] In addition, new weapon types and jades used at Xi'an probably resulted from contact with these outlying areas.

One of the conspicuous changes made in the tenth century BC, in the middle of the Western Zhou, was the use of elegant bird patterns on both bronzes and jades. At first sight this looks simply like a change in aesthetic, introducing flowing decorative lines to cover smooth, rounded vessel shapes. A wine vessel, or *you* (figs 36–7), carries long-tailed birds, for example, in place of *taotie* or more abstract patterns such as ribbing. The same motif appears on jades of this date. However, on the jade illustrated in a rubbing (fig. 38), a human figure is combined with the bird, and this figure suggests that the whole design was foreign to metropolitan Shang and Zhou areas. Human figures appear only rarely in Shang and early Western Zhou art, being much more common in the south and southwest. The most spectacular examples of human figures are bronze sculptures from the sacrificial pits at Sanxingdui at Guanghan in Sichuan province (ch. 3, figs 85–6). Much smaller but remarkably similar figures have been found at Baoji within reach of the Zhou capital,[28] and it seems probable that some fine jade figures in the Museum's collection (fig. 39) were inspired by southern contacts. Jades in which humans are shown with birds were also known in the south. When taken over by the Zhou, the human figures were gradually eliminated, leaving only the bird designs (fig. 36). So what looks at first sight to be a simple change of taste from face patterns, *taotie*, to birds, turns out to be

38 (*above*) Rubbing of the decoration on a jade handle in the collection of the Metropolitan Museum of Art, New York. Middle Western Zhou period, 10th century BC. The incised design includes (*top to bottom*) a plumed bird with a dragon in profile between its legs, and a man in profile, with a body of scrolls, standing on two further dragons in profile. L: 26.2 cm.

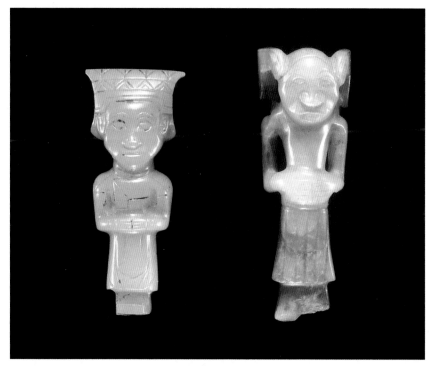

39 Two human figures carved in jade. Middle Western Zhou period, 10th century BC. Figures are rarely found in metropolitan Shang or early Zhou art, and when they do appear it is possible that they were imported from or stimulated by examples made in southern or southwestern China. HT: 6.1 cm; 7 cm.

connected with much larger issues of contact with areas outside Zhou rule, contact which may have come about through war, trade or both.

Contact with the south heralded yet more radical changes to ritual vessels. In a dramatic revision of the ritual vessel repertoire, all the shapes and much of the decoration were radically altered around 850 BC. Ancient wine vessels which had been in use for centuries were no longer made; new types were invented and new forms for older ones were also espoused. The wine cups, *jue* and *gu*, were abandoned; the food vessels, *xu* and *dou*, and the large wine flask *hu* were adapted from existing vessels; bells were introduced from the south; and new forms of food basins, *gui*, were employed. These striking changes can be illustrated by contrasting a set of vessels of the late Western Zhou with the range of types in use during the Shang and early Western Zhou (Bronze glossary). Shang vessels include a large number of different types, the majority for wine. Late Zhou vessels, by contrast, come in a much reduced number of forms. But several of the types were made in large numbers: tripods, *ding* and *li* were made in sets of nine, seven or five. The food basin, *gui*, was made in even numbers of eight, six or four. These precise numbers seem to have been correlated with status or rank. Whereas under the Shang status had been indicated by the sheer mass of vessels, their intricate shape and elaborate decoration, this was now suggested by particular numbers of *ding* and *gui*.[29]

The changes to bronzes were made for both religious and political reasons. They cannot have happened by chance, especially as an increase in numbers and sizes caused much more of that precious resource, bronze, to be used than hitherto. Bronze casters alone were certainly not responsible for the decision to produce the new vessels. They must have been ordered by the nobles and their priests, probably because a new religious ritual had been established. As most of the new vessels and bells appeared rather suddenly, this new ritual must have been well planned, taught and widely practised. Changes in the large bronze industry therefore imply changes in religious practice, probably supported by substantial changes in society.

A similar change appears in jade carving. The principal early types of jade had been sceptres, based upon ancient Neolithic tool forms (fig. 19); ritual jades, such as *bi* and *cong* (fig. 23); and small animal-shaped carvings (fig. 26). *Cong* and *bi* declined in size and scale of use; sceptres diminished likewise and small animal carvings all but disappeared. In their place, strings of personal ornaments became popular.[30]

The reasons for this change are not obvious. It seems likely that political or social upheavals led the Zhou king and his court to re-examine ritual practice. Many of the new vessel shapes, and those of the now essential bells, came from either the extreme west or from the south by way of the west. It is as though the Zhou looked back to their supposed roots in western China and attempted somewhat artificially to borrow shapes that they may have perceived as being ancient. Inscriptions describe changes in society, including new ways of transferring land, a transaction vital to all aspects of Zhou power.[31] These changes may have been reflected in what today appears to be a new ritual system, but which at the time may have been presented as a return to ancient practice.

The Eastern Zhou, Qin and Han dynasties
(c.770 BC–AD 220)

A hundred years later, another upheaval struck the Zhou state. In 771 BC the Zhou were driven from Xi'an by the Quanrong tribes; the second half of Zhou rule is known as the Eastern Zhou. In some ways the changes in bronze vessel types that followed the move of the capital eastwards to the secondary seat of power, Luoyang, were less significant than those that have just been described. There was greater freedom of design. As the court fled eastwards, they took with them their religion's practices, including their ritual vessels, but they also borrowed and incorporated local designs, with the result that the dull rigidity of late Western Zhou design gave way to increased variation.

In the major Eastern Zhou states, ritual vessels were as central to court life as they had been under the Shang and Western Zhou. Great care and attention went into their manufacture and fixed canonical forms were developed. Casters in Henan, Hubei, Hebei, Shandong and Shanxi as well as in Shaanxi perpetuated the shapes and motifs of the late Western Zhou. Thus there was a large central area in which a consensus existed as to what were the correct ritual shapes, and which had deliberately espoused Western Zhou ancient ritual practices. Outside this central area were people less closely bound to standard ritual practice, using unusual vessel types.

People living in the east, for example, continued to use shapes and motifs that had been eliminated in the west during the ritual upheaval; thus the wine bucket, or *you*, survived in this area. Figure 40 illustrates a very late *you* from eastern or southern China, shown beside the much earlier metropolitan bronze type on which it was based. The provincial *you* is extremely large, thin and roughly cast, and carries a design of coiled snakes quite unlike anything seen at the Zhou capital. However, it is an undoubted descendant of an early Zhou bronze (such as that in fig. 36), and has not been affected by the late Zhou changes to the ritual vessel repertoire. This distinct school of casting remained influential in the east, and its special features were also adopted further south and southwest.[32]

In the north, casting came to be centred on the state of Jin in present-day Shanxi province. Many Western collections, including that of the British Museum, have some very fine bronzes from Shanxi. Among them is a pair of wine vessels of the type *hu*, which can be precisely dated by an inscription around their lids referring to an important state meeting in 482 BC.[33] The area is also renowned for exceptional bells (fig. 41).

The vessels and bells illustrate methods of mechanical production that had become the norm. It can be shown that the designs with which these bronzes are covered were produced using pattern blocks: that is, small blocks of clay were carved as the masters from which to impress strips of negative design in clay to fill out the moulds. One master could be used many times. Thus all the narrow borders on the bell (fig. 41) are filled with the same dragon interlace, derived from a single pattern block, from which were produced strips of clay to set in the necessary parts of the mould. Further, the one pattern block could be used to produce strips of clay to decorate the moulds for several different bells. Rows of identically decorated vessels and

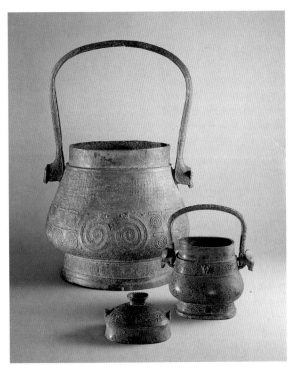

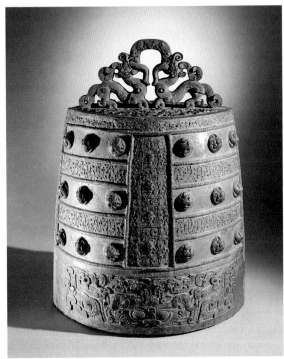

40 (*above*) Two bronze ritual vessels of the type *you*, illustrating the borrowing of a metropolitan form (*right*) for a later provincial version (*left*). The metropolitan example is middle Western Zhou, 10th century BC; the provincial version is early Eastern Zhou, 8th century BC. While this vessel type was eliminated at the capital near Xi'an in the mid 9th century, it survived in the east and south to be copied there several centuries later. HT (to handle): 62 cm; 25 cm.

41 (*above right*) Bronze bell, *bo*. Eastern Zhou period, 6th–5th century BC, made at the foundry of the Jin state at present-day Houma, in Shanxi province. The decoration was produced by the pattern-block technique, an early form of mass-production of decorative sections of bronze casting moulds. HT: 54 cm.

massed groups of bells would be produced in this way and must have been intended to impress an audience.[34]

As it seems that one of the major purposes of commissioning bronzes was to use them in ceremonies for which there was some sort of audience, highly decorated ones were much sought after, and this impulse probably fostered the development of this early form of mechanical production. It was a way of ensuring a high quality of finish across a very large number of complicated items. In a world of competing courts, conspicuous display of every kind was the order of the day. Court furnishings included not just ritual vessels, but bells and other musical instruments, an ever-growing body of bronze fittings, and furniture in other materials.

The contents of the tomb of the Marquis Yi of Zeng, the ruler of a small state on the borders of the great southern state of Chu, show what effect these casting methods could have when employed on many large and intricate bronzes.[35] The tomb consisted of four large wooden chambers, modelled on the rooms of a palace (Tombs appendix). The coffin was housed in a bed-chamber, with coffins of attendants. There was a central hall containing a spectacular set of bells (fig. 42), other musical instruments and the ritual vessels appropriate to a palace (Tombs appendix). Another chamber held the servants or concubines, who presumably played the instruments in the orchestra, and behind the ceremonial hall was a storeroom for weapons and chariot parts.

The bronzes were enormously large and very numerous. The ritual vessels comprised sets of food containers, *ding* and *gui*, and also small tripods, *li*; some small egg-shaped containers; spectacular wine vessels, *hu*; braziers and so on. There was also a pair of enormous jars and two quite exceptional

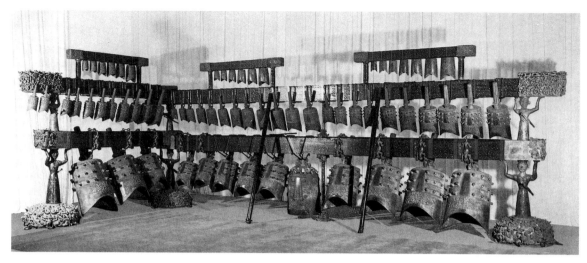

square wine containers (Bronze glossary). The tomb contained a magnificent set of sixty-five bells, the largest of which is nearly 1.5 metres high and weighs over 180 kilograms (fig. 42). When struck in two different places, each bell produced two notes. The names of the tones were inscribed in gold on the bells.[36]

Bells and vessels were impressive for both their size and intricacy. It seems likely that the most intricate among them were the most highly valued. A basin, *pan*, in which a tall beaker-like wine vessel, *zun*, was placed, carried intricate worm-like interlace, created by what was to the Chinese a new technique, the lost-wax casting method (fig. 43). The fine openwork fuzz is quite unlike the surfaces of other bronzes, developing the undercutting and interlace much further. To the courtiers of the day it must have been apparent that the workmanship of this bronze exceeded the detailing and refinement of all other bronzes in the tomb. It seems likely that this *pan* and *zun* – types not normally found in Hubei, belonging as they did to the east coast tradition – may have been particularly precious.

The impact of these pieces was made yet more dramatic by matching furnishings: lacquer tables, large lacquered frames for the bells, and boxes and coffins. The bronze vessels and bells were attached to the lacquer furnishings by bronze fittings, some in the form of human figures or even strange mythical birds with antlers (ch. 3, fig. 89). Wooden figures had probably been employed first and were then replaced by bronze at the richest courts, such as that of the Marquis Yi of Zeng.

The tomb also contained exceptional pieces in gold: a cup, a basin and a spoon, as well as some belt-hooks.[37] The gold pieces were found in or under the coffin and were, it seems, the personal possessions of the marquis himself. The items were all rather small and were obviously much less visible in court life than the bronzes and lacquers just described, but they were probably very precious. Equally small and personal were a number of very intricate jades, including a sequence of openwork plaques linked to make a belt.[38] A set of four plaques in the Museum is a much smaller and less intricate example of such work, with the same integral links (fig. 44). The whole piece was actually carved out of a single pebble of jade and has no joins.

42 Set of bronze bells on a lacquered wooden rack with vertical bronze supports in the form of figures. From the tomb of the Marquis Yi of Zeng, buried c.433 BC at Leigudun in Sui county, Hubei province. The sixty-four bells have the addition of a central *bo*, similar in shape to the bell in fig. 41 (*opposite right*), dedicated on the occasion of the funeral by the king of Chu. Bells with an elliptical section could produce two notes: one when struck from outside at the centre, and the other when struck at the corner. The names of the notes are inscribed in gold on the bells. HT (of lower figure support and base): 11.7 m.

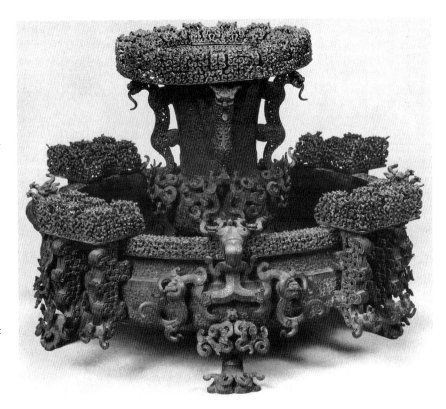

43 Bronze ritual vessel *zun* standing inside a *pan*. From the tomb of the Marquis Yi of Zeng, buried *c*.433 BC at Leigudun in Sui county, Hubei province. This very unusual vessel combination is remarkable for its openwork of dragons. These appendages were made by the lost-wax casting method, a technique foreign to China and probably introduced from the West or the south-west. Although the lost-wax method has been used for decorative sections of the vessel, the main castings were made by the traditional piece-mould system, which indeed remained in use until after the fall of the Han in the third century AD. HT (of *zun*): 33.1 cm; (of *pan*): 24 cm.

The tomb of the Marquis Yi of Zeng belongs to a stage at which the ancient ritual vessels and bells were still very sumptuous and therefore, we can assume, still highly valued. At the same time, smaller personal items such as the *pan* and *zun* (fig. 43), the gold cup and the jade belt (fig. 44) were gaining in importance, marked by the use of precious materials and a high level of craftsmanship. At the time of the Marquis Yi of Zeng, court display seems to have been centred on the practice of ancestral sacrifices and the performance of court music in an ancient tradition. Within less than a century, sacrifices and even bell music had declined: the sacrificial vessels of the late fifth century BC had been magnificently decorated, but those of the fourth century were predominantly plain. Effort was now confined to a very few obviously important vessels (not necessarily ritual vessels) and to personal items and fittings for furniture, weapons and chariots. New bronze types such as lamps and wine containers also attracted increasing attention. In such circumstances, feasts must have replaced ancestral rituals as the major court ceremonies.

At the same time as this change of emphasis new decorative techniques developed. Inlay of coloured metals and stones began to replace the spectacular casting of earlier generations (fig. 45). Cast decoration could be mass produced by using pattern blocks, as described above, but inlay had to be applied by hand to each piece. Even if the channels to hold the inlay were in part cast, they had to be finished by hand. Gold, silver and precious stones then had to be cut, again by hand, to fit the channels. It was, therefore, probably uneconomic to decorate with inlay large sets of identical

pieces. Only a few vessels were inlaid with gold and silver, such as the *dui* illustrated in figure 45, and these pieces must have been particularly valuable. But inlaid weapons and chariot parts were more common and were probably of increasing importance to society.

Here again, changes in society dictated changes in bronze decoration. Early Zhou society had been organised on the basis of family loyalties. The great lords assembled forces by calling on the members of their extended families, their relations and retainers. In this strongly family-based community it was understandable that clan and family loyalties should be celebrated in sacrifices to the ancestors. At such periods, ritual vessels represented the status of the family and were naturally highly decorated to reflect its wealth and standing.

However, by the fourth century BC many of the petty states centred on families had been eliminated, while a few had greatly expanded in size. The great lords no longer commanded authority on the basis of their family connections. Their armies were now numbered in hundreds of thousands and had, therefore, to be drawn from a wide section of the population. Large bands of fighting men were raised through members of courts whose loyalty was commanded on oath. The courtiers, or officials, gave their loyalty to the lords, whose authority they believed descended from Heaven, and whose righteousness was evident from their success in war.[39] Display, increasingly secular, was proof of the achievements of such lords. In these circumstances, weapons, chariots, furnishings in lacquered wood and textiles became ever more important. Bronzes thus had to compete with this colourful court life.[40]

Social and political changes which gave decorative prominence to weapons and chariots also singled out other types of bronzes: incense burners, lamps and mirrors were conspicuous among these (fig. 46).[41] Not only were these personal possessions rather than ritual vessels for ancestral sacrifices, but they probably also had some connection with a search for immortality that became more pressing as the Eastern Zhou progressed and power was subsequently gained, first by the Qin (221–206 BC) and then by the Han dynasty (206 BC–AD 220).

Belief in an afterlife had always been implicit in complex burials and ancestral sacrifices; it was expected that the dead would make use of the bronzes and jades interred with them, and the rituals or sacrifices implied an afterlife in which the ancestors were able to appreciate the offerings. From the fourth century BC, however, the Chinese elaborated a new conception of immortality. The home and abode of gods in the islands of Penglai, in the eastern seas or in the western mountains, became the quite explicit goals of the adept, seeking support in this world and the next. At first, paradise was thought of as a home for particular gods or as a source of elixirs that could confer immortality on men and women. Only later were ideas developed which included paradises in which men and women might dwell forever.[42]

Among the surviving bronzes of this period, incense burners and mirrors belong to this search for life in another world. Chu seems to have been the first place to witness the development of incense burners, starting with openwork beakers in bronze. An early example appears in the tomb of the Marquis Yi of Zeng (Tombs appendix). By the Han period, incense burners

44 Four linked discs of jade for the decoration of a belt or pendant. Eastern Zhou period, 5th century BC. The linked set, carved from a single pebble of jade, has no joins in it. A comparable but more complicated example was found with the bronzes in figs 42–3, in the tomb of the Marquis Yi of Zeng. L: 21 cm.

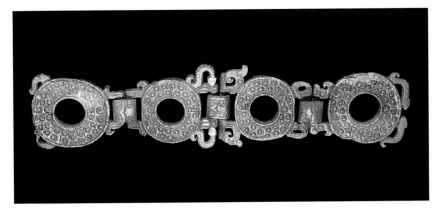

took a cup-like form, with a lid in the shape of a mountain and holes through which smoke could rise. This was a physical depiction of the mountains referred to in ancient Chinese descriptions of sacred places that were the homes of the gods and benign spirits. Mirrors illustrate a search for harmony with the cosmos and its gods. An example in figure 46 (*top left*) carries angular signs that are thought to be concerned with divination. Inscriptions on such mirrors often referred to a search for success in the present life and for harmony with spiritual forces.[43]

The carvers of Eastern Zhou and Han period jades were likewise explicitly concerned with immortality. Jade was thought to preserve the body. From the eighth century BC, small plaques were sewn to the burial garments of princes and nobles; later, distinct shapes were evolved for the eyes and mouth. Most elaborate of all were suits of small plaques, carefully worked

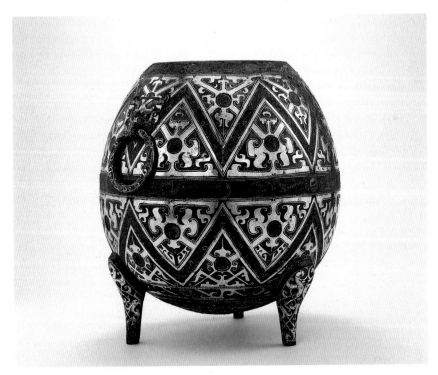

45 Bronze ritual vessel *dui*, inlaid with silver. The circles were possibly set with glass. Eastern Zhou period, 4th century BC. Inlay of gold and silver, often with semi-precious stones or glass, was developed so that the colour of the bronze vessels might match the brilliance of lacquers and textiles in use in the Eastern Zhou. HT: 30.5 cm.

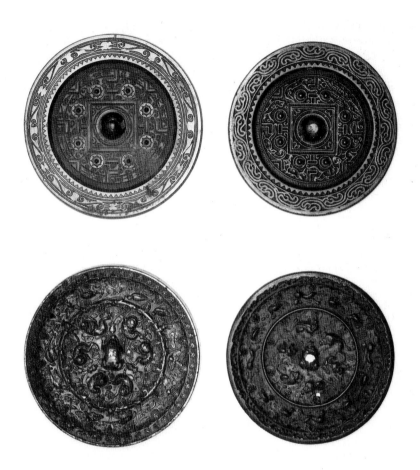

46 Four bronze mirrors, illustrating the copying of early types in later periods: (*top left*) mirror with a design made up of angular signs possibly related to divination, Han dynasty, 2nd to early 3rd century AD, DIAM: 14.5 cm; (*top right*) copy of such a mirror, 12th–13th century AD, DIAM: 13.5 cm; (*bottom left*) mirror with lion and grapevine design, Tang dynasty (AD 618–906), DIAM: 14 cm; (*bottom right*) copy of a Tang dynasty lion and grapevine mirror, 12th–13th century AD, DIAM: 13.3 cm.

to fit a human body. Famous examples have come from Western Han tombs discovered at Mancheng in Hebei province, such as the ones in which Prince Liu Sheng and his wife Dou Wan were buried (Tombs appendix).[44]

These tombs provide us with a few clues as to the relative importance of the different bronzes and jades buried in them. The main chambers were approached through long passageways in the mountainside (Tombs appendix). In Liu Sheng's tomb, on one side of the passageway, was a storage room for food and other supplies, with vessels mainly of ceramic. On the other side was a stable for chariots and horses. In the main central chamber were ritual vessels and rows of lamps. These too were of rather poor quality. Thus, though a central chamber for ritual was still significant, the riches were reserved for the rear chamber in which the prince or princess was buried in a jade suit. Here were personal valuables, mirrors and jade pendants; here too were fine bronze serving vessels, particularly *hu* vessels for wine. Incense burners were found here, or in the side annex, with figures of attendants, indicating that this was a serving room. The other conspicuous items were lamps.

Lamps had been made of bronze since the late Eastern Zhou and became an item of luxury with the decline of sacrificial vessels. Even small lamps were cunningly made in the shapes of figures and animals.[45] Large lamps

are almost all highly individual pieces with elaborate decoration, indicating to what extent individuality was obviously prized. Inscriptions incised on the lamps often record possession by, or gift to, particular princes or nobles.[46]

Such rare bronzes were personal rather than clan possessions and belonged to the category of highly decorated items that originated with the gold cup in the tomb of the Marquis Yi of Zeng. During the Han period other gold and silver pieces, especially drinking cups and boxes, came to be employed at court. With the fall of the Han, these precious metals replaced bronze for a time. Only restricted types, such as mirrors, continued to be made of bronze (fig. 46).

The afterlife of jades and bronzes

Ancient jade and bronze shapes survive up to the present day. Incense burners used on altars in the late twentieth century are based upon Shang and Zhou ritual bronzes. It was not simply a chance development of taste that kept these shapes alive, but rather a constant preoccupation with the past as a model for the present and future, stimulating a search for antiquities and the revival of past forms. As in the Zhou and Han periods, the supposed needs of society determined the aesthetic choices of later times.

The earliest recorded interest in rediscovered bronzes occurred in the Han dynasty, in 113 BC, when the unearthing of a large *ding* tripod was regarded as miraculous. The discovery was reported to the local magistrate and the *ding* handed over to the emperor. So impressed was the emperor by the news of its arrival that he went out to meet it as it was being brought to the capital. Strange flashing lights and clouds were seen accompanying it. The emperor asked his advisers for an interpretation of this find and was told that the discovery was auspicious. They took the opportunity to recount legendary stories about bronzes, then a standard view of the role of bronzes in distant antiquity:

> It is known that in antiquity when the Eminent Emperor Fu Xi flourished there was one divine *Ding*-cauldron, 'one' [signified] 'Unity': Heaven, Earth and the Myriad Beings were interwoven. Huangdi made the Three Precious *Ding*-cauldrons representing Heaven, Earth and Humanity; Yu accumulated metals from the Nine Pastors and cast the Nine *Ding*-cauldrons with which offerings were cooked in sacrifice to Shangdi, the Spirits and the Gods. Thus whenever a sage comes on the scene the *Ding*-cauldrons appear. They were transmitted to Xia and then to Shang. When the virtue of Zhou declined and the Altars of Song, the descendants of Shang, were lost the *Ding*-cauldrons fell into the waters where they were covered and lost to sight.
>
> From *Shiji*, as quoted by N. Barnard, 1973[17]

These features – the miraculous rediscovery signalled by flashing lights, the association with the legendary emperors, and the belief that possession of such ancient bronzes suggested that a sage ruler had appeared or was about to appear – gave all rediscovered bronzes a special aura. They were thought to bring good fortune in the present and to refer directly to the symbols of

legitimacy of the distant past. The ancient owners and functions of such bronzes were known not only from references to semi-legendary accounts of the Zhou bronzes, but also from quite detailed descriptions in the books describing different ritual ceremonies. These texts on ritual, which had been extensively revised in the late Zhou and Han periods, purported to describe practices of the early Zhou period (see quotation on p. 63).

A semi-magical approach to finds of bronzes persisted throughout the Han, the Six Dynasties and the Tang periods (AD 618–906). During the Tang, mirrors seem to have attracted considerable attention. Accounts of discoveries describe their magical properties: the power to cause people to faint or to give information about the future.[48] Indeed, at the height of Chinese imperial might, while the most prestigious eating and drinking vessels and religious images were made of gold and silver (ch. 4), bronzes of the past were believed to wield an awesome and little understood power.

From the Han period, and perhaps earlier, bronzes were collected by the state for the authority they gave to rulers; they formed one of the essential components of the early imperial collections.[49] Although elements of this interest in magical attributes remained, from the Song period (AD 960–1279) concern with the legitimacy which bronzes conferred on rulers took precedence. In this spirit, the scholars and rulers of the Song developed a strong and often highly academic interest in collecting bronzes. Collecting, however, did not have aesthetic goals; it was stimulated by a wish to gain access to the virtues of the past.

As mentioned in the Introduction, the Song dynasty was under constant political pressure. The states to the north, first the Liao state of the Qidan (AD 907–1125) and then the Jin state of the Ruzhen (AD 1115–1234), constantly encroached on traditional Chinese territory, in the end driving the Song southwards to establish a new capital at Hangzhou, in Zhejiang province. In a search for explanations of their problems and for solutions to their difficulties, the Song looked to the past. A vital element of this review of the past was the growth of the philosophy known as Neo-Confucianism. Philosophers and state advisers sought to revive the powers of the state by returning to the supposed values of ancient thought and practice.

This revival of Confucian thought coincided with a new wave of collecting, which had two aspects: the collection of every sort of ancient text in the most authentic edition possible, and the amassing of ancient bronzes and jades. Texts included rubbings of ancient stelae (ch. 2) and, of course, bronze inscriptions. Indeed, the bronzes were highly sought after, in part because of their inscriptions. There is an evocative description of the passions engendered by such collecting in the writings of the wife of Zhao Mincheng, an important government official at the moment when the Song had to leave their northern capital at Kaifeng. As the couple fled south, the collection was carried with them; as the political turbulence worsened, it was dispersed and lost.

> Since we could not take the over-abundance of our possessions with us, we first gave up the bulky printed volumes, the albums of paintings, and the most cumbersome of the vessels. Thus we reduced the size of the collection several times, and still we had fifteen cartloads of books.

When we reached Donghai, it took a string of boats to ferry them all across the Huai, and again across the Yangzi to Jiankang.

S. Owen, *Remembrances: The Experience of the Past in Classical Chinese Literature*, Cambridge, Mass., 1986, p. 89

Most important of all were the collections of ancient bronzes and jades belonging to the emperor. Imperial collections were in fact based upon the assemblies of bronzes and documents amassed since ancient times to establish the legitimacy of rulers. From the Song period, such collections had acquired a scholarly dimension. Catalogues detailing the sizes, provenances and inscriptions of the bronzes were now compiled and printed in woodblock-illustrated books.

In later periods collecting continued to flourish. Inscriptions and calligraphy of all sorts were always highly valued and were at all times required to establish the credentials of the emperor and the ruling classes. Emperors and officials of the Ming (AD 1368–1644) were less concerned with philosophy than those of the Song had been, and little new was written on ancient bronzes and their inscriptions. However, pieces continued to be amassed, and a literature grew up ranking bronzes and jades in relation to other items.

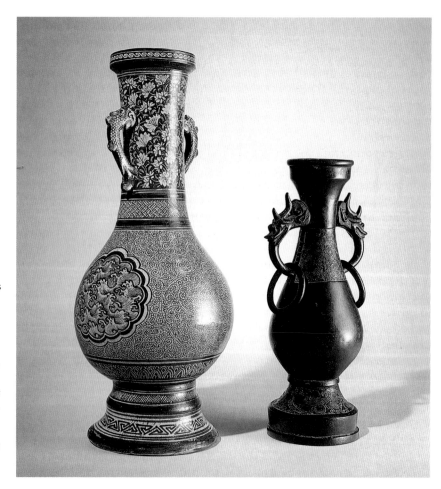

47 Two altar vases for flowers: (*left*) brown-glazed ceramic of Jizhou type; (*right*) bronze. Both Yuan dynasty, 13th–14th century AD. The bronze altar vase was adapted from a woodblock illustration depicting an ancient bronze, such as that shown in fig. 49 (*right*). Its tall angular foot is taken ultimately from a Han piece such as that in fig. 49 (*left*), but through the intermediary of the later woodblock print. The Jizhou flask with its brown colour and pronounced horizontal bands is based upon a bronze. HT: 44.8 cm; 33 cm.

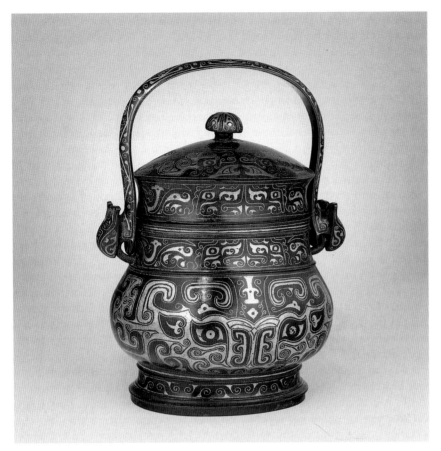

48 Inlaid bronze vessel *you*. Late Qing dynasty, 16th–17th century AD. The vessel is a copy of a *you* of the middle Western Zhou, such as those illustrated in figs 36–7. However, although the vessel is intended to be a faithful copy and may even have been made to deceive, the use of inlay is anachronistic, as gold and silver were not employed on vessels of the Western Zhou period. HT (to handle): 23.2 cm.

Ways of identifying fakes were also explored: after all, a fake could not confer the same moral authority as an original.[50]

Qing dynasty scholars turned once more to the serious study of dating and inscriptions, perhaps because government by an alien dynasty, the Manchu, again made the issue of legitimate rule a burning subject. Scholars hoped to settle current issues by referring to past formulae. In such a context, texts of every kind were combed for information on all aspects of ancient times. Bronze inscriptions were recognised as authentic ancient sources and a search for inscriptions stimulated their collection. Throughout the Qing period the imperial collection remained the central and most important body of material. A *you*, illustrated above in connection with its decoration of birds (figs 36–7), was formerly in the imperial collection. Figure 37 shows its depiction in the catalogue of bronzes in the imperial collection, the *Xi Qing gujian*.

This large body of literature on epigraphy and connoisseurship inevitably stimulated a revival in the making of bronzes themselves. Many of these later bronze vessels were made for use on altars. Officials of the Song period were conscious that one of the most important reasons for collecting bronzes was to make possible the reproduction of ancient vessels for religious use. The principal forms were the food vessels, *ding* and *gui*, employed as incense burners, and wine vessels, *hu*, used as flower vases. To these were added

candlesticks. Although these ancient shapes were placed on later altars, the original purposes of such shapes as food and wine containers were either overlooked or deliberately ignored (ch. 4, fig. 152).

The endeavour to reproduce ancient forms had certain unexpected consequences. For example, Han period wine vessels, such as *hu*, were found, collected and illustrated in the early catalogues. However, the woodblock illustrations did not reproduce them accurately. Thus, what had been a broad and heavily rounded vessel came out as tall and narrow in book illustrations. On the left of figure 49 is a drawing of a Han dynasty *hu* from a current archaeological report, and on the right is a drawing of the same type of vessel reproduced in a woodblock illustration in a Yuan period (AD 1279–1368) edition of the *Kaogu tu*, the first illustrated catalogue of bronzes. In the woodblock illustration on the right, the wide-mouthed body of the original has been compressed and the vessel has become elongated in proportion. As craftsmen worked from woodblock illustrations rather than from the real thing, this elongated shape affected the copying of bronzes. Products of Song foundries are illustrated in figure 50. Both these bronzes are much narrower than the Han originals (fig. 49 *left*) and take their proportions from woodblock illustrations (fig. 49 *right*). On the left is a tall narrow vessel, divided horizontally by raised bands which reproduce the horizontal bands on the original vessel type. Less closely based upon an illustration is the vessel on the right. None the less it imitates a Han original and was probably intended to reproduce the ancient form. Vessels similar to both Song bronzes have been found, along with ancient pieces, in hoards in Sichuan province.[51]

The tall narrow vessel shape reproduced in the woodblock illustrations was to leave an indelible imprint, not just on bronze altar vessels but also on ceramic examples. Figure 47 shows a Yuan dynasty bronze beside a flower vase from the southern kiln site of Jizhou. Both altar vessels take further the shapes reproduced in the woodblock illustrations: they are tall with relatively narrow proportions and many horizontal divisions ultimately derived from ancient bronzes. The Jizhou vase, which is a brown colour similar to bronze, shares with the bronze a pronounced step in the foot, derived ultimately from Han vessels (fig. 49).

Altar vessels in both ceramic and bronze continued in use up to and including the Qing period, though other materials were also introduced. The tombs of the Ming and Qing periods were supplied with imposing examples in stone. Sets in ceramic were used both on the altars within the tomb and in smaller temples nearby. Vessels in silver and gold were sometimes employed (ch. 4, fig. 138), and cloisonné was a very popular material for altar vessels in temples and palaces (ch. 4, fig. 140).

More or less exact replicas of a much wider range of ancient pieces were made for scholars and collectors. A *you* inlaid with gold and silver is a characteristic example (fig. 48), and is based on an ancient piece of approximately the same date as the bronze in figure 36. It was not a form that was ever employed on Song period or later altars. The original bronzes of this type, seen above in figures 36 and 40, were never inlaid in gold and silver. It seems that colourful inlays were employed on later bronzes, first because they were attractive, and second because they were thought to be features of the Xia dynasty (the supposed predecessors of the Shang), whose bronzes (if

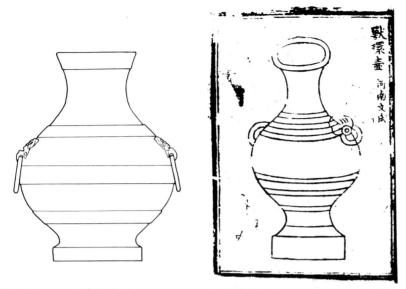

49 (*left*) Drawing of a bronze *hu* found in the tomb of Liu Sheng (d. 1st century BC). Bronzes of this type, with horizontal bands and angular footrings, were reproduced in Song dynasty (960–1279) catalogues such as the *Kaogu tu*. (*right*) Woodblock illustration taken from a Yuan period (1279–1368) edition. In these later woodblock illustrations the diameters of the originals were compressed, and the flasks were represented as tall and thin. These thin flasks were then copied in bronze to provide new altar vessels in what was seen as an ancient style, as shown in fig. 50 (*below*).

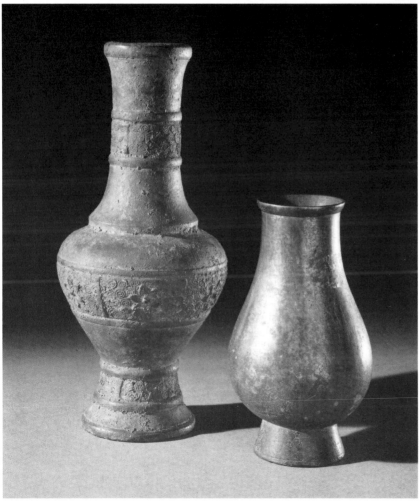

50 Two bronze flower vases of the late Song period, 12th–13th century AD. Flasks of this type have been recovered from Song hoards, buried in Sichuan province at the time of the invasions of the Mongols in the 13th century. HT: 24 cm; 21.1 cm.

51 A group of late jades in imitation of earlier pieces. Qing dynasty, 18th–19th century AD. (*top row, left to right*) Disc and sceptre combined, L: 14.3 cm; coiled dragon, based upon a Western Zhou pendant, DIAM: 12.5 cm; jade in the shape of a Shang period axe, L: 18.2 cm; (*bottom*) jade in the form of a reaping knife (see fig. 19), L: 26.3 cm.

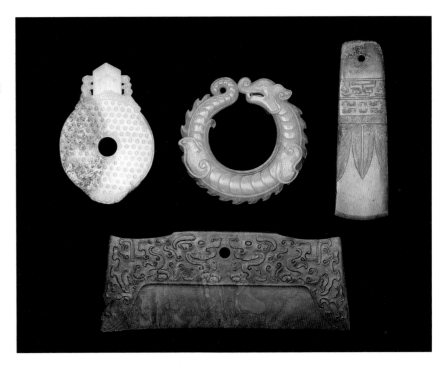

they existed at all) were made of bronze alone, as in figure 29. Thus a historical error led to interest in inlay and to the production of bronzes which were almost certainly intended to deceive their purchasers.[52]

Jades were made in the same spirit. As with the bronzes, some jade forms were revived for use in court ceremony. Princes and high officials carried sceptres based upon shapes they believed to be Han or earlier. Other jades were made for connoisseurs (fig. 51). Many of them, like the inlaid *you* (fig. 48), were collectors' playthings, and many were probably made to deceive. However, seen in the light of today's excavations, such jades are relatively easy to distinguish from their ancient models. All the jades in figure 51 are heavier, more colourful and more ornate than ancient pieces. The lower blade is based upon a reaping knife, the vertical green sceptre is copied from an ancient axe (compare fig. 19), and the coiled dragon is a greatly enlarged version of a Western Zhou pendant.

The persistence of ancient jade and bronze forms, both for genuine ritual use and to fill the cabinets of collectors, is remarkable. The two functions gave the materials enduring allure and ensured that both bronze and jade would continue to rank high in the hierarchy of Chinese art. Gold, silver and precious stones, on the other hand, never advanced beyond their use in the most sumptuous utensils of their day. They may have formed part of the offerings made to Confucian and Buddhist temples, but they do not seem to have been at the centre of major art collections. Only when they became antiques was there any chance that they might enter that charmed circle. For the Chinese, a link with past authority was all-important. From such associations, bronzes and jades derived qualities that could never be achieved by mere gold and silver.

Notes

1. For a discussion of similar practices in other societies, see J. A. Tainter, *The Collapse of Complex Societies*, Cambridge, 1988.

2. Chinese ritual vessel casting is discussed in R. W. Bagley, *Shang Ritual Bronzes in the Arthur M. Sackler Collections*, Washington DC and Cambridge, Mass., 1987, pp. 37–45; and W. T. Chase, *Ancient Chinese Bronze Art: Casting the Precious Sacral Vessel*, New York, 1991.

3. *Yinxu Fu Hao mu*, Beijing, 1980, describes the excavation of the Fu Hao tomb.

4. For illustrations of early jades recently excavated see *Zhongguo meishu quanji; gongyi meishu bian*, vol. 9, Beijing, 1986; compare E. Childs-Johnson, *Ritual and Power: Jades of Ancient China*, New York, 1988.

5. *Dawenkou*, Beijing, 1974, pls 23, 24.

6. For references to brief reports on Hongshan excavations see the bibliography to E. Childs-Johnson, 'Dragons, Masks, Axes and Blades from Four Newly-documented Jade-producing Cultures of Ancient China', *Orientations*, April 1988, pp. 30–41.

7. For Liangzhu jades see *Liangzhu wenhua yuqi*, Beijing, 1989, and references in the article cited in footnote 4 above. For additional finds see *Wenwu* 1988.1, pp. 1–31; 1990.2, pp. 1–26.

8. For excavation reports on the area see *Kaogu* 1981.3, pp. 193–200; 1984.2, pp. 109–29.

9. The *cong* from Fu Hao's tomb are varied. Some are plain, others carry cicadas or spirals, ornament typical of the south (*Yinxu Fu Hao mu*, op. cit., pls LXXXI–LXXXIII).

10. *Kaogu* 1973.2, pp. 80–7, 89, fig. 3.

11. Particularly complete burials which include many jades have been found at the tombs of the dukes of Guo at Sanmenxia (*Zhongguo wenwu bao*, 1991.1.6, no. 215); at the tomb of the Nan Yue Wang near Canton (*Jades from the Tomb of the King of Nanyue*, catalogue of an exhibition held at the Art Gallery, The Chinese University of Hong Kong, 1991–2); and at the tombs at Mancheng in Hebei province (*Mancheng Han mu fajue baogao*, Beijing, 1980).

12. A fine example is illustrated in Wen Fong (ed.), *The Great Bronze Age of China*, New York, 1980, no. 2; see also references to archaeological reports given there.

13. Dark sceptres similar to the illustrated piece have been found in Shaanxi province at Shenmu xian (*Kaogu* 1977.3, pp. 154–7, 172). They should be considered in relation to jades from Sichuan Guanghan Sanxingdui (*Wenwu* 1987.10, pp. 1–15, 16–17; 1989.5, pp. 1–20).

14. This topic is considered in J. Rawson, 'Shang and Western Zhou Designs in Jade and Bronze', a paper to be published in the proceedings of an International Symposium held at the National Palace Museum, Taipei, July 1991.

15. *Yinxu Fu Hao mu*, op. cit., pls CLXXIV–CLXXVII.

16. This topic is discussed in W. Watson, *Cultural Frontiers in Ancient East Asia*, Edinburgh, 1971, ch. 2.

17. For the excavation report of tomb 18 see *Kaogu xuebao* 1981.4, pp. 491–518.

18. The subject of the possible meaning of the *taotie* was debated at a symposium held at the School of Oriental and African Studies, London University, June 1990. The papers edited by R. Whitfield are forthcoming. Topics discussed by the present author in relation to the range and purpose of ritual vessel ornament are noted in connection with the Introduction (footnote 32). See also S. Allan, *The Shape of the Turtle: Myth, Art, and Cosmos in Early China*, New York, 1991, ch. 6, and L. Kesner, 'The *Taotie* Reconsidered: Meaning and Functions of Shang Theriomorphic Imagery', *Artibus Asiae*, vol. LI, 1/2, 1991, pp. 29–53 for opposing views on the subject.

19. For illustrations and discussions of the *taotie* see R. W. Bagley, 1987, op. cit., Introduction; J. Rawson, *Chinese Bronzes: Art and Ritual*, London, 1987, ch. 4. Both discussions are indebted to M. Loehr's pioneering article 'The Bronze Styles of the Anyang Period', *Archives of the Chinese Art Society of America*, vol. 7, 1953, pp. 42–53.

20. The use of variety to decorate vessels of different types and shapes and to distinguish rank or position is the theme of the present author's paper 'Late Shang

Bronze Design: Meaning and Purpose' in the symposium mentioned in footnote 18 above.

21. This point is very elegantly made in R. W. Bagley, 'Shang Ritual Bronzes, Casting Technique and Vessel Design', *Archives of Asian Art*, vol. XLIII, 1990, pp. 6–20.

22. This topic is discussed in a paper by the present author cited in footnote 32 to the Introduction. See also the comments there about the southern origins of realistic animal features in bronze decoration.

23. For a discussion of southern Shang bronzes see Bagley, 1987, op. cit., pp. 32–6. A pioneering study of southern bronzes was made by V. Kane, 'The Independent Bronze Industries in the South of China Contemporary with the Shang and Western Chou Dynasties', *Archives of Asian Art*, vol. 28, 1974–5, pp. 77–107. See also R. W. Bagley, 'Changjiang Bronzes and Shang Archaeology', a paper to be published in the proceedings of an International Symposium held at the National Palace Museum, Taipei, July 1991.

24. See J. Rawson, 1987, op. cit., no. 22, for references to the publication of the inscription.

25. For examples of these motifs on bronzes in the British Museum collection see ibid., nos 23, 25.

26. For a discussion of these relationships see J. Rawson, 'Statesmen or Barbarians? The Western Zhou As Seen Through Their Bronzes', *Proceedings of the British Academy*, vol. LXXV, 1989, pp. 71–95.

27. For discussion of bells from the south see Kao Chih-hsi, 'An Introduction to Shang and Chou Bronze *Nao* Excavated in South China', in K. C. Chang (ed.), *Studies of Shang Archaeology, Selected Papers from the International Conference on Shang Archaeology*, New Haven and London, 1986, pp. 275–99.

28. See Lu Liancheng and Hu Zhisheng, *Baoji Yu guo mudi*, Beijing, 1988, pls CLXIX:2, CCIII.

29. The changes to the ritual vessel set are fully discussed in J. Rawson, *Western Zhou Ritual Bronzes from the Arthur M. Sackler Collections*, Washington DC and Cambridge, Mass., 1990, pp. 93–110.

30. The new types of jade, including pendants in which interlace is used, are illustrated by finds from a tomb at Shaanxi Fufeng Qiangjia (*Wenbo* 1987.4, pp. 5–20).

31. Bronzes with such inscriptions have come from Shaanxi Qishan Dongjiacun (*Wenwu* 1976.5, pp. 26–44); for a commentary in English on the inscription on one of them, the Wei *he*, see Ma Chengyuan (trans. and ed. Hsio-Yen Shih), *Ancient Chinese Bronzes*, Hong Kong and Oxford, pp. 128–30.

32. Another vessel type which survived in the same areas, the S-shaped *zun*, is illustrated and discussed by J. So in Wen Fong (ed.), 1980, op. cit., no. 66. For comments on eastern and southern central bronzes, see C. Mackenzie, 'Chu Bronze Work: A Unilinear Tradition or a Synthesis of Diverse Sources', in T. Lawton (ed.), *New Perspectives on Chu Culture during the Eastern Zhou Period*, Princeton and Washington DC, 1991, pp. 107–57.

33. J. Rawson, 1987, op. cit., no. 34.

34. The use of pattern blocks was first proposed by B. W. Keyser, 'Décor Replication in Two Late Chou Bronze *Chien*', *Ars Orientalis*, vol. XI, 1979, pp. 127–62. Extensive further studies have been made on the use of the pattern-block technique by R. Bagley. His preliminary work is published in 'Replication Techniques in Eastern Zhou Bronze Casting', a paper presented to a symposium on the History of Things held at the Smithsonian Institution, Washington DC, April 1989 (forthcoming).

35. The tomb is described in the excavation report, *Zeng Hou Yi mu*, Beijing, 1989.

36. The bells and their context are discussed in L. von Falkenhausen, 'Chu Ritual Music', in T. Lawton (ed.), 1991, op. cit., pp. 47–106.

37. *Zeng Hou Yi mu*, op. cit., pls CXLVII, CL.

38. *Zeng Hou Yi mu*, op. cit., pl. CLVIII.

39. These changes are described in M. E. Lewis, *Sanctioned Violence in Early China*, New York, 1990.

40. Plain bronzes and painted lacquers from Chu tombs at Henan Xinyang illustrate this changing balance (*Xinyang Chu mu*, Beijing, 1986).

41. Discussed in J. Rawson, 'Chu Influence on the Development of Han Bronze Vessels', *Ars Asiatiques*, vol. XLIV, 1989, pp. 84–99.

42. Wu Hung, 'A Sanpan Shan Chariot Ornament and the Xiangrui Design in Western Han Art', *Archives of Asian Art*, vol. XXXVII, 1984, pp. 38–59 describes the growth of ideas concerning miracles and the homes of the immortals.

43. M. Loewe, *Ways to Paradise: The Chinese Quest for Immortality*, London, Boston and Sydney, 1979. For typical mirror inscriptions see also Chen Peifen, *Shanghai Bowuguan cang qingtongjing*, Shanghai, 1987.

44. *Mancheng Han mu fajue baogao*, Beijing, 1980.

45. For lamps of the Eastern Zhou period see *Wenwu* 1979.1, pp. 1–31; 1966.5, pp. 33–55; 1988.5, pp. 1–14.

46. The most remarkable lamp in this respect is a lamp from the tomb of Dou Wan at Mancheng. See Wen Fong (ed.), 1980, op. cit., no. 94.

47. N. Barnard, 'Records of Discoveries of Bronze Vessels in Literary Sources – and Some Pertinent Remarks on Aspects of Chinese Historiography', *Journal of the Institute of Chinese Studies of The Chinese University of Hong Kong*, vol. VI, no. 2, 1973, pp. 455–546.

48. Ibid., pp. 517–21.

49. Imperial collections are discussed by L. Ledderose in 'Some Observations on the Imperial Art Collection in China', *Transactions of the Oriental Ceramic Society*, vol. 43, 1978–9, pp. 33–46.

50. The ranking of antiquities as described by Li Ruhua is discussed by Chu-Tsing Li in 'The Artistic Theories of the Literati' in Chu-Tsing Li and J. C. Y. Watt (eds), *The Chinese Scholar's Studio, Artistic Life in the Late Ming Period*, New York, 1987, pp. 14–22.

51. For hoards from Sichuan that include bronzes see *Wenwu* 1984.7, pp. 82–4; 85–90; 91–4; 1984.12, pp. 68–72; 1987.2, pp. 70–87.

52. For a wide-ranging discussion of later Chinese bronzes see R. Kerr, *Later Chinese Bronzes*, London, 1990. The market in fakes is discussed by C. Clunas in 'The Art of Social Climbing in Sixteenth Century China', *Burlington Magazine*, June 1991, pp. 368–75.

2

Calligraphy and painting for official life

I seize upon wine as banners and drums, and make of my
pen a long lance;
Heaven-born strength comes to men like the Silver River
rushing down.
On the inkstone hollow from Duan Brook, I grind my ink thick;
Under the flitting candlelight, my pen crisscrosses as if flying.
In a moment I roll up the scroll and take again my wine cup,
As though all across ten thousand li *had been cleared of*
*dust and smoke!**

In all pre-modern literate societies, the written word has been a source of power. Information that is written down is usually only accessible to a few individuals, who are capable of withholding it to the disadvantage of others. Writing has always been linked to religious and political authority in China, and indeed all the earliest surviving documents are connected with the state. In part this may be because durable materials such as bronze and stone were chosen for texts of such significance; personal or ephemeral writing may have been written on more perishable materials that have since disappeared. But from the Han period (206 BC–AD 220), when the most common Chinese writing materials – ink, brush, wood and paper – came into widespread use, official writings and historical texts have survived in large quantities, pouring out in a torrent during the centuries following. While the scripts described here were developed primarily for such official writing, the forms they took and the ways in which they were executed also laid the basis for the development of the art of calligraphy, from which grew China's central artistic tradition. Furthermore (as mentioned in the Introduction, p. 20), the high esteem accorded to all writing because of its political and religious authority was carried over into the respect given the arts of calligraphy and calligraphic painting, also known as literati painting.[1]

Materials

The equipment used for writing, especially the pliable brush and absorbent paper, have had a profound effect both upon the ways in which writing has developed and the extension of writing into the arts of calligraphy and

*from 'Inscribed on My Grass-script Calligraphy Written While Drunk' by Lu Yu, in Wu-chi Liu and I. Y. Lo (eds), *Sunflower Splendor: Three Thousand Years of Chinese Poetry*, Bloomington, Indiana, 1975, pp. 382–3

painting. For the past two thousand years, Chinese painters and calligraphers have used a hair brush to apply black ink and other water-based pigments to silk or paper. The ink, made from forms of carbon, is mixed with animal glue to form sticks. The sticks are then rubbed into a small amount of water on an inkstone in order to produce the ink. Inkstones come in many shapes, but all have a flat area for grinding the ink and a depression or well for holding the excess liquid. During the tenth century, writing equipment (brush, paper, ink and inkstone) came to be known as the 'four treasures of the scholar's studio', and it has continued to attract a considerable literature since then.[2]

Almost no writing in ink survives from the Shang or early Zhou periods (c.1500–700 BC).[3] It is sometimes suggested, however, that like later texts early documents (now lost) may have been written on strips of bamboo, each bearing a single column of characters, with many strips bound together to form a mat-like roll, *bian*. The vertical lines of characters in bronze inscriptions (ch.1, fig.35) may reflect some such early forms of texts that have since disappeared. The thick and thin lines of the characters also suggest that a pliable brush, which would have produced this effect, was used for writing. The earliest surviving wood and bamboo strips date to the third and second centuries BC.[4]

By the fifth century BC documents had begun to be written on silk, which had existed in China since Neolithic times.[5] Although silk was a more expensive material than bamboo, it was softer and lighter, and a document on a roll of silk, *juan*, was much easier to handle and store than the corresponding bundle of bamboo strips. In later times both terms continued to be used to indicate sub-sections of longer texts, without reference to the material used.

Silk was also the most obvious ground for the first surviving paintings, the funerary banners of the second century BC.[6] Although the finest silk provided a smooth surface for the painter, it could only be used for this purpose after special preparation, to prevent the ink from running along the lines of the fibres and blurring the image. The silk for painting was, therefore, sized first with a coating of alum to produce a much less absorbent surface.

The high cost of silk meant that all but the most important documents were written on bamboo strips until well into the Eastern Han dynasty (AD 25–220).[7] Archaeological evidence shows that paper was being made (from hemp fibre) from the first or second century BC. The invention of paper is traditionally attributed to the eunuch Cai Lun in AD 105, whose personal contribution was probably limited to improvements in methods of paper manufacture which led to wider use of the new material for writing. Thereafter, paper was made from jute, flax, ramie or China grass, rattan, bamboo, mulberry and paper mulberry, all of which provided cheaper alternatives to silk.[8]

Paper making was a relatively simple process. In *The Exploitations of the Works of Nature (Tiangong kaiwu)*, first printed in 1637, Song Yingxing (1587–c.1665) devotes chapter 13 to the processes of making paper from both bamboo and paper mulberry (fig.52).[9] He describes how bamboo is first cut into lengths of approximately two metres and soaked in water for a

52 The processes of paper making as illustrated in the *Tiangong kaiwu* (*The Exploitations of the Works of Nature*) of 1637: (**a**) cutting and soaking lengths of bamboo; (**b**) cooking bamboo in a pot; (**c**) dipping the woven mould and lifting the pulp from the vat; (**d**) pressing damp paper sheets to release moisture; (**e–f**) drying paper sheets on a heated wall.

hundred days. After this the bamboo is pounded and washed to remove its outer coating, a process called 'killing the green'. The inner fibres are then mixed with lime and boiled for eight days. After further preparation, the resulting pulp is pounded in a mortar until it has the consistency of a thick soup and then poured into a vat, where the fibres float to the surface. To form a sheet of paper, a bamboo screen is lowered into the vat and lifted out bearing a thin coating of wet fibres. The screen is then pressed to remove surplus water and dried by spreading it vertically over a wall which has been heated from behind; the pieces are then removed as finished sheets.

The availability of paper made possible the steady increase in official documents and the widespread development of writing throughout the official class from the Han dynasty onwards; this demand for paper in turn inspired experiments in manufacture. Many types of paper were developed, the majority made from plants with long fibres which gave it great strength. To prevent the ink from soaking into the paper too quickly and to allow a more rapid movement of the brush, the paper was sized using gypsum and a gum made from lichen. Indeed, one of the advantages of paper over silk was that it made possible much quicker motions of the brush thereby

permitting the writer much more spontaneous expression and indirectly contributing to the development of the art of calligraphy.

Painters, however, continued for many centuries to prefer silk. It was not until the rise of amateur painting under the Song (AD 960–1279) and Yuan (AD 1279–1368) that paper was seen as the ideal medium.[10] Thereafter, paper which had first been produced as a cheap alternative to silk was made in a wide variety of fine qualities for calligraphy and for the mounting of scrolls. Fine letter papers were produced from the Tang onwards for calligraphy, and in the late Ming collections of fine pictorial letter papers were printed from woodblocks in several colours and included embossed designs.[11]

The ink used by the calligrapher and the coloured pigments used by the painter were water based and prepared in sticks or cakes. The earliest examples of ink are found in traces of writing dating to the fourteenth century BC.[12] Ink was principally made from carbon obtained from burning resinous pinewood, to which lampblack made from animal, vegetable or mineral oils was added. This was mixed with glue, moulded into a cake and dried. The colours were made from a variety of vegetable and mineral pigments: blue from indigo or mineral azurite, green from malachite, white from lead, and red from cinnabar and iron oxide. The cakes of ink and coloured pigments were ground by hand on an inkstone and mixed with water to produce a solution of the desired density.

53 Three moulded ink cakes. Fronts (*top row, left to right*): circular ink cake with birds and tree made by Cheng Dayue (1541–1616?), dated 1621; octagonal ink cake with celestial horse carrying Daoist scriptures made by Cheng Dayue, also dated 1621; circular ink cake with design of 'one hundred sons' made by Fang Yulu (*fl.* 1570–1619). Reverses (*bottom row*): inscription; *yin yang* symbol and the eight trigrams; design of 'one hundred sons'. DIAMS: 14 cm; 13 cm; 12.7 cm.

54 Inkstone, Jun stoneware. 13th–14th century. Although inkstones were primarily made from stone, moulded ceramic stoneware inkstones also exist in a variety of forms. L: 14.8 cm.

The manufacture of ink cakes in decorative forms began as early as the Tang and became a minor art form produced for the collector. In the late Ming two manufacturers, Cheng Dayue (1541–1616?) and Fang Yulu (*fl.* 1570–1619) from Shexian in the prefecture of Huizhou in Anhui province, were famous for their ink cakes (fig. 53), the designs of which they printed in colour in two woodblock-printed compendia, the *Fangshi mopu* (1588) and the *Chengshi moyuan* (1606).[13]

The inkstones on which the ink was ground were made from various materials, principally stone but also ceramic (fig. 54). The most prized materials were inkslabs made of Duanzhou stone from Guangdong province, Shexian stone from Anhui province, and Chengni clay from Jiangzhou in Shanxi province. Of these, Duanzhou stone, available in a range of colours, was considered the best. It is often found with concentric rings of contrasting colours, referred to as peacock or mynah bird eyes. The stone is quite dense and smooth in texture, which allows the ink to be finely and evenly ground, so producing a smooth black ink when mixed with water.[14]

While ink and the ground of silk or paper shaped much of the character of Chinese calligraphy and graphic art, the free movement of the pliable brush was the most important technical factor underlying later artistic development. The Chinese brush consisted of a carefully structured bundle of hairs which were fixed in the end of a holder, usually made of bamboo. The inner core of long hairs might be waxed for springiness; surrounding this core but leaving the tip clear was a mantle of shorter hair. Around both of these was an outer layer of hair running from the base to the tip of the brush. The gap between this outermost layer and the tip of the core not covered by the mantle provided an ink reservoir. The details of the construction of a brush could be varied according to the taste of the user or the precise purpose for which it was intended. A brush with a highly waxed core would produce a lively and responsive line, while a softer core would produce a more even stroke. Wide soft brushes might be used for applying ink or colour washes in painting. Like the other equipment used by the calligrapher and painter, the handles of the brushes were often elaborately made, using materials such as lacquer, cloisonné or bamboo inlaid with mother of pearl.[15]

Chinese script

The soft springy brush, the tool developed for writing the Chinese system of characters on bamboo, silk and paper, was ideally suited to this task. Chinese characters each convey a separate meaning (see Introduction, p. 26). A sentence is composed of a sequence of characters: in classical Chinese a single character often conveys the meaning of a separate word; in modern Chinese, two characters more frequently convey the sense. As Chinese is not an inflected language, the words do not have different endings to indicate tense or case – the characters do not change with their grammatical function. Conveying the meaning of the words has always been the primary purpose of the characters, so pronunciations have varied from time to time and place to place, and the exact pronunciation and tonal inflection of the characters have always had to be learned by rote. Although this relatively weak link

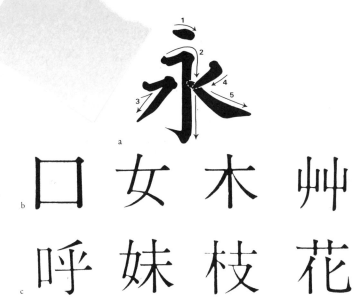

a

b 口 女 木 艸

c 呼 妹 枝 花

55 (a) *yong* (eternal) with the order and direction of strokes indicated; (b) (*from left to right*) the radicals *kou* (mouth), *nü* (woman), *mu* (tree) and *cao* (grass); (c) *hu* (to call) with the 'mouth' radical, *mei* (younger sister) with the 'woman' radical, *zhi* (branch) with the 'tree' radical and *hua* (flower) with the 'grass' radical.

with a pronunciation system may seem a disadvantage to those brought up speaking European languages, it was in fact a source of great strength and contributed to the long endurance of the writing system. Many forms of pronunciation have been used in China over the centuries, and at any one time there have been hundreds of different dialects, but at all times and all places the written language has been and still is common to all who can read and write.

Each character is made up of a series of brushstrokes, and these strokes must be executed in the correct sequence if the character is to have the correct proportions and balance of lines. For example, the well-known character *yong*, meaning eternal, is written with five strokes, and these must be performed in the order shown in figure 55a. The dot at the top comes first, then the long vertical stroke with a hook at the end, and finally the strokes to the left and right. In learning the stroke order, the writer learns the hand movements required for each one and the spacing permitted between them. Thus only tiny variations are possible, but so acute are the human eye and the control of our hand movements that the most minute changes can be made and recognised as characterising the hand of one person rather than another, or belonging to one period rather than another. Writing such carefully balanced combinations of strokes in ink on an absorbent silk or paper is highly risky, for all is ruined by one small mistaken movement. The need for practice to achieve success is therefore great, and the work of a skilful practitioner is very easily distinguished from that of someone less skilful. Indeed, the difficulty of the task means there is a wider range of skills to be developed.[16]

The character *yong* is relatively simple, consisting of only one element – the radical – composed of only a few separate strokes. Many characters, however, are much more complicated, consisting not only of radicals – characters in their own right such as 'mouth', 'woman', 'tree' or 'grass', which suggest their basic meanings (fig. 55b) – but also of one or more sub-groups of strokes, thereby forming compound characters such as 'to call', 'younger sister', 'branch' (of a tree) or 'flower' (fig. 55c). The sense of balance and proportion seen in *yong* must therefore be carried through to this more complex level as well. There are about 50,000 characters in the longest

56 *Xie* (to draw, write) written in the six scripts: (a) *xiaozhuan* (small seal script); (b) *lishu* (clerical script); (c) *caoshu* (draft or grass-script); (d) *xingshu* (running script); (e) *kaishu* (standard script); (f) *jiantizi* (simplified characters).

Chinese dictionary, of which about 5000 to 8000 are in common use. Educated individuals must not only master the latter for the purpose of recognising them in reading, but they must also learn all the proper strokes in the appropriate sequence for every single one.[17] The fact that each character requires such practice and careful execution makes writing a demanding and very personal skill, thus laying the basis for the particular forms of Chinese calligraphic achievement and for a most unusual type of painting.

In addition to the demands of writing in standard characters with a brush, the early history of the Chinese language contributed further to the reservoir of forms which were available to all writers and therefore to all educated people (fig. 56). These forms are described briefly below.

As already mentioned, the first full forms of Chinese characters to survive are found in the inscriptions recording divinations made on oracle bones from about 1300 BC (Introduction, fig. 6). About 2000 different characters have been counted on Shang bones, but only half of these have been deciphered. The character shapes are angular and irregular in size, structure and line arrangement. Within the characters, pictographic elements are conspicuous, and the standard stroke system has not yet developed fully.[18]

The next form of surviving document is the bronze inscription, cast inside ritual vessels (ch. 1, fig. 35). Inscriptions are found in Shang vessels (c. 1250 BC), but the longest and most informative ones appear on vessels cast for the Western Zhou (c. 1050–771 BC). The bronze script is generally much more regular than that on oracle bones. The characters are arranged in vertical and horizontal lines, and the proportion of pictograms within the characters has decreased. Although these characters were incised in clay prior to casting, the thickness and thinness of some of the lines indicate that brushes were already in use.[19]

As part of an attempt to unify culturally the highly diverse feudal states which had preceded it, the Qin dynasty (221–206 BC) standardised the writing forms then in use, thereby creating one of the most enduring of all ancient scripts, the small seal script, *xiaozhuan* (fig. 56a).[20] This script is very regular, with each character the same size, regardless of complexity. The use of strokes and sub-groups of strokes had also been standardised by this time. The script appears at its most dramatic on stone stelae set up to proclaim Qin Shi Huangdi's unification of the empire (Introduction, fig. 7). These were the first of a long line of stone inscriptions, which in due course were used to record events, perpetuate the memory of individuals in their epitaph tablets, and preserve the canons of Confucian, Daoist and Buddhist texts.[21] The small seal script promulgated during the Qin was based on many regional variants and contained nearly 12,000 characters, on which later scripts were based. Inscriptions have been found on stone, ceramic vessels and tiles but, most important of all, small seal script was employed for seals. It has remained the principal script employed on seals for the last two thousand years, and official documents still carry seals in this script.[22]

Seals had been made since at least the late Zhou period for official, artistic, literary, commercial and personal purposes, and were commonly used instead of a signature. They were made from any material that could be carved or moulded – bronze, silver, stone, horn and wood – and vary in size from huge imperial seals to small personal ones bearing anything from one to

twenty characters. They are carved so that the characters are either in intaglio against a solid background or in relief against a background which has been removed. At first seals were impressed into clay, but from at least the Six Dynasties period (AD 265–589) a coloured ink paste, usually red, was employed (see Preface, p. 9).[23]

Seals were commonly attached to documents once they had been received or checked. In the same way, seals came to be applied to items of calligraphy and painting, so that as a work of art passed from one collector to another, each collector would add a personal inscription or colophon and print one or more of his personal seals (fig. 57). The authentication of paintings and calligraphy can sometimes be based upon the identification of a collector's seals, although this must be done with great caution as copyists and forgers of paintings frequently copy original seals.[24] One renowned twentieth-century painter, Zhang Daqian (1899–1983), a skilled painter and copyist, is known to have forged many compositions of tenth- and eleventh-century masters and to have then given the paintings bogus authentications by the use of forged seals.[25]

The scripts mentioned above show the evolution of the characters into their fully developed forms as used by the Qin. With the exception of their special use in seals, these ancient scripts ceased to be current after the Han period (206 BC–AD 220). Scripts developed in the Han, however, remain in use to the present day. Clerical script, *lishu* (fig. 56b), was developed under the Western Han (206 BC–AD 9) as a simplified substitute for small seal script.[26] By the late third century BC it had superseded seal script as the normal script for general documents, and it is found on many thousands of official documents on bamboo and wooden slips (fig. 58). Characters in clerical script emphasise strong horizontal and vertical lines, with each character based on a square. Individual strokes vary in width, with considerable contrast between the thick and thin parts of a single stroke, and certain characters have stressed strokes, especially the powerful *bozhe* stroke, which runs diagonally towards the lower right-hand corner and is a hallmark of *lishu*. Signs of an awareness of rhythm and of the various ways of applying pressure on the brush point to the emergence of writing as a self-conscious and practised skill. An important factor in this transition is the evident refinement of writing materials in the late Han.

Draft script, *caoshu* (fig. 56c), also known as grass-script, is a fully cursive script, developed originally as a quick form of clerical script during the Han. In draft script the strokes run together and are frequently abbreviated. However, only standard, recognised abbreviations are permitted. At first used only for drafts of documents, the script was widely used by the second century AD, and during the Six Dynasties (AD 265–589) its aesthetic possibilities were recognised and it was accepted as a script in its own right. It retained an impression of informality and so could not be used for final forms of official documents or for writing Confucian classics or Buddhist or Daoist scriptures, which would have been written in the more formal *lishu*. However, the speed and flow with which *caoshu* could be written were to be widely exploited for their expressive qualities, which easily captured the individuality of the writer. A related cursive script called running script, *xingshu* (fig. 56d), was also used.[27]

57 Zou Yigui (1686–1772), *Pine and juniper trees*, section forming part of the inscriptions and colophons of the handscroll *The Admonitions of the Court Instructress* (fig. 65) attributed to Gu Kaizhi (*c*.344–*c*.406). The composition was created by Zou Yigui to accommodate the large imperial seal of the Qianlong emperor, 'Treasure of the Most Exalted Emperor' (see Preface, p. 9). All of the other seals, apart from the artist's seal below the inscription (*lower left*), also belong to the emperor.
HT: 24.8 cm, W: 74 cm.

The dominant form of writing, known as *kaishu* (fig. 56e), was evolved from clerical script, probably in the sixth century AD. The transition from *lishu* to *kaishu* may be traced through dated excavated texts: the earliest known example of *kaishu* is a fragment dated AD 479 from Turfan in Central Asia (now in the Berlin State Library). Many sixth-century dated sutras from the collection of manuscripts found by Aurel Stein in cave 17 at Dunhuang, now in the British Library (fig. 59), still show stylistic similarities to the official script of the Han.[28]

By the Six Dynasties the basic development of each of the scripts mentioned above was complete, although ensuing changes in writing styles brought many variations of standard scripts. Calligraphy also became established as an essential part of political, official, literary, artistic and religious life. The building of the tradition continued until the eighteenth century, when archaeological and epigraphical studies prompted a revival of two ancient types, seal script (*zhuanshu*) and clerical script (*lishu*).[29] The discovery, at the end of the nineteenth century, of oracle bones at Anyang in Henan province (Introduction, fig. 6) led subsequent artists and calligraphers to experiment with early scripts.

The most recent development in the evolution of Chinese calligraphy, and the only new script to be formulated since the Six Dynasties period, is 'simplified characters', *jiantizi* (fig. 56f). The official system of simplified characters was first introduced in 1956. This script type involved a reduction in the number of strokes in many Chinese characters and often the exchange of one sub-group of strokes for another.[30]

However, even today, most educated Chinese practise writing in all of the scripts described above and have mastered not simply the necessary stroke sequences and combinations, but also the variations in emphasis and pressure which make for strong or elegant hands. This ability to control the hand movements in writing is still regarded as an essential feature of a proper education, and can be readily judged by all literate Chinese whenever they see anyone's handwriting.

Calligraphy

For the utilitarian craft of writing to become the art form calligraphy, several factors were essential. First, there had to be a readily discernible difference

58 Bundle of bamboo slips from the tomb of the Marquis of Dai at Mawangdui, Changsha, Hunan province, 2nd century BC. Individual strips of bamboo or wood were strung together and rolled up to form a book.

between the best and worst examples. The craft had to be accorded esteem over and above its usefulness for communicating ideas or facts. Its practitioners also had to be highly regarded, and finally a canon had to be established so that each new generation would have a starting point from which to develop and judge their own skills.

By the Six Dynasties period (AD 265–589), all of these conditions had been fulfilled. The practice of writing was widely developed and highly demanding. Characters were complex but standardised, and a high degree of skill was required to produce elegant balanced writing. The degree of care and skill in writing could be readily discerned, since it required a great deal of practice even by those well versed in its techniques, who could never

afford to relax their concentration. Finally, the large number of people who were able to write provided a reservoir of potential skill.

The fact that writing was used in all aspects of official, religious, literary and artistic life meant that the writing tradition spread to all spheres of Chinese culture, thus fostering its role in all aspects of society. But most important of all was the use of writing in the service of politics, which meant that all writing commanded implicit respect.[31] Moreover, those who could write were the official élite of Chinese society, and over the centuries they continued to consolidate their political and social positions (Introduction, pp. 19–21). Any art practised by this élite – and the people who developed writing into calligraphy were the scholar-officials – inevitably gained their allegiance. Finally, the flexible brush used for writing was able to transmit hand movements faithfully to the page and, as the movements of each individual are different, the brush proved immensely effective in recording the personality of the officials who practised calligraphy.[32] The recognition of a particular individual's hand movements was thought to lead to an implicit understanding of his character and personal qualities, so that calligraphy (and, later, calligraphic painting) was thought to be imbued with the qualities of particular persons or groups of people and thus associated with their political, social and moral attitudes.

The development of a group of officials who became identified with the practice of government was one of the essential conditions for according all forms of writing official support. The Han to the Song periods (206 BC– AD 1279) saw the full extension of the Chinese system of government by officials and of the examination process by which they were recruited. By the first century AD there were 120,285 officials divided between the military, the centralised government, the imperial household and the provincial administration, and this group would have further spread the writing system through their official records to all parts of the empire.[33] To meet the needs of the government administration, an imperial academy was set up in 124 BC to train students for government office. The examination system, which began on an informal basis in the Eastern Han and survived until the end of the Qing dynasty as a means of competition by which young scholars entered government service, attracted large numbers of highly educated applicants who were able to write in several scripts and compose set literary forms. The candidates were examined in the principal classical texts on the subjects of philosophy, ritual and literature.

The texts at the centre of official attention were the Confucian classics, thought to embody the principles of a moral life and of good government. Such writings included the *Lunyu*, a collection of the sayings of Confucius, and the works expounding the doctrines of his followers. In addition, such ancient texts as the *Book of Documents* (*Shujing*) and the *Book of Songs* (*Shijing*), as well as books of ritual, were part of the Confucian canon.[34] These were the texts copied on to stone between AD 175 and 183.[35] They were carved on some forty-six stelae, using over 200,000 characters,[36] and great attention was given to producing an elegant and readable effect. It was not until the Eastern Han (AD 25–220) that cursive handwriting began to compete with monumental inscriptions as a medium of calligraphic expression.

Until the invention of printing in the Tang period (AD 618–906), official

documents, versions of standard texts and dynastic histories were copied and recopied by hand. We are made conscious of this process in the work of one Xun Xu, custodian of the imperial library of the Western Jin dynasty (AD 265–316), who wrote that books were discovered in a tomb in AD 280 and were recopied on to paper, eventually to be stored in three separate collections.[37] This account makes it evident that such rediscovered documents were highly treasured. We have some idea of what these early books would have looked like from the large collections of documents on bamboo and wooden slips found in Juyan and dating from the second to first century BC, which have been well preserved in the very dry conditions of Chinese Turkestan.[38]

In addition to the principal ancient texts regarded as essential to the Confucian canon, from the second century AD until the Tang dynasty (AD 618–906) religious writings attracted particular attention; Buddhist texts were translated into Chinese, and Daoist ones were extensively copied. Both religions stressed the copying of scriptures as a highly meritorious deed, merit being judged both by the quantity of texts copied and the quality of the calligraphy. Copies were generally made by anonymous professional writers who were paid by the faithful. Buddhist sutras, generally reproduced for their content rather than for their purpose of reproducing a precise calligraphic style, were thus 'free copies' (fig. 59). Much more exact copies were required for the reduplication of Daoist talismans (fu), as it seems to have been thought that the talismans would lose some of their effectiveness if they were not copied as closely as possible. Such attention to the faithful transmission of exact stroke forms was to contribute to the building up of a calligraphic canon.[39]

The engraving of Buddhist texts on stone stelae began in the sixth century (fig. 60), when they were occasionally produced on a large scale. One of the most remarkable enterprises in the history of the Buddhist faith in China was the carving of the canon on stone slabs at Yunjusi, a monastery at

59 *Mahāparinirvāna-sūtra*, j.xi (section), dated AD 506, from cave 17, Dunhuang, Gansu province. This is the earliest dated Buddhist manuscript from south China in the Stein collection. Written on thin paper with yellow preservative, the characters are even in size and number seventeen to a column. HT: 26.6 cm.

95

60 Rubbing of the stele of
Shijia, written in standard
script on the northern wall of
the Guyang Cave, Longmen,
Henan province. Northern
Wei dynasty, *c.* AD 500. The
inscription records the
erection of a statue of
Śākyamuni Buddha donated
by Wei Lingcang and Xue
Fashao. The style of the
characters, with their
wedge-shaped strokes, is
that found on many stelae in
northern China dating from
the Six Dynasties. HT: 88 cm,
W: 38 cm.

Fangshan near Beijing. A monk called Jingwan conceived the project during the Sui dynasty (AD 589–618), because he thought the end of the world was near and he wished to ensure that the Buddhist texts would survive the ensuing catastrophes. He and his successors were responsible for engraving more than 14,620 slabs, which were then buried in caves in the mountain side and in pits in the ground. This response to impending doom was not duplicated in any other Buddhist land; to the Chinese, however, it would have seemed the most appropriate thing to do.[40]

All the texts described so far were actually written by clerks or artisans and did not in their own day command respect as art, although their aesthetic qualities were probably required and respected as part of the appropriate execution of their political and religious functions. However, the continued development of writing for these august political and religious purposes undoubtedly extended its potential as a form of skill esteemed in society. Furthermore, the emperors and priests ensured that their writings endured not only by having them engraved on stone (as described), but also by having them transmitted through rubbings and copies. Making copies was indeed fundamental to the development of all aspects of the art of writing. These copies provided models for all to follow and were in addition useful to rulers wishing to promulgate one form of writing rather than another as the

principal form. In this way there developed not only a canonical body of content, but a canonical body of writing forms and styles.

Essential to this distribution and transmission of writing styles, as opposed simply to content, was the method by which copies were made. Before the invention of printing in the Tang dynasty (AD 618–906) and the widespread printing of official and religious texts under the Song (AD 960–1279), many different techniques for copying were employed.[41] There are two categories of copying: exact copying (*mu*) and free copying (*lin*). The purpose of exact copies is to reproduce the original as closely as possible. A thin sheet of paper is placed over the original, which is slowly traced. A more precise method of reproducing a copy is the technique called *shuanggou tianmo* (double contour filled with ink). In this case the outlines of the original are meticulously traced and then carefully filled in with tiny brushstrokes. To make free copies, a sheet of paper is placed next to the original calligraphy, and the calligrapher then copies the original at his own speed. The copies produced in this last manner could differ widely from the original, varying from a close copy to a piece of calligraphy bearing only a distant resemblance to the original but influenced also by the style of the copyist.

The most widely used method of reproducing writing and calligraphy was to make ink rubbings from calligraphy that had first been chiselled in stone or wood. To transfer a piece of calligraphy on to stone or wood, a copy of the original, written in black or vermilion red ink, would be pasted to the stone or wood surface. The calligraphy would then be meticulously engraved into the surface through the copy paper, showing every variation in brushstroke. To make a rubbing, a moistened sheet of paper was placed over the engraved calligraphy and the surface of the paper gently pushed into the incised areas with a broad brush. Then, a flat pad made from a piece of fine silk containing cotton wadding was soaked in ink and dabbed over the surface, leaving the background black and the calligraphy white. The earliest surviving literary reference to rubbings comes from the Tang dynasty, when calligraphy by the Eastern Jin master, Wang Xizhi, was cut into stone at the order of Tang Taizong (r. 626–49).[42] However, a much earlier date for the use of rubbings as a means of reproducing texts seems likely since paper, invented in the first century BC, was extensively used for writing by the second and third centuries AD (p. 86). Rubbings on paper would have been the easiest way of promulgating texts, but there is no surviving literary evidence to substantiate this.

These methods of copying were increasingly exploited as the value of the writing of particular individuals came to be recognised. This crucial development took place in the third to fourth century AD, when the idea arose that some writing should be regarded as calligraphy – an art form which expressed values, aesthetic and moral, as distinct from text content. The view that writing was aesthetically valuable led to the widespread copying and reduplication of calligraphy by noted masters and to the establishment as venerable of particular types and styles of calligraphy, which came to be known as the classical tradition.[43] From the Tang dynasty onwards collections of calligraphy were made, which further encouraged its development as an art form.

What seems to have made this new development possible was the division

of China (from the third century AD) into two areas, the north under foreign control and the south under Chinese. In the south a new freedom seems to have been allowed and indeed fostered. This departure is seen in the survival of examples of letters and comments of small format, know as *tie* (labels) (fig. 61). Generally written on silk in a cursive script, *caoshu* or *xingshu*, calligraphy on *tie* was usually circulated in the original and was only engraved on stone if it were an especially prized example. The fact that a number have survived, if not in the original at least in very early copies, shows that they must have been valued in their own time.

The new approach to writing is inextricably linked to the calligraphic masters of the Eastern Jin (AD 317–420), whose tradition shaped the future course of the history of Chinese calligraphy. The two major figures of this tradition were Wang Xizhi (307–65) and his son Wang Xianzhi (344–88), who lived in the south. Wang Xizhi's was one of the leading families to flee from Shandong during the last years of the Western Jin and later became one of the most important under the Eastern Jin. Wang Xizhi himself occupied an official position until he gave it up in 353, spending the last decade of his life in retirement with his literary circle of friends, discussing Buddhist and Daoist topics and cultivating the arts. These connections with religious circles may have been seen later as instrumental in the development of spiritual or personal qualities in his writing. Wang Xianzhi was the youngest of Wang Xizhi's seven sons. Because Wang Xianzhi's work was less favoured than that of his father, we know much less about it today and cannot make accurate judgements on its character and quality. Wang Xizhi's writing included calligraphy in standard, running and cursive scripts, and he is praised for having been proficient in each. His calligraphic works vary in length from several hundred characters to a few tens of characters in short

61 Attributed to Wang Xianzhi (AD 344–88), *Echun tie*, ink on paper. During the Six Dynasties period, artistic interest moved from inscriptions on monumental stelae to smaller and more informal pieces of writing on paper and silk, called *tie*.

之和
會九
稽年
山歲
陰在
之癸
蘭丑
亭暮
脩春
稧之
事初
也會

群
賢
畢
至
少
長
咸
集
此
地

有
崇
山
峻
領
茂
林
脩
竹
又
有
清
流
激

湍
暎
帶
左
右
引
以
為
流
觴
曲
水

62 Attributed to Wang Xizhi (AD 307–65), *Lanting xu* (*Preface* [*written*] *at the Orchid Pavilion*) in running script, detail of beginning section. The *Lanting xu* is one of the most celebrated pieces of calligraphy in China and set a standard for centuries afterwards.

letters. His most noted works are the *Lanting xu* (*Preface* [*written*] *at the Orchid Pavilion*) and a group of shorter pieces including some written in the *tie* format.[44]

The *Lanting xu* describes a gathering of scholar-officials at which, as was customary, each guest composed a poem, and Wang Xizhi then wrote this lyrical text as the preface for the poems (fig. 62):[45]

That day the sky was cloudless; the wind blew softly where we sat. Above us stretched in its hugeness the vault and compass of the World; around us crowded in green newness the myriad tribes of Spring. Here chimed around us every music that can soothe the ear; was spread before us every colour that can delight the eye. Yet we were sad.

63 (*opposite*) Zhang Ruitu (*fl.c.*1600), calligraphy in cursive script. Hanging scroll, ink on satin. Zhang Ruitu was considered one of the four great calligraphers of the Ming dynasty, along with Dong Qichang (1555–1636), Xing Tong (1551–1612) and Mi Wanzhong (*fl.* late 16th–early 17th century). This scroll shows a poem written in Zhang Ruitu's characteristic style of widely separated columns of characters written using the side-tip of the brush.
HT: 1.88 m, W: 53 cm.

For it is so with all men: a little while (some by the fireside talking of homely matters with their friends, others by wild ecstasies of mystic thought swept far beyond the boundaries of carnal life) they may be easy and forget their doom. But soon their fancy strays; they grow dull and listless, for they are fallen to thinking that all these things which so mightily pleased them will in the space of a nod be old things of yesterday . . .'

A. Waley, *An Introduction to the Study of Chinese Painting*, London, 1923, p. 70

It is difficult today to reconstruct precisely why the calligraphy of the two Wangs was chosen, presumably over many other works by other scholars, to set the standard for all succeeding generations. However, the content of the *Lanting xu* may suggest one major reason. The preface describes a gathering of learned men in a garden, during which they not only enjoyed the pleasures of companionable wine drinking and poetry composition, but also experienced an ineffable feeling of calm and peace. The calligraphy, the even flow of the characters and the springy lines of the strokes are seen to express this same mood. It is essential to the mood of the piece that the gathering took place in the open air, away from the daily routine of official life with which all the participants were familiar. The content of this preface is thus an implicit manifesto for retreat or even dissent from the rat race of politics and bureaucracy. It thus belongs to the dialogue, ever present in Chinese life, between the official endorsement of order and hierarchy and the individual's wish to escape from such constraints to seek a deeper spiritual meaning in the natural world.[46] Both in connection with such influential pieces of calligraphy and in later amateur literati landscape painting (pp. 115 ff.), the mention or depiction of a garden was a shorthand reference to this alternative path. As the preface headed a collection of poems, poetry too became linked to calligraphy and served as a metaphor to explain the ways in which both calligraphy and, later, literati painting were expressive.[47]

Other pieces by the two Wangs also suggest an essential informality or spontaneity, especially those in the *tie* format. It is indeed important that the Wangs are not famous for writing monumental works reproduced on stone stelae. Their writings were respected as expressing their personal feelings and qualities, rather than as the medium for conveying official truths, such as the formal calligraphy carved in stone to preserve the Confucian classics or Buddhist texts.[48] The tradition of the two Wangs thus celebrated the expressiveness of the well-educated official in some sense in retirement. This use first of calligraphy and later of calligraphic painting to exhibit the qualities of the individual, especially of the official in retirement from official life, was to remain at the centre of the tradition for which the works of the two Wangs provided the starting point.

Thus, although the Chinese calligraphic tradition had gained its weight and authority because it arose out of the practices of religion and politics, and though it was further widely disseminated through the transmission of classical and religious texts, the life of the tradition from this date onwards was sustained by the notion that calligraphy could convey the spontaneous feelings of the truly perceptive individual through an outflowing of spirit at a particular instant. These expressive moments were to be compared with

the composition of poetry and associated with retreat from the routines of daily official life and with distance from the centres of power. The garden setting, whether referred to or illustrated, would remain concrete evidence of this distance. But in fact those who were to be deemed the great calligraphers and later the great painters were always individuals who might have held power. In a sense, the weight of the official literary tradition gave birth to this alternative form of art, allied to and yet at variance with the dictates of official life – be they in the execution of government from day to day, or in the inscribing of the classical canon that sustained that life.

At all periods, the survival and development of artistic styles that emerged among individuals in retreat depended on official patronage. That in itself is one of the great ironies of the Chinese artistic tradition. While only retreat could sustain the spontaneity so much sought after, only support from the court could ensure its survival in calligraphic works. Indeed, for lack of this support the works of many artists have probably perished without trace. The calligraphic tradition of the two Wangs was no exception to this rule. Calligraphy by Wang Xianzhi has been almost totally lost because it did not gain official support, while that of Wang Xizhi became pre-eminent precisely because it was endorsed by the Sui and Tang emperors.

The calligraphic art of the Eastern Jin masters remained confined to the south for two centuries until the reunification of the empire under the Sui (AD 589–618), when 800 scrolls were saved from the Chen dynasty (557–89) in the south. These included many works of the southern calligraphers. Both Sui Wendi (r.589–604) and Sui Yangdi (r.605–17) continued collecting works in the Wang Xizhi tradition, but it received its most influential endorsement from the Tang emperor Taizong (r.626–49), who emulated Wang Xizhi in his own writing, thereby creating interest at court in the master's work and assembling a huge collection of rubbings.[49] Copies of the rubbings were distributed by the emperor to members of his family and court in an effort to establish the calligraphy of Wang Xizhi as the most important model. Wang Xizhi's style was thereby fostered at the expense of that of both his son and of contemporary Tang calligraphers. The tradition thus founded on Wang Xizhi continued, with the reduplication of his work by copies and rubbings preserved in private collections, and formed the basis of the calligraphic styles of all the important calligraphers from the Sui through to the eighteenth century, including Mi Fu (1051–1107), Su Shi (1036–1101), Zhao Mengfu (1254–1322), Dong Qichang (1555–1636) and Zhang Ruitu (*fl.c.*1600) (fig. 63). All aspiring calligraphers would study these august predecessors and develop the skills needed to render their styles. In this way the calligraphic tradition was maintained.[50] Over this long period many other (often contrasting) calligraphic works were also drawn into this tradition and assiduously copied. Among these were such freely exuberant writings as the spontaneously written autobiography of the monk Huaisu.[51]

For such study to be possible, the calligraphic tradition had to be supported both by the circulation of copies and by the formation of collections, not only by the emperors but also by officials. The first collections were of talismanic objects, the maps and documents deemed essential to proper management of the state, and bronzes thought to be miraculously

rediscovered.[52] To these were added writings that emperors especially prized, for example, the texts written by Wang Xizhi which were in the possession of the Emperor Taizong. The considerable political difficulties of the Song period (AD 960–1279) encouraged the further development of imperial and official collections as a means of bolstering the state and society. In addition to the imperial and official collections, temples were repositories of religious documents. The Beilin (Forest of Stelae) was established in the Song dynasty in a Confucian temple in the present-day city of Xi'an as a treasury of important stone stelae, with literary and official works, and the collection continued to be added to until the twentieth century. All such collections and their later descendants provided a repository of works which could then be studied, emulated and transmitted.[53]

Painting

Although all of the most highly respected later Chinese painting evolved directly from calligraphy, early painting was more varied and had many functions. In the late Eastern Zhou period (fifth to fourth century BC) it was used to decorate coffins and boxes, on which were represented the heavens and the underworld. From such very early beginnings grew two of the major painting genres: decorative painting and didactic painting.[54] Finally, China developed forms of painting that exploited calligraphic techniques and also embodied the values of calligraphy. At the same time a critical theory was evolved which articulated the links between the calligraphic tradition and such painting.[55] The Northern Song artist Guo Xi (c. 1001–90) wrote, 'The difficulty of handling the brush and the ink [in painting] is the same as in calligraphy'.[56]

As in calligraphy, the nature of the brush was essential to the development of painting, and the contrast with the use of the brush in Europe is strong. In the West a bird's quill was used, which was sharp and stiff and produced writing that was angular and sharp-edged. Writing with the quill was a craft practised by scribes rather than a skill essential to the role and identity of an entire élite class of officials. The brush used by the Chinese artist was flexible and also used for all types of writing. Brushes of different flexibility and thickness could be applied with differing pressure to achieve a huge number of varieties of stroke types; the practice of writing had already made the stroke forms familiar to all the literati. These stroke forms could then be adapted to represent form and space, light and shade. In both calligraphy and painting, moreover, the tones of ink play an important role. In Western painting, colour was used for the modelling of forms and to show the variations of tone. In Chinese literati painting, ink alone was used to model objects in light and dark, and to represent forms in the context of space.

Didactic painting

Early texts on Chinese painting discuss its moral, ceremonial or political purpose.[57] In the *Records of the Grand Historian* (*Shiji*) by Sima Qian (c. 145–86 BC), his biography of Confucius relates how the sage is said to have visited the Zhou capital and inspected the grounds set apart for sacrifices to Heaven and Earth, the court precincts and the Ming Tang (Hall of Holiness).[58] On

the walls of the Ming Tang were painted national heroes and notorious scoundrels of antiquity, and each picture was appropriately inscribed with words of praise or warning. Sima Qian's account of the existence of didactic figure wall paintings in the time of Confucius (c.551–479 BC) cannot be verified, but it is a clear indication that such paintings of a didactic nature were important in his own time, c.100 BC, under the Western Han. All reports of painting during the Han dynasty reflect the hierarchical nature of Confucian attitudes to the world, which embraced the ancient rituals of respect for the ancestors as well as concepts of the harmony of society with the cosmic forces of Heaven and Earth (Introduction, pp. 22–3). The Wei kingdom poet and essayist Cao Zhi (AD 192–232) mentions the portraits of emperors, sages, faithful subjects, obedient empresses and good secondary consorts, and rebels and unfilial sons, with the comments, 'By this we may realise that paintings serve as moral examples or as mirrors of conduct'.[59] Indeed, the didactic character of all early painting may have led to the notion that all good painting should display a high moral tone relevant to the conduct of society. In later times the modes changed whereby such values were expressed, but the idea that the best painting expressed values did not.

The earliest extant major didactic pictorial works are wall paintings, stone bas reliefs and moulded clay tiles made for the decoration of funerary chambers during the Eastern Han dynasty (AD 25–220). The most important group are stone bas reliefs from the Wu family offering shrines in south-western Shandong province, which are generally dated to between AD 151 and 170. The three major themes shown in these shrines are the concept of filial piety, the good omens that appeared as signs of Heaven's response to virtuous conduct, and the journey of the soul (hun) of the deceased and its safe arrival in its new celestial home.[60] The bas reliefs of the Wu shrines are engraved on stone slabs of which the background is textured with vertical striations. The lower section of the west wall of the left shrine displays a battle scene, with figures seated in chariots and standing in combat, arranged in horizontal registers and shown in silhouette (fig. 64). There is little to suggest scenery apart from the bridge, below which fish and birds represent a river and the sky above.

64 Rubbing from stone bas relief from the Wu family offering shrines (AD 151–c.170), showing a battle scene from the lower west wall of the left shrine. Han period bas reliefs incised in stone and moulded clay tiles show the range of two-dimensional figure and landscape art of the period.

Also during the Han dynasty, individual painters begin to emerge from the general anonymity of the artisan-painters responsible for this didactic tradition. The Wu offering shrines of the Eastern Han display an inscription stating that 'the able artisan Wei Gai carved the designs'. The formalised and restrained images of the Shandong bas reliefs contrast with the naturalistic representations on clay tiles from Sichuan province, perhaps indicating that naturalism developed first in the south and southwest rather than in the north.

Early texts record a number of figure painters and titles of works, including Gu Kaizhi (c.344–c.406), Lu Tanwei (fl.465–72), Yan Lide (d. 656) and Yan Liben (d. 673)[61]. However, since no genuine paintings survive by any of these artists, their work must be assessed through later copies. Gu Kaizhi, a native of Wuxi in Jiangsu province, gained a reputation as a painter at the Jin court in Nanjing. He was famous for his portraits and figures, but he also painted landscapes. A number of important paintings are attributed to him, but they were not associated with him in texts until the Song dynasty, so the relationship to him is tenuous. The handscroll *The Admonitions of the Court Instructress* exists in two versions, the earlier of which, thought to be a Tang dynasty copy, is in the British Museum. It illustrates a moralising text by Zhang Hua (AD232–300) which discusses the correct behaviour of ladies of the imperial harem. The scroll consists of quotations from the text, followed in each case by figure illustrations without any background or at

65 Attributed to Gu Kaizhi (c.344–c.406), *The Admonitions of the Court Instructress*, scene 7. Handscroll, ink and colour on silk. This is the finest extant work attributed to Gu Kaizhi and one of two versions of this theme (the other is in the Palace Museum, Beijing). This scene shows a court lady advancing towards the emperor, who repulses her with a gesture of his raised hand. HT: 25 cm.

66 Ma Hezhi (*fl.c.* 1131–62), *Illustrations to the Odes of Chen*. Handscroll, ink and colour on silk. This is one of a number of surviving scrolls illustrating sections from the *Shijing* (*Book of Songs*), with illustrations by Ma Hezhi (detail *left*) and accompanying calligraphy in standard script, probably written by a court calligrapher in the emperor's style. HT (paintings): 26.8cm, W: 1.87 m; HT (colophons): 29.6 cm, W: 1.87 m.

most slight suggestions of setting.[62] The British Museum scroll contains nine of the eleven scenes originally illustrated (ch. 4, fig. 148). Scene seven shows a court lady advancing towards the emperor, who repulses her with a gesture of his raised hand (fig. 65). The drapery is portrayed with long,

continuous, even brushstrokes; movement is shown through the vitality of the swirling draperies, a continuation of Han traditions. The facial expressions of the figures have advanced beyond the generalised types of Han figures; the characterisation of facial expression is here closer to portraiture, displaying individual character and emotion.

Didactic works of this kind continued to be produced into the Southern Song (1127–1279). The Emperor Gaozong (r. 1127–63) commissioned the court painter Ma Hezhi (*fl. c.* 1131–62) to illustrate the entire *Shijing* (*Book of Songs*). Many scrolls survive showing sections of this work, in which the text of each song – traditionally thought to have been written by Emperor Gaozong, but probably done by a court calligrapher – preceded each illustration. A handscroll illustrating the ten odes of the State of Chen in the British Museum collection portrays various figures in landscape settings (fig. 66).

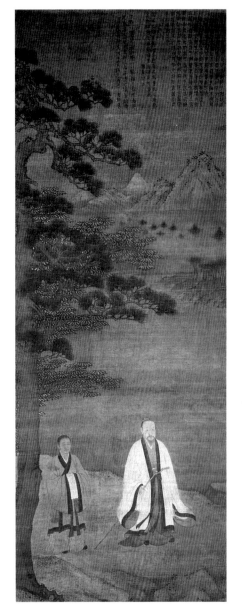

67 Chen Yuan (*fl.* mid 14th century), *Portrait of Xia Zhenyi*. Hanging scroll, ink and colours on silk. Both the prominent pine tree, symbolising strength and enduring virtue, and the archaistic 'blue and green' landscape serve to enhance the intellectual and moral qualities of Xia Zhenyi (detail *below*). HT: 1.22 m, W: 44 cm.

Imperial patronage of these illustrated versions of ancient classics demonstrates the intention of the emperor to reinforce his dynastic claims by reference to ancient virtues. The Southern Song were under considerable political pressure, having been forced to move their capital south to Lin'an (present-day Hangzhou) after the Jin capture of Bianliang (present-day Kaifeng), and in these circumstances turned to traditional methods of support for their political claims and aspirations.[63]

In China portraiture is part of the didactic mode of painting.[64] The value of all portraits depended largely on the virtues they represented, which were usually Confucian ideals such as good government, filial piety and so on. Some of the earliest portraits, documented from Han times, were idealised images of virtuous rulers and exemplary men. Thus the portraits in the *Emperors Scroll* attributed to the Tang artist Yan Liben, in the Museum of Fine Arts, Boston, were not painted from life but represented the painter's vision of the moral qualities of the people depicted.[65] A later type of portrait relied on symbolic or metaphorical means to represent the subject; for example, the figure could be placed in a setting that presented to the viewer a supposed projection of the subject's mind. In the portrait of Xia Zhenyi by the mid fourteenth-century painter Chen Yuan, the figures are portrayed next to a tall pine tree, representing strength and enduring virtue, and set in a landscape in the 'blue and green' style of Tang painting (fig. 67).[66] This gives an archaic quality to the painting, thus suggesting a link between Xia Zhenyi and the sages of antiquity. Portraits of masters of Chan (Zen) Buddhism, painted by anonymous artisans during the lifetime of the subject, were often given to disciples. Song and Yuan examples of this type of portrait have survived, many of them taken to Japan by priests who had studied in China.[67] The ancestral portrait painted by a professional artist was meant to be displayed at shrines and altars of the deceased, in accordance with Confucian belief.

Buddhist painting

Didactic painting in the Confucian tradition is intimately bound up with society and the state, and in this sense might be regarded as secular. However, the Confucian tradition contained most of the features of a religious tradition, and in this sense it was paralleled by Buddhism. Buddhism probably arrived in China during the Han dynasty (206 BC–AD 220), and established itself as a central element in Chinese culture during the period of division that followed the Han. Buddhist teaching ascribed great merit to the reproduction of images of Buddhas and Bodhisattvas, in which the artisans had to conform to strict iconographic rules; such limits were, however, no different from those set down for other earlier types of didactic painting.

The *Xuanhe huapu*, an early twelfth-century catalogue of the imperial painting collection, lists paintings of Buddhist and Daoist subjects by artists from the time of Gu Kaizhi (c.344–c.406) onwards.[68] However, no paintings by major artists of this period have survived, as the proscription of foreign religions in China between 842 and 845 resulted in the widespread destruction of Buddhist monuments and works of art. What has survived from the Tang period is an important collection of Buddhist paintings on silk and

68 (*overleaf*) Paradise of Śākyamuni, with illustrations of episodes from the *Baoen-jing* (*Sutra of requiting blessings received*). Tang dynasty, early 9th century. Ink and colours on silk. From cave 17, Dunhuang, Gansu province. The paradise paintings are among the largest and most important from cave 17. Figures are symmetrically arranged in tiers in an architectural framework. This uncluttered composition is in contrast to the more complex compositions of the 10th century (see ch.3, fig. 110). HT: 1.68 m, W: 1.21 m.

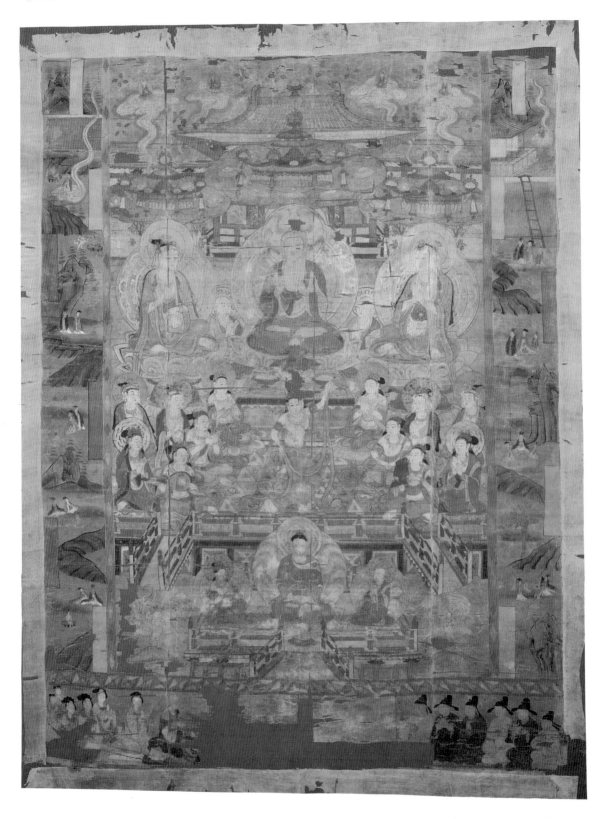

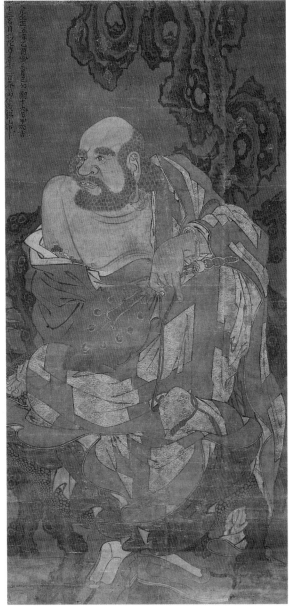

70 (*above*) *The thirteenth arhat, Ingada*, dated 1345. Hanging scroll, ink and colours on silk. In China the painting of arhats (luohan in Chinese) in series of sixteen or eighteen dates back to the Tang dynasty. This was one of a set of eighteen. HT: 1.26 m, W: 61.5 cm.

69 (*left*) Vajrapāṇi, Tang dynasty, late 9th century. Ink and colours on silk. From cave 17, Dunhuang, Gansu province. This painting of a Vajrapāṇi or thunderbolt-bearer is the central part of a banner whose triangular headpiece above and four grey silk streamers would have brought the original length of the banner to just over 2 metres. HT: 79.5 cm, W: 25.5 cm.

paper found by Aurel Stein in cave 17 in the Valley of the Thousand Buddhas, near the oasis town of Dunhuang at the Chinese end of the Silk Route (map III, p. 288). Since Dunhuang was under Tibetan occupation between 781 and 847, its cave shrines and paintings escaped destruction. The paintings from cave 17 represent a wide range of devotional art by anonymous artisans, showing a mixture of Chinese, Tibetan, Khotanese and Central Asian influences. The paintings, dating from the eighth to the tenth century, were stored together with many thousands of manuscripts in bundles in the former memorial chapel of the monk Hong Bian (d.c.862), a cave walled up in the tenth century. Paintings from cave 17 represent gifts from individuals for use in monasteries, perhaps for display when prayers were said for a particular deceased relative.[69]

The largest and most elaborate of the paintings on silk found in cave 17 are those showing paradise scenes. The compositions of the ninth- and tenth-century paradise paintings show a complex array of figures arranged in an architectural setting (ch. 3, fig. 110). In an early ninth-century painting of the paradise of the historical Buddha Śākyamuni, the figures are arranged symmetrically on three architectural tiers under a roof (fig. 68). The first tier depicts Śākyamuni and attendant Bodhisattvas; the second tier shows a dancer and heavenly musicians, and the third depicts the figure of a Buddha who is possibly the Cosmic Buddha Vairocana. Along the lower edge of the painting are male and female donor figures grouped on either side of what was originally a central cartouche, which in similar instances frequently bore an inscription.

Along the sides of the painting run vertical scenes illustrating the story of Prince Sujati as told in the *Baoen-jing* (*Sutra of requiting blessings received*), one of many *jātaka* stories which recount events in Śākyamuni's previous incarnations. Shown in landscape settings, the scenes provide rare instances of landscape in the corpus of Dunhuang paintings; such settings for religious stories were to make an important contribution to China's long tradition of landscape painting, as mentioned below. The composition of the paradise scene itself is simple and uncluttered, with the principal figures standing prominently against the background. The painting has a textile border and along the topmost edge would have been loops through which a pole would have been passed for hanging.[70]

Banner paintings from Dunhuang representing single Buddhist divinities are composed of triangular headpieces from which two streamers hang, the central rectangular portion usually bearing a single image sometimes reproduced by stencil. Below this hang additional streamers. Banners such as these were carried in processions and hung from buildings. This painting (fig. 69) of a Vajrapāṇi or thunderbolt-bearer, dating from the late ninth century, was the central part of a banner. The short, highly inflected brush-strokes are reminiscent of the brushwork said to have been associated with the famous eighth-century painter Wu Daozi;[71] they contrast markedly with the thin flowing lines of Buddha and Bodhisattva figures elsewhere. The same network of modelling in pink is found on paintings of attendant and demonic figures at Dunhuang from this period.

Another genre of didactic painting was the depiction in groups of sixteen or eighteen of arhats (luohan), a Sanskrit term for saintly men who remained

in the mortal world to defend the Buddhist doctrine. There are celebrated examples of arhats by the monk Guanxiu (832–912) of the late Tang dynasty.[72] Grotesque figures with Western features are shown seated on rustic seats, on a rock or under a tree holding a staff. A Yuan dynasty example dated 1345 showing the thirteenth arhat, Ingada, is one of a set of eighteen paintings probably produced in Zhejiang province (fig. 70). Series of such paintings dating from the Yuan or early Ming, made in Ningbo in Zhejiang province, were exported to Japan.

Landscape painting

Chinese landscape painting, which eventually dominated the artistic tradition, seems to have originated in depictions of the land of the spirits, the paradise of the immortals and the settings of didactic scenes as mentioned above. Such backgrounds provided the appropriate scenery in which to place spiritual figures and may also, perhaps, have been imbued with the same qualities; landscape thus became a source of spiritual values.

Early depictions of landscape occur in the guise of rocky mountains considered the dwellings of the immortals.[73] Incense burners of the Han period (206 BC–AD 220) were cast in the forms of such mountains, and as the incense rose through them it resembled mist hanging over the hills.[74] Banner paintings from cave 17 at Dunhuang give a few early examples of landscape; in one example showing scenes from the life of the Buddha (fig. 71), certain basic techniques of landscape construction are already evident which were later to be discussed by Song theorists. It is clear that the distinction between deep and high distance, described by the Northern Song painter Guo Xi (c. 1001–c. 1090), is being employed. The ridges of the mountains are modelled using short brushstrokes to create texture, as discussed by Song writers.[75]

Not long after the end of the Han dynasty, in the third and fourth centuries AD, Chinese painters and connoisseurs began to claim explicitly that landscape painting had a spiritual and aesthetic value above other painting. Zong Bing (375–443) from Henan province, who was a contemporary of Gu Kaizhi, said '. . . sages follow the Dao through their spirits . . . landscapes display the beauty of the Dao through their forms and humane men delight in this'. He thus implies that to paint a successful landscape shows the depth of the artist's perception of Dao as seen in nature.[76]

We know little about the qualities of landscape painting of the Tang and Five Dynasties periods, as almost none has survived. Under the Tang, leading painters by the names of Li Sixun (651–716) and Li Zhaodao (c. 670–730) are said to have excelled in landscape painting, but few copies of their work have survived.[77].

We can infer that landscape painting became important as an expressive medium during the Northern Song from the influential texts on landscape painting that survive from that date.[78] In addition, several copies of landscape paintings and possibly some originals have survived. Painters such as Dong Yuan (d. 962), his pupil Juran (fl. 960–85) and Guo Xi (c. 1001–c. 1090) are among the main figures associated with this time. In later periods some of these artists were described as belonging to a Southern school of painting (Painters appendix), but this judgement is entirely retrospective

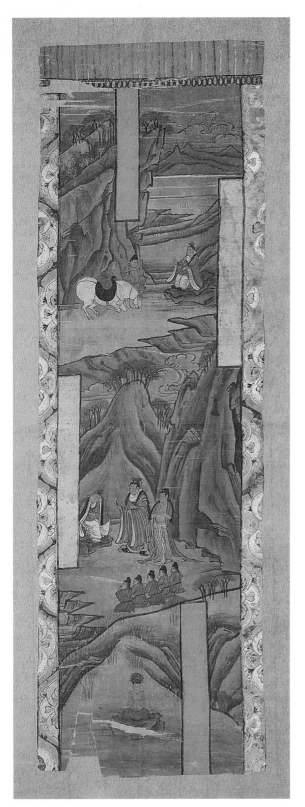

71 (*left and detail above*) Scenes from the life of the Buddha: *The Farewell*, *The Cutting of the Locks*, and *The Life of Austerities*. 8th–early 9th century AD, ink and colour on silk. From cave 17, Dunhuang, Gansu province. HT: 58.5 cm, W: 18.5 cm.

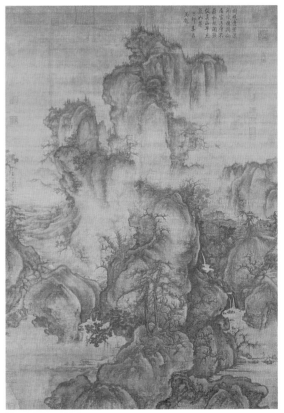

73 (*right*) Attributed to Ma Yuan (*fl.* 1190–after 1225), *Banquet by Lanternlight*. Hanging scroll, ink and colours on silk. In landscapes of the Southern Song academy the composition is simplified, the landscape elements are tamed and the focus of the composition is frequently confined to one corner of the painting. HT: 1.11 m, W: 53.5 cm.

72 (*left*) Guo Xi (*c.* 1001–*c.* 1090), *Early Spring*, dated 1072. Ink and colour on silk. The precise brushwork and compositions of earlier Northern Song landscape painting have been replaced here by a rendering in which movement is emphasised through rich ink washes. This painting is one of the few of the period to be generally accepted as a genuine work. HT: 1.58 m, W: 1.08 m.

and says very little about their origins or allegiances at the time. Indeed, almost nothing is known about these painters. Their importance lies in the technical and aesthetic mastery exhibited in the few landscape paintings attributed to them, which may indeed be by them or may otherwise reflect their styles. These paintings are, on the whole, large compositions, in both hanging scroll and handscroll formats. They employ a calligraphic brush technique to convey not just a representation of particular places but, as James Cahill has argued, the embodiment of philosophical concepts and attitudes towards the natural world.[79] Later generations also read many other interpretations into these paintings. Although it is almost impossible for us now to recreate the feelings and understanding with which such paintings were viewed in their day, it is essential to realise that to all later generations they were seen as representing much more than a simple picture of a place.

The possibilities of elaborating brushstrokes so as to create compositions with them rather than with coloured washes, as seen in the early landscapes accompanying Buddhist images (fig. 71), were taken in a slightly different direction by Dong Yuan and Juran. These artists worked with long, often undulating strokes, which were combined with heavy dots to suggest the rocky contours of hills and clumps of vegetation (fig. 74). These particular types of brushwork were to be self-consciously copied by many later artists. Their vigorous lines match the freedom of those works of calligraphy displaying the spontaneity and moral personality associated with the Wang Xizhi tradition (pp. 98–100). One of the most striking of these early landscapes is Guo Xi's *Early Spring* (dated 1072) in the National Palace Museum, Taipei, which shows the use of dense black swirling lines of ink to create the impression of a bleak landscape turbulent with latent energy (fig. 72).

In later times, as a theory of painting was elaborated to match that

74 Dong Yuan (d.962), *Summer Mountains*. Handscroll, ink and colour on silk. The landscapes of Dong Yuan and his pupil Juran provided the models for the Yuan and Ming literati painters. This painting exemplifies the descriptions by early writers of Dong Yuan's clouds and mist, and deep plains rendered in rough brushwork.

associated with calligraphy, these early landscape masters were contrasted with the so-called court painters of the Northern and Southern Song. These painters are sometimes described as belonging to an academy, although there is only fragmentary knowledge of the working practices of such groups.[80] The Northern Song Emperor Huizong (r. 1101–25) favoured realistic bird and flower painting, essentially the continuation of a long tradition of decorative painting for fans, screens and other utensils of court and élite life.[81] There are no surviving landscape paintings attributed to the Northern Song academy, but some influential paintings are assigned to the court academy after the Song had fled south to Lin'an (present-day Hangzhou). Li Tang (c. 1050–after 1130) is said to have been a formative influence and a mentor of Ma Yuan (fl. 1190–after 1225), one of the artists of the Southern Song, who is particularly well known today through his influence on Japanese painting. Ma Yuan's paintings exploited coloured washes as well as strong, often rather angular black ink brushstrokes. The type of composition he favoured – the so-called 'one-corner' format, in which the lowest elements of a diagonal arrangement were stressed (fig. 73) – was to have a strong influence on later academic painting under the Ming (1368–1644).[82] The presumed link with the court meant that such painting was assumed, at least by later Chinese writers, to be of less value than the works executed by the scholar-officials themselves, preferably away from court life.

From the Song onwards Chinese theorists began to distinguish between the professional and the amateur ideals in painting. Under the Northern Song, a group of scholar-officials led by the famous poet, Su Shi (1036–1101), turned to painting as a means of self-expression: 'From ancient times on, painters have not been common men; their excellent visualisations of reality are produced in the same way as poetry'.[83] The mastery of the brush had of course always been considered a central requirement of a high official. Now such officials sought a parallel in painting to the ideals expressed in the tradition of calligraphy: the use of painting to express the views of the cultivated individual. Scholar-officials such as Su Shi were not concerned with formal likeness and artistic style but with the character and intellectual approach of the individual.[84] The paintings attributed to him, of rocks, bamboo and desiccated trees, are in contrast to the more atmospheric paintings of Ma Yuan. Austerity was intended to signify the integrity of the artist. Moreover, what was sought after was the essence of a scene and the metaphors it might offer for life, rather than a superficial attractive resemblance. In this endeavour Su Shi and his associates were distancing themselves from the painting styles patronised by the court, just as Wang Xizhi was regarded as having distinguished himself from the more traditional official calligraphic styles of his own day.

Four painters who worked under the foreign Mongol dynasty, the Yuan (1279–1368), were seen with hindsight to have extended and exploited this tradition. With foreigners in power, it was natural for the educated élite to distance themselves from court life; indeed, some had no other option. The four Yuan masters were Huang Gongwang (1269–1354), Wu Zhen (1280–1354), Ni Zan (1301–74) and Wang Meng (1308–85).[85] All four artists share the rather spare brushwork that was to be regarded as the sign of integrity. Their works were moreover executed on paper, again a move away

75 Huang Gongwang (1269–1354), *Dwelling in the Fuchun Mountains*, dated 1350. Handscroll, ink on paper. The painting of Huang Gongwang, one of the four Yuan masters, was of fundamental importance to the work of amateur literati painters of the Ming and Qing. HT: 33 cm, L: 6.39 m.

from the more obviously pleasing coloured compositions of religious and court artists. Although the character of such painting is very different from the landscapes of the tenth and eleventh centuries, being on a smaller scale, some of the earlier qualities of brushwork were captured. For example, in Huang Gongwang's handscroll *Dwelling in the Fuchun Mountains*, dated 1350 and now in the Palace Museum, Taipei (fig. 75), the long undulating lines delineating the mountains are reminiscent of some of the brushwork attributed to Dong Yuan (d.962). This self-conscious reuse of earlier styles reinforced the development of a painting tradition just as the calligraphic tradition had been developed earlier.

The sense of the creation of a tradition was further fostered under the Ming dynasty (1368–1644), but although the amateur and professional categories were maintained and indeed elaborated, what had been the so-called amateur work of scholars slightly outside court circles proved much less easy to distinguish from professional work. The two principal early schools considered to represent the two approaches were the Zhe school (after Zhejiang province) of court and professional painters (fig. 76) and the Wu school of the scholar-officials, denoting the Wu district around Suzhou, where many official families made their homes.[86] The principal artists of the Wu school were Shen Zhou (1427–1509) and Wen Zhengming (1470–1559).[87] They looked back to the work of the Yuan masters and were preoccupied with the identification of different forms of brushwork as suitably expressive for different occasions.

Wen Zhengming's painting *Wintry Trees* (fig. 77) was said by him to have

76 (*above*) Attributed to Jiang Song (*fl.c.*1500), *Taking a qin to a friend.* Hanging scroll, ink and slight colour on silk. This is a fine example of landscape painting of the late Zhe school, which was based on the tradition of the Southern Song academy. The artist's signature and seal have been removed from the top left-hand corner of the painting, and the work has been reattributed to the Northern Song painter Xu Daoning (*c.*970–1051/2). HT: 1.48 m, W: 89.5 cm.

77 (*above*) Wen Zhengming (1470–1559), *Wintry Trees*, dated 1543. Hanging scroll, ink on paper. Wen Zhengming was the leading amateur-literati painter of the 16th century. HT: 90 cm, W: 31 cm.

been inspired by the work of Li Cheng, a tenth-century landscape artist.[88] Its spare, rather dry brushwork again repeats the deliberately simple, austere quality that is the feature of many so-called literati paintings. However, the clear distinction between the painters working in the professional tradition, based on Song academy styles, and those working in the scholarly tradition based on Five Dynasties and Yuan masters, was very difficult to maintain. This may be seen in the work of Tang Yin, who had to earn a living from his work as an artist; his paintings were characterised by attributes drawn from both traditions, reflecting the tastes of the particular patrons who commissioned them.[89]

In the late Ming the assimilation of amateur literati styles into the orthodox tradition was finally achieved with the writings of Dong Qichang (1555–1636). Dong, who held office as a minister of the Board of Rites, set out his theory of two contrasting schools, the Northern and Southern schools (Painters appendix). He was such a successful insider, however, that the work he supported and sustained could no longer be viewed as belonging to the amateur dissenting tradition of the four Yuan masters and the artists they supposedly emulated.[90] Indeed, the works in this so-called amateur-literati style from the hands of four seventeenth-century painters, known as the four Wangs – Wang Shimin (1592–1680), Wang Jian (1598–1677), Wang Hui (1632–1717) and Wang Yuanqi (1642–1715) – show how stereotyped and even formal such painting had become.[91] Landscapes in ink and wash on paper were now somewhat repetitively executed (fig. 79). As in the calligraphic tradition, the inevitable had happened: a painting style originally seen as privately expressive of individuals, preferably working in seclusion (as demonstrated by the frequent references to gardens and to southern landscapes, which were distant from the court), had been appropriated as the expression of the orthodoxy of a whole class. Indeed, as in the calligraphic tradition, the Chinese system had tamed the outsider, making him the insider.

78 Kuncan (1612–73), *Winter*, dated 1666. Album leaf mounted in handscroll form, ink and colour on paper. The album to which this leaf belongs, representing the four seasons, is one of Kuncan's finest works. The British Museum has the two leaves representing *Autumn* and *Winter*; the leaf showing *Spring* is in the Cleveland Museum of Art, Ohio, and *Summer* is in the Museum für Ostasiatische Kunst, Berlin. HT: 31.4 cm, W: 64.9 cm.

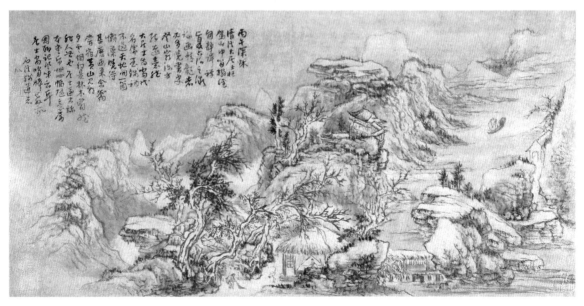

There remained the approach also available to the calligrapher – to create a new, eccentric, individualistic style. The history of later Chinese painting is indeed rich with examples of individualist painters, including Zhu Da (1626–1705), Daoji (1642–1707), Kuncan (1612–73) and Hongren (1610–64), whose styles were quite diverse and are generally identified as belonging to a group of artists from a particular region such as Anhui, Nanjing and Yangzhou. Although there is no stylistic unity among these artists, they all exhibited enthusiasm for the long tradition of using brush-work to convey a personal experience rather than create a representation (fig. 78). Indeed, their different methods show clear links with the orthodoxy of the four Wangs of the late seventeenth and early eighteenth century (fig. 79), whose work followed the theories of the late Ming literati painter Dong Qichang (mentioned above).

Although landscape painting in the literati tradition continued from the eighteenth century, the absence of major masters led to its gradual decline. A group of professional painters, which included Gao Fenghan (1683–1748), Huang Shen (1687–1766), Zheng Xie (1693–1765), Jin Nong (1687–1763) and Luo Ping (1733–99), was attracted to the city of Yangzhou in the early eighteenth century,[92] where they served the large merchant clien-tèle with works often unconventional in style which experimented with the use of brush and ink. This became the basis of the Shanghai school in the nineteenth century, from which emerged such artists as Wu Changshi (1844–1927) and Qi Baishi (1863–1957).

With the end of the Qing dynasty in 1911, the Chinese began to look outside for new ideas to rejuvenate their painting tradition. Painters such as Gao Qifeng (1889–1933), Xu Beihong (1895–1953), Lin Fengmian (1900–91), and Liu Haisu (b. 1896) studied in Japan and the West and returned to China to teach the new styles and techniques they had learnt abroad. The fusion of traditional and Western traditions has been a major factor in Chinese painting of the late twentieth century, both in works in ink and colour on paper (*guohua* or 'national painting') and in oils. The literati landscape tradition has continued in the work of such painters as Huang Binhong (1864–1955) and Fu Baoshi (1904–65) as well as other major masters such as Zhang Daqian (1899–1983), who from his traditional train-ing developed abstract-expressionist styles. More recently the important developments in Chinese painting have come not only from the People's Republic but also from Taiwan, Hong Kong and the United States.[93]

Printing

The English philosopher Francis Bacon (1561–1626) mentioned printing, along with the magnet and gunpowder, as one of the great inventions 'of obscure and inglorious origin' unknown to the ancients which had changed the face of the Western world.[94] In fact, all three of these came from China. Chinese printers were using woodblocks to reproduce text seven hundred years before the technique first appeared in Europe, during the fourteenth century. From Han times onwards, texts of permanent significance were reproduced by rubbings made from engraved stone stelae (p. 97). The inven-tion of printing under the Tang dynasty had an enormous effect on the

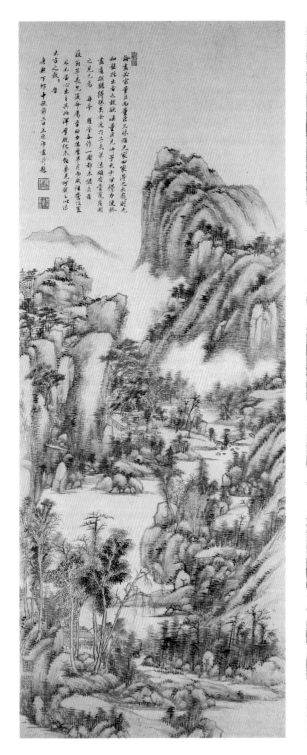

79 Wang Yuanqi (1642–1715), *Landscape in the style of Huang Gongwang*, dated 1687. Hanging scroll, ink and colour on paper(*detail right*). The artist's inscription at the top of the painting describes the way the early Qing Orthodox masters approached the past and made use of earlier styles. HT: 1.32 m, W: 51.4 cm.

reproduction and circulation of documents and images of all kinds.

Printing was first used for the replication of religious texts of Buddhist origin, in which benefits were promised to those who copied and distributed them. Evidence for printing in the seventh century comes from texts referring to the printing of Buddhist sutras and images on silk and paper.[95] The earliest extant specimen of printing is an eighth-century scroll of a *dhāraṇī* or invocation text, which was discovered in 1966 in a stone stupa in the Buddhist temple of Pulguk-sa, Kyongju, in southeast Korea.[96] The scroll includes certain special forms of characters created and used when Empress Wu (r. 680–704) was ruling China, and it was almost certainly printed in China between 704 and 751. Printing moved with Buddhism to Japan, where between 764 and 770 a huge print-run of a million *dhāraṇī* charm texts was produced. Contemporary texts relate that, in 764, copies of one of four versions of the *dhāraṇī* were placed in a million miniature wooden pagodas ordered by Empress Shotoku to be distributed to and stored in ten different temples.[97] The earliest extant complete printed book is the Diamond Sutra of 868, recovered by Aurel Stein from cave 17 at Dunhuang in 1907 and now preserved in the British Library (fig. 80).[98] The book, in the form of a scroll nearly six metres in length, consists of a pictorial frontispiece followed by the text of the sutra. The colophon at the end of the sutra reads: 'Reverently [caused to be] made for universal free distribution by Wang Jie on behalf of his parents on the 15th day of the 4th moon of the 9th year of Xiantong [11 May 868]'. The perfection of the printing of both the calligraphy and the frontispiece shows that a complete mastery of the technical processes of printing had already been achieved.

During the three centuries of the Song (960–1279), the scale of printing of Buddhist texts expanded with the printing of the *Tripitaka* – the complete

80 The Diamond Sutra, translation into Chinese, dated AD 868, of the *Vajracchedikaprajñāpāramitā-sūtra*. Woodblock print in roll form with illustrated frontispiece. This is the earliest dated printed book, found by Aurel Stein in cave 17, Dunhuang, Gansu province, in 1907 on his second Central Asian expedition. HT: 26.5 cm, L: 5.33 m.

corpus of Buddhist scriptures in three sections.[99] Six different editions of the *Tripiṭaka* were printed under the Song, and two editions were printed under the Liao and Jin dynasties during the same period. One of the imperial prefaces to the Kaibao edition of the *Tripiṭaka*, the *Yuzhi Bizangguan* (cut between 984 and 991, and printed in 1108), has in chapter 13 a set of four fine landscape woodcuts.[100] The size of the printing operation was immense: five of the six Song editions consisted of between 5000 and 7000 sections or *juan* (literally, 'roll') each bound in folded form, for which a total of 60,000 to 80,000 blocks were cut. During this period Daoists began to print their own canon, the *Daozang*, which was comparable in scale to that of the Buddhist *Tripiṭaka*.

Confucianism also placed great value on the transmission of written texts. To standardise the texts, Confucian classics had been engraved on stone at least three times since the second century AD (p. 88), but it was not until the Song that they were first printed.[101] The printing and consequent wide availability of the Confucian classics were crucial to the expansion and systematisation of the civil service entrance examination during this period. Whereas printing in the West was closely associated with such movements of change as the Renaissance, the Reformation and the scientific revolution, in China it helped the state to enforce Confucian orthodoxy upon all those aspiring to government office. The first printing of the Confucian classics was begun in 932 and was completed twenty-two years later, in 953. Scholars from the National Academy collated the text from the Tang version of the classics engraved in stone, and calligraphers transcribed the text in standard script which was then cut on woodblocks.

During the Song the National Academy was responsible for the printing of large numbers of official publications in addition to the Confucian canon, commentaries on the classics and the standard histories. Under official sponsorship, the printing of several rhymed dictionaries, encyclopaedias and anthologies of literature was undertaken. Printing was in fact extended to cover every field of knowledge, including scientific and technical works, medicine, divination, geography and literature.[102]

Although the printing of most reputable works took place either as a government project or under official or semi-official patronage, some of the most popular books were produced by private families as a money-making enterprise. Jianyang in Fujian province was a centre of the book trade and private printing from the eleventh until the sixteenth century, the Yu family being the most prominent.[103] In the sixteenth and early seventeenth century was another burst of creative energy, driven by the business acumen of commercial printers. Although Fujian continued to produce works of relatively low quality, other centres such as Xin'an in Anhui province, Nanjing and Suzhou in Jiangsu province, and Hangzhou in Zhejiang province became the leading centres for the production of high-quality editions.[104] Fine editions of plays, novels, biographical texts, painting manuals and erotic works were produced for the rich and cultivated purchaser. These works were usually accompanied by fine illustrations, whose purpose was to enhance the text as well as provide a powerful commercial attraction. As competition grew between publishing houses, greater emphasis was given to the artistic content of their books. Brush styles and formats taken from painting were

心萬不容已既不能放下他又不肯輕動着他所以
時時只問內豎與看其飲食不如此則其心都過不
去了孟子說孩提之童無不知愛其親也只看孩提
離却父母便一時也難過文王雖聖人亦不失其孩
提之心而已若無此一段真意縱依着文王的格式
行去終是勉強非善學文王者也

81 *Yangzheng tujie (Illustrated History of Righteous Men)*, Nanjing, dating from the 1590s. One of the earliest fine printed books of the late Ming, with full-page illustrations. In an attempt to upgrade the status of the illustrations, the artist has imitated the more respected medium of painting. HT (of image on each half folio): *c*.22.4 cm, W: *c*.14.6 cm.

introduced into the previously static architectural and landscape compositions of book illustration.[105] Although in all but a few editions the designs were by anonymous artisans and the actual printing was carried out by a different group of unnamed individuals, greater credit was given to the cutters of the woodblocks, whose names are frequently included in the illustrations. The leading cutters belonged to the Huang and Wang clans from Anhui province.[106] The *Yangzheng tujie (Illustrated History of Righteous Men)* is one important work cut by the Huangs; editions were printed in both Xin'an and Nanjing in the 1590s (fig. 81), with sixty fine full-page illustrations attributed to the late Ming artist Ding Yunpeng (1547–*c*.1621). The blocks were cut by Huang Yulin (b. 1565).[107]

The peak of technical achievement in Ming woodblock illustration was the production of colour illustrations using the same technique. The process, known as *taoban* ('set of blocks'), involved the cutting of a separate block for each colour. Although colour printing had been used in the Yuan for the printing of classical commentaries, the technique was not fully perfected until the late Ming.[108] Up to ten blocks, each for a different colour, might be required for a single illustration. The use of fine coloured lines is found in illustrations to erotic works dating from the 1570s,[109] and in compendia

82 *Shizhuzhai shuhuapu* (*A Manual of Calligraphy and Painting from the Ten Bamboo Studio*), by Hu Zhengyan, originally printed in sixteen parts between 1619 and 1633. This pair of openings from a late Ming edition shows prunus and bamboo followed by accompanying calligraphy. This is the most important of the early colour-printed woodblock books, and it is the first of the painting manuals to use colour. HT (of each opening): *c.*25.4 cm, W: *c.*27.2 cm.

of ink cake designs and letter papers produced in the early seventeenth century (fig. 53). Other works, principally the *Shizhuzhai shuhuapu* (*A Manual of Calligraphy and Painting from the Ten Bamboo Studio*), produced between 1619 and 1633,[110] reproduce brushwork from paintings showing the quality of brush line and the subtle gradation of colour (fig. 82). Here at last the spontaneity of calligraphy and painting had been entrapped and frozen in the medium of printing.

With the end of the Ming, the social and cultural circumstances which had supported the market for fine printing of this kind changed drastically. Under the strict Confucian orthodoxy of the Qing administration it was no longer deemed respectable for scholars to be interested in works of fiction. Illustrated works continued to be produced, but the creativity of the late Ming was never revived. The art of colour printing continued in such famous works of the Qing dynasty as the manual on painting instruction, *Jieziyuan huazhuan* (*Mustard Seed Garden Manual of Painting*).[111] New editions of traditional works such as the *Gengzhi tu* (*Illustrations of Ploughing and Weaving*)[112] were produced with official sponsorship in the late seventeenth century. The engraving of illustrations on copper was introduced to China from Europe during the early eighteenth century. The Qianlong emperor commissioned a large series of copper engravings of his military campaigns, which were produced under Jesuit influence in Beijing and also by French engravers in Paris (ch. 4, fig. 145; ch. 6, fig. 212).[113]

At a more popular level, the production of the printed image was little affected by the succession of Chinese dynasties. From the Tang onwards, household gods and other auspicious scenes had been pasted up on the walls of houses, particularly at New Year (fig. 83).[114] The earliest extant specimen of a New Year print dates from the twelfth century and was found in the cavity of a pillar in the Beilin in Xi'an in western China.[115] The tradition continued over several centuries, but the ephemeral nature of the prints meant that very little has survived from before the late Ming and early Qing dynasties.[116] From this time, large-scale production of popular prints began

香山

三皇姑

83 Woodblock print from the theme *Three Nuns of Xiangshan*, with hand colouring, ink, colour and varnish on paper. Made in Gaomi, Shandong province, late Qing dynasty, 19th century. This New Year print is printed in two colours from a pair of blocks with the image joined in the centre, to which other colours are applied by hand. Blocks for New Year prints were produced over a period of many decades and printed annually for the lunar New Year. HT: 95 cm, W: 48.5 cm.

84 (below) Li Hua (b. 1907), *Raging Tide I*, 1947. Woodcut, ink and colour on paper. Li Hua was one of the leading artists of Lu Xun's Modern Woodcut Movement, which introduced social-realist styles from Germany and Russia. The work of the German Expressionist Käthe Kollwitz (1867–1945) was particularly admired. HT: 19.5 cm, W: 27 cm.

(*opposite*) Song Yuanwen (b. 1933), *White Mountains and Black Water*, 1981. Watercolour woodblock print, using the multi-block technique of printing. HT: 37 cm, W: 39 cm.

at the two major centres: Suzhou in Jiangsu and Yangliuqing near Tianjin. A group of fine, late seventeenth-century coloured New Year prints produced by the Ding family in Suzhou shows highly decorative subjects of fruit, birds, insects and flowering plants. A collection of these in the British Museum was acquired by Sir Hans Sloane from a certain Dr Kaempfer, who purchased the prints in Japan in 1692.[117] Other eighteenth-century Qing prints from Suzhou reflect the influence of Western metal engraving.[118] The introduction of Western-manufactured dyestuffs to China in the nineteenth century has fundamentally changed the character of this art form. The tradition of New Year prints has survived to the present day, though the wealth of subject matter has declined.

In the twentieth century, traditional print making in China has continued in two respects. The first is in the field of popular prints, which are still produced though in smaller quantities than before. The second is in the continuation of seventeenth-century techniques of colour printing for making fine reproductions of paintings. This is still carried on in the Rongbaozhai in Beijing.[119] A new departure in print making has, however, occurred in this century, in terms of the development of the print as a medium of individual artistic creativity in its own right, rather than a craft produced

by anonymous artisans (as it had largely been in the Ming and Qing). This change came about with the Modern Woodcut Movement of the late 1920s, in which Lu Xun (1881–1936) revived print making and introduced European and Russian styles as a new popular form of graphic art (fig. 84).[120] The idea of the fine art print, which is now produced in art schools throughout China, grew out of this movement.[121]

There has been this apparent meeting between East and West in the arts of painting and print making, but in most other areas the artistic aspirations of China have remained as distant from those of the West as ever. China's major artistic tradition, the art of calligraphy, is untouched by Western influence and remains a living art practised by intellectuals and politicians, as it has always been. Expressing moral as well as aesthetic values, as it has always done, it is shared among friends and distributed more widely for political purposes. The printed title of China's main newspaper reproduces the sweeping lines of the hand of Chairman Mao.[122] Such a headline is part of an ancient tradition, in which the hand of a widely acclaimed figure is employed to endorse the writings to which it is attached. Twentieth-century Chinese statesmen have frequently been accomplished poets, whose verse and calligraphy are often combined in printed editions of their work, thereby reaffirming that one of China's most ancient arts is still alive today.

Notes

1. The fields of Chinese painting and calligraphy are vast. The description and arguments presented here have been selected to illustrate some of the points made in the Introduction. For further studies the reader is referred to the sources given in the footnotes and in the bibliography.

2. This term was first used in a treatise on writing equipment in a scholar's studio entitled *Wenfang sipu* compiled by Si Yijian (953–96). See J. Needham and Tsien Tsuen-hsuin, *Science and Civilisation in China*, vol. v, *Chemistry and Chemical Technology; Part 1: Paper and Printing*, Cambridge, 1985, pp. 13–16. Examples are illustrated in Chu-tsing Li and J. C. Y. Watt, *The Chinese Scholar's Studio, Artistic Life in the Late Ming Period, An Exhibition from the Shanghai Museum*, New York and London, 1987, pp. 123–33.

3. See D. N. Keightley, *Sources of Shang History, The Oracle-Bone Inscriptions of Bronze Age China*, Berkeley, Los Angeles and London, 1978, pp. 46–7.

4. For some introductory comments on bamboo slips see Fu Shen, G. D. Lowry, and A. Yonemura, *From Concept to Context: Approaches to Asian and Islamic Calligraphy*, Washington DC, 1986, p. 22.

5. Pre-Qin philosophers such as Mozi mention that ancient sage-kings recorded their beliefs on bamboo and silk: see Mei Yi-pao (trans.), *The Ethical and Political Works of Motse*, London, 1929, p. 167; *Huai nan zi*, ch. 13, pp. 20 a–b; and J. Needham and Tsien Tsuen-hsuin, 1985, op. cit., pp. 32–3.

6. Several painted silk banners have been recovered from Han period tombs in the area of the former Chu state south of the Yangzi. Of these the banner from tomb no. 1 at Mawangdui is the most elaborate and best preserved (*Changsha Mawangdui yihao Hanmu*, Beijing, 1973, pl. 71).

7. It is recorded that texts by the scholar Liu Xiang (*c.* 80–8 BC) were first written on bamboo and then copied on to silk when completed; cited in *Taiping yulan*, ch. 606, p. 2a, in J. Needham and Tsien Tsuen-hsuin, 1985, op. cit., p. 33 n. (b).

8. Origins of paper are discussed in J. Needham and Tsien Tsuen-hsuin, 1985, op. cit. The paper mulberry (*Broussonetia papyrifera*), a shrub that grows naturally in many parts of China, is quite distinct from the mulberry tree (*Morus alba*). See J. Needham and Tsien Tsuen-hsuin, 1985, op. cit. pp. 56–9.

9. For a translation of the *Tiangong kaiwu* see Sung Ying-hsing, *T'ien-kung k'ai-wu: Chinese Technology in the Seventeenth Century* (trans. Sun E-tu Zen and Sun Shiou-chuan), University Park, Pennsylvania and London, 1966.

10. The Northern Song calligrapher and scholar painter Mi Fu (1051–1107) wrote on the suitability of contemporary papers for artistic purposes. See *Ping zhi tie*, in *Meishu congshu*, vol. 6, Shanghai, 1947, pp. 305–7.

11. At least two collections are known: *Luoxuan biangu jianpu* (Collection of Letter Papers with Antique and New Designs from the Wisteria Pavilion*), printed in 1626; and *Shizhuzhai jianpu* (Collection of Letter Papers from the Ten Bamboo Studio), printed in 1644. Decorated letter papers are described in J. Needham and Tsien Tsuen-hsuin, 1985, op. cit., pp. 94–5 and in Chu-tsing Li and J. C. Y. Watt, 1987, op. cit., pp. 56–61.

12. See footnote 3.

13. The making of ink is discussed in J. Needham and Tsien Tsuen-hsuin, 1985, op. cit., pp. 243–51.

14. For discussion and illustration of inkstones see Chu-tsing Li and J. C. Y. Watt, 1987, op. cit., pp. 184–5.

15. For a discussion of the shape and construction of the brush see Tseng Yu-ho Ecke, *Chinese Calligraphy*, exhibition catalogue, Philadelphia Museum of Art, 1971, Introduction.

16. D. Pye, *The Nature and Art of Workmanship*, Cambridge, 1968, discusses the role of risk in the success of workmanship. Writing with a brush would fall within his definition, although he was unaware of the technique.

17. For a simple introduction to the Chinese language and the formation of characters see W. McNaughton, *Reading and Writing Chinese, A Guide to the Chinese Writing System: The Student's 1,020 List, The Official 2,000 List*, Tokyo, 1979.

18. D. N. Keightley, 1978, op. cit., figs 4–30.

19. E. L. Shaughnessy, *Sources of Western*

Zhou History: Inscribed Bronze Vessels, Berkeley, Los Angeles and Oxford, 1991, pp. 121–6.

20. The small seal script is so called in contrast with the less well defined term, large seal script or *da zhuan*, used to refer generally to bronze inscription characters. For a discussion of seal script see L. Ledderose, *Die Siegelschrift (Chuan-Shu) in der Ch'ing Zeit*, Wiesbaden, 1970, and L. Ledderose and A. Schlombs, *Jenseits der Grossen Mauer: der Erste Kaiser von China und seine Terrakotta Armee*, Munich, 1990, pp. 243–8.

21. The sources of the tradition of stone inscriptions are a matter of some debate. From the beginning of the Qin a formidable tradition was established; many thousands of stone inscriptions survive recorded in large compendia of rubbings such as that in the Beijing Library: *Beijing Tushuguan zang Zhongguo lidai shike taben huibian*, Beijing, 1988, vols 1–100.

22. The special uses of seal script are described in L. Ledderose, 1970, op. cit.; see also Fu Shen, *Traces of the Brush: Studies in Chinese Calligraphy*, New Haven, 1977, pp. 43–77.

23. Seals are discussed and illustrated in *Zhongguo meishu quanji: shufa zhuanke bian, xiyin zhuanke*, Shanghai, 1989.

24. Seals on paintings are listed in two major works: V. Contag and Wang Chi-ch'ien, *Seals of Chinese Painters and Collectors of the Ming and Ch'ing Periods*, revised edition, Hong Kong, 1965, and *The Signatures and Seals of Artists, Connoisseurs and Collectors of Painting and Calligraphy since the Tsin Dynasty*, vols 1–6, Hong Kong, 1964.

25. Fu Shen and J. Stuart, *Challenging the Past: The Paintings of Chang Dai-chien*, Washington DC, Seattle and London, 1991.

26. Fu Shen, 1977, op cit., pp. 43–60.

27. Ibid., pp. 81–123.

28. L. Ledderose, *Mi Fu and the Classical Tradition of Chinese Calligraphy*, Princeton, 1979, p. 8; Fu Shen, 1977, op. cit., pp. 127–75.

29. L. Ledderose, 1970, op. cit.

30. L. Ledderose, 1979, op. cit., p. 9.

31. For a general discussion of writing in Western society and its antecedents in the Near East see J. Goody, *The Logic of Writing and the Organization of Society*, Cambridge, 1986.

32. This point is eloquently explained in L. Ledderose, 'Chinese Calligraphy: Its Aesthetic Dimension and Social Function', *Orientations*, October 1986, pp. 35–50. In the discussion that follows much use has been made of this article and L. Ledderose, 1979, op. cit.

33. For a discussion of the structure of bureaucracy under the Han see D. Twitchett and M. Loewe (eds), *The Cambridge History of China, vol. 1: The Ch'in and Han Empires 221 BC–AD 220*, Cambridge, 1986, ch. 7; for information on the structure and titles of officials in later periods see C. O. Hucker, *A Dictionary of Official Titles in Imperial China*, Stanford, 1985.

34. For a survey of the works in the Confucian canon, see J. Legge, *The Chinese Classics, with a translation, critical and exegetical notes, prolegomena and copious indexes*, vol. 1: *Confucian Analects, the Great Learning and the Doctrine of the Mean*, Hong Kong, 1861.

35. D. Twitchett and M. Loewe (eds), 1986, op. cit., pp. 69–71.

36. Ibid., p. 340; Tsien Tsuen-hsuin, *Written on Bamboo and Silk: The Beginnings of Chinese Books and Inscriptions*, Chicago and London, 1962, pp. 74 ff.

37. See Xun Xu's preface to the *Mu tian zi zhuan (Account of the Travels of the Emperor Mu)*, *Sibu congkan* edition, p. 3a. Cited in J. Needham and Tsien Tsuen-hsuin, 1985, op. cit., p. 86n.c.

38. For manuscripts found in the desert conditions of Dunhuang in Gansu province and sites in Xinjiang province see A. F. R. Hoernle, *Manuscript Remains of Buddhist Literature Found in Eastern Turkestan*, Parts I and II, Oxford, 1916.

39. L. Ledderose, 1979, op. cit., pp. 34–9.

40. L. Ledderose, 'Massenproduktion angesichts der Katastrophe', *Asiatische Studien*, vol. XLIV.2, 1990, pp. 217–33; and L. Ledderose, *Module and Mass-production in Chinese Art*, Cambridge Slade Lecture, Lent Term 1992, forthcoming.

41. For a discussion of copies see L. Ledderose, 1979, op. cit., pp. 34–6; Fu Shen, 1977, op. cit., pp. 1–20.

42. L. Ledderose, 1979, op. cit., p. 36.

43. For a discussion of the classical tradition and the role of Wang Xizhi see ibid., ch. 1.

44. For reproduction of calligraphy by Wang Xizhi, see *Shodo zenshu*, vol. 4, Tokyo, 1960, and *Shoseki meihin sokan*, Tokyo, 1958–81, vols 21–2.

45. This is a free translation. Other translations follow the Chinese text more closely. See Lin Yutang, *The Importance of Understanding: Translations from the Chinese*, London, 1961, pp. 98–9.

46. Introduction, p. 39.

47. The connections of the calligraphic tradition with gardens and with poetry, initiated by Wang Xizhi, are mentioned in L. Ledderose, 1986, op. cit. See also A. Murck and Fong Wen (eds), *Words and Images: Chinese Poetry, Calligraphy and Painting*, New York and Princeton, 1991.

48. In many secondary sources the calligraphy of the two Wangs is contrasted with a so-called northern tradition, which is associated with the continuation of the tradition of carving official texts on large stone stelae (L. Ledderose, 1979, op. cit., p. 24).

49. L. Ledderose, 1979, op. cit., p. 24.

50. This tradition is the subject of ibid.

51. For reproduction of calligraphy by Huaisu (737 – after 798) see *Shodo zenshu*, vol. 10, Tokyo, 1956, and *Shoseki meihin sokan*, Tokyo, 1958–81, vol. 27.

52. For the role of collections and ancient objects in legitimating government see L. Ledderose, 'Some Observations on the Imperial Art Collections in China', *Transactions of the Oriental Ceramic Society*, vol. 43, 1978–9, pp. 33–46; A. Seidal, 'Imperial Treasures and Taoist Sacraments: Taoist Roots in the Apocrypha', in M. Strickman (ed.), *Tantric and Taoist Studies in Honour of R. A. Stein*, Brussels, 1983, vol. 2, pp. 291–371; J. Murray, 'Sung Kao-tsung as Artist and Patron: The Theme of Dynastic Revival', in Chu-tsing Li (ed.), *Artists and Patrons: Some Social and Economic Aspects of Chinese Painting*, Lawrence, Kansas, 1989, pp. 27–36; J. Rawson, 'The Ancestry of Chinese Bronze Vessels', in W. D. Kingery and S. Lubar (eds), *Learning from Things: Working Papers on Material Culture*, forthcoming.

53. The stelae from the Beilin in Xi'an are published in *Xi'an beilin shufa yishu*, Shaanxi, 1989. The engraving on stone of works from the Confucian, Buddhist and Daoist canons provided a relatively permanent and safe means of preserving texts from destruction over a long period of time. The stone stelae in the Beilin include a set of the Confucian classics engraved in the Tang dynasty, and a large collection of stelae recording Buddhist texts has survived at Fangshan, near Beijing. The collection and study of rubbings of inscriptions from stone stelae and bronze vessels have given Chinese scholars a large and fascinating source for the study of epigraphy, history and literature. One such collection made by Zhao Defu in the twelfth century became the basis of an epigraphical study by him entitled *Records on Metal and Stone*. See S. Owen, *Remembrances: The Experience of the Past in Classical Literature*, Cambridge, Mass., 1986, pp. 80–81.

54. A very large body of painting has been omitted from this chapter, namely all forms of decorative painting. Painting was used for simple patterns on everyday utensils, particularly those of wood and lacquer. It appeared on such items as fans and hangings, of which early examples have survived in the Shōsō-in at the Tōdai-ji temple in Nara, Japan. Tomb paintings constitute another large area. See *The Shōsō-in: An Eighth Century Treasure House*, compiled by Mosaku Ishida and Gunichi Wada, Tokyo, Osaka and Moji, 1954.

55. Early views on calligraphy and painting are found in S. Bush (ed.), *The Chinese Literati on Painting: Su Shih (1037–1101) to Tung Ch'i-ch'ang (1555–1636)*, Cambridge, Mass., 1971.

56. Quoted from the *Hua jue (Rules for painting)* which is part of the *Linchuan gaozhi (An essay on landscape painting)* by Guo Xi. See G. Rowley, *Principles of Chinese Painting*, Princeton, 1947, p. 44; also translated in *An Essay on Landscape Painting*, by Shio Sakanishi, London, 1935, p. 55.

57. See S. Bush and Hsio-yen Shih, *Early Chinese Texts on Painting*, Cambridge, Mass., 1985, pp. 18–28.

58. As quoted in W. P. Yetts, *The Legend of Confucius*, London, 1943, published in *Nine Dragon Screen*, London, 1965, pp. 16–18.

59. Cited in O. Sirén, *The Chinese on the Art of Painting: Translations and Comments*, Beijing, 1936, p. 9, and S. Bush and Hsio-yen Shih, 1985, op. cit., p. 26.

60. For a discussion both of the Wu family shrine and the significance of the subject matter of the reliefs see Wu Hung, *The Wu Liang Shrine: The Ideology of Early Chinese Pictorial Art*, Stanford, 1989, and J. J. James, *The Iconographic Program of the Wu Family Offering Shrines* AD *151–c. 170), Artibus Asiae*, vol. XLIX, 1/2, 1988–9, pp. 39–72.

61. These names are quoted in the famous work on early Chinese painting, the *Lidai minghua ji (A Record of the Famous Painters of all the Dynasties)*, completed in 847 by Zhang Yanyuan. The *Lidai minghua ji* is translated in W. R. B. Acker, *Some T'ang and Pre-T'ang Texts on Chinese Painting*, Leiden, 1954, pp. 60–382.

62. Studies of the paintings attributed to Gu Kaizhi are by A. Waley, *An Introduction to Chinese Painting*, London, 1923, pp. 50 ff.; Hsio-yen Shih, 'Poetry Illustration and the Works of Ku K'ai-Chih', *Renditions*, no. 6, Spring 1976, pp. 6–29; and Kohara Hironobu, 'On the Picture-scroll of the Admonitions of the Instructress to Ladies in the Palace', parts I and II, *Kokka*, no. 908, November 1967, pp. 17–31 and *Kokka*, no. 909, December 1967, pp. 13–27.

63. J. Murray, *Ma Hezhi and the Book of Odes*, Cambridge, forthcoming.

64. A. Spiro, *Contemplating the Ancients: Aesthetic and Social Issues in Early Chinese Portraiture*, Berkeley, Los Angeles and Oxford, 1990.

65. Discussed and illustrated in O. Sirén, *Chinese Painting: Leading Masters and Principles*, London, 1956, vol. I, pp. 98–100, and vol. III, pls 72–5.

66. Also published in A. Farrer, *The Brush Dances and the Ink Sings: Chinese Paintings and Calligraphy from the British Museum*, London, 1990, pp. 92–3.

67. See for example a portrait of a priest by an anonymous artist in the British Museum (OA 1926.4–10.011, Add. 42), reproduced in A. Farrer, 1990, op. cit., pp. 100–101.

68. Cited by L. Sickman and A. Soper, *The Art and Architecture of China*, London,

1971, p. 171. For translations from the *Xuanhe huapu* see S. Bush and Hsio-yen Shih, 1985, op. cit.

69. R. Whitfield and A. Farrer, *Caves of the Thousand Buddhas: Chinese Art from the Silk Route*, London, 1990, p. 19.

70. This painting is also reproduced in ibid., p. 25.

71. For studies of the work of Wu Daozi (*fl.c. 710–c. 760) see O. Sirén, 1956, op. cit., vol. I, pp. 109–25, and M. Loehr, *The Great Painters of China*, Oxford, 1980, pp. 41–5.

72. O. Sirén, 1956, op. cit., vol. I, pp. 154–7, and M. Loehr, 1980, op. cit., pp. 54–60.

73. For a study of early landscape see M. Sullivan, *The Birth of Landscape Painting in China*, London, 1962.

74. Wu Hung, 'A Sanpan Shan Chariot Ornament and the Xiangrui Design in Western Han Art', *Archives of Asian Art*, vol. XXXVII, 1984, pp. 38–59.

75. See S. Bush and Hsio-yen Shih, 1985, op cit., pp. 118, 168–9.

76. Zong Bing's comments are cited in the *Lidai minghua ji* by Zhang Yanyuan (see S. Bush and Hsio-yen Shih, 1985, op. cit., pp. 36–8). The idea that painting should express the *dao* to be perceived in nature developed alongside the notion that a painting should express certain kinds of moral and personal qualities. For a discussion of pre-Tang painting theory, see S. Bush and Hsio-yen Shih, 1985, op. cit., pp. 18 ff.

77. Tang dynasty landscape painters are described in M. Loehr, 1980, op. cit., pp. 61–8.

78. Texts on landscape painting are found in O. Sirén, 1936, op. cit., pp. 38–90.

79. J. Cahill, *Three Alternative Histories of Chinese Painting: The Franklin D. Murphy Lectures IX*, Lawrence, Kansas, 1988.

80. Ho Wai-kam, 'Aspects of Chinese Painting from 1100 to 1350', in *Eight Dynasties of Chinese Painting: The Collections of the Nelson-Atkins Museum, Kansas City, and The Cleveland Museum of Art*, Cleveland, 1980, pp. XXV–XXXIV.

81. Song decorative painting is discussed in O. Sirén, 1956, op. cit., vol. II.

82. The influence of landscape painting

of the Southern Song on the Zhe school is discussed in Suzuki Kei, *Mindai kaigashi no kenkyū: Seppa (A Study of Ming Painting: the Zhe School)*, Tokyo, 1968; and Suzuki Kei, 'Ri Tō, Ba En, Ka Kei (Li Tang, Ma Yuan, Xia Gui)', in *Suiboku bijutsu taikei*, vol II, Tokyo, 1974.

83. S. Bush, 1971, op. cit., p. 30.

84. S. Bush, 1971, op. cit., p. 66.

85. J. Cahill, *Hills Beyond a River: Chinese Painting of the Yuan Dynasty, 1279–1368*, New York and Tokyo, 1976.

86. R. Whitfield, 'Che School Paintings in the British Museum', *The Burlington Magazine*, vol. CXIV, no. 830, May 1972, pp. 285–94.

87. J. Cahill, *Parting at the Shore: Chinese Painting of the Early and Middle Ming Dynasty, 1368–1580*, New York and Tokyo, 1978; and R. Whitfield, *In Pursuit of Antiquity*, Princeton, 1969.

88. A. de Coursey Clapp, *Wen Chengming: The Ming Artist and Antiquity*, Ascona, 1975.

89. A. de Coursey Clapp, *The Painting of Tang Yin*, Chicago and London, 1991.

90. For the role of Dong Qichang in the formation of the Chinese literati tradition see C. C. Riely, 'Tung ch'i-ch'ang's Ownership of Huang Kungwang's "Dwelling in the Fu-ch'un Mountains"', *Archives of Asian Art*, vol. 28, 1974–5, pp. 57–68; and Ho Wai-kam and J. Smith, *The Century of Tung Chi'-ch'ang (1555–1636)*, 2 vols, Kansas City, 1992.

91. For a discussion of these painters and their works see O. Sirén, 1956, op. cit., vol. V.

92. J. Cahill, *Fantastics and Eccentrics in Chinese Painting*, New York, 1976.

93. Principal developments in twentieth-century Chinese painting are discussed in Chu-tsing Li, 'Trends in Modern Chinese Painting (The C. A. Drenowatz Collection)', *Artibus Asiae*, supp. XXXVI, 1979.

94. See R. Dawson, *Legacy of China*, Oxford, 1964, pp. 148–9.

95. Texts are mentioned in J. Needham and Tsien Tsuen-hsuin, 1985, op. cit., pp. 148–9.

96. Ibid., p. 149.

97. Ibid., pp. 149–50.

98. T. F. Carter, *The Invention of Printing in China and its Spread Westward*, revised edition, New York, 1955, ch. 8, p. 21; F. Wood, *Chinese Illustration*, London, 1985, pp. 8–9, 11.

99. J. Needham and Tsien Tsuen-hsuin, 1985, op. cit., pp. 159 ff.

100. The four landscape woodcuts are the subject of M. Loehr's *Chinese Landscape Woodcuts*, Cambridge, Mass., 1968.

101. J. Needham and Tsien Tsuenhsuin, 1985, op. cit., pp. 162–3.

102. Ibid., p. 163. Southern Song printing in the Hangzhou area in the twelfth and thirteenth centuries is described in S. Edgren, 'Southern Song Printing at Hangzhou', *Bulletin of the Museum of Far Eastern Antiquities*, no. 61, Stockholm, 1989.

103. Ming printing is discussed in K. T. Wu, 'Ming Printing and Printers', *Harvard Journal of Asiatic Studies*, vol. 7, 1942–3, pp. 203–60.

104. Ibid., and Guo Weiqu, *Zhongguo banhua shilue*, Beijing, 1962, pp. 38–131.

105. A. Farrer, 'The Shui-hu chuan: A Study in the Development of Late Ming Book Illustration', Ph.D. thesis, University of London, 1984. Late Ming editions are extensively reproduced in Zheng Zhenduo, *Zhongguo banhuashi tulu*, Shanghai, 1940–42.

106. Cutters of the Huang family are listed in Zhou Wu, *Huipai banhuashi lunji*, Hefei, 1983.

107. Other editions of this work have been published in *Chugoku Kodai Hangaten*, exhibition catalogue, Machida City Museum of Graphic Art, 1988, p. 189; and Zheng Zhenduo, 1940–42, op. cit.

108. J. Needham and Tsien Tsuenhsuin, 1985, op. cit., pp. 282 ff.

109. R. van Gulik, *Sexual Life in Ancient China*, Leiden, 1961, pp. 322 ff.

110. For Chinese colour printing see K. T. Wu, 'Colour Printing in the Ming Dynasty', *Tien Hsia Monthly*, no. 11, Shanghai, 1940; and J. Needham and Tsien Tsuen-hsuin, 1985, op. cit., pp. 277–87. For a study of the Ten Bamboo Studio Manual see S. Edgren, *Chinese Rare Books in American Collections*, New York, 1984, pp. 114–15, and R. T. Paine Jr, 'The Ten Bamboo Studio:

Its Early Editions, Pictures, and Artists', *Archives of the Chinese Art Society of America*, vol. V, 1951, pp. 39–54.

111. For a study of this work see S. Edgren, 1984, op. cit., pp. 118–19, and D. H. Delbanco, 'Nanking and the Mustard Seed Garden Painting Manual', Ph.D. dissertation, Harvard University, Cambridge, Mass., 1981.

112. There is a 1696 edition of this work in the British Museum (OA 1949.7–9.01).

113. For a description of certain works from these series see *Europa und die Kaiser von China 1240–1816*, Berliner Festspiele Insel Verlag, 1985, pp. 337 ff.

114. J. Needham and Tsien Tsuen-hsuin, 1985, op. cit., pp. 287–91; and *Zhongguo meishu quanji (Treasury of Chinese Art): Chinese Painting*, vol. 21: *New Year Prints*, New York and Beijing, 1985.

115. *Wenwu* 1979.5, pp. 1–6, pl. 1, cited in J. Needham and Tsien Tsuen-hsuin, 1985, op. cit., pp. 280, n. (d), 280–1.

116. See, for example, *Zhongguo meishu quanji*, 1985, op. cit., nos 1, 3, 4, 5.

117. L. Binyon, *A Catalogue of Japanese and Chinese Woodcuts Preserved in the Sub-Department of Oriental Prints and Drawings in the British Museum*, London, 1916, pp. 581–7.

118. *Chugoku kodai hangaten*, 1988, op. cit., pp. 50–6.

119. J. Needham and Tsien Tsuen-hsuin, 1985, op. cit., pp. 277–80.

120. The Modern Woodcut Movement is described in S. Sun, *Modern Chinese Woodcuts*, exhibition catalogue, San Francisco, 1979; and *Cinquante Ans de Gravures sur Bois Chinoises, 1930–1980*, exhibition catalogue, Grenoble, 1981.

121. For reproductions of prints by Chinese artists since the 1950s see *Zhongguo xinxing banhua wushinian xuanji*, 2 vols, Shanghai, 1981; *Zhongguo banhuajia xinzuo xuan*, 2 vols, Sichuan, 1985; and *Modern Chinese Prints from the Central Academy of Fine Arts, Peking*, exhibition catalogue, Preston, Lancashire, 1986.

122. L. Ledderose, 1986, op. cit., fig. 20.

3

Sculpture for tombs and temples

This evening I visit a Ch'en-dynasty temple,
its corridors and halls filled with ancient treasures.
In crumbling niches, gold Buddhas shine;
marvelous paintings cover the high walls.
A broken stele can no longer be read:
*cracked, and covered with moss.**

Sculpture abounds in China: figures and animals stand in temples and tombs, guard doorways and decorate roofs, and that these are mentioned in the same breath as buildings is no coincidence. In China sculpture is intimately connected with architecture, transforming tombs, tomb parks and temples into living visions of the world. It could be said that the buildings are the scenery and the scenery is brought to life by the figures.

The decision to group three-dimensional representations in one chapter under a single heading means that a Western approach has been adopted. But China and the West have quite different attitudes to sculpture, and this must be made clear at the beginning. In the West it is regarded as a major art form. It has been used to represent deities, political figures and related scenes, all subjects central to the religious and secular life of the various states of the Western world and of its predecessors in the Mediterranean area. Works in stone and bronze therefore attracted patronage and high levels of craftsmanship. Both the functions of the pieces and the skill with which they were executed have made them highly valued.

Although sculpture was widely employed in China, it never enjoyed the high status accorded to it in the West. There are two principal reasons: the nature of its functions, and the people who executed it. The major deities of the early dynasties, the High God (Shangdi) of the Shang and Heaven (Tian) of the Zhou, were never depicted, nor were deities represented at the highest level in the practice of Confucian ritual. The principal rites of the state in early times were carried out at altars without images. Thus, at the apex of religious life, the representation of gods in human form was of little importance, and perhaps for this reason the depiction of kings did not develop. Because sculpture was not employed at the highest levels of early Chinese society, when religious figures did at last appear it was through the introduction of Buddhism, a foreign religion which did not always enjoy imperial support.

*from 'Staying Overnight at T'ien-ning Ch'an Temple' by Chang Yü, in J. Chaves (trans. and ed.), *The Columbia Book of Later Chinese Poetry*, New York, 1986, p. 81

The second reason why sculpture was little valued was that all images were made by artisans. In China, the highest arts – calligraphy and literati painting – were practised by scholar-officials, and only those arts undertaken by them were considered to be true art. Because of the physical nature of the work, there was no possibility that sculpting could be done by scholar-officials, making it thus unlikely that sculpture would ever be regarded as art. None the less, it fulfilled essential functions in supplying the images for the worlds of the dead and serving some aspects of religious worship. Because such sculpture had important functions, it was executed with great skill and, in the case of tomb figurines, considerable attention to lifelike detail.

Early sculpture

Within the areas controlled by the Shang (c. 1500–c. 1050 BC) and the early Zhou (c. 1050–771 BC), sculpture was rare and relatively unimportant. This did not mean that the early Chinese could not produce it. A few representations of people or animals predate the development of tomb sculpture, from about the fourth century BC, and these are described briefly below. They show that the Chinese were indeed skilled in rendering form in three dimensions, although they only rarely pursued this end.

Occasional human images appear from the Neolithic period. In ceramic they were, however, often no more than almost incidental ornament. Jade carvings, on the other hand, were fully realised, if miniature, sculptures. Animal figures carved by the Hongshan and Liangzhu Neolithic cultures have already been mentioned (ch. 1, fig. 22), and these may have inspired the carvings of the Shang (ch. 1, fig. 26) and Zhou. Despite their surface decoration of abstract intaglio lines, these creatures were realistic, demonstrating careful observation of natural forms. Jade was, however, primarily employed for ritual implements, and at this date did not become the medium for a wide-ranging exploration of animal and human forms. Indeed, there are very few surviving jade figures of humans (ch. 1, fig. 39).

Shang and Zhou bronzes include a few striking sculptures, the most vivid examples coming from areas outside their rule, in the south (ch. 1, fig. 33). Throughout the Bronze Age, southern China – that is, the Yangzi valley, the southeastern coastal area and the tributaries of the Yangzi in Sichuan province – was inhabited by peoples who had more use for sculpture than did the inhabitants of the great Shang and Zhou capitals in Henan and Shaanxi provinces. For example, bronze vessels in the shapes of boar, buffalo and elephants have been found in Hunan province, and various debased versions of such bronze vessels have come from sites further west.

The single most memorable recent find is the discovery of human heads, masks and one complete figure (fig. 85), all in bronze, in two sacrificial pits at Sanxingdui, Guanghan, in Sichuan province. The bronzes, many damaged, were found with gold, jade, elephant tusks and quantities of burned animal remains. This cache of precious items suggests that the pits contained offerings to gods or spirits.[1]

We have no idea what or whom the figures and masks represent. There are two types. The first group comprises human heads and one standing

85 Bronze figure of a man on a high base, from Sanxingdui in Guanghan county, Sichuan province. Shang period, 12th century BC. The discovery of two sacrificial pits with one complete figure and many masks in bronze (see fig. 86), as well as elephant tusks, jades and gold, is one of the most remarkable archaeological finds of the 1980s. The figure clearly held something in his hands, possibly a tusk. The robe is decorated with small figures. Sculptures of this size in human form are unknown from the metropolitan areas of the Shang and early Zhou. HT: 2.62 m.

figure (fig. 85), displaying sharply slanting wide eyes, broad deep lines around the eyes which may represent masks, and various hairstyles and headdresses. The second type was made as a mask (fig. 86), fitting, it would appear, around a pillar or some other part of a wooden building. The section of the bronze is U-shaped and forms an approximately square head. Eyes stand out on stalks and the heads have broad noses and long outstretched ears. Although by no means realistic, the most unusual quality of these images is that they depict spirits, gods or priests as manlike.

The interest of the Sanxingdui sculpture lies in the fact that it stands almost alone. The scarcity of other early images of gods, spirits or even human figures demonstrates how very emphatically figural images were excluded by convention from the main Chinese artistic traditions. These traditions not only excluded sculpture, but also erased from the records any mention of peoples for whom figures were significant. Nowhere in the contemporary written accounts of the Shang or Zhou period is any mention made of the artistic or religious practices of the peoples who competed and did battle with these early Chinese rulers. A few names are sometimes recorded, but without the bronzes and jades revealed in excavations we would never have known that such peoples had religious objects and beliefs that were quite unlike those of their Shang and Zhou contemporaries. Among Shang and Zhou artefacts, a few jade figures and figural motifs on chariots and weapon fittings do, however, demonstrate that the metropolitan carvers and casters of the thirteenth to eighth century BC were aware of the skills of their neighbours. But the small scale and relatively obscure positions of such motifs reveal the low esteem in which figural representation was held.

This situation changed after China fragmented into the competing states of the Eastern Zhou period (770–221 BC). An interest in sculpture was probably fuelled by the customs of the southern state of Chu, which dominated the area of the great lakes north of the Yangzi. It seems likely that this southern area, which had employed figures of animals for its bronze vessels, retained a deep-seated interest in representing form in three dimensions. In this heavily forested area the abundance of wood made wooden sculpture possible.[2] We do not know whether other areas produced such carvings, as little has survived, but it does not seem likely in the light of the history of sculpture generally.

Chu is renowned for its complex views of the spirit world recorded in the later, Han period, text, the *Shanhaijing* (*Classic of the mountains and seas*). Wooden guardian figures in the tombs of the fourth century BC seem to

86 Drawing of a bronze mask with projecting eyes and large ears, from Sanxingdui in Guanghan county, Sichuan province. Shang period, 12th century BC. This large mask and others like it were evidently made to be fixed to some large structure. Other heads from the pits bore a closer resemblance to the figure in fig. 85. The religion which required such sculptures is completely unknown, although clearly it differed in essential respects from the beliefs of the Shang. HT: 65 cm, W: 1.38 m.

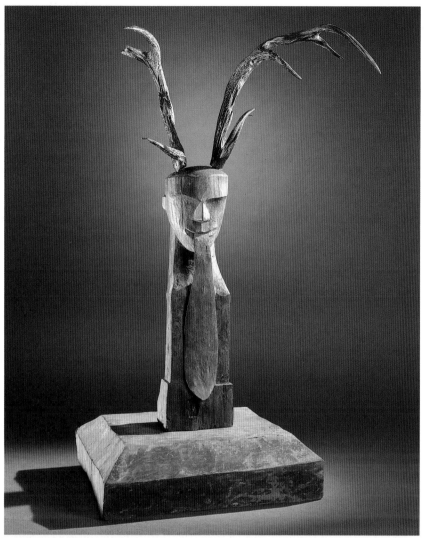

87 Wooden guardian figure
with a long protruding
tongue and crowned by
antlers made of dry lacquer.
Eastern Zhou period,
possibly from the Chu state,
4th century BC. Wooden
figures with monstrous faces,
long tongues and antlers
were placed as guardians in
Chu tombs in southern
Henan and northern Hubei
provinces. This tradition of
sculpture also embraced more
realistic creatures, such as
cranes and deer. HT (from
base): 43.7 cm.

88 Bronze support in the
shape of an animal. Eastern
Zhou period, 6th–5th
century BC. This may have
been one of three or four
animal-shaped feet for a basin
or tray. Like the bell in ch. 1,
fig. 41, it was made at the
foundry of the Jin state in the
present-day city of Houma,
in Shanxi province.
HT: 11.7 cm.

embody its descriptions of strange spirits. Many have large eyes, long protruding tongues and antlers (fig. 87). Apart from its long tongue, the example illustrated is a rather restrained form of the extraordinary creatures depicted in such carvings. Presumably it was originally brilliantly coloured with lacquer. Other figures are more realistic, carved in the shapes of birds standing on animals or snakes. Smaller sculptures of animals, especially deer, were also placed in the Chu tombs. As figures were thus carved in wood, it was probably quite natural to make wooden stands for musical instruments in the shapes of creatures. In the most sumptuous of tombs, such as that of the Marquis Yi of Zeng, such stands were of bronze (ch. 1, fig. 42). A tall bronze sculpture from this tomb, in the shape of a bird with antlers, was probably intended to hold a drum (fig. 89). Its rounded body and greatly stretched neck seem to be based upon forms that could be readily carved in wood.

From these southern examples of figures in wood and bronze there developed a much wider use of figures, usually in miniature, as supports for furniture, lamps and basins (fig. 88). Many different creatures were employed to hold lamps: men riding camels, spirits holding snakes, birds and tossing bulls.[3] Spectacular inlaid animal figures, probably parts of furniture in wood now decayed, have come from the state of Zhongshan in Hebei province.[4] None the less, although some very engaging figures formed part of the furnishings in palaces and tombs, the effort that went into sculptures of any sort was very modest by comparison with the great industry dedicated to making vessels in, for example, bronze or lacquer. Not until the development of tomb figures from the Qin and Han periods and of later religious images in human form, carved under foreign influence (p. 150), was this situation to change significantly.

Tomb sculpture

At the same time as small bronze sculptural fittings were devised, the first sculptures were made depicting the servants, guards and charioteers required by the dead in the afterlife. During the Shang and much of the Zhou period kings and great lords were buried with their attendants so that the latter could serve them after death. Servants and soldiers lie at the entrance to the great royal tombs at Anyang (ch. 1, fig. 28); in a side chamber of the tomb of the Marquis Yi of Zeng thirteen young women were buried – probably musicians in the marquis's orchestra (Tombs appendix). Chariots, horses and charioteers had been interred in pits adjacent to the tombs of kings and nobles for many centuries.

The change from the burial of people to the use of replicas in wood, stone or pottery took place over quite a long period of time, and in really sumptuous burials men and women were for a long time still sacrificed in preference to models. Likewise, large numbers of real horses and chariots were interred in pits adjacent to the principal tombs of the Eastern Zhou princes and kings.[5] As late as the burial of the emperor who unified China, Qin Shi Huangdi, real horses were buried in pits depicting his stable, and animals and birds were slaughtered to represent the creatures of his hunting park. His army, however, was modelled in ceramic, as we shall see. In discussing

89 Bronze bird crowned with antlers, possibly to carry a musical instrument, from the tomb of the Marquis Yi of Zeng, buried c.433 BC at Leigudun in Sui county, Hubei province. The wealth of the marquis was such (see also ch. 1, figs 42–3) that he could commission in bronze large sculptures more usually made in wood. HT: 1.42 m.

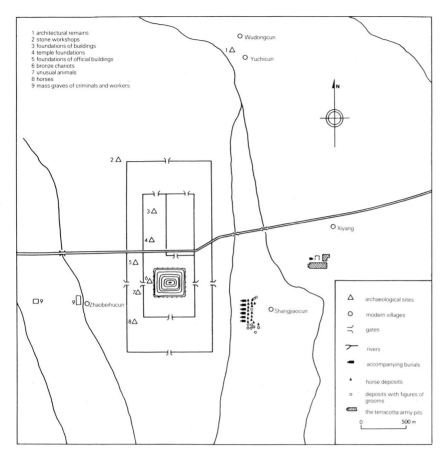

1 architectural remains
2 stone workshops
3 foundations of buildings
4 temple foundations
5 foundations of official buildings
6 bronze chariots
7 unusual animals
8 horses
9 mass graves of criminals and workers

N

○ Wudongcun
1 △
○ Yuchicun

2 △

3 △

4 △
○ Xiyang

5 △

6 △
7 △

□ 9 9 □ ○ Zhaobeihucun

8 △
○ Shangjiaocun

△ archaeological sites

○ modern villages

⌣ gates

∓ rivers

◼ accompanying burials

▲ horse deposits

○ deposits with figures of grooms

▨ the terracotta army pits

0 _____ 500 m

90 Plan of the area around the tomb of the Emperor Qin Shi Huangdi, at Lintong in Shaanxi province, showing the tumulus at the centre, surrounded by walls. 3rd century BC. Within the inner walls were a temple and two bronze chariots, and between the two pairs of walls were burials of sundry animals and horses. The burials of the workers and criminals who worked on the complex lie to the west, and the pits for the terracotta army (fig. 91) to the east.

all such burials, be they of real servants or of models, we should bear in mind that the ancient rulers of China sought to perpetuate the world as they knew it both within their tombs and in the parks which surrounded their tombs above ground.

Among the earliest examples of substitute figures are four in wood from a sixth-century BC tomb at Zhangzi in Shanxi province.[6] These were in addition to three humans who were also buried with the main occupant of the tomb. The four standing figures are shown with long heavy garments reaching to their ankles. They are without arms, which suggests that their arms were constructed of some perishable material, such as a textile, and may indeed have been attached to a cloth overgarment. If this was the case, the aim would have been to make substitutes in the form of dolls dressed in real clothes, rather than to create convincing depictions in a different material.

By the fifth century BC wooden figures had become quite common. In tombs in south China, in the area of the Chu state, examples have come from Jiangling in Hubei province and Xinyang in Henan.[7] Their forms were rudimentary, with almost tubular bodies, rounded heads and painted faces. Some show the dress carved in wood, painted to resemble textile. Others without arms were presumably originally dressed in silk. In later tombs of the Han dynasty, these real silken dresses were usually replaced by painted clothes.

Whether because the evidence we have is less complete or because figures were simply less popular in the north, we have a much sparser picture of what went on in Henan and Hebei in the late Zhou period. In Shaanxi, by contrast, we are faced with the most amazing finds, renowned everywhere – the pottery warriors from the tomb of Qin Shi Huangdi (fig. 91) – and at a single stroke our whole notion of burial figures has been transformed.[8]

The first Qin emperor, Qin Shi Huangdi, unified China in 221 BC and consolidated his state by unifying the script, the axle lengths of the carts, and the weights and measures. He constructed replicas of the palaces of all the minor kingdoms he had conquered in order to indicate his domination of the known world. He also arranged for the construction of a magnificent tomb for himself, a description of which is given by Sima Qian, the Han dynasty court historian:

> As soon as the First Emperor became king of Qin, excavations and buildings had been started at Mount Li, while after he had won the empire more than seven hundred thousand conscripts from all parts of the country worked there. They dug through three subterranean streams and poured molten copper for the outer coffin, and the tomb was filled with models of palaces, pavilions and offices, as well as fine vessels, precious stones and rarities. Artisans were ordered to fix up crossbows so that any thief breaking in would be shot. All the country's streams, the Yellow River and the Yangzi, were reproduced in quick-silver and by some mechanical means made to flow into a miniature ocean. The heavenly constellations were shown above and the regions of earth below. The candles were made of whale oil to ensure their burning for the longest possible time.
>
> Szuma Chien, *Selections from Records of the Historian*,
> trans. Yang Hsien-yi and G. Yang, Beijing, 1979, p. 186

This tomb was probably robbed soon after the burial of Qin Shi Huangdi and has not yet been scientifically excavated. However, excavations around the actual tomb mound have revealed a complex of additional burials, not mentioned at all by Sima Qian (fig. 90). Among the lesser burials surrounding the main tomb were two small pits holding exquisite bronze chariots and drivers, the burials of princes and concubines and the horses in their stables, the tombs of the high officials, and the pits with the renowned pottery warriors. The pottery warriors replaced the burials of massed chariots, horses and charioteers found at the most sumptuous tombs of the Eastern Zhou period. The tomb, together with the subsidiary burials, recreated the emperor's world: the underground buildings and the pits with horses, animals and concubines represented the world he had lived in, while the army stood for his forces, which had not only conquered the known world but which defended and would continue to defend the empire of which he was the source and fountainhead.

Unlike the earlier figure models, the warriors were made of clay rather than wood and cloth or stone (fig. 91). This choice was to be an important one, as from this source developed a long tradition of clay burial sculpture. Clay probably seemed a natural choice, as ceramic models of farm buildings

had been buried in tombs of the original Qin state in the west prior to the Qin conquest of the rest of China. Moreover, long experience of using clay for eating vessels and architectural ceramics, such as tiles and drains, gave the Qin a large reservoir of skills in modelling and in the use of moulds for mass-production. Clay was also a happy choice in that, when fired, it is durable, and as a result the warriors have survived, right up to the present day – which is probably what the first emperor had hoped would happen.

Much more extraordinary than the choice of material were the quite astonishing advances that had been made in the conception of the role of figures. In place of a few figures of servants, a whole army was produced. Moreover, the army was created complete in every detail: not only in the detail so often mentioned – the so-called individuality of each warrior – but in the detail required to provide a convincing, indeed an accurate, picture of the proper fighting force to defend the empire. The different ranks of the soldiers were deployed in their correct positions, with their appropriate armour, weapons and chariots. The full portrait of an army evidently required

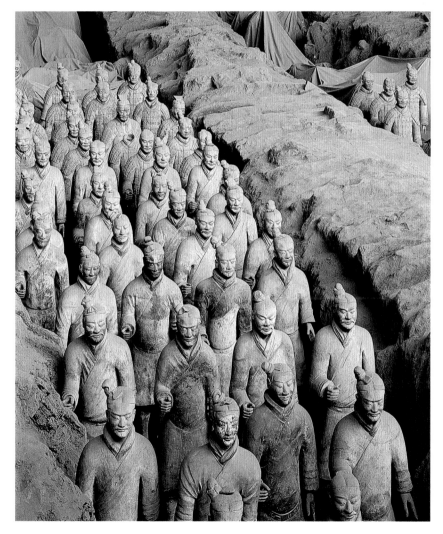

91 Detail of a group of terracotta warriors from pit 1 at the tomb complex of the Emperor Qin Shi Huangdi. Although small differences in facial features suggest the variety of individuals, these figures were made by mass-producing sections in moulds and then combining the various parts to produce a large mass of figures, all with these small, lifelike differences.

minutely accurate depictions of dress, hairstyles and weaponry if it were to achieve a convincing effect.

Even without the need to give a full account of the different styles of armour and dress, the sheer creation of a mass of several thousand complete life-size figures would have been a most demanding task. Simply the transport of clay and of the fuel needed to fire it would have required hundreds of men. In addition, the accuracy of the depiction of the army presupposes a large body of planners, familiar with and able to record military equipment and emblems of rank, as well as executors, who could carry out what must have been very explicit directions. The project had to be proposed, described and planned, and then the work had to be divided among many workers. We know nothing of the discussions and 'paperwork' which must have preceded the process of making the army in clay. However, the figures themselves provide much information as to how the army was actually made. The method chosen for production was that of mould making. Hands, feet and heads were all made from moulds, often of several parts. Further, several different types of head, hand and foot were put together in different combinations to create soldiers both in different postures and with varying appearances. In this way a convincing depiction of an army was achieved. No other ancient civilisation has created the world in which its dead were to live on such a life-size scale.[9]

In the following period large figures gave way to less impressive armies, but massed figures were still employed, both for the tombs of emperors and for those of generals. The tomb of the Emperor Jingdi (156–141 BC) was accompanied by several thousand naked figures without arms. Their condition suggests that they were related to the wooden figures with textile dress known from the Chu state. Both arms and dress may have been made in textile. Complete figures, many mounted on horses, have also come from Xianyang in Shaanxi and Xuzhou in Jiangsu province.[10] Like the warriors of the tombs of Qin Shi Huangdi, these were functional, intended not only to protect the tomb and the person of the occupant, but to complete a depiction of his world and his role in life, which was considered to continue without interruption after his death.

Within the tomb chambers of the early Han, ceramic figures had a relatively small part to play. Indeed, such ceramic figures would probably not have appeared in the tomb proper of Qin Shi Huangdi. As in the examples mentioned above, they were often subordinate to the contents of the main tomb, occupying outlying chambers or pits. In other words, there was a hierarchy of burial goods and practices within the tomb complex itself. During the Western Han (206 BC–AD 9) genuine items were buried in the main part of the tomb, while substitutes were confined to outlying sections. The tombs of Prince Liu Sheng and his consort Dou Wan, buried in the late second century BC at Mancheng in Hebei province, illustrate this practice (Tombs appendix). These tombs were dug into the mountainside and, if approached from the entrance, the chambers held objects in an ascending hierarchy of value (ch. 1, p. 28). Some of the most valuable items were in the rear chamber with the deceased and in the adjacent serving room. In the latter were stone figures of servants. This relatively expensive material was in keeping with the central position of the servants within the burial, where

they were placed with such fine items as a gold inlaid incense burner and gold wine vessels.[11]

The plans of the Qin (fig. 90) and Mancheng tombs (Tombs appendix) illustrate the arrangement of the burial as part of the ceremonial complex in which offerings were made to the dead person, and in which he also made his own obeisances to his ancestors. In subsequent centuries tombs were developed to resemble houses and palaces. In a later Han tomb in Gansu province (Tombs appendix), for example, different rooms were assigned different functions, rather as in the tomb of the Marquis Yi of Zeng (Tombs appendix). The subsidiary areas for storage, carts and carriages were even named.

During the second half of the Han period, the state was heavily committed to controlling a larger territory and funds were short. Burial of precious materials seems to have been restricted, if not forbidden. Indeed, rules seem to have been promulgated to limit the burial of all items of high value; if the genuine objects of life could not be buried, then models had to take their place. The skills that had been developed for the pottery warriors (fig. 91) were extended to produce ceramic tomb models of all types. Interestingly, figures of men and women, whether servants or soldiers, were less in evidence than were replicas of buildings, granaries, wellheads and other structures of rural life.[12] This interest in buildings had probably been initiated by the Qin, in their western state in Shaanxi province, where the burial of model granaries had been common.[13] As with the armies in clay, model buildings were probably interred to perpetuate below ground a convincing picture of the living world.

Not only do the models depict buildings of different functions, but they also show regional variations. In the north, multistoreyed towers illustrate the wooden and tiled buildings that were to dominate all later architecture. Such buildings had probably been in existence from at least the Shang period, but there are only traces in the ground to tell us what the earlier examples may have been like. In the south, models show the courtyard building typical of the area, and from the extreme south and west come models of buildings on the stilts which elevated them above the marshy ground.[14]

After the fall of the Han, the use of tomb models declined. They reappear some centuries later, but with a new emphasis on figures rather than buildings. The first signs of a revival are apparent in the fifth century AD in tombs at Deng xian in Henan province and in the tomb of Sima Jinlong at Datong, in Shaanxi.[15] In this latter tomb were rows of small figures and horsemen in glazed ceramic. A cart and figures made of a dark clay, now in the Museum, belong to a similar or slightly later period (fig. 92). Like the Qin pottery warriors and Han dynasty models, these figures were made by moulding.

Ceramic figures were mass-produced for all later tombs, those of the early Tang period (AD 618–906) being particularly dramatic. In the early eighth century princes and officials commissioned large, brilliantly glazed examples. The Museum's set of figures (part of which is shown in figure 93), said to come from the tomb of Liu Tingxun at Luoyang, is one of the most outstanding to survive. These large figures were generally placed at the openings of the main chambers (Tombs appendix). They were in effect guardians, and

92 Model of a bullock cart in ceramic with dark brown glaze. Six Dynasties period, 6th century AD. Such relatively rare examples anticipate the large tomb figure industry which grew from the 7th century AD. HT: 42 cm, L: 54.5 cm.

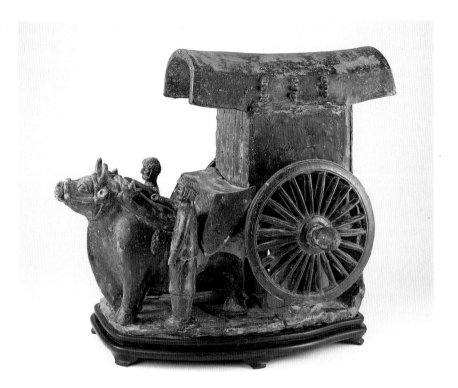

include figures from the Buddhist world as well as images of civil officials, similar to those carved in stone outside tombs as depictions of a guard of honour.

Along the main access ramp of the grandest tombs were small niches, and in these lesser positions were placed groups of smaller figures, which offered the dead man or woman the support and services they would have had in their lives (Tombs appendix). For a man, soldiers and servants were arrayed, while women had serving women and household utensils. Such niches were rather like the subordinate pits or rooms of the Qin and Han tombs, and thus lower down the hierarchy than the main chamber.

In later tombs pottery figures generally played a lesser role, although they continued in use up to and including the Qing period. Their function of depicting the world of the living was maintained.[16] In the particularly elaborate tombs of the Jin dynasty (AD 1115–1234) of northern China, whole buildings were created in carved and moulded brick (fig. 94), imitating the complex bracketing system developed for wooden buildings (Architecture appendix). Figures were inserted among these buildings, where they stood in doorways and on small stages. Occasionally more elaborate settings were achieved, as with a row of actors in a tomb at Houma: they were presumably performing in front of the dead man and his wife, who are depicted on either side of a table. This careful series of buildings is both literally and metaphorically a stage setting.[17]

Sometimes a building was the backdrop within a tomb; at others, as in Ming tombs, buildings were produced as complete models and supplied with miniature figures undertaking various activities. In a model in the

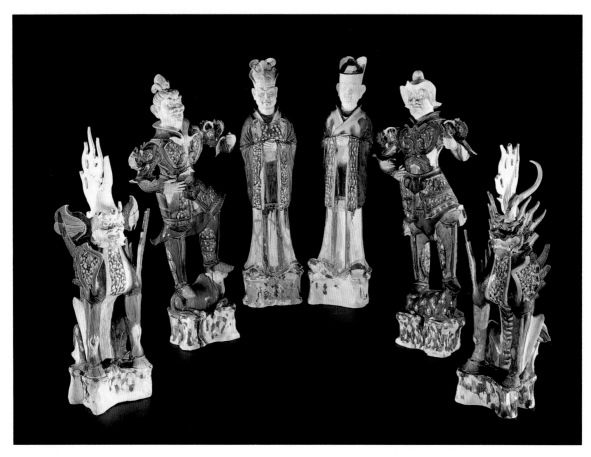

Museum (fig. 95), the courtyard and sequence of buildings give a more rounded view of a building than was possible in the Jin period tomb. The wooden structure, however, is less fully rendered.

Tomb sculpture above ground

The main burial below ground, whether a single stepped pit with access ramps or a complex multi-chambered palace (Tombs appendix), was only ever one element of the tomb structure. From at least the Shang period and the time of Fu Hao, *c.*1250 BC, buildings also stood above ground over or adjacent to tombs. In almost all the early tombs these buildings, which were made of wood, have decayed and disappeared. However, a plan found in one fourth-century BC tomb at Zhongshan in north China has enabled a reconstruction to be proposed (fig. 96); here large wooden buildings probably rose over a row of tombs. Mounds piled over tombs also began in this area of north China.

Most large Eastern Zhou (770–221 BC) tombs had wooden buildings within a tomb compound; the principal ancestral temples dedicated to the deceased were generally outside the tomb area. At the tomb of the first Qin emperor an ancestral hall was built beside the tomb (fig. 90). Individual Han emperors had offering temples built near their tombs and, during the Eastern

93 Part of a group of thirteen tomb figures said to have come from the tomb of the general Liu Tingxun, who died in AD 728 and was buried at Luoyang. The pieces illustrated here include two earth spirits, two *lokapālas* (Buddhist guardian figures) and two civil officials. Two horses (one is shown in ch. 5, fig. 158), two camels and three grooms are also in the Museum's collection. These figures would have been placed at the entrance to the main burial chamber, or just inside it.

145

94 Decoration in brick of a
Jin period tomb at Houma in
Shanxi province. 13th
century AD. Such tombs
reconstructed the life of the
deceased, who is shown here
seated at a table with his wife
as if in his house.

95 (below) Ceramic tomb
model of a house. Ming
dynasty (1368–1644). HT
(of largest building): 44 cm.

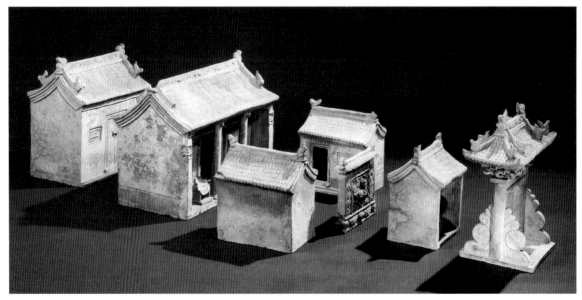

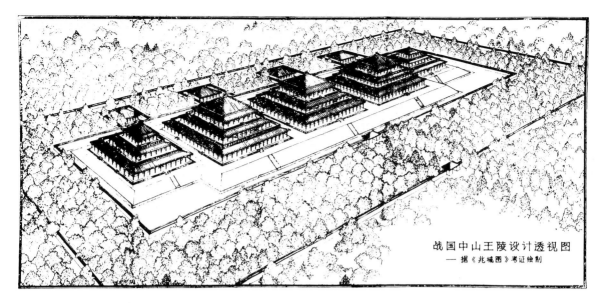

战国中山王陵设计透视图
—— 据《兆域图》考证绘制

Han (first century AD), the offering shrines were placed within the temple complex.[18] Although further changes followed the fall of the Han, later tomb complexes comprised a series of monumental gates and pavilions, among which were halls for offering or retiring as well as pavilions for stelae and sacrifices (Tombs appendix).

Early gateways, entrance buildings, shrines and halls were made of wood in the traditional manner, employing the standard Chinese structure in which horizontal beams were supported on columns. Large brackets joined the beams and the columns, and the roofs were tiled with ceramic (Tombs appendix). In later centuries such tiles were coloured in bright lead glazes, and many were shaped in the forms of figures and auspicious beasts.

Stone carving became an essential feature of such tomb complexes. In part the stone was used as in other buildings such as palaces and temples, for ceremonial gateways, balustrades and stairways. However, tombs attracted special categories of sculpture: pillars at the entrances and large carvings of animals and men.

96 Proposed reconstruction of buildings above ground for the site of the tombs of the Zhongshan kings, buried near Pingshan in Hebei province. Eastern Zhou period, 4th century BC. The reconstruction is based upon a plan shown on a bronze plate found in one of the tombs.

97 Stone carving of a boar from the tomb mound of the Han dynasty general Huo Qubing (d. 116 BC). The boar is one of several stone animals that were among the earliest sculptures produced to enhance a tomb park. The animals were placed on the mound itself, as if to represent the exotic dwellings of spirits in distant mountainous lands.
HT: 62 cm, L: 1.63 m.

147

99 (*opposite above*) Site of the imperial tombs at the Qianling, burials of the Tang Emperor Gaozong (r. AD 650–84) and his consort who ruled in her own right after his death, the Empress Wu Zetian (r. 684–705). The natural hills have been modified to make the mounds more pronounced. There is an avenue of stone animals on the ridge, and the tombs of princes, princesses and ministers are situated around the main tomb.

The search for suitable large boulders of stone from which to make these enduring sculptures seems to have been related to the Qin and Han desire for immortality.[19] The Qin emperor had, for example, established stone stelae announcing his achievements at the four quarters of his empire (Introduction, fig. 7). From this period stone became an ever growing element of imperial architecture, in palaces and especially at tombs.

The very earliest surviving examples of stone animals at a tomb occur at the tomb of Huo Qubing (d. 116 BC), a general who directed the Han Emperor Wu's major campaigns in Central Asia. Unlike the later carvings, which stood along an approach road, these animal figures were originally scattered over the tomb mound.[20] The animals emerge from the stones, which in many cases still retain their original boulder forms. The boar in figure 97 seems to grin and grow out of the stone.

The most striking use of stone can be seen in the sculptures of animals and men who act as a guard of honour. This stone guard of honour served a dual purpose: to protect and to impress. The stone sculptures replaced the living guards of honour that would have lined the way for the emperor in life, and protected the deceased with a permanent guard. It provided a link with the next world by illustrating auspicious beasts and served also as a symbol of status, reflecting the rank and might of the deceased.

A few isolated Han figures exist. Some are compact and block-like, emphasising the solidity of the stone. Others suggest the qualities of the animals they represent, such as the power of pacing felines. The most magnificent animals of this sort are those which were set up near Nanjing, in the fifth and sixth centuries, at the tombs of rulers of the Southern dynasties (AD 420–589).[21] Large winged creatures represent lions, their powerful bodies and small wings embellished with relief scrolls (fig. 98). From this date these

98 Stone *qilin* from the tomb of Emperor Wendi (d. AD 453) of the Liu Song dynasty, buried at Shizichong Ganjiaxiang near Nanjing. The Southern Dynasties developed vigorous depictions of pacing and often winged felines, which were placed in pairs to guard the sacred ways to the royal tombs.

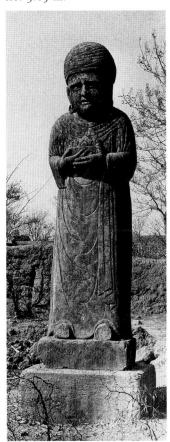

100 (*below*) Stone figure of an Arab ambassador at the tomb of the Song Emperor Zhenzong (d. AD 1022), south of the city of Gong xian in Henan province. The relative political weakness of the Song, constantly at war with their northern neighbours, and the relative economic prosperity of the period encouraged trade with foreigners. This contact, and the wish to represent China's pre-eminence among the states of the world, encouraged such depictions of foreigners at the tombs of the Song emperors. HT: 3.15 m.

mythical figures are found at tombs of all periods. Also typical of the southern tombs are columns which support lions standing on lotus flowers. Fluting on the columns may come from Central Asia and may, perhaps, be derived from the columns of the Hellenistic and Roman worlds further to the west. The lion on a lotus is indeed also a Central Asian motif, found in the Indian subcontinent on the so-called Asokan columns.[22]

Pillars or columns and figures of animals and officials recur at almost all later imperial tombs. Whereas Southern Dynasties tombs seem to have been concerned with the supernatural, particularly with the powers of creatures, those of the Tang and the Song depicted the real world. Figures of both civil and military officials were particularly important, as they recreated in stone an actual ceremonial occasion. Auspicious animals also occur (fig. 97): the vermilion bird of the south, the lion as a symbol of power, and the ram as a symbol of filial piety.[23]

Song tombs are enlivened by figures of foreigners.[24] Many of the figures, who represented Central Asian and South Asian states, carry offerings, such as jade or rhinoceros horn (fig. 100), and a mahout escorts an elephant. The countries of the different ambassadors are suggested by their features – noses, beards and hair – by their dress and, to a lesser extent, by their gifts. The care with which these ambassadors are shown is equivalent to the detail given to the armour and armaments of the pottery warriors. Their function, as with Qin and Han figures, was to complete a picture of the world, in this case a picture that showed the links between the Song empire and surrounding states. As the Song were under particular pressure from the small states on their northern borders, they probably wished to emphasise the sound diplomatic relations they had built up with their neighbours, perhaps feeling the need to illustrate the embassies of these so-called tributary states precisely

101 Stone figure of a kneeling elephant from the tomb of the first Ming emperor, Hongwu, buried at Nanjing in AD 1398. After the Hongwu emperor's death the capital was moved to Beijing, and the tombs of the later Ming emperors are at Changping near Beijing.

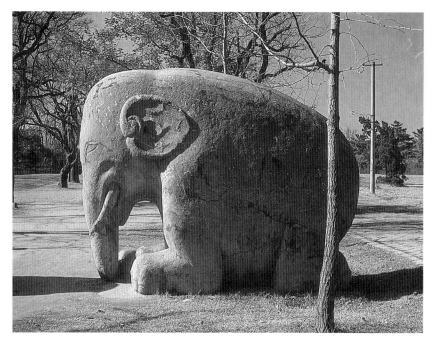

because the Song were less powerful than their predecessors, the Tang.

The Ming and Qing dynasties are also famous for stone figures along their tomb avenues.[25] The tomb of the first Ming emperor was built at Nanjing and has its own avenue of stone animals and figures (fig. 101). All the subsequent ones were built near Beijing, at Changping, and share a single approach avenue. The two groups of Qing tombs, on the other hand, have both main spirit roads leading to the whole complex, and smaller groups of stone figures at each tomb. Here, too, much attention was paid to the correct depiction of dress to indicate the rank of the officers and civil officials lining the road (ch. 4, fig. 149).

Buddhist sculpture

Much of the most discussed body of Chinese sculpture is Buddhist, dating from the fourth to the fourteenth century. Throughout its existence in China, Buddhism remained essentially a foreign religion. Most indigenous Chinese rituals were concerned with the prosperity of the family and of society, whereas Buddhism was primarily concerned with personal salvation. It did, of course, develop in response to the Chinese concern with the family. However, many individuals left their families, to take vows as monks and nuns and retire from the world to pursue the service of religion. Their monasteries attracted gifts of land and goods from the faithful, who wished to be associated with them. Whenever possible, the emperors harnessed the religion and its powerful following to their own ends, but from time to time this was imperfectly achieved and prolonged persecutions followed, with monasteries razed to the ground and monks and nuns forcibly returned to lay life. In the first five hundred years of Buddhist life in China there were

major persecutions in AD 446–52 under the Northern Wei, in 574–9 under the Northern Zhou, in 842–5 under the Tang, and in 951–60 under the later Zhou.[26]

Inevitably the beliefs, practices and images of devout Buddhists were foreign. Both texts and images were assiduously sought in the West, and several famous accounts of difficult journeys to India survive in the descriptions by Fa Xian (fl. 399–414) and Xuan Zang (fl. 629–45), who brought scriptures back to Chang'an (present-day Xi'an), where they were preserved in the Great Goose Pagoda.[27] Although such monks were primarily seeking reliable religious texts, they also carried images from India and Central Asia back to China. In addition, their descriptions of images seen in the West gave the Chinese information on which to base their own religious sculptures.

The history of Buddhist sculpture in China concerns the introduction, adaptation and assimilation of new forms and styles, followed by the introduction of further new forms and styles. As Buddhism developed, new teachings and types of image were introduced. During the first thousand years of Chinese Buddhist art, painting and sculpture seem to have been closely and at times intimately linked.

The sources of the earliest Chinese Buddhist images were the kingdoms of Central Asia, which in turn were in contact with the Buddhist kingdoms in Gandhara, in present-day Afghanistan and Pakistan. In this area Alexander the Great had established his most eastern kingdoms and introduced provincial forms of classical architecture and sculpture. From these areas under Western classical influence the Chinese took iconographic forms and sculptural types, absorbing at the same time other Indian sculpture styles then current there.

In Gandhara the Buddha was portrayed in his human form, not symbolically as had been the custom earlier in the Indian subcontinent.[28] The image in figure 102 is a typical example. The Buddha stands dressed in a loose robe which clings closely to his body. The cloth between his legs falls in concentric U-shaped folds, reminiscent of the robes seen on sculptures in the classical West. This model was adapted by the Chinese for their earliest images of the Buddha, and the first Chinese bronze figures display the U-shaped folds. Early Chinese images of Bodhisattvas, with their bare torsos and arrays of jewels, were equally dependent on foreign examples (fig. 103).

The very first Buddhist images in China had appeared only as incidental ornament in tombs, and on mirrors and ceramics.[29] In such contexts they were equated with depictions of such spirits as the Queen Mother of the West, a figure that came to be represented also on mirrors in the Han period. Under Chinese rule Buddhism was absorbed alongside other religious beliefs. Only under the rule of outsiders, from the fourth to the sixth century AD, such as the Liang in Gansu province and the Toba tribes (who took the title of Wei when they occupied north China), did Buddhism enjoy substantial imperial patronage. These foreign rulers encouraged the making of images in both stone and metal, including bronze, gold and silver.

The most extensive surviving early Chinese Buddhist remains are large cave temple sites, stretching from the eastern end of the Silk Route, at Dunhuang, into the heart of China (map VI, p. 324, Buddhist sites appendix). In many places caves were hollowed out of the cliff face and decorated

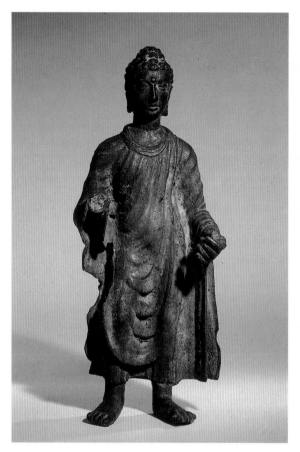

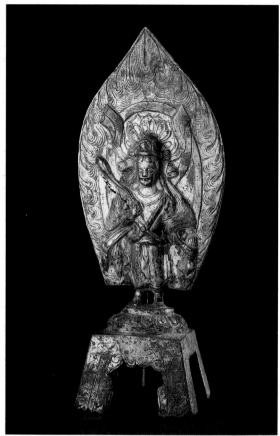

102 (*above left*) Bronze standing figure of the Buddha, from Gandhara in present-day Afghanistan and Pakistan. 4th–5th century AD. This figure wears the long flowing toga-like robe copied from Hellenistic or Roman dress, revealing the limbs below. HT: 41 cm.

103 (*above right*) Gilt bronze figure of the Bodhisattva Padmapāṇi, the lotus-bearing manifestation of the Bodhisattva Guanyin (Sanskrit Avalokiteśvara). Northern Wei dynasty, 5th year of Huangxing, AD 471. This small image retains the strong rounded forms that the Chinese adopted from lands to the west. HT: 25.5 cm.

with images and figure scenes. The foreign character of these great caves is evident in all their features: in the image types, with their rounded bodies and bare torsos, at Dunhuang; in the use of large, often massive central images, as at Yungang (fig. 104); in the display of lesser images on the walls, as in multi-storeyed buildings (ch. 6, fig. 193); and in the use of dense figure compositions to describe the life of the Buddha and the glories of paradise.

A most impressive group of early images is found at the caves of Yungang, near the capital of the Northern Wei at Datong in Shanxi province (fig. 104). In the main, these caves were hollowed out and decorated before the end of the fifth century AD, and illustrate the first major phase of Chinese Buddhist activity. Five massive Buddha figures recall the great images of the West, not only in the Buddhist but also the Roman world. The heavy solidity of the forms illustrates the Chinese attempts to create monumental sculptures of the type that they had heard described. The shoulders and torso of the figure in cave 20 are bulky and angular, while the robe is shown as delicate and thin by comparison, lying in neat sharp folds which mimic the folds of the robes on figures from Gandhara.

The early caves display many smaller images, arranged within niches (ch. 6, fig. 193). These are like the windows or openings in a classical building in the Hellenistic West, or the Buddhist buildings in Pakistan and Central Asia ultimately based upon Parthian and Hellenistic structures. In

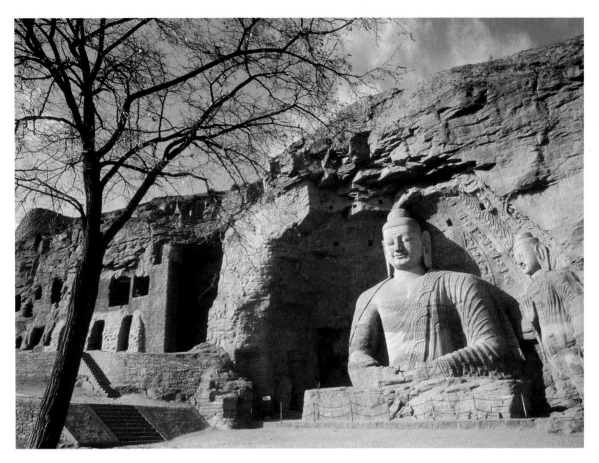

China, multi-storeyed buildings with windows or other openings between columns or piers, especially of stone, were unknown. Façades in this form were dependent on foreign example, as is evident in such features as the rudimentary columns and running scrolls between each tier of figures.

In the sixth-century cave temples at Longmen and Gong xian, heavy figure forms gave way to much more slender images, whose dress had a linear, almost calligraphic quality. Several of the principal images at Longmen wear long flaring robes that hide the body of the Buddha, modifying the simple toga-like robe inherited from Gandhara. In addition, smaller carvings, depicting processions of donor figures, are almost two-dimensional, making use of the sweeping lines of the dress and parasols (fig. 105). These sculptures are closely allied to contemporary figure-painting styles of the Chinese courts in southern China, and indicate the degree to which the Wei court was anxious to develop truly Chinese modes of depiction.

It proved easier, however, to allow for such Chinese tastes in the depiction of lesser figures rather than in representations of the Buddha. After the fall of the Wei in the mid sixth century and the rise of Tantric Buddhism, which saw the Buddha as a cosmic saviour, regal figure groups were made in stone, wood, bronze and stucco, emphasising the power and majesty of the Buddha and his attendants. Once more the achievements of Indian figural art were drawn upon to lend majesty to these figures, and craftsmen devised ways to

104 Massive seated figure of the Buddha in cave 20 at Yungang, near Datong in Shanxi province. Northern Wei period, late 5th century AD. Work started at the Yungang caves after the persecution of Buddhism in AD 446–52. These rock-cut figures were meant to reinforce the permanence of the teaching of the Buddha. Five caves, each with a gigantic figure of the Buddha, were among the first to be cut. Further caves were carved during the latter part of the 5th century, although activity declined after the dynasty transferred its capital to Luoyang in AD 494.

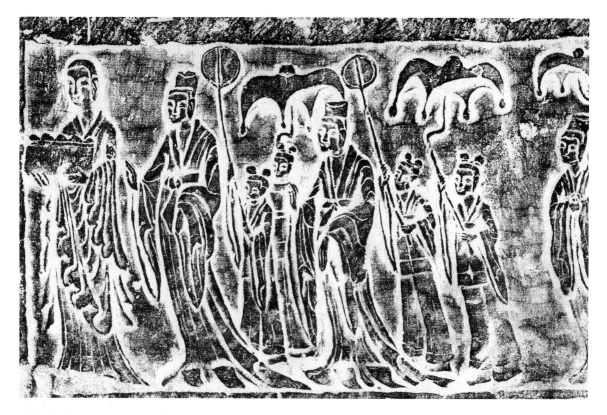

105 Rubbing of figures of donors from the Guyang cave at Longmen, Henan province. Northern Wei dynasty, AD 511. At Longmen great emphasis was placed on sculpture in which the figures of deities were clothed in heavy robes, with a complex pattern of folds. For minor figures such as donors, as seen here, an even more Chinese form was adopted, rendering the relief sculpture almost as drawing. DIMENSIONS (of rubbing): 31.5 x 104.5 cm.

assert the Buddha's presence with solid three-dimensional forms and realistic treatment of the features and clothes. Thus an immense Sui period figure of Amitābha Buddha in the Museum, dated to AD 585, is carved as a single mass, almost without articulation; his robes by contrast appear thin and delicate, lying in fine ridges over the smooth planes of the body (fig. 106). In the following Tang period a more dramatic interpretation of human form was achieved, illustrated by a small image of the Bodhisattva Padmapāṇi (fig. 108). A slightly twisted, asymmetrical body, surrounded by floating textile ribbons, provides new life to the traditional form. But both the solidity of the Sui Buddha and the movement of the Tang Bodhisattva show the influence of foreign examples.

Those two images are at the extremes of size: the Buddha is 5.78 metres high, the gilt figure a mere 18.5 centimetres. The former is an image that parallels the great cave temple sculptures, and must have stood flanked by other figures at the centre of a massive temple, probably in Hebei province. The gilt bronze is a small, intimate image, either from a household altar or possibly made for dedication by an individual to a shrine.

The creation of images, both large and small, highlights the devotional intent of Buddhist art (fig. 107). The pious hoped to gain merit in the next world by making and offering images of the Buddha and of Bodhisattvas, beings who have attained enlightenment but have elected to remain in the world in order to assist mankind. Images were also didactic, conveying aspects of doctrine and belief. Early cave sculpture and painting emphasised the historical Buddha, Śākyamuni, and recounted stories of his life (and his

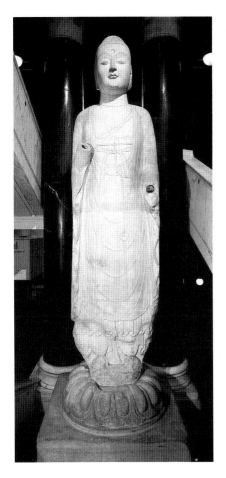

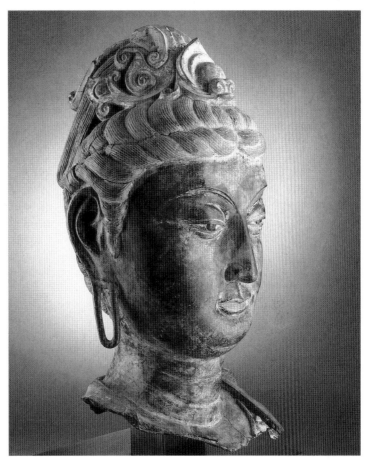

previous lives) as examples of the pure life to be followed by the faithful (ch. 4, fig. 118). Such images were dependent on earlier texts and images from the Indian subcontinent.

Over the first centuries of Buddhism in India, two schools or vehicles had developed: the lesser, Hīnayāna, and the greater, Mahāyāna. Hīnayāna is the name given to the earlier school, with its concentration on the life of the Buddha and the goal of the individual to achieve enlightenment, by extinguishing desire, and to attain *nirvāṇa* – release from rebirth into a state of non-being. Mahāyāna, which had arisen in southern India in about the first century AD, preached as its central aim not the attainment of *nirvāṇa* but the gradual salvation of all mankind with the assistance of Bodhisattvas. Another great body of teaching, Vajrayāna, established the roles of five Buddhas who became associated with the directions.[30] In China, the Buddha of the West, Amitābha, was to become particularly important. The five Buddhas dwelt in paradises wherein the faithful could hope to reside. Thus the combination of a belief in Bodhisattvas, who would help afflicted mankind, and the aspiration to rebirth, not in this world but in paradise, created new sources of comfort for the devout. New images were also required.

An early Chinese depiction of a paradise of the historical Buddha, Śākyamuni, appears on a stone lintel (fig. 109) now in the Museum. This half-

106 (*above left*) White marble figure of the Buddha Amitābha. Dated 5th year of Kaihuang, AD 585. The inscription on the base of the figure records that it was dedicated at the Chongguang temple in Hancui village in Hebei province. The figure has very solid form and drapery in extremely flat folds, typical of the Sui period. Its hands, now missing, would have been fixed into the sockets of the arms with wooden dowels. HT: 5.78 m.

107 (*above right*) Dry lacquer head of a Bodhisattva. Tang dynasty, 8th–9th century AD. Large Buddhist figures in dry lacquer were probably once common. HT: 51 cm.

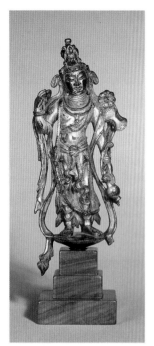

moon of black stone would have been placed over a doorway of a temple or pagoda.[31] Similar examples are found at the Great Goose Pagoda in Xi'an. At the centre of the half-moon sits Śākyamuni, surrounded by Bodhisattvas and disciples. The jewelled trees and musicians in the cartouches below signify the bliss of paradise.

Much more complicated arrays of figures and structures appear in the painted paradises in the Buddhist cave temples at Dunhuang in western Gansu province. These caves are famous for wall paintings as well as painted stucco images. Texts and banner paintings were walled up in a cave in the twelfth century AD, where they were preserved in the dry atmosphere until they were rediscovered early this century.[32] Today documents and paintings from this great treasury are in museums in India, France, Russia and Japan, as well as in Britain and China (ch. 2, p. 110).

The paintings include narrow textile hangings, which would have been suspended by a loop from a pole carried in procession or during religious services. Other paintings, including the depictions of paradises, are much larger and may have been hung in certain caves at particular festivals or services. The central Buddha of the paradise in figure 110 is Bhaiṣajyaguru, the Buddha of Healing. He is seated before an extensive palace and surrounded by six figures making offerings. On either side are tall buildings, while a large compound lies at the rear. A tall pagoda (much damaged) rises above a coloured parasol, which hangs over the central figure. These complex scenes of buildings were modelled on the palace buildings of the day and give us important information about wooden structures that have long since perished. They also indicate that concepts of paradise were interpreted through images of court life.

It was not only paradises that were depicted in a thoroughly Chinese style. The story of the layman Vimalakīrti disputing theological texts with the

108 (*above*) Gilt bronze figure of the Bodhisattva Padmapāṇi. Tang dynasty, 8th century AD.
HT: 18.5 cm.

109 (*right*) Stone door lintel engraved with a paradise scene. Sui or early Tang dynasty, 6th–7th century AD. The Buddha is seated under a large canopy flanked by Bodhisattvas and luohan.

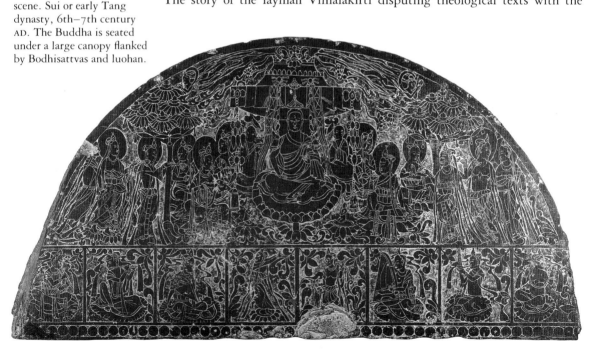

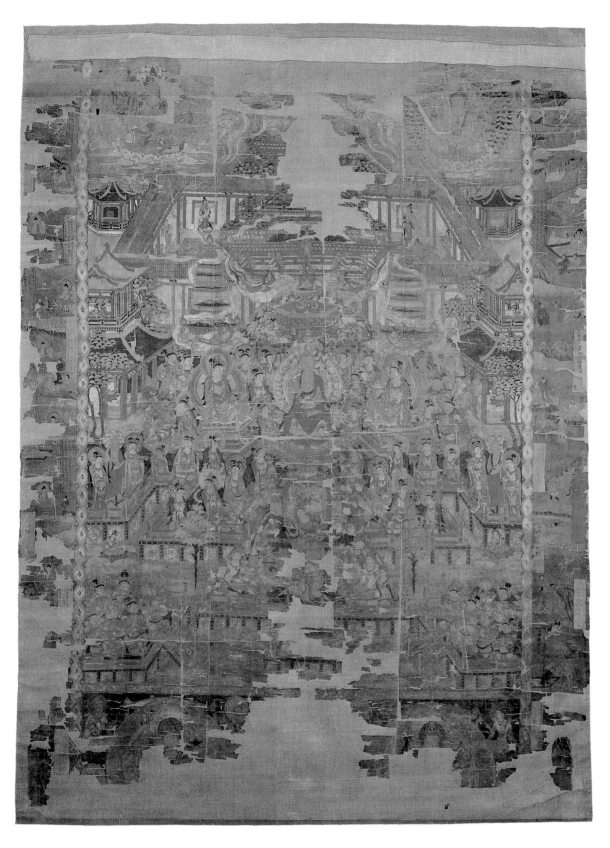

157

110 (*previous page*) Bhaiṣajyaguru's paradise. Painting on silk from cave 17, Dunhuang, in Gansu province. Tang dynasty, 9th century AD. Bhaiṣajyaguru, the Buddha of Healing, occupied the eastern paradise, in opposition to Amitābha in his western paradise. The Buddha is seated at the centre, surrounded by Bodhisattvas and attendants making offerings. The terraces in front and buildings behind suggest the luxurious Tang court life. At the top (to the left and right) are the Bodhisattva Avalokiteśvara with a thousand hands and Mañjuśrī, the Buddha of the Future Era, with a hundred bowls. 2.06 x 1.67 m.

Bodhisattva Mañjuśrī (ch. 4, fig. 147) appealed especially to Chinese scholar-officials. For the Chinese, Vimalakīrti represented the intellectual, so dominant in early Chinese society and especially in government. The idea that a devout scholar might match the skills and piety of a Bodhisattva was particularly flattering.

The concept of the luohan, or arhat, likewise satisfied the educated Chinese. Arhats were the followers of the Buddha, his major apostles and patriarchs. It was believed that they were able to use their magical powers to remain alive indefinitely and so preserve the Buddha's teachings, even in

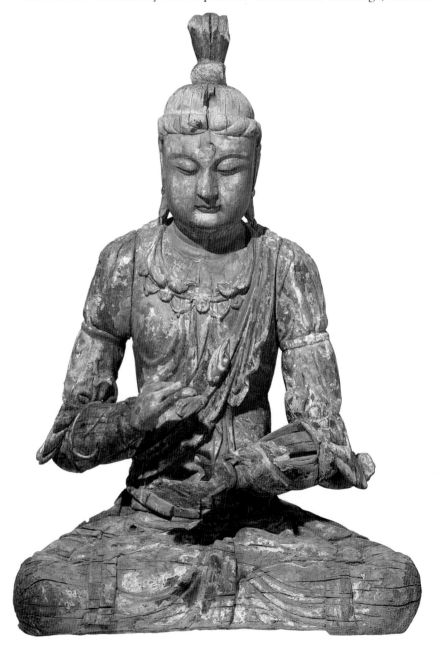

111 Wooden figure of the Bodhisattva Guanyin. Five Dynasties period, 10th century AD. This monumental figure is in Tang style; details of dress, such as the light undergarment, suggest a 10th-century date. HT: 1.41 m.

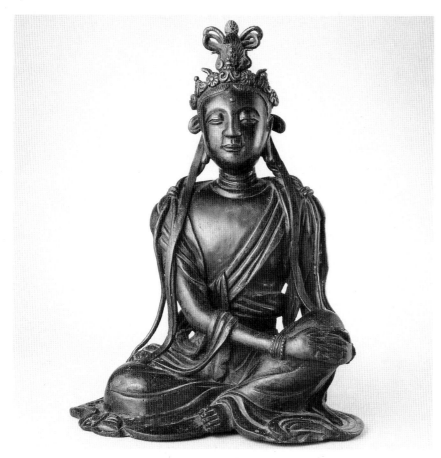

112 Bronze seated figure of the Bodhisattva Guanyin. Yuan dynasty, dated 1339. The inscription on this figure, which gives the date, records its offering by a monk, Zhijing, in his search for enlightenment.
HT: 34 cm.

times of trouble. In China, a tradition of sixteen luohans was known from the fifth century AD, and by the Tang period they were often depicted in groups of eighteen. At this time sets of luohans were made for the side walls of entrance halls in temples. As a tribute to their humanity in the transmission of Buddhist teaching, they were often shown with strongly characterised faces, as if they were particular recognisable individuals. The example illustrated in figure 113 belongs to the Liao dynasty (907–1125) and was found in a cave at Yi xian in Hebei along with seven others, all but one now in museums in the West.[33] A stern but serene face gives the impression of an individual but at the same time suggests a commanding religious belief, embracing all upon whom his gaze falls. As with the pottery warriors (fig. 91), such images were not intended as depictions of individuals; the impression was created of a particular person in order to fulfil a religious purpose, in this case to promote the view that all mankind might aspire to the spiritual understanding represented by the luohan.

Large glazed ceramic figures such as the one in figure 113 extended to Buddhism the tradition of moulding and modelling developed for pottery tomb figures. In the Ming and Qing periods imposing representations of many different Buddhist and Daoist deities were made, and their brilliant glazing resembles that of the tiles and figures decorating temple buildings.

The post-Tang history of Buddhist imagery and figure styles was in part determined by sculpture evolved in the Tang period (AD618–906). From time to time, iconography and artistic styles were modified by greater or

159

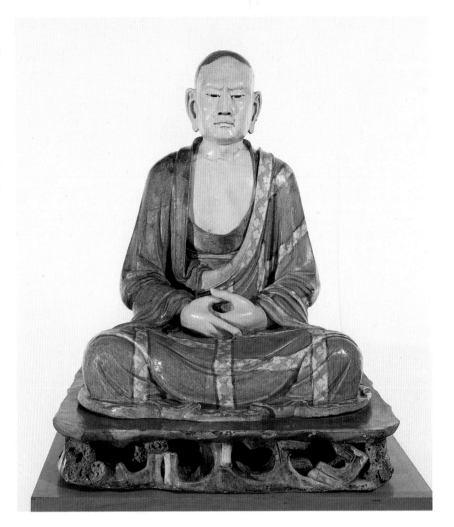

113 Glazed ceramic figure of a luohan, found at Yi xian in Hebei province. Liao dynasty (AD 907–1125). This figure belongs to a set of eight, of which seven survive. All the known examples are remarkable for the character of their faces. They are made in the tradition of Tang dynasty portraiture of monks and priests and represent the aspirations of the educated man to attain spiritual enlightenment. HT: 1.03 m.

lesser contributions from Tibet, Nepal and the Indian subcontinent, where forms of Mahāyāna Buddhism were developed that attracted imperial patronage in China.

The late Tang sculptural style, which formed the basis for much later Chinese sculpture, is seen in a majestic wooden figure of a Bodhisattva (fig. 111). This post-Tang sculpture combines elegant form with a concern for representing the body convincingly, with growing solidity, as seen in figure 102. A thin robe draped over the upper part of the torso is a feature of tenth- and eleventh-century sculpture. The strong shape and bold face give an impression of inward contemplation, and the power of the image lies in its static form. Over the next five centuries relatively solid figures, descended from sculptures such as this, alternated with more sinuous styles borrowed from Tibet.

Much heavier sculpture in the same vein is found at the site of Feilaifeng near Hangzhou, the capital of the Southern Song. Here, under the direction of one Guanzhuba, a monk of Tibetan origin, a new edition of the Tibetan *Tripiṭaka* was printed in the early fourteenth century.[34] Stone carvings at Feilaifeng incorporate elements of Tantric Buddhism (the Buddhism of Tibet), displaying figures with several heads and arms, which are features

ultimately derived from Hinduism. For example, many of the deities carved on the rock face at Feilaifeng carry heavy jewelled crowns and have many arms which hold their various attributes.

The Mongol dynasty, the Yuan (1279–1368), patronised foreigners in the search for orthodox teachings in all aspects of government. Religion, particularly Buddhism, was an aspect of good government. The Mongols are said to have employed sculptors from Nepal, who introduced Nepalese and Tibetan forms of architecture and sculpture. The heavier sculptures of the Song were supplemented by a new and more elegant figure style, as can be seen in a bronze seated Bodhisattva dated to 1339 (fig. 112). The deeply curved body and lightly flowing drapery provide a sense of movement missing from earlier sculptures. Indeed, the contrast is evident in the difference in form and atmosphere of the two Bodhisattvas illustrated in figures 111 and 112.

A similar sense of movement appears in figures made in the early Ming.

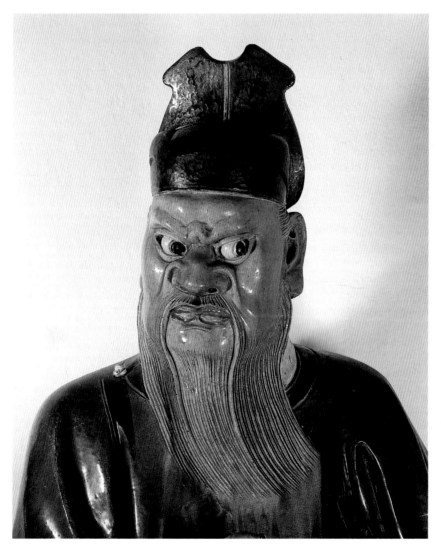

114 Assistant to a Judge of Hell. Detail of a figure in glazed ceramic. Ming dynasty, 16th century AD. Ten judges presided over the Hells of Buddhism, before whom all souls of the dead would have to pass to account for their deeds in the world. The judges were conceived as magistrates seated at desks with all the paraphernalia of court life to enable them to examine the lives of those presented to them. Their assistants would carry the rolls of documents required to support a case. HT (of whole figure): 1.37 m.

Under the Yongle and Xuande emperors in the early fifteenth century, a number of gilt bronzes were cast which are strongly Tibetan in their style and iconography. Later Ming bronzes assimilated these initially alien features into the heavier sculptural styles characteristic of China. In the seventeenth and eighteenth centuries Tibetan Buddhism was once more in vogue at the capital, where it was patronised in particular by the Qing emperors. While conquering and subduing the western regions, the Qianlong emperor (1736–95) paid special attention to their religious forms, temples and images. At his summer resort at Chengde, north of Beijing, he surrounded the palace buildings with replicas of temples from the regions in which he had successfully waged campaigns. Thus there are temples in the style of buildings in Central Asia and, most conspicuous of all, several in Tibetan style, one resembling the Potala at Lhasa.

Among the features of Tibetan Buddhism taken up not only in China but also in Japan was the mandala, a method of depicting the cosmos, usually a circle surrounding a square. Such objects were important aids to meditation. Depictions of the Buddhist universe might be two-dimensional, as in paintings, or they might consist of a three-dimensional building, as in the cloisonné example in chapter 4 (fig. 141). Buildings were often inhabited by figures of the Buddha and other deities. Other depictions consist of figures arrayed in a circle, on platforms made of lotus petals, and sometimes full-size figure sculptures, precisely arranged.

While the concept of the mandala involves some of the most complicated and esoteric of all Buddhist teachings, other Chinese Buddhist sculptural imagery arises out of more popular, even folk, beliefs. Indeed, the attributes of many Buddhist deities were gradually altered by popular religion. From the Song period, the giving and saving aspects of the Bodhisattva Guanyin became the attributes of a female deity who could assist those in pain and difficulty. Some conventions for representing Guanyin appear remarkably similar to those of Christians for depicting the Virgin Mary (ch. 6, fig. 208).[35] In this way a Buddhist deity was drawn out of the mainstream of Buddhist thought and into the folk tradition.

Minor deities in the Buddhist pantheon also entered the folk tradition. Thus the Judges of Hell and their assistants, before whom the dead would have to parade so that their virtues and vices could be assessed, became regular figures in secular folk literature (fig. 114). They appear in paintings of the eighth and ninth centuries from Dunhuang and also, much later, in bold and vigorous Ming ceramic images. Despite their sometimes slightly humorous appearance, these figures combine features of Chinese magistrates with the duties required of the Buddhist world. The dead had to account to them for their deeds in the same way as the living did to their secular counterparts. In the novel loosely based upon the pilgrimage of the monk Xuan Zang to India, assembled under the title *The Journey to the West*, several encounters with the bureaucracy of the underworld are described. One underworld official tells how he made the transition from the position of magistrate in life to a similar one after death:

When your humble servant was alive I used to serve His Late Majesty. I was magistrate of Cizhou and later made Vice-president of the Ministry of Rites. My name is Cui Jue. I have now been given office in the underworld as judge in charge of cases at Fengdu.

Wu Cheng'en, *The Journey to the West*,
trans. W. J. F. Jenner, Beijing, 1990, p. 198

Popular religious images

The Buddhist figures just described were only one aspect of the very diverse popular religions that grew up from the eleventh century. By definition, a popular religion is of the people rather than of the priest, and as such is never as fully recorded in texts and religious accounts as are the official forms. Local gods had always existed: their help was sought to bring rain, assist in childbirth and restore the sick. In many cases, these figures were originally living individuals to whom miracles were attributed and who were

115 Soapstone figure of the god Guandi, the apotheosis of Guan Yu, one of the heroes of the Three Kingdoms period (AD 221–280). Qing dynasty, 17th–18th century AD. Reference to the oath of everlasting loyalty sworn by the Han pretender Liu Bei, Guan Yu and Zhang Fei is always understood as shorthand for loyalty, trust and sincerity. After his death, especially in later periods, Guandi was associated with loyalty and with defence of the empire. He was also appropriated to the Confucian system.
HT: 25.1 cm.

163

subsequently deified, when they were given small temples and images. Both the temple structures and the images were based on those already employed by Buddhism, Confucianism and Daoism.

One of the best-known figures was Guan Yu (fig. 115). He had been a general under the third-century leader Cao Cao, who came to power during the upheavals which followed the fall of the Han. Deified very early, Guan Yu was associated with war and loyalty, and he came to personify the direction of the North. His temples were found in all major cities, and offerings to him were part of the official system of rites.

Daoist images were often based upon Buddhist counterparts and are not always easy to distinguish from Buddhist images; indeed, many aspects of Daoist ritual were borrowed from Buddhism. One of the major figures was the semi-mystical philosopher Laozi, who came to be worshipped as a god. Later Daoist leaders of the Six Dynasties period were also revered and prayed to, and many other gods were drawn into the Daoist pantheon, such as the gods of the five directions.

Astronomy, astrology and star lore played a major part in Daoist belief; star worship had been established in state ceremonial since Han times. During the Six Dynasties and the Tang, Daoism's largely educated and prosperous adherents were responsible for introducing a compelling mixture of religious aspiration and fantasy, summoning the stars into literature, both poetry and prose. Powerful cults grew up around certain stellar entities such as Xuanwu, the Dark Warrior and Lord of the North. Xuanwu was one of several star gods connected with the Dipper constellation, and Wen Chang was another. Other figures prominent during the Ming and Qing were the Longevity god, Shou Xing, the Emoluments god, Lu Xing, and the Happiness god, Fu Xing.

Another class of god was the *xian*, or immortal. Immortality was one of the primary aims of some Daoists. Elixirs were used to purify the body and preserve corpses. In the Southern Song, however, Confucianism returned in force, and some of the cults of immortality faded, although Yuan and early Ming drama drew together and created a group of figures called the Eight Immortals. These included all types – old, young, rich, poor, beautiful and ugly – and generally signified long life. The Eight Immortals were also used as auspicious and decorative elements in ceramics, conveying messages of long life, prosperity and hopes for the birth of children.

Rather surprisingly, images of such deities did not become widespread until the middle of the Ming period; their belated popularity may have been the product of a growing interest in alchemy and longevity associated with the court of the Jiajing emperor (1522–66). In addition, image making may have been stimulated by drama and the printing of stories, in which immortals and gods performed miraculous feats, and by books of hagiography. As with the Buddhist figures already described, images of deities were made in several different materials, including ceramic, bronze, iron and precious ones such as coral and ivory; many of the images in the Museum were produced on a small scale. A bronze group of Shou Xing surrounded by the Eight Immortals is a dramatic representation of this deity and his attendants in a mountainous landscape, symbolising the mountains of immortality (fig. 116).

All of the works described here were made for the tomb or temple. Sculpture meant for public display in an urban setting had no role in ancient China's system of beliefs or practices. Only in the twentieth century have large concrete statues of Chairman Mao been placed in front of public buildings, following Western models. Carved figures of the youth of the future now stand in the centre of Beijing, in Tiananmen Square. These sculptures appear at first sight to expand the category of civic sculpture inspired by Western practice (fig. 117). However, situated behind the figures is Chairman Mao's mausoleum; the sculpture in front is not therefore civic sculpture, but part of a tomb complex, thereby perpetuating an ancient Chinese tradition. Figures of civil and military officials are here replaced by youths carrying guns, giving solid form to the world Chairman Mao hoped would replace the existing one. Despite this new vision, which was intended to leave old China behind, the planners of the mausoleum were still bound by traditional practices, and surrounded the tomb with sculptures that contributed to a picture of the world.[36] Sculpture today, as in China's past, is functional, animating the stage on which great rituals are performed.

116 Bronze group of figures on a mountain, showing Shou Xing, the god of Longevity, surrounded by the Eight Immortals. Qing dynasty, 17th century AD. Shou Xing is usually shown, as here, with a tall cranium; he is often associated with the Three Stars, signifying longevity, rank and happiness. HT: 45 cm.

117 The sculptures on Tiananmen Square, Beijing, adjacent to the Mausoleum of Chairman Mao. The mausoleum stands on the axis of the Forbidden City and is integrated into the ceremonial structures of central Beijing. At the same time it has many features in common with ancient Chinese tombs, including the sculptures placed near it, which animate a vision of the eternal world.

Notes

1. For reports and discussion on the Guanghan finds see *Wenwu* 1987.10, pp. 1–15; 1989.5, pp. 1–20; R. W. Bagley, 'Sacrificial Pits of the Shang Period at Sanxingdui in Guanghan County, Sichuan Province', *Ars Asiatiques*, vol. 43, 1988, pp. 78–86; 'A Shang City in Sichuan Province', *Orientations*, November 1990, pp. 52–67.

2. C. Mackenzie, 'The Chu Tradition of Wood Carving', in R. E. Scott and G. Hutt (eds), *Style in the East Asian Tradition: Colloquies on Art and Archaeology in Asia, no. 14*, London, 1987, pp. 82–102.

3. Li Xueqin, *Zhongguo meishu quanji, gongyi meishu bian 4, qingtongqi*, vol. 2,

Beijing, 1986, pls 103, 131, 137, 203, 204.

4. *Zhongshan: Tombes des Rois Oubliés, Exposition archéologique chinoise du Royaume de Zhongshan*, Paris, 1984.

5. For examples see *Wenwu* 1984.9, pp. 14–19; 1984.10, pp. 1–17, 18–27; 1989.9, pp. 59–86.

6. *Kaogu xuebao* 1984.4, pp. 503–30, fig. 10.

7. *Jiangling Yutaishan Chu mu*, Beijing, 1984, pls LXIX–LXXI; *Wenwu* 1989.3, pp. 35–50, 62; *Xinyang Chu mu*, Beijing, 1986, pls CVI–CVIII.

8. For discussion of the pottery warriors and other Qin achievements see L. Led-

derose and A. Schlombs, *Jenseits der Grossen Mauer, Der Erste Kaiser von China und Seine Terrakotta Armee*, Munich, 1990; Wen Fong (ed.), *The Great Bronze Age of China*, New York, 1980, pp. 352–73; A. Cotterell, *The First Emperor of China*, London, 1981.

9. The extraordinary achievement of this method of mass-production is described by L. Ledderose in 'Modul und Serie in der Chinesischen Kunst', *Jahrbuch der Heidelberger Akademie der Wissenschaften für 1989*, Heidelberg, 1990, pp. 53–5; and in the Slade lectures at the University of Cambridge for 1992, *Module and Mass-production in Chinese Art*. Discussion by the chief archaeologist working on the warriors is found in *Qin Shi Huang ling bingmayong keng, yihao keng fajue baogao 1974–1984*, 2 vols, Beijing, 1988; Yuan Zhongyi, *Qin Shi Huang ling bingmayong yanjiu*, Beijing, 1990.

10. *Wenwu* 1977.10, pp. 10–21; Los Angeles County Museum of Art, *The Quest for Eternity: Chinese Ceramic Sculptures from the People's Republic of China*, Los Angeles and London, 1987, pp. 63–93; Wang Kai, 'Han Terra-cotta Army in Xuzhou', *Orientations*, October 1990, pp. 62–6.

11. *Mancheng Han mu fajue baogao*, Beijing, 1980.

12. Akiyama Terukazu et al., *Arts of China, Neolithic Cultures to the T'ang Dynasty, Recent Discoveries*, Tokyo and Palo Alto, 1968, pp. 172–6.

13. L. Ledderose and A. Schlombs, 1990, op. cit., pp. 168–72.

14. For a southern house in bronze see *Kaogu* 1972.5, pp. 20–30, pl. 4.

15. For the tombs at Deng xian see *Wenwu* 1960.8–9, pp. 37–42; for Sima Jinlong's tomb see *Wenwu* 1972.3, pp. 20–33.

16. For some later tomb figures see Los Angeles County Museum of Art, 1987, op. cit., pp. 144–54.

17. For discussion of and references to Jin dynasty tombs see E. J. Laing, 'Chin "Tartar" Dynasty (1115–1234) Material Culture', *Artibus Asiae*, vol. XLIX, 1/2, 1988–9, pp. 73–126. For Mongol tombs see N. Shatzman Steinhardt, 'Yuan Period Tombs and Their Decoration: Cases at Chifeng', *Oriental Art*, vol. XXXVI.4, Winter 1990/91, pp. 198–221.

18. See discussion in Wu Hung, 'From Temple to Tomb, Ancient Chinese Art and Religion in Transition', *Early China*, vol. 13, Berkeley, 1988, pp. 78–115.

19. I owe this idea to Ann Paludan and am much indebted to her for her comments and her works: A. Paludan, *The Chinese Spirit Road: The Classical Tradition of Stone Tomb Statuary*, New Haven and London, 1991, pp. 8–9.

20. Ibid., pp. 15–27.

21. Ibid., pp. 52–83.

22. Ibid., pp. 73–83, figs 89–91.

23. Ibid., pp. 84–120.

24. Ibid., pp. 121–55.

25. Ibid., pp. 156–225; A. Paludan, *The Imperial Ming Tombs*, New Haven and London, 1981.

26. K. K. S. Ch'en, *Buddhism in China: A Historical Survey*, Princeton, 1964.

27. A. Waley, *The Real Tripitaka*, London, 1952.

28. W. Zwalf (ed.), *Buddhism: Art and Faith*, London, 1985.

29. Wu Hung, 'Buddhist Elements in Early Chinese Art', *Artibus Asiae*, vol. 47, 1986, pp. 263–376.

30. W. Zwalf, op. cit., pp. 9–20.

31. Nishikawa Yasushi, *Seian Hirin*, Tokyo, 1966, nos 61–6.

32. R. Whitfield, *The Art of Central Asia: The Stein Collection in the British Museum*, 3 vols, Tokyo and London, 1982–5; R. Whitfield and A. Farrer, *The Caves of the Thousand Buddhas*, London, 1990.

33. R. Smithies, 'The Search for the Lohans of I-Chou (Yixian)', *Oriental Art*, vol. XXX, 1984, pp. 260–74.

34. H. Karmay, *Early Sino-Tibetan Art*, Warminster, 1975.

35. *Chinese Ivories from the Shang to the Qing, an exhibition organized by the Oriental Ceramic Society jointly with the British Museum*, London, 1984, pp. 35–52.

36. L. Ledderose, 'Die Gedenkhalle für Mao Zedong. Ein Beispiel von Gedächtnisarchitektur', in J. Assmann and T. Hölscher (eds), *Kultur und Gedächtnis*, 1988, pp. 311–39.

4

Decorative arts for display

'O soul, come back! Return to your old abode.
All the quarters of the world are full of harm and evil.
Hear while I describe for you your quiet and reposeful home . . .
Beyond the hall, in the apartments, the ceilings and floors
are vermilion,
The chambers of polished stone, with kingfisher curtains hanging
from jasper hooks;
Bedspreads of kingfisher seeded with pearls, dazzling in brightness:
Arras of fine silk covers the walls; damask canopies stretch overhead,
Braids and ribbons, brocades and satins, fastened with rings
of precious stone.
Many a rich and curious thing is to be seen in the
*furnishings of the chamber.'**

The Western perception of China is synonymous with porcelain, but this was not by any means the most highly valued luxury material. Silk, jade and lacquer were used from at least the late Neolithic period, and bronze was employed before 1500 BC. All these materials required a considerable outlay in terms of manpower; the items made from them were all probably viewed as precious, and they were used in religious and political display as well as in burials. A long history added to the value placed on them later in China, when ancient bronze and jade shapes were consciously revived and then imitated in other materials such as porcelain (ch. 1, pp. 74–80). Many other materials were also employed: bone, ivory, horn, stone, gold and silver, enamels and glass.

In addition to covering a wide range of different materials, the Chinese decorative arts are remarkable for their consistently high quality and for the sheer number of objects that were made. They were produced by highly organised manufacturing processes involving the subdivision of labour (Introduction, pp. 30–31). As early as the Han dynasty (206 BC–AD 220), large workshops were making lacquer, silk, ivory and jade of astonishing quality. The Chinese ability to organise people in this way eventually resulted in the huge porcelain workshops at Jingdezhen in the eighteenth century (ch. 5).

*from 'Summons of the Soul' by Qu Yuan, in D. Hawkes (trans.), *The Songs of the South*, Harmondsworth, 1985, p. 226

The efficient organisation of manpower was only one part of the overall organisation of society in China, where a deep desire for order and harmony found expression in many aspects of life. Society was divided into hierarchies, with rank or position clearly marked. It was a traditional Confucian idea that if each person knew his or her place and acted appropriately, then peace and prosperity would prevail.

Objects were used in many contexts to emphasise status. Materials, like their owners, had their places in a hierarchy, with jade, bronze and silk at the top. Jade and bronze were first used for ceremonial weapons and vessels and later offered to the gods at grand state sacrifices (ch. 1). In dress, the materials used for belts and hats were explicitly recognised as displaying rank, and the materials used for interior furnishings performed the same function in houses. Size and number, as well as material, were also ways of signalling status.

As a hierarchy of values was implicit in the use of materials, expensive, high-status objects were often copied in lesser, cheaper ones. Silver items, for example, were often copied in porcelain or lacquer. As a result, vessel shapes and ornamental motifs were transferred from one material to another. In some cases the shapes or motifs transferred were native Chinese ones, such as the monster face (*taotie*) on bronzes (ch. 1), but in other cases, Chinese craftsmen incorporated and sinicised foreign motifs such as the Buddhist lotus and lion, introduced from India and Central Asia. Imported materials were often associated with new techniques and decorative motifs. For instance, the Tang dynasty (AD 618–906) élite used gold and silver items whose shapes and decorative motifs derived from Central Asia, Iran, and even from the Hellenistic world (ch. 6, fig. 197).

As with the bronzes and jades already described, large numbers of objects have been preserved in all materials from very ancient times. Some have come from the many magnificent tombs that have been excavated; other precious items, especially paintings, textiles and glass, have been discovered in the crypts of Buddhist pagodas such as that of the Famensi at Fufeng, Shaanxi province, sealed in the late ninth century.[1] Many early pieces now in the British Museum come from the discoveries made by Aurel Stein early this century, at sites along the Silk Route and at the Buddhist caves at Dunhuang in Gansu province; here Stein discovered a walled-up library of texts, painted images and textiles. Also important to the present discussion is the imperial repository of the Shōsō-in at the Tōdai-ji temple in Nara, Japan. This scrupulously recorded treasury of luxury goods in many materials belonged to the Japanese Emperor Shōmu. After the principal donation by the empress in AD 756, few other pieces were added. The treasury therefore represents a unique source of information, both about Chinese objects exported to Japan before this date and about those objects considered precious by the Japanese. Later decorative arts were collected by Chinese emperors in the Forbidden City, and these can now be seen either in Beijing or Taipei, in the respective palace museums. Much of the imperial collection was amassed by the Emperor Qianlong (1736–95), who built on the collections of earlier emperors. A large part of this collection was removed to Taiwan in 1949, but the British Museum's collection contains a few items purchased and collected in the early twentieth century, when control

of the imperial collection was relaxed and some of its pieces appeared on the market.

Chinese materials and techniques

Silk

China is justly famous for its silk production, which probably began more than six thousand years ago. Excavations of Neolithic sites have revealed clay artefacts with impressions made apparently by silk cloth, as well as stone ornaments carved in the shape of silkworms.[2] The earliest find of silk itself, dated to around 2800 BC, is from Wuxing xian in Zhejiang province, where a fragment of cloth was preserved in damp conditions inside a bamboo box.[3] Zhejiang province, in southeast China, has always been an important silk-producing area and was probably also the centre of one of the major prehistoric cultures.

Later writers attributed a well-organised system of production to the Western Zhou dynasty (1050–771 BC). A text compiled or revised in the Han period describes a silk supervisor, a hemp supervisor, dyers and weavers working in the women's section of the palace. Although one silk workworm, making its cocoon, spins a pair of filaments which may be up to one kilometre in length, because of the fineness of these filaments thousands of silkworms are required to produce enough silk to weave a length of cloth. From an early date in China it was found best to carry out the manufacture of silk cloth on a large scale, with division of labour according to the various tasks: picking the mulberry leaves, reeling the filaments from the cocoons, weaving, etc. In the eighteenth and nineteenth centuries this highly organised and subdivided industry fascinated Westerners, who collected sets of illustrations of the different stages similar to those illustrating ceramic processes (ch. 5, fig. 156). Silk production has traditionally been associated with women in China, and in imperial days the empress would perform an annual mulberry leaf-picking ceremony outside the Hall of Sericulture in Beijing.

By the Han dynasty (206 BC–AD 220) the silk industry was already highly specialised, producing, in addition to plain cloth, self-patterned monochrome 'damasks', figured gauzes and thicker multicoloured cloth in warp-faced compound tabby weave. The latter was highly valued, costing up to fifteen times as much as plain silk. Chain-stitch embroidery also became widespread at this time and was used to decorate clothes, wall hangings, pillows and horse trappings. Elaborate examples have been found in Han dynasty tombs in Hubei and Hunan provinces, where waterlogged land has preserved much organic material.[4]

Although produced in large quantities, silk remained an expensive luxury. Both woven and raw silk were used as tribute to the emperor and as offerings to foreign tribes, such as the Xiongnu on the northwestern borders of China. From here Chinese silk must have been traded along the Silk Route as far as Europe. Most early examples of silk cloth in the West appear to have been woven locally, but from cultivated silk fibre of the *Bombyx mori* worm. The fact that China was the origin of this fibre or yarn was acknowledged by the ancient Greeks and Romans, who referred to silk as *serica*, literally

'Chinese'. By the end of the Han period, silk cultivation and knowledge of silk processing must have begun to spread westwards, and by the fifth or sixth century had reached the Mediterranean area. But Western silk production throughout the Middle Ages was never sufficient to satisfy European and Near Eastern demand, and imported Chinese silk remained very important.

All types of textile art flourished during the Tang dynasty (AD 618–906) in China. An important group of Tang textiles has recently been found in excavations at the Famensi at Fufeng, in Shaanxi province; gifts to this monastery evidently included clothing as well as glass, silver and ceramics.[5] Embroidery also continued to be developed and was used for large images of the Buddha built up in satin and chain stitch. A large Buddhist group in the Museum is particularly fine (fig. 118). Most of the textiles found by Aurel Stein at Dunhuang in Gansu province, including banners, altar hangings and monks' apparel, follow the Buddhist convention of being made up of small cut pieces of different cloth.[6] These 'patchwork' items provide an invaluable cross-section of the different types of silk cloth and embroidery available at the time (fig. 119).

Trade along the Silk Route was at its most vigorous during the Tang dynasty, and travellers record the bazaars of the Middle East as being full of Chinese patterned cloth and embroideries. Simultaneously we are told that the Tang capital at Chang'an (present-day Xi'an) was populated by large numbers of Iranian craftsmen. A silk weave now known as weft-faced compound twill appears among Chinese textiles for a few centuries from about AD 700. This may well have been a technique introduced by foreign weavers, as it seems to have been developed originally in Iran. In the West it was particularly associated with repeating designs of roundels enclosing paired or single animals, with flower heads or rosettes between the roundels (fig. 120). The paired animals, rosettes and the ring of pearl-like dots which often made up the roundel frame all passed into Chinese design.

Indeed, trade in textiles or other items may have carried the motif of the pearl roundel to China before any transfer of technology, since it first appears in China as early as the fifth century AD, on stone carvings at the Buddhist cave temples at Yungang.[7]

Another Western weft-faced weave that made its first appearance in China in the Tang dynasty was tapestry, known in Chinese as *kesi*. Tapestry is very adaptable and, like embroidery, can be used for large-scale designs without repeats. In China it was particularly associated with the use of gold thread, principally in the form of gilded paper: either cut strips woven in flat, or strips wound around a silk core. *Kesi* was to become the most highly prized of all Chinese silk textiles, and later in China it was developed into a major art form used for large pictures, chair covers and temple hangings as well as for album leaves and scroll mounts. One of the most elaborate examples of *kesi* in the Museum is a panel of peony flowers that was used as a wrapping for the painting *The Admonitions of the Court Instructress* by Gu Kaizhi (fig. 121).

Finds from the Silk Route site of Astāna, also of the Tang period, attest to the use of cheaper non-woven patterning techniques: tie-dyed resist and block-printed wax resist. Silks with larger multicoloured printed designs preserved in the treasury of the Shōsō-in at the Tōdai-ji temple in Nara, Japan, and at Dunhuang confirm the development of the clamp resist method.

118 (*overleaf*) Śākyamuni, the Buddha, preaching on the Vulture Peak. Silk embroidery on hemp cloth from cave 17, Dunhuang. Tang dynasty, 8th century AD. This magnificent embroidery is one of the largest Chinese examples known. It was among the group of paintings and documents discovered by Aurel Stein in 1907 at Dunhuang, on the Silk Route. Heavy damage to two of the attendant figures has been caused by folding. HT: 2.41 m, W: 1.59 m.

119 (*overleaf above right*) Detail of an embroidered panel with flowers and ducks from cave 17, Dunhuang. Tang dynasty, 9th–10th century AD. The scroll of leaves and flowers is of embroidered silk thread on a ground of cream figured silk twill, while the ducks are formed of couched gold-covered thread. The scroll design with flowers and birds occurs in ceramics and other decorative arts from the Tang dynasty onwards. HT: 23.4 cm, W: 91.7 cm.

120 (*overleaf below right*) Two banner headings of printed silk from cave 17, Dunhuang. Tang dynasty, 8th–9th century AD. The outer border of this design is a sinicised version of the pearl roundel motif found on Sasanian metalwork and stucco while the naturalistic pairs of birds occur on Tang silver and gold. These pieces of silk would have been folded diagonally and used as the tops of long Buddhist banners. (*left*) HT: 23.8 cm, W: 23.8 cm; (*right*) HT: 26.3 cm, W: 26 cm.

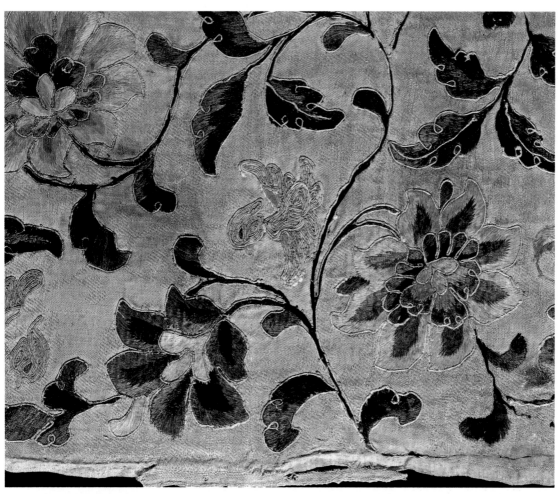

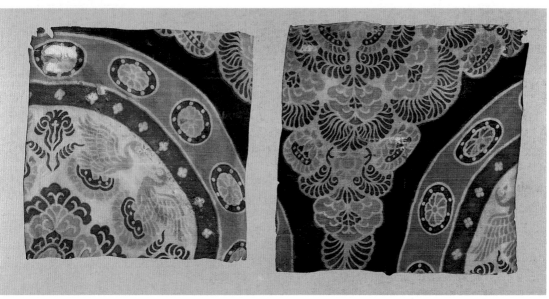

121 Detail of a silk tapestry (*kesi*) panel decorated with peonies, from the scroll mounting for the handscroll painting *The Admonitions of the Court Instructress* (see ch. 2, fig. 65), attributed to Gu Kaizhi (*c*.344–*c*.406). Song dynasty, 11th–12th century AD. The *kesi* technique was used later in China for large pictures and temple hangings.

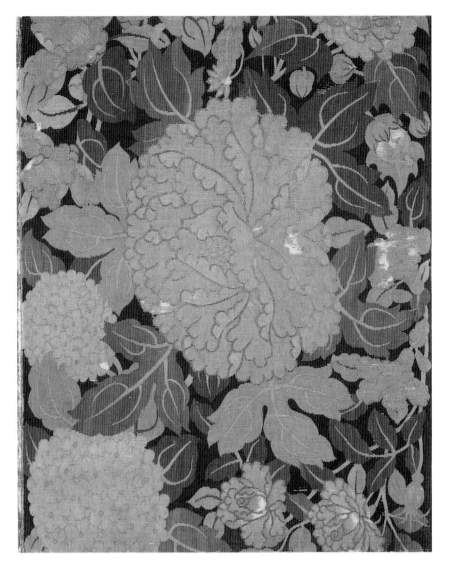

Lacquer

Lacquer is a uniquely Far Eastern product, being the sap from a tree indigenous to China and Japan called *rhus verniciflua*. It was used as early as the Neolithic period in China, and was particularly useful as an impermeable coating for objects made of delicate materials such as bamboo, wood and silk. It was valued not only for its resistance to water but also for withstanding heat and insects, and for providing a surface that could be brilliantly coloured.

The high value placed on lacquer is apparent from a reference in the *Discourses on Salt and Iron*, dated *c*.80 BC in the Han dynasty, which says that a lacquer piece cost ten times as much as a bronze.[8] The same text offers one reason for the high cost of lacquer when it states that one hundred workmen would be needed to make one lacquered cup. This does not mean that a hundred workmen were dedicated to making a single cup, but rather

that large groups of workers were so organised as each to contribute to a stage in the production of a large number of cups. An eared wine cup of the Han dynasty (Introduction, fig. 10) in the Museum has a very revealing inscription in minute characters around its edge, listing the names and trades of all the people involved in its manufacture (Introduction, p. 30).

The organisation of a large workforce to provide great numbers of beautiful objects of first-class quality, a constant in the history of Chinese decorative arts, made sense in economic terms, as each craftsman could perform one stage of the process on a large number of pieces. For example, bases had to be made in wood or cloth, to which lacquer was then applied in several thin coats, each coat taking weeks to dry and harden thoroughly. The temperature and humidity were also critical, the humidity preventing the lacquer from drying out and cracking. Indeed, lacquer has to be kept damp if it is to harden at all. The hard lacquer surface was then painted with different colours to give it patterns.

During the Warring States period (475–221 BC) and the Han dynasty lacquer was predominantly used to provide painted surfaces for coffins, cosmetic boxes, musical instruments and food vessels. The vessels were often made in shapes associated with bronze, for at this time lacquer supplemented and then supplanted bronze in popularity. Cheaper ceramic versions of painted lacquer vessels were also placed in some tombs. At first, geometric painted patterns were employed, but during the Han a more flowing linear style developed in accordance with the natural tendencies of brush painting. These flowing lines were read as cloud patterns and as landscapes, among which were scattered detailed animals and figures. Such scenes were linked to the Han dynasty preoccupation with immortality and belief in paradises, in which dwelt gods and immortals. Goblins and fairies, fantastic animals and birds are all depicted floating about in cloud- and wave-filled Daoist heavens. In addition, lacquer as a material was thought to have magical qualities as an elixir of immortality, which may have contributed to its popularity at this time (fig. 123).[9]

During the Tang dynasty (AD 618–906), lacquer was inlaid with gold, silver and mother-of-pearl. Such rich surfaces appear on the reverse of bronze and silver mirrors (fig. 122) and on musical instruments, for example. Lacquer was also used to make Buddhist sculptures, using the 'dry lacquer' technique (ch. 3, fig. 107). A ceramic model was covered in cloth to which layers of lacquer were applied; when the lacquer was hard, the ceramic core was removed. This technique was transferred to Japan, where it became very popular. Lacquer was also used in the Tang to cover armour made of small overlapping rectangular pieces of leather. Some eighth- to ninth-century examples made of camel hide, covered in alternate layers of red and black lacquer, were brought back from Fort Mirān on the Silk Route by Aurel Stein in 1906 and are now in the Museum. They are the earliest known examples of Chinese carved lacquer, decorated with carved circles, commas and S-shapes cut through several layers of different colours (fig. 125). These lacquer coatings are much thinner than those employed from the Southern Song onwards, when decorative carved lacquer flourished. In the carved technique, patterns are cut through several layers of lacquer to reveal some of the lower layers alongside the top one.

122 Bronze mirror inlaid with mother-of-pearl decoration of two phoenixes. Tang dynasty, 8th–9th century AD. The shell used is in much larger and thicker slices than those used for inlaying lacquer later in China. In mirrors such as these lacquer is used as a bed for the shell inlay, and descriptive details are incised in the shell. Similar mirrors have been excavated in China and some are preserved in the Shōsō-in, in Nara, Japan. DIAM: 29.3 cm.

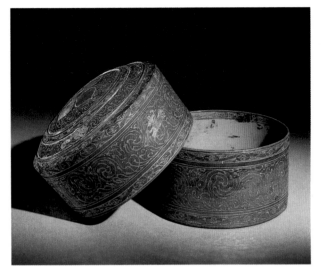

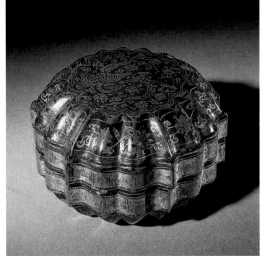

123 (*above left*) Toilet box of lacquered wood, painted with cloud scrolls and inlaid with silver. Han dynasty, 2nd–3rd century AD. Fantastic heavenly creatures can be seen hidden amongst the flowing lines of the painted scrolls. A box similar to this one can be seen in use by court ladies in fig. 148.

124 (*above right*) Foliate box and cover of lacquered wood decorated in the *qiangjin* technique with a design of phoenixes and flowers. Ming dynasty, 14th–15th century AD. The shape and decoration of this box show the influence of Tang and Song dynasty silver.
DIAM: 12.5 cm, H: 8 cm.

125 (*centre*) Four pieces of leather armour covered with black and red lacquer and carved. From Mirān, on the Silk Route. Tang dynasty, 8th–9th century AD. These are the earliest known examples of carved *guri* lacquer. However, only seven layers of lacquer have been used, whereas Chinese lacquer usually consists of hundreds of layers.
9.6 x 28.2 cm.

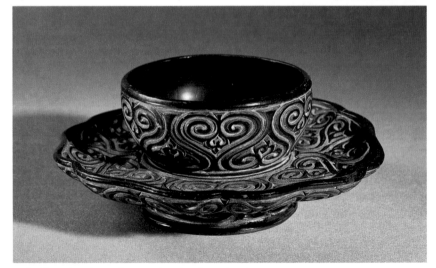

126 (*above*) Bowl stand covered in black, red and yellow lacquer and carved with *guri* scrolls. Southern Song dynasty, 13th century AD. This bowl stand would have been used to hold a porcelain teabowl. Examples can be seen in use in figs 153–4. HT: 6 cm, DIAM: 16 cm.

127 Rectangular panel of red lacquer carved on a yellow ground. Ming dynasty, early 15th century. In the centre is an ogival panel enclosing two five-clawed dragons with a flaming pearl and peony scrolls. In the corners are phoenixes amongst the flowers of the four seasons. One claw on each foot of the dragons has been removed, possibly to disguise imperial provenance. This panel was originally the side of a small cabinet containing drawers. 44.2 x 36.1 cm.

128 Carved polychrome lacquer dish. Ming dynasty, dated 1489. The dish is decorated with a scene of a famous 4th-century drinking and poetry party at the Lanting (Orchid Pavilion) in Zhejiang province. The sky is full of clouds and cranes, birds symbolic of immortality. The party arriving in the foreground is accompanied by deer, also associated with immortality, and the Islands of the Immortals rise out of waves around the border of the dish. The bracketing and tiling of the buildings are executed with great intricacy, and the carver has signed his name and the date of carving around the door of the pavilion. DIAM: 19 cm.

In the early stages the shapes and decoration of lacquer pieces were borrowed from vessels and containers made of precious metals – first bronze, as in the Han dynasty, and then gold and silver from the Tang and Song. Completely plain, undecorated lacquer dishes and bowls were produced in the Song (960–1279), often in flower shapes similar to those made in gold and silver as well as in white and green porcelain. A group of seventy-two such dishes and bowls was excavated from five tombs in Yangmiaozhen, Jiangsu province, dating to the late eleventh century.[10] The technique of engraving fine linear designs on lacquer and then filling them in with gold (*qiangjin*) began in the Song dynasty, following the model of the chased silver vessels of the Tang and Song (fig. 124). Lacquering in gold and painting in gold on lacquer were also techniques which may have started in the Song dynasty. A hoard of lacquer sutra boxes buried underneath a pagoda in southeast China included both gold-lacquered boxes and gold-painted lacquer boxes as well as a sandalwood casket, dated AD 1042, painted in gold and decorated in applied moulded lacquer.[11] Another Song fashion was for lacquer vessels with gold or silver liners.

Plain, undecorated lacquer vessels were current in the Yuan dynasty (1279–1368). Red and black undecorated lacquer bowls and dishes were found in a shipwreck off the coast of southwest Korea at Sinan dating to *c.*1323, along with a carved lacquer vase, decorated with peonies.[12]

Carved lacquer was, however, first decorated with the so-called *guri* pattern (a Japanese word used to describe a heart-shaped, geometric scroll pattern; *tixi* in Chinese). These scrolls were cut with a deep V-shaped profile through alternate layers of different-coloured lacquer (black, red and yellow), and dishes, boxes, trays and bowl and cup stands were all produced (fig. 126). This technique seems to have developed by the time of the Song dynasty, as items of *guri* carved lacquer, such as a mirror box, fan handles and boxes, have been excavated from Song tombs. The undulating surface created by the design and the deep cutting seem to imitate silver designs of the period. The interchange of motifs and designs between metalwork, lacquer, silk and ceramics continued over many centuries; for example, black stonewares from Jizhou in Jiangxi province were painted with the same *guri* scrolls as are found on lacquer vessels.

Although it was certainly known much earlier, pictorial carved lacquer was perfected in the early Ming dynasty (1368–1644), with designs such as peonies, flowers of the seasons, landscapes, birds and dragons being produced with great skill and craftsmanship (fig. 127). These beautiful, perfectly executed and probably extremely expensive pieces were often made to imperial order, and some were exported to Japan as diplomatic gifts in the early fifteenth century. Lacquer objects had been exported to Japan since the Tang dynasty, when they were deposited in the treasury of the Shōsō-in at the Tōdai-ji temple in Nara. Another group was taken to Japan by the founder of the Engaku-ji temple in Kamakura in 1279.[13] One of the earliest known examples of polychrome carved lacquer with a pictorial scene is a small dish now in the Museum, carved with the date 1489 and the name of the carver (fig. 128); red, green, yellow and black lacquer are used. Polychrome carved lacquer gained in popularity, reaching a highpoint in the late Ming dynasty (sixteenth to seventeenth century).

The late Ming period also saw the popularity of lacquer inlaid with mother-of-pearl, a technique which had begun as early as the Shang dynasty. During the Tang, thick slices of shell were used for inlay, and the technique was yet further refined by the Southern Song. During the Yuan and Ming, hundreds of tiny pieces of thin shell were put together to create complex pictures, including perspective scenes of buildings, and flower compositions, some of which imitated the brushstrokes of Chinese ink painting. This technique was borrowed by craftsmen on the Ryukyu Islands (Okinawa) between Japan and Taiwan, where the native shells produced particularly beautiful inlaid pieces. The Ryukyus were noted for inlaid lacquer as well as *qiangjin* (incised, gold-filled) lacquer. Sets of lacquer bowls and trays inlaid with dragons in mother-of-pearl were several times offered as gifts to the Qing emperors by the king of the Ryukyus during the eighteenth century.[14]

Another method of decorating lacquer is usually known by the name *tianqi* (literally 'filled-in' lacquer). This is a form of the *qiangjin* technique in which the designs are incised in double lines, the lines are filled in with gold, and then the space between the two lines is filled in with coloured lacquers. Objects decorated in this way have been excavated from tombs dating as early as AD 1200. In the Ming, another type of filled-in lacquer was developed, known in Chinese as *moxian* ('polish-reveal'). In this method certain parts of the design outline are built up on the surface and then the ground is filled in with different-coloured lacquers until they rise above the level of the outline lacquers. The whole is finally polished down to reveal the colourful design.[15]

Sometimes parts of the basketwork body of a lacquered piece were left uncovered, a practice particularly common on boxes and handled baskets produced in Fujian from the seventeenth century onwards. Often the tops of these boxes and baskets were decorated with painted scenes.[16]

Lacquer produced in the Qing dynasty (1644–1911) shows the use of all these decorative techniques, but red carved lacquer was particularly popular, especially with the Emperor Qianlong (1736–95). Lacquer was also increasingly exported to the West, with items such as bureaux and screens, tea caddies and games boxes made to Western order.

Carvings

From earliest times, Chinese craftsmen have worked stone, wood and other materials to make both functional and decorative objects. Jade, turquoise, bamboo, bone, horn, teeth and roots were carved with great skill into vessels, jewellery, sculptures, ritual items, utensils and curiosities. Few works were signed and many were the co-operative effort of large, well-organised groups of craftsmen. However, the names of a few carvers have been recorded, some of whom worked in more than one material. The Ming dynasty bamboo carver of the famous Jiading school of bamboo carving, Zhu Xiaosong, also worked in wood, while a Qing member of the same school, Feng Qi, also worked in ivory, rhinoceros horn, wood and lacquer.[17]

In early China the most valued materials, as we have seen, were jade, bronze, silk and lacquer. Objects made of ivory, wood, horn and bone were not so highly valued, but there persisted an almost continuous tradition of

129 Miniature mountain of bamboo root (detail), carved to look like rock, with pine trees and an assemblage of Daoist immortals, some contemplating a scroll on which is painted the *yin yang* symbol. Qing dynasty, 18th century. The mountain would have been placed on a scholar's desk or in a cabinet, as an object of contemplation (see Introduction, fig. 18). HT: 24.7 cm.

132 (*opposite below*) Group of snuff bottles of (*left to right*) pudding stone, carved lacquer, porcelain, carved ivory, jade, inside-painted glass and hair crystal. Qing dynasty, 18th–20th century. The stoppers are not always made of the same material as the bottles. Snuff bottles show the Chinese love of working on a miniature scale. HT (max.): 8.5 cm.

carving in these materials. Of the bone workshops excavated at Shang dynasty sites, the largest, dating to the eleventh century BC, contained 35,000 pieces of animal bone, together with bronze tools such as saws, drills, grinding stones, knives and sickles. There were ox, pig, deer and dog bones as well as those of humans. Even at this early time the manufacturing process must have been well organised; large numbers of items were produced and decorated in a wide variety of ways, including incising and carving, painting, staining, and inlaying with materials such as turquoise, stone and shell. At some bone workshop sites ivory has also been found.[18]

Many decorative motifs on early carvings reflect those used on the most highly valued materials: bronze, jade and lacquer. A Shang dynasty ivory handle in the Museum, for example, is decorated with the same *taotie*, dragons and squared spirals as bronzes of the same period (twelfth to eleventh century BC) (fig. 133). Shapes were also imitated: it seems likely that some bone and ivory vessels were used alongside bronze ones in rituals for offering food to ancestors.

There are numerous references in early Chinese historical literature to objects made of rhinoceros horn, which is in fact not a horn but a solid mass of hair. It was thought by Daoists to have magical properties as well as being valued as an aphrodisiac. By the Tang dynasty (AD 618–906) it was carved into cups which were given to scholars who were successful in examinations (fig. 134). It is fortunate that Chinese rhinoceros horn cups dating from this

130 Group of jade carvings depicting: (*left to right, back row*) a crab and a dragon, (*front row*) a squirrel, tortoise and a child. Qing dynasty, 18th century. Although they are all carved out of jade, the stone differs in colour. These carvings would have been used as paper-weights or ornaments. L (max.): 7.5 cm.

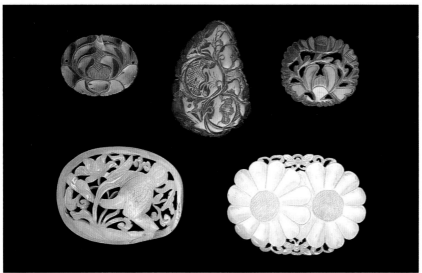

131 (*left*) Carvings of jade, amber and agate, with bird and flower decoration in openwork. Qing dynasty, 18th century. Some of these carvings, which are flat, would have been sewn on to clothing as personal ornaments. DIAM (max.): 7 cm.

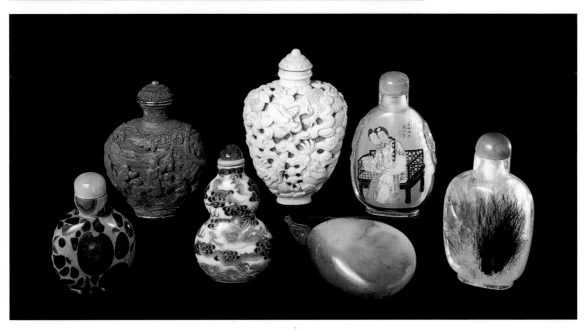

133 Ivory handle. Shang dynasty, 12th–11th century BC. The handle is carved with a decorative scheme very similar to that found on Shang dynasty bronzes (see ch. 1, figs 31–2), with *taotie* faces, spiral patterns (*leiwen*) and flanges with hooks. L: 24 cm.

period have been preserved in Japan in the Shōsō-in in Nara. Also preserved in this remarkable treasury are rulers, fish-shaped amulets, sceptres and belts made of rhinoceros horn, as well as ivory dice, plectra, stained and engraved daggers and sheaths, engraved ivory rulers and bamboo flutes.

These bamboo flutes are the earliest surviving examples of objects decorated by a technique called *liuqing* ('retaining the green'), which was to become very popular in Ming and Qing dynasty bamboo carving. Parts of the green outer skin of the bamboo are retained in the design, while the surrounding skin is scraped off to reveal the flesh which forms the background. As the piece ages, the flesh darkens and the skin turns yellow, the resulting contrast in colours making the design more apparent.[19] The art of bamboo carving was at its height in the mid to late Ming and early Qing dynasty (sixteenth to eighteenth centuries), when the Jiading and Jinling schools competed for supremacy in southeast China. The natural cylindrical shape of the bamboo stem made it ideal for brush holders, incense holders and perfumers and, cut in half lengthways, for wrist-rests. The root of the bamboo, being denser in texture, was used to fashion sculptures and vessels (fig. 129).

Bamboo carving enjoyed a status higher than many other similar crafts. This is possibly because bamboo, a relatively soft material, was workable by individual craftsmen and thus did not need to be carved in large workshops. It could, therefore, even be worked by scholar-officials. Indeed, almost all the great bamboo carvers of the Ming and Qing dynasties were also accomplished in the scholarly pursuits of painting and poetry, calligraphy and seal carving. Like calligraphy and paintings, bamboo carvings were often signed, and by the late Ming dynasty some rhinoceros horn and soapstone carvings, as well as inksticks and bronzes, were also signed.

Ivory was used in the sixteenth century for carving sculptures of Daoist and Buddhist gods and immortals, particularly in Fujian (ch. 6, fig. 208). Ceramic and bronze images based on these ivory carvings are illustrated in chapter 3 (figs 114 and 116). By the Qing dynasty ivory was also used for brush holders, brush handles and wrist-rests, as well as wine cups, trays and boxes. Ivories from Canton, the leading centre for ivory carving in the eighteenth century, were presented to the court as tribute from that area and were also exported to the West. Unique to the craftsmen of Canton were intricately carved architectural ivories such as miniature pagodas; carving, piercing, openwork, staining and the plaiting of thin strips of ivory were all techniques mastered by workshops there.[20] Artisans from Canton, as well as from Hangzhou, Suzhou, Nanjing and Jiading, were recruited by the Imperial Household Workshop and the Ruyi Academy in Beijing.

Of all the hardstones, jade was the most precious: worked since the Neolithic period in China, it was not only valued for its hardness and rarity but was imbued with moral qualities; it was also thought to confer immortality (ch. 1). Because it was so hard, jade could not be carved with tools but had to be ground with abrasive sands. Used in early China for ritual objects, it was later used for decorative items, jewellery, paper-weights and small sculptures (fig. 130).

The variety of stones carved by Chinese craftsmen is vast: agate, coral, crystal, lapis lazuli, malachite, quartz, serpentine, soapstone, tourmaline,

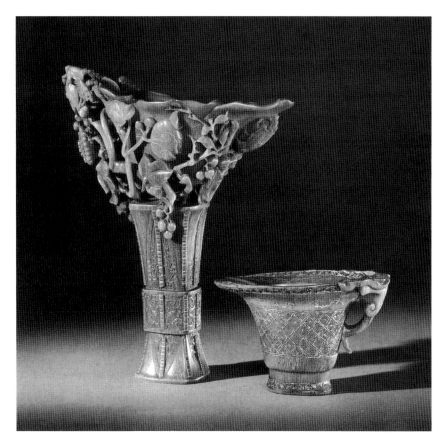

134 Two rhinoceros horn cups. Qing dynasty, 18th century. The base of the left-hand cup is carved in the shape of an ancient bronze *gu* (see ch. 1, fig. 29) and the right-hand one has spiral thunder pattern (*leiwen*) decoration derived from ancient bronzes (see ch. 1, fig. 32). Rhinoceros horn cups were collectors' items, given as gifts to successful scholars. HT: 22.3 cm, 8.3 cm.

turquoise and many others were all used (fig. 131). These stones were admired for the variety of their colours and for the high-quality finish they gave the carvings. Some stones such as realgar were valued as supposed elixirs of immortality, while coral, appreciated for its fine veins and glossy surface, was one of the seven Buddhist treasures and was used in Buddhist artefacts (fig. 141). Large pieces of rock crystal were sometimes collected and placed in gardens. Rock crystal from Wuzishan in Qiangzhou, Guangdong province, was described as 'brilliant, lustrous and white as snow'. Stone from Duanxi in Zhaoqing, Guangdong province, was considered especially valuable, as the best material for making inkstones on which to grind ink (ch. 2, fig. 54). Other stones were carved into the shapes of ancient bronze vessels, small sculptures, popular gods and immortals, seals, miniature mountains and archer's thumb-rings. Large numbers of snuff bottles in a variety of different stones were produced in the nineteenth century, and many of these were collected by Westerners (fig. 132).

Foreign materials and techniques

Foreign materials and techniques must be seen in the wider context of China's foreign trade, which is discussed in chapter 6, but there were essentially three main periods when foreign techniques, forms and decorative motifs particularly influenced the development of Chinese decorative arts. The first

was the Six Dynasties period (AD 220–589), when Buddhism was introduced from India and Buddhist architecture, images and vessels, as well as foreign gold, silver and glass, were brought to China from Central Asia and the Indian subcontinent. During the following Sui (AD 589–618) and Tang (AD 618–906) dynasties, gold and silver vessels related in shape, design and technique to Hellenistic, eastern Iranian and Central Asian metalwork, were made in China (ch. 6, fig. 197). Chinese ceramics, textiles and lacquer were also influenced by forms and designs from the West.

The second major period of foreign influence was during the thirteenth and fourteenth centuries, when the Mongols controlled large parts of Asia and trade therefore expanded under the new political conditions. It was at this time that cobalt, called 'Mohammedan blue', was adopted for use in underglaze painting on porcelain (ch. 5, p. 240), and cloisonné enamelling (discussed below) was introduced to China from Western Asia. This technique had reached a highpoint in Byzantium in the eleventh century and was transported to China across Central Asia, perhaps through the Caucasus.

The third period of contact between China and the West occurred in the late seventeenth and eighteenth centuries, when Jesuit missionaries established themselves at the Chinese court. They brought with them Western techniques such as glass making (fig. 144), painting in enamels on copper (fig. 143), and the use of a rose-pink enamel derived from colloidal gold which was to form the basis of the well-known *famille rose* palette (ch. 5, fig. 187). They were also responsible for the introduction of such Western artistic traditions as perspective in painting. The habit of taking snuff was also brought in by the Jesuits, stimulating a surge in the production of intricately carved and painted snuff bottles (fig. 132).

Gold and silver

By the eleventh century, the visiting Japanese monk Jojin was recording the magnificent utensils and images of gold and silver that were displayed in Buddhist temples.[21] However, in ancient China, gold and silver were not given the high status accorded them in the West (ch. 1, p. 80). Before the Tang dynasty (AD 618–906), bronze, jade and lacquer were the most highly valued materials for vessels; gold and silver were used decoratively, for inlay on both bronzes and lacquer, and for personal ornaments such as belt-hooks, but only on rare occasions – such as the burial of the Marquis Yi of Zeng at the end of the fifth century AD – were gold vessels employed. Even in this case, however, the gold vessels were in the shapes of bronzes (Tombs appendix). During the Han dynasty (206 BC–AD 220) some silver vessels were used, a few of which were in foreign shapes; large numbers of silvered bronze vessels were also made and are decorated with gilded cloud scrolls, perhaps as substitutes for more expensive silver vessels.

Gold and silver rose dramatically in status after the fall of the Han, when foreign rulers introduced foreign tastes and objects to China. During the Six Dynasties period (AD 220–589), provincial copies of silver used in the eastern Mediterranean and Iran were brought in by the foreign rulers of northern and northwestern China. Foreign shapes such as stemcups, lobed bowls and cups with flanged handles, as well as foreign decoration in the form of single and double animal designs in central positions, often in repoussé, became

136 (*opposite below*) Gold garment plaque decorated with two dragons and a flaming pearl among clouds, worked in relief with chased detail and openwork and inlaid with semi-precious stones. Ming dynasty, 15th century. The plaque is pierced around the edge for attachment to a robe. It is one of a pair, probably for imperial use. Such plaques can be seen as high-quality versions of embroidered rank badges (see Introduction, fig. 14). L: 18 cm.

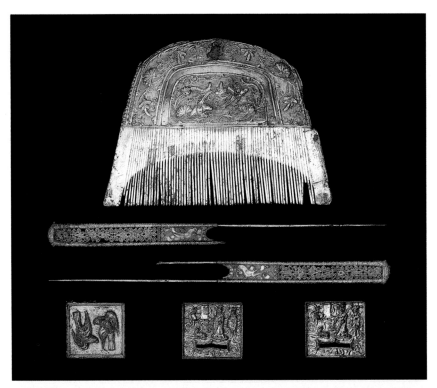

135 Group of gold, silver and silver gilt jewellery, comprising (*top to bottom*) a decorative comb, two hairpins and three buckles. Tang or Liao dynasty, 7th–10th century AD. The hairpins are decorated with granulation and the comb with repoussé and ring-punching. Hair ornaments and buckles were two of the main forms of personal ornament in China. L (max.): 17 cm.

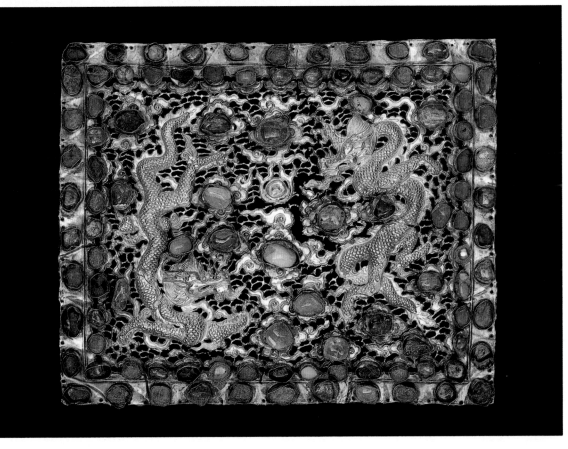

familiar. During the Tang these shapes were adapted to local taste. A stemcup (ch. 6, fig. 197) in the Museum is an example of this practice.

In the early Tang, luxury items such as those made of gold and silver were rarely buried in tombs, but large numbers have been found in hoards. The Hejiacun hoard near Xi'an is thought to have been buried in AD 755, at the time of the An Lushan rebellion and the flight of the Emperor Xuanzong to Sichuan.[22] It contained 270 pieces of gold and silver, including many in foreign shapes together with some Chinese types such as eared wine cups. Another hoard, at Ding Maoqiao, Jiangsu province, held the utensils of a grand Tang household: 960 items in all, including eighteen pairs of chopsticks, ten spoons, twenty-eight boxes, eight cup stands and six small platters.[23] Many of these were decorated with figures of animals and birds in repoussé against a ring-punched ground. This particular household seems to have indulged in drinking parties, as the hoard also included a set of counters inscribed with quotations from the Analects of Confucius, used in wine-drinking games.[24]

Gold and silver were directly linked with Buddhism because in Central Asia and Gandhara (in present-day Afghanistan and Pakistan) images of the Buddha were made from these bright, shiny metals. This tradition was brought to China where the most cherished images and reliquaries, surviving today in temple crypts beneath pagodas, were also made of these fine metals. Reliquaries usually contained precious fragments of the bones of the Buddha. In a crypt below the pagoda at the Famensi at Fufeng, Shaanxi province, a whole set of gold and silver boxes of diminishing sizes was found, one inside the other, with the innermost (house-shaped) gold container containing a finger-bone of the Buddha. In the same find was a rare set of tea utensils including a wheel and stand for grinding the tea and an openwork silver container with the appearance of basketwork. A tiered silver box (fig. 137) provides a prototype for later Chinese tiered lacquer trays (fig. 154).

Silver was occasionally buried in Song dynasty (AD 960–1279) tombs but appears more often in hoards and pagoda deposits, sometimes with white Ding ware ceramic vessels in similar shapes and with similar decoration (ch. 5, p. 236). This suggests that the Ding pieces were made in imitation of, or as substitutes for, silver ones. Sometimes the Ding dishes were bound with silver. Silver and gold were also widely used in the Song to decorate lacquer; they were either painted on to the surface or used as fillings in incised designs (qiangjin technique, fig. 124). Indeed, gold and silver had a great influence on the development of lacquer shapes. It has also been suggested that the repoussé designs on silver of this period were reflected in the carved designs of Song and later lacquer.[25]

Silver and gold were used in even greater quantities in tombs of the northern Liao dynasty (AD 907–1125): for openwork crowns, belts, boots and masks adorning corpses, such as that of Princess Chen and her husband, buried in 1018.[26] Items such as spittoons, bottles, platters, bowls, horse trappings and pillows, for use by the deceased, were also buried. Many of the bowls were flower-shaped, descended from the lobed bowls imported from Iran. These flower shapes were continued in the Song and later copied in lacquer and porcelain.

Gold and silver jewellery was worn by the élite in the Tang and Song

137 Tiered box of silver with openwork sides and chased decoration. Excavated from beneath the pagoda at the Famensi Buddhist temple in Fufeng, west of Xi'an, which was inventoried in the late 9th century. The shape and style of this box were copied in lacquer from the Song dynasty onwards, and a later set of similar tiered lacquer trays can be seen in the painting in fig. 154.

periods. The most popular forms were hairpins and combs, although a few rings and bangles have also been found. Intricate openwork of flowers and birds was sometimes embellished with fine beading known as granulation (fig. 135), a technique introduced from Western and Central Asia. Gold and silver fine filigree jewellery is also characteristic of all later periods, particularly on hair ornaments such as the phoenix-shaped pins from the tomb of a royal prince dated 1539.[27] The gold garment plaque illustrated in figure 136 is a superb example of early Ming jewellery.

Silver and gold from the Yuan period (1279–1368) onwards is rare, as much was melted down. However, pear-shaped bottles, spouted bowls and lobed dishes have been found in a Yuan dynasty hoard in Anhui province,[28] and all these shapes were commonly imitated in blue-and-white porcelain. References in the literature of the Ming and Qing dynasties tell us that gold and silver were used at court, both for eating and drinking vessels and for jewellery. Some tableware has also been excavated from tombs. An interesting source of information is the inventory made of the property of Grand Secretary Yan Song (he was purged in 1562). He owned 3185 pure gold vessels, 367 gold vessels studded with gems, 1649 silver vessels and much jewellery. Many pieces were very large, such as incense burners weighing 756 ounces of silver.[29] Because they were regarded as the most valuable materials, gold and silver were limited in their use by Ming sumptuary laws. It is clear that the shapes of gold and silver vessels and their decoration provided the prototypes for many porcelain vessels (ch. 5), and it seems to have been regarded as somewhat ostentatious to use gold and silver in the household. The use of gold and silver in ritual was restricted to the imperial family.

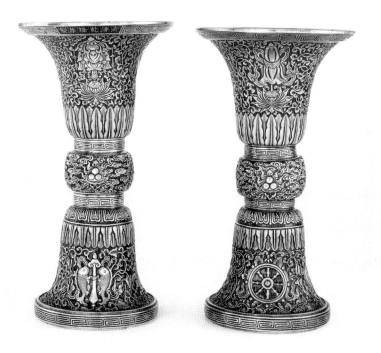

138 Pair of silver vases in the shape of ancient bronze *gu*, decorated in *champlevé* blue enamel with the Eight Buddhist Symbols. Qing dynasty, Qianlong mark and period (1736–95). These vases would have been made for use on a Buddhist altar (see fig. 152). HT: 29 cm.

Qing dynasty (1644–1911) silver made for use in China is now very rare, apart from pieces in the two palace museum collections in Beijing and Taipei. Images and ritual implements employed forms better known in bronze and were often embellished with openwork, precious stones and enamels, as on a pair of silver *gu* in the Museum (fig. 138). Much silver in Western shapes, made to comply with Western tastes, was exported to Europe and the United States during the eighteenth and nineteenth centuries.

Cloisonné

Cloisonné enamel decoration consists of coloured glass paste applied to metal vessels and contained within enclosures made of copper (fig. 139). Various metallic oxides were mixed with the glass paste in order to colour it. For instance, cobalt gives blue, manganese oxide purple, and uranium oxide orange; iron gives either red or brown, tin gives opaque white and copper either green (in oxidation) or blue/red (in reduction). The vessel to be decorated in cloisonné enamel was usually cast rather than made of sheet metal. Unlike Byzantine cloisonné, which was usually on gold vessels, Chinese cloisonné was normally on a copper or bronze base. The enclosures, or cloisons, were made from copper or bronze strips, bent and shaped into the required patterns. They were then stuck on to the vessel either with vegetable glue or by soldering. Coloured enamel pastes were applied with a brush to fill the cloisons. The vessel was then fired at a fairly low temperature (*c*.800°C) to

139 (*below left*) Large cloisonné enamel jar with a domed cover, decorated with vigorous dragons among clouds. Ming dynasty, Xuande mark and period (1426–35). The decoration is very similar to that on blue-and-white porcelain of the same period. The bright colours of cloisonné enamels were first thought vulgar by Chinese connoisseurs, but by the time this jar was made it was considered appropriate for palace use. HT: 62 cm.

140 (*below right*) Small water sprinkler (*kuṇḍikā*) for use in Buddhist ritual, decorated in cloisonné enamel with lotuses. Ming dynasty, 15th century. The shape is of Indian origin. HT: 20 cm.

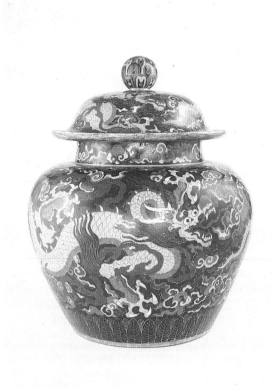

melt the enamels. This process was repeated several times, because the enamel shrinks on heating and does not completely fill the cloisons. Once each cloison was full to overflowing, the surface of the vessel was rubbed until the edges of the enclosures were visible and flush with the enamel. Then the cloison edges were usually gilded, using the parcel-gilding technique.

Inlay of metalwork with glass and glass paste existed in China from the Shang dynasty onwards and was used on bronzes, ceramic and silver. In the Tang dynasty, cloisons filled with precious stones appear on silver jewellery and vessels.[30] However, the earliest dated Chinese cloisonné occurs in the Xuande period (1426–35) of the Ming dynasty, by which time very high-quality imperial pieces were being produced, such as the large jar in the Museum (fig. 139). The size of the jar and the clarity and variety of the colours suggest that there may have been a considerable period of experimentation and development during the fourteenth century. Several pieces in the collection of the Palace Museum in Beijing have been dated tentatively to the Yuan dynasty.[31]

Although cloisonné was a foreign technique and was at first considered extremely vulgar and garish, the Chinese seem to have grown to like it, perfecting the technique during the fifteenth century and producing some superb vessels for palace and temple use (fig. 140). Some of the vessel shapes were borrowed from ancient Chinese bronzes, while others resembled contemporary porcelain and lacquer. The decorative motifs used on cloisonné were those already common on porcelain and lacquer, such as lotus scrolls,

141 (*below left*) Model of a miniature building representing a Buddhist mandala in three dimensions. Qing dynasty, dated the *renzhen* year of the Qianlong period (AD 1772). Cloisonné enamel mandalas were particularly popular under the Emperor Qianlong for use in the Tibetan-style palaces at the Manchu summer resort of Jehol (present-day Chengde). This mandala is inlaid with coral, with bells of jade and silver. HT: 56 cm.

142 (*below right*) Large incense burner with legs in the form of three cranes and decorated in cloisonné enamels with cranes and deer, symbolising longevity. Qing dynasty, Qianlong period, second half of the 18th century. HT: 1 m.

vines, dragons, birds, flowers and landscapes. The large dragon on the Museum's Xuande period jar, for instance (fig. 139), is paralleled in underglaze blue porcelain jars of the same period.

In technique cloisonné can be compared with a type of porcelain made in the fifteenth and sixteenth centuries called *fahua* (ch. 5, p. 250; Ceramics glossary). To produce *fahua*, thin lines of trailed slip were applied to the walls of porcelain vessels and then the resulting cloisons filled with coloured glazes and fired. As on cloisonné, turquoise and cobalt were favourite colours.

Some connection is also apparent between another type of overglaze enamelled porcelain, *doucai*, and cloisonné. Cloisonné reputedly reached a highpoint in the reign of the Emperor Jingtai of the Ming dynasty (1450–6), while *doucai* flourished in the reign of a later emperor, Chenghua (1465–87). It seems likely that the *doucai* technique of painting an outline under the glaze in blue and filling it in over the glaze with different coloured enamels (Ceramics glossary) derived from the cloisonné technique.[32]

During the sixteenth century the cloisonné repertoire was expanded by the introduction of dense background decoration of spiralling cloison wires and also by mixing different coloured enamels within each cloison. Many later pieces bore false Jingtai marks and in fact cloisonné is still called 'Jingtai blue' in the Chinese language. Qing dynasty cloisonné vessels often have gilded bronze additions such as elephant-shaped legs, curling dragon-shaped knobs, and spouts. The bright enamel colours, combined with gilt bronze, made cloisonné an attractive medium for imposing ritual vessels and paraphernalia (fig. 141) as well as for large palace utensils such as ice boxes, fish bowls, incense burners and wash basins (fig. 142).

Painted enamels

The introduction to China of painted enamels, invented in the French town of Limoges in the fifteenth century, is attributed to the Jesuits at the court of the Emperor Kangxi (1662–1722). The base of the painted enamels was usually of copper, although examples of gold, silver and brass do exist. On to this base were painted enamels – that is, coloured glasses. The decorative style reflects that of Chinese overglaze enamelled porcelain of the same period and is predominantly of the so-called *famille rose* type (ch. 5, pp. 225 and 241; Ceramics glossary). The most striking colour is a pink enamel derived from colloidal gold, introduced from the West in the late seventeenth to eighteenth century; two firings are needed for both painted enamels and enamelled porcelain. Painted enamels for the emperors were manufactured in the Imperial Household Workshop set up under Emperor Kangxi (p. 202), while non-imperial pieces were produced in the areas of Suzhou and Yangzhou in southeast China, and in Canton.

As with *famille rose* overglaze enamelled porcelain, designs in painted enamels on copper were made in Chinese style at the beginning of the eighteenth century; flowers, fruit, landscapes and figures were common motifs (fig. 143). During the mid and late Qianlong period in the second half of the eighteenth century, Western techniques of shading and perspective were introduced, as well as painting in grey (grisaille). Western figures and scenery, subjects introduced by the Jesuit artists patronised by the emperor, also became popular.

Objects decorated in painted enamels range from small teabowls and teapots to large dishes, handwarmers and ewers. Many objects were also made in Canton in Western shapes to suit Western tastes; these were not always of high quality. The name 'Canton enamels' came to be used in the West for these export pieces. Chinese painted enamels were shipped to the West as early as 1721 by the Russian ambassador.[33] Documents such as bills of lading survive from the mid eighteenth century for items exported to the West. For example, a pair of candelabra and a tray were ordered in 1740, along with items of furniture, for shipment in a supercargo of the Danish Asiatic Company. They are now in the collection of Rosenborg Castle, Copenhagen.[34]

Glass

It is probably true that glass manufacture never occupied a dominant place in Chinese decorative arts due to the excellence of other materials such as jade, porcelain and lacquer, all of which could produce glossy, translucent surfaces. The impetus for glass making came from outside China. Until the end of the eleventh century the manufacture of glass in China was repeatedly stimulated and reinforced by the import of fine and fragile pieces from Central Asia and further west. Chinese glass beads dating from the fifth to third centuries BC are similar to those produced in Western Asia, although the Chinese beads have a higher lead and barium content (ch. 6, fig. 190). During the Eastern Zhou and Han periods, glass was used in the shape of plaques, as a cheaper material than jade, to cover the bodies of the dead, and as discs in pendant sets.

Roman glass entered China along the Silk Route during the Han dynasty (206 BC–AD 220), and moulded examples have been excavated from Chinese tombs of this period.[35] Han Chinese glass was usually moulded and made in typically Chinese shapes such as the two-handled cup, which is also found in Han jade and lacquer (fig. 126).

Glass blowing was introduced from Western Asia around the fifth century AD, and imported blown-glass vessels have been excavated from fifth-century tombs in China.[36] Glass vessels seem to have had a close connection with Buddhism: reliquary vases of glass were often found inside nests of caskets, usually of gold or silver, buried in stone coffers underneath pagodas.

The use of glass for Buddhist reliquaries and for vessels buried in the tombs of members of the imperial family, such as that of Li Jingxun (AD 608), Li Tai (AD 652), Li Shou (AD 631) and Li Shuang (AD 668), shows that it must have been highly prized. In the Famensi at Fufeng, Shaanxi province, inventoried in the late ninth century, Chinese and imported Syrian glass were buried together with other highly prized objects such as silver, gold, textiles and porcelain.[37]

During the Song dynasty (960–1279), glass was used to make gourd-shaped bottles, egg-shaped objects of unknown use and occasionally foliate bowls. For this period, too, most of the surviving examples have come from Buddhist sites. The main production area for Chinese glass from the Yuan period (1279–1368) onwards was Boshan in Shandong province, in northeast China. There is literary evidence in the *Mount Yan Miscellany*, an early Qing dynasty publication, that by the Ming dynasty glass making had reached a

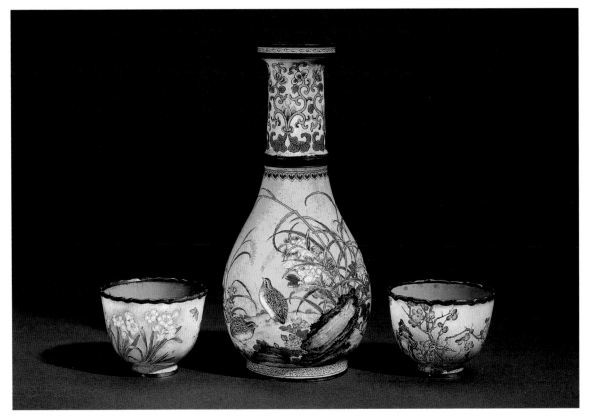

143 Small vase and cups of metal decorated in painted enamels with flowers and quails. Qing dynasty, 18th century. The delicately painted decoration parallels that on early 18th-century overglaze enamelled porcelain. These pieces are in Chinese taste, although many pieces of painted enamel were later made in Western shapes and designs for export. HT (of vase): 12.4 cm.

high level in this area.[38] Although excavations at Boshan have revealed furnace sites and glass rods in considerable numbers, existing glass vessels of this period are rare; those that are known are turquoise in colour.[39]

In the Qing dynasty, under Emperor Kangxi (1662–1722), a glasshouse was set up in 1696 within the Imperial Workshop in the Forbidden City in Beijing. This greatly increased the status of glass and resulted in a flourishing of glass production (fig. 144). The glasshouse was supervised by a German Jesuit called Stumpf, and glass produced during the first half of the eighteenth century seems to have suffered from the same defect as much Western glass of that period – crizzling.[40] This is a gradual cracking and flaking in a web-like structure caused by an excess of alkali (too much soda and too little lime).

Although the Western supervisors influenced the technology of glass making, they were not to be responsible for any great changes in the style of glass vessels. The shapes produced were undoubtedly Chinese, often reflecting those of ceramic, lacquer, jade and bronze vessels. The vessels were decorated in a variety of techniques such as moulding, incising, carving, diamond-point engraving, overlay (or cameo glass) and enamelling. Glass was also made to imitate stones such as realgar (fig. 144) and aventurine, lapis lazuli, turquoise and jasper, just as it had been in earlier times, as a cheap substitute for jade. Realgar, poisonous arsenic sulphide, had been used by Daoists in the practice of alchemy in their search for substances that would confer longevity, and glass imitations of realgar were safer while still

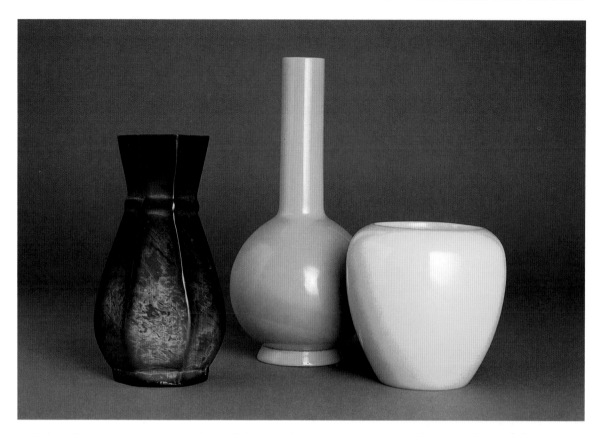

144 Group of glass vases. Qing dynasty, 18th century. The vase on the left is made in imitation of realgar, a poisonous substance thought by Daoists to be capable of conferring immortality. HT (max.): 22 cm.

retaining the auspicious connotations of the genuine stone. Some examples of pink glass, imitating rose quartz, are particularly beautiful; the pink was the same as that used in the *famille rose* enamel palette for porcelain decoration and enamelled glass. Enamelled decoration on glass was usually applied to opaque white glass, reinforcing the similarity with painted enamels and enamelled porcelain. The art of enamelled glass reached a highpoint in the Qianlong period (1736–95), when a group of high-quality pieces marked with the characters *Guyuexuan* (literally 'Old Moon Pavilion') was produced. These pieces were undoubtedly for imperial use, although the exact location and significance of the pavilion is unknown.

By the Qing dynasty glass was used not only for decorative vessels but also for utilitarian objects such as lamps and lanterns, window panes, venetian blinds, scientific instruments, lenses and spectacles. It was occasionally used for Buddhist figures and writing equipment. In jewellery its function was again to imitate precious stones, and it was used in hairpins, toggles and plaques.

Paintings on glass were produced mainly in Canton. Two panels depicting landscapes were considered good enough to make fitting tributes from Canton to the Emperor Qianlong.[41] Glass paintings were also produced in large numbers for export to the West, and many, usually depicting landscapes or women, can be found in country houses and private collections. The picture was painted to be viewed from the front but the paint was applied to the back of the glass, so the foreground had to be painted before

the background. This technique is sometimes called 'reverse painting' and was paralleled by the delicate technique of inside-painted snuff bottles (fig. 132).

Dress

Dress was used in China, as in many other societies, as an adjunct to social hierarchy (Introduction, p. 34). The Chinese developed clothing in different colours and styles in order to indicate rank, and belts and hats were also important markers of status. The different ranks of the figures in the painting in figure 147 are shown not only by the relative sizes of the figures, but also in the elaboration and colour of their robes. As a complex official style of dress developed, gradations in dress were refined and became increasingly prescriptive. These rules are recorded in the official histories of each dynasty. By regulating what people wore on official occasions, the Chinese rulers advertised the hierarchy of officials both in ceremonies and in daily life. In fact, imperial power depended on a system of favours and rewards by which officials rose through the hierarchy, this rise being indicated outwardly by changes in dress. When officials gathered together at court audiences, rituals and sacrifices, their positions were laid down in minute detail (fig. 145) and could be gauged by their apparel. When they were accompanied by their wives, the costume and accessories of the wife had to accord with the rank of her husband. At the top of the hierarchy, of course, were the emperor and the imperial family.

Evidence for the variety of ancient Chinese dress survives in historical texts, in excavated robes, in ceramic tomb figures buried with the dead, and in paintings. Few early garments have themselves survived, but we can learn something of the role of dress in the official hierarchy from texts of the Han period which purport to describe an earlier time. The texts on ritual, known as the *Liji* and the *Zhou li*, probably reflect Zhou dynasty practices, although they were compiled some time later. The *Liji* draws attention to the importance of the hat in formal dress, saying, 'Rites start with the hat' and describing in detail the sorts of hats, hat ribbons and tassels needed for certain rituals.[42] The correct dress was absolutely essential, when performing rituals and official sacrifices, to ensure their success.

The *Zhou li* contains precise instructions on the various colours to be worn and their individual meanings. Colours were regarded as symbolic: 'The east is blue, the south is red, the west is white, the north is black, heaven is dark blue and earth is yellow'.[43] Throughout Chinese history one of the most important things a new dynasty had to do was to choose a dynastic colour; that of the Ming dynasty, for instance, was red. From the Sui dynasty (AD 589–618) onwards, yellow was not allowed to be used by anyone except the emperor.

Early Chinese styles of dress can be seen on wooden and ceramic figures made for burial from the Eastern Zhou and Han periods. Actual robes, such as those excavated from tomb no. 1 at Mawangdui near Changsha, also survive from these periods.[44] The principal garment was a simple wrapover jacket with long, wide sleeves (fig. 146). The elegant, flowing robes of the fifth-century AD court can be seen in a famous painting attributed to Gu

145 (*above*) Copperplate engraving on paper of a court audience, Qing dynasty, *c.*AD 1830. This celebrates the campaign against eastern Turkestan (see also ch. 6, fig. 212). The officials can be seen lined up in the proper order, wearing their court robes, hats, necklaces and rank badges (see fig. 149). The emperor is seated on the upper floor above the Noon Gate (Wu men) of the Forbidden City (see Introduction, fig. 17). 51 x 88.5 cm.

146 Painted wooden tomb figures showing silk robes decorated with lozenge-shaped patterns and flower scrolls. Early Western Han dynasty, 2nd century BC. Excavated from tomb no. 1 at Mawangdui, near Changsha in Hunan province, in 1972. Painted, printed and embroidered silk fabrics, robes and accessories, as well as damask and brocade, were excavated from this tomb, which belonged to the wife of a high-ranking marquis.

147 Painting of Mañjuśrī, Bodhisattva of Wisdom, brought back from Dunhuang, on the Silk Route, by Aurel Stein. Mid 10th century AD. Ink and colours on paper. Mañjuśrī is here seen visiting Vimalakīrti (not shown), a rich Indian layman, on his deathbed to admire his wisdom. In the foreground is a king, identified as such by his robe which is decorated with dragons and the sun and moon motifs, and by his official hat. HT: 73.2 cm.

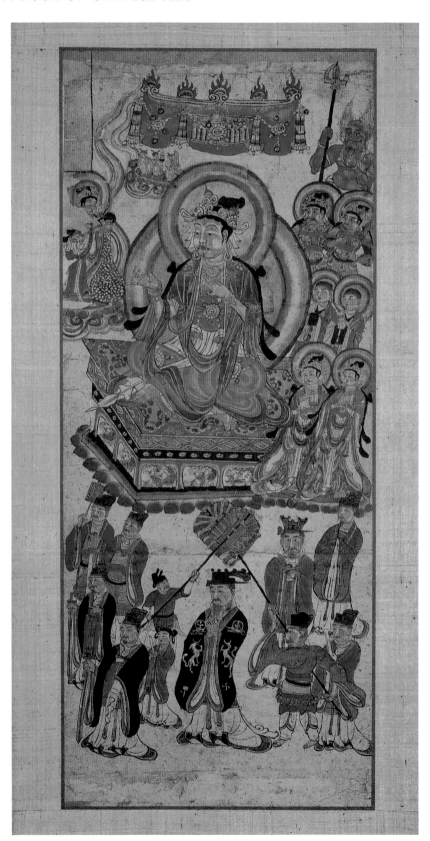

出其言善千里應之苟違斯義
同衾以疑

148 Detail from the painting *The Admonitions of the Court Instructress* (see ch. 2, fig. 65), attributed to Gu Kaizhi (c.344–c.406). Tang dynasty copy, 8th century. Scene showing a court concubine at her toilet with a maid. The concubine wears a long-sleeved wrapover robe while the maid has a separate skirt and wrapover top, and an elaborate hair ornament. A bronze mirror can be seen in use on a lacquered wood stand, as well as lacquered toilet boxes. The large lacquer box lid (*lower right*) is inlaid with silver, as is the toilet box in fig. 123. Handscroll, ink and colour on silk.

Kaizhi and surviving in an eighth-century copy (fig. 148). The crossover-style opening and long, wide sleeves were obviously still popular.

Elaborate hairstyles involving a variety of topknots were, from early times, decorated with hairpins, combs and headdresses (fig. 135). These items comprise the main types of women's jewellery, just as belt-hooks and belt-plaques are important items of men's jewellery (fig. 150).

A tenth-century Buddhist painting on silk from Dunhuang, on the Silk Route, shows the sort of official costume worn by dignitaries in the Tang (fig. 147). The long, flowing sleeves of the robes feature embroidered auspicious symbols, some of which may be dragons. 'Dragon robes', that is, robes embroidered with large dragons and other auspicious symbols, were already in use by the Tang dynasty emperors and were referred to in the *Old Tang History* (*Jiu Tang shu*). We can assume that 'dragon robes' continued in use thereafter as official symbols. Splendid examples of Ming dynasty dragon robes have been excavated from the tomb of the Ming emperor Wanli (1573–1620). By the Qing dynasty (1644–1911) they had become rather commonplace items of clothing, which explains why they exist in such large numbers in Western collections. The dragon robe was not, in itself, a symbol of the status of the wearer, which was shown by the other items worn with it, such as embroidered rank badges, belts, hats and necklaces.

Although there are descriptions of prescribed dress in all Chinese court histories, we have no illustrations of them, so it is fortunate that the Qing dynasty rules on court dress were set down in an illustrated work, com-

149 Stone sculpture of a civil official from the sacred way leading to the tombs of the Qing dynasty emperors at Dongling, east of Beijing. Qing dynasty, 18th century. He is dressed as for an official court audience (see fig. 145), wearing his hat, court necklace and dragon robe, covered by a dark outer coat on which is applied a square rank badge, embroidered with a bird to indicate civil rank.

missioned in 1759 by the Emperor Qianlong, called the *Illustrated Precedents for the Ritual Paraphernalia of the Imperial Court (Huangchao liqi tushi)*. In this work, court dress is only one aspect of the mass of ritual paraphernalia, which also includes sacrificial vessels, astronomical instruments used to calculate auspicious dates for imperial ceremonies, court musical instruments, the state insignia of the emperor and empress, and the military uniforms and weapons used by the emperor and imperial princes.

The details of Qing dynasty court dress can also be clearly observed in the figures of officials lining the way to the tombs of the Qing emperors to the east of Beijing (fig. 149). In the illustration, the court robe, *chaofu*, is covered by a three-quarter-length plain overcoat. Hats were worn at all times and the details were strictly regulated, for example in respect of the types of lining fur that could be employed by different ranks. The status of a person was also shown by stone or glass insignia mounted on the top of the hat, a practice dating to the sumptuary laws issued in 1636. The emperor had a complex pile of pearls and openwork gold dragons. The stones used by officials were also strictly regulated according to rank, as was the size of the setting. In 1736 it was decreed that rubies were to be used by officials of the first to third ranks, sapphires by fourth-rank officials, crystals by fifth-

150 Set of jade belt-plaques carved in relief with dragons and flowers. Ming dynasty, 16th–17th century. They would have been applied to a textile belt, using the small holes around the edges and on the back. L (max.): 15.4 cm.

to sixth-rank officials, and gold by those of the seventh and eighth ranks. Officials of the ninth rank had no jewel.[45]

In 1652 it was decided that hat insignia were not sufficient to distinguish officials within the complex bureaucracy, perhaps because they could not be clearly seen when people were crowded together. Therefore, from this time all civilian and military officials had to wear rank badges (fig. 149), displayed on three-quarter-length dark overcoats. These badges were smaller versions of those displaying birds and animals which had been applied directly to robes during the Ming dynasty. The imperial nobility wore round badges decorated with dragons, while civil officials wore square ones displaying a different type of bird according to their rank. Military officials wore square badges displaying animals symbolising courage. A Ming example of a high-quality gold version of the embroidered rank badges can be seen in figure 136. It probably came from an imperial tomb.

Court necklaces, *chaozhu*, based on Buddhist rosaries, were used only by officials of the fifth rank and above. A *chaozhu* is worn by the official in figure 149. It consisted of 108 beads, equally divided into groups of twenty-seven by four larger beads called 'Buddha heads'. There were also subsidiary strings of ten beads each. The materials used for these were again strictly regulated.

Court belts (*chaodai*) varied in colour according to rank; the belt cannot be seen in figure 149 because it was worn under the overcoat. These belts were of cloth or leather and were decorated with ornamental plaques, a practice current in the Ming dynasty but probably dating from much earlier. Belts decorated with gilt bronze plaques appeared in China from the third to fourth century AD and are similar to belts used much further west.[46] A set of Ming dynasty belt-plaques made of jade can be seen in figure 150.

While belt-plaques and belt-hooks formed the major items of jewellery and rank insignia for men in China, women concentrated on hair ornaments. Hairpins and combs made of gold and silver, jade and glass were in widespread use by the Tang dynasty (fig. 135). Hairpins and combs of bone and ivory have been found from sites dating as early as the Neolithic period.[47] From the Song period onwards, complex tiaras and crowns of silver and gold were inlaid with pearls and kingfisher feathers, decorated in openwork and fastened with multiple hairpins. One feature was the characteristic design of protruding components which swayed as the woman walked. The four phoenix crowns excavated from the tomb of the Emperor Wanli (1573– 1620) – two for each empress – were elaborate concoctions combining jade, gold, precious stones and kingfisher feathers and weighing over two kilograms. Hollow hair ornaments of gold and jade were of practical use, to encase a knot or bun of hair. Earrings, bracelets and necklaces were also worn, particularly pendants of semi-precious stones and of porcelain carved with auspicious or religious symbols and characters.

Settings for the decorative arts

Interiors

A brief account of late domestic interiors is given below, as so many of the objects illustrated above served straightforward functions inside houses, palaces and temples and were not primarily regarded as works of art.

Chinese houses and palaces were arranged in a symmetrical fashion, with rectangular plans and orderly sequences of buildings, rooms and open corridors (Introduction, fig. 17). By contrast, gardens were irregular (fig. 151). While gardens reproduced the irregularity of nature, the house could be seen as a mirror of society on a miniature scale, reflecting in three dimensions the Chinese desire to order society. Specific areas were allocated for formal use, such as entertaining outsiders, while other areas were only for members of the inner family. This separation of public and private affairs is a characteristically Chinese way of dealing with questions of social relationships, politics and diplomacy.

The house or palace was also divided into men's and women's quarters, with men rarely visiting the areas allocated to women. In the imperial palace, the emperor's rooms were totally separate from those of his wives and concubines. Since extended families lived together in the same family compound, the generations were also divided up, with courtyards leading to the quarters of smaller family units.

Although of a comparatively late date, the eighteenth-century novel *Hong-loumeng* (*The Dream of the Red Chamber* or *The Story of the Stone*) gives a splendid picture of the life of such an extended family.[48] In it is a description, which

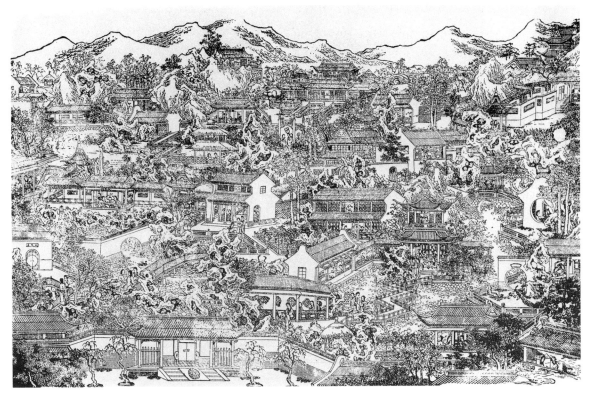

is probably also relevant to family life at much earlier periods, of Uncle Zheng's residence, which was reached by riding along endless paths in a sedan chair. There was a central reception hall, called the Hall of Glory and Beatitude (the Chinese loved to give names to halls, pavilions and gardens – either morally uplifting names or clever couplets containing references from literature – and indeed continue to do so to this day). The reception hall clearly contained all the best and most valuable objects which the family wanted to show to the outside world: a red sandalwood carved table, a one-metre-high tripod, gold goblets, crystal bowls and carved cedarwood seats. The living room, situated to the east of the reception hall, was much more homely. It contained 'divan seats in the corners with cushions and upholstered back-rests, soft armchairs and carpets, lacquered tea tables set for tea, footstools, incense burners and fresh flowers'. The quality of interior furnishings owned by this family was high: they were both noble and prosperous, with a daughter who had become an imperial concubine. Their prosperity is brought home to the reader when this daughter pays a visit to the family and distributes presents, which include gold and jade sceptres, a sandalwood bead rosary, four pairs of embroidered satin sheets, a gold writing-brush case, ten gold and ten silver bars in the shape of auspicious Chinese characters, and many bottles of wine.

The internal organisation of the Forbidden City demonstrates the same order on a grander scale (Introduction, fig. 17). It was not only the layout that reflected the desire for order in society, but also the names of the main audience halls along the central south-north axis: the Hall of Supreme

151 An imaginary reconstruction of the garden in the 18th-century novel *Hongloumeng* (*The Dream of the Red Chamber* or *The Story of the Stone*), showing the assymetrical layout. A winding stream is crossed by bridges and named pavilions. Open walkways, windows of varied shapes and imported, strangely eroded rocks are important features of Chinese gardens.

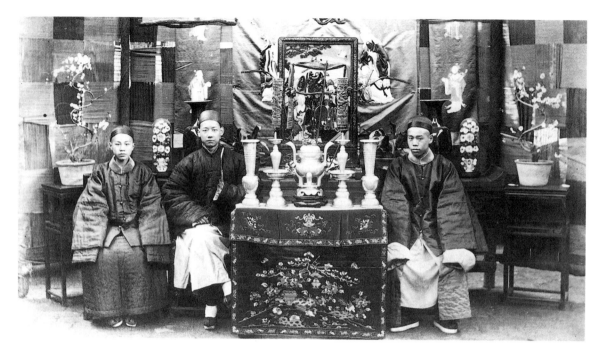

152 Photograph showing a late Qing dynasty domestic altar with a five-piece altar set, the shapes based on ancient Chinese bronze vessels. Above the two candlesticks are suspended carved cylindrical perfumers of wood or bamboo. The figure of Shoulao, Daoist God of Longevity, with his tall, phallic forehead, appears on the screen behind, while the altar valance is embroidered with auspicious symbols of Buddhist origin, such as a pair of fish.

Harmony, the Hall of Complete Harmony and the Hall of Protecting Harmony. To the east were the emperor's and the male quarters, while the women lived in the western apartments. As in most Chinese buildings, the entrance was at the south, partly because the emperor symbolised the *yang* element in the cosmic system of *yin yang* (*yang* was represented by the south, the sun and the male, while *yin* comprised the north, the female and the dark). Inside the emperor's apartments were objects sent as tribute from all over China. Only items of the highest quality were approved for imperial use, and there was a sort of private governing body within the Forbidden City called the Imperial Household Department (Neiwufu) which supervised supplies. The office of the Privy Purse (Guangqu si) collected revenue to support the imperial family in an appropriate fashion.

During the Ming and Qing dynasties many decorative arts were produced in official workshops, attached either to the Neiwufu or to the Ministry of Works (Gongbu). There were also workshops run by local governments in areas associated with a particular craft. Although a sub-department of the Neiwufu called the Yuyongjian was set up in the Ming, it is probably not the case that all pieces for imperial use were made here. The Qing Emperor Kangxi (1662–1722) was instrumental in establishing workshops in the Forbidden City for many different crafts, including enamels, glass, porcelain, weaving and dyeing, and the carving of ivory and stones. The enamel and glass workshops employed foreign Jesuits as well as Chinese master craftsmen, many of whom were brought to Beijing from their native regions to produce work of imperial quality.

Although objects for imperial use were furnished with reign marks from the Ming dynasty onwards, there was a steady flow of these pieces out of the palace, both through official imperial gifts and unofficial sales and bribes by palace workers. Sometimes the imperial provenance of an object was dis-

guised, for instance by removing a claw from the five-clawed imperial dragon (fig. 127). Collectors in later times have paid much attention to marks or decoration indicating that particular pieces had been used by the imperial household – partly in the hope of obtaining items of the highest quality, but perhaps more importantly in an effort to share in the mystique that seems to surround objects once used by famous people.

Items made for palace use were often larger than ordinary everyday pieces. Cloisonné objects taken from the Old Summer Palace near Beijing in 1860 by British and French troops were exceptionally large. Large bronze incense burners and sculptures of auspicious creatures, such as cranes and lions, were needed to fill the vast spaces inside the palace (fig. 142). Enormous enamel items in the shape of elephants or stupas were sent as tribute from Canton to the court of Emperor Qianlong (1736–95).[49] There are also records of vast glass chandeliers being produced by the imperial glasshouse in the early eighteenth century. A few of the very large pieces made for palace use can now be seen in Western museums.

Palaces were obviously associated with court ritual and religious cere-monies, but ordinary houses also had their religious aspects. For example, inside most houses was a household altar, although they varied in size (fig. 152). The altar may have been Buddhist, Daoist or dedicated to a popular god such as the god of wealth, or it may have been dedicated to gods common to all these pantheons. However, the set of ritual vessels would have been the same in most cases, comprising a tripod (*ding*), two *gu* beakers and two candlesticks (fig. 152). These were based on ancient Chinese bronze ritual vessels, but their uses had changed: the *gu* beakers had become flower vases and the *ding* tripod was now used to hold incense sticks or to burn powdered incense (ch. 1, p. 78).

As all families practised ancestor worship, ancestor paintings were often a feature of the household altar. However, most families also had a separate family ancestral temple, which would have accorded in size to the status of the family. There would always be ancestral tablets placed in front of an incense table, with tablets of the most recently deceased on either side.

Although five-piece ritual sets were commonplace, there were also other shapes of ritual vessel, associated particularly with Buddhism and imported from India or Tibet. From the fourteenth century onwards China was greatly influenced by Tibetan Lamaistic Buddhism, and vessel shapes reflected this. The *kuṇḍikā* (fig. 140), *khaṭvāṅga* (sceptre), conch, and monk's cap ewer (similar in shape to a Tibetan monk's cap) are all examples of such Buddhist ritual paraphernalia. However, shapes based on ancient bronzes such as *gu* also appeared in different materials and covered in Buddhist symbols, for use in Buddhist ritual (fig. 138).

At table

Any collection of Chinese ceramics, lacquer and glass contains many eating and drinking vessels. Indeed, most of the cups and bowls, ewers and plates in the British Museum come from sets produced for the feasts and banquets that have always formed an important part of Chinese life (fig. 153). Vast sets of vessels were necessary for imperial banquets as well as for large clan feasts. The ability to produce large quantities of identical vessels depended

on a highly developed production process which would continue to turn out perfectly executed designs time after time.

Chinese cuisine is world renowned and, from earliest times, food was appreciated in literature and art. The food of the ordinary peasant differed greatly from that at court, however, as is shown in the poem by the Tang poet Gao Shi: 'Ploughing the land between the mulberry trees, the land is rich, the vegetables ripen fast. May I ask how these mallows and beans compare with the viands at court?'.[50]

By the Tang dynasty, although millet was still the staple, exotic Near Eastern crops such as spinach, almonds and figs had been introduced through contacts along the Silk Route. Tropical southern products such as dates, cassia, bananas and lichees were brought to court. Lichees were considered a great delicacy and were carried on ice by couriers.[51] Rice was cultivated in southern China near Shanghai from about 5000 BC (Introduction, fig. 3); there were many differences between northern Chinese cuisine, which used meat, dairy products and grains, and southern cuisine which was based on rice and fish. Even in the Song, Sichuan province was as renowned as it is today for spicy food, while a Song text describes, 'little frogs in Fujian and Zhejiang, large frogs in central China, snake soup in Canton. The islanders of Hainan eat various insects (flies, gnats, earthworms) cooked in pieces of bamboo. The foreigners in Canton, Muslims for the most part, flavour their food with sugar, honey and musk'.[52] The Chinese have always valued diversity and have produced compendia on plants and food – for example the Ming dynasty (1368–1644) encyclopaedia of herbs, *Bencao gangmu* (*Mirror of Basic Herbs*), published by Li Shichen.

Cuisine at court was elaborate and luxurious, with a kitchen staff of 9462 in the fifteenth century.[53] The Qing Emperor Kangxi (1662–1722), on the other hand, preferred simple outdoor cooking reminiscent of his Manchu upbringing: 'Peasants make strong old men because their food is plain; on all my travels I have eaten the local vegetables and felt better for it'.[54] Novels such as *The Scholars* (*Rulin waishi*), written in the early Qing dynasty, are full of descriptions of the enjoyment of food, even by supposedly vegetarian Buddhist monks: 'Ho told his wife to cook a chicken, slice the ham and heat the wine. The abbot's face glistened as he fell to'.[55]

It seems that drinking alcohol was an even more important aspect of life than consuming edible delicacies. As early as *The Book of Songs* (*Shijing*, datable to 800–600 BC), references to feasting almost always refer to wine:

Sopping lies the dew;
Not till the sun comes will it dry.
Deep we quaff at our night-drinking;
Not till we are drunk shall we go home.

A. Waley (trans.), *The Book of Songs*, London, 1937, p. 201

In fact, getting drunk was not regarded with disapproval but was rather seen as a means of inducing a sense of power and identification with the universe. A state of intoxication was considered by many painters and poets to be a necessary aid to creativity and spontaneity. That drinking games were popular is evidenced by archaeological discoveries such as the hoard of

silver at Ding Maoqiao, which included a set of counters, inscribed with quotations from the *Analects of Confucius*, used for wine-drinking games.[56]

It is sometimes difficult to distinguish vessels used for wine drinking from those used for tea drinking; both can be seen in the banquet scene in figure 153. The high-footed cups and stands used for drinking wine were known as *taizhan*.[57]

The medicinal and stimulating effects of tea had been known to the Chinese since ancient times. There is archaeological evidence for the use of tea in the second century BC from Mawangdui, Changsha, in Hunan province, and by the fifth century AD it was a tribute item sent to court.[58]

153 Detail of a banquet scene from the painting *A Literary Gathering*, attributed to Song Huizong of the Song dynasty (AD 960–1279). Tea is being prepared in the foreground, and the larger table holds sets of vessels such as teabowls on bowl stands and spouted ewers in bowls.

154 Two wall paintings from an 11th–12th-century Liao dynasty tomb in Hebei province, showing the preparation and drinking of tea. In the left-hand painting is a lacquer bowl stand similar to that in fig. 126. In the right-hand painting, porcelain teabowls and stands and a set of tiered lacquer trays, similar to the silver box in fig. 137, are laid on a table while water is heated on a metal brazier.

During the Tang dynasty tea became a subject of connoisseurship, largely due to the publication of the *Classic of Tea* (*Chajing*) by Lu Yu. Tea came to be associated with Buddhism, particularly the Chan (Zen) sect. The Buddhist connection is apparent in the discovery of a ninth-century set of tea-drinking paraphernalia at the Famensi at Fufeng, Shaanxi province. This included a silver tea basket, tea grinder and tea strainer, as well as a glass teabowl, bowl stand and a set of Yue ware green teabowls. The tea-drinking habit was transported by Buddhist monks from Tang China to Korea and Japan. In the Song dynasty, black ceramic teabowls, particularly Jian ware, were regarded as the best for drinking tea which was whipped until white froth appeared on the surface – the white froth stood out best against a black bowl.

Teabowls and stands can be seen in the two wall paintings from an eleventh- to twelfth-century Liao tomb in Hebei province (fig. 154). In the left-hand painting, a porcelain teabowl is held in a lacquer stand; such a stand in the Museum can be seen in figure 126. In the right-hand painting a servant is heating water to make tea in a metal ewer on the brazier below the table. On the table is a pile of porcelain teabowls, upside down, their lobed sides and scalloped rims suggesting a silver prototype. There is also a set of trays made of lacquer. Their elongated flower shape, as well as the openwork sides, also suggest the influence of a silver prototype, such as the

ninth-century tiered silver box found at the Famensi Buddhist temple at Fufeng, Shaanxi province (fig. 137).

In the banquet scene painting in figure 153 tea is being prepared. There are several teabowls on lacquer stands and a servant is pouring tea into a teabowl with a long spoon. There is a square brazier heating water in metal ewers, and beside the table a girl sits drinking tea from a bowl.

Powdered tea gave way to loose tea leaves in the Yuan dynasty, which led to the development of teapots and teacups. A white porcelain ewer excavated at the site of the imperial kiln at Jingdezhen and dating to the Yongle period (1403–25) of the Ming dynasty is perhaps one of the earliest Chinese teapots. It has ring loops on the shoulder, which suggest a metal prototype.[59]

It was at Yixing in Jiangsu province, from the early sixteenth century onwards, that the most favoured teapots were made, small in size and of brown stoneware (ch. 5, fig. 184). Teapots were later made in great quantities and varieties for export to Japan and the West, where they inspired European imitations in the eighteenth century (ch. 6, fig. 215).

Miniature worlds

A recurring theme in Chinese art is the reproduction of the world in miniature, a practice which stemmed from a desire to give a sense of order to the world by depicting it in a smaller and therefore more comprehensible form. The world consisted of heaven and earth; landscape, with its mountains and water, embodied both, and was called in Chinese *shan shui*, meaning literally 'mountains and water'. Mountains, because of their height, were seen as a bridge between earth and heaven: 'The very hill, I at once knew, from which mortals may ascend into heaven,' wrote the poet Xie Linyun (AD 385–433).[60]

Chinese emperors showed their desire to demonstrate their control of the world as they knew it by collecting together rare animals and plants from faraway lands in imperial parks. They also represented the world in the plans of their tomb compounds, which incorporated mountains, both artificial and natural, to represent the ancient link between mountains, long life and immortality.[61] It was, no doubt, his wish for immortality (in addition to a lust for power) that prompted the first emperor of China, Qin Shi Huangdi (221–206 BC), to order the creation of a miniature universe beneath the artificial mountain that formed his (as yet unexcavated) tomb (ch. 3, p. 140).

The depiction of paradise in miniature was particularly common in the Han dynasty (206 BC–AD 220) because of the widespread adherence to Daoism and its notions of immortality (Introduction, p. 39). One example of a Daoist miniaturised paradise is the type of incense burner called a *boshanlu*, fashioned with a conical lid in the shape of a mountain on a sea-encircled base. The mountain represented the Daoist paradise mountain Penglai emerging from the sea. Holes in the lid permitted the smoke from the burning incense to rise. Such incense burners display an interesting coincidence of form and function: the form depicts paradise, an idea that is enhanced by the otherworldly atmosphere of the burning incense. Later, ceramic tripod incense burners were made with the same mountain-shaped lids.

The Chinese garden (fig. 151) was also a representation of the world in miniature. The essential features, mountains and water, were replicated by artificial hills, imported rocks and man-made streams and lakes. Gardens represented not only the world but also paradise. Sometimes the artificial mountains were given the name of the Buddhist holy mountain Sumeru or of the Daoist paradise Penglai.[62]

From the designing of gardens as miniature worlds came the creation of miniature gardens in basins (*penjing*). This practice was already well developed in the Tang dynasty, and can be seen on a wall painting dated AD 706 in the tomb of Li Xian.[63] The *penjing* made paradise accessible to anyone who could afford a basin, either of enamel or ceramic. In one kind of *penjing* real trees, grasses and rocks were planted, while in the other the garden was created from wire and jade, ivory and coral. It is interesting that, just as in Chinese landscape painting, there is often a small figure depicted in miniature landscapes in basins. The ever-present human figure represents the human desire to gain access to paradise. Indeed, there are stories dating from the ninth century about Daoist magicians such as Xuan Jie who could make themselves very small and jump into the miniature landscape, thus escaping from the world into paradise.[64]

References to paradises or miniature worlds can also be seen in small carvings. Tiny mountains, carved out of stone, root and wood, were collected and placed in cabinets and on scholars' desks, so that miniature worlds could be contemplated at leisure in one's study. Some of the miniature mountains included hermits' caves, which reinforced the idea of escaping from the world into a paradise or retreat (Introduction, fig. 18). Mountain-shaped brushrests were produced in jade and porcelain, enamel and ivory.

Rocks, representing miniature mountains, were also collected and placed where they could be admired, either in the home or the garden. Rocks which had been eroded by water into strange shapes were particularly valued and sought after. The Emperor Huizong (r. 1101–25) of the Northern Song was an avid collector of rocks, which he assembled in his imperial park, the Genyueyuan in Kaifeng.[65] Rocks were a popular motif on Chinese ceramics and lacquer, and were also carved out of jade and other stones.

The gourd is another example of a miniature world. A gourd was often used in Chinese literature as a metaphor for a separate, perfect world or retreat, and the gourd-heaven (*hutian*) was a term used to refer to paradise, the gourd's narrow neck representing the difficult entrance to paradise. Gourds were associated with immortals and Daoism. The Daoist immortal Li Tieguai was reputed to be able to disappear into his medicine gourd. There is also a legend, recorded in the *Hou han shu*, of a medicine-seller who hung a gourd-shaped vessel in front of his shop. Whenever the market closed, he jumped into the vessel without anyone seeing him. Of course, he turned out to be an immortal, condemned to living on earth because of a previous misdeed.[66] Gourd-shaped vases were produced in celadon, porcelain and Yixing stoneware as well as in bamboo and ivory. Real gourds were also carefully grown into moulds, usually of miniature size (fig. 155).

The Chinese passion for miniature objects can even be seen in the alacrity with which they adopted the snuff bottle in the eighteenth century, on which they then carved and painted miniature landscapes (fig. 132). Intricate

155 Small gourd grown in a hexagonal mould decorated with symbols of longevity. Qing dynasty, Kangxi period (AD 1662–1722). HT: 7.3 cm.

carvings of ivory balls within balls, produced in Canton in the eighteenth and nineteenth centuries, may also be seen as miniature worlds within worlds. Even smaller than these were fruit stones and nuts, intricately carved with paradise-like landscape scenes, which were sometimes strung together to form Buddhist rosaries. They were also placed on stands and admired as curiosities or kept in curio cabinets, together with other miniature objects. Some are so small that the details can only be seen under a magnifying glass. These delightful objects no doubt had religious connotations, connected not only with Daoist paradises but also with the Buddhist idea of 'seeing the world in a seed'.

Although the decorative arts described in this chapter are quite diverse, they share several qualities: above all, great technical accomplishment and large-scale production. Such large-scale production made it possible for large numbers of officials and members of the élite to own beautiful objects, both to wear and to use. Their beauty was often rendered in brilliant colours and refined surfaces, alluring to the eye and delicate to the touch. This abundance gave the Chinese a material lifestyle that few in other parts of the world could emulate until the twentieth century. From their elaborate ritual objects for court ceremonies to the tiny worlds carved in miniature, Chinese decorative arts provided an immensely satisfying feast for the eyes.

Notes

1. *Wenwu* 1988.10.

2. S. J. Vainker, 'Textiles from Dunhuang', in R. Whitfield and A. Farrer, *Caves of the Thousand Buddhas*, London, 1990, p. 108.

3. S. J. Vainker, 1990, loc. cit.

4. For the Han tomb at Mawangdui, see *Changsha Mawangdui yihao Han mu*, Beijing, 1973.

5. *Wenwu* 1988.10.

6. R. Whitfield and A. Farrer, 1990, op. cit.

7. Although some of the earliest appearances of the pearl roundel in China occur on architecture, it was originally a feature of metalwork, derived from beading on Hellenistic and Roman gold and silverwork such as the Mildenhall Treasure in the British Museum. An early occurrence of the motif in Chinese metalwork is on a sixth-century gilded silver ewer from Ningxia, Guyuan (*Wenwu* 1985.11, pp. 1–20).

8. Wang Zhongshu, *Han Civilisation*, New Haven and London, 1982, p. 83, quoting the *Discourses on Salt and Iron*. Also see R. Krahl, *Chinese Lacquer of the Yuan and Early Ming Dynasties*, London, 1989, p. 10.

9. R. Krahl, 1989, op. cit., p. 10.

10. *Wenwu* 1960.9, pp. 43–51.

11. *Wenwu* 1973.1, pp. 48–58.

12. National Museum of Korea, *Cultural Relics Found off Sinan Coast*, Seoul, 1977.

13. J. C. Y. Watt, *East Asian Lacquer: The Florence and Herbert Irving Collection*, New York, 1991, p. 27.

14. G. Kuwayama, *Far Eastern Lacquer*, Los Angeles, 1982, p. 50.

15. J. C. Y. Watt, 1991, op. cit., p. 34.

16. J. C. Y. Watt, *The Sumptuous Basket*, New York, 1985, p. 23.

17. Wang Shixiang and Wango Weng, *Bamboo Carving of China*, New York, 1983.

18. P. Lam, *Chinese Ivories from the Kwan Collection*, Hong Kong, 1990, p. 45.

19. Wang Shixiang and Wango Weng, 1983, op. cit., p. 49; *Chinese Bamboo Carving*, Hong Kong, 1975.

20. Yang Boda, *Tributes from Guangdong to the Qing Court*, Beijing and Hong Kong, 1987.

21. J. Rawson, 'Chinese Gold and Silver', in *The Macmillan Dictionary of Art*, London, forthcoming.

22. *Wenwu* 1972.6, pp. 52–5.

23. *Wenwu* 1982.11, pp. 15–27.

24. J. Rawson, 'Tombs or Hoards', in M. Vickers (ed.), *Pots and Pans, A Colloquium on Precious Metals and Ceramics in the Muslim, Chinese and Graeco-Roman Worlds, Oxford 1985*, Oxford, 1986, p. 36.

25. J. Rawson, 'Chinese Gold and Silver', forthcoming, op. cit.

26. *Wenwu* 1987.11, pp. 4–24.

27. *Wenwu* 1973.3, p. 43.

28. *Wenwu* 1957.2, pp. 51–8.

29. C. Clunas, 'Ming Gold and Silver', in M. Vickers (ed.), *Pots and Pans, A Colloquium on Precious Metals and Ceramics in the Muslim, Chinese and Graeco-Roman Worlds, Oxford 1985*, Oxford, 1986, p. 85.

30. A. Lutz and H. Brinker, *Chinese Cloisonné: The Pierre Uldry Collection*, Zurich, 1985, p. 44.

31. Yang Boda, *Zhongguo meishu quanji, Gongyi meishu*, vol. 10, Beijing, 1987, p. 23 and pp. 158–9.

32. Chang Linsheng, 'Ching-t'ai lan' ('Early Ming Dynasty Cloisonné), *National Palace Museum Bulletin*, vol. XXIV, nos 1–3, 1989; J. Henderson, N. Wood and M. Tregear, 'The Relationship between Glass, Enamel and Glaze Technologies', in P. E. McGovern and M. Notis (eds), *Ceramics and Civilization*, vol. IV, *Cross-Craft and Cross-Cultural Interactions in Ceramics*, Westerville, Ohio, 1989.

33. M. Gillingham, *Chinese Painted Enamels*, Oxford, 1978, p. 7.

34. S. Jenyns in S. Jenyns and W. Watson, *Chinese Art: The Minor Arts*, London, 1963, p. 264.

35. An Jiayao, 'Early Chinese Glassware', *Kaogu xuebao*, 1984.4, pp. 413–48 (trans. M. Henderson, *Oriental Ceramic Society Translations Number 12*, 1987, p. 2).

36. Ibid., p. 4.

37. *Wenwu* 1988.10.

38. Yang Boda, 'A Short Account of Qing Glass', in C. Brown (ed.), *Chinese Glass of the Qing Dynasty 1644–1911*, Phoenix, Arizona, 1987, p. 76.

39. C. Brown and D. Rabiner, *Clear as Crystal, Red as Flame*, New York, 1990, p. 21.

40. Ibid., pp. 22–3.

41. Yang Boda, 1987, op. cit., p. 139.

42. J. Legge (trans.), *Li Chi, Book of Rites*, New York, 1967, vol. 2, p. 9.

43. E. Biot (trans.), *Zhou li*, translated as *Le Tcheou-Li*, Paris, 1851, vol. 2, p. 514 (reprinted Taiwan, 1975).

44. *Changsha Mawangdui yihao Han mu*, Beijing, 1973. Examples of later, twelfth-century, royal costumes excavated from northeast China can be seen in Zhu Qixin, 'Royal Costumes of the Jin Dynasty', *Orientations*, December 1990, pp. 59–64.

45. G. Dickinson and L. Wrigglesworth, *Imperial Wardrobe*, London, 1990, pp. 98–114. Much of the information on Qing dress has been drawn from this source.

46. J. Rawson in J. Rawson and E. Bunker, *Ancient Chinese and Ordos Bronzes*, Hong Kong, 1990, p. 224.

47. S. Kwan, 'The Art of Ivory and Bone Carving in Ancient China', in *Chinese Ivories from the Kwan Collection*, Hong Kong, 1990, p. 16.

48. Translated as *The Story of the Stone* in 5 vols by D. Hawkes and J. Minford, London, 1973–86. Also translated and abridged as *The Dream of the Red Chamber*, by Franz Kuhn, London, 1958.

49. Yang Boda, 1987, op. cit.

50. E. N. Anderson, *The Food of China*, New Haven, 1988, p. 67.

51. Ibid.

52. J. Gernet, *Daily Life in China on the Eve of the Mongol Invasion: 1250–1276*, Stanford, 1962, p. 142.

53. E. N. Anderson, 1988, op. cit., p. 103.

54. J. Spence, *Emperor of China: Self-Portrait of K'ang-hsi*, London, 1974, p. 97.

55. E. N. Anderson, 1988, op. cit., p. 120.

56. See footnote 24.

57. J. Ayers, 'From Cauldron to Teapot', in *Chinese Ceramic Tea Vessels*, Hong Kong, 1991, p. 69.

58. S. Chiu, 'The History of Tea and Tea Making in China', in *Chinese Ceramic Tea Vessels*, Hong Kong, 1991, pp. 27–8.

59. J. Ayers, 1991, op. cit., pp. 73–4.

60. H. C. Chang, *Chinese Literature 2: Nature Poetry*, Edinburgh, 1977, p. 52.

61. L. Ledderose, 'The Earthly Paradise: Religious Elements in Chinese Landscape Art', in S. Bush and C. Murck (eds), *Theories of the Arts in China*, Princeton, 1981.

62. Ibid.

63. J. Hay, *Kernels of Energy, Bones of Earth: The Rock in Chinese Art*, New York, 1986, p. 76.

64. R. A. Stein, *The World in Miniature: Container Gardens and Dwellings in Far Eastern Religious Thought*, Stanford, 1990, p. 53.

65. J. Hay, 1986, op. cit., p. 25.

66. R. A. Stein, 1990, op. cit., p. 67.

5

Ceramics for use

*The scrolls of a master
require fine, solid boxes;
Exquisite tea requires
bowls from the Yue kilns.**

Ceramics are the most enduring of all China's decorative arts: they have been produced for a longer period (more than eight thousand years), over a wider area (the entire country) and with greater artifice than any other category of luxury or everyday object (map VII, p. 367). Ceramic production, however, was never devoted to the creation of 'art objects', and such items occur only rarely within a ceramic history which includes architectural, burial, utilitarian, trade and ceremonial objects.[1]

The ceramics preserved today in museums comprise only a tiny proportion of the huge quantities made. Most ceramics were used in everyday life, broken and thrown away, and only a few types have been seriously collected. The first high-quality ceramics to be prized by collectors were those of the Song dynasty (AD 960–1279), which were collected in the Ming (1368–1644) and Qing (1644–1911) dynasties.

In the West, Chinese porcelain has been valued for its variety in shape, brightness of ornament, and the fineness and whiteness of a body material which inspired many elaborate imitations; it is well known because of the quantities in which European countries imported it from the sixteenth century onwards. The strong forms and subtle glazes of earlier Chinese ceramics are probably most familiar in Britain as a source for the work of Bernard Leach and other twentieth-century 'studio potters'.

The excellence of Chinese ceramics, however, owes little to the inspiration of individual potters. It is rather the result of the efficient organisation which existed in all manufacturing industries, but especially in the ceramic industry, from earliest times (Introduction, pp. 30–1). Bronze foundries of the thirteenth century BC, for example, were already highly organised, with probably several separate stages of production, requiring very specialised ceramic skills for mould making (ch. 1, fig. 21). One millennium later, comparable division of labour in ceramic workshops made possible the production in the late third century BC of the famous pottery army of China's first emperor, comprising more than seven thousand life-size figures of warriors and horses (ch. 3, fig. 91). During the Ming dynasty kilns at a single

*from 'Song li bu cao lang zhong mian guan nan gui' by Zheng Gu, in Tong Jiaoying (ed.), *Tong Shuye meishu lunji*, Shanghai, 1989, p. 751

centre in south China – Jingdezhen – produced sufficient porcelain to supply the whole country and much of the rest of the world as well, using related methods of mass-production.

The different tasks, such as preparing the material, forming and decorating the pieces, were subdivided among a number of different craftsmen with many workers involved at each stage, as shown in a series of illustrations of the processes of porcelain making (fig. 156). A single item might pass through the hands of as many as seventy men, as described by the Jesuit missionary Père d'Entrecolles in two letters, dated 1712 and 1722:

All of the symmetrical work is made in the first manner [on the wheel]. A cup for example, when it comes off the wheel is only an imperfect cap-shape, a little like the top part of a hat which has not yet been applied to a form. This worker only gives it the height and the diameter that is desired, and it leaves his hands nearly as soon as it starts there; for he only makes three deniers [cash] per plank, and each plank contains twenty-six pieces. The foot of the cup is then only a piece of clay of the size and diameter that is desired, and must be hollowed out with a chisel when the cup is dry and has the proper consistency, that is to say after it has received all the ornamentation that one wishes to give it. The cup, on leaving the wheel, is next received by a second

156 Four watercolour prints from a series of twenty-four scenes illustrating 'ceramic processes': (*top left*) painting the unglazed ware, no. 5; (*top right*) applying the glaze, no. 6; (*lower left*) transport from the factory, no. 11; (*lower right*) packing in cases for export, no. 12. Canton, 19th century AD. The first such series was that painted for the Emperor Qianlong (r. 1736–95) and annotated by his supervisor of porcelain production, Tang Ying. Many similar series were produced in the 19th century in the southern port of Canton, and sold to foreigners. (each print): 39.5 x 51 cm.

worker who sets it on its base. A little after that it is delivered to a third who puts it on its mold and impresses the form on it. This mold is on a kind of wheel. A fourth worker polishes this cup with a chisel, especially toward the rim, and makes it as thin as is necessary to give it some transparency. He scrapes it several times, moistening it a little each time if it is too dry, for fear that it might break. When one takes the cup off the mold, it is necessary to rotate it gently on the same mold without pressing it more on one side than on the other, for without this treatment there would be hollows in it, or it might even collapse. It is surprising to see with what speed these vessels pass through so many hands. It is said that one piece of fired porcelain passes through the hands of seventy workers.

R. Tichane, *Ching-Te-Chen: Views of a Porcelain City*, New York, 1983, pp. 71–3

The highly organised methods of production at Jingdezhen merely elaborated and standardised methods already employed at many other kilns. Indeed, other kilns had by these means achieved an immense output, some of very high quality and others of a much lower grade. As we shall see, top-quality objects included wine cups, flasks and bowls, vases and temple wares for use at court. Even today such pieces are among the most impressive ceramics ever made. Lower-grade pieces were baked bricks and earthenware jars. The great diversity of China's geology, as well as the size of both the country and its demands, stimulated one of the most enduring and varied craft industries the world has ever known.[2]

Materials

No amount of manufacturing and managerial skill could have produced such results from mediocre raw materials, however, and the availability of a variety of high-quality clays is of prime importance to China's ceramic success. Three geological types are dominant: loess, sedimentary clay and porcelain stone.

Loess is the thick blanket of dusty, ochre-coloured clay that lies across north China's 'yellow earth' (Introduction, fig. 2). It consists of rock from the Inner Mongolian deserts, initially broken up by alternate freezing and thawing, and then carried eastwards as dust by the winds to settle across the north China plains in a layer which lies 300 metres deep in some places.[3]

Loess consists mainly of quartz, feldspar and mica, with less than 15 per cent of its composition accounted for by true clay minerals. In its primary form, Chinese loess is not plastic and is, therefore, of limited use as a ceramic material. The main application of primary loess in manufacturing is in bronze technology, as the material for the piece moulds from which bronze vessels were cast in the Shang dynasty (c. 1500–1050 BC) (ch. 1, fig. 21). The low clay content limited shrinking during drying and firing, so that the moulds were able to retain the necessary complex interlocking forms, as well as fine ornamental detail.

Loess that has been either weathered or redeposited after transportation in water becomes enriched with clay and can be used for making vessels and models. Important examples are the bowls and jars made in the Yangshao

Neolithic culture of northwest China, as early as 5000 BC; the pottery army made for the tomb of the first Qin emperor in the late third century BC (ch. 3, fig. 91); and the lead-glazed burial wares produced during the Han dynasty (206 BC–AD 220). A widespread use of loess was in the construction of city walls, such as those of the middle Shang capital Zhengzhou in Henan province (c. 1500 BC), which are built up of layers of loess stamped down hard to a thickness of only a few centimetres.

Beneath the loess lie occasional deposits of the sedimentary clays, kaolin and fire clay, mostly of good quality, which provided the material for the high-fired ceramics produced at hundreds of kiln centres across north China right up until the early Ming dynasty. Famous Song dynasty (AD 960–1279) wares, such as Ding porcelain and the various green-glazed wares (Ru, Jun and Yaozhou), as well as the painted wares of Cizhou, were all products of northern Chinese kilns, as are many other, more mundane, black wares, white wares and greenwares. The extraordinary diversity produced from relatively uniform materials is described below.

The purest of the northern clays is a sedimentary clay known as secondary kaolin, derived naturally from primary kaolin, a clay that is washed out from granite rocks, then dried and formed into bricks. Secondary kaolin has already been washed from its rocks, mixed with other minerals and deposited in sedimentary strata far from its original source. Secondary kaolin is usually low in iron oxides, which are the prevalent contaminant of clay throughout the world. These almost pure white clays were first used for ceramic vessels in the later part of the Shang dynasty, from the thirteenth to the eleventh century BC, when thick-walled shapes with deeply cut ornament were made for burial alongside the cast bronze and carved marble vessels that they were imitating. All the surviving examples have been excavated in Henan province at Anyang, the late Shang capital, and the material appears not to have been used after that dynasty's downfall until the sixth century AD, 1500 years later (fig. 157).

The tomb of Fan Cui at Anyang, dated AD 575,[4] contained high-fired white wares made of kaolinitic clay, and throughout the Sui (589–618) and Tang dynasties such white wares continued to be made in that area at the Gong xian kilns and also at the Xing kilns in Hebei province (discussed below).

Both kiln complexes are situated in the foothills of the Taihang mountain range, where the loess is thinner and the underlying clay therefore more accessible. In the ninth century, and throughout the Song dynasty, high-quality white wares continued to be produced in Hebei at the Ding kilns not far from the Xing kiln site (ch. 6, fig. 195). Some of the seventh-century white wares are so white, so hard and so thin-bodied, and fired at such high temperatures, that they are considered by many to be the world's earliest porcelain. A few of these early northern porcelains are translucent, but they are none the less quite distinct from the ceramics made from the southern Chinese porcelain stone for which China is famous, and which were first produced only in the tenth century AD.

The third type of high-quality clay, porcelain stone, comes from deposits in southern China, which are part of a geological formation extending from Japan and Korea in the east, across China from Zhejiang on the coast to

157 White-ware jar with four lug handles. 7th century AD. The jar was made in north China, possibly at the Gong xian kilns in Henan province. The flat base, lug handles and proportions are comparable to the greenware jar illustrated in fig. 161. The base is unglazed, and a swag mark above the foot suggests that the glaze was applied by dipping. The simple, full form of the jar is in contrast to the metal-influenced West Asian forms produced in white high-fired porcelain at the same period (see ch. 6, fig. 195). HT: 30.1 cm.

158 (*opposite*) Lead-glazed horse. Tang dynasty, first half of the 8th century AD. The horse belongs to the tomb group illustrated in ch. 3, fig. 93. The cream glaze has been splashed with yellow in small amounts and the green, which has run considerably, has tinged much of the animal. Lead glazes, despite their relatively high viscosity, run quite easily, and on the neck of this piece the glaze has also crawled, which is less usual. A deep groove along the back of the animal's neck would have held a hair mane, and an aperture at the end of the horse would similarly have provided a fixing for a tail. The horse is boldly modelled, and its body is hollow. HT: 85 cm.

Yunnan in the southwest, and continuing on into northern Vietnam. The material is the result of volcanic processes that alter the structure of quartz-feldspar rock; it is especially pure in Jiangxi province around Boyang Lake and the city of Jingdezhen. In this region particularly, potters mixed porcelain stone with primary kaolin, which often occurs in association with it. Porcelain stone was used, unmixed, from the tenth century, and primary kaolin was first added in the Yuan dynasty, producing a smoother, more plastic paste. Underglaze painting on porcelain was introduced at Jingdezhen at around the same period, and indeed one of the great advantages of adding kaolin was the better ground it provided for painted ornament. It is probably this characteristic, combined with its capacity to help prevent wares from slumping in the kiln, that explains the steadily increasing proportion of kaolin in porcelain throughout the Ming dynasty, resulting in the eighteenth century in a fifty-fifty composition.[5]

So far we have distinguished the main Chinese ceramics by their body clay. Ceramics may also be categorised by glaze type, the three principal types in China being lead, high-temperature and alkaline glazes.[6] All glazes are composed of silica, the main glass-forming oxide; alumina, which occurs in clays together with silica; and a range of fluxes. Flux is the term for a material added to the glaze in order to lower its melting temperature. As pure silica does not begin to melt to glass until the temperature reaches 1700°C, providing the hardest possible material in the ceramic spectrum, fluxes are essential ingredients in any ceramic glaze, and it is the flux which dictates the nature of the glaze. Lead oxide, for example, has a low melting point and can provide a glaze at earthenware temperatures, from as low as 700°C to as high as 1200°C. A further advantage of lead glaze is that it responds well to colouring oxides, hence iron oxide (to give yellows and browns) and copper oxide (to give green) were both widely used as colourants of the earliest lead glazes. Glazes fluxed with lead first occurred in China during the third century BC, shortly before the Han dynasty (206 BC–AD 220), during which time their use on burial ceramics became widespread (fig. 158). The models of houses, stoves, watchtowers, animals and humans which accompany even quite modest Han burials are mostly glazed green, though on many examples the colour has since deteriorated to a silvery iridescence, bearing only faint resemblance to the deep, glossy tones of a newly fired or well-preserved green lead glaze. This is a result of exposure to water during burial, and does not occur on the famous three-colour lead glazes of the Tang dynasty.[7]

Between the Han and Tang dynasties, that is from the third to the seventh century AD, evidence of lead glaze is scant. The tomb of Sima Jinlong, situated at Datong in Shanxi province and dated AD 484, yielded dozens of lead-glazed figures, but otherwise few examples are known.[8] The tomb of Li Feng, prince of Guozhong, fifteenth son of the Tang Emperor Gaozu, is dated 675 and provides the next significant group of lead-glazed wares.[9] The green, amber and cream glazes produced between then and the middle of the eighth century were, like their antecedents in the Han dynasty, applied to burial wares, particularly figures, and represent one of the great achievements in Chinese ceramic history (these are described below).

A suitable glaze flux applied raw to a clay body can react with the silica

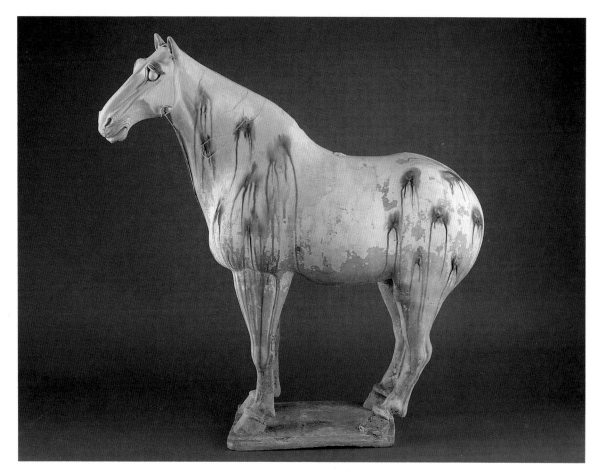

content of the clay to produce a glaze. This simple method of creating a 'sacrificial' glaze, by applying flux to a clay body and firing it, is the origin of China's longest and most distinguished glaze tradition, that known loosely as high-temperature glaze.

Limestone and woodash both contain the fluxing agent calcium oxide. The very earliest glazes are supposed to have formed accidentally when woodash in the kiln fell on the pots during firing, reacting to form a glaze. Deliberately glazed vessels found at the middle Shang capital at Zhengzhou in Henan are coated with a thin, transparent, yellowish-green glaze. The colour is the result of iron being fired in a reducing atmosphere (where the amount of oxygen in the form of air entering the kiln is slightly restricted). As glazing and firing skills developed over the centuries, thicker, more greyish-green glazes were produced, culminating in the 'secret colour' Yue wares of the late Tang period (pp. 233–4). This class of ceramic is known generally as greenware and has often been called the backbone of Chinese ceramics.[10] The various glazes of the Song wares from north China are fluxed with limestone and/or woodash and fall into the same high-temperature category. Glazes fluxed mainly with calcium oxide can melt at temperatures from about 1170°C upwards, temperatures suitable for producing strong-bodied ware from northern clay; such high-fired wares form the group of

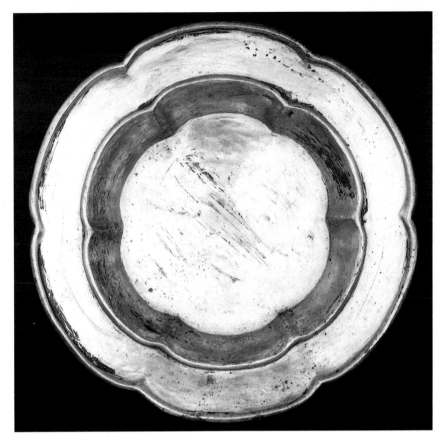

159 Silver dish. 12th century AD. The lobing is also seen on many high-fired ceramic shapes, although Ding ware more than any other imitated the forms of silver. The most evident feature is the thickened rim, which has been copied in the Ding dish in figure 160. DIAM: 19.8 cm.

ceramics often referred to, for want of a better term, as stonewares.

In south China particularly, the silica and alumina which form the base of a glaze are usually derived from the same or similar materials as those used for the ceramic body. Porcelain glazes are thus composed of porcelain stone, fluxed with calcium carbonate in the form of burnt limestone, and are high-temperature glazes.

Alkaline glazes, often brightly coloured, are the third and least significant of the major glaze types. They are fluxed with potassium and/or sodium oxides and, while central to the ceramic tradition of the Middle and Near East, in China this type of glaze was used mainly for temple ceramics in the Ming and Qing dynasties, and on the vessels known as *fahua* type (Ceramics glossary). The most easily recognisable alkaline glaze is the turquoise of the *fahua* palette.[11]

Techniques

The quality, diversity and distribution of ceramic materials in China are remarkable; equally impressive, however, are the skilful and innovative techniques by which these materials were transformed into pots, bricks and ornaments. Even some of China's earliest ceramics, such as Banshan phase Neolithic urns from northwest China, are of such an even consistency that the body material, if not actually washed, was probably at least selected with care; some even appear to have been finished at the rim on a slow wheel.

Technology can advance in two ways. The fundamental processes, which

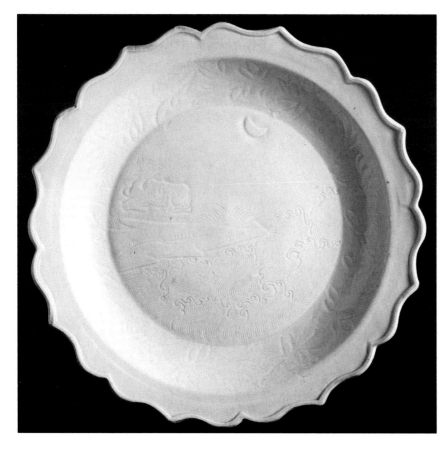

160 Dish, Ding ware. 12th century AD. The rim, copied from silver ware of the same period (fig. 159), has been formed by shaping the dish on a mould. This piece is unusual for combining a moulded shape with incised decoration, particularly as the complete design of a contemporaneous Southern Song album leaf painting has been reproduced, with a diagonal composition of a cow by a shore gazing at the moon. The cavetto is incised with a floral design and the base is glazed.
DIAM: 20.8 cm.

in the case of ceramics are modelling, decorating, glazing and firing, may be explored, improved and taken to the limit, so that one particular perfect pot may be produced by essentially the same means as a much older or rougher prototype. Alternatively, demand for new types may stimulate innovation. On occasions when, for example, a metalwork shape[12] or a hardstone surface appearance was required of ceramic material,[13] new ways of modelling clay and new glaze recipes were developed in response.

Taking early ceramics as examples, the first form of technological advance may be demonstrated by the comparison between a glazed ware, one of the first, excavated at the mid Shang capital Zhengzhou (c. fourteenth century BC), and a late Tang dynasty greenware from the Yue kilns in Zhejiang province. The Zhengzhou piece has a thin, transparent, yellowish-green glaze, while the Yue ware is rather more evenly glazed, with a smooth, grey-green appearance. The contrast is evident, yet both glazes are the result of iron within the glaze being fired in a reducing atmosphere and both belong to the class of ceramics termed *qingci* ('green-coloured high-fired ceramic') in Chinese, and greenware in English.[14]

The second, market-led type of advance is best exemplified amongst early ceramics by the relationship between Ding ware and silver (figs 159–60). The fine white porcelaneous ceramics made at the Ding kilns in Hebei province in north China, from the tenth to the thirteenth century AD, resemble silver not only in their carinated shapes and pale colour but above all in their extraordinarily thin bodies and light weight. Early white wares are fairly thick and heavy. However, as demand for high-quality silver wine

161 Greenware jar. Sui dynasty, 6th–7th century AD. The green glaze on this piece has the yellowish tone of Shang and Zhou greenwares rather than the typical grey-green hue of the Zhejiang greenwares produced from the 3rd to 10th century AD. The glaze coats the vessel thinly and has mostly pooled around the shoulder ridge and the pinched band around the middle of the jar. Where it has pooled, the glaze has fired to an opaque pale blue, comparable to the splashes on Tang dynasty black wares from Henan. The flat base and lug handles are typical of Sui dynasty (589–618) vessels from north China. HT: 25.2 cm.

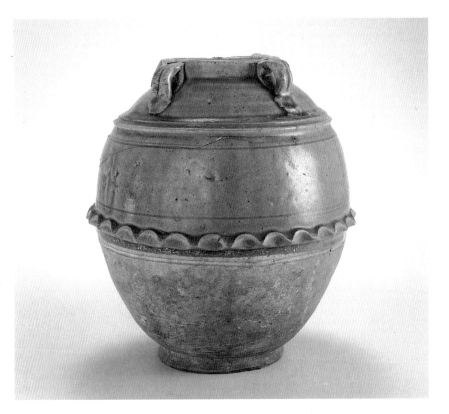

vessels grew and, it seems, eventually exceeded supplies, silver shapes were copied in white porcelains, the potters developing ways of carving the sides of the cups and bowls to make them as thin as beaten metal. To fire such delicate forms, Ding wares were turned upside down so that the rim would support the vessel as it was heated in the kiln.

At Jingdezhen in south China technical progress occurred by both means simultaneously, so that the ultimately white, smooth, translucent porcelains of the eighteenth century were produced at the same time and at the same kiln centre as were the elaborate sculptural pieces demanded by European customers. These latter pieces were not at all easy to produce in porcelain paste, and complex moulds had to be constructed for them in an effort to reduce the likelihood of drying cracks and kiln distortion.

The processes of ceramic production

Modelling

Earthenware vessels were modelled by hand until some time in the middle of the Neolithic period and, in most regions, probably for some time after that. The earliest vessels appear to have been constructed from pads of clay, usually no greater than about 6 by 4 centimetres, pressed together to build up a pot by creating a patchwork in vessel form.[15] The technique appears to have been used in what is loosely called the Peiligang culture (c.6500–5000 BC) of central north China. The next process to be established was coiling, used in Henan, Shaanxi, Gansu and Qinghai provinces in central

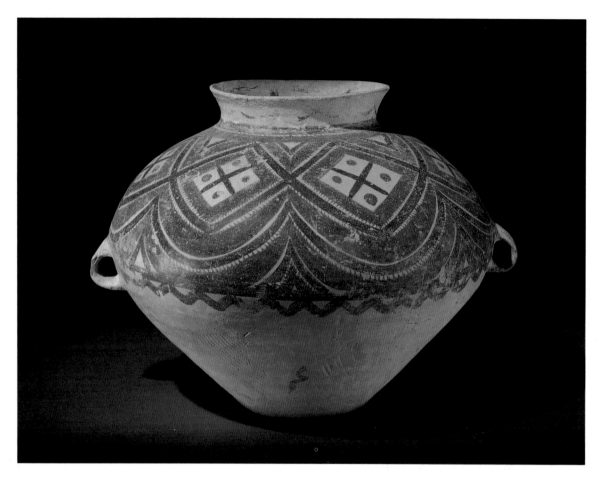

and northwest China to form some of the best-known early ceramics – the large painted urns of the Yangshao culture (fig. 162). The method was simple: thick ropes of clay were rolled out and then coiled round on top of one another in order to give the vessel the desired profile; the joins of the coils were then smoothed so that no ridges remained between the original layers. The smoothed vessel was beaten into its final shape with a paddle and anvil, that is, a support held against the inside of the vessel, while the exterior was beaten smooth. Close inspection of Yangshao earthenwares shows neither ridges nor paddle marks, and examination under xeroradiography (a process similar to X-ray, but more revealing) has shown that the paddle-beating was impressively neat and regular, following the pot upwards diagonally from base to rim.[16] The vessels were then finished by scraping and burnishing, occasionally followed by painting and further burnishing.

The great advance in clay modelling took place in east China, during the middle phase of the coastal Neolithic culture called Dawenkou. In Shandong province, in about 2900 BC, the fast potter's wheel was invented;[17] five thousand years later it remains the principal means of producing ceramic vessels. Wheel-throwing as a technique enabled speedier manufacture and was more versatile than hand-modelling. It was only ever superseded in China by moulding, a practice which was a little slower than throwing by

162 Urn from northwest China. Yangshao Banshan type. Red earthenware with black and purple painted decoration. The bold linear decoration is executed with a soft brush. Wave and net designs are typical of Neolithic painted decoration in northwest China where, at that time, most communities settled near and were dependent on rivers and fish. Vessels of this type are light, despite their large size. HT: 34 cm.

hand on a wheel, but gave less variable results. It was ultimately a quicker process than wheel-throwing because shaping and decorating were achieved simultaneously in a single process. Moulding of vessels only began on a large scale in the Song dynasty, when it was introduced at the white ware and greenware Ding and Yaozhou kilns in the north, towards the end of the eleventh century AD. Moulding of figures, however, began considerably earlier, indeed no later than the Qin dynasty (221–207 BC), when the famous pottery warriors were made. The best-known examples, however, are the burial wares of the Tang dynasty, which include horses, camels and a variety of human figures, moulded in several parts and then luted together with diluted clay. Much earlier use of moulds is found in bronze casting and in the making of the pottery army (ch. 3, fig. 91). The introduction of moulds for producing bowls and dishes during the Song dynasty almost certainly occurred in response to market demand. Although there is no reason why many different shapes and sizes of mould should not be produced, any one piece will be identical to many others. This makes the vessels less desirable as individual artefacts, but available to many more people. The quality of body and glaze is not compromised, and only the vigour of the decoration may be deemed to have suffered slightly. Moulding techniques pioneered in China were later refined at European potteries, most notably in the system known as a 'jigger and jolly', and finally reintroduced to south China in the European form.

Decorating

The decorating process follows on from modelling. Chinese ceramics are justly famous for their glazes, but they may also be decorated by painting, incising and moulding. Painted decoration occurs in bold and often intriguing forms on the Neolithic urns of the Yangshao culture (mentioned above) and also on some Neolithic vessels from China's east coast. However, painted ceramics were ousted by elaborately formed and pierced examples made by Neolithic people on the east coast, and painted ornament only reappeared, much altered, towards the end of the Bronze Age as a means of reproducing lacquer-painting styles on earthenware burial vessels of bronze form.

From the Western Han dynasty until the late Tang, painting on ceramics was more or less confined to iron-brown highlight spots on greenwares from eastern China and pigment painting of clothes, ornaments and facial features on tomb models. Proper painted ornament first appeared in the late eighth or early ninth century on vessels made at the Tongguan kilns near Changsha in Hunan province, in south China.[18] Tongguan wares were high-fired, robust stonewares, usually with iron-yellow glazes. As well as being a widespread utilitarian ware throughout south China, they were exported (via the port of Yangzhou in the east) as far afield as Africa. Tongguan wares are technologically innovative on several counts, the most significant being the established use of underglaze painting. The painted decoration on earlier ceramics may be beneath, mixed in with, or on top of the glaze; on the late eighth- and ninth-century products of the Tongguan kilns, however, it clearly lies beneath the glaze. The decoration, like the pots themselves, is vigorous and everyday, consisting of bird, plant and child motifs as well as

dotted patterns, and brief poems, of similar metre but more rustic content than those composed contemporaneously at the Tang capital in the north.[19]

Underglaze painting does not appear to have been developed elsewhere after the demise of the Changsha kilns in the tenth century, despite occurring at the same time at Qionglai in Sichuan province. The closest subsequent type is the equally robust ceramic known loosely as Cizhou ware, although it was produced at a large number of kilns in Henan and Shaanxi provinces as well as at the site of this name in Hebei. Cizhou ware is renowned for the use of contrasting black and white slips to produce bold, fluid or fine designs beneath a transparent glaze.[20] The decoration is frequently delineated with incised lines, or created by scraping away one slip to reveal a design through contrast with an underlying slip layer, but equally often it is painted in sweeping strokes of black slip on white. This slip-painted ornament frequently includes calligraphy, as did its southern underglaze predecessor, yet it also takes the form of narrative scenes from popular legend and literature (fig. 163). Narrative figure painting on Cizhou-type wares is a source for some of the less formal ornament on blue-and-white Jingdezhen porcelain of the fourteenth and fifteenth century. It is remarkable that a step as momentous as painted decoration should take such a long, winding path of development, from ninth-century Hunan via eleventh-century Henan to fifteenth-century Jiangxi.[21] Not much that was innovative occurred within the Jingdezhen giant, yet so many shapes and incised motifs were adopted from the north during Jingdezhen's early production period, in the eleventh and twelfth centuries, that it is tempting to conclude that painted ornament

163 Painted high-fired ceramics: (*back row, left to right*) *meiping* vase with turquoise glaze over slip-painted decoration, Cizhou type, 15th century AD; porcelain *guan* vase with underglaze cobalt-blue decoration, Jingdezhen, 15th century AD; vase with brown and white slip-painted decoration beneath a transparent glaze, Cizhou type, 12th century AD; (*front*) bowl with underglaze painted schematic floral decoration, Qionglai, 9th century AD. The decoration on these robust pieces includes hastily executed floral designs and narrative scenes from vernacular literature; all four pieces illustrate the popular origins of painted ornament on ceramics. HT: 28.5 cm; 33.5 cm; 23.4 cm; DIAM: 18.5 cm.

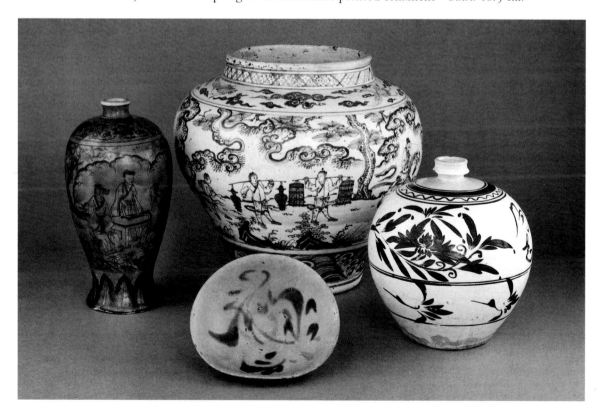

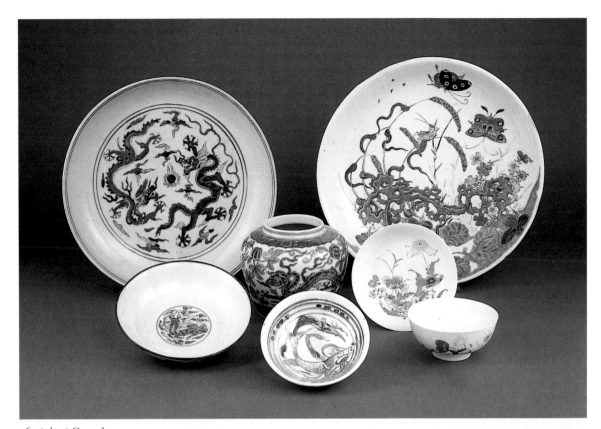

164 (*above*) Overglaze enamel-decorated wares. In chronological order: Cizhou-type bowl with iron-red fish, north China, 13th century AD, HT: 5.5 cm, DIAM: 13.8 cm; Jingdezhen dish with beast in the centre and enamelled exterior, metal rim, Chenghua mark and period (1465–87), DIAM: 18 cm; Jingdezhen jar with dragon amidst melons and foliage, Chenghua mark and period HT: 12 cm, DIAM: 11 cm; Jingdezhen dish with two dragons chasing a flaming pearl, Longqing mark and period (1567–72), DIAM: 32.5 cm; Jingdezhen *famille verte* dish with plant and butterfly decoration, early 18th century, DIAM: 34.3 cm, HT: 6 cm; Jingdezhen *famille rose* bowl and stand, Yongzheng mark and period (1723–35), HT: 6.4 cm, DIAM: 15.5 cm.

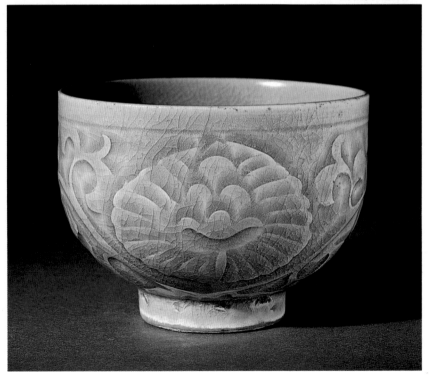

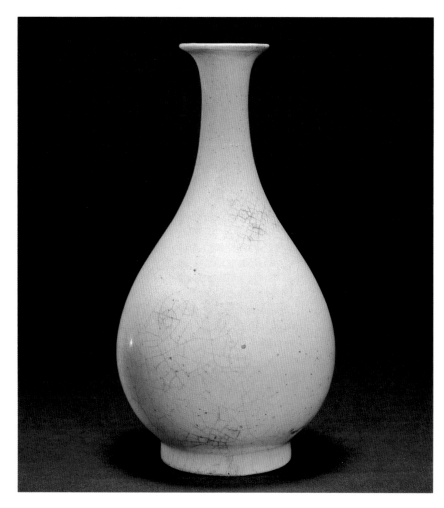

166 Vase, Ru ware. Late
11th–early 12th century.
Bottle-shaped vases of the
Northern Song dynasty
(960–1126) were probably
developed from Tang dynasty
Buddhist bronze and
white-ware flasks (see
fig. 173). The shape
continued throughout the
Southern Song and Yuan
dynasties, when porcelain
versions from south China
were decorated with either
incised or painted ornament.
The proportions of Northern
Song monochrome vases vary
from kiln to kiln, this
example being most closely
matched in Yaozhou wares
from Shaanxi province. The
shape shows high-quality
glazes to advantage; the
thick, smooth, duck-egg-
blue glaze on this piece
covers the entire vessel
except for the footring.
HT: 19.8 cm.

165 (opposite below)
Straight-sided cup, Yaozhou
ware. Song dynasty, 11th
century AD. The small,
straight-sided cup is a
Northern Song shape
particularly favoured at the
Yaozhou kilns of Shaanxi.
Deeply carved decoration is
typical of Yaozhou
greenwares, though the
opened flower motif also
occurs widely on both
Cizhou wares of the north and
qingbai wares from the south.
Yaozhou wares are often
known as northern celadon
and may be broadly
distinguished from the
greenwares of east China by
their olive-yellow rather than
blue-grey tone. The Yaozhou
kilns are best known for
greenwares but, like other
northern kilns in the Song
dynasty, produced a wide
range of black wares, white
wares and sancai in addition
to the principal type.
HT: 11.1 cm.

was for some reason simply not of interest to those in charge of the kiln at that time.

Just as underglaze painting originated on Tongguan wares, so overglaze enamelling began on Cizhou wares. Ferric oxide, suspended in a glaze to form a red enamel,[22] occurs painted over the glaze on bowls and figures from Henan, Shaanxi and Shandong in the thirteenth century. At fourteenth-century Jingdezhen painted decoration was applied to the modelled and dried porcelain body, which was subsequently glazed and given a single firing (fig. 164). During the Yongle period (1403–25) of the Ming dynasty, wares thus produced were painted in enamels on top of the fired glaze and given a second firing at a lower temperature. The adjustments to this technique which gave rise to the *famille verte* enamel palette at the end of the seventeenth century and to the *famille rose* some twenty years later are the main post-Xuande technical innovations at the imperial kiln complex (Ceramics glossary); almost every other development in painted ornament may be seen rather as a refinement of existing practice. The history of painted decoration on Chinese ceramics is, then, a tale of popular style influencing courtly tastes.

Incising ornament offers the same possibilities as painting, but with subtler results. Incised motifs occur most widely on Song dynasty ceramics, though the technique had been used previously on Tang *sancai* ware, to define the different coloured glazes where they ran together, and even more widely on Tang Yue wares, where it was a primary ornamental technique.[23] The motifs incised on Song dynasty Ding, Yaozhou and *qingbai* wares are fluid, often brief, and frequently pictorial. Yaozhou greenwares are renowned for being so deeply incised as to be termed carved or even cut (fig. 165); deeply incised designs and the use of an asymmetric bamboo tip to make lightly incised lines create decoration with a double impact, for the line carved on the leatherhard body is emphasised by the glaze pooling along the deeper side of the cut. Incised designs on *qingbai* wares of the fourteenth century are reproduced on early underglaze painted wares; though eclipsed by the establishment of painting as a decorative technique, incised decoration was continued throughout the Ming and Qing dynasties, even if contrasting designs were painted over it in enamel or it was executed so subtly on white vessel interiors that it was barely evident unless the vessel were viewed by transmitted light (for example, filled with liquid).

Although mentioned last, glazing was the most important method of decorating ceramics. Fired at high temperatures, with careful control of impurities such as iron and copper, glazes produced both subtle and brilliant colours. These effects made possible the imitation of metalwork and hardstone surfaces and as a result raised the status and artistry of the whole ceramic industry. The most famous examples are the principal wares of the Song period (AD 960–1279): Ding white ware, and the various subtle greenwares – Ru (duck-egg blue, fig. 166), Guan (crackled grey-green) and Longquan (turquoise green) – all except Guan named after the places where they were made. These were produced from the tenth to the thirteenth century, and developed from earlier monochrome wares of the seventh century onwards. Smooth texture and fine colour can preclude the need for more vibrant methods of decoration, and a comparison between the forms of Song monochrome pieces and those of porcelain with painted decoration would suggest that the proportions of the single-colour pieces seem superior to our eyes, as indeed they need to be when there is no decorative distraction. Monochrome porcelains of the Ming and Qing dynasties, used mostly for ceremony, represent comparable technical accomplishment in their glaze effects. Indeed, their brilliant colours perhaps even surpassed the generally muted tones of Song porcelains, matching the bright colours of textiles also used in ceremonies. The bright, dark red colours were particularly difficult to make and were inevitably much prized.

Firing
Firing is the last major process in ceramic production. Modelled and decorated wares, once placed in the kiln, undergo three states of firing: loss of water from between the clay particles; loss of chemically combined water from the clay molecules themselves (at 350–800°C); and the gradual breakdown and re-forming of the altered clay crystals into new molecules. This last process accelerates at high temperatures (1200°C+), which often results in fired ceramics of great strength.

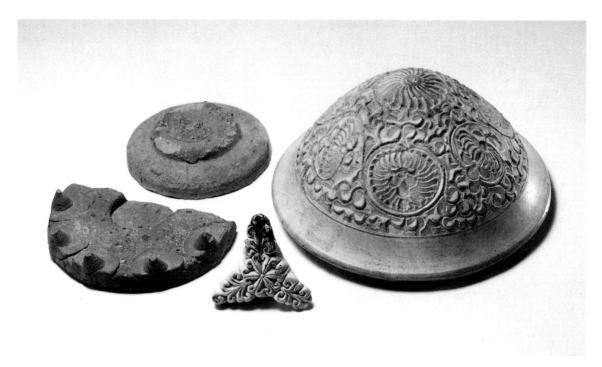

Firing is a lengthy process, possibly taking as long as a whole week at some northern kilns, and it can be complicated to control. The atmosphere inside a kiln affects the colour and texture of the ceramics being fired, but the foremost dictator of colour is the amount of oxygen allowed into the kiln to burn the fuel.

Unglazed earthenwares fired in an oxygen-rich (oxidising) atmosphere are red, while those fired in a kiln where the amount of air burning the fuel is slightly restricted (a reducing atmosphere) are grey. Oxidising and reducing atmospheres can follow one another within a single firing, so that control of the firing cycle can also affect the final appearance of the pots. Cleanliness is another important factor in kiln atmospheres. Too much fuel dust can discolour the wares, particularly when the kiln is fired by coal, as kilns in north China usually were. The problem of dirt in the kiln was eased by the invention of saggars, rough clay boxes for encasing individual pieces during firing. Saggars could be neatly stacked to avoid wasting space, which was at a premium in the high narrow kilns suitable for firing northern clay.

Saggars and clay spurs, pads and other setters are classed as kiln furniture (fig. 167) and, though saggars are made of coarse clay, firing supports were usually made of a clay as close as possible to the body type of the wares, so that any shrinking during firing would not cause distortion. Setters were used only once and then discarded, and they were always in the same raw or biscuit state as the wares being fired. Kilns themselves were built of various materials and to a high standard of design, appropriate to the raw materials of the region. The principal Chinese kiln types are Yangshao Neolithic, *mantou* (bread roll), dragon and egg-shaped (Ceramics glossary).

The excellence of Chinese ceramics stems from the combination of two rather diverse factors: raw materials and industrial organisation. The follow-

167 Moulds and setters. 11th–13th century AD. The conical mould was used for producing greenwares at northern kilns, where the technique was introduced, though it rapidly spread to southern kilns such as Jingdezhen in Jiangxi, and Xicun near Guangzhou. The triangular stamp, probably also from the north, was used for impressing designs on ceramics in a leather hard state. The two firing rings were collected at Phoenix Hill in Hangzhou, Zhejiang province, the site where Southern Song Guan wares were produced. The rings were used for supporting items in the kiln. DIAM (of mould): 14.2 cm; (of stamp): 9.8 cm; (of firing rings): 9.8 cm, 7.7 cm.

ing sections highlight the variety of ceramics achieved in different clays and using different techniques over the long period from the Neolithic to the present day.

Neolithic ceramics

The excellence of Chinese potters was already established by the Neolithic period.[24] At that time, as evidenced by recent excavations, ceramics served many purposes over and above their obvious functions as cooking pots. Small functional items, such as spindle whorls and net sinkers, were found at Banpo village in Henan (c.4500 BC); ceramic sculpture from Peiligang culture sites (c.6500 BC[25]) and other areas of north China suggests that some ceramics had a decorative role; and a wide variety of vessel types indicates a broad range of functions, as much ceremonial as utilitarian (fig. 168). The earliest ceramic wares yet identified are from north China and may be ten thousand years old; between eight and nine thousand years ago impressed ceramics were made in the far south, near Guilin in Guangxi province.[26] The earliest identified large-scale ceramic-using culture appears to be Peiligang (c.6500 BC), mentioned above, but there is no doubt that the oldest good-quality ceramics to have survived in significant quantity and diversity are the red earthenwares of the Yangshao culture of c.4500 BC.

Kiln design made an important contribution to successful ceramics. Yangshao kilns have a firing chamber with a pierced floor, allowing heat to rise into it evenly from the fire passage beneath; the fire itself was situated up to a metre or more away from the chamber, so that heat travelled along the passage and then up into the chamber containing the pots.[27] It is reputed that, in such a kiln, firing temperatures of over 1200°C could be achieved. The rows of figures painted on some Yangshao bowls have been interpreted as signs of religious use, and the 139 symbols on a single vessel from Ledu Liuwan in Qinghai as early writing.[28] Graphs of a construction similar to that of later Chinese characters have been recognised on ceramics of the Dawenkou culture.[29] It is not possible to demonstrate all those particular claims, but it is clear that in a general sense Neolithic pots were used in rites and ceremonies.

Elaborate and possibly ritual ceramic vessels produced on China's eastern seaboard between 3000 and 2000 BC display the finest of Neolithic technology. The complex forms of vessels from many sites along the east coast from Shandong to Zhejiang, often described as belonging to the Dawenkou culture, suggest that ordinary cooking and serving dishes were elaborated for religious ceremony (fig. 168). The three principal types are tripods, pouring vessels with three lobes, and platters and cups on high footrings. In the Neolithic period, in the absence of furniture, most activities took place at ground level; ceremonial vessels are thus likely to have been distinguished from the everyday by height. This was certainly the case in the Shang and Zhou dynasties about two thousand years later, when bronze vessel shapes, based on functional shapes, were given feet to make them suitable for ritual use. A raised vessel has greater presence and is therefore more appropriate for ceremony than a flat or round-bottomed one.[30]

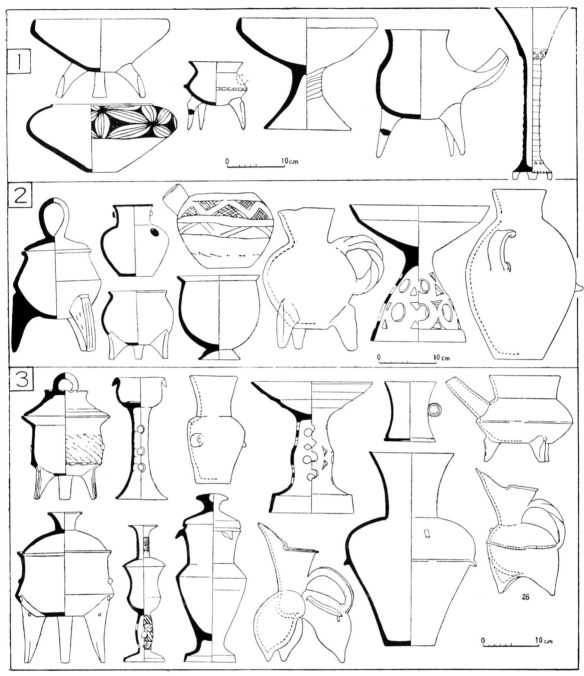

Several sites in Shandong province have yielded tall beakers supported on slender, often pierced stems.[31] The beakers are black, which shows that they have been impregnated with carbon in the form of thick smoke or burning matter, and burnished; unusual attention has been given to surface finishing. Turning on a fast wheel has produced a thin-bodied vessel with a sharp profile, and the hardness of the body implies a high firing temperature. The firing conditions, the lustrous surface, the intricate if not precarious shapes, and the relatively small capacity of the beakers are all inconsistent with their being common drinking vessels. At the site of Sanlihe in Shandong, dating

168 Profiles of Neolithic ceramics from the Dawenkou culture: (1) early period; (2) middle period; (3) late period. The tall stems and pierced pedestals are typical features, as are the tripod feet and lobed bodies, which provided models for early cast bronze vessel shapes.

169 Grey earthenware vessel in *jue* form. Shang dynasty, *c.*13th century BC. The flattened mouth rim of the vessel is a feature of sheet metalworking technology which has been carried over into this ceramic version of a ritual bronze vessel. The slightly flattened shape of the handle is a comparable feature. HT: 12.3 cm.

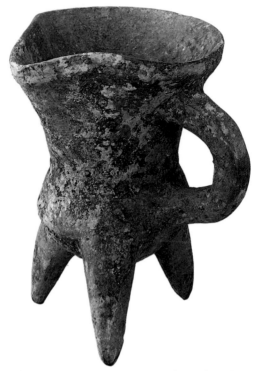

between 2900 BC and 2400 BC, such vessels have been found alongside carved objects made of jade, the principal ritual material of the Neolithic period.[32] Jade carving required weeks of labour with abrasive and thong (ch. 1, p. 48). The context, as well as the shapes and workmanship, suggest that these objects were meant to be ceremonial rather than functional.[33]

Ceremonial ceramics were displaced by ritual bronzes in the seventeenth or sixteenth century BC, at the beginning of the Shang dynasty (fig. 169). Chinese ritual bronzes are unique in ancient metallurgy for their fully developed piece-mould casting technology; yet, intermediate between the Dawenkou beakers and the Shang bronzes is a class of fine ceramic objects made in shapes that were to be exploited by the bronze casters. Further, it appears that many of the lobed vessels were made by moulding, thus anticipating the techniques employed by bronze casters. The Neolithic potters may therefore have passed on to the bronze casters both a repertoire of forms and some essential technical processes.[34]

Tang *sancai*

Ceramics of all sorts were transformed by painted and glazed decoration. Such ornament was not simply enrichment; it made possible the imitation of other materials, including bronze and lacquer. Glazes transformed the relatively dull matt grey and red clays into brightly gleaming colours. Burial wares were covered with lead glazes to make a spectacular display at funerals and to provide for the eternal life of the dead. As already mentioned, lead-glazed ceramics were made from the Han period; those of the Tang were, however, yet more dramatic in form and decoration.[35]

For a period of just over fifty years, from the end of the seventh to the middle of the eighth century AD, brightly glazed, vigorously modelled figures were produced in huge quantity for placing in tombs (of those who could afford them) in and around the Tang capitals Chang'an (present-day Xi'an) in Shaanxi province and Luoyang in Henan province. Such figures were employed to express the status and provide for the needs of the deceased. Horses, camels, guardians and exotic figures have created one of the most vivid and lasting images of the cosmopolitan life of the Tang court, situated at the eastern end of the Silk Route. The quantities in which they have been unearthed suggest a large industry devoted to the production of *sancai* ('three-colour') wares for burial, yet their use was apparently subject to restrictions of size and number according to the official position of the tomb occupant.[36] The general Liu Tingxun (d. AD728), whose tomb models are illustrated in chapter 3 (fig. 93), would have been entitled to a full set of civil officials, guardian figures or *lokapāla* and earth spirits as well as horses, camels and grooms, most of which stand a full metre in height (fig. 158). The figures would have been displayed on a cart as part of Liu Tingxun's funeral cortège, then lined up outside the tomb until the coffin was in place, and finally positioned appropriately within the tomb before it was sealed.

Burial figures provided pomp for funerals, service for the afterlife and even, according to one contemporary story, a barometer of events in the world. A story which circulated in the late eighth century relates how a travelling merchant was accompanied on a journey for several days by a man who eventually announced himself to be a ghost. The ghost complained that he had been buried with numerous tomb figures whose continual squabbling and din prevented him from resting day or night; he requested that when they reached his tomb, the merchant should shout loudly that the figures were to be beheaded by imperial command. This he duly did, and the ghost reappeared with several headless gold and silver figures which he presented to the merchant. Subsequent inspection of the tomb revealed hundreds of decapitated gold and silver burial models.[37]

Gold and silver tomb figures may have replaced *sancai* wares after the destruction of *sancai*-producing kilns during the An Lushan rebellion of AD756–66; it is also possible that the gold and silver figures mentioned in *Shangxiang ren* are heavily gilded, glazed figures. *Sancai* wares were produced in north China and are associated particularly with the Yaozhou kilns near Chang'an (present-day Xi'an) and with the kilns at Gong xian to the north-west of the secondary Tang capital Luoyang. In addition to figures, vessels and architectural ornaments were also made.

Sancai glazes were applied to many vessels, often in forms derived from Western Asiatic metal and glass shapes (ch. 6, fig. 199). It is possible, indeed, that these *sancai* wares were alternatives for more valuable materials (fig. 170). Lead glaze is relatively viscous but has a tendency to melt and suddenly run, creating the well-known streaked and mottled effects in copper green, iron yellow and cream. Tripod trays and incense burners, bottle vases with ribbed necks, ewers sporting 'Parthian' archers and carefully decorated oviform jars are just a few of the vessel shapes occurring in *sancai* ware. While certain forms and motifs originated to the west of China, examples

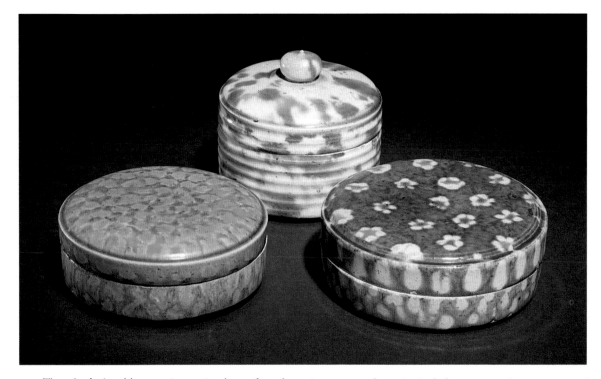

170 Three lead-glazed boxes. Tang dynasty, 8th–9th century AD. The boxes illustrate the combinations in which *sancai* glazes were used. The two flat-lidded boxes have been decorated using resists, while the taller box has been splashed with cobalt blue. All three pieces have unglazed bases. The flat-lidded type was made through the first quarter of the 9th century, while the taller, knop-lidded box continued to be made until the end of the century. HT (*left to right*): 3.8 cm; 7.1 cm; 3.9 cm.

have also been found to the east, and are included amongst the treasures of the Shōsō-in repository at the Tōdai-ji temple in Nara in Japan.[38] *Sancai* was exported westwards to Sri Lanka, Samarra (in modern Iraq) and Fustat (Cairo), where it inspired Middle Eastern copies.[39]

The successors to *sancai* ware appear in vernacular literature, as mentioned above, and over many centuries brightly glazed figures were employed in burials. Ceramic burial goods, however, have traditionally held no appeal for Chinese collectors, and in consequence are not referred to in the writings of the Ming and Qing connoisseurs describing the most highly valued antiquities. Though they remain unattractive to many serious-minded collectors of Chinese art on the grounds that burial wares may be unlucky, the distinct appearance and accessible forms of Tang *sancai* have forged in the Western mind a popular image of gaiety and exoticism, equated with the high achievement and bold nature of Chinese art.

Green and white wares of the late Tang (ninth to eleventh century AD)

The backbone of the Chinese ceramic tradition is provided by the green and white wares that first came to prominence in the Tang dynasty. For many centuries these fine glazed ceramics were the wine and tea vessels of the élite. Greenwares stemmed from a long tradition, first seen in the glazed Shang pots mentioned above (fig. 159). A highly productive branch of the southern greenware tradition was situated in Zhejiang province, where the imitation of bronzes was a particular speciality of the late Zhou and Han period. This area supported the production of what is now known as Yue ware.

Yue wares are named after the region in which they were made, in Zhejiang province, which was in pre-imperial times the kingdom of Yue. They are exceptional amongst early Chinese ceramics for their high status as imperial and tributary wares. Kilns proliferated in the northern part of Zhejiang between the third and tenth centuries AD, but the significant sites for the high Tang are Shanglinhu and Gongyao. The technical aspects of the greenware tradition have been outlined above; for a number of reasons the Yue wares of the Tang period may be regarded as the pinnacle of that tradition despite its continuing, after the early Song demise of the Yue kilns, at the Longquan kilns in the southern part of the same province and at the Yaozhou kilns in the northern province of Shaanxi.[40]

Yue wares began as a local product used to replicate bronze forms (fig. 172) and occasionally local stone sculpture. Some early wares of the third to fourth century in the shapes of bronze *ding*, *he* and basins are comparable to northern burial wares of the same period, as are the tomb models of domestic animals, buildings and utensils. In the Yue area, however, particular forms developed, including ewers with chicken-headed spouts. Their unique role in burial is also marked by their use as memorial tablets, incised beneath the green glaze with the sort of biographical and elegiac prose customarily found on stone stelae.[41]

Also unique to Yue ware are the many praises heaped upon it in contemporary prose. References to ceramics in the writings of connoisseurs are exclusively to the antique.[42] Yue ware, on the other hand, is not only extolled in Lu Yu's *Chajing* (*Classic of tea*) of AD 760 as the superior ware from which to imbibe tea, and for elaborate reasons, but in AD 881 the poet Lu Guimeng even devoted a complete work to it under the title *Mise Yueyao*. *Mise* ('secret colour') has long been used to denote the most attractive and

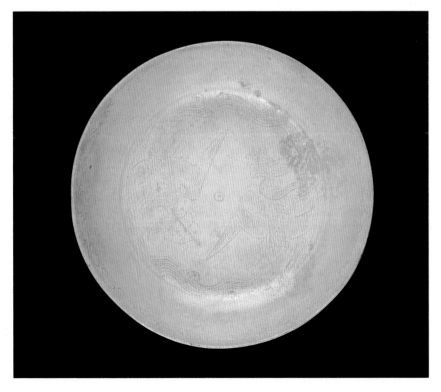

171 Dish, Yue ware. Late 9th or early 10th century, probably from Yuyao xian. The overlapping petals on the exterior of the bowl and the very fine incised decoration on the interior are both comparable to decoration of contemporaneous silver wares. The central motif of two phoenixes and the interior border scroll are executed with a fineness evident only on Yue wares. The base is incised with the character *yong* (eternal) and is glazed save for the marks of the clay pads or ring which supported the vessel in the kiln. HT: 6.5 cm, DIAM: 17.8 cm.

172 Bowl, Yue ware.
Eastern Jin dynasty (AD 317–
420). Many Yue wares of the
3rd and 4th centuries
resemble bronzes in their
forms. Registers of impressed
rhomboid design occur
frequently on such pieces and
possibly imitate the bands of
ornament cast on bronzes.
The interior of the high foot
of this piece is unglazed, and
three small spur marks on
the interior of the bowl
indicate that another piece
was stacked on top of it in the
kiln. HT: 13.3 cm.

desirable Yue wares; it has only been clearly defined, however, since 1987. The discovery of the contents of the crypt belonging to the pagoda of the Famensi Buddhist temple at Fufeng, Shaanxi province, sealed in AD 874, not only revealed silks, gold and glass (ch. 6, fig. 196) of extraordinary quality, but also a group of Yue ware vessels which are described on an accompanying tablet listing the contents as 'secret colour' pieces.[43] The tablet also remarks that one of the pieces was used by the Emperor Yizong for offering the cremated finger-bones of the Śākyamuni Buddha. The bones reside in a small gold reliquary found in the crypt, at the heart of a set of seven outer boxes, also made in gold.

That a post-Neolithic ceramic was used in a ceremony of religious and imperial importance is clear evidence that Yue ware was esteemed indeed; that its reputation echoed down the centuries and was finally vulgarised is shown in the thirteenth-century note of Lu You, who remarks, à propos the Yaozhou wares of Shaanxi: 'The greenwares of Yaozhou are called Yue wares, because they resemble the secret colour of Yuyao [kilns]. Yet they are extremely coarse and are used only in restaurants because they are durable.'[44]

What made for the elusive *mise* quality remains difficult to explain in terms of its technology. The chemical composition of Yue wares found within China changed little throughout the seven centuries of the kilns' activity: the almost ubiquitous ceramic contaminants of iron and titanium retain a more or less constant percentage in the body material, which is greyish-white, while in the glaze their total remains below 3 per cent; the firing temperature, probably at least 1190°C or 1200°C, also remained constant.[45] However, certain sherds at the Shanglinhu kiln site, though they have not been analysed, have a visibly superior body and bluer glaze colour than most examples, and thus may be fragments of *mise* wares.[46]

The variation in glaze colour is probably due to kiln atmosphere. Yue wares were fired in dragon kilns, which were long and narrow and set into hillsides; they were prevalent in south China from the Han dynasty onwards (Ceramics glossary). Dragon kilns could be up to 60 metres in length, with a single, large firebox at the lower end and smaller stoke holes along the

entire length. The atmosphere varies considerably in such a large kiln, and the strong optimum reducing atmosphere required for good green glaze shades only occurred in small areas, and for unpredictable lengths of time, during each firing. The finest of fine wares within the world's most successful ceramic tradition were probably achieved by a coincidence of small numbers of superior-bodied wares and optimum firing conditions in one, unpredicted part of a large kiln (fig. 171).

Complementing Yue wares from the south were fine white wares from Hebei province. In a few tombs of about AD900 at Lin'an in Zhejiang province these white wares are found with local greenware.

Three major kilns produced white wares: Gong xian in Henan province, and Xing and Ding in Hebei province.[47] Gong xian is the earliest of these, and in addition to white ware, made a large proportion of the lead-glazed three-colour wares of the early eighth century; it is therefore one of the earliest kilns known to have fired a variety of high-quality wares. Gong xian white wares are the first recorded tribute ceramics. The statement in a provincial gazetteer, *Yuanhe junxian zhi*, that in the Kaiyuan (AD713–42) period Henan offered white porcelain as tribute is supported by the discovery of Gong xian-type white sherds at excavations of the Daming palace at Xi'an, the site of the Tang capital Chang'an.[48]

The Xing kilns situated at Lincheng and Neiqiu counties in Hebei province produced wares of similar chemical composition to Gong xian pieces, and distinguishing between the wares of the two kiln sites up until the ninth century is not straightforward. Sui and Tang dynasty white wares manifest, in their exotic shapes and complex moulded decoration, features borrowed

173 High-fired white wares associated with Buddhist ritual. 7th–9th century AD. Items used in religious ceremony include flasks, censers, stands and offering bowls. These pieces are all from north China and date before the Song dynasty; some of the finest Ding wares of the 10th century, including pieces embellished with gilding, are those found in the Jingzhi and Jingzhong pagodas of Ding xian, Hebei province, indicating that white wares were highly valued among Buddhist ceremonial paraphernalia. HT (*left to right*): 12.8 cm; 4.5 cm; 12 cm; 23 cm; 11.4 cm; 13.3 cm; 10.4 cm; 19.8 cm.

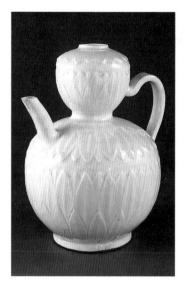

174 (*above*) Ewer in double-gourd form, Ding ware. 11th century AD. This porcelain ewer has carved lotus petal ornament beneath a yellow-tinged glaze. The base is unglazed. Carved pieces are comparatively rare, and date from the Northern Song dynasty. HT: 22 cm.

176 (*opposite below*) Bottle and bowl, black wares. 12th–13th century AD. The bottle from Henan province in north China is glazed with an iron-rich glaze (c. 5–6% iron oxide) and decorated with an iron-saturated glaze (over 6% iron oxide) in which the excess iron has precipitated to the surface of the glaze and burnt, producing the rust-brown contrast. Combinations of iron glazes of differing concentrations were used in Fujian province in the south to produce a variety of glaze effects. This bowl has been decorated with a leaf, placed on to the glaze before firing, and burnt away in the kiln to leave its pattern on the bowl. The bases of both bottle and bowl are unglazed. HT (bottle): 28 cm; DIAM (bowl): 14.9 cm.

from Iran and Central Asia by way of the Silk Route (ch. 6, fig. 195), and also seen on *sancai* wares. In their more restrained versions they match the forms of the finest of contemporary Yue wares. The Xing kilns produced a type of flared dish with a thickly rolled lip that may perhaps be explained as an imitation of the glass forms of Western Asia. In fact the type, further defined by its broad unglazed footring, has been discovered in the Middle East in such quantity that it is known as a 'Samarra bowl'. These bowls, made in the ninth century, represent as close an overlap between late Xing and early Ding wares (fig. 174) as that between Xing and Gong xian wares.[49]

Ding wares were made at kilns very near the Xing kilns, and developed further the skills initiated at Gong xian and Xing. The kilns seem to have met demands for high-quality white wares, many in the shapes of metal vessels. Fine white ceramics for use in Buddhist rituals have survived in some quantity (fig. 173). Censers, stands, long-necked flasks, vases and other assorted ceremonial items frequently imitate the shapes and quite possibly the colour of metalwork, since comparable items in silver are well known. A group found in the crypts of two pagodas at Ding xian, deposited with relics and gold and silver reliquaries and vessels, demonstrates the value of white Ding wares in Buddhist ritual (Buddhist sites appendix).[50]

The relationship between white porcellaneous ware and silver was developed ever more closely at the Ding kilns, as discussed above. The well-organised production of Ding ware, its lightness of body, the flair of its ornament, and its long-lasting status make it probably the single most important Chinese ceramic type. Not only are Ding wares amongst the most commented on, collected and forged of ceramics, particular during the Ming dynasty, but they are also centrally placed between the two major traditions of earlier high-fired wares and later porcelain.[51]

The Song dynasty (AD960–1279) and the diversity of fine ceramics

The Song dynasty (960–1279) is the richest period of ceramic history in China. The quality of Song ceramics has been highly praised since the latter part of the dynasty itself; the variety and the quantity are less widely appreciated.[52]

During the tenth and eleventh centuries, Tang dynasty trends in high-fired ceramics were developed at an ever-increasing number of kilns, particularly in north China but also south of the Yangzi. The period is associated with the emergence of specialist kilns, each producing one type of ware to high standards of technical and often aesthetic accomplishment. Recent excavations at major Northern Song kiln complexes also reveal, however, an astonishing array of ceramic styles and glaze types at each site, suggesting strongly that the motive for production was economic and that artistic achievements were the result of demands for high-quality wares. Quantity and diversity were thus the principal aims, not just the achievement of a single perfect type.

The multiplicity of wares discovered at kilns hitherto renowned for famous ceramics, such as Jun, Ru, Ding, Yaozhou, Longquan and Guan, reveals

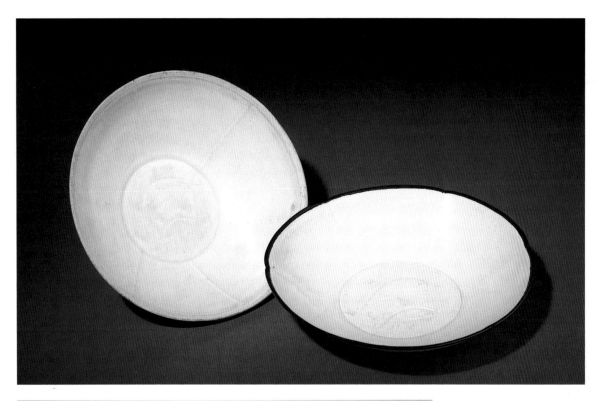

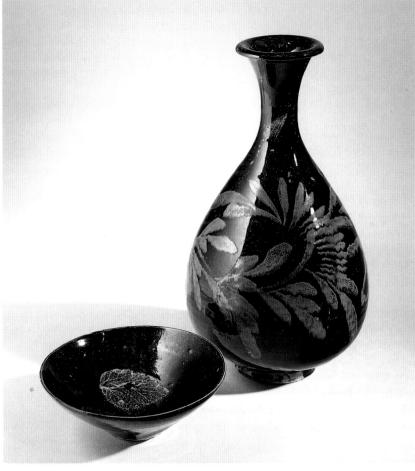

175 (*above*) Two porcelain bowls. 11th–12th century AD: (*left*) *qingbai* ware, south China, probably from Jingdezhen; (*right*) Ding ware, Hebei province. Although similar in shape, decoration and size, and made in the same period, these bowls were manufactured at sites hundreds of kilometres apart. The southern piece was almost certainly made in imitation of the northern piece, and the two clearly demonstrate the differences between northern and southern white ware. The Ding bowl was fired in a coal-fuelled oxidising atmosphere, resulting in a warm ivory tone; the *qingbai* bowl was fired in a wood-fuelled reducing atmosphere, resulting in a cool tone. The *qingbai* glaze of early Jingdezhen wares is essentially the same in composition as the transparent glazes on Ming and Qing porcelains.
DIAM: 19.4 cm; 20.0 cm.

that this diversity was fuelled by widespread demand. The circulation of ceramic shapes, glazes and decorative motifs appears to have occurred with a facility and speed more easily equated in the modern Western mind with, say, international fashion industries than with the essentially rural production of pots in medieval China. This is nowhere more evident than in the production at Jingdezhen in Jiangxi province of lobed bowls with floral or piscatorial designs incised beneath a bluish-white glaze in imitation of Ding wares from Hebei (fig. 175); or in the thick teabowls with streaked iron-black and iron-brown glazes, so beloved by Japanese monks, produced simultaneously at Henan in the north and Fujian in the south (fig. 176); or in the deeply moulded, olive-green-glazed wares in the style of northern Yaozhou greenwares, produced on the south coast at the Xicun kilns near Canton for export as far afield as East Africa.

The centres of innovation do seem to have been situated in the north, but the kiln that first produced a given glaze, technique or style is in most cases difficult to identify. Southern kilns copied northern kilns and northern kilns copied one another; the chief interest of this phenomenon is that kilns were not only aware of what was being produced at other sites, no matter how distant, but were even able to reproduce the prototype with considerable success, no matter how complex it was. A high degree of technical skill and a highly developed empirical understanding of ceramic chemistry must therefore have existed throughout the country.

The level of skill was probably due to the already centuries-old tradition of potting and the number of people engaged in it. It is known, for example, that pottery households in Jiangxi province comprised farming families who took potting work in the agricultural off-season – a clear indication that the creators of Song ceramics were artisan labourers earning their rice, and not craftsmen potters expressing themselves.[53]

Demand for so many ceramics came chiefly from the middle classes formed by a new meritocracy, who gained wealth and position by passing public examinations, and who slowly replaced the Tang landowning aristocracy as the guardians of political power. Demand came also from merchants who exported ceramics as a prime commodity throughout East and Southeast Asia, to the Middle East and beyond. Large demand, proliferation of kilns and consistently high quality all distinguish the Song dynasty as an important period in Chinese ceramics. The importance of the period lies also in its pivotal position between two great traditions: that of richly varied high-fired wares produced over a wide geographical area, and the monolithic porcelain tradition concentrated in one province of south China.

Jingdezhen

The diversity of the Song gave way in succeeding centuries to a much less varied situation, in which the kilns at Jingdezhen, in Jiangxi province, dominated production. In addition, the removal of the Song capital from Kaifeng to Hangzhou in 1127 transferred imperial influence towards the already economically powerful south.

The city of Jingdezhen is named after the Emperor Jingde (1004–7) in whose reign the kiln centre was established. The kilns are remarkable both

for the quality and quantity of their products and for the extended period of their operation, which continues today. In a basin surrounded by hills are the remains of large numbers of kilns, and piles of debris tower over the dwellings of those who work in the kilns today.

Many of the kiln centres in other parts of the country were active for several centuries, and all had fluctuations in production levels. None, however, succeeded in dominating the ceramic manufacture of China and ultimately the world as has Jingdezhen over the last millennium. The success of the Jingdezhen kiln complex lies mainly in the combination of three factors: its geographical position, the organisation of its workforce, and its state backing.

Jingdezhen, despite its apparently remote mountainous location, is in fact ideally situated for porcelain production and transportation. Of the porcelain stone that lies across East Asia from Japan and Korea, over China south of the Yangzi, and continues into parts of Southeast Asia, the purest deposits are in Jiangxi province. Moreover, the hills surrounding Jingdezhen are covered in woodland suitable for kiln fuel. From the point of view of transportation of materials and finished products, Jingdezhen stands close to two major river systems, one leading north to the Yangzi and thence to the Grand Canal, the other going south towards Canton.

The second factor that was to contribute to the success of Jingdezhen was the division of production into specialist tasks (fig. 156). This has been discussed elsewhere in this book as a feature of Chinese manufacturing industry (Introduction, p. 30). In terms of ceramic manufacture, these principles apply nowhere more keenly than at Jingdezhen, and the imitative nature of much of Jingdezhen's earlier products should also be considered as part of a rich inheritance of ceramic types. Thirdly, it must be said that it is unlikely that raw materials and workshop organisation alone would have produced so many pots for so long without the state backing that the Jingdezhen kiln complex has enjoyed for a great part of its history.

The earliest wares excavated at the site come from the lowest level of Liujiawan kiln at Hutian, just to the east of Jingdezhen;[54] they date to the first half of the tenth century and appear to be imitations of greenwares produced in east China during the Five Dynasties period (AD 907–60), as well as white wares in the same style. The characteristic blue-tinged transparent glaze known as *qingbai* appeared approximately one hundred years later; many *qingbai* wares imitated white wares produced in north China, as discussed above.

Song dynasty wares peculiar to Jingdezhen and perhaps a few other kilns in Jiangxi comprise burial wares, such as tall narrow urns with elaborate moulded applied ornament, and tomb models, as well as small utilitarian pieces, such as boxes and jars, which were exported around Southeast Asia in addition to being used throughout south China.[55] By the third quarter of the thirteenth century the kiln's reputation was sufficient for the Mongols to establish an official agency, the Fouliang Porcelain Bureau, to control production. Shortly after his conquest of the Mongols a century later, the first Ming emperor, Hongwu, founded a porcelain factory at Zhushan, also in Jingdezhen. Zhushan remained the site of the imperial porcelain factory throughout the Ming and Qing dynasties.

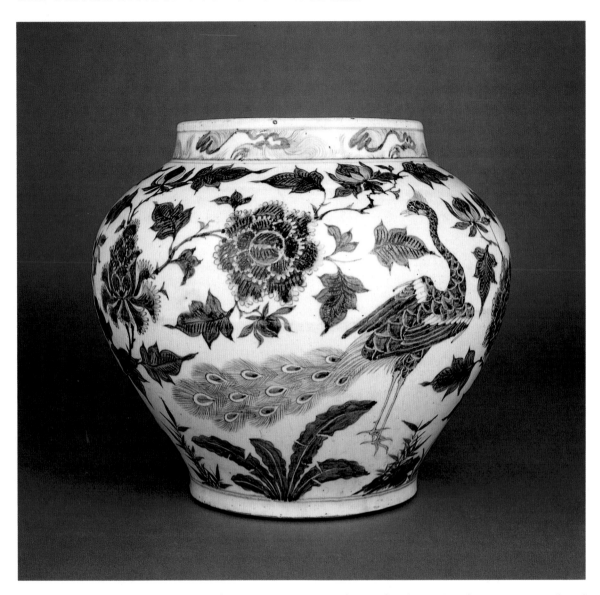

177 *Guan* jar, porcelain with underglaze cobalt-blue decoration of a peacock and peahen. 14th century AD. The jar is thick and heavy, which is typical of early large pieces from Jingdezhen, before the strength of the ceramic material had been fully discovered. The decoration on this example is amongst the boldest to appear on 14th-century wares. The base is unglazed.
HT: 31.5 cm.

In the fourteenth century the first underglaze painted wares were produced at Jingdezhen, and *qingbai* wares were made in decreasing quantity (fig. 177). Underglaze painting had, of course, made its appearance elsewhere considerably earlier. The painted decoration of fourteenth-century Jingdezhen ware may be compared to Cizhou wares in some of its pictorial qualities, and to lacquer work in its more formal ornament.[56] The brown and white slip-painted wares from Jizhou in Fujian province adopt Cizhou technique for ornament which often relates to Jingdezhen blue-and-white, and may possibly thus form the link between the northern and southern painted styles. Most fourteenth-century painted Jingdezhen wares were exported, to Southeast Asia and the Middle East, and it was in the succeeding century, most particularly during the reigns of Xuande (1426–35) and Chenghua (1465–87), that the finest Ming blue-and-white was produced.

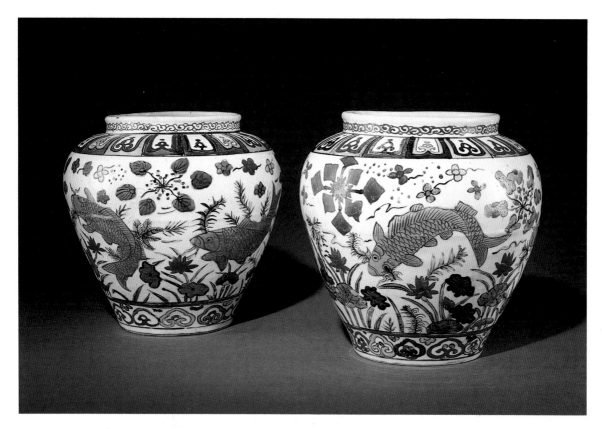

The imperial kilns at Jingdezhen enjoyed the finest raw materials and the most skilled craftsmen, but they were not the only kilns situated in Jingdezhen. Numerous privately owned kilns operated alongside the imperial ones and when, as in the late Ming period, imperial patronage of Jingdezhen was reduced, the city none the less remained a thriving centre of porcelain production. Jingdezhen wares from non-imperial workshops tend to display a more lively style of pictorial decoration, and this is nowhere more evident than in the wares produced between 1621 and 1683, when the relatively few imperial pieces sport not the formal dragon and lotus ornament of the Ming dynasty, but rather the figure scenes and plants associated with *min yao*, or 'popular kilns' (fig. 178).

In 1683, after some twenty years on the throne, the Kangxi emperor appointed an official to the post of supervisor of the imperial kilns, an act which marked the beginning of a century of excellence at Jingdezhen. In the reign of Kangxi, the overglaze enamel palettes known as *famille verte* and *famille rose* were invented; the short reign of his successor Yongzheng (1723–35) saw the finest of the *famille rose* type; and the reign of Qianlong (1736–95) was one of the most intense periods of collecting, patronage and craft production the world has known. Porcelain from the Qianlong period is renowned for its technical excellence and stylistic variety. In 1743 the emperor summoned his porcelain supervisor Tang Ying to Beijing in order to annotate a series of illustrations of porcelain manufacture. The twenty headings he composed provide a useful outline of the production processes:

178 Pair of jars, porcelain with underglaze blue and overglaze enamel decoration. Ming dynasty, Jiajing mark and period (1522–66). The jars are thick and the decoration is boldly rather than carefully executed. Later Ming enamelled wares are notably coarser than the 15th-century wares that preceded them. The breeding of ornamental goldfish, which began in the Song dynasty during the reign of Huizong (1101–25), was by the 16th century a popular domestic pastime, and hence provided a reasonably widespread motif. HT: 25 cm.

Collection of clay/refinement of clay/making of glaze/making of saggars/making of prototypes/shaping of circular wares/shaping of non-circular wares/grading of underglaze blue/grading of cobalt mineral/grinding of cobalt/application of blue pigment/decorating the wares/application of glaze/finishing of biscuit/firing the kilns/firing/application of overglaze decoration/baking for overglaze decoration/grading and packing/thanksgiving to the gods.

As quoted in The Chinese University of Hong Kong,
Imperial Porcelain of Late Qing, Hong Kong, 1983, p. 21

Each stage would have been carried out by a different artisan and the overall organisation of production outlined by Tang Ying probably did not differ substantially from that of the Ming dynasty. The level of technology at Jingdezhen in the Qianlong period, however, is unmatched. Not only are the porcelain bodies fine and the glazes smooth and bright, but the number of new glazes is large. The surface effects of lacquer, bronze, wood and hardstones were all imitated in porcelain glazes from the imperial kilns, while other workshops grappled successfully with the extraordinary shapes, often deriving from European metalwork, demanded by Western clients. The skill with which the Jingdezhen potters met these Western demands encouraged an ever-growing market and stimulated the growth of Western ceramic manufacture to emulate Chinese achievements (ch. 6, fig. 215).

Attitudes to ceramics

Imperial patronage

While Chinese ceramics can most readily be discussed in terms of production techniques, diversity of kiln sites and the functions of the products, they can also be seen to belong to a hierarchy similar to that which existed within other materials (Introduction, pp. 27–8). Some ceramics were much more highly valued than others. We can identify the most valued types by their associations with the court, either as tribute offerings, or as products of kilns under imperial supervision. Jade, silk and lacquer were the primary offerings made to the emperors of China from the people of their dominions. Ceramics are first known to have been included amongst tribute during the Tang dynasty, when white wares from Gong xian were offered; the Song dynasty more than any other is the period associated with ceramics as imperial tribute. Indeed, the majority of Song 'imperial ceramics' were included amongst annual provincial offerings of local produce. At this early date ceramics were rarely directly commissioned for the court, although some literary evidence exists to support the view that the pale duck-egg-blue Ru wares were made as 'imperial wares' (fig. 179).[57] Ru ware was produced at Baofeng Qingliangsi in Henan province for the emperors Zhezong (1086–1102) and Huizong (1101–25). When the court fled to Hangzhou the grey-green crackled Guan wares were produced there, possibly as a local replacement for Ru ware.[58] These two kiln areas are early examples of kilns producing high-quality wares under official supervision.

There is some reason to discern imperial patronage at Jingdezhen as the Mongol rulers of the Yuan dynasty established an official bureau, known as

the Fouliang Porcelain Bureau, at Jingdezhen, yet they appear not to have taken a close interest in its produce. In the succeeding Ming dynasty, however, Jingdezhen porcelain seems to have become a matter for imperial pride. The Yongle emperor (1403–25) erected a white porcelain brick-faced pagoda at Nanjing, and an exceptionally smoothly glazed type of white porcelain is peculiar to his reign (fig. 180). His successor Xuande (1426–35) appears to have favoured red-glazed porcelain:[59] the bowl illustrated in figure 181 has a copper-red glaze of notorious complexity, the details of which vanished with the emperor. Attempts to reproduce it even within fifty years of his death were unsuccessful, as indeed they largely remain today, suggesting that this very short-lived glaze type was the jealously guarded secret of a small group of potters working within the imperial kiln.

Excavations carried out between 1982 and 1984 at the imperial kiln site at Jingdezhen revealed that extensive quantities of porcelain were produced for the court, mostly as utilitarian items for eating and drinking, to a certain extent for temples and tombs, and possibly also for decorative purposes. The Yongle white wares and Xuande red wares were ceremonial pieces for use in temples in the palaces. Contemporary porcelain was not collected. From texts on collecting written in the Ming dynasty, it would appear that only antique items, especially of the Song period, were valued for this purpose.

An indication of the regard in which early Ming ceramics were held is the introduction, during the Yongle period, of the reign mark. Incised in the centre of a stemcup, the characters *Yongle nian zhi* ('made in the reign of Yongle') resemble in style the work of the court calligrapher Shen Du, whose task it was to write the mark on antiques and valuables within the palace.[60] Yongle marks are rare, but by the Xuande period the six-character mark in the format 'Great [dynasty] [emperor's name] years made', in clear *kaishu* script, was well established. The mark of Chenghua (1465–87) was to become the most widely used of all (fig. 182), as it was added to blue-and-white porcelain of the eighteenth and nineteenth centuries, probably in recognition of that period's excellence in the type.

The role of marks to indicate some sort of esteem is illustrated at a much later date by porcelains commissioned by General Yuan Shikai. When in 1916 he declared himself emperor, one of his first acts was to order 40,000 items of porcelain bearing the mark of his adopted reign title, 'Hong Xian'. He abdicated after eighty-two days on the throne, and died shortly afterwards with few if any of his commission to the Jingdezhen kilns completed.

Despite their main purpose as utilitarian items of high quality, once they became antiques, ceramics were more highly valued. Huge numbers still survive in the palace collections in Beijing and Taipei, and the ceramics removed from China to Taiwan in 1948 outnumber by a factor of three the next most numerous category, painting and calligraphy.[61] Whether this is because they have always been produced in greater quantity, or because they are more durable, or because utility wares as well as antiques were removed, is not certain. What is beyond dispute is that, from originally humble materials and status, ceramics rose to heights of technical achievement and imperial status.

179 Cup stand, Ru ware. Late 11th–early 12th century. This essentially functional shape is known in lacquerware of the Song dynasty, which appears to have had a marginally higher status than even Ru ware. Cup stands occur frequently in *qingbai* porcelain from south China, and are depicted in the late Song painting *Han Xizai's Night Revels* in the Palace Museum, Beijing, copied after the lost 10th-century original by Gu Hongzhong. The Ru ware cup stand would therefore appear to have had a utilitarian role, despite its superb quality and revered place of production. DIAM: 16.2 cm, HT: 7.6 cm.

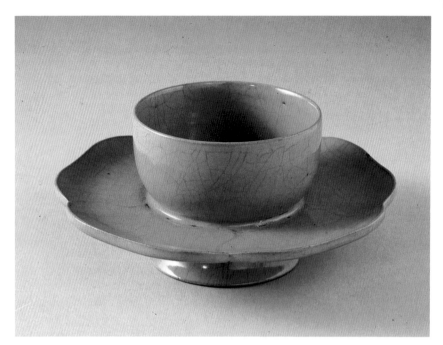

180 Porcelain dish and 'monk's cap' ewer, Jingdezhen. Ming dynasty, Yongle period (1403–25). The use of smoothly glazed white porcelain for ceremonial vessels, daily utensils and architectural tiles, coupled with the compositional peculiarity of the wares to the reign of Yongle, suggest that the third Ming emperor was particularly keen on white. The 'monk's cap' ewer takes its name from a type of hat worn by Tibetan monks, and its shape from Tibetan metalwork. The large dish may also have foreign connotations for, like the large blue-and-white dishes of the 14th century, the type is virtually unknown within China, while being well represented amongst the Ardebil shrine porcelains in Iran. The incised decoration includes dragons on the dish, Buddhist emblems on the ewer and lotus scrolls (on both). DIAM (of dish): 36.6 cm; HT (of ewer): 19.4 cm.

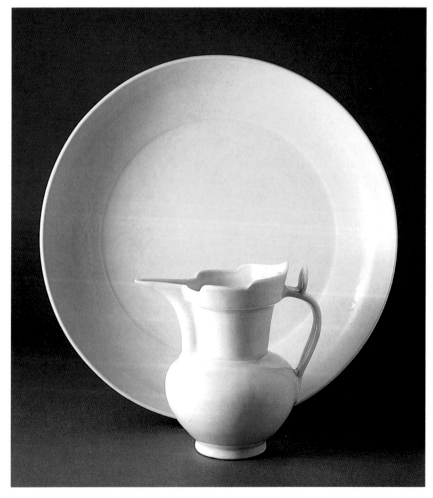

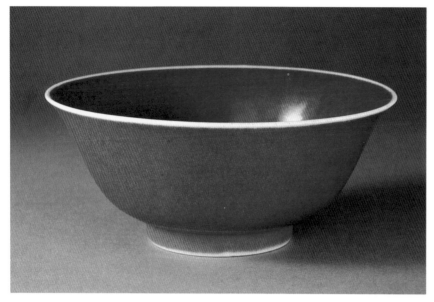

181 (*above*) Bowl with copper-red glaze. Ming dynasty, Xuande mark and period (1426–35). Red is the most elusive colour in the glaze spectrum. The glaze composition on pieces like this is the same as the clear porcelain glaze developed at Jingdezhen in the 14th century, with the addition of a small percentage of copper oxide. Too much copper gives a liverish colour, too little no colour at all, and almost half of the added copper volatises during firing. The margin of error for the quantity of copper is therefore probably no greater than 1%. This most successful type of copper-red glaze was produced only during the Xuande period and is often referred to as *xian hong* (fresh red). HT: 8.5 cm, DIAM: 18.5 cm.

182 (*above*) Reign mark of Chenghua (1465–87). The reign of Chenghua is widely accepted as one of the finest periods for the production of blue-and-white porcelain. This mark reads (from right to left, top to bottom) *Da Ming Cheng Hua nian zhi* (Made in the Chenghua period of the Great Ming [dynasty]). The high quality of Chenghua wares caused the mark to be the most reproduced of all reign marks, particularly in the 18th and 19th centuries.

183 Bowl, Jun ware, Henan province. 11th–12th century AD. The opacity of the thick, light-blue glazes produced at the Jun kilns renders them unique amongst high-fired glazes. Jun glazes are often pitted where bubbles have risen to the glaze surface and burst; some Jun wares are splashed with a purple copper glaze. Though they are traditionally classified amongst the great ceramic wares of China, most Jun wares are robustly potted in utilitarian shapes. It has been suggested that the very pale blue monochrome Jun wares, like this piece, might possibly be Chai wares, or their forerunners, known only through literature and not so far by example. HT: 10.6 cm.

Collecting ceramics

In addition to assessing the value of ceramics in terms of their functions and owners when new, we can also look at the way in which ceramics were valued in later periods when occasionally they entered collections.[62]

As described above, Chinese collections began with the imperial collections of texts and antiquities that were seen as reinforcing or even legitimating political power. Emperors began collecting texts, calligraphy, bronzes and jades in the Qin and Han dynasties (third century BC), but it was only in the Song period (AD960–1279) that collections of antiques and fine objects, in addition to texts and paintings, were formed by officials and men of letters. Ceramics were included in these collections, but only as antiquities thought like the calligraphy and bronzes to embody ancient values.[63] As Song and Ming collectors frequently wrote about the objects that graced their collections, their retrospective and often arbitrary views of the medium have been passed down through generations. These views do not necessarily correspond to the status of those objects at the time of their manufacture.

The anomaly is most vividly illustrated by the pre-eminence of the *wu da yao* ('five great wares') in Ming and Qing attitudes to porcelain. The five great wares are Ding, Ru, Jun, Guan and Ge, all of which, as high-quality products of the Song dynasty, were desirable to later collectors on the dual grounds of aesthetic and antique value (fig. 183). All have been regarded as imperial wares, yet this claim is only true for Ru and Guan; Ding, Jun and Ge were produced for household or religious use, or for export, and accorded retrospective status on the perfectly correct grounds of their exceptionally fine techniques and appearances.

Rather surprisingly, the Chinese collector's ware *par excellence* is Yixing ware (fig. 184), the only such ware to bear signatures.[64] Yixing is a town in Jiangsu province, immediately north of Zhejiang province, renowned for red and brown unglazed wares known mainly in the West by the teapots they inspired in Germany (Böttger porcelain) and Staffordshire, and from which they are not always easily distinguished. Though kilns had existed in the area since the Song dynasty, it was in the late Ming that demand for wares became high, with the work of Shi Dabin, the most famous Ming potter, being faked even in his own lifetime. In the Qing dynasty Yixing teapots and small ornaments in natural form remained collectable and the written work *Yangxian minghu xi* by Zhou Gaoqi (1695), for example, is devoted to the ware. The wares have an intricacy which matched the bamboo and wood carvings valued by the scholar-officials. It is this alignment with the values of the scholar-officials that contributed to the high esteem of Yixing ware. Its popularity with collectors has never waned, and the red and brown individually created wares of Yixing remain amongst the most highly priced contemporary Chinese ceramics.

But most ceramics, as already mentioned, were rarely held in high esteem in their own time. In the late Ming dynasty, blue-and-white porcelain was essentially tableware for those who could not afford gold and silver; Song wares, on the other hand, were so desirable that they were frequently faked and sold for vast sums.[65] In the Qing dynasty, particularly during the reign of Qianlong (1736–95), Song and early Ming wares were reproduced at Jingdezhen on a considerable scale, while the genuine articles were worthy

of note in the great Qing novel of manners, *Hongloumeng* (*The Dream of the Red Chamber*).[66]

The religious use of ceramics

In any scale of values within Chinese society, religious uses probably came below those of the court and of the collector. Yet religious ceremonies require every item of paraphernalia to be of high quality, so that the materials used are generally expensive, and the objects made in them acquire significance as a group quite separate from that of other classes of objects. For many periods, indeed, the most important religious utensils were made of bronze or of gold and silver. However, many items were also made in a variety of ceramics. Certain wares of extremely fine quality were used as ceremonial vessels, while other wares, of coarser quality, provided temple furnishings such as large altar sets, figural sculpture or glazed roof ornaments.

Ceremonial ceramics already discussed include Neolithic wares from the east coast, Tang dynasty greenwares from the Yue kilns of Zhejiang, and Yongle white wares. Further examples are Ding ware, which includes Buddhist vessels – of which gilded examples matching real gold and silver have been discovered at two tenth-century pagodas in Hebei province – and numerous monochrome Jingdezhen wares of the Ming and Qing dynasties.

184 Lotus pod and teapot, Yixing ware. Qing dynasty (1644–1911). The lotus pod displays the interest amongst Yixing potters in modelling forms from the natural world; the contrasting clays are used to good effect, as is typical with the plant-inspired pieces. The teapot is in the form of a Han dynasty impressed brick, complete with calligraphy. Reproductions of archaic objects such as tiles and bells were made increasingly throughout the late Qing dynasty. HT (of lotus pod): 6.7 cm; (of teapot with lid): 6.6 cm, L: 13.9 cm, W: 9.9 cm.

247

185 Altar vessels, Dehua and Longquan wares. 13th–17th century AD. Dehua wares (*left to right*): stemcup, HT: 12.1 cm; censer, with incised six-character mark of Chenghua (1465–87), HT: 8.5 cm. Longquan wares: tripod, HT: 11.5 cm; stemcup, HT: 12.6 cm. The Longquan kilns were amongst the earliest to reproduce the shapes of bronze vessels in ceramic. The fine colour and unctuous texture of Longquan glazes, reminiscent of jade, lend the pieces a double reference to early ritual objects. Longquan altar vessels were used in Japan and Korea as well as within China, where they were probably favoured by scholar-officials. It is likely that Dehua altar vessels, on the other hand, were used in households throughout the country, together with the popular images of Guanyin produced at the same kiln complex. Both wares follow imperial preference for monochrome glaze and archaistic forms.

186 Sacrificial oven with tiled roof at Changling, tomb of the Emperor Yongle (d. 1424) and Empress Xu (d. 1407). The tomb buildings extend for almost a kilometre, and all the principal monuments are roofed with imperial yellow glazed tiles. The sacrificial ovens were positioned between the Gate and the Hall of Heavenly Favours, at some distance from the tumulus itself. The ovens, used for burning offerings such as paper money and silks, are built like miniature houses. The use of glazed tiles for decorating ceremonial buildings and making replicas was a Ming dynasty innovation.

187 (*previous page*) Vase with *famille rose* enamel decoration. Qing dynasty, Qianlong mark and period (1736–95). The opaque white enamel of the *famille rose* palette could be mixed with other enamels to produce subtler shades, and the impact is best seen on the delicately painted fine porcelains of the Yongzheng period (1723–35). The flowering peach branch decorating this massive vase continues a subject well known on Yongzheng wares, on a scale and with a complexity typical of the adventurous style of Qianlong porcelain. HT: 52 cm.

The Xuande copper-red wares already mentioned were probably ceremonial wares, and in the Qianlong period sets of vessels in the shapes of archaic bronzes were made in different glaze colours, each specific to one of the imperial temples in Beijing. All these wares represent the most skilled ceramic technology of their period, and are finely honed rather than innovative.

In addition, certain wares were made in the shapes of bronze vessels, primarily for use on household or local temple altars. Among these ceramics are greenwares made at the Longquan kilns in southern Zhejiang province in the twelfth and thirteenth centuries (Introduction, fig. 8).[67] Longquan did supply the court at Hangzhou, but only with imitations of Guan 'official' ware, which the Hangzhou kilns could not produce in sufficient quantity; these imitations are barely distinguishable from the Hangzhou Guan wares, but are quite separate from the Longquan greenwares produced for domestic altars.

From the late Ming dynasty until at least the middle of the Qing dynasty, a comparable role was fulfilled by the bright white porcelain of the Dehua kilns in the southeastern coastal province of Fujian.[68] Censers, religious images and an extended range of archaic bronze vessel shapes were all produced for family religious purposes, along with just as many figures and secular vessels for export to the West where they are famous as *blanc de Chine*. Dehua wares, from the point of view of Chinese connoisseurs, were a good deal less desirable than Longquan, even when they were new, but some degree of collectors' interest is manifest in the signatures borne by so many of them (fig. 185). Signatures imply individual work, which, as we have seen, is far from the norm in Chinese ceramic production. The signatures on Dehua ware are impressed on the base or back of a piece but, as yet, the names and not the genealogies of the potters are known, and until the latter can complement the former to provide a reliable chronology, the signatures reveal little useful information about Ming and Qing activity at those kilns.

Heavy altar vessel sets, comprising two vases, a censer and two pricket candlesticks, were often produced in enamel on biscuit, sometimes in the *fahua* style and sometimes in much brighter palettes. The sets often stand more than half a metre high and would have been placed in front rather than on top of an altar.

Other large ceramics in these types of ware are religious figures (ch. 3, p. 159), including images of the Judges of Hell and their assistants represented as civilian officials (ch. 3, fig. 114). These vessels and figures were all products of the Ming and Qing dynasties. An outstanding earlier example of ceramic temple sculpture is the seated luohan from Yizhou in Hebei province, magnificently modelled in northern clay and glazed in *sancai* colours (ch. 3, fig. 113). Liao dynasty *sancai* wares continue the technique developed in the Tang dynasty, and were in turn continued in the enamel-on-biscuit temple wares of the fifteenth century onwards, often known as 'Ming *sancai*'.

Sancai colours appear not only on temple objects but even more widely on the roofs of imperial, domestic and particularly religious buildings.[69] Unglazed tiles with impressed designs were used at least as early as the Western Zhou dynasty (1050–771 BC), but the first known glazed examples

are those from a palace at Datong in Shanxi province, dating to the fifth or sixth century AD. The designs of the tiles, in common with those of other architectural components, changed little over the centuries and their manufacture, in common with that of other functional ceramics, was strictly local. Low-fired wares of the type used in architecture were technically simple to produce, and it has been suggested that temporary tile kilns were established at building sites all over the country to serve immediate needs.

The tiles are normally green or yellow, though a rich purplish blue is also known, and in addition to the roof tiles there are eaves tiles and roof ornaments (fig. 186). The ornaments range from large elaborate pieces standing at either end of the straight centre roof section, to small animals seated on the tiles running down the characteristic curve of a Chinese traditional building from the top to the eaves. The animals usually follow a sequence of species, decreasing in size from the top to the eaves, or they may, as at the temple near the Mao mausoleum outside Xi'an, take the form of large sinuous felines bowling down the curve of the roof. Sometimes whole buildings were constructed of glazed bricks, where the bricks imitated all the usual features of wooden construction found in traditional buildings. As in all other crafts, the Chinese potters demonstrated once more their versatility and accomplishment.

From the Neolithic to the present day, ceramics have been made in many different forms and qualities, depending on their functions and on the status of their users. Inevitably this chapter has described only the most skilfully made ceramics. Fine porcelains were made at official kilns for use at court; local kilns supplied the cities and estates; village kilns supplied the peasantry. In almost all cases ceramics were intended for daily use. Often that use was at the apex of society, at the court and in the great temples and palaces; further, many of the objects made from the other materials described in this book were equally utilitarian, and indeed were employed in the same contexts as ceramics. Owners would have expected the ceramics to match the qualities and colours of the surrounding materials – gold and silver, lacquer and silk. Ceramics were thus inspired by these materials, but they too contributed to the visual world of their owners, and they too were therefore responsible for the ever greater attention to fine decorative detail and brilliant colour seen in all these materials during the Ming and Qing dynasties (fig. 187).

The high quality of all material life in China and the wide range of qualities in all materials were some of the potent stimuli working on the very impressive Chinese ceramic industry (fig. 188). Once removed from China and exported to the rest of the world, Chinese ceramics were employed in countries which only rarely saw materials of the colours and textures described here. Imported ceramics thus stood out as quite astonishing in their new contexts. In addition, as they were relatively abundant, they could be purchased by large numbers of people; while few in the Middle East or Europe could own Chinese silks, many could and did own Chinese ceramics. The ceramics industry was thus to become one of the major influences on the daily visual life of the rest of the world.

188 Ewer and *meiping* vase, both modern Song wares. The greenware ewer replicates the shape, decoration and colour of Northern Song dynasty Yaozhou ware. The proportions, thickness of the body and decorative motifs all appear slightly inconsistent with Song examples, but it is the highly bubbly texture of the glaze which indicates most clearly the recentness of manufacture. The iron-glazed *meiping* has the shape and colouring of northern ware of the 12th century, but the lug handles, high shine and distribution of the splashes against a mottled background are all modern features. HT (of ewer): 18.9 cm; (of *meiping*): 31.5 cm.

Notes

1. The author is grateful for comments by Nigel Wood on all technical matters discussed in this chapter. For further information the reader is referred to the Ceramics glossary, and to *Scientific and Technological Insights on Ancient Chinese Pottery and Porcelain: Proceedings of the International Conference on Ancient Chinese Pottery and Porcelain held in Shanghai; November 1–5, 1982*, Beijing, 1986; *The 2nd International Conference on Ancient Chinese Pottery and Porcelain (Abstracts)*, Beijing, 1985; *'89 Gudai taoci kexue jishu guoji taolunhui: lunwenji (The Proceedings of the 1989 International Symposium on Ancient Ceramics)*, Shanghai, 1989; N. Wood, 'Recent Researches into the Technology of Chinese Ceramics', in *New Insights into the Technology of Chinese Ceramics*, Los Angeles, forthcoming; N. Wood, 'Two International Conferences on Ancient Chinese Pottery and Porcelain, held in Shanghai in November 1982 and Beijing in November 1985', *Transactions of the Oriental Ceramic Society*, 1985–6, vol. 50, pp. 37–57; Oriental Ceramic Society, *Iron in the Fire: The Chinese Potters' Exploration of Iron Oxide Glazes*, London, 1988.

2. For surveys of the history of Chinese ceramics with which to supplement this account the reader is referred to Sato Masahiko, *Chinese Ceramics: A Short History*, New York, 1981; M. Medley, *The Chinese Potter: A Practical History of*

Chinese Ceramics, Oxford, 1976; S. J. Vainker, *Chinese Pottery and Porcelain: From Prehistory to the Present*, London, 1991; S. G. Valenstein, *A Handbook of Chinese Ceramics*, New York, 1975 (2nd edition, 1989); Feng et al., *Zhongguo taoci shi*, Beijing, 1982.

3. K. Pye, *Aeolian Dust and Dust Deposits*, Cambridge, 1987.

4. For finds from Fan Cui's tomb see *Wenwu* 1972.1, pp. 47–57.

5. H. Hatcher, M. Pollard, M. Tregear and N. Wood, 'Ceramic Change at Jingdezhen in the Seventeenth Century AD', in *The 2nd International Conference on Ancient Chinese Pottery and Porcelain (Abstracts)*, Beijing, 1985, pp. 69–70; M. Pollard and N. Wood, 'The Development of Chinese Porcelain Technology at Jingdezhen', in *Proceedings of the 24th International Symposium on Archaeometry*, Washington DC, 1986, pp. 105–16.

6. For glaze compositions and other aspects of ceramic technology see W. D. Kingery and P. B. Vandiver, *Ceramic Masterpieces: Art, Structure, Technology*, New York, 1986; F. and J. Hamer, *The Potter's Dictionary of Materials and Techniques*, 3rd edition, London, 1991.

7. For lead glaze technology see Wood et al., *An examination of some Han dynasty lead-glazed wares*, forthcoming.

8. *Wenwu* 1972.3, pp. 20–33.

9. For the tomb of Li Feng see *Kaogu* 1977.5, pp. 313–26.

10. For a survey of greenwares see Y. Mino and K. Tsiang, *Ice and Green Clouds: Traditions of Chinese Celadon*, Indianapolis, 1986.

11. For *fahua* technology see N. Wood and M. Tregear, 'An examination of Chinese *fahua* glazes', in '89 *Gudai taoci kexue jishu guoji taolunhui: lunwenji*, 1989, op. cit., pp. 172–82.

12. For the relationship between silver and ceramics see J. Rawson, 'Central Asian Silver and Its Influence on Chinese Ceramics', *Bulletin of the Art Institute*, vol. 5, 1992, pp. 155–67; J. Rawson, 'Chinese Silver and its Influence on Porcelain Development', in P. E. McGovern and M. Notis (eds), *Ceramics and Civilization*, vol. IV: *Cross-Craft and Cross-Cultural Interactions in Ceramics*, Westerville, Ohio, 1989.

13. For early comparisons of ceramics with other media see Lu Yu, *Chajing*, AD760, in *Wuchao xiaoshuo daguan*, Shanghai, 1926.

14. The more accurate term *qingci* is to be preferred to the widely used 'celadon', which denotes the same class of object but is derived from the name of the shepherdess wearing a dress of that colour in the seventeenth-century French novel *L'Astrée* by Honoré D'Urfé.

15. This technique was suggested by Wu Jia'an of the Institute of Archaeology, Chinese Academy of Social Sciences, Beijing, at a seminar conducted in the Department of Oriental Antiquities, British Museum, Autumn 1990.

16. P. Vandiver, 'The Forming of Neolithic Ceramics in West Asia and Northern China', in 89 *Gudai taoci kexue jishu guoji taolunhui: lunwenji*, 1989, op. cit., pp. 8–14.

17. The fast wheel is a major technological innovation attributable to several places, among them China and Egypt. It has been suggested that the Egyptian fast wheel appeared *c.*3000 BC (F. and J. Hamer, *The Potter's Dictionary of Materials and Techniques*, 2nd edition, London, 1986, p. 336). A late third or second millennium BC date is, however, more likely (J. Bourriau, *Umm El-Ga'ab: Pottery from the Nile Valley before the Arab Conquest*, Cambridge, 1981, pp. 15–16; C. A. Hope, 'Two Ancient Egyptian Pottery Wheels', *Journal of the Society for the Study of Egyptian Antiquity*, vol. XI, 3, 1981, pp. 127–33); I am grateful to Helen Whitehouse for these references. For the slow wheel in China, see *Kaogu* 1990.12, pp. 1100–106.

18. For Tongguan kiln sites see *Kaogu xuebao* 1980.1, pp. 67–96.

19. Ibid.

20. For Cizhou wares see Y. Mino, *Freedom of Clay and Brush through Seven Centuries in Northern China: Tz'u-chou type wares 960–1600 AD*, Indianapolis, 1980.

21. S. J. Vainker, 1991, op. cit., p. 181.

22. For enamel technology see Oriental Ceramic Society, 1988, op. cit., pp. 47,61 and 68. See also R. E. Scott, '18th-Century Overglaze Enamels: The Influence of Technological Development on Painting Style', in *Style in the East Asian Tradition: Colloquies on Art and*

Archaeology in Asia, no. 14, Percival David Foundation of Chinese Art, London, 1987, pp. 149–88.

23. Lai Suk Yee, 'The Style and Dating of Yue Ware in the Ninth and Tenth Centuries on the Basis of Recent Chinese Archaeology', thesis submitted for the degree of Master of Philosophy in the Faculty of Arts, School of Oriental and African Studies, University of London, 1981 (unpublished thesis no. 1247), pp. 127–31.

24. For an account of Neolithic cultures in China see K. C. Chang, The Archaeology of Ancient China, 4th edition, New Haven and London, 1986. For early ceramics, see W. Watson, Pre-Tang Ceramics of China, London, 1991.

25. For Peiligang see Kaogu 1978.2, pp. 73–9; 1979.3, p. 197; 1983.12, pp. 1057–65; and Kaogu xuebao 1984.1, pp. 23–52.

26. Sherds from Guangxi Guilin Zengpiyan are displayed in the Shanghai Museum.

27. Liu Zhenchun, 'Investigations of the Kilns and Firing Processes of Pottery and Porcelain in Chinese Past Dynasties', in Scientific and Technological Insights on Ancient Chinese Pottery and Porcelain, 1986, op. cit., pp. 295–300.

28. K. C. Chang, 1986, op. cit., pp. 150–51.

29. Wenwu 1987.12, pp. 75–80.

30. C. Mackenzie, private communication.

31. For Neolithic ceramics from Shandong see W. Watson, Pre-Tang Ceramics of China, 1991, op. cit., pp. 50–57.

32. For Sanlihe see Kaogu 1977.4, pp. 262–7.

33. For further east coast sites see Kiln site reports bibliography: Neolithic (Longshan, Dawenkou and Songze).

34. For a discussion of the relationship between late Neolithic ceramics and early bronze casting see R. Bagley, Shang Ritual Bronzes in the Arthur M. Sackler Collections, Cambridge, Mass., 1987, pp. 15–64.

35. For an account of Tang sancai see W. Watson, Tang and Liao Ceramics, London, 1984. For sancai technology see Li Zhiyan and Zhang Fukang, 'On the Technical Aspects of Tang sancai', in Scientific and Technological Insights on Ancient Chinese Pottery and Porcelain, 1986, op. cit., pp. 69–76; Li Guozhen et al., 'A Study of Tang Sancai', in ibid., pp. 77–81; J. Rawson, M. Tite and M. J. Hughes, 'The Export of Tang Sancai Wares: some recent research', Transactions of the Oriental Ceramic Society 1987–8, vol. 52, 1989, pp. 39–61. For kiln site reports see bibliography: Tang (sancai).

36. For regulations regarding tomb figures see W. Watson, Tang and Liao Ceramics, 1984, op. cit., p. 37.

37. Taiping Guangji 372:2956: Shangxiang ren, taken from Guang Yiji, a collection made in the eighth century and now lost. A French translation appears in L. Wieger, Folk-lore chinois moderne (1st edition, 1909, reprinted Farnborough, 1969), no. 165, pp. 294–6. I am indebted to Professor Glen Dudbridge for this reference.

38. Shōsō-in Office, Treasures of the Shōsō-in, Tokyo, 1965, pls 10, 87–93.

39. J. Rawson, M. Tite and M. J. Hughes, 1989, op. cit., pp. 39–61.

40. See footnote 10.

41. A Yue ware memorial tablet dated AD 823 and dedicated to a Mme Yao is in the Shanghai Museum. See also Zhongguo taoci vol. 4: Yue Yao, Shanghai, 1983, pl. 149.

42. For example, Ge gu yao lun, 1388, trans. Sir Percival David, Chinese Connoisseurship: The Ko Ku Yao Lun, The Essential Criteria of Antiquities, a translation made and edited by Sir Percival David, London, 1971.

43. Wenwu 1988.10, pp. 1–56.

44. Lu You (Song), Lao xue an biji, cited in S. J. Vainker, 1991, op. cit., p. 99.

45. See Li Jiazhi et al., 'Study of Ancient Yue Ware Body, Glaze and Firing Technique of Shanglinhu', in '89 Gudai taoci kexue jishu guoji taolunhui: lunwenji, 1989, op. cit., pp. 365–71.

46. N. Wood, private communication.

47. For kiln site reports of Gong xian, Xing and Ding kilns see bibliography: Tang (white wares) and Song (Ding ware).

48. Feng et al., 1982, op. cit., p. 205.

49. British Museum OA 1956.12–10.22, illustrated in S. J. Vainker, 1991, op. cit., pl. 68.

50. Feng et al., 1982, op. cit., pp. 236-7.

51. C. Clunas, 'The Cost of Ceramics and the Cost of Collecting Ceramics in the Ming Period', *Transactions of the Oriental Ceramic Society of Hong Kong, 1986-8*, Bulletin no. 8, pp. 47-53; paper given on 25 January 1989.

52. For Song ceramics see M. Tregear, *Song Ceramics*, London, 1982; for Song economics see J. W. Haeger (ed.), *Crisis and Prosperity in Song China*, Phoenix, Arizona, 1975.

53. Lu Jiuyan, cited in R. P. Hymes, *Statesmen and Gentlemen: the Elite of Fu-chou, Chiang-hsi in Northern and Southern Song*, Cambridge, 1988.

54. J. M. Addis, 'The Evolution of Techniques at Jingdezhen with Particular Reference to the Yuan Dynasty', in *Jingdezhen Wares: The Yuan Evolution*, Hong Kong, 1984, pp. 11-19; M. Tregear, 'Early Jingdezhen', in op. cit., pp. 20-22.

55. Feng et al., 1982, op. cit., pp. 266-7.

56. J. Rawson, *Chinese Ornament: The Lotus and the Dragon*, London, 1984 (2nd edition, 1990).

57. See footnote 44.

58. *Catalogue of the Special Exhibition of Sung Dynasty Kwan Ware, National Palace Museum*, Taipei, 1989; Yao Guifang, 'Brief Account of Southern Song Guan Kiln's Firing Date and Development', in '89 *Gudai taoci kexue jishu guoji taolunhui: lunwenji*, 1989, op. cit.

59. For copper-red glaze technology see Zhang Fukang and Zhang Pusheng, 'Analysis of Ming and Qing Sacrificial Red Glazes', in '89 *Gudai taoci kexue jishu guoji taolunhui: lunwenji*, 1989, op. cit., pp. 267-71; R. E. Scott (ed.), *Chinese Copper Red Wares*, London, 1992.

60. Liu Xinyuan, *Imperial Porcelain of the Yongle and Xuande Periods Excavated from the Site of the Ming Imperial Factory at Jingdezhen*, Hong Kong, 1989.

61. Ibid., pp. 74-5.

62. Chu-Tsing Li, 'Recent History of the Palace Collection', *Archives of the Chinese Art Society of America*, vol. XII, 1958, pp. 61-75.

63. For collecting see Chu-Tsing Li, 'The Artistic Theories of the Literati', quoting Li Ruhua on the ranking of antique objects, in Chu-Tsing Li and J. C. Y. Watt (eds), *The Chinese Scholar's Studio: Artistic Life in the Late Ming Period*, London, 1987, pp. 15-16; C. Clunas, *Superfluous Things: Material Culture and Social Status in Early Modern China*, Cambridge, 1991; and footnote 51.

64. For Yixing ware see *The Art of the Yixing Potter: The K. S. Lo Collection, Flagstaff House Museum of Tea Ware*, Hong Kong, 1990.

65. See footnote 51.

66. Cao Xueqin, *Hongloumeng* (trans. D. Hawkes and J. Minford), *The Story of the Stone*, 5 vols, London, 1973-86: vol. 1, p. 96; vol. 2, p. 292. Note the Ru ware, mentioned by Cao Xueqin in vol. 1, p. 96, is in the shape of a *gu* vessel, a shape not made in the Northern Song period, and therefore must be later in date.

67. For Longquan excavation reports see Kiln site reports bibliography: Song (Longquan ware).

68. For Dehua see P. S. Donnelly, *Blanc de Chine: The Porcelain of Tehua in Fukien*, London, 1969; and Kiln site reports bibliography: Song (Dehua).

69. R. Krahl, 'Glazed Roofs and Other Tiles', *Orientations*, March 1991, pp. 47-61; Zhang Pusheng, 'Notes on Some Recently Discovered Glazed Tiles from the Former Ming Palace in Nanjing', ibid., pp. 62-3.

6

Luxuries for trade

*This oriental country, year after year,
sends its long-journeying ships;
presenting a tribute of wind and moonlight
they come to China.
I trust you will not view this as some trifling affair:
the world now is a single family.**

Trade with China presented the West with new standards of elegance and delicacy, and the technical mastery of Chinese luxuries gave tantalising hints of a sophisticated society which had much to offer to Europe. And indeed it had. Yet the country was as effectively hidden by the surface sophistication of its luxuries as it had once been by the physical barriers – mountains and deserts – of its geography.

At most periods and for most merchants, the trade was in luxuries. Chinese spices, silks, teas and porcelains certainly added to the comforts and visual pleasures of life in India, the Middle East and the Western world, but the merchants and their customers, beguiled by these pleasures, did not often look beyond them. Lacking access to the objects the Chinese themselves valued most highly – the imperial court's collections of bronzes, jades and calligraphy – their understanding of the culture was inevitably incomplete.

China's most esteemed works of art were therefore never discovered by the traders and did not find their way to the West or even to the Middle East. Equally, the items of Western manufacture which the West considered of the highest value were never part of the trade: the great devotional paintings from churches and the portrait sculptures, in stone or bronze, were not known in China, and indeed were too much prized at home to be exported.[1] In fact, the traders rarely entered the heart of the country; they were excluded from the hinterland and confined to specified ports. Trade thus transformed the material quality of Western life, and in due course Western Europe developed industrial processes with which to match Chinese products. But neither side of the trading bargain understood the central preoccupations of the other or the objects that represented them, and the trade had little effect on the fundamental values of the societies involved.[2]

Trade started in early times, as China's neighbours coveted her brilliantly

**'A Fan from Korea' by Chu Yün-ming, in J. Chaves (trans. and ed.), The Columbia Book of Later Chinese Poetry, New York, 1986, p. 187*

coloured silks, lacquers and porcelains and began raiding and trading to satisfy their desires. Merchants from all parts of the world – from Southeast Asia, the Middle East and Europe – found their way to her borders and ports, pressing to be let in. China for her part could not remain aloof: politics and economics inexorably drew her into various trading networks.

The first exchanges between China and her neighbours were concentrated along her northern and northwestern borders, setting the scene for trade overland across Central Asia. From very early periods, the peoples here on the fringes of the country, bartered and invaded, swapping goods and techniques along the way. As mentioned in chapter 1, foreign weapons found their way in and Chinese ones were acquired by her neighbours from about 1300 BC (p. 55). The peoples on her borders soon developed an appetite for the luxuries which China produced in such abundance and of a quality unobtainable elsewhere. Initially trade centred on exchanges of horses for silk, but many more goods were eventually drawn into the process, creating what is known as the tribute system.[3]

Under the tribute system foreigners were allowed to bring goods as tribute to court, and to take away gifts. This was in itself a form of trade between the governments of the day. In addition, the envoys were able both legitimately and clandestinely to trade with the local people during the periods of their embassies. Yet the exchange of envoys was tightly controlled. Foreigners could only enter the country at fixed points along the border, and they had to be escorted to the cities whence they were bound, staying only at state guest houses. Officials coached the envoys in their conduct at court, and the rituals they followed implied that their own rulers were subordinate to the Chinese emperors.

Among the many tributaries to the Chinese courts were the rulers of the small states along what is known in the West as the Silk Route, sited at the oases of the Tarim basin (map III, p. 288). Descriptions of trade in this area have always appealed to Westerners because they provide a link, if a tenuous one, between our world and that of China, which was otherwise obscured by immense distances and almost insuperable geographical obstacles (Introduction, fig. 4). The Silk Route joined both the Indian subcontinent and Iran with China by way of the Tarim, and it is along this route that Western goods moved eastwards and Chinese ones travelled westwards (fig. 189).

Trade along the Silk Route, and indeed across China's northern borders, was much affected by the strengths and weaknesses of neighbouring states and by internal Chinese politics. Confederations of nomadic or semi-nomadic groups were formed by the Xiongnu (second century BC to first century AD), the Turks (fifth to seventh century AD) and the Mongols (thirteenth to fourteenth century AD). These powerful neighbours threatened Chinese interests and indeed, in the case of the Mongols, overran the country. Provoked by attacks on her border, China in her turn formed great empires across Central Asia under the Han (206 BC–AD 220), the Tang (AD 618–906) and the Qing (1644–1911).

Trade flourished, particularly at the times when China controlled the Tarim basin and installed her own officials to work with the local rulers. Contact with the Tarim basin, Iran and the Indian subcontinent also developed the Chinese taste for foreign luxuries. Foreign goods and traditions

were also introduced when northern China was ruled by foreigners. Buddh-ism, for example, was fostered by those who conquered the north after the fall of the Han dynasty. Other dominant foreign powers who introduced foreign practices and goods were the Qidan, who established the Liao dynasty (AD907–1125), and the Ruzhen, who ruled under the title of the Jin (AD1115–1234). Further west, the Xi Xia and the Tibetans set up formid-able states in competition with the Chinese. In due course, these powers on her northwestern and western borders became barriers to merchant traffic, and China's attention turned from the land routes to the sea.

Pressure from the north and periods of foreign rule also encouraged move-ment southwards, stimulating the growth of ports in the southeast. Although sea trade developed during the Tang, the Chinese ships were small and for a long time many craft were plied by the Arabs and peoples from Southeast Asia. Under the Song the sea-going junk was greatly improved, and from then until the fifteenth century much of the sea trade was in the hands of the Chinese. The Tang had abandoned strict control over commerce and begun to exploit it as a source of revenue; the Song followed the same course. Indeed, as their taxable territory shrank with the Jin conquests in the north, a flourishing sea trade was encouraged as a welcome source of revenue.

Ports grew larger at Yangzhou and later Quanzhou, and foreign settle-ments there are recorded not just by the Chinese but also by the Arab Ibn Battuta, in the mid fourteenth century.[4] Some of the most ambitious voyages were made under Ming sponsorship, and in the early fifteenth century the eunuch Zheng He reached the coast of Africa. Had the Chinese continued their policy of official support, they might have discovered Europe.

The challenge fell instead to the Portuguese, who arrived in the East shortly thereafter, and control of the seas fell into the hands of the Europeans. At first the Portuguese dominated trade. However, the discovery of the silver mines of Peru by the Spanish transformed the situation. The bullion they acquired gave the Spanish great purchasing power in Manila and the Far East, greatly expanding trade and feeding quantities of luxury goods back to Europe. Once an appetite had been created, other countries entered the competition, with the Dutch and then the British following the Portuguese. Only as this sea trade grew did the diplomatic and economic implications of sea access begin to impinge upon the Chinese authorities. The new world of the twentieth century was born as China struggled to come to terms with cultures whose achievements challenged her own.

Trade overland

China's early contacts with Western Asia

From the beginning of written Chinese records, it is plain that the ancient rulers of China saw only two classes of peoples: those of the metropolitan centre and those of the periphery, who were generally classed as not belong-ing at all. During the Shang and Western Zhou periods (c. 1500–771 BC), many areas which today lie well within China were regarded as alien and foreign. The Shang and Zhou were none the less in contact with them. Turtle shells and cowries, bronze and other precious materials were coveted

and imported from the south. We can trace contacts with these peripheral areas not just through these exotic raw materials, but in the use of foreign shapes and decorative motifs. As already discussed, during the Bronze Age southern China specialised in bell music and sculpture (ch. 1, figs 41–2; ch. 3, fig. 85). Bells and sculpture appeared from time to time at the Shang and Zhou capitals, indicating contact with foreign peoples and their ideas. However foreign such ideas may have seemed at the time, they were ultimately to be assimilated. Further, as China grew to engulf all these regions, it became more difficult to remember that they had been, in ancient times, distant and alien.

The Bronze Age also saw the introduction of products and technologies from areas that still today remain outside China. The use of foreign weapons in China has already been mentioned (ch. 1, p. 55). Small knives and weapons with tubular hafts were shared with Siberia and even Iran (ch. 1, fig. 27). The chariot too was a foreign weapon, features of its structure and the harness suggesting that it may have been acquired from the Caucasus.[5]

Weapons of war were obvious technological benefits that any people would wish to gain from their neighbours. Contact which brought warring parties together seems also to have led to minor exchanges of luxuries, among which were faience and glass. Faience beads are found in Western Zhou tombs (tenth to ninth century BC).[6] Both the use of these foreign materials and the forms in which they were made indicate that the Chinese were in contact not merely with their neighbours in Central Asia, but through them with the lands of the Middle East. Glass beads found, for example, in such

189 Photograph of excavations undertaken by Aurel Stein at Niya, one of the oasis cities on the southern Silk Route. Decoration on wooden houses and other buildings excavated at Niya and further east at Loulan was based upon Hellenistic, Iranian and Indian motifs. Here the winged creatures on the beam above the column are similar to mythical winged creatures found in Iranian decoration.

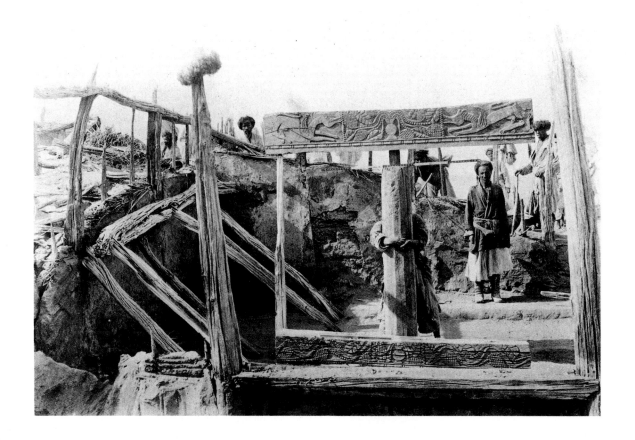

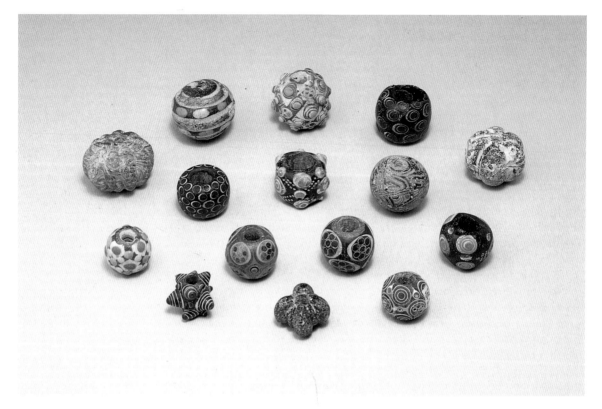

190 A group of glass and earthenware beads. Eastern Zhou period, 5th–3rd century BC. Beads decorated with layers of coloured glasses, making what are called eyes, are known from many parts of the world, including Egypt, Mesopotamia and Europe. The form of these beads was probably copied from such foreign examples. The chemical composition, however, indicates that the beads were made in China.

fifth-century BC tombs as that of the Marquis Yi of Zeng were made in the colours and shapes of beads found in the Middle East, Egypt and even Europe (fig. 190).[7] The minute layers of different colours on the surface of the beads, which make what are called the eyes, appear on beads from all these areas. Traces of barium in beads excavated in China show that they were not imports but local copies of foreign ones. Cobalt needed for the blue colour came from Afghanistan.

Another episode in the early contact between China and the lands to the west involved the semi-nomadic tribes known to the Chinese as the Xiongnu. Their battering of the Chinese borders provoked a full Chinese offensive into Central Asia under the forceful Han Emperor Wudi (140–87 BC).[8] Assailed by the Xiongnu, the emperor decided to deal with the menace by making alliances with peoples in western Central Asia, hoping to take the Xiongnu from the rear. This decision led to the famous embassy of Wudi's emissary, Zhang Qian, renowned especially for his enquiries about the coveted blood-sweating horses of Ferghana. Zhang Qian set off to seek alliances with the rulers of the oasis cities of Central Asia, but to no avail, and he was captured. In the succeeding centuries the Chinese followed up his failed embassy with conquest and control.

The Chinese official histories give vivid and very specific accounts of the small states that occupied the oases along the routes to the west in the Han period. It was clear to the Chinese that they would need allies in these vast tracts of hostile land if they were to exert any influence so far from their own cities. The dangers are well described in the Han history:

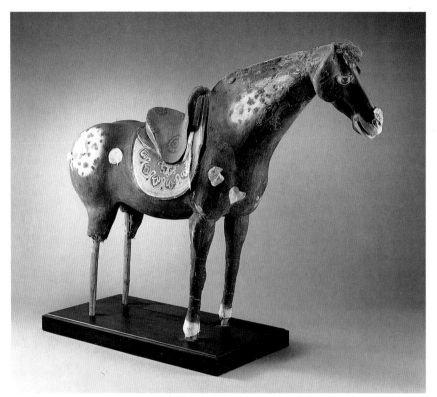

191 Model of a horse in clay and wood, painted. From Astāna, near Turfan, in Xinjiang province. Tang period, 8th century AD. The tombs at Astāna were probably those of high-ranking members of the families of rulers and merchants of the town of Gaochang, a seat of a Chinese governor-general until its destruction by the Tibetans in AD 791. The figures of horses, camels and earth spirits found in the tomb were based upon the examples in *sancai*-glazed ceramic used at Xi'an and Luoyang (see ch. 3, fig. 93). HT: 60.5 cm.

A patrol of some hundred officers and men may divide the night into five watches and, striking their cooking pots [to mark the hours] so keep guard; but there are still occasions when they will be subjected to attack and robbery. For asses, stock animals and transported provisions they depend on supplies from the various states to maintain themselves. But some of the states may be poor or small and unable to provide supplies, and some may be refractory and unwilling to do so. So our envoys clasp the emblems of mighty Han and starve to death in the hills and valleys.

> A. F. P. Hulsewé, *China in Central Asia, The Early Stage: 125BC–AD23, An Annotated Translation of Chapters 61 and 96 of the History of the Former Han Dynasty*, Leiden, 1979, p. 56

Traces of the dialogue between the Chinese and the Xiongnu and of the Chinese embassies and conquests in the west are found in the form of Chinese luxury goods in Xiongnu tombs, particularly those at Noin Ula in Outer Mongolia.[9] Here, among the bronze plaques made by the Xiongnu to decorate their belts and harnesses, are Chinese mirrors and scraps of Chinese textiles and lacquer. At the same period mirrors, lacquer and textiles found their way as far west as Afghanistan. A bronze mirror of the Han period has been found in the golden hoard from Tillya-tepe in Bactria (now Afghanistan).[10]

To fight the mounted nomads the Chinese required fine horses. The climate and terrain of the Yellow River basin were not very well suited to

horse breeding, and throughout her history China bartered and traded horses with her northern neighbours, among them the Uygur Turks. In the Han and Tang periods there were regular exchanges of horses for silk. Often the Turks demanded extortionate quantities of silk in return for inferior horses:

> In the last decades of the eighth century, the ordinary price of a Uighur [Uygur] horse was forty bolts of Chinese silk, a stupefying expenditure. In the early part of the ninth century, it was not unusual for the shattered nation to pay out a million bolts of taffeta in a year in exchange for a hundred thousand decrepit nags, the dregs of the northern marches.
>
> E. H. Schafer, *The Golden Peaches of Samarkand: A Study of T'ang Exotics*, Berkeley and Los Angeles, 1963, p. 64

So prized were such horses in the Tang period that they were frequently modelled in brightly glazed pottery for burials. In the Chinese colony at Astāna, near Turfan in the Tarim basin, a similar model was made in wood and clay, and painted rather than glazed (fig. 191).

China under foreign rule and the advent of Buddhism

The decline of the Han (206 BC–AD 220) transformed Chinese society. Their collapse altered the balance of power in East Asia, with foreigners invading and taking over northern China. The dominant power in this period was the Northern Wei dynasty, set up by the people known as the Toba (AD 386–535). To the west was the small Liang kingdom ruling Gansu province, and the oases were dominated by Iranian groups.

The rulers of the Liang were devout Buddhists and those of the Northern Wei became so, especially after their conquest of the Liang state in the mid fifth century. This faith had a profound effect on the development of many aspects of Chinese arts and technology, affecting not just the making of Buddhist images (ch. 3) but also the whole repertoire of Chinese decorative motifs and many of the objects to which they were applied. To see why this should have been so it is necessary to give a brief account of the history of Central Asia.

192 Two wooden beams from Loulan in Xinjiang province. 3rd century AD. These two beams are decorated with ornament typical of the Hellenistic and Roman worlds: rosettes within a binding on the upper one, and an undulating scroll with half palmette leaves on the lower one, above a pattern derived from a wreath.
L (*top*): 2.15 m;
(*bottom*): 1.68 m.

As already mentioned in connection with religious images (ch. 3, p. 150), the whole apparatus of Buddhism in the northwest corner of the Indian subcontinent had benefited from the Hellenisation of the area following Alexander's conquest.[11] The rulers of Gandhara (in present-day Afghanistan and Pakistan) were the Kushans, a people who had moved to this area from East Asia. They combined their faith in the Buddha with the use of Hellenistic and Roman figure types, as well as the buildings in which to set them. Buildings as settings for sculpture had ancient Near Eastern roots – for example, in the palaces of the Assyrian kings. These practices had been employed in Greece and Rome and in Parthian Iran, and were adapted for the Buddhist monuments in Gandhara. Figures in robes similar to the Roman toga were set on buildings, between columns carrying provincial forms of Corinthian capitals. Such architectural schemes survive today in the Buddhist stupas of Afghanistan and Pakistan.[12]

The Kushans who built these monuments were great proselytisers. In the second and third centuries AD, they sent out missionaries to the oases of the Tarim basin and established Buddhist foundations at all the major cities

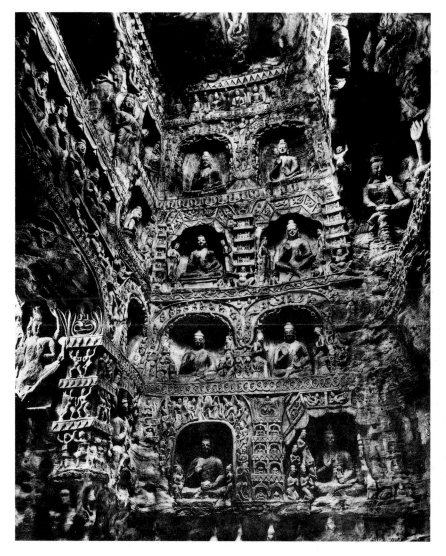

193 East wall of the rear room of cave 7 at Yungang, Datong, Shanxi province. Northern Wei dynasty, late 5th century AD. The suggestion of a high building with figures seated in door-like openings was derived from the West by way of Central Asia. The running scroll, between the lowest and the second tier of openings, is likewise based on a Western design (the same scroll can be seen on the lower beam in fig. 192).

263

there.[13] The impact of these missions can be seen in every aspect of the remains from the area. The wooden buildings from sites such as Loulan were decorated in classical style (fig. 189).[14] Columns here also carry Corinthian capitals, and beams and small pieces of furniture bear the rosettes and palmette bands familiar from Western classical architecture (fig. 192). In addition, pots carry decorative beading, heads and dotting, all in Greek or Iranian style.

It is directly from these sources that the Buddhist architecture of the great Chinese caves at Yungang derived such features as figures set in niches, leafy capitals and palmette borders. A wall in Yungang is divided by tiers of niches, each enclosing a figure, and each tier is separated by a horizontal border (fig. 193). In the border is the undulating leaf scroll known as a palmette. These simple leafy patterns were the sources for the much more complicated flower patterns evolved in China over the succeeding centuries.

It is sometimes suggested that such flower designs may have entered China on textiles or silver, and this is a possibility. However, without the impact of a wholesale change in direction, such as that involved in the introduction of Buddhism, it is unlikely that a series of completely foreign decorative motifs could have been so successfully transplanted. The decoration of Buddhist architecture in China from the fifth to the eighth century illustrates

194 Line drawings illustrating the development of flower scrolls in China based upon half palmette designs introduced with Buddhism from lands further west (*from top to bottom*): (a) leaf scroll from cave 8 at Yungang near Datong, Northern Wei period, late 5th century AD (cf. fig. 193); (b) loped scroll with half palmette leaves, from cave 9 at Yungang near Datong, Northern Wei period, late 5th century AD; (c) undulating scroll with fluffy, flower-like heads suggesting peonies, from the epitaph cover for Wang Gan, Tang dynasty, AD 693; (d) lotus scroll with lotus flowers inserted into an undulating scroll with palmette leaves, from cave 427 at Dunhuang, Gansu province, Sui dynasty, 6th century AD; (e) peony scroll with large flowers added to an undulating scroll with leaves based upon half palmettes, an elaborate version of (c), from a stone lunette from the tomb of Yang Zhiyi, Tang dynasty, AD 736.

the transformation of the Western palmette scroll, first into a lotus pattern and then into peony scrolls.[15]

At first only combinations of leaves were used, as shown in the upper drawing of figure 194. These could lie horizontally (fig. 194a) or vertically in relation to the stem, the paired examples suggesting flowers (fig. 194b). Alternatively, real lotus could be inserted as flowers in their place, as in many examples in Buddhist caves (fig. 194d). Peonies came into the repertoire in the late seventh century, when the Empress Wu Zetian encouraged their cultivation (fig. 194e). The early forms of flower decoration were made by manipulating the design of half palmette leaves so as to encourage the viewer to see the shape of a peony (fig. 194c). From such simple ornamental manipulations arose almost all the different flower patterns employed not only in Buddhist caves and architecture but in all the later decorative arts. The transfer was swiftly made from architecture to textiles and precious metalwork, more slowly to ceramics. In effect, the visual world was transformed. This change was accelerated, as we shall see below, by the import of foreign luxuries, particularly gold and silver, and glass vessels.

Indeed, the period from the fifth century AD was one of the principal times in Chinese history when both the religious and the decorative arts, especially utensils for eating and drinking, were radically altered in shape, texture and decoration by the introduction of foreign customs and motifs. In most circumstances such changes are very difficult to make; before the twentieth century almost all societies were very resistant to altering anything at the centre of their traditions.

Two factors made change possible. The first and most important was that the rulers of the day were outsiders, to whom foreign practices and utensils were possibly more familiar and more desirable than indigenous Chinese ones. To those at the apex of society, the rulers and their courtiers and officials, these new artefacts seemed appropriate.

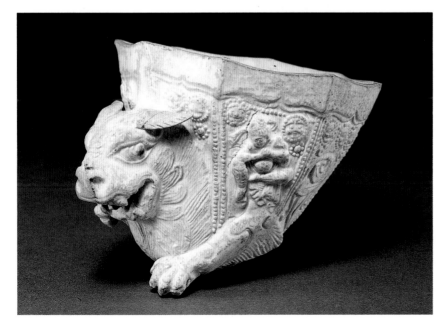

195 Porcelain octagonal rhyton supported on an animal head. Tang dynasty, 7th century AD. The rhyton shape and its decoration were borrowed from Iran and Central Asia. It is likely that this example refers to a metal prototype, for in silver the flat sides, borders of small dots and the relief figures would have been easy to work. HT: 9 cm.

Their support of foreign decorative styles and utensils was given additional emphasis by their patronage of Buddhism. A religion led by a central government, especially a court with a king seeking justification to underpin his rule, has special power and receives support from the highest figures in the land, thereby conferring legitimacy on them. Everything pertaining to the religion is then supported by the court and also copied in the lower levels of society by those wishing to demonstrate their allegiance, either to the ruler or to the society as a whole. Buddhism required foreign image forms and foreign utensils, of which the most highly prized examples were made in gold and silver. Descriptions of Buddhist temples give vivid pictures of precious objects now long since melted down:

> On the road to the south of the Stone Bridge was the Jingxing Nunnery [Flourishing Prospect Nunnery], which was also built by a group of eunuchs as a joint enterprise. There was a gold carriage with an image, which was thirty Chinese feet off the ground. A jeweled canopy was hung above the carriage, from which were suspended gold bells, beads made out of seven varieties of precious materials, and images of Buddhist musicians and entertainers who appeared high up in the clouds. The craftsmanship was so superb it was hard to describe. When the [carriage-held] image was on parade, the emperor as a rule would order one hundred *yü-lin* guards to carry it, with the accompanying music and variety shows all provided for by the court.
>
> Yi-t'ung Wang (trans.), *A Record of Buddhist Monasteries in Lo-yang* by Yang Hsüan-chih, Princeton, 1984, pp. 77–8

Secular life was equally affected. In particular gold and silver vessels, which had previously been used on a very small scale alongside those of bronze, lacquer and ceramic, were now increasingly sought after and thus came to stand above the utensils made of the more traditional materials. Glass, too, was imported and treasured.

We have three sources of evidence of the high esteem in which utensils in these materials were held: tombs; the treasury of the Shōsō-in at the Tōdai-ji temple in Nara, in Japan; and pagoda deposits. Tombs of the fifth and sixth centuries on the western edge of central China, in Shanxi, Gansu and Ningxia, have revealed imported gold and silver. Both the forms and designs are related to those employed in Central Asia, Iran and the Indian subcontinent. Among the most striking finds are a bowl with repoussé hunting scenes showing a king killing a boar,[16] stemcups decorated with relief figures and vine scrolls,[17] and an elegant ewer carrying figure scenes from Greek mythology.[18] All the examples mentioned include figure scenes, rarely seen on Chinese eating vessels, and all are executed in repoussé. These foreign pieces decorated in repoussé are rare, but close imitations in ceramic were widely distributed. One of these, a rhyton, is in the Museum (fig. 195). Its sharp angles and flat sides are typical of metalwork, as are the fine beading and relief figures.

Similar foreign silver pieces are found in the Shōsō-in. But here they appear along with Chinese silver descended from foreign examples and many other luxuries, including foreign glass. Many of these precious items were

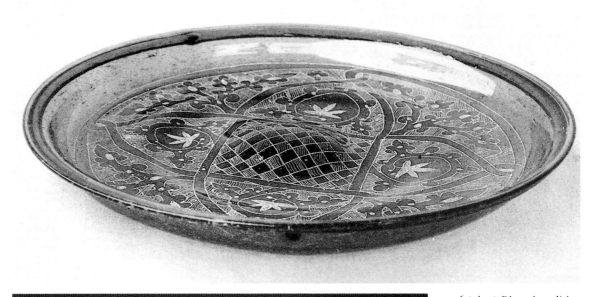

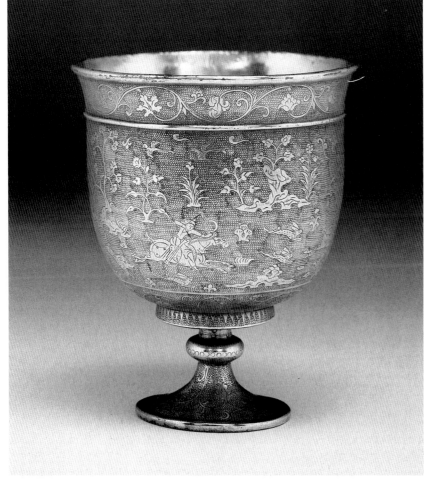

196 (*above*) Blue glass dish with an incised design. From the deposits under the pagoda at the Famen Buddhist temple in Fufeng county, Shaanxi province, closed in the late 9th century AD. Very little glass was made in China, the best pieces being imported from the Islamic world. Incised blue glass has been found at Samarra in Iraq, where this piece may have been made. DIAM: 20 cm.

197 Silver stemcup with an incised and ring-punched design of huntsmen amid a landscape. Tang dynasty, 8th century AD. Stemcups in gold, silver and gilded bronze were introduced to China from Central Asia and lands further west. They thus closely resemble stemcups used in the Mediterranean area, although the decoration is typically Chinese. HT: 9.8 cm.

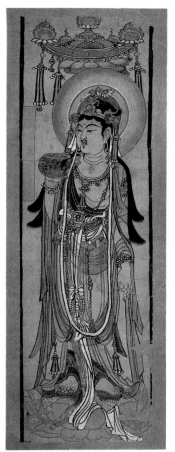

198 (*above*) Figure of a Bodhisattva holding a faceted glass. Part of a banner painting in colours on silk, from cave 17 at Dunhuang, Gansu province. Tang dynasty, late 9th century AD. Faceted glass bowls similar to this one were made in Iran and a few were imported into the Far East, as indicated by relics found in Buddhist deposits. There is a fine example in the treasury of the Shōsō-in at the Tōdai-ji temple in Nara, Japan. W: 26.5 cm.

the personal possessions of the Japanese Emperor Shōmu (d.756), and were dedicated to the Tōdai-ji temple at his death. They are evidence of an extended trade from Iran in the west to Japan in the east, drawing in China along the way. The Japanese at this date emulated the court life of Korea and China, and we can surmise that the fine textiles, musical instruments, silver and glass owned by a Japanese ruler were similar to those of the emperors of China.

Finally, we have conclusive evidence of the value of gold, silver and glass from pagoda deposits. Pagodas held relics of the Buddha, as mentioned above (ch. 4, p. 186). Sumptuous containers, often placed one inside the other, protected the fragments of bone or other precious relics, and only the most highly valued materials would have been used for such purposes. At the Famensi at Fufeng, Shaanxi province, a pagoda deposit sealed in the late ninth century, the bone relics were placed inside caskets made of gold and silver. It was very common, as at the deposit at the site of the Qingshan temple, near Lintong in Shaanxi province, to place the relics in small glass bottles, thus proclaiming the high value of all these materials.[19]

The vessels deposited alongside the caskets were equally fine. In addition to large numbers of gold and silver pieces (ch. 4, fig. 137) probably made in China, the Famen temple contained foreign glass. The dish shown in figure 196 is blue with an incised design, a type found also in Iraq at Samarra.[20] The high status of glass in Buddhist contexts and by extension in society at large is confirmed by a painting of a Bodhisattva, shown holding a glass bowl in his hand (fig. 198).[21]

Although the number of foreign gold, silver and glass items retrieved is relatively small, we can survey their enormous impact by looking at their effect on Chinese-made silver and ceramics. Whereas in the Han period Chinese silver was extremely rare, by the Tang it was quite widely used. Hoards, buried at Xi'an and also in the south in Jiangsu province, show that members of the élite owned large sets of silver vessels for drinking parties.[22] The shapes were derived from the West and include stemcups, for example, which resemble those used as far away as Western Europe (fig. 197).

Now that the most highly valued eating and drinking utensils were made of either thin shiny glass or hammered thin metal, the demand for very thin, often white ceramics grew (ch. 5, fig. 157; Introduction, fig. 9). Many of the shapes of Tang and Song ceramics can only be understood as being based upon these prototypes.[23] Further evidence for the high standing in which foreign shapes and materials were held is provided by burial ceramics. Although made in lead-glazed ceramic, many Tang *sancai* pieces are in the shapes of foreign metalwork. Two ewers and an amphora in figure 199 reproduce Central Asian metalwork, ceramic and glass shapes.

If throughout the Tang (AD 618–906) and Liao (AD 907–1125) periods luxury goods were brought into China, Chinese trade outwards towards the West was also developing in extent and variety. Much of this new trade was carried by sea and is described below. However, a vital element was the movement of Chinese goods westwards in the wake of the Mongol conquests of Central and Western Asia. Genghis Khan formed his confederation of Mongol tribes during the early part of the thirteenth century, and from 1211 turned his attention to the powers surrounding Mongolia.[24] Over more

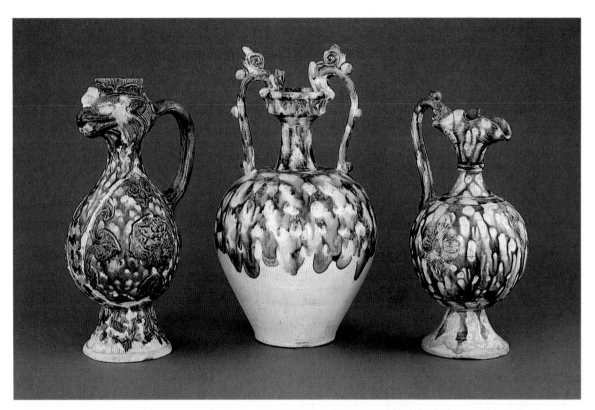

201 A wall painting of a Mongol and his wife and servants from a tomb excavated at Yuanbaoshan, near the city of Ulanhad in Liaoning province, China. Yuan period, 13th–14th century. As rulers of China, the Mongols adopted many aspects of Chinese life, including their furnishings, such as the chairs and stools shown here, and indeed the practice of constructing and painting tombs.

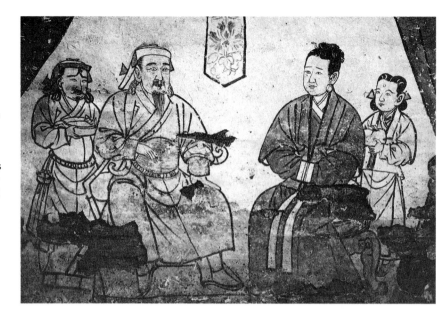

199 (*previous page above*) Two ewers and an amphora in *sancai*-glazed ceramic. Tang dynasty, 8th century AD. The shapes of all three pieces are reminiscent of Central Asian, Iranian and Hellenistic and Roman ceramics, metalwork and glass. Such pieces were made for burial rather than for daily use and imitate metalwork and glass rather than the finest ceramics. HT (*from left to right*): 28 cm; 31.2 cm; 27 cm.

200 (*previous page below*) Folio from a *Divan* (collected poems) of Hafiz. Copied in 1451, probably at Herat in Afghanistan. The coloured paper, flecked and decorated with buildings in a landscape in gold, was either made in China or copied from a Chinese example. In due course, such Chinese-style decoration was confined to the borders of manuscripts.

than twenty years, Central Asia, Iran, Iraq and, in the east, China fell under Mongol rule. By 1235 Mongols controlled the whole of the Asian continent as far west as the boundaries of Europe.

The Mongols themselves had irreparably damaged the world they took over; there was therefore scope for changes in direction as the areas were regenerated. Like other nomadic peoples before them, the Mongols were fascinated by the luxuries of China, introducing these not only to their homelands in Mongolia but to many parts of Western Asia (fig. 201). Textiles, lacquer and ceramics in Chinese style all appear in Iranian illuminations of the fifteenth century, illustrating the transformation of the daily life of the élite. The impact of Mongol rule on Western Asia was as strong as that of the foreign rulers of northern China who, by patronising Buddhism, had unwittingly changed the Chinese decorative arts.

We can assess the intensity and permanence of Chinese influence in the visual world by looking at manuscripts. In Iran and Turkey, manuscripts were some of the most highly valued items (in any society, the most precious items are the least susceptible to foreign influence), yet they too were altered under the impact of Chinese fashions. One of the most subtle yet pervasive changes was brought about by the introduction of Chinese-type papers to the Iranian world. In China coloured paper, particularly dark blue paper sometimes flecked with gold, was employed for Buddhist texts or sutras. Other colours were also available, as we know from documents discovered at Dunhuang in Gansu province. In Japan, too, the Chinese tradition of decorating coloured papers with gold has survived, and some ancient examples have been preserved.

The Mongols carried this interest in Chinese papers westwards. A few surviving fifteenth-century Iranian manuscripts are written on examples of decorated Chinese papers or on close copies of them. Figure 200 shows a folio of blue paper on which appears a small landscape with pine trees, shrubs and some buildings painted in gold. The writer of the text has completely

disregarded the design, treating it as a decorative background, as the Chinese would themselves have done.

This paper must have been in relatively short supply and much valued, being of better quality than anything available locally. It was to have long-lived influence. Later manuscripts from Turkey as well as Iran retain a Chinese influence, particularly in the borders. These are frequently pale salmon-coloured, green or off-white, with patterns in gold, often of Chinese motifs. It is as though, having first used Chinese paper for the whole page, a Chinese flavour was retained in the borders, a less decorated paper being employed for the area of main text. In this way Chinese taste was modified to meet Islamic needs.[25]

Sea trade

Once southern coastal areas of China had grown in population and sophistication, and once the Tang had relaxed the regulations restricting sea trade between China and her neighbours, sea trade developed gradually and naturally, spreading outwards in all directions as knowledge of the seas increased and the design of ships improved. Command of the sea required both good ships and good maps, and these the Chinese rapidly developed. In the thirteenth century Marco Polo described Chinese sea-going junks as having cabins, a rudder, multiple masts and a bulkhead-built hull. He was impressed by the separate holds, which meant that if water entered one hold, the other remained dry. He also mentioned the use of tung-oil and lime, and remarked on the great size and tonnage of the ships (fig. 202).[26]

Archaeological evidence now verifies Marco Polo's description, for in 1973 a junk dating to about 1274 was discovered during dredging near Quanzhou, the most important port at this time, situated on China's southeast coast (Marco Polo calls it Zayton). This ship was made of cedarwood, with sails of bamboo and hempen cords, and incorporated many of the features described by Marco Polo, including separate holds. It was found to be on its return journey to Quanzhou, carrying tortoise shell, frankincense, mercury, rare woods and dried herbs.[27]

Chinese junks were impressively strong, due to the separate bulkheads in the hull; strength was essential as they had to withstand the frequent typhoons of the South China Sea. They could also operate in the shallow waters surrounding the many islands in the South China Sea because they had a stern rudder that could be raised or lowered by a windlass.[28] European shipbuilders later adopted this feature, as it did away with the need for an oar at the back and allowed for the construction of much larger ships controlled by a wheel. Multiple masts were also taken up in the West, as were watertight bulkheads.

The use at sea of the magnetic compass, invented by the Chinese, dates to 1090 in China and was introduced to the West a century later. At first it was used in China by geomancers for divination purposes, but its value at sea, especially at night, was quickly appreciated. The earliest Chinese compass taken to sea was probably a magnetised needle floating on water in a small cup.[29]

Maps and charts, both terrestrial and astronomical, were also vital to

202 Drawing of a Chinese freighter with five masts. The 15th-century treasure ships of Admiral Zheng He would probably have been built like this but were much bigger, approximately 150 metres long. They sailed in large fleets and each ship displaced about 1500 tonnes, five times as much as the contemporary Portuguese caravels.

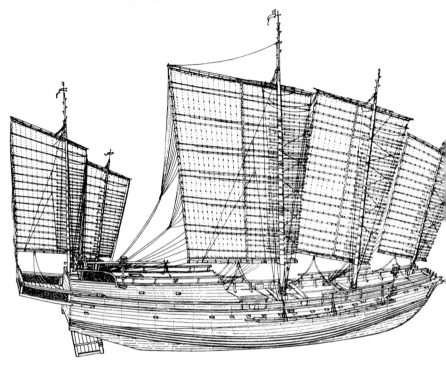

China's early predominance in trade and navigation. It has been estimated that the Chinese were a century ahead of the West in map making at this time, as can be seen by comparing a fourteenth-century world map drawn by the Yuan cartographer Zhu Siben with the Catalan atlas produced in 1375 for Charles V of France by Abraham Cresques.[30]

Evidence for early Chinese sea trade exists from at least AD 90, when Ban Gu wrote the *Qian Han shu (History of the Former Han period)*, describing trade with the south seas. Chinese coins from the first century AD, found in tombs at Dongson in northern Annam, corroborate this.[31]

During the Tang dynasty only one port, Canton, was officially allowed to trade with foreigners. During the Southern Song period (1127–1279), however, sea trade flourished. The Song Emperor Gaozong founded the Chinese navy in about AD 1145, after northern China had been overtaken by the Jin Tartars and the Song forced southwards. Gaozong said: 'The profits from maritime commerce are very great. If properly managed they amount to millions [of strings of cash]. Is this not better than taxing the people?'[32] A maritime trade commission was set up to supervise and tax merchant ships, and other ports along China's southeast coast, such as Quanzhou, were opened up to trade with foreigners.

During the Southern Song, ships sailed out from Quanzhou to Japan and Korea, Southeast Asia, India, East Africa and the Islamic world. Arab merchants came to live in Quanzhou, as witnessed by a large number of Muslim gravestones inscribed in Arabic script in the cemetery there.[33]

The apogee of China's sea trade was reached in the early Ming dynasty under the renowned Muslim eunuch, Admiral Zheng He. Between 1405 and 1433 he made distant expeditions which took Chinese junks to the African coast and the Persian Gulf. They may even have reached Australia.

Known by the Chinese as the 'Three-Jewel Eunuch', he succeeded not only in encouraging overseas trade but also in impressing foreign countries with China's wealth and power. Several times he brought back foreign chiefs as prisoners to pay tribute to the delighted emperor. He also collected exotic plants and animals, including a giraffe from Africa. Zheng He's 'treasure ships' must have been approximately 150 metres long as calculated on the basis of a rudderpost from one of his ships, discovered at the site of one of the Ming shipyards near Nanjing in 1962.[34]

Ships leaving Quanzhou exported porcelain, silks, lacquer, medicines, handicrafts, wine, silver, gold and iron ore. They imported spices and medicinal herbs, amethysts, rhinoceros horn, ivory, glass, precious woods and dyestuffs. Because many of the exported items were fragile, it is usually porcelain and coins, the most durable, which survive in many parts of the world as tangible evidence of this trade.

Trade with Korea and Japan

China had traded with Korea and Japan since early times. Early southern Chinese ceramics, white wares excavated from the tomb of King Muryong dating to AD 523, provide evidence for sea trade between the two countries at this early date, supplementing the overland northern route.[35] The development of Koryo celadons in the tenth century owed much to the import of Yue wares from Zhejiang province. The quickest route from Zhejiang to Korea was by sea to the southwest coast, the area in which Korean celadons were made.

Japan also imported Chinese products as early as the Tang dynasty. The imperial treasury of the Shōsō-in at the Tōdai-ji temple in Nara contains a wealth of Chinese luxury goods made of lacquer, bamboo, ivory, gold, silver,

203 A group of Chinese celadons being salvaged from the seabed in 1976, some of the 9600 pieces which formed part of the cargo of a ship travelling from southeast China to a temple in Japan, via Korea. It was shipwrecked at Sinan, off the southwest Korean coast, in AD 1323.

273

glass and silk. It also includes Near Eastern glass vessels which would have started their long journey overland across the Silk Route and have then been transported by sea to Japan.

Ceramics exported to Japan include Tang *sancai* wares as well as the black wares (*temmoku*) favoured by Buddhist monks, white wares and Longquan celadons. The shapes of many of these vessels – teabowls, sutra boxes, censers – suggest that they were used primarily by monks. The demand for celadons in Japan can be seen in the large numbers recovered from a shipwreck discovered at Sinan, off the southwest coast of Korea, in 1976. The ship is dated to AD 1323 and was probably on its way to a temple in Japan from Ningbo in southeast China, via Korea. As well as over 9600 Chinese celadons (fig. 203), it carried bronze vessels, *qingbai*, black wares and lacquer.[36]

Trade with Southeast Asia and India

There are various Chinese texts which describe maritime trade during the Song (960–1279) and Yuan (1279–1368) dynasties, such as the *Zhu fan zhi* (*Records of foreign peoples*) by Zhao Rugua (AD 1225) and the *Dao yi zhi lue* by Wang Dayuan (*c.*1349). The latter mentions ninety-nine different countries visited, including Taiwan, the Philippines, Borneo, the Moluccas, Vietnam, Malaya, Sumatra, Bengal and India.

Chinese exports to Southeast Asia at this time consisted mainly of silk, ceramics and copper coinage. Chinese ceramics were regarded as luxury items in Southeast Asia because of their rarity, and were buried in tombs and kept as family heirlooms. There was a continuous history of trade between China and Southeast Asia, with blue-and-white porcelain and celadons exported in large quantities during the Ming (1368–1644) and Qing (1644–1911) dynasties. Many of the ceramics were made in shapes particularly popular in the area, including the *kendi*, a squat pouring vessel. A variety of coarser wares, made in Guangdong province during the sixteenth and seventeenth centuries for export to Southeast Asia, are usually grouped under the name Swatow; these include polychrome enamels, blue-and-white and slip-painted wares. Chinese celadons and porcelain were imitated in several countries of Southeast Asia with varying degrees of success (fig. 204).

Chinese trade with India is recorded both by Marco Polo and by the Arab traveller Ibn Battuta, who describes Calicut as the principal port for Chinese trade in the 1340s.[37] Several of Zheng He's expeditions reached Ceylon and Calicut in the early fifteenth century, and it seems that the latter was a great entrepôt port for the Persian Gulf and East Africa. In 1436 Fei Xin records that the Chinese brought back from India gum, amber, jade, rubies and exotic fruit while exporting gold, silver, satin, blue-and-white porcelain, betels, musk and quicksilver.[38]

Chinese porcelain was highly valued in India. In 1616 Sir Thomas Roe recorded that the Emperor Jahangir valued China ware and crystal 'more than gold and silver, horses and jewels'. He also records that the price of Chinese porcelain in India was higher than it was in England.[39] Hindus disliked eating off porcelain, and it was the Muslim ruling class who collected it, often marking it with a sign of their ownership in the form of holes drilled in geometric patterns into the base of the piece. Imperial Mughal marks of ownership can occasionally be found on Ming porcelain, engraved

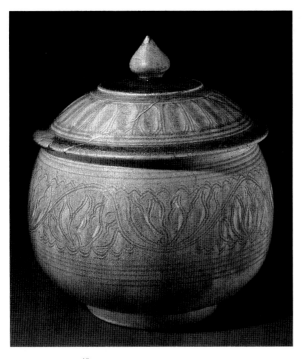

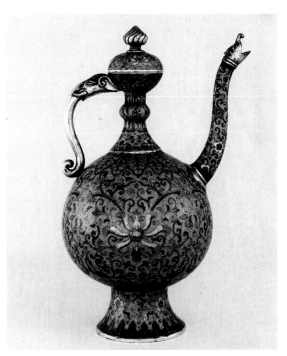

in the glaze.[40] Both celadons and blue-and-white vessels appear in Mughal painting. In China, Indian influence was particularly noticeable in the late seventeenth and early eighteenth century. Specialist items were produced for the Indian market, such as porcelain huqqahs,[41] or in Indian shapes such as the cloisonné ewer in figure 205. The Emperor Qianlong (1736–95) was particularly fond of Mughal jades, which he collected in considerable numbers. Chinese jade carvers made bowls and dishes with very thin walls, in Mughal and 'Hindustani' flower shapes.

Trade with the Arab world

Maritime trade flourished between China and the Middle East from at least the Tang dynasty. Sherds of Tang *sancai*, Changsha wares and Gong xian-type white wares decorated in blue have been excavated from the port of Yangzhou in Jiangsu province, which suggests that they were destined for export. Sherds of these wares have also been found at Mantai in Sri Lanka, Samarra in Iraq and Fustat in Egypt. The decoration and shapes of these ceramics were suited to Middle Eastern rather than Chinese taste and illustrate the Chinese responsiveness to the demands of distant markets.[42] This trade also resulted in Islamic imitations of Tang *sancai*, white wares, celadons and porcelain. The most important collection of Chinese ceramics exported to the Middle East is contained in the Topkapi Palace of the Ottoman sultans in Istanbul. It comprises over 10,000 pieces, dating from the Yuan to the Qing dynasties.[43] Many of these pieces are massive platters and bowls for use in ceremonial banquets. They differ from the small jars, pouring vessels, boxes and bowls popular in Southeast Asia and from the ceremonial vases and censers favoured in Japan.[44]

In early seventeenth-century Iran, 1162 pieces of Chinese porcelain, pre-

204 (*above left*) Covered jar with lotus-shaped knob and incised lotus scrolls. Thailand, Sawankhalok, 14th–16th century. While the celadon glaze and decorative motifs show Chinese influence, the shape is typically Southeast Asian.

205 (*above*) Chinese cloisonné enamel lidded ewer. Qing dynasty, 17th century. The globular shape of this ewer, as well as the elephant-shaped handle, the *makara*-headed spout and the spirals on the knob, all suggest either that it was made for the Indian Mughal market or that it was influenced by Indian metalwork. Similar shapes occur in 17th-century bidri ware from India and in white Iranian fritware of the 17th century.

206 Fritware dish painted with underglaze stylised chinoiserie lotuses and spring flowers. Ottoman Turkey, Iznik, 'Damascus' group, c.1500–1570. The border decoration is derived from the cloud and wave scrolls on Chinese blue-and-white porcelain of the 15th century. However, both the colours and the arrangement of the central group of hyacinths, tulips and lotuses are in Turkish taste.

207 (opposite left) One side of the pyramidal ceiling of the Casa das Porçolanas in the Santos Palace, Lisbon. The palace contains more than 260 Chinese blue-and-white porcelain dishes and plates dating from the 16th and early 17th century. 'Chinese' rooms were created in palaces and country houses all over Europe from the late 17th century onwards, a testimony to the vogue for exotic Chinese porcelain and decorative arts.

dominantly blue-and-white, were collected at the shrine of the fourteenth-century Sheikh Safi and dedicated by Shah Abbas in 1611, a testimony to the high value of Chinese porcelain in Iran at this time.[45] An imitation porcelain, known as frit and composed of a mixture of clay and crushed quartz, had been made in Iran and Syria as early as the twelfth and thirteenth centuries. Imitation celadons were made in Timurid Persia (AD 1378–1506) and, by the seventeenth century, imitation blue-and-white, after Chinese export-type originals, was being mass-produced there.

In Turkey, Chinese imported porcelain was imitated by and supplemented with blue-and-white decorated fritware from Kutahya and Iznik. Whereas the decorative designs were first based on Chinese motifs, they developed into imaginative polychrome creations. Tulips and hyacinths were painted side by side with remnants of Chinese clouds and waves to produce a unique combination (fig. 206).

Trade with Africa

Coins and coin hoards attest to China's voyages to the east coast of Africa, the earliest dating from about AD 620. Coins have been found from Mogadishu in Somalia down to Kenya and Tanzania. Hundreds of sherds of porcelain have also been excavated as well as whole vessels, found set into plastered walls or niches in houses and mosques. There are celadons from the Song to the Ming as well as blue-and-white porcelain.[46] The Chinese imported from

Africa items such as elephant tusks, rhinoceros horns, pearls and incense.

It is therefore clear that in the fifteenth century Chinese junks made frequent voyages to the east coast of Africa, and they may have even sailed southwest of the Cape. Zheng He's ships sailed in large fleets, and his ships had more manpower, guns and greater cargo capacity than the Portuguese caravels plying the west coast of Africa at this time (map IV, p. 289). Zheng He's ships each displaced about 1500 tonnes, five times as much as the 300 tonnes of the Portuguese.[47]

However, by the time Vasco da Gama sailed around the Cape from Portugal to reach India in 1497, there were no Chinese junks active in the Indian Ocean. This was the result of a deliberate policy on the part of the Ming emperor. Merchants and traders had always been regarded as upstarts by the traditional Confucian bureaucrats, who now advised the emperor to run down the navy and ban overseas trade in order to concentrate on the problem of defending China's northern borders. At the time this advice appeared reasonable; Ming China, controlling a large territory, had a large tax base and was less in need of taxation from shipping. State support of long ocean voyages was no longer deemed worthwhile. When the Emperor Gaozong proclaimed: 'China's territory produces all goods in abundance, so why should we buy useless trifles from abroad?', he voiced the xenophobic tendencies that were to characterise the official Chinese attitude to foreign trade until it was forced open as a result of the later Opium Wars. The overseas

208 (*below right*) Ivory figure of the Bodhisattva Guanyin holding a baby. Ming dynasty, late 16th century. This figure was probably influenced by the Virgin-and-child figures made by Chinese craftsmen for the Spanish, who established a trading centre in the Philippines in the second half of the 16th century.

trade ban in the fifteenth century had a devastating effect on the merchants and ports of the south China coast, and many merchants turned to piracy. Indeed, it is tantalising to speculate how different history might have been had Zheng He been allowed to continue and extend the voyages of his fleets.

Trade with the Portuguese and Spanish

During the sixteenth century Portugal and Spain had a virtual monopoly of trade with China and the Far East, due to the vast quantities of silver bullion available to them from their newly colonised territories in South America. The resulting import of so much South American silver to Ming China had a great impact on the pace of the country's economic development. Domestic production of bullion in China had by this time decreased so much that the Chinese were avid for the silver brought by foreign traders. This, combined with an intense foreign demand for Chinese goods, resulted in a great expansion of commercial activity (map IV, p. 289).[48]

The Portuguese also became middlemen in the Sino-Japanese trade when the Ming closed China's ports to trade with Japan, owing to problems with pirates. The Portuguese exported to Japan silks from China and textiles from India, obtaining in return gold and lacquer as well as porcelain. In 1557 China reluctantly permitted Portugal to rent Macao, a peninsula at the mouth of the Pearl River. The first buildings erected by Westerners on Chinese soil made the Praya Grande Bay look remarkably like a Mediterranean port, with Baroque churches and a crescent of stone and plaster houses.[49]

Evidence of Ming blue-and-white porcelain which was exported to Portugal can be seen in the Santos Palace in Lisbon, one of the residences of Don Manuel I, king of Portugal from 1495 to 1521 (fig. 207). A remarkable pyramidal ceiling was constructed between 1664 and 1687 and lined with Chinese plates and bowls suspended from long iron hooks.[50] Not only porcelain but spices, rhubarb, lacquer, exotic woods and textiles were exported to Portugal.[51]

The Spanish established their own trading centre in the Philippines, which they conquered in the mid sixteenth century. Here they traded with Chinese from Zhangzhou, a port in southeast China. Chinese traders arriving in Luzon in the Philippines in 1574 brought 'quicksilver, powder, pepper, fine cinnamon, cloves, sugar, iron, copper, tin, brass, silks in textiles of many kinds and in skeins, realgar, camphor, various kinds of crockery, luscious and sweet oranges; and a thousand other goods and trifles'.[52] Many Chinese traders settled in Luzon, and in return for Spanish silver bullion from the Americas they produced handicrafts for the Spanish settlers. These included Christian images in ivory, made by Chinese either in the Philippines or in Fujian province. Virgin-and-child figures made by Chinese craftsmen for the Spanish market in turn stimulated the production for the Chinese market of similarly designed images of the Bodhisattva Guanyin, to whom Chinese traditionally prayed for children (fig. 208). These Chinese Gothic-style Guanyin images were not only produced in carved ivory but also in moulded white porcelain from Dehua in Fujian province.[53]

The Spanish acquisition of the Portuguese crown in 1580, combined with Portugal's ejection from Japan in the early seventeenth century, signalled

the end of Portugal's monopoly of the import of oriental goods into Europe. An enthusiasm for exotic oriental articles had, however, been fired; Portugal had sold items to fellow European countries while others had been procured by the Dutch when they captured Portuguese carracks in the early seventeenth century. Amsterdam was to replace Lisbon as the centre for feeding Europe's insatiable appetite for products from the Far East.

Trade with the Dutch

The Dutch trade in Chinese porcelain is well known from the frequent appearance of Kraak porcelain in sixteenth- and seventeenth-century Dutch paintings, as well as from the imitations made of it in earthenware at Delft. The Dutch East India Company (VOC) was set up in 1602 and a trading post established at Batavia (present-day Jakarta) in Java, from where the Dutch dominated the sea routes to Europe throughout the seventeenth century. Because they were not allowed to land in China, the Dutch traded with the Chinese junks which had long sailed these waters. The Chinese immediately expanded their commercial activity in Java, however, as a result of the arrival of the Dutch. Pepper and tin were shipped from Batavia to Canton, and the large profits made on these materials were used to finance the purchase of imports to the Netherlands. Interest in tea began to grow in the mid seventeenth century and it was imported in increasing quantities, stimulating demand in turn for porcelain teasets and teapots. Both green and black teas were imported, but black tea was much more popular, though not always cheaper. Tea was to dominate eighteenth-century European trade with China.

Wrecks recovered of VOC ships, such as the *Witte Leeuw* (1613), an unknown wreck dated *c.*1640, and the *Geldermalsen* (1752), show the astoundingly large quantities of porcelain stowed in their holds (fig. 209). The 1640 wreck, for instance, contained 25,000 unbroken pieces of blue-and-white porcelain. However, it has been calculated that, by the mid eighteenth century, 70 per cent of the total value of purchases made by a Dutch ship's supercargo in Canton was represented by tea. The next most valuable were textiles such as raw and woven silk and 'nankeen' (shiny linen). Porcelain came third in value, followed by other miscellaneous luxury items such as painted wallpapers, fans and lacquer.[54] Porcelain was stowed first because it was bulky and waterproof. Other exports were tin, mercury, lead, hardwoods, turmeric, sago, anise, China root (Chinese sarsaparilla, *smilax China*), rhubarb and other spices and drugs. Some of this cargo was deposited in India and some at the Cape, during the return journey to the Netherlands. It is thought that the coarser blue-and-white porcelain found on the *Geldermalsen* was destined for the Cape. Recent archaeological excavation in Cape Town and Stellenbosch has recovered eighteenth-century wares similar to some of those found on the *Geldermalsen*.[55]

In 1729 the VOC opened an office in Canton to which models were sent of the Western shapes they wished to have made in porcelain. Some of these models were wooden, and it was hoped that they could be used as moulds by Chinese potters. In 1751 thirteen drawings and twenty samples were sent to China, including requests for herring dishes, 'the painting being left to the imagination of the Chinese, except that a herring must be painted on the herring dishes'.[56] Drawings proved more successful than models and

209 (*above left*) Rows of export blue-and-white porcelain salvaged from the wreck of the Dutch East India Company ship the *Geldermalsen*, bound for Amsterdam in 1752. Piles of identical dinner plates are evidence of the vast quantities that were carried in one ship, destined to be sold in sets to the upper classes of Europe.

210 (*above right*) Design for a plate decorated with *The three doctors*, one of a set of four watercolours painted in Holland by Cornelius Pronk (1691–1759) as a means of commissioning designs to be painted on porcelain in China. The same four designs were painted on many different shapes of vessel.

four designs by Cornelius Pronk became particularly well known, including *The parasol lady* and *The three doctors* (fig. 210). These designs were produced both on Chinese and Japanese porcelains, in underglaze blue and overglaze enamels, and on wares of various shapes.

Trade with the British

The British were not as successful as the Dutch in their trade with China in the seventeenth century, but they rose to a position of dominance in the eighteenth century. At first several British companies were engaged in the quest for spices, silks and tea. However, these were merged in 1709 to form the British East India Company, which set up an office in Canton in 1715, closely followed by the Dutch, French, Danish, Swedish and, later, in 1784, the Americans. In 1729 the Chinese deliberately restricted trade with the West to the port of Canton, where it was closely supervised by an official from the Imperial Household Department.[57] The row of foreign 'factories' or offices along the Canton waterfront was painted on porcelain as well as in oils and watercolour for Western traders to take home as souvenirs. On the Museum's punchbowl (fig. 211), the flags of thirteen different countries are represented.

Whole services of porcelain were ordered for export to Europe. For instance, the Dutch ship *Geldermalsen* was carrying entire dinner services in underglaze blue and overglaze enamels when it was wrecked. Some dinner,

tea, coffee and chocolate sets were painted with coats of arms based on pattern books sent out to China. These armorial wares were greatly in vogue in England by the end of the eighteenth century.

From 1740 to 1760 porcelain was also painted with copies of Western prints and engravings; historical, religious, masonic and mythological scenes were enamelled in grey and in *famille rose*. Mistakes were often made in the details, showing the Chinese potters' ignorance of the significance of the scenes they were painting. Other exported items, much smaller in numbers than porcelain, had a considerable impact on Western taste; these included reverse paintings on glass depicting idealised ladies, landscapes or lovers; wallpaper painted with chinoiserie scenes; carved ivory fans, balls, boxes, chess sets, pagodas and junks; tobacco boxes of tortoise shell; Western-shaped vessels and cutlery sets of Chinese silver; furniture of rattan and lacquer; silk shawls; and painted clay figures of Chinamen and Western merchants.

Many of these items were the products of workshops in Canton, although paintings sometimes bore the signatures of the best-known Chinese artists such as Spoilum, Lamqua, Namcheong and Sunqua. Paintings on glass, oils on canvas, watercolours or gouache on paper portrayed Chinese landscapes, scenes of Canton and Macao life, Chinese people and costumes, birds, fish, manufacturing processes and, in the later nineteenth century, copies of photographs.

In order to purchase these items, Western countries had to find something the Chinese needed or wanted in return. Very little profit was made on items exported to China for sale, and the Chinese were really only interested in

211 Porcelain punchbowl decorated in overglaze enamels with a scene showing the waterfront at Canton, including the different European *hong* (factories). Qing dynasty, *c.*1785. In this view only two flags, including that of Great Britain, can be seen, but there are thirteen different flags in all. The absence of the American flag suggests a date not later than 1785. Bowls such as this are sometimes called *hong* bowls.

silver. However, due to the Napoleonic wars and the consequent continental blockade in Europe, private British traders in India were cut off from their supply of silver from the New World, which came via Amsterdam. They began to ship large quantities of opium from India to China, for which the Chinese had to pay with their own much-valued silver. The private British traders then sold the Chinese silver to the East India Company, which used it to buy the new tea crop for import to Europe.[58] It has been estimated that, by the mid 1830s, there were more than 40 million opium addicts in China. This illegal opium trade was not only to cause the First Opium War between Britain and China, in 1839–42, but also led to the British occupation of Hong Kong and the resulting opening of China by force.

The effects of trade

China

By the time of the forced opening of China after the Opium Wars, the Chinese had developed a deep suspicion of Western traders. However, there had been previous periods of close co-operation and trust, when foreigners had been employed at the courts of various emperors and had impressed the Chinese with their knowledge of the West. Marco Polo, for instance, who travelled in Asia between 1271 and 1295, served the Mongol emperor Khubilai Khan for about seventeen years. Above all, however, it was the Jesuit missionaries who best bridged Western and Chinese culture. Matteo Ricci, an Italian Jesuit who arrived in Beijing in 1601, was followed by a steady stream of accomplished Jesuits who studied Chinese language, philosophy and literature and introduced the emperors of China to many aspects of Western science. Often skilled painters, they were sometimes employed to paint porcelain or enamel vessels. They supervised the imperial glasshouse under the Emperor Kangxi, while one Jesuit, Giuseppe Castiglione, produced paintings of a very high quality using an eclectic blend of Western and Chinese styles. Another combination of Chinese and Western techniques is shown in the clocks produced in Canton – complete with revolving medallions, movable scenery and miniature fountains. The hundreds of clocks now preserved in the Palace Museum in Beijing were mostly tribute from Canton in the later eighteenth century,[59] either of European or Cantonese manufacture. Many of those made in Europe were products of the clockmaker James Cox, who specialised in elaborate clocks for the Chinese market. Other items exported to China were sheets of glass used for reverse paintings, which in turn were exported to the West and hung in country houses.

Under the Emperor Qianlong there was a vogue in China for objects painted with Western scenes in the Western manner, using perspective. The Emperor Qianlong also followed Western custom by commissioning a series of celebratory prints showing battle campaigns in which he had subdued peoples on China's borders. The first set of these was actually made in Paris and the rest in China, copying the Parisian technique (fig. 212). The culmination of this vogue for Western design and techniques was the building of the Yuanming Yuan, the imperial summer palace outside Beijing, a glorious rococo-style white stone building with sweeping staircases, foun-

tains and Italian gardens. Designed by Jesuits, it was sadly destroyed and looted by British and French troops in 1860.

The West

China's effect on the West was immeasurable. Although the Greeks and Romans had known China as a source of silk, it was not until Marco Polo's account of his travels was published in Europe in the early fourteenth century that the high level of Chinese civilisation was revealed to the West. Many doubted the veracity of his description of Kanbalu, capital of the great khan. His partial account – for he described only those aspects he chose to record – was the seed of a semi-fictitious idea of China which was to develop into the idealised Cathay. At least Marco Polo's account, however embroidered, was based on the truth; another influential medieval book, *The Travels of Sir John Mandeville*, was complete fiction, but from its fantastic descriptions was developed a general perception of China which persisted until the sixteenth century, when exotic oriental objects began to arrive in Europe.

Europeans seem to have had little idea of the exact origin of the objects imported by the Portuguese, and Chinese objects were often, for instance, described as Indian. It was at this time that the fashion for the *Kunstkammer* or *Wunderkammer* – a private collection of exotic items, both man-made and natural – developed into a mania in many parts of Europe. Particularly famous collections were those of Paludanus in the Netherlands, Archduke Albrecht V of Bavaria and Rudolph II of Prague. Archduke Albrecht's collection comprised 4000 items and was the first to have a published catalogue.[60] Albrecht Dürer, who was fascinated by orientalia and exotic items, produced fantastic concoctions incorporating real imported Chinese porcelain (fig. 213).[61] Chinese porcelain also appears in Italian Renaissance paintings

212 One of a series of sixteen copperplate engravings made, following Western practice, to celebrate the Emperor Qianlong's victorious campaign against eastern Turkestan. Qing dynasty, *c.*1764–72. This set was made in Paris by Nicholas de Launay and others, and the poems were then handwritten by the Emperor Qianlong (1736–95). After this, further series were made in China to show the emperor's victories over other border peoples (see ch. 4, fig. 145).

213 Two fantastic columns drawn in coloured ink by Albrecht Dürer, c.1515. The columns incorporate Chinese blue-and-white porcelain of the Ming dynasty, possibly from Dürer's own collection, illustrating the fascination felt by many Europeans for exotic oriental items when they first appeared in Europe in the 16th century. 29.6 x 17.2 cm.

214 *Le Chinois Galant*, by François Boucher, 1742. This charming painting shows a typical 18th-century mixture of ideas and motifs associated with an idealised fairytale China. A gallant Chinaman is paying court to a Western woman seated under a parasol, looked down on by a benevolent Buddha-like figure surrounded by a halo of small bells. The background has certain 'oriental' features, such as palm trees, a thatched pavilion and a porcelain vase, the shape of which is based on an ancient bronze *zun*. The whole scene is painted in blue and white, as was most export porcelain at this time. 1.04 x 1.45 m.

and in Dutch still-life paintings of the sixteenth and seventeenth centuries.

The frivolous painted depictions of an idealised Cathay began in the early seventeenth century, developing into the wonderfully inaccurate rococo fantasies epitomised by the paintings of Watteau and Boucher in the eighteenth century (fig. 214). Combined with this fantastical representation of China was a genuine idealisation of its philosophy and government, until it became a utopia in the minds of many Europeans. Voltaire, for instance, saw Confucius as a precursor of eighteenth-century rationalism: 'I have read his books with attention, I have made extracts from them; I found that they spoke only the purest morality. He appeals only to virtue, he preaches no miracles, there is nothing in them of religious allegory'.[62]

The vogue for Chinese decorative arts – based, for the most part, on relatively low-quality Chinese items produced specifically for undiscriminating foreigners – also resulted in Chinese porcelain being honoured with elaborate European ormolu mounts. In addition, a race was on to produce a European porcelain to match the wares being imported. Chinese motifs, familiar from exported blue-and-white *kraakporselein*, had already been reproduced on tin-glazed earthenware, first at Delft and later at Lambeth, Bristol and Liverpool. Yixing red stoneware from China was also imitated in the seventeenth century in Holland, then in Staffordshire, and most successfully at Meissen by the chemist Johann Friedrich Böttger, working for Augustus the Strong of Saxony in the early eighteenth century. It was also at Meissen that the first European hard-paste porcelain was produced; much of it was decorated in Japanese *kakiemon* style, showing the influence of Augustus the Strong's large collection of oriental porcelain. His passion for Chinese porcelain was such that he is reported to have once acquired a set of twelve large Chinese blue-and-white vases in exchange for a regiment of dragoons.[63]

215 Cup, saucer and teapot, all of porcelain decorated in pink and gold overglaze enamels. The cup and saucer are Chinese, made for export to the West, dating to the Yongzheng period (1723–35) and decorated with Western figures. The teapot is Meissen, with a KPM mark, dated 1723–5, and decorated with 'Chinese' figures. DIAM (saucer): 11.5 cm; HT (cup): 3.8 cm; (teapot): 11.8 cm.

English porcelain was eventually produced in Worcester and London – Chelsea and Bow – using Cornish stone similar to Chinese porcelain stone. Much European porcelain was a direct imitation of Chinese pieces, both in shape and decoration (fig. 215). Benevolent Buddhas, usually called 'Pagods', appeared at Meissen, Chantilly and Chelsea, their religious significance presumably escaping their collectors. They are usually plain white, suggesting that they were based on *blanc de Chine* prototypes from Dehua in Fujian province, southeast China, many of which were exported. Whole rooms full of oriental porcelain were created in European castles, palaces and mansions. Sometimes their walls were decorated with chinoiserie scenes, either in lacquered wood panels or in painted wallpaper; the latter was completely alien to the Chinese, who never decorated their houses with painted wallpaper – another example of a genre created specifically to cater to Western demand. The first Chinese room was that of the Rosenborg Castle in Copenhagen, which was 'japanned' in the 1690s with motifs taken from *A Treatise of Japanning and Varnishing*, published by Stalker and Parker in 1688. This publication gave recipes for different European imitations of Japanese and Chinese lacquer and offered suggestions for chinoiserie motifs.

216 Drawing of the Great Pagoda in Kew Gardens, from W. Chambers, *Plans, Elevations, Sections and Perspective Views of the Gardens and Buildings at Kew in Surrey*, London, 1763. Not only is the pagoda shape borrowed from China, but also the latticed wooden railings and roof dragons.

European garden design was greatly influenced by the asymmetry and the interest in scenery characteristic of Chinese gardens. The resulting Anglo-Chinese gardens contrasted with the formality of Italian gardens, which were derived from models drawn from classical antiquity. The importation of garden pavilions can also be attributed to Chinese influence. They sprang up all over Europe in the eighteenth century, many in the form of Chinese pagodas (fig. 216).

By the nineteenth century there was no excuse for the continued idealised representation of Cathay, as there were plenty of Western eyewitnesses to the real China. Lord Macartney's unsuccessful embassy to the court of Qianlong in 1793–4 was recorded by the official 'draughtsman', William Alexander. Although some of his works were at least in part imaginary, he did bring back drawings of the interior of China, hitherto unknown to Westerners other than Jesuit missionaries.[64] However, there seems to have been a continued desire among Europeans to prolong their erroneous but attractive picture of China, even in the face of proof that it did not exist. The fashion for chinoiserie was revived in the early to mid nineteenth century when, in 1821, the Prince Regent built the Brighton Pavilion, that splendidly eclectic mish-mash of oriental nostalgia designed in the 'Hindoo' architectural style, with a combination of Chinese and imitation Chinese interior decoration. A contemporary cartoon by Cruickshank satirises this new China mania (fig. 217).

In reality, the balance of trade had now swung in favour of the West. For instance, European factories could now meet the Western demand for porcelain, producing it more cheaply than importing it from China. China had mass-produced goods such as porcelain, silk and lacquer at a time when Europe could not hope to compete, but with the Industrial Revolution, mass-production also became a Western phenomenon. Indeed, many advances associated with the modernisation of Europe could well have come ultimately from China: printing, gunpowder and the compass were all Chinese inventions. The extensive subdivision of labour at the porcelain

The COURT at Brighton à la Chinese !!

factories of Jingdezhen was reported to the West by the French Jesuit priest Père d'Entrecolles (ch. 5, p. 213), and it seems possible that such reports laid the groundwork for the organisation of factories by Josiah Wedgwood and others.

Building upon the technological inventions derived from China and the aspiration to a life filled with high-quality consumer goods, the West rapidly outstripped China in these areas. In their long trading relationship, however, little was learned by either side about the societies which harboured these diverse skills and traditions, and it has taken most of the twentieth century for China and the West to learn a little more about each other.

217 A cartoon by George Cruikshank, dated 1816, satirising the Prince Regent's passion for chinoiserie which was to culminate in the building of Brighton Pavilion in 1821. Here the Prince Regent (portrayed as a corpulent Chinese emperor) is giving Lord Amherst instructions to 'get fresh Patterns of Chinese deformities to finish the decorations of G. Pavillion'. The royal family and attending ministers are all dressed as mandarins, and Princess Charlotte is saying: 'Papa, had'nt you better tell him to bring me over a *China* man instead of getting me a Husband among our German cousins!'

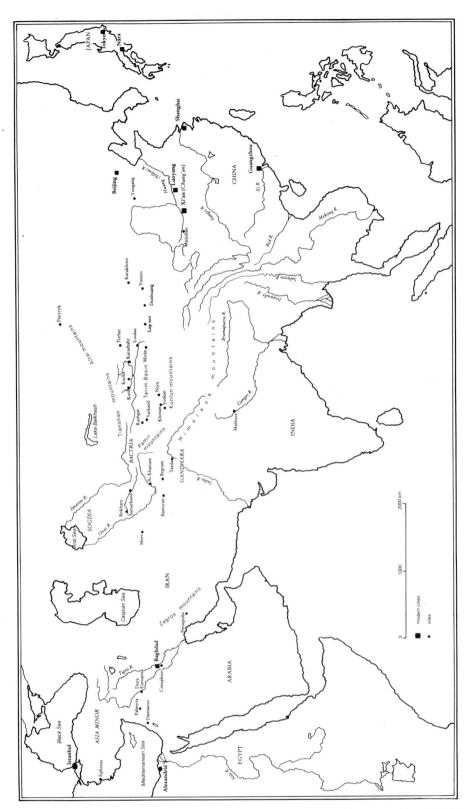

Map iii Central Asia, showing sites along the trade routes known as the Silk Route.

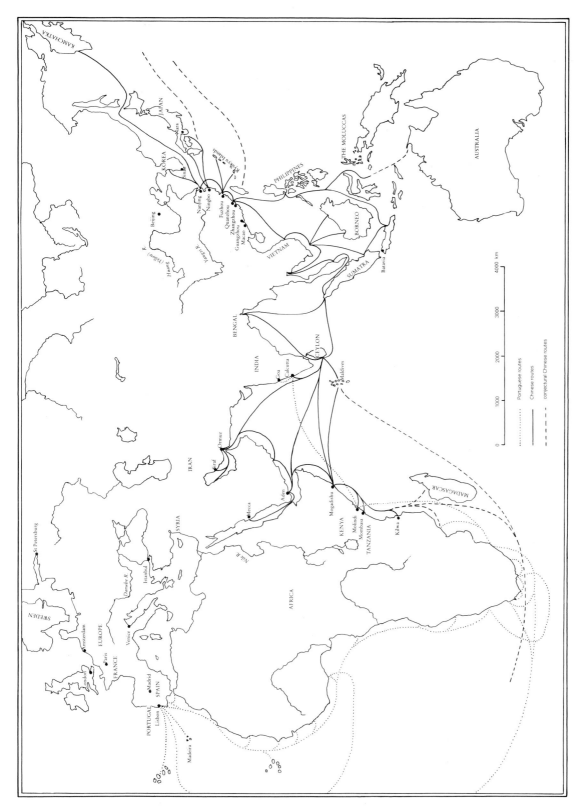

MAP IV Chinese and Portuguese sea trade routes in the 15th century.

Notes

1. C. Clunas, *Superfluous Things, Material Culture and Social Status in Early Modern China*, Cambridge, 1991, p. 94 quotes Matteo Ricci's observation that the Chinese had no use for such things.

2. This topic is discussed in L. Ledderose, 'Chinese Influence on European Art, Sixteenth to Eighteenth Centuries', in T. H. C. Lee (ed.), *China and Europe, Images and Influences in Sixteenth to Eighteenth Centuries*, Hong Kong, 1991.

3. For a description of the tribute system see M. Rossabi (ed.), *China Among Equals, The Middle Kingdom and Its Neighbors, 10th–14th Centuries*, Berkeley, 1983, pp. 2–4.

4. C. Defremery and B. R. Sanguinetti (trans.), *Voyages d'ibn Batoutah*, 5 vols, Paris, 1853–9.

5. S. Piggot, 'Chinese Chariotry: An Outsider's View', in P. Denwood (ed.), *Arts of the Eurasian Steppelands, Colloquies on Art and Archaeology in Asia, no. 7*, London, 1978.

6. For faience beads see Lu Liancheng and Hu Zhisheng, *Baoji Yu Guo mudi*, Beijing, 1988, pls CLXXVII, CCVI.

7. *Zeng Hou Yi mu*, Beijing, 1989, pl. CLX:3,4.

8. A translation of the account of Han dynasty relations with Central Asia is given in A. F. P. Hulsewé, *China in Central Asia, The Early Stage: 125 BC–AD 23, An Annotated Translation of Chapters 61 and 96 of the History of the Former Han Dynasty*, Leiden, 1979.

9. Excavation of the tombs at Noin Ula is reported in S. I. Rudenko, *Die Kultur der Hsiung-nu und die Hügelgräber von Noin Ula*, Bonn, 1969.

10. V. Sarianidi, *The Golden Hoard of Bactria, from the Tillya-tepe Excavations in Northern Afghanistan*, New York, 1985, p. 145.

11. D. Schlumberger, *L'Orient Hellénise, l'Art Grec et ses Héritiers dans l'Asie non Méditerranée*, Paris, 1970.

12. This development is outlined in J. Rawson, *Chinese Ornament: The Lotus and the Dragon*, London, 1984 (2nd edition, 1990).

13. D. Sinor, *The Cambridge History of Early Inner Asia*, Cambridge, 1990, ch. 6.

14. For further description and illustration of the cities of the Tarim basin see M. A. Stein, *Ruins of Desert Cathay: Personal Narrative of Exploration in Central Asia and Western China*, London, 1912.

15. This subject is discussed more fully in J. Rawson, 1984, op. cit., ch. 4.

16. Found in the tomb of Feng Hetu (d. 501). See *Wenwu* 1983.8, pp. 1–4.

17. A group of cups was found at Datong in Shanxi province. See *Wenhua da geming qijian chutu wenwu di yi ji*, Beijing, 1972, pp. 149–52.

18. Wu Zhou, 'Notes on the Silver Ewer from the Tomb of Li Xian', *Bulletin of the Asia Institute*, no. 3, 1989, pp. 61–70; also described in *Wenwu* 1985.11, pp. 1–20; 1987.5, pp. 66–76.

19. For the deposit at the Famensi see *Wenwu* 1988.10, pp. 1–20; Zhu Qixin, 'Buddhist Treasures from Famensi, The Recent Excavation of a Tang Underground Palace'; and R. Whitfield, 'The Significance of the Famensi Deposit', *Orientations*, May 1990, pp. 77–83, 84–5. For the Qingshansi see *Wenbo* 1985.5, pp. 12–37.

20. C. J. Lamm, *Das Glas von Samarra. Die Ausgrabungen von Samarra, vierterband*, Berlin, 1928, pl. VIII, p. 256.

21. For a discussion of foreign glass in China, see An Jiayao (trans. M. Henderson), *Early Chinese Glassware, Oriental Ceramic Society Translations Number 12*, London, 1987.

22. For excavation of silver see J. Rawson, 'Tombs or Hoards: The Survival of Chinese Silver of the Tang and Song Periods, Seventh to Thirteenth Centuries AD', in M. Vickers (ed.), *Pots and Pans, A Colloquium on Precious Metals and Ceramics in the Muslim, Chinese and Graeco-Roman Worlds, Oxford 1985*, Oxford, 1986, pp. 31–56.

23. For a discussion of the relationship of hammered metalwork and fine, thin white ceramics, see J. Rawson, 'Chinese Silver and its Influence on Porcelain Development', in P. E. McGovern and M. D. Notis (eds.), *Ceramics and Civilization*, vol. IV: *Cross-Craft and Cross-Cultural Interactions in Ceramics*, Westerville, Ohio, 1989, pp. 275–99.

24. D. Sinor, 1990, op. cit., ch. 15; and

J. J. Saunders, *The History of the Mongol Conquests*, London, 1971.

25. For manuscripts that show Chinese influence see B. Gray, *The Arts of the Book in Central Asia 14th–16th Centuries*, Paris and London, 1979; and J. Rawson, 1984, op. cit., ch. 5.

26. J. Needham, *Science and Civilisation in China*, vol. IV:3, Cambridge, 1971, pp. 467–8.

27. F. Wood, *Blue Guide: China*, London, 1992, pp. 491–6.

28. J. Vollmer, E. J. Keall and E. Nagai-Berthrong, *Silk Roads, China Ships*, Toronto, 1983, p. 99.

29. J. Needham, 1971, op. cit., p. 563.

30. Ibid., p. 471.

31. Ibid., p. 443.

32. *Song Hui yao kao*, quoted in ibid., p. 488.

33. *Quanzhou Yisilanjiao yanjiu lunwenxuan*, Fujian, 1983.

34. J. Needham, 1971, op. cit., p. 481.

35. Kim Hongnam, 'China's Earliest Datable White Stonewares from the Tomb of King Muryong (d. AD 523), Paekche, Korea', *Oriental Art*, vol. XXXVII, no. 1, Spring 1991, pp. 17–34.

36. National Museum of Korea, *Special Exhibition of Cultural Relics found off Sinan Coast*, Seoul, 1977.

37. B. Gray, 'The Export of Chinese Porcelain to India', *Transactions of the Oriental Ceramic Society*, 1964–6, vol. 36, p. 25.

38. Ibid., p. 29.

39. Ibid., p. 33.

40. Ibid., loc. cit.

41. P. Hardie, 'China's Ceramic Trade with India', *Transactions of the Oriental Ceramic Society*, 1983–4, vol. 48, p. 25.

42. J. Rawson, 'The Export of Tang Sancai Wares: Some Recent Research', *Transactions of the Oriental Ceramic Society*, 1987–8, vol. 52, p. 56.

43. R. Krahl and J. Ayers, *Chinese Ceramics in the Topkapi Saray Museum, Istanbul*, 3 vols, London, 1986.

44. J. Ayers, 'Chinese Porcelain of the Sultans in Istanbul', *Transactions of the Oriental Ceramic Society*, 1982–3, vol. 47, p. 84.

45. J. Pope, *Chinese Porcelains from the Ardebil Shrine*, Washington DC, 1956.

46. J. Needham, 1971, op. cit., pp. 494–8.

47. W. McNeil, *The Pursuit of Power*, Chicago, 1982, p. 44.

48. W. S. Atwell, 'International Bullion Flows and the Chinese Economy circa 1530–1650', *Past and Present*, no. 95, May 1982.

49. P. Conner, *The China Trade, 1600–1860*, Brighton, 1986, p. 40.

50. D. Lion-Goldschmidt, 'Ming Porcelains in the Santos Palace Collection, Lisbon', *Transactions of the Oriental Ceramic Society*, 1984–5, vol. 49, pp. 79–93; and *Arts Asiatiques*, vol. 39, 1984, pp. 5–73.

51. D. F. Lach, *Asia in the Making of Europe*, vol. II, Chicago, 1965–78, pp. 10–16.

52. D. Gillman in W. Watson (ed.), *Chinese Ivories from the Shang to the Qing*, London, 1984, p. 37.

53. Ibid., p. 41.

54. C. J. A. Jörg, *Porcelain and the Dutch China Trade*, The Hague, 1982; C. Sheaf, *The Hatcher Porcelain Cargoes*, Oxford, 1988, p. 88.

55. C. J. A. Jörg, *The Geldermalsen, History and Porcelain*, Groningen, 1986, p. 95.

56. C. J. A. Jörg, 1982, op. cit., p. 102.

57. C. Clunas (ed.), *Chinese Export Art and Design*, London, 1987, p. 16.

58. Ibid., p. 18; C. Sheaf, 1988, op. cit., p. 93.

59. Yang Boda, *Tribute from Canton to the Qing Court*, Beijing and Hong Kong, 1987, p. 63.

60. O. Impey, *Chinoiserie*, Oxford, 1977, p. 57.

61. D. F. Lach, 1965–78, op. cit., pp. 17–21, fig. 29.

62. H. Honour, *Chinoiserie*, London, 1961, p. 24.

63. O. Impey, 1977, op. cit., p. 104.

64. J. L. Cranmer-Byng (ed.), *An Embassy to China: Lord Macartney's Journal, 1793–1794*, London, 1962.

Supplements

Chronologies

NEOLITHIC CULTURES

Cishan-Peiligang	c.6500–5000 BC
Central Yangshao	c.5000–3000 BC
Gansu Yangshao	c.3000–1500 BC
Hemudu	c.5000–3000 BC
Daxi	c.5000–3000 BC
Majiabang	c.5000–3500 BC
Dawenkou	c.4300–2400 BC
Songze	c.4000–2500 BC
Hongshan	c.3800–2700 BC
Liangzhu	c.3300–2250 BC
Longshan	c.3000–1700 BC
Qijia	c.2250–1900 BC

EARLY DYNASTIES

Shang	c.1500–1050 BC
Western Zhou	1050–771 BC
Eastern Zhou	
Spring and Autumn	770–475 BC
Warring States	475–221 BC

IMPERIAL CHINA

Qin	221–207 BC
Han	
Western Han	206 BC–AD 9
Xin	AD 9–25
Eastern Han	AD 25–220
Three Kingdoms	
Shu (Han)	221–263
Wei	220–265
Wu	222–280

Southern dynasties (Six Dynasties)

Western Jin	265–316
Eastern Jin	317–420
Liu Song	420–479
Southern Qi	479–502
Liang	502–557
Chen	557–589
Northern dynasties	
Northern Wei	386–535
Eastern Wei	534–550
Western Wei	535–557
Northern Qi	550–577
Northern Zhou	557–581
Sui	589–618
Tang	618–906
Five Dynasties	907–960
Liao	907–1125
Song	
Northern Song	960–1126
Southern Song	1127–1279
Jin	1115–1234
Yuan	1279–1368
Ming	1368–1644
Qing	1644–1911

REPUBLICAN CHINA

Republic	1912–49
People's Republic	1949–

Neolithic period

The transition from a nomadic, hunting existence to one of farming, with the domestication of plants and animals, is generally taken as defining the beginning of settled lifestyles that culminated in complex civilisations. Such a period, before the use of metal, is known as the Neolithic period, and in China it began about 7000 BC. In northwest China the principal crop was millet and in the southeast and south it was rice. The pig was the main domestic animal, taking the place of the goat or sheep of the Middle East.

The peoples who lived settled lives farming have left many traces behind: their houses, burials, pottery and tools. The different groups who inhabited the vast land mass of China can be distinguished from one another by such artefacts. As they did not write, we do not know who they were, what languages they spoke or what their social systems were.

In the north the earliest settlements were in Henan, Hebei, eastern Shaanxi and southern Shanxi provinces and are known as the Peiligang and Cishan cultures. In the south even earlier signs of settlement, in the form of pottery and traces of agriculture, have been found in the Guangxi and Guizhou areas. Following these early beginnings, large settlements developed along the rivers and coastal areas. Two main complexes of cultures appeared: a central and western one, along the Yellow River and its tributary the Wei, and an eastern and southeastern one, along the east coast. Other groups of people also inhabited the area of the Yangzi and its tributaries and along the southern coasts.

In central and western China the Yangshao culture was centred on the Wei River. It is famous for its painted pottery. The early phase is named after Banpo, at Xi'an (c.4800−4300 BC); a later phase, namely Miaodigou (c.3900 BC), extended along the Yellow River eastwards, while western cultures with painted pottery, known as the Majiayao (latter part of fourth millennium BC), Banshan (c.2800−2500) and Machang (c.2500−2200 BC) cultures, have been found in Gansu province.

Along the east coast a series of different cultures came to prominence one after another. The earliest known so far was discovered at Hemudu (c.5000 BC), near Hangzhou. Here, rice cultivation supported a village whose wooden houses, built on stilts, are still partly preserved in the waterlogged ground. Thereafter, the east coast cultures became intensively specialised, with much effort devoted to jade working and fine ceramics, whose uses may have been ritual or ceremonial. The jades consist of fine versions of everyday weapons, tools and decorative items. The ceramics were elaborately formed, with high pierced stands and lobed bodies. The principal east coast culture centred in Shandong is known as Dawenkou (c.4300−2400 BC), and a later culture with exceptionally fine jades is identified as the Liangzhu (c.3300−2250 BC), in the Hangzhou and Shanghai areas. In Shandong the principal late Neolithic culture is the Longshan (c.3000−1700 BC), renowned for its fine black ceramics.

Shang dynasty (c.1500−1050 BC)

The manufacture of bronze distinguishes the Shang period from the preceding Neolithic period. In later historical records another ruling house, the Xia, earlier than the Shang, is also mentioned, and in recent years Chinese archaeologists have identified in Henan province a late stage of the Neolithic and an early stage of the Bronze Age as belonging to the Xia. Such identification is, however, controversial and not necessarily correct. Until written records positively identify a site as belonging to the Xia, all such attempts to link the Xia as described in later texts with known finds will remain speculative.

The Shang peoples are recognised by their bronzes, particularly their bronze vessels in which food and wine were offered to the ancestors. The very earliest bronzes probably belong to the pre-Shang period and have been found, as mentioned above, at Yanshi Erlitou in Henan province near Luoyang. The Erlitou phase (c.1650−1500) of Chinese culture represents the earliest known stage of the Chinese Bronze Age and spans the first half of the second millennium BC. Later large sites include a city at the modern town of Zhengzhou and are accepted as having been constructed by the early

Shang, c.1500 BC. A massive city wall, specialised workshops and buildings of differing standing all indicate a highly organised and stratified society. At this stage in the development of bronze vessels, known as the Erligang period (c.1500−1400 BC), following the Erlitou phase), the influence of the Shang must have been considerable, as vessels of this date in metropolitan style are found at widely separate sites in Shaanxi, Anhui, Hubei and Henan provinces.

A slightly later Shang centre may have been the site of Gaocheng Taixicun in Hebei province. Despite the seeming extension of Shang power to the north, it seems probable that Shang power gradually diminished in extent. The major centre of the late Shang from c.1300 BC was established at Anyang, also known as Yinxu. The Anyang site, excavated over the last fifty years, has revealed large palace buildings, workshops, burials both of kings and of nobles, and deposits, such as large finds of inscribed oracle bones. Among the most significant discoveries is the tomb of Fu Hao, wife of the Shang king, Wu Ding (d. c.1250−1200 BC). This is the only intact Shang tomb to have been scientifically excavated.

The large numbers of inscribed oracle bones and bronze inscriptions found at Anyang are China's earliest examples of writing and serve also to validate many later historical records, as a number of inscriptions include names of kings. It is likely that other metropolitan Shang sites of the Anyang period lie buried under the flood plains of the lower Yellow River in eastern Henan and Shandong provinces.

A number of quite separate peoples with their own distinctive cultures occupied Anhui, Hubei, Jiangxi, Hunan, Sichuan and areas of Hebei and Shanxi provinces. These peoples employed Shang techniques of bronze casting but also developed their own religious practices, which are evident in the types of bronzes and jades employed and in their decoration. Contact between the Shang and these peoples brought exotic motifs into bronze decoration and stimulated the use of new objects, such as mirrors and animal-headed knives.

Zhou dynasty (1050–221 BC)

The long period during which the Zhou nominally ruled China is divided into two parts: the Western Zhou, covering the years from the conquest in *c*.1050 BC to the move of the capital from Xi'an to Luoyang in 771 BC, and the Eastern Zhou, during which China was subdivided into many small states from 770 BC to the ascendancy of the Qin kingdom in 221 BC.

WESTERN ZHOU

The Zhou were among a number of western peoples who were at different stages both allied to and enemies of the Shang. In about 1050 BC the Zhou were strong enough to attack Shang centres and defeat them, assuming power over what was to them the known world. While the Zhou shared a number of traditions with the Shang, such as the use of Chinese language, oracle bone divination and bronze casting, their roots lay in western China outside the Shang orbit. They had, for example, relatively close links with peoples both on the northern periphery and in the southwest, in Sichuan province. These links can be traced in the types of ceramics and bronzes they employed.

At the time of the conquest, the Zhou established a capital at (present-day) Xi'an, but they also maintained a stronghold and ritual centre further west, in the present-day counties of Fufeng and Qishan, now called the Zhouyuan. Control over central and northern China was maintained by assigning large territories to relatives of the kings, who ruled these as fiefs. The names of the kings and an outline of their exploits are known from the *Shiji (Records of the Historian)* by Sima Qian (completed *c*.90 BC), and from mentions in inscriptions on bronze ritual vessels.

Under the first kings, Wu, Cheng and Kang, Zhou rule was consolidated; under King Zhao and King Mu the kingdom was threatened by the growing powers of the centre and the east coast and various battles are recorded. King Zhao is said to have been killed on one such campaign. The later part of the Western Zhou period seems to have been a time during which the whole ritual and political system was reorganised. In the face of pressure from peoples in the west, the Zhou seem to have withdrawn into the Shaanxi area, leaving other parts of the country to develop their own traditions.

EASTERN ZHOU

In its turn this period is traditionally divided into two: the Spring and Autumn period (770–475 BC) and the period of the Warring States (475–221 BC). These names are taken from contemporary historical documents which describe the periods in question. After the conquest of Xi'an by the Quanrong, the Zhou established their capital at Luoyang. No longer did they control their territory as undisputed kings, but now ruled alongside a number of other equally or more powerful rulers.

In the centre and the north, the state of Jin was dominant, while the states of Yan and Qi occupied the present-day provinces of Hebei and Shandong respectively. Jin disintegrated in the fifth century BC, and three states, Han, Wei and Zhao, assumed its territory. In the west the Qin succeeded to the mantle of the Zhou, and in the south the state of Chu dominated the Yangzi basin. During the sixth and fifth centuries BC, Chu threatened and then swallowed up the small eastern states of Wu and Yue, as well as states such as Zeng on its northern boundary. Although for much of the period Chu was a successful and dominant power, in due course it fell in 223 BC before the might of Qin, its rulers fleeing eastwards to Anhui province. The unification of China under the Qin brought to an end a period of co-existent kingdoms.

Despite its many conflicts, this period was a time of great economic expansion and development. Agricultural work may have increased greatly with the use of iron tools for ploughing. There are many textual references to the use of iron in the Eastern Zhou period, suggesting that by this time iron was being extensively employed. Cities developed rapidly in size and number as did trade between them. Economic expansion led to political struggles, the growth of armies and of courtly display. Less visible, but essential to the period, were the competing philosophical ideologies propounded by the philosophers Confucius (*c*.551–479 BC), Mozi (*fl.* 479–438 BC), Zhuang Zhou (*c*.399–295 BC), Shang Yang (*c*.390–338 BC), Mencius (*c*.371–289 BC), Xunzi (between 335 and 238 BC) and Han Fei (*c*.280–233 BC).

Qin dynasty (221–207 BC)

Qin inherited the territory and traditions of Zhou in the Wei River area. Politically the state of Qin did not become significant before the time of King Mu Gong (r. 659–621 BC), who was responsible for making Qin the main power in the west of China. Qin attempted to gain a foothold in the central heartland of the Yellow River area, but was blocked by Jin. It then set out to conquer and absorb many non-Chinese tribes and states scattered within, west and below the big loop of the Yellow River, also moving southwards and east into Hubei province. Because of its occupation of relatively remote western regions, Qin was regarded by other Chinese states as somewhat foreign and backward.

By the end of the Warring States period there were seven main contenders for supreme power in China, challenging the Zhou's mandate to rule. They were Han, Zhao, Yan, Wei, Chu and Qi, which Qin destroyed in 232, 228, 226, 225, 223 and 221 BC respectively. Thus in the period between 256 and 221 BC Qin succeeded in ousting all its rivals, while at the same time reforming its own government institutions. The rulers of Qin espoused the political theories known as Legalism, a philosophy that established the role of the ruler as paramount. Shang Yang (d. 338 BC), chief minister of Qin and a foremost exponent of Legalism, instituted a radical reform programme, creating systems of collective responsibility for groups of five and ten families, proclaiming new ranks based upon achievements in war, and setting up new administrative districts. Shang Yang and Han Fei (c. 280–233 BC) also developed what is now regarded as a Qin School

of Law (or Legalism) evidence of which was found inscribed on bamboo slips excavated from tomb 11 in the Shuihudi area, Xiaogan district of Yunmeng prefecture, in central Hubei province, dating to c. 217 BC. (Bamboo and wooden slips were the forerunner of paper which was being made, from hemp fibre, from the second or first century BC.)

Although the Qin dynasty was shortlived it was crucial to the formation of China as a unified and homogeneous state. (It also gave China its name in European languages, Qin being pronounced 'chin'.) Qin Shi Huangdi, the first Qin emperor, together with his very capable chancellor, Li Si, consolidated his power by centralising the administration as had already been done within Qin's own state boundaries. Qin Shi Huangdi standardised scripts, weights, measures and coins throughout the empire. Road networks were established and a number of walls unified, thus forming the first 'Great Wall' which served to keep out the marauding nomads. This wall eventually extended from the Zhili Gulf westwards across present-day Inner Mongolia to the edge of Tibet through the Yellow River valley. A complex of fortified walls, garrison stations and signal towers was built. The emperor also conscripted hundreds of thousands of workers to work on various building projects, including the famous E-Pang palace in the capital and replicas of the palaces of the various states which he had conquered. He was buried in a huge tomb complex that included the excavated ancillary pits 1 to 3 where the impressive underground pottery army was discovered.

Han dynasty (206 BC–AD 220)

The Han dynasty was one of the most notable dynasties in Chinese history, lasting over four hundred years in its entirety and building on the foundations inherited from the Qin dynasty. The Han ruled contemporaneously with the Roman Republic and the empire.

Following the fall of the Qin empire in 206 BC there was civil war until Liu Bang became king of Han, taking the title of the first emperor of the Han dynasty in 202 BC. He was posthumously known as Gaodi and ruled from 206 to 195 BC. The Han dynasty is divided by historians into three periods: the Western Han period (also known as Former Han) dating from 206 BC to AD 9, followed by a short interregnum during which China was ruled by Wang Mang until AD 23; in AD 25 the Liu family reasserted itself as the Eastern Han dynasty (also known as Later Han) until its fall in 220.

WESTERN HAN PERIOD (206 BC–AD 9)
With its capital at Chang'an (present-day Xi'an), the Han began with a period of political consolidation, followed by expansion and finally by retrenchment and a weakening of political and social cohesion.

Gaodi retained the centralised administrative system bequeathed by the Qin, as well as many of their laws. One of the main contributions of the Han dynasty to imperial China was its gradual development of the civil service and the structure of central and provincial government.

There was a general revival of learning after the proscriptions of Qin. From the reign of Wendi (180–57 BC) orders were given to search for lost classics, and various Confucian and other texts such as the *Shijing* (*Book of Songs*), *Shujing* or *Shangshu* (*Book of Documents*) and *Chunqiu* (*The Spring and Autumn Annals*) became necessary learning tools for officials and candidates for the civil service. Sima Qian (d. c. 90 BC) wrote the *Shiji* (*Records of the Historian*), recording Chinese history from the mythical past up to his own day, and his format was followed by all Chinese dynastic historians until the end of the imperial period. Government monopolies of mining and coinage, salt and iron provided revenues for the state, and state factories were developed and expanded for the manufacture of many

artefacts, including objects of daily use, bronzes, lacquers and textiles, as well as weapons for war. Engineering projects, including water conservancy projects, were also government-sponsored. Attention to astronomical observations and their recording were inspired by the need for more accurate calendars, allowing the various communities to adjust their work to the seasons and enabling officials to maintain their records correctly.

In the early period Chinese territory was enlarged by the martial emperor, Wudi (140–87 BC), with expansion into areas of southern and southwestern China, Korea, Vietnam and Central Asia and many campaigns against nomadic tribes, such as the Xiongnu. The envoy Zhang Qian was sent to investigate and make diplomatic contacts with Central Asia from 138 to 126 BC. Territorial extension was followed by colonisation programmes, including state-sponsored, border military farming settlements. This expansion was accompanied by the opening up of the so-called Silk Routes. The import of Ferghana horses, Asian thoroughbreds, was important to Wudi's use of cavalry and an inspiration to Chinese artisans. Trading in Chinese goods, especially silk, extended as far as Rome. Trade routes included the Silk Routes through Central Asia as well as sea routes to Burma and India, and thus at least indirect contact was made with Iranian, Hellenistic and Roman cultures.

After Wudi, the next capable emperor was Xuandi (73–49 BC), who was considerably less martial than Wudi and more concerned with the implementation of the Han laws and edicts. The following reigns marked the beginning of a series of weak emperors and the growth of rivalry between the families of imperial consorts. The Western Han period ended when one of these powerful consort families temporarily gained control and established a new dynasty, the Xin, for a brief interlude (AD 9–25).

WANG MANG (AD 9–23)

Wang Mang was a member of the powerful family of an imperial consort and acted as regent to one of the young emperors of the Western Han period. In AD 9 he founded his own dynasty, under the title of Xin. In his short reign he tried to institute some new social measures, nationalising land and giving more relief to the poor, issuing new types of coinage and changing the structure of government. He re-established various monopolies, such as those in salt and iron, and tried to control market prices. However, the time was insufficient to enable him to make headway with any of his radical changes or to counteract the stiff opposition he faced.

Historians still argue as to whether he was a revolutionary socialist or merely an ambitious intriguer who took advantage of the corrupt and weak conditions of the imperial court of his time. He attempted to call on precedents from China's distant past in order to justify his measures and his own rule, but his policies antagonised many. Any increased revenue was expended on disastrous campaigns against the Xiongnu nomadic peoples. His final years saw the rise of a number of rival factions who fought one another and himself. Eventually the capital, Chang'an, was invaded and Wang Mang captured and killed in AD 23.

EASTERN HAN DYNASTY (AD 25–220)

The Han dynasty was restored in AD 25 by Liu Xiu, a distant cousin of the last Western Han emperor, and he ruled as Guang Wudi (r. AD 25–57). He was a competent leader, strengthening the central government with the support of the wealthy families and moving the capital to Luoyang. He then advanced Chinese influence again in south China and northern Vietnam, and his successor Mingdi (r. AD 58–75) briefly re-established Han rule in Central Asia.

Buddhism was introduced at some time during this period, probably by traders from Central Asia, but did not yet gain a large following. The first mention of Buddhism in the Han empire dates from AD 65 and concerns a Buddhist community established at the court of Prince Ying of Chu, at Pengcheng in the north of Jiangsu province. The first Buddhist sculptures are also found in this region, dating from the end of the Eastern Han or the period of the Three Kingdoms. The penetration of Buddhism by sea would seem to date from the end of the Han dynasty, again spread through the activities of foreign traders.

Han administration produced a proliferation of documents and official returns which were sometimes kept in duplicate. By about AD 105 paper manufacture had been improved, leading to a wider use of this new material for government needs, although wooden or bamboo strips and silk were still used for some time. The first Chinese dictionary (*Shuo wen*) was compiled c. AD 100 and included more than 9000 characters, their variant forms and explanations of their meanings. The records of titles in the imperial library have been preserved and constitute China's first bibliographical list.

Following a change in the Yellow River's course (c. AD 2–11) and pressure from non-Chinese peoples in the border areas at the end of the first century AD, migration southwards increased, with a gradual shift of population from northern China to the central and southern regions. This period marked the beginning of a change in the demographic and economic centre of gravity, which reached its height a thousand years later. Many non-ethnic Chinese were drawn into the Chinese orbit, and their cultures inevitably influenced Chinese customs.

The Han dynasty began to decline from the time of Hedi (r. AD 88–105), with powerful families and eunuchs gradually gaining power at the expense of the central government. The great landowning families sought self-sufficiency, and estates often possessed their own markets, armed forces and tenant farmers. The decline of the dynasty was also evident in extrava-

gant burials, which were condemned by moralists throughout the last two centuries of the Han dynasty, and against which laws were enacted.

In AD 189 there was a massacre of eunuchs, who had become very powerful (a phenomenon that was to recur several times in Chinese history), by imperial consort families. This led to the formation of rebel bands including the Yellow Turbans, who were fired by a belief in supernatural influences and led by inspired demagogues. The rivalry between eunuchs, bureaucrats and consort families, and the growth of popular revolts by messianic groups, finally led to the downfall of the dynasty. Civil war followed between the three kingdoms of Wei, Shu and Wu, which emerged as the Han dynasty weakened, and the country was finally split in AD 220.

Period of disunity (AD 221–589)

With the collapse of the Han dynasty in the third century AD, China was divided into a number of smaller kingdoms and then subdivided again in the following centuries. The country began a long period of political disunity, social change and intellectual ferment, with an absence of strong unifying forces. The period from AD 221–80 is known as the Three Kingdoms and that from AD 386–589 is referred to as either the Northern and Southern Dynasties or the Six Dynasties.

At first the three kingdoms, Wei, Wu and Shu, fought among themselves, and this era has been romanticised by China's storytellers ever since as a traditional time of brave heroes, heroic deeds, comradely sacrifices and brilliant tactics; some of the stories and anecdotes were collected together in the fourteenth century to form the novel, *Sanguozhi yanyi (The Romance of the Three Kingdoms)*. This period ended when the successors to the state of Wei took power and briefly ruled the whole of China under the dynastic name of Western Jin (AD 265–316). Their capital was Luoyang.

SIX DYNASTIES

The brief unity achieved by the Jin dynasty ended when, in 311, a Xiongnu aristocrat occupied Luoyang and then Chang'an, signalling the end of the Western Jin and the division of China into groups of northern and southern states, which lasted until its reunification under the Sui dynasty in 589. In 316 the Chinese court fled south to Jiankang (present-day Nanjing), leaving the north to the invaders, and setting up the dynasty of the Eastern Jin (AD 317–420) (see below).

North China was then ruled by a succession of sixteen ruling houses. The most significant group, the Toba branch of the Xianbei people, first ruled part of the area before reunifying all of the north in the mid fifth century as the Northern Wei dynasty (386–535).

Their first capital was at Pingcheng in Shanxi province, east of present-day Datong, but in 494 it was moved to Luoyang. The Toba peoples had gradually become sinicised; Chinese became the official language, intermarriage with Chinese was actively promoted and their own traditions scorned. It was thus felt necessary to move the capital nearer to the Chinese heartland. The Northern Wei provided north China with about a century of peace before the Xianbei generals stationed on the frontiers rebelled in 534, whereupon their territory was split into two chronologically overlapping states: Eastern Wei (534–50), whose capital was at Ye, Anyang, and Western Wei (535–57), whose capital was at Chang'an. These were themselves succeeded by two short dynasties, Northern Qi (550–77), whose capital remained at Ye, Anyang, and Northern Zhou (557–81), whose capital remained at Chang'an, until a Northern Zhou general succeeded in reunifying the whole of China in 589, under the dynastic name of Sui.

Buddhism, introduced from the Indian subcontinent in the Han period, was adopted by a number of ruling houses, most notably by the Northern Wei. At Yungang in northern Shanxi province, near the first Northern Wei capital, caves were hollowed out of a cliff and carved with representations of the Buddha and other deities. The carving of several colossal figures began in the late fifth century. When the capital was moved to Luoyang in AD 494 another complex was started at Longmen. Buddhist caves were also established at Gong xian, and work already started at Dunhuang and Maijishan in the northwest was advanced during these years of disunity.

During this period the practice of translating the Indian Buddhist texts into Chinese began in earnest. Fa Xian, the first important Chinese pilgrim, left China for India in 399 and travelled to Buddhist centres in Central Asia, Sri Lanka and Indonesia, returning to Jiankang (present-day Nanjing) with many religious texts. He was the first actually to reach India, study there for a considerable time, and return to China with the sacred Buddhist scriptures. He also brought back to China a knowledge of Indian history and geography.

Six dynasties ruled successively in the south, including the Western Jin (265–316), Eastern Jin (317–420), the Song (420–79), Southern Qi (479–502), Liang (502–57) and Chen (557–89). They all made their capital Jiankang, which continued as a cultural and political centre visited by merchants and Buddhist missionaries from Southeast Asia and India, making it one of the world's greatest cities. As southern China was saved from the devastation of the foreign invaders in the north, the economic and cultural centre of China gradually shifted from the northwest to the southeast.

Literature, philosophy, painting, calligraphy and art

theory flourished simultaneously in many areas, as it often did in Chinese history during periods of disunity when several political centres co-existed. The troubled political background led to much philosophical speculation, and there are many writings related to the School of Mysteries (Xuan Xue) and Neo-Daoism. The famous poet Tao Yuanming (365–427), the calligrapher Wang Xizhi (321–79) and the painter Gu Kaizhi (c.344–c.406) all lived during this period.

Once the Northern Zhou general Yang Jian (541–604), Duke of Sui, had consolidated his position in north China, he swept into Jiankang, thereby ending the Chen dynasty and the Six Dynasties period and reuniting all of China under the Sui dynasty in 589.

Sui dynasty (589–618)

This dynasty, like the shortlived Qin, was crucial to Chinese history, despite being in power for such a brief period. The dynasty reunified northern and southern China after centuries of division and laid political, educational and economic foundations on which the great Tang and later dynasties were able to build.

The dynasty was founded by a Northern Zhou general, Yang Jian (541–604), who reunited China and established himself at Chang'an as Emperor Wendi. Yang Jian's position in northern China by the mid 580s was secure enough for him to succeed in reuniting the whole country. In 587 he dethroned the later Liang emperor and in 589 overwhelmed the Chen, thereby becoming emperor of all China.

Wendi successfully re-established law and order and made many improvements to the internal administration and bureaucracy by unifying many institutions. He was interested in law and promulgated a new penal code in 581, revised in 583, which provided the pattern for the Tang code, possibly the most influential body of law in Far Eastern history. He also masterminded and personally ruled over a complex system of ministries, courts, boards and directorates which became the basic framework for the Tang central government. Local government was rationalised, a new census was undertaken and the tax system reformed.

The first Sui emperor also instituted an extensive programme of public works, including the construction of the Grand Canal system, which linked the Yellow, Huai and Yangzi rivers, and this project was expanded in his son's reign. It was a network of 1790 kilometres which enabled grain to be transported in famines and also improved internal communications within the empire.

Wendi made the architect Yuwen Kai (555–612) responsible for the plan of the new capital, southeast of the Han city of Chang'an. The royal residences were situated in the north of the city and the remainder of the city divided into residential neighbourhoods and two marketplaces.

The second Sui emperor, Yangdi (569–618), was ambitious and energetic and made constant tours of inspection around the country. By using conscript labour, Yangdi rebuilt the eastern capital at Luoyang in an attempt to weaken the predominance of the northwest. He also expanded the formal examination system based on the Confucian classics as a way of attracting scholars from the southern and northeastern élites into the bureaucracy, as earlier bureaucrats had tended to be from less cultivated, northwestern aristocratic families.

Both emperors were ardent Buddhists and are recorded as being responsible for the creation and repair of innumerable Buddhist images, such as those in the cave temples at Tianlongshan and at Taiyuan, Shanxi province. The British Museum's huge marble Amitābha is one such Buddhist figure, dated by inscription to 585. Early in the seventh century, a Buddhist monk by the name of Jingwan began a project at the Yunjusi, a monastery at Fangshan, Hebei province, which involved carving the Buddhist sutras on stone and was to last until the twelfth century. These stone slabs, totalling nearly 15,000, were rediscovered this century (see Buddhist sites appendix).

Yangdi pursued a very active foreign policy, including sending expeditions to Taiwan, initiating diplomatic relations with Japan, driving out the natives of Gansu and eastern Turkestan and establishing Sui colonies along the great Western trade routes. Many petty local states became tributaries of the Sui and a prosperous trade developed with Central Asia and the West. The Turks were a constant threat, but Yangdi's most costly ventures were his Korean campaigns from 612 to 614. The cost and eventual failure of these campaigns left the Sui demoralised, and militarily and financially ruined. A final campaign against the Turks also ended in failure, and Yangdi withdrew to the south, leaving the north of China divided among various rebel regimes. His military failures were compounded by natural disasters such as floods, and peasant uprisings multiplied. When he was finally murdered by members of his entourage, a general who had been responsible for defending China against the nomads, Li Yuan, rebelled, marched on Chang'an and founded the Tang dynasty in 618.

Tang dynasty (618–906)

The Tang dynasty spanned three centuries of Chinese history. It is regarded by the Chinese as one of their most glorious periods and an affirmation of the integrity of China as a single, unified empire. It was an era of cultural brilliance, territorial expansion and great prosperity for much of the time, so that by the reign of Xuanzong (712–56), China was the richest and most powerful political unit in the world. It was also a golden age for poetry and the arts generally.

The Tang dynasty was founded by a Sui general, Li Yuan (566–635), who was posthumously known as Emperor Gaozu. Gaozu perpetuated many Sui administrative government agencies and policies, and early Tang government was highly centralised and dependent on a complex system of administrative law, much of which was inherited from the Sui. During the Tang period several attempts, ultimately unsuccessful, were made to arrange for an equitable system of land tenure. However, over the centuries of Sui and Tang dynastic rule the aristocracy's power and influence gradually declined, and its place in government was taken by professional bureaucrats who were recruited by examination on the basis of their talents. The intellectual and social effects of this change had important repercussions for China, leading to the widening of the social base of the ruling class by offering greater access to government office to people of non-aristocratic birth. These new bureaucrats gradually became the agents of the ruling dynasty, rather than the representatives of their own social group. These changes took place slowly and were not immediately apparent.

The Tang felt themselves to be heirs of the Han, and during the sixth and seventh centuries they recovered much of the territory in Central Asia formerly penetrated by Han armies and colonists. They expanded further westwards than ever before, well into Central Asia, and eastwards as far as Korea, with the empire eventually incorporating parts of Mongolia, Manchuria and Annam (present-day Vietnam). The Chinese controlled the oasis towns along the Taklamakan desert, and trade flourished, bringing exotic foods, textiles, furs, animals and above all fine horses to the court at Chang'an (present-day Xi'an). As well as the silk sent westwards along the Silk Route, the Chinese exported ceramics by sea to Southeast Asia, India and Western Asia. The main Chinese cities had many foreigners living in them, whose ethnic customs influenced many aspects of Chinese arts and culture.

Early in the Tang period Buddhism was probably the most pervasive of all foreign influences. The monk Xuan Zang (602–64) visited India and Nepal and brought back Buddhist texts, many of which were translated by the Chinese. Many Buddhist works were commissioned by the imperial family.

China controlled her far-flung possessions by stationing large numbers of troops in the frontier regions under the command of very powerful viceroys.

This policy stretched the government's financial resources, and the crisis was compounded by political difficulties when the Empress Wu Zetian (r. 690–705), wife of Tang Gaozong (r. 649–83), seized power after her husband's death, establishing herself as the first empress of the Zhou dynasty seven years later. A few years after her death, and the overthrow of her dynasty, one of the culturally most brilliant periods in Tang history was presided over by Emperor Xuanzong, also known as Minghuang (r. 712–56). He was himself a considerable scholar and patron of the arts, and his court became a centre of cultural activity. Towards the end of his reign, however, he lost control of government affairs and Chinese expansion came to a halt.

China went on the defensive, suffering a series of defeats and retreats from its expanded borders. In 751 the Arabs attacked and overwhelmed the Chinese garrisons at the Battle of the Talas River. This began the period of the destruction of China's power in Central Asia, cutting her off from the overland trade routes to the West and to India. These difficulties were compounded by a viceroy, An Lushan, of Sogdian and Turkish parentage, who became increasingly powerful and marched on Luoyang and Chang'an in 755; both fell without a struggle. He plunged the empire into a bloodthirsty civil war and Minghuang abdicated.

Xenophobia led to foreigners being blamed as scapegoats for China's troubles, and Buddhism suffered the great proscription of 842–5, which marked its nadir. Many Buddhists had exploited their special privileges, becoming powerful landowners exempt from tax and corvée, and became targets when the dynasty was short of money and manpower. Millions of monks and nuns were forcibly secularised and retaxed, and their temples and lands reclaimed for the government. With routes to the West and India blocked by Chinese defeats, Indian Buddhist sources became inaccessible and Chan Buddhism (known in the West by its Japanese name, Zen) became the most popular form of Buddhism.

During the late eighth and the ninth century great economic and social changes took place. The population was gradually moving southwards, to avoid taxation and to seek out new land; the Yangzi valley began to replace the great plain of Hebei-Henan as China's most populous and richest area. The south now had greater agricultural production, new industries and influential groups of merchants.

Commanders on the edges of the empire also became increasingly powerful and autonomous. As the empire began to disintegrate, peasant rebellions increased. Eunuch generals commanded the best troops and infiltrated many levels of government, and finally an army commander deposed the last Tang emperor to become the first emperor of the later Liang dynasty. This began the period known as the Five Dynasties and the Ten Kingdoms, during which the empire was divided, until it was reunited in 960 under the Song.

Five Dynasties (907–60)

After the collapse of the Tang, China was again divided into north and south. In the north the Qidan (Khitan) people, the Liao dynasty, succeeded the Tang and ruled from 907 to 1125. The south was ruled by a number of shortlived kingdoms, known as the Five Dynasties and the Ten Kingdoms. China was thus markedly divided into two, with the north militarily strong and the south economically and culturally wealthy. However, the idea of imperial unification, deeply rooted in tradition, survived during this relatively brief period of disunity and was eventually resuscitated by the Song in 960.

The later Liang dynasty, with its base at Bian (later to become Kaifeng), was the first of the Five Kingdoms and was followed by the later Tang, the Jin, the Han and the later Zhou, all led by military usurpers and backed by recruits from the lower classes. The Song dynasty (960–1279) was eventually founded by Zhao Kuangyin, a military commander of the later Zhou dynasty, ending a period which saw the decline of the great aristocratic families and their large estates, and the reality of a new bureaucratic age.

It was in the south that matters more crucial to the development of Chinese culture evolved, and the contents of rich tombs in the Nanjing area, for example, provide an idea of the extent of the luxury of these times. Eight of the ten southern 'Kingdoms' in the Yangzi River valley and south of it managed to achieve relative stability, but none was strong enough to achieve unification of the whole country. Along the coast sea trade expanded, promoting both urban prosperity and cultural diversity. On land many refugees moved southwards, practising a frontier type of agriculture and pushing aside the local peoples. This process turned south China into a cultural centre of great complexity, with various sub-cultural areas sandwiched between one another. Particularly in the area of Sichuan province, which was somewhat protected by its surrounding mountains, the heritage of Tang culture survived and progressed. The intellectual trends in Sichuan foreshadowed an eclectic synthesis of Confucianism, Daoism and Buddhism which became more fully developed in the Song dynasty. As during the Tang period, the Buddhist monasteries with large estates were usually the first to introduce new and better technology.

On the economic scene, a lack of copper was met by an increasing output of iron, made possible through more efficient methods and sophisticated production by division of labour. When the limited number of copper coins could no longer cope with the growing volume of trade, iron currency briefly came into circulation. Another device was called flying money, first used among merchants and then adopted in the form of official notes issued by the salt monopoly government agencies; this was the forerunner of paper currency as the legal tender of the subsequent Song period. It was closely related to the use of movable type in printing, which evolved during the tenth century.

From the period of the Five Dynasties, southeast China, particularly in the heartland of the Yangzi delta, began to lead the country in economic prosperity and cultural refinement. It was fertile, irrigated and efficient at intensive farming. Rice replaced millet as the predominant crop. Many markets, towns, cities and metropolitan areas were the source of an ever-expanding variety of consumer goods. This made regional trade more important and stimulated other parts to adopt specialisation and become part of the overseas trade. Refined culture also developed away from the coast in such inland mountainous areas as modern Jiangxi, which became the centre for ceramic manufacture. This cultural domination particularly asserted itself much later, when the Northern Song fell to the barbarians in 1127, and the Southern Song chose to base itself in this very area, locating its capital at Lin'an (present-day Hangzhou).

Liao dynasty (907–1125)

The Tang dynasty was succeeded on the northeastern periphery of its empire by the Liao, a northeastern people called the Qidan, who controlled territory in Liaoning province and parts of present-day Hebei and Inner Mongolia, and made their southern capital at a city now known as Beijing (thus starting its career as a capital city). They had five capitals in all, based on the five-fold division of power according to the centre of Tantric Buddhist mandalas, and dual prime ministers, Chinese and Qidan. They ruled contemporaneously with the Five Dynasties in the south of China and later with the Northern Song, with whom they traded and from whom they received money to keep the peace.

The Qidan were a semi-nomadic and pastoral people. The word Qidan (Khitan) is the source of Cathay, the name for north China in medieval Europe, as reported by Marco Polo. The Qidan chief declared himself emperor in 907 and then, expanding their territory from the borders of Mongolia into both southern Manchuria and the sixteen prefectures below the Great Wall, his successors began to aspire to rule all China.

The Liao maintained a dual administrative system to ensure that they did not become completely sinicised: they used tribal laws, steppe styles of food and clothing, and their own Mongolian language for themselves. A second administration governed the farming

regions under the old Tang system, complete with Tang official titles, examinations, taxes, and the Chinese language. The Qidan economy was based on horses and sheep and on agriculture, with millet as the main crop. They were patrons of Chinese Buddhism, but their achievements were more military and administrative than cultural.

The assimilation of Chinese wealth and culture and the pacifism of Buddhism gradually undermined the Liao's once martial character. They were eventually overthrown by the Ruzhen (Jurchen), another semi-nomadic and semi-pastoral people who originated in Manchuria. The Northern Song aided the Jin in defeating the Liao, after which the Jin turned on the Northern Song and established the Jin dynasty (1115–1234).

WESTERN LIAO (OR KARA KHITAI) (1125–1211)
As the Jin forced the Liao westwards, a Liao royal descendant took some of the Liao people to an area around the Tianshan mountains with a capital at Tok-mak, in the steppes of Central Asia. They were victorious over the Seljuk Turks near Samarkand in 1141, but in 1211 were defeated by the Mongols under Genghis Khan.

Contemporary with the Liao were the Xi Xia (c.990–1227), a people who inhabited present-day Ningxia and western Gansu province in northwest China. The Xi Xia were a Tibetan-related people, the Tanguts being the dominant ethnic component, but they were much influenced by the Chinese. Mainly Buddhists, they adopted many Tang dynasty institutions. They recognised the Liao as their overlords and united with them to block any Song advance northwards into their territory. The Song also paid the Xi Xia handsomely, from 1044 for several decades, in return for peace. From 1115 to 1119 the Song attacked the Xi Xia without much success, but the Xi Xia were finally defeated by the Mongols in their campaign of 1225–7 and were incorporated into the Mongol empire with the rest of China.

Song dynasty (960–1279)

The Song dynasty is divided chronologically into two parts: the Northern Song, with its capital at Bianliang (present-day Kaifeng), from 960 to 1126, and the Southern Song, with its capital at Lin'an (present-day Hangzhou), from 1127 until their defeat at the hands of the Mongols in 1279. The Song never ruled all of China, as did some earlier dynasties, nor did it exert effective political control over the border areas.

NORTHERN SONG (960–1126)
General Zhao Kuangyin, a military commander of the later Zhou dynasty, reunified China after the period of the Five Dynasties and became the first Song emperor (r. 960–76), posthumously known as Taizu. The northeast of China, beyond the Great Wall, however, remained under Liao control through a Qidan confederation of Turkish and Mongol tribes, and the Ruzhen Jin and Xi Xia peoples were constant threats.

Taizu instituted a policy of subordinating the military to the civil officers, and as a rule during the Song period there was more consultation between emperors and ministers than previously. The Song never aspired to the military prowess of the Han or the Tang, and the country was more cut off from Central Asia than under the Tang; gradually its attention turned towards the sea. In order to meet the extra revenue needed to maintain the huge standing armies which protected the northern borders, the Song deliberately set out to stimulate foreign trade, establishing a maritime trade commission to supervise and tax merchant ships. The growth of sea trade led to a new emphasis on boat building, and many new types of vessel were designed, including the first paddle boat in the world. Also at this period the south-facing compass was adapted for navigational use and the stern-post rudder invented.

The use of compasses, charts and other sea instruments helped in navigation, and the expanding sea trade moved southwards and linked up with the activities of merchants from Islamic Iran and Arabia. Some Chinese merchants began to settle in Southeast Asia. The Southern Song had a flourishing trade with north China, and with both the Liao and Jin peoples. Trade grew to such an extent that during the Southern Song period income from the state monopolies – on salt, tea, wine and silk – and excise duties on trade combined to produce 50 per cent of total government revenue.

The early Song emperors strengthened the administration by ruling directly through a new set of administrative offices. However, they had great difficulty in managing finance because of inflation, caused in part by the cost of tax evasion by great landowners, the huge bribes which the Chinese paid to various border peoples as the price of peace, and the use of paper money without reserves. A reform programme of major institutional changes, proposed by Wang Anshi (1021–86), the chief councillor, failed because it met with severe opposition from conservative bureaucrats. The factionalism between the bureaucratic reformers and conservatives proved fatal to the imperial system, which began to disintegrate.

The Song emperors were among the greatest imperial patrons of the arts that China was ever to enjoy. Particularly outstanding in this respect was Emperor Huizong (r. 1101–25), who supported a painting academy and was a great collector. Indeed, patronage of the arts was linked to the political instability of the period. Both emperors and officials sought to buttress their positions with the support of ancient precedents and values, as expressed in texts and

antiquities. This interest in the past also led the Chinese to collect and write about antiquities, and albums of ancient bronzes and jades were compiled. Information was now disseminated more widely in handbooks and encyclopaedias, promoted by greater use of wood-block printing methods. The emperors particularly promoted the painting of themes associated with dynastic legitimacy and stability, at a time when the north was controlled by the Jin. Emperor Huizong was not, however, an effective ruler and much corruption and extravagance marked his reign. He abdicated in favour of his son, but in 1127 the Ruzhen, seeing how weak the Song had become and having already overcome the Liao with Song aid, swept into China and overran the capital of Kaifeng, capturing the emperor. The Song court fled to a new capital, Lin'an (present-day Hangzhou), south of the Yangzi River.

SOUTHERN SONG (1127–1279)
The Southern Song, having fled south, based their capital at Lin'an ('temporary safety'), later called Hangzhou.

The Southern Song period, despite its reduced territory, was commercially rich and powerful. In the search for past authority as a justification for present political action, there was renewed interest in ancient Chinese history. Emperor Gaozong (r. 1127–62), for example, commissioned from Ma Hezhi a series of scrolls illustrating the *Shijing (Book of Songs)*, a classical text, with the texts purportedly written by the emperor himself.

The rise of Neo-Confucianism, which had begun in the late Tang, was promoted by the improved printing techniques and the dissemination of Confucian texts. A movement led by Zhu Xi (1130–1200), who synthesised Confucian thought and formed one of the most influential schools in China for some centuries, had two distinct aims: self-cultivation and institutional reform.

The Song period was characterised by many changes in both rural and urban life. An agricultural revolution, including new strains of rice and improved agri-

cultural tools, produced plentiful supplies for the very large population, estimated to be one hundred million. Mineral productivity of gold, silver, lead and tin increased, and better processing in industry generally, together with improved industrial skills, led to more diversified specialisation. The Chinese underwent an 'industrial revolution' during this period in many industries and their internal economy dwarfed that of Europe generally. For example, they produced salt on an industrial scale, reaching 30,000 tons in Sichuan province alone, and iron production was about 125,000 tons a year, a scale not reached in Europe until the eighteenth century. Their skill in metal-casting techniques and mass-production meant they were able to produce standardised military and agricultural equipment for the whole empire and to deliver it by canal transport. As facilities for river, canal and road transportation improved, this also allowed production in areas far from sources of raw materials and the goods to be made available to distant parts.

This development of communications and transport led to an unprecedented growth of urban life. The officially controlled city markets came to an end, as did legal restrictions confining merchants and artisans generally. Interlinked rural, periodic markets proliferated and a nationwide market system was formed, with regional specialisation and new advances in the division of labour. The official use of paper money, promissory notes and bills of exchange resulted in a 'commercial' revolution and a huge growth of the merchant classes. Cities grew enormously, particularly in southern China, where by 1100 at least four cities had populations of over one million.

Although the Southern Song administration was militarily weak, it still maintained an effective defence against the Mongols for four decades. However, heavy taxation, along with the inflation of paper currency, concentration of land ownership, bureaucratic laxity, clerical abuses and lack of justice for the poorer peasants, led to internal rebellions. Eventually the genius of Khubilai Khan and his Mongol troops proved too much for the Song to resist.

Jin dynasty (1115–1234)

The founders of the Jin dynasty were Ruzhen Tartars, who inhabited an area to the northeast of the Great Wall. They were a Tungusic people from Manchuria, previously subject to the Qidan state of Liao. They had a semi-nomadic lifestyle and bred horses for tribute and trade with the Liao, the Koreans and the Chinese, developing at the same time a formidable military force based on their horsemanship and their hunting skills.

During the early twelfth century they joined with the Northern Song and destroyed the Liao empire. The Jin dynasty was established in 1115 and within ten years had rounded upon the Chinese, seizing control of the capital Kaifeng in 1127 and forcing the Song south of the Huai River. Ruzhen attempts to take the

whole country failed, and they lived for a period in a generally peaceful co-existence with the Song until their defeat by a Song fleet in 1161.

For most of its time in power the Jin dynasty had its capital at Yanjing (Beijing). In the early years the Ruzhen adopted Liao institutions in addition to their own tribal systems, but after 1140 they tended to follow Chinese Tang and Song bureaucratic forms. Chinese and Ruzhen officials could receive appointment to the civil service by the examination system, but there was always a bias towards the Ruzhen which, together with the favoured position of the Ruzhen aristocracy, eventually alienated the Chinese élite.

From 1206 to 1208 the Jin were exhausted by a war

against the Song, and many alienated nobles defected to the Mongols. The Mongol armies began to attack Jin from 1211 and pillaged for several years. In 1214 the Jin moved their capital from Beijing to Kaifeng in Henan province, and the Mongols captured Beijing in 1215. Thereafter the Jin formed a small buffer state between the Mongols in the north and Southern Song China. In 1227 Genghis Khan died and the Song Chinese allied with the Mongols and besieged Kaifeng in 1232. In 1234 the Jin emperor committed suicide, and the Mongols integrated the Jin state into their empire.

Yuan dynasty (1279–1368)

The Yuan dynasty emperors were Mongols, the descendants of Genghis Khan (c.1162–1227), an exceptionally able leader. Genghis had conquered part of north China in 1215, having already united the various nomadic, Mongol-speaking tribes of the steppe land. He divided his empire into four kingdoms, each ruled and expanded by a son of his chief wife.

Genghis's grandson, Khubilai Khan (r. 1260–94), ruler of the eastern Great Khanate, completed the Mongol conquest of China by defeating the Southern Song in 1279. He ruled China as emperor, with the dynastic title of Yuan. China during the Yuan dynasty was the most easterly territory in a vast Mongol empire which stretched across Asia as far west as Poland, Hungary and Bohemia.

The Yuan emperors had two capitals. In 1274 Khubilai transferred the winter capital to present-day Beijing, then called Dadu or Khanbalik, thus revealing that the central focus of the Mongol empire had shifted from Karakorum, south of present-day Ulan Bator. He kept the summer palace and capital at Shangdu (Marco Polo's and Coleridge's Xanadu, present-day Dolon Nor in Inner Mongolia). Few Yuan buildings remain in Beijing as the Ming rebuilt the city.

The Silk Route was again opened and European interest in China, both diplomatic and religious, took root. Franciscan missionaries and other Europeans now arrived for the first time. Some reported back on what they had seen, the most famous being Marco Polo, who spent from c.1271 to 1292 in Khubilai's service. Interregional trade also flourished, and a second version of the Grand Canal was built, partly along a new route. Many merchants were Muslims, some of whom were also active scientifically, building astronomical instruments and hydraulic engineering works. Cartography and many medical works of this period are evidence of the high level of technology achieved by the Yuan.

The Mongols ruled through a military type of government, rather than relying on the scholar-bureaucrats selected by examinations. The administration was bilingual, in Mongolian and Chinese, with many interpreters and translators. Unlike the Jin, the Mongols did not encourage Chinese scholars to enter government service, preferring instead foreigners, such as the Muslims from Central and Western Asia. The educated Chinese response to such foreign domination was to withdraw into the traditions of their native Chinese past and to avoid association with the conquerors. Many alienated Chinese scholars therefore went into retirement, either forced or voluntary. Since they could no longer follow official careers, their energies were often channelled into literature. There was a flowering of vernacular drama, and of the arts in general.

The Mongol emperors and bureaucrats were not great patrons of traditional Chinese arts, and craftsmen were free to develop and exploit new influences, many dictated by the demands of trade. By reuniting China, though, the Mongols also brought together the differing traditions of Northern and Southern Song art.

The Mongols had no fixed rules for succession. This situation precipitated in-fighting among contenders for the throne, leading to the eventual downfall of their dynasty after less than a hundred years of foreign rule in China.

Ming dynasty (1368–1644)

The Ming (literally 'brilliant') dynasty was founded in 1368 by General Zhu Yuanzhang, a rebel leader based in Nanjing who came from a very unconventional background, being an orphan and a Buddhist novice.

The last Mongol rulers had generally been inept. Peasant unrest was compounded by disastrous droughts and famines, and antagonism grew against alien rule. Zhu Yuanzhang, the most successful general in the south, emerged victorious from among the warring factions and pushed the Yuan court into Inner Mongolia. He declared himself emperor with the reign title Hongwu ('vast military accomplishment'). (Beginning early in the Han dynasty, a Chinese emperor, on his accession, would adopt a title by which his reign would be known, and sometimes this was changed several times during a reign because of auspicious or inauspicious events.) The Hongwu emperor maintained his capital in Nanjing and changed the name of the Yuan dynasty's southern capital Dadu to Beiping (literally 'the north pacified').

It was the first time since 1127 that a Chinese dynasty had ruled over the whole of China. However, many of the early emperors' policies were based on those of the Mongol dynasty that preceded them, and there was a strong military emphasis, which was somewhat at variance with traditional Confucian practice.

The Ming dynasty proved one of the most stable and longest dynasties of Chinese history. Rulers of Korea, Mongolia, Chinese Turkestan, Burma, Siam and Vietnam regularly acknowledged Ming overlordship, and tribute was received from as far away as Samarkand.

The third emperor, Zhudi (reign title Yongle, 1403–24), sent out six great maritime expeditions under the eunuch admiral Zheng He. Zheng's fleet reached as far as the east coast of Africa. The Yongle emperor also moved the capital to Beijing. He had been Prince of Yan in his father Hongwu's time, and Yan with its power base in the north made him feel that the northern frontiers of China could be better defended from the north than from the southern Nanjing. He embarked on a huge programme which involved a complete rebuilding of the old Yuan capital. Beijing became the official capital in 1421, and though rebuilt in part many times since, the Ming design has been maintained.

The Hongwu emperor reorganised the central government in 1380 and made the changes binding on all his successors. This reorganisation made the heads of the Six Ministries and other agencies directly responsible to the emperor and not to a Central Secretariat headed by chancellors. Such a system only worked well when the emperor had the energy and interest to supervise and co-ordinate all the various agencies; otherwise his secretaries, eunuchs and other members of the Inner Court of government were responsible. After the first two emperors, Hongwu and Yongle, few of the later Ming dynasty emperors were as conscientious in their duties, which gradually led to abuses of power and neglect of good government.

The reign of the Xuande emperor (1426–35), however, regarded by later Ming scholars as a golden age, was characterised by good Confucian government and patronage of the arts. The Xuande emperor was himself a talented artist and poet. He gathered together a coterie of artists at court and was the first Ming emperor to patronise the arts extensively. His patronage of the porcelain industry at Jingdezhen resulted in the large number of wares modelled on those of the Song, as he considered himself a spiritual successor to the emperor-aesthete, Huizong, of the Song dynasty. Later in the Ming dynasty, although political conditions deteriorated, some of the greatest dramas and classic novels of Chinese literature were written.

The Xuande emperor allowed one final maritime expedition in 1431–3, but after that the Confucian-dominated court restricted overseas relations and trade. The late fifteenth-century emperors, Chenghua (1465–87) and Hongzhi (1488–1505), presided over competent administrations, but later Ming monarchs were less interested in the details of government, which consequently deteriorated. The late Ming period was constantly troubled by peasant uprisings, and by incursions by Japanese and native pirates and Mongolian tribes. Excessive eunuch power eventually led to the temporary capture of an emperor in battle in 1450 against the Mongolian tribes, and he was released only after huge indemnities had been paid.

European traders began direct contact with the Chinese during the late Ming period: the Portuguese landed in China in 1514, and in the seventeenth century China also traded openly with The Netherlands. Tea wares were also made specifically for the Japanese. (However, this was a two-way trade, as the Chinese admired many Japanese works of art and it became fashionable at this time to collect Japanese swords, lacquer and porcelain.) The Jesuit Father Matteo Ricci entered southern China in 1583 and began his missionary activities. He was a remarkably talented intellectual and linguist and though he made only a few important converts, he became a stipendiary of the court and enabled other Jesuits to become employees of the Bureau of Astronomy. He and his colleagues were admired for their learning, but other Catholic orders criticised their activities and the resulting dispute led to the Rites Controversy of the seventeenth and eighteenth centuries, an important factor in the intellectual life of that time.

The Hongwu emperor, himself a commoner, had understood and tried to help the problems of rural society. He improved local government and the lives of farmers. Private individuals in village society were combined to form *lijia*; the *li* was a group of 110 households subdivided into ten *jia*. This body was responsible for census registrations, maps of landholdings, levying and collecting taxes and labour services. Early in the Ming period the government continued the twice-yearly tax system that had been in use since the Tang dynasty. Many of the taxes and services were payable by money rather than in kind but the system was not efficient. It was then reformed by making quotas relating to acreage, grade of registered land and numbers of adult males, and by combining all the previous taxes into one 'single-whip' tax, payable annually in silver. This proved successful and by the end of the sixteenth century was generally in force throughout China.

From the end of the fifteenth century the Mongols again threatened from the north and Japanese pirates had become a constant menace. Large landowners became increasingly powerful, workers went on strike in many areas and the emperors' authority waned as eunuchs took over power in many areas (as had happened before in Chinese history). By the late 1500s the Ming government had become effete, partly because of the lack of co-operation between emperor and officials. The long reign of the Wanli emperor (1573–1620) began well, with a decade of reforms by a vigorous Chief Grand Secretary, Zhang Zhuzheng, but the emperor thereafter took no interest in government, and the start of the decline of the dynasty is ascribed to his reign. Rebellions increased within China, and marauding forces from without joined together to force the end of Ming rule. They entered Beijing, and the last Ming emperor committed suicide. The

Manchus invaded north China and proclaimed the Qing dynasty, although it took several years to quell the Ming loyalist movement completely in the southern provinces.

Qing dynasty (1644–1911)

The Qing dynasty was established by Manchurian tribesmen who were ethnically related to the Ruzhen, the founders of the Jin dynasty in the eleventh century. The Manchus were organised around the turn of the seventeenth century by Nurhachi (1559–1626), who called his new empire the Later Jin and divided his forces into 'banner' units, each distinguished by a particular coloured flag. In 1636 his son Abahai (1592–1643) changed the dynastic name to Qing (literally 'pure'). Abahai subdued Korea and Inner Mongolia and prepared the way for the capture of Beijing in 1644, although Ming loyalists in south China continued fighting and only during the 1680s was there domestic peace again.

As with several other foreign rulers of China, the Manchus quickly became sinicised. The Manchu emperors were enthusiastic patrons of all forms of Chinese art and culture and took over the Chinese form of bureaucracy. The second Qing emperor, Xuanye (who reigned as Kangxi, 1662–1722), was a strong and capable ruler who successfully attracted Chinese scholars into the service of his dynasty by holding special examinations and sponsoring scholarly projects. He employed craftsmen in a palace department and also promoted aspects of regional crafts, as well as encouraging Western inventions.

The Kangxi emperor and his grandson, the Qianlong emperor (1736–95), were enlightened rulers; they were conservative in outlook, but the relative mildness of their reigns and the stimulation of intellectual life by their publishing enterprises won over many hardened, patriotic Chinese. The Qing period fostered a very high level of scholarship.

Both the Kangxi and Qianlong emperors had extraordinarily long reigns. Qianlong's reign particularly has been termed one of China's golden ages, during which the economy expanded and it became probably the strongest, most populous and wealthiest country in the world. By the mid eighteenth century, there were more than two hundred million Chinese. The Qianlong emperor was determined to be remembered as one of the greatest of Chinese emperors and to extend the empire farther than the Tang had done. By the middle of the eighteenth century the Chinese had established a protectorate in Tibet. In 1758–9 the Qing conquests of Ili and Turkestan added about fifteen and a half million square kilometres to the empire. In 1788 the Burmese acknowledged Chinese suzerainty and sent tribute. Revolts were subdued in Taiwan in 1787–8, and in 1788–9 the Qing sent expeditions to Vietnam. In 1791–2 the Qing armies went to Nepal and fought the Gurkhas, who were forced to acknowledge the suzerainty of the Qing emperors. Only in the last decade of his reign, when the emperor was old and delegated many decisions to a powerful eunuch, He Shen, did corruption and inefficiency erupt, resulting in the White Lotus Rebellion (1796–1805), which represented antidynastic feelings. However, despite the literary inquisition the Qianlong emperor imposed from 1772 to 1788, during which period about two thousand works of literature were ordered to be destroyed on political or moral grounds, he is generally regarded as a patron of the arts. Certainly he regarded himself as such, inscribing his name and sentiments over many works of art, as well as writing much poetry and sponsoring the issuing and publication of numerous catalogues of the royal collections.

China was thus a powerful and prosperous empire during the first hundred and fifty years of Qing rule. Its bureaucratic system was admired by those Europeans who saw it, and the population and trade expanded on an unprecedented scale. Contacts with the West increased, particularly through Christian missionaries and, later in the dynasty, through traders and the incursions of the European colonial powers. In the mid eighteenth century, the Chinese brought Western trade under the so-called Canton system, placing many restrictions on trade and traders coming to China. The first treaty China signed with a foreign power was that with Russia in 1689, when the two countries defined their boundaries. In 1793 the British sent an ambassador, Lord Macartney, to China, but he was received only informally by the Qianlong emperor, as Macartney refused to kowtow to him.

Beijing remained the Chinese capital, and the Qing emperors embellished it with new buildings on an impressive scale, increasingly in brick, glazed tiling and stone, some brought from Dali in Yunnan province. The Qianlong emperor greatly expanded his summer palace, the Yuanming Yuan, situated northeast of Beijing, and it showed the influence of European forms of architecture. The Qing rulers also built in the ethnic minority regions, particularly Lamaist Buddhist temples, as many of them patronised this form of Buddhism. Many merchants were also important artistic patrons at this time, in areas such as Yangzhou.

The initially flourishing Qing commerce was stimulated by the influx into China of large sums of silver and copper from abroad, which increased the amount of money in circulation. The silver imported into China by the Europeans and other foreigners in the late Ming and Qing periods meant peasants were often victims of the economy's increasing monetisation, suffering the effects of usury and inflation. The nineteenth century was generally a period of decline, when

Western trading interests forced on China an awareness of international politics. The White Lotus Rebellion (1796–1805), one of many secret society rebellions, which were the poor peasants' means of self-defence, damaged both the prestige of the dynasty and its wealth; it was the end of an era, and after this time Qing finances never recovered.

The Opium Wars (1840–2) began after the Chinese commissioner in Canton seized British property and subjects in an attempt to suppress the opium trade, in which the British had long been engaged. The British decided that the Chinese had humiliated them, and declared war. By 1842 the British forces had opened up the way to Nanjing and the Qing government was forced to accept the British terms, set out in the Treaty of Nanjing in 1842. The terms included a huge indemnity to be paid by the Chinese, the opening of four more ports besides Canton to foreign trade, the establishment of an equality of relationship between the English and the Chinese, fixed tariffs on exports and imports, and the cession of Hong Kong to Britain. The treaty was forced on the Chinese and marked the beginning of several international defeats. The humiliating treaty was a contributing factor to the Taiping rebellion (1851–64), a serious internal military opposition to Qing rule. The Arrow War of 1856–60, over matters such as the British right to enter Canton, eventually brought a joint Anglo-French force which overran Canton and then moved northwards to Tianjin. There, in 1858, a treaty was made with the Chinese, whereby they agreed that Britain and France should have diplomatic representation in Beijing, that ten new ports should be opened up and that the European powers should receive more indemnities. Both Russia and the United States subsequently obtained similar treaties. When the Chinese refused Lord Elgin permission to go to Beijing, war started again, and eventually the Anglo-French forces occupied Beijing, burned the Summer Palace and drove the Xianfeng emperor into exile. The Conventions of Beijing in 1860 reaffirmed the humiliating terms of the Arrow Treaty, with more indemnities to be paid and the Kowloon Peninsula ceded to Britain. Russia gained territory north of the Amur and east of the Ussuri rivers.

The huge indemnities demanded by the foreign powers after their victories in the Opium Wars, and the loans China needed to rebuild, together with the depression of the currency in relation to the gold of world trade, all contributed to China's economic collapse. Territorial loss also increased as Japan absorbed the Liuqiu islands (Ryukyu islands) in 1875, the French occupied Vietnam in 1885 and the British annexed Burma in 1886. After the first Sino-Japanese War (1894–5) China ceded Taiwan to Japan and conceded the independence of Korea. In 1898 China was forced to grant territorial leases to Britain, Russia, France and Germany. Anti-Christian and foreign sentiment fuelled the Boxer uprising of 1900, which had to be put down with the help of an international reinforcement of troops. Brief sporadic attempts at reform proved futile, such as that instigated by the Guangxu emperor (1875–1908) which was aborted by the Empress Dowager, Cixi, who virtually controlled the government and the emperors from the mid 1860s, ruling behind the scenes until her death in 1908.

Natural calamities such as deforestation and soil erosion, combined with demographic pressure, caused many floods which were followed by droughts and epidemics. All these factors hastened the collapse of this last imperial dynasty, the end of which was formally marked by the abdication of the infant emperor, Puyi, on 12 February 1912.

Archaeological sites

This list includes some of the most important early (pre-Neolithic to Han) archaeological sites in China, with a brief description of each. They are divided by period; an alphabetical index and a map appear on pp. 316–17.

For further information the reader is referred to: K. C. Chang, *The Archaeology of Ancient China*, New Haven and London, 1986; R. D. Whitehouse (ed.), *The Macmillan Dictionary of Archaeology*, London, 1983, on which parts of this list are based; and Institute of Archaeology, the Chinese Academy of Social Sciences, *Xin zhongguo de kaogu*

faxian he yanjiu (*Archaeological discoveries and research in New China*), Beijing, 1984. The reader is also referred to English summaries of a selection of archaeological reports in: *Chinese Archaeological Abstracts*, R. C. Rudolph (ed.), Monumenta Archaeologica 6; *Chinese Archaeological Abstracts 2, Prehistoric to Western Zhou*, A. E. Dien, J. K. Riegel and N. T. Price (eds), Monumenta Archaeologica 9; *Chinese Archaeological Abstracts 3, Eastern Zhou to Han*, A. E. Dien, J. K. Riegel and N. T. Price (eds), Monumenta Archaeologica 10; Los Angeles, 1978 and 1985.

Pre-Neolithic and Neolithic to Shang cultures (up to *c.*1500 BC)

Banpo, Shaanxi province. Early Yangshao culture site (q.v.), *c.*4800–*c.*4300 BC. The remains of a village site are now preserved in a museum in the suburbs of Xi'an. A large residential area, with houses of different periods sunk below the level of the ground which presumably had wood and thatch roofs, was surrounded by a ditch, outside which was a cemetery and kilns. Some ceramics are cord-marked or impressed; others are painted in black or red with motifs that include fish designs. Comparable sites have been excavated in Shaanxi province at Jiangzhai in Lintong xian and at Baoji Beishouling (qq.v.) and Hua xian, Yuanjunmiao. The British Museum has some ceramics from Banpo.

Banshan, Gansu province, *c.*2800–2500 BC. Cemetery in Tao River valley, south of Lanzhou. The name Banshan refers to both a site and a culture. Banshan culture belongs to the western or Gansu Yangshao Neolithic culture (q.v.) and may be derived from the earlier Majiayao culture (q.v.). A later stage of the Banshan culture is found at the site at Machang (q.v.). The culture is known for its urns painted with spiral designs in black, purple and red.

Beiyinyangying, Jiangsu province, Nanjing. Neolithic cemetery site, probably dating to about 3000 BC. The finds include finely polished jade ornaments and disc-like axes. See also **Songze culture**

Cishan-Peiligang culture, Hebei and Henan provinces, *c.*6500–5000 BC. Name applied to Neolithic cultures earlier than the Yangshao (q.v.). They have been identified at Cishan in Wuan, Hebei province, and Peiligang in Xinzheng, Henan province. Typical finds include rounded bowls on three legs, and stone grinders.

Dadunzi, Jiangsu province, Pei xian. Neolithic site revealing three levels of Neolithic culture, dating from *c.*4500 BC to *c.*3000 BC. The three principal levels are named by reference to other east coast Neolithic sites: Qinglian'gang (q.v.), Liulin and Huating, the third being the latest chronologically.

Dahe, Henan province. Site of a Neolithic village, now a museum near Zhengzhou city. The earliest remains belong to the middle Yangshao culture (q.v.), *c.*3700–3050 BC, and are overlaid with Shang dynasty remains.

Finds include both painted ceramics of the late Yangshao culture and some ceramics of shapes – *ding* (tripods) and *dou* (cups and platters on high, pierced or decorated stems) – that may indicate contact with east coast Neolithic cultures. See also **Dawenkou culture**

Dapenkeng, Taiwan. Neolithic site near Taipei with coarse, cord-marked ceramics. It dates from the late fifth to the third millennium BC.

Dawenkou culture, Shandong province, *c.*4300–2400 BC. Site whose lower levels are contemporary with finds made at sites further south, such as Liulin and Huating (qq.v.). The culture is characterised by elaborate ceramic forms, the principal types being the *ding* (tripods), *gui* (lobed pouring vessels) and *dou*. Sacrificial pigs appear in the graves (rather than the dogs of earlier sites), and stepped pit burials (graves with *ercengtai*) foreshadow the later Shang period shaft tombs. The name Dawenkou is also used more generally to describe early east coast Neolithic cultures. It has replaced Longshan (q.v.) as the name commonly used for Neolithic cultures in this area.

Daxi culture, Sichuan province, Wushan county. Neolithic culture, *c.*5000–3000 BC, characterised by forms of painted ceramics that include tall tubular supports for cups or dishes, decorated with a twisted rope pattern.

Hemudu site, Zhejiang province, *c.*5000–3000 BC. Early Neolithic site in Yuyao xian. Hemudu is the earliest known stage of east coast Neolithic culture, showing evidence of rice cultivation and the domestication of pigs and dogs as well as possibly water buffalo. Low-fired, hand-made ceramics, bone tools and complex wooden buildings were produced there. Both ceramics and bone are decorated with incised figures of animals and birds. This site establishes the Changjiang basin, as well as that of the Yellow River, as a source of a highly developed early culture. The site has also revealed remains of the Majiabang and Songze (qq.v.) phases.

Hongshan culture, Liaoning province, *c.*3800–2700 BC. Late Neolithic culture found at Chifeng, Liaoning province. Hongshan culture sites are distributed in the three provinces of northeast China, Inner Mongolia

and Xinjiang. Both buildings and tombs have been excavated. The Hongshan culture is remarkable for fine jades, including particularly types such as the 'pig-dragon', bird and turtle pendants. In addition, small female 'fertility' figures in ceramic have been found.

Hougang, Henan province. Type site of Henan Longshan culture (q.v.) at Anyang, *c*.4400–2350 BC. It was the first site excavated to show evidence of Yangshao (q.v.), Henan Longshan and Shang cultural remains in a clear stratigraphic succession.

Huxizhuang, Shaanxi province, Weihe River valley. Neolithic site of Banpo and Miaodigou types of Yangshao culture (qq.v.), *c*.4000–3500 BC. (Some Western Zhou and Warring States remains survive also.) Archaeological finds include house foundations, pottery kilns, tombs, ceramic vessels, tools and ornaments, nearly all of Miaodigou type. See also **Zhaojialai**

Jiangzhai, Shaanxi province, Lintong xian, *c*.5000–4000 BC. Site on the Linhe River, about one kilometre north of Lintong city at the foot of Mount Li. The remains correspond to Yangshao culture at Banpo (q.v.), Shijia, Miaodigou (q.v.) and Xiwangcun in phases one to four, and the fifth corresponds to Kexingzhuang II culture (q.v.), second phase. Of the five archaeological periods, the first comprises houses, pens for animals and cemeteries, corresponding to the lower stratum of Banpo xian and the middle phases of Beishouling at Baoji (q.v.). The second, in which tombs were found together with items of everyday use and polished stone implements, corresponds to the Shijia site at Weinan. The third period has few remains other than some painted pots, and corresponds to Miaodigou culture at Sanmenxia (q.v.). The fourth shows much technological advancement in tools and house building, and corresponds to Banpo levels and the Xiwangcun village site in Ruicheng county. In the fifth the houses are plastered with lime and the ceramics more advanced still; this phase corresponds to the Kexingzhuang site in Chang'an county and the Kangjia site at Lintong (q.v.).

Kexingzhuang II, Shaanxi province. Neolithic culture, *c*.2500 BC, named after a village in Chang'an xian, belonging to the stage when eastern features of pottery making had been introduced to Henan and Shaanxi.

Liangzhu culture, Zhejiang province, Liangzhu, near Hangzhou, *c*.3300–2250 BC. Culture perpetuating some features of Majiabang culture in the same area (q.v.). Liangzhu culture is chiefly distributed in sites in Jiangsu, Zhejiang and Shanghai. Elaborate ceramic forms with pierced decoration were employed and there was a highly developed jade industry producing ceremonial axes and also *cong* and *bi*.

Longshan culture, Shandong province, *c*.3000–1700 BC. Later Neolithic culture and general name given to a Neolithic culture now more commonly known as Dawenkou (q.v.). The term has three applications. The first refers to Classic Longshan or Shandong Longshan of the late third and second millennium BC. Possibly the last stages of these were contemporary with the bronze-using Shang civilisation. It is sometimes called the Black

Pottery culture, as a very small proportion of its pottery is a thin, finely potted, polished black ware. The term Longshan culture is also loosely used in reference to the entire Neolithic tradition of the east coast of China, of which the Shandong Longshan is a late representative. Further, the term is sometimes applied generally to late Neolithic cultures in Henan, Shaanxi and Gansu provinces which incorporated features from east coast Neolithic ceramics, particularly lobed vessels and cups and platters on high stands, but which are otherwise quite distinct from the principal east coast tradition, e.g. Kexingzhuang II (q.v.).

Luoyang area, western Henan province. Later the capital of ten dynasties, with a long history, the earlier parts relating to Neolithic cultures, e.g. the Tonglezhai site of Yangshao, Miaodigou type (qq.v.), Xigangou of Yangshao and Longshan phases (q.v.) and the Donggangou site of Longshan and Erlitou (q.v.) cultures. Still later phases relate to its occupation as a secondary Western Zhou capital, as the Eastern Zhou city of Luoyang and as a new city built during the late Western Han period.

Machang culture, eastern Qinghai province, east of Ledu, latter half of third millennium BC. Machang culture is part of the late Yangshao (q.v.) Neolithic culture, belonging to its western or Gansu branch. It succeeds Banshan and precedes Qijia (qq.v.). Machang ceramics are similar to but less refined than Banshan types.

Majiabang culture, northern Zhejiang province, near Shanghai, *c*.5000–3500 BC. Type site of Majiabang culture (q.v.), which is descended from Hemudu culture (q.v.), of the fifth millennium BC, as seen in the Majiabang site itself and a later stage as represented by the Qingpu Songze (q.v.) middle stratum in a Shanghai site. Most archaeological sites of Majiabang culture are found on high ground or mounds. The villagers were farmers, hunters, collectors and fishermen. Majiabang ceramics are characteristically reddish or reddish grey and sometimes greyish black, particularly in early strata. Most ceramics have undecorated surfaces. Houses were rectangular, of timber, and had reed and clay walls. Cemeteries have been found at several sites. The terms Majiabang and Songze, referring to the succeeding phase of the Neolithic, are sometimes used generally to describe Neolithic cultures in southern Jiangsu and northern Zhejiang provinces. These phases were succeeded by the third millennium BC Liangzhu culture (q.v.).

Majiayao, Gansu province. Type site of Majiayao culture, latter part of fourth millennium BC. Remains of this culture are found as far west as Wuwei in Gansu and in eastern Qinghai province. It is generally considered to be the earliest form of the Western or Gansu Yangshao culture (q.v.). Its ceramics are painted in black only, with inventive line and scroll designs, and are among the finest produced by any of the Chinese Neolithic cultures.

Miaodigou, Henan province. Neolithic site in Shan xian on the Yellow River. The oldest, lowest level belongs to the Yangshao Neolithic culture (q.v.) of *c*.3900 BC, but the upper level is very different, containing unpainted

ceramics in shapes unlike those of the Yangshao tradition. This upper cultural layer was probably influenced by the eastern Neolithic cultures. The Yangshao period ceramics are decorated with painted arc-shaped motifs.

Peiligang See **Cishan-Peiligang**

Qijia culture, Gansu province, c.2250–1900 BC. Type site in Qijiaping in the Tao River valley. Qijia culture belongs to the Gansu Longshan culture (q.v.). It is characterised by very fine unpainted ceramics and simple tools. A cast bronze mirror has also been found, suggesting that some elements of early Chinese bronze casting may have originated in western China and may even have been linked to the bronze casting of Central Asia and the Iranian area.

Qinglian'gang, Jiangsu province, Huaian xian, beginning c.4500 BC. The name refers to a site in Jiangsu province. It has also been used more generally to refer to early stages of Neolithic sequences north of the Yangzi River in Jiangsu and Shandong provinces. More recently the name Dawenkou (q.v.) has been employed to refer to the same area.

Qujialing culture, Hubei province. Type site is Jingshan xian, a late Neolithic rice-growing culture of c.3100–c.2650 BC. It probably had connections with the east coast Neolithic cultures of the lower Yangzi covering the Changjiang-Hanshui plain. Large tripod vessels with flat legs, and basins on pierced ring supports, are typical finds.

Songze culture, Zhejiang province. Named after finds at Qingpu Songze in Shanghai. The Songze culture is a later stage of Majiabang culture (q.v.), the earlier represented by the type site Majiabang itself. The lower stratum at Songze belongs to a period of c.4000 BC and the middle stratum is that which is taken to represent the later stage of Majiabang culture. Archaeologists also classify the site of Beiyinyangying in Nanjing (q.v.) as belonging to the Songze culture.

Xiawanggang, Henan province, southwest Xichuan county, third millennium BC. Site bounded by the Danjiang River on the east, north and south, making it a vital link on the route from the Changjiang-Hanshui River valleys to the Huanghe River valley. Archaeologically it shows features from the Yangshao, Qujialing, Longshan, Erlitou (and Western Zhou) cultures (qq.v.). The first three phases are Yangshao culture, with a settled domestic lifestyle and cemeteries and kilns. The fourth phase was similar to Qujialing culture and also a transitional period from Qujialing to Longshan culture. Links with the Erlitou culture near Luoyang are indicated by the penetration of Erlitou ceramic types as far as the Danjiang River.

Yangshao culture, Henan province, c.5000–3000 BC. Site which has given its name to one of the two main Chinese Neolithic cultures. Also called the Painted Pottery culture. Yangshao economy was based on the cultivation of millet and the domestication of dogs and pigs and has two regional subgroups: an eastern branch, including the Banpo and Miaodigou sites (qq.v.), which would appear to be earlier than its western counterpart in Gansu province, including the Majiayao, Banshan and Machang sites (qq.v.).

Yinjiacheng, Shandong province, at Sishui, c.2800–2000 BC. Longshan culture site, revealing remains from both Longshan and Dawenkou cultures (qq.v.).

Zhaojialai, Shaanxi province, Wugong county. Site facing the Huxizhuang site (q.v.). The finds are in the main related to Kexingzhuang II culture (q.v.), a later Neolithic culture. Some finds are also of the Yangshao and Miaodigou cultures (qq.v.) (as well as of the Western Zhou period). Finds include house foundations, fenced areas, beaten earth ruins of a court-type building, ash pits, tombs, a pottery kiln, ceramic vessels and pieces of tools and ornaments, etc. This site is important for showing the distribution of Miaodigou and Kexingzhuang II cultures in the Weihe River valley and the relationship between them.

Zhoukoudian, Hebei province, 42 km southwest of Beijing. Site where human fossil remains of 'Peking' man were found, one of two fossil populations on which *homo erectus* was based.

Shang dynasty (c.1500–1050 BC)

Anyang, Henan province. Site of late Shang dynasty city (c.1300–1050 BC), sometimes called Yinxu, the Wastes of Yin, as Yin was an ancient name for the Shang dynasty. Excavations either side of the Huan River have revealed tombs, foundations of palaces and temples (but no city wall), bronzes, jade carvings, lacquer, many inlaid items, white carved ceramics and high-fired green-glazed wares as well as oracle bones. Sites with major tombs, including chariot burials, have been discovered at many of the surrounding villages, including Xiaotun (see **Fu Hao's tomb**), Wuguancun and Dasikongcun. Large cruciform tombs of the Shang period, all of which had been robbed at an early date, were found north of the Huan at Xibeigang near the village of Houjiazhuang.

Beijing, Hebei province. Chinese capital since AD 1421, but its origins go back 3000 years when it was part of the fief or state of Yan held by Shao Gong, brother of King Wu and uncle of the Zhou King Cheng. Shang and Zhou remains have been found in this area, especially at Fangshan Liulihe (q.v.), south of the city.

Dayangzhou, Jiangxi province, Xingan, late second millennium BC. Large excavated burial or tomb containing bronze vessels, weapons and tools in Shang style, but exhibiting many southern features, including small tiger figures perched on the handles of many *ding*, which also have flat feet in the shape of tigers.

Dongxiafeng, Shanxi province, Xiaxian county, mid second millennium BC. One of the largest sites of the pre-Shang and Shang dynasties period in this province. Remains include those from four phases of Erlitou culture (q.v.) and two phases of Erligang (Shang dynasty) culture.

Finds include house foundations, ash pits, small store-rooms, pottery kilns, rectangular ditches, the ruins of a city of which only parts of the walls have been revealed, forty-five tombs and many ceramic, stone and jade objects, as well as a few copper, bronze and shell objects.

Doujitai, Shaanxi province, Baoji. Site of pre-dynastic Zhou and Qin dynasty finds and tombs. The site is best known for the recognition of a culture ancestral to that of the Western Zhou, characterised by lobed vessels or *li* (food vessels made of three separate lobed sections).

Erlitou, Henan province, first half of second millennium BC. Type site of Erlitou phase of Chinese culture, now regarded as belonging to the pre-Shang period, discovered at Yanshi, near Luoyang. The remains of both palace-like buildings and tombs have been excavated. The site exhibits the earliest known phase of Bronze Age culture and has produced bronze ritual vessels in three shapes – *jue* (cup-shaped drinking vessel with spouted mouth and supported on three blade-like legs), *jia* (cup-shaped drinking vessel with circular mouth and supported on three legs) and *he* (pouring vessel with three lobes) – as well as very fine jades.

Fu Hao's tomb, Henan province, Anyang, *c.* 1250 BC. Fu Hao was a consort of the Shang dynasty king Wu Ding, and her tomb was particularly rich in finds, including many bronzes, inscribed with her name. It is the only intact royal tomb found in the Anyang area. (Fu Hao is mentioned in many oracle bone texts.)

Gaocheng, Hebei province, *c.* 1400–1300 BC. Site where many Shang remains have been found, the most significant being those near Taixicun. The site is possibly the remains of an intermediate Shang capital city dating to the period between the cities of Zhengzhou and Anyang (qq.v.). Stamped earth architectural remains (*hangtu*) and bronze ritual vessels have been excavated.

Liulige, Henan province, Hui xian. Shang site of the Erligang phase, *c.* 1500–1400 BC. Eastern Zhou burials have also been found here, revealing one of China's largest chariot burials, totalling nineteen chariots in one pit.

Ningxiang, Hunan province. Site where many bronze ritual vessels and large bells have been found over the years, dating from the late Shang period, in styles which indicate that the region was independent of the Shang state yet obviously had connections with it, gaining knowledge of metal working and of ritual vessel shapes.

Panlongcheng, Hubei province, Huangpi. Shang city of the Erligang phase, near Wuhan, *c.* 1500–1400 BC. The site has revealed ritual vessels, a city wall and palatial foundations. Tombs have also been discovered containing bronzes of Erligang type. The remains are culturally similar to Zhengzhou (q.v.) and other more northerly Shang cities of the Erligang period.

Sanxingdui, Sichuan province, Guanghan xian. Site with four strata, dating from second millennium BC to the early Western Zhou period. The site of a large walled city contains many large and small houses and workshops inside the wall. Outside the city wall, dating from the thirteenth or twelfth century BC, two sacrificial pits have been excavated containing bronze masks, human-like heads, one life-size bronze figure, small bronzes, jades, gold and the remains of charred elephant tusks. These discoveries showed that there was a bronze-working culture in the Ba-Shu area a thousand years earlier than previously thought.

Shilou, Shanxi province. Site yielding Shang bronze weapons and ritual vessels dating from the Anyang period (q.v.). These differ stylistically from metropolitan Shang bronzes, showing some influence from contact with peoples farther north and west.

Sufutun, Shandong province. Site where large cruciform and shaft tombs have been found containing sacrificial victims, dating to very late Shang or Early Zhou times.

Taixicun See **Gaocheng**

Wucheng, Jiangxi province. Shang site probably belonging to the late Erligang phase. Unique to this site were finds of stone moulds, some inscribed, for the casting of bronze weapons and tools, and incised potsherds.

Xindian, Gansu province, Lintao. Western Painted Pottery culture contemporary with the bronze-using cultures of central China.

Zhengzhou, Henan province. Site of an early Shang city. Remains of this stage of Shang rule are also described as belonging to the Erligang culture of *c.* 1500 BC. Erligang succeeds the Erlitou culture and precedes the Anyang cultural stage (qq.v.); Erligang remains are distributed widely, from Shaanxi in the northwest to Panlongcheng in Hubei (q.v.) and Hefei in Anhui province in the south. Zhengzhou displays massive walls, tombs, and workshops for ceramic, bone and bronze.

Western Zhou dynasty (1050–771 BC)

Baoji, extreme west of Shaanxi province. In addition to pre-dynastic Zhou remains found at Doujitai (q.v.), sites at Baoji exhibit the remains of the small kingdom, or petty state, of Yu. Twenty tombs were found at the villages of Zhifangtou, Zhuyuangou and Rujiazhuang. The Baoji area has been recognised for some time as the source of certain boldly designed ritual bronzes, mainly now in Western collections (e.g. a four-handled *gui* in the Freer Gallery, Washington DC). Baoji would appear, therefore, to have been one of the principal centres for the use of and possibly the manufacturing of some flamboyant bronzes made in early Zhou times. There was contact with Sichuan province by way of the tributaries of the Yangzi.

Chang'an (present-day Xi'an), Shaanxi province. One of the principal cities of the Zhou, Qin, Western Han and Tang dynasties. The Western Zhou capital cities of Feng and Hao (q.v.) were sited in the area southwest of present-day Xi'an. See **Fengxi**

Chengdu, Sichuan province. Western Zhou period and later sites where bronze ritual vessels have been found at nearby Peng xian (q.v.). In the Han period it was a centre of lacquer manufacture, which was evidently widely exported in China.

Fengxi, Shaanxi province. Site of the capital cities of the Western Zhou. Buildings, tombs, hoards and workshops have been excavated. Many tombs and chariot burials have been found near the village of Zhangjiapo (q.v.).

Fufeng See **Zhouyuan**

Linzi, Shandong province. Ancient capital of the Qi state, supposedly established about 850 BC, remaining the capital until Qi's annexation by Qin Shi Huangdi in 221 BC.

Liulihe, Hebei province, Fangshan xian. Western Zhou site containing burials and chariot pits belonging to the fief or state of Yan, ruled by the descendants of Shao Gong, brother of the Zhou King Wu and uncle of King Cheng.

Luoyang, Henan province. Site on which have been built many ancient cities, from the Western Zhou period of the late eleventh and early tenth century BC to the mid eighth century AD. Luoyang became the Eastern Zhou capital after the Quanrong nomads forced the Zhou out of the west, and later it became the capital for the Eastern Han from AD 25–220 and the Northern Wei from 494–535.

Peng xian, Sichuan province. Site yielding important Zhou finds including hoards of bronze ritual vessels dating to the early Western Zhou period. A number of *lei* have flamboyant decoration with animal heads bearing projecting horns, and flanges in the shapes of birds.

Qishan See **Zhouyuan**

Tunxi, Anhui province. Late Western Zhou and early

Eastern Zhou finds here show local traditions of geometric pottery decoration, combined with elements of metropolitan Zhou style. Bronzes from this area descend from those made at the metropolitan middle Western Zhou centres at Chang'an and Luoyang (qq.v.).

Xincun, Henan province. Site of eight large shaft tombs and seventy-four other burials. It is probably the burial ground of the Wei state nobles of the Western Zhou period. The British Museum's bronze Kang Hou *gui* comes from this area.

Zhangjiapo, Shaanxi province, southwest of Xi'an. Western Zhou site near the Feng River, whose remains have been linked by archaeologists with the Zhou capitals Feng and Hao (q.v.). See **Fengxi**

Zhouyuan, Shaanxi province, west of Xi'an. Name given to western half of Fufeng xian, together with the east of Qishan xian. This area was part of the district where the Zhou people were based before their overthrow of the Shang. It was also a major Zhou centre after the foundation of the Zhou dynasty. It is a large city site containing remains of a ceremonial building found at Fufeng Shaochencun. Its tiled roofs are the earliest known in China. Oracle bones, of pre-dynastic Zhou date, have also been found in the foundations of buildings in Qishan Fengchucun. Large hoards of bronze vessels have been recovered, among them the most important Western Zhou find of bronzes yet made from Fufeng Zhuangbai (q.v.). Many bronzes were inscribed, the longest inscription, on the Shi Qiang *pan*, having 284 characters. These bronzes were probably employed in family temples here and were buried when the Zhou had to flee in 771 BC. Workshops for ceramics and bone have been discovered.

Zhuangbai, Shaanxi province, Fufeng. Western Zhou site where a hoard of 103 bronzes, many with inscriptions dedicating them to members of one family, were found.

Eastern Zhou dynasty (770–221 BC)

Guweicun, Henan province. Large Eastern Zhou cemetery containing three large shaft tombs where many cast iron tools were found.

Handan, Hebei province, about 4 km southwest of present-day Handan. Site of the Eastern Zhou capital of Zhao state (386–228 BC), comprising a walled city of about three square kilometres, and, 5 km to the north, a cemetery containing six chariot burials and twelve other tombs.

Houma, Shanxi province. City site of Jin state (584–453 BC). Remains of a large foundry complex, where many fragments of clay moulds and pattern blocks have been found. The moulds reveal a complex manufacturing process, involving specialised work and subdivision of labour.

Huang tombs, southern Henan province, Guangshan, near Xinyang. Site of burial of a man and his wife in lacquered coffins with a complete set of ritual vessels and

a large group of jades, the latter containing examples of plaques ancestral to later jade burial suits. Because it is known that this state was extinguished in 648 BC by Chu, the contents of the tombs probably predate this time.

Jiangling, Hubei province, north bank of the Yangzi River. Although some finds of the Western Zhou have been made, many more remains of the Eastern Zhou, associated with the state of Chu, and Han dynasty have been discovered. Ji'nan, a walled city just outside Jiangling, is believed to have been the ancient Chu capital of Ying from 689–278 BC. Many hundreds of Chu burials have been found in the area, dating from the eighth to the second century BC and including two fourth-century BC tombs at Wangshan, containing high-quality early painted lacquers. Han dynasty tomb finds include lacquers and bamboo slips.

Jincun, Henan province, near Luoyang. Site of many rich tombs of the fifth to second century BC, whose contents included inlaid bronze ritual vessels and carved jades. The

cemetery is thought to be that of the Zhou ruling house, after their move to the east in 770 BC. The tombs were mostly robbed early this century.

Liyu, Shanxi province. Name of a village near Hunyuan. Because of the bronzes found here dating from the sixth and fifth centuries BC, Liyu is the name given to the bronze decorative style featuring ribbon-like bodies and dragon interlace, textured with fine meander and volute patterns, cast at the Houma foundry (q.v.).

Mashan, Hubei province, Jiangling, *c.* fourth century BC. Small Warring States tomb site containing a wooden chamber and a coffin. Bamboo trunks were discovered containing bronzes and lacquered objects. Tomb no. 1 contained twenty-one pieces of Chu embroidery, plain silk fabrics, brocade, gauze, ribbons and ropes. The silk fabrics belong to the same tradition as those from the Han dynasty Mawangdui tombs (q.v.) and are a very important find.

Pingshan, Hebei province. Site of two fourth-century BC royal tombs and other burials of the Zhongshan kingdom, a minor state founded by the Di people in the late sixth century BC. The inhabitants became sinicised and the kingdom was destroyed in 296 BC. The two royal tombs contained many unusual gold and bronze objects and two bronze ritual vessels with the longest inscriptions yet known from Eastern Zhou times.

Sanmenxia, Henan province. A large Eastern Zhou cemetery has been found at Shangcunling, a village nearby, where the Guo royal family was buried (Guo was a state extinguished in 655 BC). The site contained well-preserved chariot burials and some bronze ritual vessels. Further tombs have been found in which high-quality jades have been recovered, but the bronze vessels were rudimentary, often only replicas.

Shizhaishan, Yunnan province. Burial site of kings and nobles of the state of Dian, an independent kingdom on the Chinese frontier until its submission in 109 BC. The tombs date from the late Eastern Zhou period, and many of the excavated objects were Chinese imports while others were decorated more in Chu state style. There are several other sites in this area.

Shou xian, Anhui province, district south of the Huai River. Area much fought over during the Warring States period and ruled by Wu, Yue and Chu. Many bronzes and mirrors were found here. A fifth-century BC tomb is the most important find, containing 486 bronze objects. Some were dedicated to the Marquis of Cai, a state whose rulers were exiled at Shou xian until 447 BC when the last ruler was murdered.

Sui xian, tomb of the Marquis Yi of Zeng, Hubei province. Warring States period site, in Leigudun. It is a rich burial, dated to *c.*433 BC as it contains an inscribed, dated bell dedicated by a king of Chu. The contents, considered to be representative of the finest of Chu culture (though no comparable Chu burials have been found)

include lacquers, jades, gold, leather armour suits, inscribed bamboo slips, bronzes including a *pan-zun* with decoration made by lost-wax casting, and the largest matched set of bells yet found. The tomb has four compartments. See also Tombs appendix

Wujin Yancheng, Jiangsu province. Walled city site dating to the late sixth and early fifth century BC. It was possibly the Eastern Zhou capital of Yan. Bronze ritual vessels found belong to a local and provincial rather than a metropolitan style.

Xianyang, Shaanxi province. Palace site dating to the mid fourth century BC on the site later occupied by the last capital of the Qin state. Palace site no. 1 was 60 metres long east-west, 45 metres wide north-south and about 6 metres high, the buildings originally constructed on large and high *hangtu* platforms. Bays all round the four sides were paved with bricks. The roof had drainage leading into underground water mains, and the walls and floors of the rooms were plastered with layers of wattle and daub and then painted in red or white. The polychrome murals are particularly noteworthy.

Xiasi, Henan province, Xichuan xian. Eastern Zhou cemetery site of the Chu type, containing five chariot burials, nine large tombs and sixteen other tombs. In all, more than two hundred bronze ritual vessels and bells dating from the sixth century BC have been excavated. The Xiasi bronzes include some with decoration made by the lost-wax method, the earliest examples of this casting type found in China. It has been suggested that two of the tombs are those of Yuan Zifeng, Lingyin of Chu (d. 548 BC), and his wife.

Xinyang, Henan province, Xinyang county, about 20 km north of Xinyang town. Site of Chu state tombs dating to the late fourth or beginning of the third century BC, including a set of thirteen bronze bells and lacquers. Tomb 2 is of a later date than tomb 1. The tombs were partially robbed long before their discovery this century. The bodies were in wooden coffins. Side compartments of the tombs contained ritual vessels, musical instruments, bamboo strips, harness and chariot fittings, food vessels, tomb figures and guardian animals, furniture and bamboo strips. Tomb 1 contained 900 objects and tomb 2 about 400. Tomb 1 had thirteen tuned bronze bells, the largest of which also carried an inscription. The wooden case for the Chinese musical instrument, *se,* was decorated with a remarkable painting, a colourful scene painted with gold and silver dust. The high drum stand of tomb 2 and the grotesque tomb guardian animal of tomb 1 are unique.

Xinzheng county, Henan province. A tomb was excavated at Lijialou early this century which contained eighty-eight ritual bronze vessels and musical instruments of the sixth century BC.

Yanxiadu, Hebei province, near Yi xian. Site of an ancient, lower capital of the state of Yan, established from the seventh century BC.

Qin state (c.700–221 BC) and Qin dynasty (221–207 BC)

Fengxiang, Shaanxi province, Nanzhihui. Tombs of the dukes of Qin of quite enormous dimensions have been found here. Tomb no. 1 has been excavated; it is 25 metres deep and has an area of more than 5000 square metres. The tomb was robbed in antiquity.

The Great Wall Begun by various states as early as the fifth century BC to keep out the northern peoples. Sections were joined up from the Qin dynasty onwards.

Lintong, Shaanxi province. Site of Qin Shi Huangdi's tomb and the pits containing the pottery warriors.

Shibeidi, Liaoning province, Wanjiaxiang. Around the villages of Shibeidi, Heishantou and Shangmiaowan were discovered architectural sites including the remains of large buildings. At Shibeidi, the largest site, there are roof tiles similar to those found at Qin Shi Huangdi's mausoleum, and the remains are possibly those of a palace.

Xianyang, Shaanxi province. Ancient capital of the Qin state and site of the Qin capital from c.350 BC until it was burned down by Xiang Yu, a Chu rebel leader, in 206 BC. The remains of a palace site, probably the principal one of the city, were excavated in the 1970s on raised ground about 15 km east of modern Xianyang. The remains suggest the buildings were several storeys tall with continuous walkways surrounding each level. Dating to the mid fourth century BC, the palace remains have revealed many pottery fragments, some with characters stamped on them, and scraps of silk and mural paintings. Earlier palace sites have been investigated at Yong, south of Fengxiang (q.v.), and Yueyang, south of Fuping, both in Shaanxi.

Yunmeng, Hubei province. Tombs excavated at Yunmeng Shuihudi belong to the Qin occupation of c.278–206 BC. Nearly two hundred fine lacquers have been found in the tombs and are inscribed with the name Xianyang, the Qin capital (q.v.), and presumably the place of manufacture. Tomb 11 belonged to a Qin official of c.217 BC and contained many manuscripts written on bamboo slips, including a history of Qin's conquests.

Han dynasty (206 BC–AD 220)

Horinger, Inner Mongolia. Eastern Han tomb belonging to a military colonel of the Wuhuan district. The murals in his tomb illustrate his official career, showing scenes from the various places where he had worked and giving a good idea of how he and his contemporaries lived at this time.

Juyan, Gansu province. Site of a Han beacon tower in the Ejin River basin where 30,000 wooden strips of the Han dynasty were found. These document colony and garrison affairs dating to between late Western Han and early Eastern Han times.

Leitai, Gansu province, Wuwei xian. Second-century AD tomb of a Han official containing, besides the well-known 'flying bronze horse', miniature bronze cavalry, chariots and other bronzes.

Lelang, Korea. Han dynasty commandery established after their Korean conquest in 108 BC. Tombs found here reveal Han lacquers, bronze mirrors and gold filigree work. Some lacquers were dated ranging from c.85 BC to AD 102, and were made in Sichuan province.

Lop Nur, Xinjiang province. Site where seventy-one wooden strips of manuscripts were found dealing with garrison affairs.

Luoyang, Henan province. Area where many tombs have been excavated. In the northwestern corner of the old city of Luoyang was a Western Han dynasty tomb revealing over four hundred pieces of pottery, bronze and iron. The hollow bricks were impressed with geometrical patterns and the polychrome wall paintings are some of the earliest tomb wall paintings found in China. Subject matter includes the sun, moon and stars, and mythical and historical stories. The predominant colours in the painting are purple, red, ochre, green and blue.

Mahao cave tomb, Sichuan province, Leshan. Eastern Han tomb cut into the red sandstone cliff, with the tomb entrance cut out of rock anticipating the forms of the fifth-century Northern Wei Buddhist caves at Yungang in north China. Pictorial reliefs decorate the front chamber but are quite badly damaged. However, there are two important reliefs of the Buddha and a scene portraying the attempted assassination of the king of Qin.

Mancheng, Hebei province. Site of the tombs of Prince Liu Sheng and Princess Dou Wan, his wife. Liu Sheng was a member of the Han royal family and was enfeoffed in the principality of Zhongshan in 154 BC, dying in 113 BC. They are richly furnished tombs, with the couple in jade burial suits (Tombs appendix).

Mangshanzhen, Henan province, Yongcheng xian. Site of large tomb of a Western Han aristocrat, containing many jades and bronzes and also lacquerware, bamboo, textiles and a well-preserved jade burial suit.

Maoling mausoleum, Shaanxi province, Xingping xian. Site of the tomb of Emperor Wudi (d. 87 BC). Western Han tombs had large rectangular mounds of rammed earth built over them and the mound was then surrounded by a large rectangular enclosure with gates on each of the four sides. Emperor Wudi's mound is the largest example of such Western Han mausolea, measuring 480 metres east-west and 414 metres north-south, with walls about 6 metres thick. No archaeological excavations have yet taken place at any of the Han imperial mausolea. However, in 1981 several attendant tomb pits were found east of Wudi's tomb in which about 230 articles were discovered, including bronzes, some iron, lacquer and lead ware. Near the imperial mausolea were satellite graves, where imperial relatives and meritorious officials were buried. See also **Xingping xian**

Mawangdui, Hunan province, Changsha. Site of three excavated tombs of the Western Han dynasty attributed to Li Cang, a prime minister of Changsha (d. 186 BC), his wife and son (who died in 168 BC or shortly after). The Lady Dai's tomb was undisturbed and well preserved, yielding important finds – particularly lacquered items, a silk banner (with a painting of heaven, the world and the underworld on it), and clothing, as well as a complete inventory of the grave furniture inscribed on bamboo slips. The tombs show the influence of the traditions and culture of the state of Chu. The son's tomb contained important manuscripts of medical and astronomical literature.

Mi xian, Henan province, west of Dahuting village. Site of two large Eastern Han period (AD 25–220) tombs. The larger, no. 1, has fine stone-engraved decoration and the smaller, no. 2, contains painted frescoes of processions of horses, carriages and banqueting scenes, portraying a very luxurious lifestyle.

Nan Yue tombs, Guangdong province, Canton. Nan Yue was an independent state (Southern Yue) in southern China from 203–111 BC, contemporary with the Western Han. Near the site of the Nan Yue royal palace in Canton, which was then called Panyu, the capital of the Nan Yue kingdom, was found a large group of tombs including that of the second king of Nan Yue, Wendi (r. 137–122 BC), and some belonging to minor officials. Finds in the undisturbed royal tomb include jades, both vessels and ritual objects, as well as a jade shroud, bronzes and musical instruments, some of which show evidence of a regional style and others of mainstream Han style, either imported or made locally in Han style.

Pinglu xian, Shanxi province, Caoyuan cun. Eastern Han brick-vaulted tomb with murals depicting the four directional animals, landscapes and farming scenes.

Wangdu, Hebei province, Wangdu xian. Site of brick chamber tombs, which, by the Eastern Han period (AD 25–220), were the prevailing form of burial throughout the country. Those of high nobles, such as that of Prince Jing of Pengcheng in Xuzhou, Jiangsu, and Prince Jian of Zhongshan in Ding xian, Hebei, are complex constructions mirroring the homes in which they would have lived while alive. That of the Marquis of Fuyang in Wangdu was decorated with frescoes depicting various officials and attendants in order to make the tomb resemble the Marquis's official quarters.

Wu Liang Ci, Shandong province, Jiaxiang xian. Generic name given to group of shrines belonging to the Wu family. Wu Liang himself died in AD 151. The family were wealthy merchants. The shrines are noted for the figural decoration engraved on the stone slabs with scenes illustrating Confucian virtues.

Xingping xian, Shanxi province. Western Han dynasty tomb of General Huo Qubing, particularly known for the stone horse in front of his tomb mound trampling a Xiongnu barbarian and for other stone sculptures in the shapes of animals which were placed upon his tomb mound.

Xuzhou, Jiangsu province. In the eastern suburbs of Xuzhou at Shizishan several pits have been excavated, revealing an army of thousands of terracotta soldiers. Three pits had foot soldiers in them and a fourth contained what are assumed to be the guards. The standing figures are approximately 42–7 cm high, much smaller than the life-size figures found in the pits accompanying the burial of Qin Shi Huangdi. Two further pits contained horses, which were much damaged. The burial is dated to the early years of the middle Western Han, either to the reign of Jingdi (156–141 BC) or Wudi (140–87 BC). The terracotta figures have characteristics in common with those of Qin Shi Huangdi though the style of clothing shown is more characteristic of the Han, as is the sculpting of the figures which tends to be more abstract than the animated style of the Qin artisans.

Yangjiawan, Shaanxi province, Xianyang. Two Han tomb mounds at Yangjiawan are satellite graves of the Changling, mausoleum of Emperor Gaozu, the first Han emperor. The tombs are dated, on the basis of finds of coins, earthenware, jades and other items, to the middle of the second century BC. It has been postulated that they belong to Zhou Bo and his son, Zhou Yafu, who were ministers in the early Western Han period. The finds include 583 mounted cavalrymen and 1965 standing figures arranged in formation. Both military and civil figures, such as dancers, musicians and other attendants, were included. The quantity and variety of figure types have been very useful for gauging information about daily civil and military life of this period. Another tomb at Xianyang, Han tomb 11 at Langjiagou, also included figures of warriors.

Yangling, Shaanxi province, Zhangjiawan. Imperial tomb and burial ground of Emperor Jingdi of the Western Han (156–141 BC). It is one of the four known sites where terracotta army figures have been excavated. Only the satellite tomb, and not the imperial tomb, has been excavated so far, and it has twenty-four vaults. These vaults contain thousands of miniature terracotta figures, averaging 62 cm in height, many with movable wooden arms; the figures were originally probably clothed and represented the emperor's needs after death. Besides soldiers, there were farmers, servants, children and farm animals. Miniature pots and pans have been discovered and the soldiers were equipped with miniature weapons. As with the burial at Xuzhou (q.v.), the figures are much smaller than the life-size soldiers of Qin Shi Huangdi.

Yangzishan tomb no. 1, Sichuan province, north of Chengdu. The largest and most impressive of a group of about two hundred tombs. It is a vaulted brick tomb, its walls decorated with various pictorial scenes on the tomb tiles and stones. The procession scenes are very elaborate and the decoration generally interesting as it portrays the lavish lifestyle lived by some officials in Sichuan during the Han dynasty.

Yinan, Shandong province. Subterranean tomb dating to the last quarter of the first century AD. From the early Eastern Han period stone chamber graves gradually became popular. The burial chamber of the Yinan tomb was built with neatly dressed stones on which were

engraved designs and pictorial scenes portraying the owner's house in his lifetime (identical to the layout of the tomb). Other scenes show that his career was probably that of a military officer.

Yinqueshan, Shandong province, Linyi. Site of ten Western Han tombs containing important silks and lacquer. One tomb at Linyi Yinqueshan had about 5000 bamboo slips of Eastern Zhou manuscripts.

Alphabetical index of sites

MAP V Archaeological sites of the pre-Neolithic to Han periods (up to AD 220).

Buddhist sites and reliquary deposits

The first section of this appendix concentrates on Buddhist temple sites hollowed out of rock faces, following a practice developed in the Indian subcontinent. Those still extant in China date from the fourth century AD, from which time Buddhism generally flourished and spread widely. However, Buddhism suffered great persecutions in 446, 560–78 and 842–5, when great numbers of Buddhist temples, statuary and paintings were destroyed. Often located in remote areas, the cave temples suffered less than did the large numbers of monasteries in the capital cities and those in the provinces. A number of other Buddhist monuments are also described in this section. For ease of reference, the sites in the first section have been divided into the following geographical areas: those in the western regions of the Silk Route; those on the Silk Route in Gansu province; those in metropolitan China; and those in other provinces. An alphabetical index of sites appears on p. 323, and there is a map on p. 324.

The second section (p. 325) contains notes on a few surviving Buddhist temple buildings, pagodas and reliquary deposits. Major wooden structures are listed in the separate appendix of traditional architecture (p. 327).

Buddhist cave temples and sites

SILK ROUTE (WESTERN REGIONS)

Bamiyan cave temples, Afghanistan. Though not in China, Bamiyan was a stopping place on the Silk Route and an important Buddhist centre, which was flourishing in 632 when the famous Chinese monk Xuanzang stayed there on his sixteen-year journey to India (629–45) and reported seeing at least a rock-hewn Buddha in this region. Particularly noteworthy are the colossal figures of the Buddha (38 metres and 55 metres high) which dominate the cliff face. Although in the past these were assumed to have been the model for Chinese colossal figures, a recent study sees Bamiyan as a relatively late site, with some of the work done in the eighth and ninth centuries before its decline in the tenth.

Bezeklik, Xinjiang province, 8 km northwest of Gaochang, 2.5 km south of Murtuq village, near Turfan, on the northern Silk Route. There are fifty-seven surviving cave temples cut out of the rock, most of them originally decorated with wall paintings. However, very few paintings now remain *in situ*.

Gaochang, Xinjiang province, southeast of Turfan. Gaochang (Kharakhoja) was a city state of Chinese ancestry, founded by the rulers of the Northern Liang after their defeat by the Northern Wei in 439. Around 800 the area was ceded by the Chinese to the Uygurs, who were themselves succeeded by the Xi Xia people in the eleventh century. Both Yarkhoto, also near Turfan, and Gaochang have many ruins of buildings, including Buddhist temples. The ancient cemetery of Astāna lies nearby, and the cave temples of Bezeklik (q.v.) are a few kilometres away. Objects found at Gaochang, in contrast to many found elsewhere in the Central Asian region, are markedly Chinese in style.

Karashahr, Xinjiang province, on the northern branch of the Silk Route. Like Kucha and Khotan (qq.v.), Karashahr was the centre of a local kingdom with its own distinctive culture and clear links with the West. The stylistic affiliation of the images found at Karashahr, Mirān (q.v.) and Khotan to the art of Gandhara is evident. The Tibetans captured Kucha, Khotan, Kashgar and Karashahr in 670 and although Khotan was retaken in 694, by 790 the Tang had lost control of all of the territory west of Gansu province. However, early in the history of the Silk Route the northern route from Dunhuang, via Turfan, Karashahr, Kucha and Aksu, was more often used than the southern. The two routes met at Kashgar. Near Karashahr are the **Ming-oi** (one thousand dwellings, also known as Shorchuk and Chikchin), which were free-standing buildings, with numerous stucco images forming crowded compositions on the walls of the cella and passages. The British Museum has an extensive collection from this area, including two panels of wall painting.

Khotan, Xinjiang province. Formerly a major Buddhist centre and the ancient capital of the kingdom of Khotan. The city's importance as a Buddhist centre is perhaps best represented by sites some distance from it such as Rawak (q.v.) with its great stupa and *vihāra* court, Akterek, Siyelik, Khādalik, Yotkan (close to the modern town) and the Buddhist sanctuaries at Dandān-oilik and Farhādbēg-yailaki. Yotkan was identified as the ancient capital of Khotan by Aurel Stein and was occupied from early in the first century AD until the coming of Islam in the eighth century. Gandhara-type draped figures of the second to third century evidently provided the models for figures at Khotan and perhaps thence for the early figures at Yungang in Shanxi province (q.v.). The wooden plaques from Dandān-oilik are amongst the finest pieces in the British Museum's collection from this area, and the Museum also has a large number of small terracottas from Yotkan.

Kizil, Xinjiang province, near Kucha. The Kizil caves are among the earliest and finest of all Buddhist cave temples, reflecting the great prosperity of the kingdom of Kucha (q.v.) and the patronage of Buddhism by its ruling class. The caves are barrel vaulted with preaching scenes and musicians in balconies on the side walls, and *jātaka* illustrations in formalised landscapes on the ceilings. The earliest date from the third century, reaching a peak in the fourth and fifth centuries when they pro-

vided the style and iconography for some of the earliest caves at Dunhuang (q.v.). The architectural plan of the caves, with a main chamber and pillar with side passages, allowing circumambulation around the main image, is reflected in the free-standing shrines at the Ming-oi near Karashahr (q.v.).

Kucha, Xinjiang province. Lying on the northern branch of the Silk Route almost due north of Khotan (q.v.), Kucha was the centre of a local kingdom, with its own distinctive culture. It was one of four major Buddhist sites in the area (the others were Aksu, Karashahr (q.v.) and Turfan), lying between Aksu and Karashahr in a very fertile region. By the fourth century Kucha was an important Buddhist centre, with monks who actively promoted the spread of Buddhism to China and translated the sutras into Chinese. Graeco-Indian culture from Hadda, Fondukistan, Taxila and Gilgit showed its influence here. Chinese cultural influence came via Karashahr. There are wall paintings at several sites near Kucha, such as at Kizil (q.v.), Kumtura and Simsin, which are important for the understanding of the development of Buddhist art in Central Asia. With the exception of those at Dunhuang, these paintings are the most extensive and complete in Central Asia.

Mirān, Xinjiang province. Sited on the southern Silk Route, west of Lop Nur on the way to Khotan (q.v.), best known for its wall painting series clearly influenced by Gandharan art. Xuan Zang, the seventh-century Chinese monk who travelled to India to collect Buddhist scriptures, referred to huge images in this area, most of which have now disappeared. However, the British Museum's colossal head of Buddha (50.4 cm high) from Mirān, is an example [MAS 627 (M.II.007)].

Rawak, Xinjiang province, just outside Khotan (q.v.). Protected by desert sands, the great stupa and *vihāra* court here were thus preserved. Many rows of clay statues, both colossal and smaller images, were investigated early this century by Aurel Stein, but have never been fully revealed.

SILK ROUTE (GANSU PROVINCE)
Binglingsi caves, Gansu province, about 120 km north of Lanzhou, Linxia, close to the Yellow River, dating from the Northern Liang (502–57) to the Ming dynasty. Unlike Yungang and Longmen (qq.v.), the earliest and largest cave is a natural one, with large clay images of the standing Buddha in a style closely following Gupta sculpture. The finest sculptures at this site date from the Northern Zhou (557–81).

Dunhuang cave temples, northwestern corner of Gansu province, *c.*366–*c.*1300. Also called Mogao Caves, or Caves of the Thousand Buddhas (Qianfodong). Dunhuang became an important Buddhist centre because of its position near the junction of the northern and southern tracks of the Silk Route. The caves display both stucco and painted images and scenes. The earliest wall paintings belong to the Northern Wei period, probably to the mid fifth century though a few may date even earlier to the Northern Liang (502–57), and are closely related stylistically to those of the shrines at Kizil near Kucha (qq.v.). They show the eastward influence of Central Asian

Buddhist traditions. Unlike Longmen and Yungang (qq.v.), there are no imperially commissioned cave temples, but some caves, such as no. 220, dated to AD 642 in the early Tang, show a sophistication which reflects close links with Buddhist art at the Tang capital, Chang'an. The caves were excavated from the gravel conglomerate of the cliff and the sculpture was modelled in clay on wooden or brushwood armatures. Originally there may have been up to a thousand caves; now 492 caves survive. One cave, no. 17, was walled up early in the eleventh century and only rediscovered this century. Inside were hundreds of silk paintings, thousands of manuscripts on paper, including Buddhist sutras, and legal documents. Textiles, paintings and prints from this deposit are now in the collection of the British Museum; many of the documents are in the British Library. Collections of antiquities from Dunhuang are also held in the Museum of Central Asian Antiquities in New Delhi; in the Musée Guimet and the Bibliothèque Nationale, Paris; the Tokyo National Museum, Japan; the National Museum of Korea; Beijing National Library and Dunhuang Research Academy, and at Lüshun, China; and in the State Hermitage in St Petersburg.

Maijishan caves, southern Gansu province, about 50 km southwest of Tianshui, approximately 300 km west of Xi'an. These caves date mainly from the Northern Wei to Tang dynasty with some later (Qing) additions. The isolation of the site, on an inaccessible cliff face, has ensured the survival of both clay and stone images. There are approximately 194 caves, some painted and the majority adorned with clay sculpture. The artistic importance of Maijishan lies partly in the variety of the works and in the influences displayed by them. The geographical position of the caves, just off the main route between China and Central Asia, has resulted in a particular synthesis of artistic forms of which there are no comparable examples surviving elsewhere in China. A small number of magnificent stone sculptures and stelae of the sixth century were hauled up the cliff face; many of the cave chambers were accessible only by wooden galleries cantilevered out from the cliff face, which rises sheer for over 50 metres.

Qingyang, North Grotto temple, Gansu province, 25 km southwest of Sifengzhen township in Qingyang xian. Other temple grottoes in the area include those at **Shidaopo, Huabaoya, Shiyadongtai** and **Loudicun.** There are 282 grottoes still in existence, containing 1252 large and small statues; the murals have been destroyed. Of the 282 grottoes, 165 were cut in the Northern Wei period, and the remainder in the Western Wei, Northern Zhou, Sui, Tang and Song dynasties.

Wenshushan, Gansu province, about 15 km south of Jiuquan. Wenshushan was the chief religious centre of this area from the beginning of the Wei dynasty (AD 386) to modern times. The complex comprises ten extant caves, of which two are quite well preserved. The sculptures are of clay. The **Qianfodong** (Thousand Buddhas cave), the oldest cave in Wenshushan, has a pagoda-shaped carved central pillar, wall and ceiling murals, and sculptures which exhibit early Buddhist features of the Northern Wei period (386–535). The **Wanfodong** (Ten

Thousand Buddhas cave) contains sculpture with early features similar to that in the Qianfodong, but the murals date to the Yuan and Ming periods.

Wushan, Gansu province, Northern Zhou period (557–81). This site has a great cliff-cut engraving of a Northern Zhou Buddha triad with unusual accompanying lions, deer and elephants carved in sharper relief around a smaller triad in the lotus throne beneath. The engraving is 60 metres in height and width and dated by inscription to about 559.

METROPOLITAN CHINA
Hebei province
Xiangtangshan caves, Hebei province, Ci xian, and Henan province, Fu'an xian. There are seven shrines on the south Xiangtang mountain, in Ci xian, Hebei province, and three on the north of the mountain, in Fu'an xian, Henan province, dating from Northern Qi times (550–77). The caves and their sculptures represent some of the best work of the Northern Qi dynasty. Some Central Asian influence is visible in the decoration of the doorways.

Yizhou caves, Hebei province, south of Beijing, mainly Liao dynasty (907–1125), but ranging from tenth to thirteenth century. Several famous ceramic figures from a possible set of eight luohan are thought to have come from this site. Slightly over life size, they are masterpieces of ceramic sculpture with a *sancai* glaze. There is an example in the British Museum [OA 1913.11–21.1].

Yunjusi, Hebei province, Fangshan. The Yunju monastery is located at the foot of the Baidai mountain. Several kilometres from the monastery, caves were excavated near the summit of the mountain. Early in the seventh century a monk called Jingwan decided to have Buddhist sutras carved on stone to ensure their survival. This project was continued and expanded by his successors, so that the texts were still being carved in the twelfth century. The stone carvings of the sutras were put into caves and pits for further protection and the 14,620 stone slabs, still extant, many carved on both sides, contain a major part of the Buddhist canon. Some of the texts are the oldest dated versions now available to us. The major periods of carving were the Tang, Liao and Jin.

Henan province
Gong xian caves, Henan province, mostly dating to the late Northern Wei period (386–535). The sculpture at Gong xian is close in style to that of the contemporary caves at Longmen (q.v.). There are five caves, three large cliffside images, thousand-Buddha niches and 238 cliffside figure niches. Caves 1, 3 and 4 were carved in the Northern Wei period and cave 2 was never finished. Cave 5 is a little later. There were few additions other than votive stelae. Gong xian is one of the sites in China in which the original Northern Wei wall carvings of imperial processions are preserved *in situ*.

Longmen caves, Henan province, Longmenshan, near Luoyang, 494–c.900. Work began here after the transfer of the Chinese capital to Luoyang in 494 under the imperial patronage of the Northern Wei emperors. The main periods of activity were in the early sixth and late

seventh century. There are twelve main caves dating from 494 to 684 and later, which contain late Northern Wei sculpture in the local hard, grey limestone. Impressive carvings from the Binyang cave, which was begun in 505 by Emperor Xuan Wudi, include the statue of Amitābha Buddha with his favourite disciples Ānanda and Kāśyapa, Bodhisattvas and processions of imperial donors, the latter now in the Nelson-Atkins Museum, Kansas City, and the Metropolitan Museum of Art, New York. The Guyang cave has twenty dedicatory inscriptions highly regarded for their calligraphy. The colossal images of Buddha Vairocana and attendants on the terrace of the Fengxian temple dominating the site were commissioned by the Tang Emperor Gaozong and sculpted in 672–3.

Shaolin temple, Henan province, Dengfeng county. The monastery where Bodhidharma meditated for nine years facing a rock. Though now associated with Chinese martial arts, little remains of much interest save for the Forest of Stupas, monuments to monks dating from the Tang to the Qing dynasty.

Songyuesi, Henan province, Songshan. This twelve-sided brick pagoda built in 520, in the Northern Wei period, is the oldest surviving Chinese pagoda, with many Indian features in its decoration. Nothing remains of the monastery to which it belonged.

Xiudingsi pagoda, Henan province, Mount Qingliang, 30 km west of Anyang. This one-storey pagoda was originally part of a Chan (Zen) monastic complex. The monastery was founded between 494 and 550 and probably rebuilt in the Tang dynasty (eighth century). The pagoda is completely covered with red moulded and decorated bricks, mainly of diamond shape, with vigorous figures and designs. The British Museum has a brick with a demonic mask from this pagoda [OA 1983.7–25.1].

Shandong province
Feicheng, Shandong province. About 33 km to the north of Feicheng is **Lianhuadong** (Lotus Flower cave), which contains a few sculptures of Buddhas and Bodhisattvas dating to Northern Qi and Northern Zhou times (mid to late sixth century). The cave is so named because of the decoration of the ceiling, which incorporates one large and several smaller lotus flowers.

Licheng xian caves, Shandong province, mid sixth century. There are a number of Buddhist sites and temples carved into the Shandong hills in this area, including the **Lianhuadong** (Lotus cave) with some sculpture dated to 562 and the **Qianfoyan** (Thousand Buddhas cliff) dating to the 650s. **Longdongsi** (Dragon Cave temple) is about 20 km southeast of Jinan in a soft, sandy area where there are many caves which have not weathered well over the years. On the mountain face is a standing Buddha in flowing robes dated to the Eastern Wei (534–50) period. The contents of the caves include rows of Buddhas, and groups of Buddhas and Bodhisattvas dating to the Sui period (589–618). There is also a Buddhist group dated to 1318. The **Foyusi** (Buddha Ravine temple), about 13 km from Jinan, was a place of pilgrimage, and the mountain slope here has many inscriptions of various dates and some remains of Sui dynasty sculpture. Five Buddhas are dated to 587. There are also some Tang

sculptures. **Yunmenshan** (Cloud Gate mountain) has sculptures dating to 596 and 599, of the Sui dynasty. The figures are placed in flat niches rather than caves. The Sui dynasty figures include a four-metre-high Buddha, seated cross-legged. Outside on the mountain wall are figures of Tang date, and also two small caves with sculptures dated by inscription to 734. **Tuoshan** (Camel mountain), across the valley from Yunmenshan, has six caves in total, the majority of Sui dynasty date. One small grotto has Tang inscriptions dating to 702 and 703. **Lingyansi**, a famous monastery south of Jinan, is situated in a valley enclosed by mountains. High up on the southern mountain slopes is a very large seated Buddha, nearly 6 metres in height, with four attendants. There are no inscriptions but stylistically the figures belong to the Sui period. **Yuhanshan** (Jade Casket mountain), about 16 km south of Jinan, has a great number of rock sculptures arranged halfway up, in rows of flat niches. Many Buddha and Bodhisattva figures survive, some dated to the late sixth century, in the Sui dynasty. The **Kaiyuansi**, on the slope of the limestone cliff near Jinan, is a temple containing a huge Song dynasty Buddha's head at least 4.57 metres in height, in high relief.

Shentongsi (Spirit Communicating temple), Shandong province, Licheng xian (q.v.). The cave sculptures at Shentongsi were begun in the Northern Qi period (550–77), but the most numerous and interesting date from the Tang period and are contained within small caves and niches. The sculptures are generally rather flat and stiff. Some figures are dated by inscription to 644, 657 and 658. The **Simenta** (Four Gate pagoda) at Shentongsi is about 50 km southeast of Jinan. The temple and sculpture also belong stylistically to the Northern Qi and Tang periods. Figures of large Buddhas were made of white marble and then coated in plaster. The **Jiutasi** (Nine Tower pagoda), Shandong province, about 53 km southeast of Jinan, is an unusually shaped octagonal mud and brick tower with nine small towers on the roof. On the mountain behind the temple are many small niches containing mostly small sculptures, some perhaps pre-Tang in date and others of a mature Tang style.

Shanxi province
Huayan monastery, Lower, Shanxi province, Datong. Datong, previously known as Pingcheng, was the political and cultural centre of north China from 386 to 493 in the Northern Wei period and became the western capital of the Liao dynasty and also the capital of the Jin dynasty. The Lower Huayan monastery is in Datong city. The main hall was built in the reign of Emperor Daozong (1055–64) of the Liao dynasty, and the renowned Buddhist Bhagavat Storage Hall was built in 1038, in the style of an imperial palace. It contains three groups of contemporary clay stucco images, with the principal figures up to 5 metres in height, and a unique set of built-in bookcases in architectural form around the walls, including a splendid arching centrepiece.

Jinci (Jin memorial temple), Shanxi province, 25 km from Taiyuan. Part of this temple complex was already in existence in the mid fifth century, as it was described in a text of that time. The temple was enlarged and repaired many times between 550 and 1034. Other buildings in the complex were added over the centuries, including a terrace of iron statues with a figure at each corner, one of which was cast in 1097. The **Shengmudian** (Hall of the Saintly Mother), built between 1023 and 1031, is the oldest building extant and contains forty-three polychrome clay figures of exceptional beauty dating to the Song dynasty. The **Zhenguan baohan** pavilion houses famous stone tablets with calligraphy by Emperor Taizong, written in 646 in the style of the famous calligrapher Wang Xizhi.

Tianlongshan caves, southern Shanxi province, about 25 km south of present-day Taiyuan, fifth to eighth century. Five caves date to the Northern Qi period (550–77), one to the Sui (589–618) and the rest to the Tang (618–906). Amongst the sculptures are a Buddha on a nine-tiered throne in cave 7 (the Sui cave), and the head of a Bodhisattva dating to the early eighth century. The British Museum has some examples of sculpture from these caves.

Wutaishan (Five Terrace mountain), Shanxi province, 240 km from Taiyuan provincial capital. This famous area, also known as Qingliangshan (Mountain of Clear Coolness), has many temples. Wutaishan and Taiyuan were the two pre-eminent Buddhist centres in north China, renowned for their wooden sculptures, often life size or larger, dating from the tenth to the fourteenth century. The terraces are about 3000 metres above sea level on average, with the Northern Terrace at 3058 metres. Wutaishan is one of the four major Buddhist mountain sanctuaries in China (the others are Putuoshan in Zhejiang province, Emeishan in Sichuan province, and Jiuhuashan in Anhui province). It is said that Buddhism reached this area during the Eastern Han period (AD 25–220). Temples were built on Wutaishan from the Northern Dynasties onwards and by the Northern Qi period (550–77) there were more than two hundred. The three most important and best preserved today are the Nanchansi, with a main hall dated 782 (the oldest wooden building in China still standing), the Foguangsi, with its Eastern Great Hall built in 857 in the Tang period (the second oldest wooden building in China), and the Daxiantongsi, probably built originally in Eastern Han times and rebuilt in the Ming and Qing dynasties. Yanshansi, just on the edge of the area, has important mural paintings of the Jin dynasty (1115–1234) in its Mañjuśrī hall.

Yungang caves, Shanxi province, near Datong, c.460–94. There are fifty-three caves, twenty major ones, with about 51,000 Buddhist images. These represent the middle phase of Northern Wei style begun by Emperor Wen Cheng in 460 to compensate for his predecessor's persecution of Buddhism. As the images were executed by imperial order and supervised by the court they are of impressive size. The early great seated Buddha, over 14 metres in height, fills cave 20 and shows Central Asian influence particularly in the treatment of the mantle with its flattened folds. By the end of the fifth century the imported styles had been absorbed and a distinctively Chinese style had emerged, which was perpetuated at Longmen (q.v.).

Zhejiang province

Feilaifengsi, Zhejiang province, near Hangzhou. Yuan dynasty (1279–1368). The stone images in this temple area reflect Mongol interest in Tibetan Buddhism, with Tantric deities and Vajrayāna iconography.

Tiantaishan, Zhejiang province, a beauty spot famed since the fourth century and a Buddhist centre from the sixth century onwards. In 575 the great Buddhist monk and teacher Zhiyi (538–97) settled at Tiantaishan and founded the Tiantai school. He was honoured by Emperor Xuandi (r. 569–82) of the Chen and by the succeeding Sui dynasty (589–618). The Tiantai doctrinal system was an eclectic and popular one within Mahāyāna Buddhism, and its popularity made the Guoqingsi, the principal temple of the Tiantai sect, a flourishing centre. Japanese Buddhists were frequent visitors to the temple and the Japanese Tendai sect regard it as their ancestral temple. Most of the present buildings date from the eighteenth-century rebuilding of the Guoqingsi complex, but a nine-storey hexagonal pagoda erected in 598 stands outside the compound. Many famous calligraphers, such as Mi Fu (1051–1107), and painters have been associated with this area and inscriptions are carved into the nearby cliffs and rocks.

Sichuan province

Bamiaoxiang, Sichuan province, Nirvāṇa gully, about 40 km northwest of Anyüe. The site is situated around a gully, enclosed by two cliffs which stretch for 400 metres. Sculptures depicting the *nirvāṇa* were carved on the northern side. On the southern cliff, opposite, are fifteen chambers and additional niches. The chambers are important for the sutra texts on the walls. At this site, on the northern and southern cliffs, there are also 125 niches with sculpture and nearly 1600 images. The *nirvāṇa* scene itself is dated on stylistic grounds to the High Tang, similar to metropolitan artistic styles at the capital Chang'an at that period, the first half of the eighth century.

Bazhong, Sichuan province, about 85 km southeast of Guangyuan (q.v.). There are four sites in this area with Buddhist sculpture, carved on the hills surrounding the town in each of the four directions. The Southern cliff, the richest and best preserved site, has many inscriptions dated to the Tang period commemorating the making of the images in the niches or their repair. The Western cliff, about 2 km from Bazhong, has about thirty niches and small chambers and dates to an earlier period than the Southern cliff, one chamber having an inscription dating it to the Sui dynasty (589–618). The Northern cliff has about thirty niches datable to c.700, the High Tang period. The **Shuiningsi** (Shuining temple), at Qingjiangxiang, is about 35 km southeast of Bazhong and contains nine niches filled with sculpture which has been dated to the first half of the eighth century.

Dazu caves, Sichuan province, Dazu, dating from the Tang to the Qing dynasty. These contain Buddhist, Daoist and Confucian statuary. There are twelve sites of Tang and Song date and eight of Ming and Qing date. There are more than 50,000 statues in over forty places in the Dazu hills but most are concentrated in Beishan and Baodingshan. Shrine 245 at Beishan illustrates in serial form the Buddhist sutras in the artistic style of the late Tang, while the largest grotto in Beishan, the 'Grotto of the Revolving Wheel', reflects Song dynasty style. Baodingshan is the centre of Southern Song sculpture, the relief 'Scenes from Hell' being unique among all stone sculpture in China.

Guangyuan, Sichuan province. This area includes the **Huangzesi** (Temple of Imperial Largesse), which has six rock chambers of differing sizes and forty-one niches still extant. Most of the sculpture dates stylistically to the seventh century, the early Tang period. The niches and grottoes vary in size from monumental to small and the sculptures placed in them show some differences in style. The **Qianfoyan** (Thousand Buddhas cliff) lies opposite the Huangzesi. The size and quality of the site are comparable to Longmen (q.v.) but full excavation reports are not yet available. Approximately 400 niches and 7000 sculptures remain in what is mainly a Tang dynasty site, as inscriptions and sculptural style testify. At nearby **Guanyinyan** (Guanyin cliff) there are about 150 fairly small niches datable to the eighth and ninth centuries and some inscriptions. Most niches display triads or pentads and many representations of Guanyin. The site has not yet been surveyed or published.

Jiajiang (Thousand Buddhas cliff), Sichuan province, southwest of the town of Jiajiang. Here there are about 160 niches and 2470 images extant, some dating to the early eighth century and the majority to the ninth century, according to inscriptions.

Qionglai xian, Sichuan province, about 100 km southwest of Chengdu. Here there are several Buddhist sites, including **Shisunshan**, where there are thirty-three niches of differing sizes containing sculptures. Most sculpture is dated from the mid to late Tang period, in the ninth century.

Wanfosi (Temple of Ten Thousand Buddhas), Sichuan province, west of Chengdu. The remains date from the fifth to the eighth century although the history of the temple is said to go back to Eastern Han times (AD 25–220). The temple contains a standing Buddha inscribed with the year 529, when the temple was part of the Liang state. It also contains many fine-quality stone images, which survived destruction in the late Ming period.

Wanniansi (Temple of Ten Thousand Years), Sichuan province, Emeishan. This temple contains the venerated bronze statue of the Bodhisattva Puxian on the back of a white elephant with three pairs of tusks, dating to the Northern Song period.

OTHER PROVINCES OF CHINA

Shizhongshan caves (Stone Bell mountain caves), Yunnan province, near Jianchuan, 100 km north of Dali. There are eight grottoes at the Shizhong temple site which contain images of many civil figures commemorat-

ing members of the Nanzhao local royal house, dressed in national dress and depicted in secular scenes as well as religious ones. The sculptures are good representative examples of the style of art sponsored by the rulers of the independent Nanzhao kingdom, which expanded rapidly in the mid seventh century and was strong enough to resist the Tang dynasty in the early eighth century, although eventually it allied with the Tang later that century. The sculptures are dated to the ninth century. The Buddhist representations at the site follow two main iconographic trends: that of northern China, and the local beliefs of Yunnan. The Bodhisattva Guanyin had a particularly popular and widespread following in Yunnan and a number of representations of this figure, including monumental ones – monumental sculpture was particularly favoured in Yunnan during the Nanzhao period – were made at this time. There are other cliff carvings in the area such as at Shadengqing, which is part of the Shizhongshan site.

Xumishan grottoes, Ningxia Autonomous region, on the eastern slope of Xumishan, 55 km northwest of Guyuan county. Work here probably began in the reign of Xiaowendi (477–99) of the Northern Wei dynasty, but many carvings were done during the Northern Zhou and Tang periods. By the Tang dynasty a grand grotto temple, the **Jingyunsi**, was built. There were more than 132 grottoes, of which about seventy had carvings and statues, and about twenty survive today.

Yan'an, Shaanxi province. Cave temples here include the **Wanfodongsi**, which comprises three caves. Cave no. 1 has sculptures covering the walls and platform sides with rows of small 'one thousand' Buddhas and about fifty larger figures (about a metre high) of Buddhas, Bodhisattvas and Guanyin. Cave no. 3 has a combination of Buddhist and Daoist elements. Inscriptions in the three caves date primarily to 1078–85 (Northern Song), although some are later, dating to the Jin and Ming dynasties. The Song cave temples are more complex in content than their Tang counterparts, although they are smaller in size and plan.

Alphabetical index of Buddhist cave temples and sites

MAP VI Buddhist cave temples and other sites.

Buddhist reliquary deposits

For a fuller description of the following list of Buddhist reliquary deposits see R. Whitfield, 'Buddhist Monuments in China: Some Recent Finds of Śarīra Deposits', in T. Skorupski (ed.), *Buddhica Britannica, Series Continua 1, The Buddhist Heritage*, Tring, Hertfordshire, 1989, from where the information below has been taken.

Beizheng village, Hebei province, Fangshan, near Beijing, Liao dynasty. In this thirteen-storey octagonal brick pagoda, which collapsed in 1977, were found model pottery pagodas, a pottery *dhāraṇī* column in compartments, and a three-metre stone *dhāraṇī* column dated 956 in the base, over a chamber housing a stone casket dated 1051. Inside the casket were a figure of the Buddha, porcelain dishes, bronze vessels and mirrors, two silver sprays of flowers and two silver model banners, replicating in miniature textile banners of the type found at Dunhuang (q.v.).

Chongsheng temple, Yunnan province, Dali (former independent kingdom). The temple has long vanished, but three pagodas still remain. The largest of these, the Qianxun pagoda, was built about 930. In the base of one of the pagodas 104 items were discovered in a cavity, and 567 were found at the base of the mast at the top. Gold, silver and gilt bronze Buddhas were found, as well as one each of crystal, jade and iron, five of wood and three of ceramic. There are also sixty-five Bodhisattvas, most of them Avalokiteśvara in various forms, and nine guardians or heavenly kings. There were various other esoteric Buddhist items, reflecting the type of esoteric Buddhism introduced into this part of Tang China in the ninth century. These included *vajras*, a mandala in a copper case, and guardian figures with multiple arms. The British Museum's Avalokiteśvara figure [OA 1950.2–15.1] probably came from this temple when various items came to light after an earthquake in 1925.

Ding xian, Hebei province. There are at least three important Buddhist deposit finds at Ding xian. The earliest was on the site of a pagoda which had been destroyed by the Ming dynasty. Here were found fragments of Buddhist images of the Northern Wei (386–535), Eastern Wei (534–50) and Northern Qi (550–77) periods. The centre of the mound revealed a stone casket dated by inscription to 481 and although quite small (about 26 cm deep and 61 cm square), it contained 5657 items including coins (some Sasanian, the most recent dated to 470), agate and glass beads, official seals, and personal ornaments including jewellery. There were also glass vessels, made locally, in which the actual relics, probably crematory remains, were contained.

The second set of finds at Ding xian dates to the Sui dynasty. These finds included a stone casket dated 606 and a gilt bronze one dated to 603 (found together with a stone casket of the Northern Wei dated 453), all of which were redeposited in the Song dynasty in pagoda 5 at Ding xian after the destruction of the pagoda in 947. The contents of the casket were inscribed and listed and included jade images, gold and silver hairpins and a gold casket, inside which was a small silver pagoda wrapped in silk containing two glass bottles. The decorative motifs on the casket of 603 show Sasanian influence, confirming

the importance of the Silk Route as a means of transmission of cultural ideas and decorative styles.

The two Northern Song deposits also excavated at Ding xian from the consecratory deposits of pagodas 5 and 6 were contained within large stone chambers, both imitating wooden architecture with painted interior walls. In pagoda 5, which also contained the Northern Wei and Sui deposits mentioned above, were 115 pieces of ceramic, mainly of very fine Ding ware, including Buddhist vessels such as water sprinklers, a censer and a vessel in the shape of a conch shell. Also in this deposit were some gilt bronze Buddhist images, wooden carvings and stupas.

Famensi, Shaanxi province, Fufeng, 122 km west of Xi'an. This monastery was completed in 532 at the end of the Northern Wei dynasty (386–535) and renowned in its time as one of the twenty-four Buddhist temples in China said to contain relics of the historical Buddha himself. In the Tang dynasty an 'underground palace' was built under the foundations of the Famensi square wooden pagoda to house the relics. From time to time the relics were transported to the imperial palace in Chang'an and then returned, accompanied by costly gifts. The last deposit was made *c.*874 and remained intact even when the original pagoda was destroyed and replaced with an octagonal one of brick in the Ming dynasty. This pagoda collapsed and was excavated in 1987, when the 'underground palace' of three chambers yielded many treasures including 121 items of gold and silver, rare examples of *mise* ('secret colour') porcelain, imported glass and fine textiles.

Ganlusi (Temple of Sweet Dew), Jiangsu province, Zhenjiang, Tang dynasty. Here a stone tablet and a number of gold and silver *śarīra* coffins, dated to between 824/5 and 829, were found in the foundations of an iron pagoda.

Hongjuesi, Jiangsu province, Niutoushan, Nanjing, Ming dynasty. A spectacular gilt bronze reliquary was found here this century, surrounded by four underglaze blue porcelain jars. The *śarīra* casket, with a gold recumbent figure of the Buddha, was in the traditional shape of a Chinese coffin. The influence of Lamaist Buddhism, which flourished during the Ming and Qing dynasties, is indicated by the changed shape of the pagoda or stupa, inside which there was a concentrically arranged group of esoteric gilt bronze figures.

Huiguang pagoda, Zhejiang province, Ruian, Northern Song dynasty. This deposit included gilt wood images and one of the gilt stupas of the prince of Wu Yue, dated 965. All but three of the sixty-nine items are datable to before 1043 and include a splendid silver seven-storey pagoda, which was contained with other items in a *śarīra* case, dated 1042, decorated with assemblies of immortals painted in gold. The sutra boxes have an inner and outer part, decorated in gold and with Buddhist images in raised lacquer.

Huqiu Yunyansi ta (Tiger Hill pagoda of the Yunyan temple), Jiangsu province. The Song dynasty (960–1279)

finds from this deposit are now in the Suzhou museum. The deposit included a stone casket with Buddha groups carved in relief on the four sides. Inside this was a sutra box of lacquered wood with silver gilt fittings, containing the seven scrolls of the *Lotus Sutra*. Other finds included a folding sandalwood shrine and a gilt stupa, wrapped in silk and placed in an iron casket which was itself inside a five-tiered stone casket.

Jingchuan xian, Gansu province, Tang dynasty. In this deposit, a stone casket was found inside a stone chamber, and the lid of the casket was inscribed with the dynastic name Zhou, which was that proclaimed by Empress Wu Zetian when she usurped the throne in the late seventh century. The empress ordered the founding of countless temples named Dayunsi, after the discovery of the *Dayunjing*, a Buddhist text, which she interpreted as a vindication of her rule. This deposit was apparently made for one of these temples. Inscriptions cover all four sides of the casket, naming some sixty people who paid for the deposit. The casket contained a bronze casket inside which was a silver coffin containing a gold coffin. In the gold coffin was a sandalwood board on which was placed a glass bottle containing the fourteen relic grains referred to in the inscription on the outer stone lid. The workman-ship of the gold coffin studded with pearls and of the silver coffin is very fine.

Ruiguangsi pagoda, Jiangsu province, Suzhou, Song dynasty (960–1279). This pagoda's *śarīra* deposits are particularly notable. They include bronze figurines of Bodhisattvas and *lokapālas*, richly illuminated frontispieces to the *Lotus Sutra* and a lacquer sutra casket inlaid with mother-of-pearl. There were also printed sutras, bronze images and votive stupas, and an elaborately decorated *śarīra* pillar, with a wooden core and red lacquer finish, painted in gold and carved with eight silver lions around its base. It was contained in a wooden casket painted on the outside with figures of the four guardian kings and is important for the study of early Song Buddhist painting.

Wanfota (Myriad Buddhas pagoda), Zhejiang province, Jinhua township, Five Dynasties period (907–60). The pagoda was destroyed in 1942 but the deposit was rediscovered in 1956. The deposit was originally made in 1062 in the Northern Song dynasty and contained bronze images dating to that period. There were also fifteen gilt bronze and four (so far unique) gilt iron stupas dating to 955 and 965.

Traditional architecture

Chinese architecture has been little discussed in this book as it is barely represented in the British Museum's collection. However, architecture has played an important role at all periods in China, and the building forms and structural systems developed there have had a major impact on architecture in all the countries of East and Southeast Asia.

The Chinese architectural tradition began in the Yellow Earth region of China, where there was little good building stone but abundant timber, as elsewhere in the country. Timber was easy to transport, work and carve. Protected by a periodically renewable covering, such as lacquer, it was durable. Fire was its greatest hazard.

The fundamental elements of Chinese architecture are simple. A rectangular platform of rammed earth, faced with stone or brick, was built originally to raise the floor of the building above the damp ground. It varied in height and size, according to the status of the building. On this platform timber columns were placed in straight lines. The columns stood on, but not in, stone bases, giving them freedom to move in earthquakes. They carried horizontal beams, and the rows of columns and beams were held in position by tie beams joining the building from front to back. All the joints were mortised and tenoned with the minimum of nails. These wooden joints also made possible a certain amount of movement in the event of an earthquake.

To support the heavy and overhanging ceramic tiled roofs (which gave the buildings stability in high winds), a complex wooden bracket system was devised whereby the pillar and beam met to increase the surface of contact and reduce the span. The *dougong*, or bracket set, was the most outstanding characteristic of Chinese architecture, as both a structural and decorative feature, being visible from the interior as well as the exterior of the building. At first the bracketing system consisted of simple U-shaped brackets standing on the top of columns; next, small blocks were placed at the ends where the brackets met the beams (fig. 220). Many more brackets and blocks could be added to increase the length of beam supported. As the numbers of brackets increased, the weight and overhang of the roof were also extended. The bracketing system allowed for great liberty in roof design, so that unlike Western ones, Chinese traditional buildings made great play with the roof (Introduction, figs 15–16). All major buildings had large curved overhanging roofs. A further ingenious element in the structure was the *ang* or sloping rafter. This sloping beam allowed weight to be added to the upper part of the pitch of the roof, or for the construction of an additional storey. The sloping beam carried the weight from the upper purlins downwards and, as a lever, the pressure from the top caused its lower end to give an upwards thrust to the tiles at the outer edge (fig. 218).

The outer walls and inner dividing walls of Chinese buildings had no structural function but were merely screens, protected from the weather by the overhanging roofs. The interior floor plan was therefore very flexible, and buildings could be extended by adding units along the length as well as by increasing the depth.

Colour was another feature of Chinese architecture. The more important buildings had white platforms, red walls and columns, blue and green beams and brackets and yellow and green roof tiles, with decorative ornaments along the roof ridges and ribs. There was less colour on ordinary domestic buildings whose roof tiles were only lightly fired and grey in colour.

Buildings in China were considered an integral part of their surroundings and were planned on a south-north axis, the most important buildings facing south. The chief buildings of a complex lay one behind the other along this axis, separated by courtyards which were themselves flanked by buildings of minor importance to the east and west. The Forbidden City in Beijing and other palace complexes, as well as domestic buildings, were all designed along these lines (Introduction, fig. 17).

From the earliest times the erection of buildings has been subject to official regulations. Few documentary records exist before the Song period when the *Yingzao fashi (Treatise on Architectural Methods)* was written by Li Jie, an official; it was presented to the emperor in 1100 and published in 1103. This compendium of Chinese traditional architecture and building methods has chapters devoted to technical terms, and sets out the rules concerning building methods, decorative fabrics, and the relative measurements and proportions of various architectural elements. It also gives the sizes and costs of the different elements appropriate to the different grades of building. The manual in effect prescribes a standard system for the wooden parts of a building, enabling officials efficiently to oversee, organise and cost building projects.

Relatively few old Chinese buildings have survived because of the nature of the material, wood, in which most were built, and the predictable consequences of fire and earthquakes over time. However, some extant buildings are listed below. It is also possible to refer to several buildings which have been continually rebuilt in the Chinese classical style in Japan, where Chinese architectural influence was always strong.

Chronological list of some extant pre-Ming wooden buildings

Nanchansi Buddhist temple, Wutai mountains, Shanxi province. Its Buddha Hall, dated to AD 782, is the oldest wooden building surviving in China today.

Foguangsi Buddhist temple, Wutai mountains, Shanxi province (figs 219–20). Its Buddha Hall was built in 857 (Introduction, fig. 15).

Dulesi Buddhist temple, Jixian, Hebei province. The **Guanyinge**, or Pavilion of Avalokiteśvara, a double-storeyed building, and Main Gate were built in 984.

Fengguosi Buddhist temple, Yixian, Liaoning province. Built in 1020.

Jinci Daoist Memorial temple complex near Taiyuan, Shanxi province. The nucleus of this complex includes the **Shengmudian** (Hall of the Saintly Mother), which is a double-eaved building, and a sacrificial hall and a cross-shaped bridge. The two halls and bridge were built between 1023 and 1031.

Huayansi and **Shanhuasi** Buddhist temples, Datong, Shanxi province. The Bhagavad Sutra repository of Lower Huayansi, inside the West Gate of Datong, and its side hall are both Liao dynasty structures dating to 1038. Within the Shanhua group of buildings, inside the South Gate of Datong, the Main Hall and the **Puxian** pavilion are also of the Liao dynasty, but their exact date is unknown.

Longxingsi Buddhist temple, Zhengding, Hebei province. This temple complex has a number of early buildings, including the **Monidian** (Śākyamuni Hall) of 1052,

the **Cishi** pavilion of the twelfth century, and the Hall of the Revolving Bookcase, built in the Northern Song period (960–1126).

Fogongsi Buddhist temple, Yingxian, Shanxi province. Contains the **Yingxian muta**, an octagonal, five-storey wooden pagoda built in 1056.

Jingtusi Buddhist temple, Yingxian, Shanxi province. Contains a Main Buddha Hall built in 1124.

Shaolinsi Buddhist temple, Song mountains, Henan province. Contains the **Chuzuan**, a nunnery, built in 1125.

Shanhuasi Buddhist temple, Datong, Shanxi province. The **Sansheng** Hall and Main Gate were built between 1128 and 1143.

Xuanmiaoguan Daoist temple, Suzhou, Jiangsu province. The **Sanqingdian**, Main Hall, was built in 1179.

Beiyuemiao Daoist temple, Quyang, Hebei province. The **Deningdian**, Main Hall, was built in 1270.

Guangshengsi Buddhist temple, Zhaocheng, Shanxi province. The **Mingyingwangdian**, the Main Hall, in the Water God temple, was built about 1319.

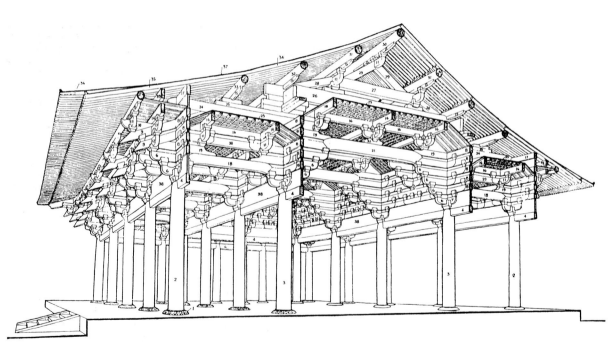

218 (*above*) Section of the Foguangsi (see fig. 219 opposite) illustrating the wooden structure of the building. The main elements are the vertical columns, the horizontal beams parallel with the front of the building, and the beams tying the building from front to back. At the top of the columns are clusters of brackets and blocks which support the beams. The sloping members below the roof tiles are *ang*, which act as levers. The load of beams and tiles at their upper points exerts a downwards thrust, thus pushing up the lower end of the *ang* and supporting the tiles lower down the roof.

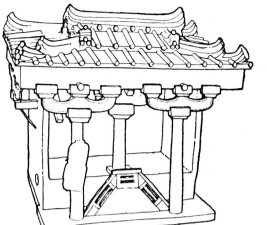

220 (*left*) Drawing of a ceramic model of a building recovered from an Eastern Han tomb (AD 25–220) at Muma in Sichuan province. The drawing shows the use of simple brackets, each one supporting three square blocks below the beams.

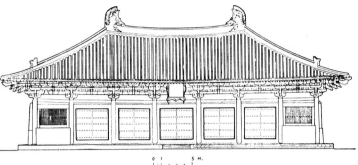

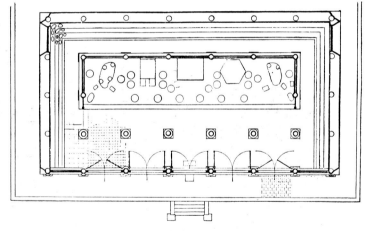

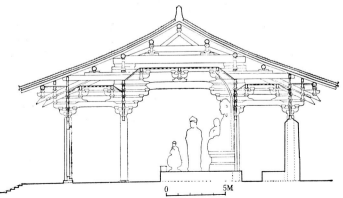

219 (*right*) Elevation, plan and cross-section of the Foguangsi (see fig. 218 opposite) at Wutaishan in Shanxi province (Introduction, fig. 15). Tang dynasty, 9th century AD.

Tombs

Many of the objects surviving from early ancient Chinese civilisation have been found in tombs. Burials were large and sumptuously equipped. Life was viewed as literally continuing after death, and the dead would, as they had when alive, require all the utensils of daily life and of ritual. In addition to the actual contents of the tombs, the structures both below and above ground served the tomb occupant. The burial chambers were the homes of the deceased, and the buildings above ground – the temples and halls – were the places where descendants offered their respects and cared for the well-being of the dead. Early tombs consisted primarily of structures under the ground, but as time passed more and more complex buildings and sculptures were placed above ground. A few of the major tombs mentioned in this book are illustrated here to chart the development of the underground chambers.

Early tombs had the following features: a large vertical pit with a step, or terrace-like feature, *ercengtai,* on which some of the burial goods were placed. This platform or step had also been employed by the peoples of late Neolithic cultures of eastern China. The largest pits had access ramps on the north-south axis and small ramps on the east-west axis (ch. 1, fig. 28). At the bottom of the pit were the two coffins of wood: an outer coffin or *guo* and an inner coffin or *guan.* In the Shang and much of the Zhou periods these coffins were both rectangular. In the

Western Zhou, however, a few examples of subsidiary chambers within the *guo* began to appear, and this practice heralded the development of more complicated tomb structures, in which the coffins represented parts of the buildings of the types that the person had lived in when alive.

Tomb areas were probably always surrounded by some sort of small wall and traces of these remain from the Eastern Zhou period. A plan found in a tomb of the state of Zhongshan has allowed a proposed reconstruction of the walls and buildings above ground (ch. 3, fig. 96). During the latter part of the Eastern Zhou, mounds were constructed over tombs, culminating in the huge mound over the tomb of the first Qin emperor within a large burial complex surrounded by two walls (ch. 3, fig. 90). Around the tomb stands the army in pottery (ch. 3, fig. 91), slaughtered horses from his stable and animals from his hunting park. These subsidiary burials replaced and elaborated the pits of horses and chariots that had been customary in the Shang, and the Western and Eastern Zhou periods.

In place of the vertical pits of earlier centuries, Han burials were constructed to resemble mansions or palaces. This tradition continued in later centuries, with the burial chambers underground imitating the contemporary buildings above ground.

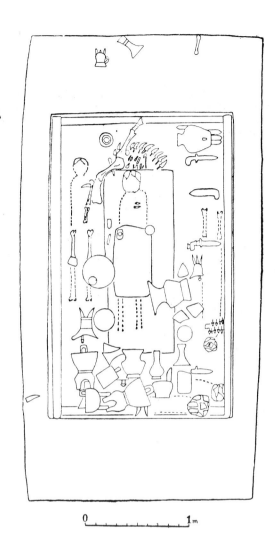

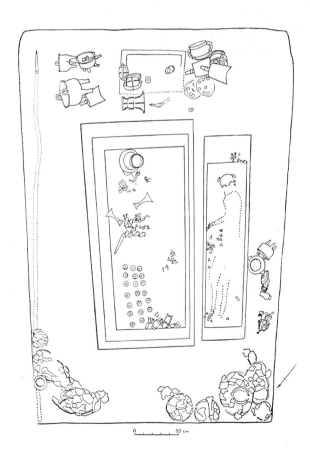

221 (*left*) Tomb 18 at Anyang Xiaotun, Henan province. Shang period, *c*. 1250–1200 BC (for bronzes from this tomb see fig. 229). The tomb consists of a vertical pit with a step or *ercengtai*. The body lies in an inner coffin, *guan*, above a small pit known as a *yaokeng* or waste pit, in which small offerings of dogs were sometimes made. The burial goods, including bronze ritual vessels, were placed between the *guan* and the outer coffin, *guo*.

0 1m

222 (*right*) Tomb 7 at Baoji Zhuyuangou in Shaanxi province. Early Western Zhou period *c*. 950 BC (for vessels from this tomb see fig. 230). The tomb contains two burials, the larger one being the grave of a member of the ruling house of the Yu state, the smaller one being the grave of his wife or concubine. The main burial has three coffins, two inner *guan* and an outer *guo*, and the subsidiary burial has one of each. Most of the burial goods are on the stepped platform (*ercengtai*) around the coffins. Some items lay on top of the *guan* and some inside the *guan*.

0 50 cm

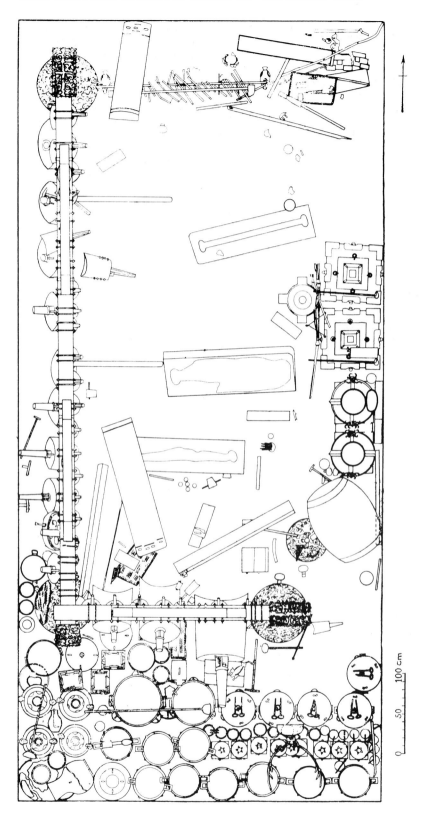

223 (*left* and *opposite above*) Tomb of the Marquis Yi of Zeng at Sui xian, Leigudun, in Hubei province. Eastern Zhou period, *c*.433 BC (for bronzes from this tomb see ch. 1, figs 42–3, and fig. 232). This is a very elaborate form of the tombs illustrated in figs 221–2. (*right*) The outer coffin, *guo*, was constructed as four separate rooms. At the centre is a ceremonial hall (*left*) holding the ritual vessels and bells, and to the east is the chamber of the occupant which contained his coffin, painted with windows and a door like a house, more musical instruments, and many items in lacquer, jade and bronze. The rear chamber held weapons and the west chamber housed the coffins of female attendants, who presumably played the musical instruments.

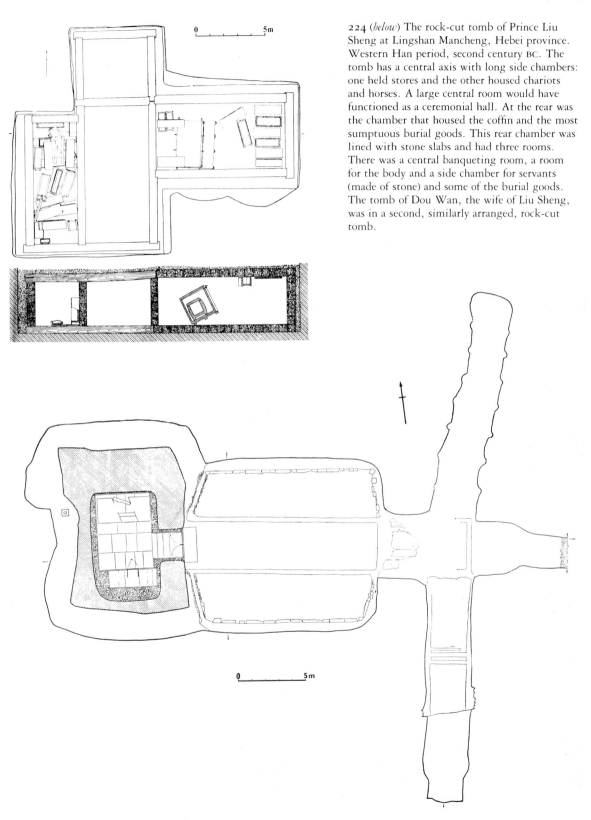

224 (*below*) The rock-cut tomb of Prince Liu Sheng at Lingshan Mancheng, Hebei province. Western Han period, second century BC. The tomb has a central axis with long side chambers: one held stores and the other housed chariots and horses. A large central room would have functioned as a ceremonial hall. At the rear was the chamber that housed the coffin and the most sumptuous burial goods. This rear chamber was lined with stone slabs and had three rooms. There was a central banqueting room, a room for the body and a side chamber for servants (made of stone) and some of the burial goods. The tomb of Dou Wan, the wife of Liu Sheng, was in a second, similarly arranged, rock-cut tomb.

225 (*right*) Painted brick tomb at
Jiayuguan, Gansu province. Eastern
Han period, second century AD. Late
Han tombs commonly followed the
threefold division illustrated by the
tomb at Mancheng (fig. 224) At
Jiayuguan the first room is a general
assembly chamber. The middle room
was probably for formal receptions
and the rear chamber is the private
room of the tomb occupant, housing
his coffin. The tomb is constructed
of bricks and painted with scenes of
daily life, recreating a picture of the
world to which the tomb occupant
belonged.

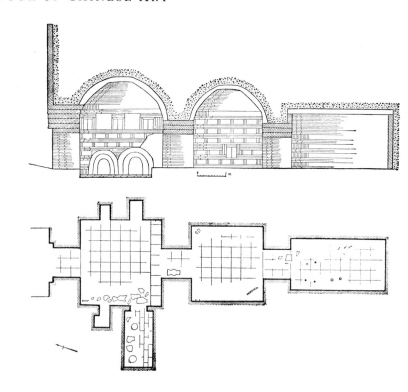

226 (*below*) Tomb of the Tang Prince
Li Zhongrun, also known as Prince
Yi De (AD 682–701), buried near
the Qianling, the tombs of Emperor
Taizong and Empress Wu Zetian.
The tomb has two main chambers: a
front chamber resembling a
courtyard, and a rear chamber in
which the inner coffin was housed.
The access ramp is painted with
scenes from the life of a royal prince.

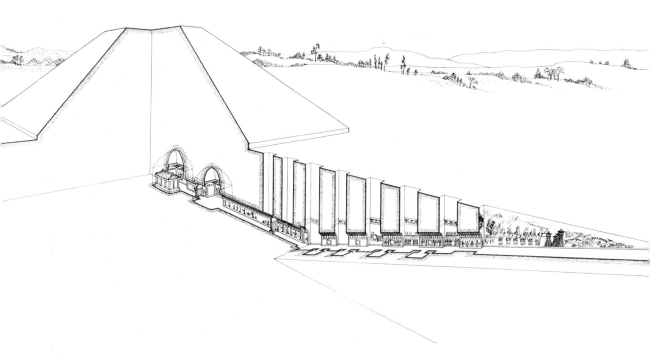

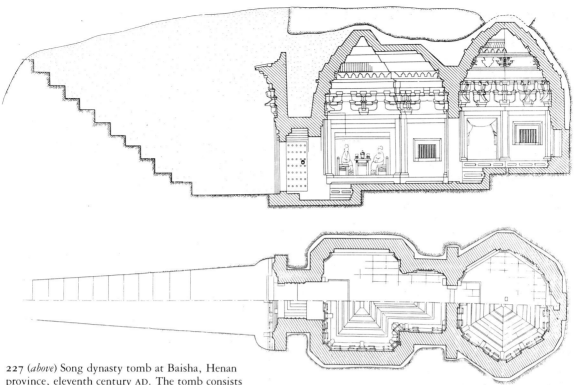

227 (*above*) Song dynasty tomb at Baisha, Henan province, eleventh century AD. The tomb consists of two chambers with access steps and a formal gateway. The front room is a dining room and the back one a bedroom. The tomb is decorated in the architectural style of the day with reproductions of columns, beams and bracketed supports (*dougong*). Painting embellishes the architecture with motifs designated for such buildings.

228 (*below*) The plan of Changling, the tomb of the Yongle emperor (AD 1403–24), is illustrated here because, although it has not been excavated, it contains the most complete sequence of buildings above ground (see ch. 5, fig. 186). The plan consists of three courtyards in front of a large circular tomb mound. Two halls and other structures are built upon raised terraces spanning the whole length of the complex. There is a large doorway behind the hall leading to the third courtyard in which an altar is placed at the foot of a tall stone tower, on which stands the stele pavilion.

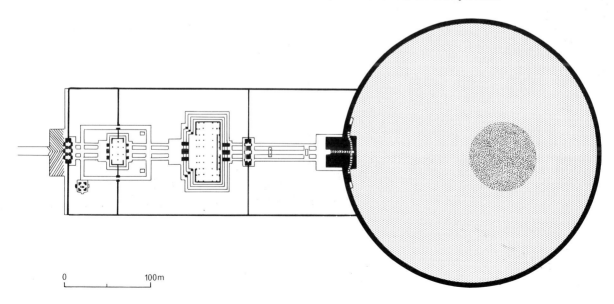

0 100m

Painters

The following is a selection of painters listed in chronological order, with brief biographical information and references to one or two of their attributed works in the British Museum or elsewhere (an alphabetical index of these painters can be found on pp. 345–6). Although not all these attributions are widely accepted, most of the principal British Museum paintings have been included, together with their registration numbers. (NPM means a painting is in the National Palace Museum, Taipei,

Taiwan.) Indeed, in the case of many artists, scholars and connoisseurs are not always in agreement over questions of authenticity, as the making of close copies was a recognised and legitimate way of maintaining the tradition of painting in China.

All painters used, besides their family and given names, a variety of studio and other names too numerous in most cases to list here; a few studio names are cited when necessary.

Period of disunity (221–589)

Gu Kaizhi (c.344–c.406), b. Jiangsu province. One of the earliest important painters of antiquity known by name. He is known primarily as a figure painter and the source of one of the two principal styles of figure painting (the source of the other being Wu Daozi, q.v.). By the ninth century, Gu's style was characterised as exhibiting fine continuous line, with a sensitive rendering of character. The most famous painting attributed to him, a handscroll entitled *The Admonitions of the Court Instructress*, in the British Museum [OA 1903.4–8.1], is probably a close copy of Tang or earlier date. Other paintings linked with his name include various copies of the *Nymph of the Luo River*, one of which, possibly dating from the Jin or early Yuan period (thirteenth to fourteenth century), is also in the British Museum [OA 1930.10–15.02, Add 71].

Lu Tanwei (Southern Dynasties), active in the reign of Mingdi of the Song (r. 465–72). Though none of his

paintings has survived it has been argued that the brick reliefs portraying *The Seven Sages of the Bamboo Grove and Rong Qiqi*, found in royal tombs of the Southern Dynasties at Nanjing and in Danyang county, Jiangsu province, may well be based on his work.

Zhang Sengyou (*fl.* 500–50). Official in the Southern Dynasties under the Liang dynasty. Comparing his figure style with that of other early masters, Zhang Yanyuan (q.v.) wrote that Zhang Sengyou obtained the flesh, Lu Tanwei (q.v.) the bone, and Gu Kaizhi (q.v.) the spirit of their subjects. He painted religious and figural subjects on the walls of Buddhist and Daoist temples, and also landscapes. *The Five Planets and Twenty-eight Constellations*, Osaka Municipal Museum, Japan, a copy possibly made after a Tang composition, is the only surviving work associated with his name.

Tang dynasty (618–906)

Yan Liben (d. 673). Official who became Prime Minister under the Emperor Gaozong (r. 649–83). As the leading figure painter of the seventh century, he is recorded as having portrayed dignitaries and tribute bearers who visited Chang'an, the Tang capital. He also helped to design the mausoleum of the Emperor Taizong (d. 649), at Zhaoling, including portraits of the emperor's six favourite war steeds, which survive in the form of bas-relief sculptures. *Portraits of Thirteen Emperors*, a handscroll in the Museum of Fine Arts, Boston, is his finest surviving work.

Li Sixun (651–716). Relative of the imperial family who held high positions at court. He and his son Li Zhaodao are known for their colourful 'blue and green' landscapes, using azurite blue, malachite green and gold. Retrospectively, Li Sixun was considered to be the founder of the Northern school of Chinese painting, as defined by Dong Qichang (Painting glossary, Northern and Southern schools). Although no original works survive, the painting of *Tang Ming Huang's Flight to Shu*, NPM, Taipei, affords a fine example of Tang composition in the 'blue and green' manner, with tall mountains and distant plains glimpsed through narrow defiles.

Weichi Yiseng (*fl.* late 7th–early 8th century). Member of the royal house of Khotan. His figure style was characterised by agitated draperies. A handscroll of figures in the Berenson collection, Villa I Tatti, Settignano, Italy, is associated with his name.

Wang Wei (699–759). Famous poet and painter, named by Dong Qichang (q.v.) as the source of the Southern school of painting (Painting glossary, Northern and Southern schools). An official as well as an ardent Buddhist, he painted both Buddhist and Daoist subjects and retired to his estate at Wangchuan Villa. Here he apparently painted landscapes using the technical innovation of ink wash or broken ink, *pomo*. Although no paintings of his have survived in the original, *Portrait of the Scholar Fu Sheng*, Osaka, and *Clearing after Snow on the River*, Ogawa collection, Kyoto, are both associated with his name.

Wu Daozi (*fl. c.*710–c.760). Considered one of China's greatest figure painters, his style contrasts that of Gu Kaizhi (q.v.). He is said to have used an impetuous brush-stroke, with thick and thin lines of uneven width and broken outlines, scattering dots and strokes to create a three-dimensional effect. Wu served as a court painter

during the reign of Xuanzong (712–56). He travelled a lot and executed wall paintings in many Buddhist and Daoist temples in Chang'an and Luoyang. He is also famous as a landscape painter, but his work now survives only in rubbings from engraved stones, such as *The Black Warrior (Tortoise and Snake)*. A rubbing from this stone is in the British Museum [OA 1913.10–1.01, Rubbing 30].

Han Gan (*c*.715–after 781). Famous painter of horses and grooms, he was summoned by Emperor Xuanzong (712–56) to paint the imperial horses. *Shining White in the Night*, a portrait of one of these, formerly in the collection of Sir Percival David, is his most reliably attributed work, now in the Metropolitan Museum of Art, New York.

Zhang Yanyuan (*c*.815–?). Wrote *Lidai minghuaji (A Record of the Famous Painters of all the Dynasties)* (trans. W. R. B. Acker, *Some T'ang and Pre-T'ang Texts on Chinese Painting*, Leiden, 1954) in 847 after the destruction of many Buddhist temples and their wall paintings in the religious persecution (842–5) of the Huichang reign. This work is the most important source of information on early painting and theory in China.

Guanxiu (832–912). Monk painter, famous above all for his craggy representation of Buddhist arhats, preserved in Japan and attributed to him.

Five Dynasties and Ten Kingdoms (907–60)

Jing Hao (b. *c*.870/80, d. *c*.925/35). Landscape painter and the author of a famous treatise on painting, *Bifaji (Notes on the Art of the Brush*, trans. K. Munakata, Ascona, 1974). *Travellers in a Snowy Landscape* (excavated from a tomb), Nelson-Atkins Museum, Kansas City.

Guan Tong (*fl. c*.907–23). After the fall of the Tang dynasty he became a subject of the later Liang dynasty (907–23), which ruled north China, and was admired, along with Fan Kuan and Li Cheng (qq.v.), as one of the three greatest landscape painters of the tenth century. Jing Hao (q.v.) was his teacher early in his career. In his later years he painted with a relatively free, unlaboured and sketchy brushwork. *Waiting for the Ferry*, NPM, Taipei.

Li Cheng (919–67). One of the most influential masters of the Five Dynasties and early Northern Song, known for his wintry landscapes, especially for his leafless trees. He is said to have used ink very sparingly. He came from a family of scholar-officials and was himself a scholar. Probably no original works by him survive, but *Lonely Monastery amid Clearing Peaks*, Nelson-Atkins Museum, Kansas City, is a fine Northern Song painting attributed to him.

Dong Yuan (d. 962), from Nanjing, Jiangsu province. His fame rests on his landscapes, which greatly influenced the leading masters of the late Yuan period (fourteenth century). He was later named as the leading master of Dong Qichang's (q.v.) Southern school of landscape painting (Painting glossary, Northern and Southern schools). He and his follower Juran (q.v.) painted river landscapes textured with long, soft, earthy brushstrokes, his mountain slopes gently rounded and piled with boulders, moist and misty like the actual landscapes of the Jiangnan (lower Yangzi) region where he worked. Attributed paintings include *Xiao and Xiang Rivers*, Gugong, Beijing, and *Wintry Forests and Lake Shores*, Kurokawa Institute, Hyogo, Japan.

Shi Ke (d. after 975). Famous for his humorous subjects and wall paintings. Ordered by the Emperor Taizu to paint Buddhist and Daoist figures in the Xiangguo mon-astery in the capital, Kaifeng. *Two Patriarchs Harmonising their Minds*, Tokyo National Museum, though possibly a later copy, is the oldest extant example of Chan (Zen) painting with garments portrayed by rough brushwork and faces delineated in fine detail.

Juran (*fl.* 960–85). Monk painter and follower of Dong Yuan (q.v.), using similar 'hemp-fibre' strokes, interspersed with rounded 'alum-head' boulders. *Seeking the Dao in the Autumn Mountains* and *Xiao Yi Seizing the Lanting*, NPM, Taipei; *Buddhist Monastery on a Mountainside*, Cleveland Museum, Ohio. The British Museum has an impressive landscape hanging scroll bearing his name but actually a twentieth-century forgery by Zhang Daqian (Chang Dai-ch'ien, q.v.) [OA 1961.12–9.01, Add 314].

Anonymous Buddhist paintings from the Tang and Five Dynasties in the Stein Collection. The British Museum has a large collection of manuscripts, textiles and paintings which were discovered in cave 17 at the Caves of the Thousand Buddhas, Dunhuang, Gansu province, in the closing years of the nineteenth century. Marc Aurel Stein, the first Westerner to visit the site after the discovery, collected some five hundred paintings and prints and over ten thousand manuscript scrolls from this cave. About two hundred of the paintings and prints are in the British Museum, the remainder in New Delhi, and the manuscripts in the British Library. Other paintings from the same source are in the Pelliot collection in the Musée Guimet, Paris, and further manuscripts in the Bibliothèque Nationale, Paris. The paintings, on silk, hemp cloth or paper, include votive paintings dedicated by lay Buddhists, as well as large compositions depicting the Pure Lands or paradises in which they hoped to be reborn. The British Museum also has a number of other anonymous religious paintings, mainly of Buddhist and occasionally of Daoist figures. Among them, *The Thirteenth Arhat, Ingada* (dated 1345) [OA 1962.12–8.01, Add 317], and *Four Arhats and Attendants* (Ming dynasty, fifteenth century) [OA 1983.7–5.02, Add 442] are both single examples from sets of paintings of arhats or luohans, guardians of the Buddhist law often represented in China in groups of sixteen, eighteen or five hundred.

Song dynasty (960–1279)

Fan Kuan (c. 960–1030), b. Huayuan, Shaanxi province. Famous for austere and grand landscapes. Together with Li Cheng (q.v.), he developed the so-called monumental style of landscape. He was known for his 'raindrop' surface modelling strokes (*cun*). He chose to live in a barren, mountainous area in Taihua in the Zhongnan mountains. *Travellers among Streams and Mountains*, NPM, Taipei.

Yan Wengui (967–1044), b. Wuxing, Zhejiang province. Academy painter under the third Song emperor. His style was as monumental as that of his contemporary Fan Kuan (q.v.), with a show of profusion and turbulence in his paintings. *Temples among Streams and Mountains*, NPM, Taipei; *River and Mountains with Temples*, handscroll, Osaka City Museum, Japan.

Xu Daoning (c.970–1051/2), from Chang'an, Shaanxi province. Like Guo Xi (q.v.), he was a follower of Li Cheng (q.v.) and regarded very highly by his contemporaries (see Guo Ruoxu's *Experiences in Painting*, trans. A. Soper, Washington DC, 1951). *Fishing in a Mountain Stream*, Nelson-Atkins Museum, Kansas City, is a majestic handscroll with fishermen and travellers, a roadside inn and secluded pavilions, all dwarfed by an outlandish series of precipitous cliffs and stark mountain ranges.

Guo Xi (c.1001–c.1090), b. northern Henan province. According to his contemporaries, he was a skilful landscape painter in the Imperial Academy. He was also the author of an essay entitled 'Lofty Message of Forests and Streams', an exceedingly valuable source of information on Song attitudes to landscape and techniques of composition and brushwork (passages translated by John Hay in Bush, S. and Shih Hsio-yen (eds), *Early Chinese Texts on Painting*, Cambridge, Mass. and London, 1985). He painted landscapes after the style of Li Cheng (q.v.), using texture strokes and ink wash to create the illusion of space and distance, with more complex compositions than those of earlier painters such as Fan Kuan (q.v.). Mountains were the dominant elements of his compositions, changing in appearance according to the seasons; his paintings display atmospheric effects which would be further exploited by the Southern Song painters. *Early Spring*, NPM, Taipei, is an impressive hanging scroll on silk, signed and dated 1072.

Su Shi (1036–1101). Famous statesman, poet, calligrapher, art critic and painter of bamboo, also known as **Su Dongpo**. With those in his circle, such as the bamboo painter Wen Tong and the calligrapher Huang Tingjian, he established the concept of *wenrenhua*, that is, painting by literati, arguing that painting could share the values and status of poetry. In his view, 'natural genius and originality' were more important than form-likeness in painting. He held official posts but was also banished several times during his career. None of his paintings survive, but *Dry Tree, Bamboo and Stone*, Shanghai Museum, is attributed to him and provides clues to his subject matter and manner. Many examples of his calligraphy are still extant.

Li Gonglin/Li Longmian (c.1049–1106), b. Shucheng,

Anhui province. Most famous figure painter of the Northern Song period. He painted in *baimiao* (outline drawing), a fine linear style derived from Gu Kaizhi (q.v.), associated with historical themes and Buddhist divinities, and also in the Wu Daozi (q.v.) tradition with short and lively, fluctuating brushwork. He was also appreciated as a painter of horses and landscapes. Thus, Li was the first artist to transmit the styles of several past masters rather than that of just one, establishing classic standards in each genre. *Five Tribute Horses and Grooms* (present whereabouts unknown, perhaps destroyed) was the finest example of his work; *Metamorphoses of Heavenly Beings*, British Museum [OA 1963.12–14.03, Add 337], is a close copy of his style, perhaps early Ming in date.

Li Tang (c.1050–after 1130), b. Sancheng, northern Henan province. Academy painter under the Song Emperor Huizong (r. 1101–25) of the Northern Song in the capital Bianliang (present-day Kaifeng) and then under Gaozong of the Southern Song at Lin'an (present-day Hangzhou). As a transitional painter, his landscapes include subjects on a smaller scale than those of the great Northern Song masters, and his techniques innovate the axe-cut stroke produced with a slanting brush. *Autumn and Winter Landscapes*, Kōtō-in, Daitoku-ji, Kyoto; *Whispering Pines in the Gorges*, dated 1120, NPM, Taipei; *Gathering Herbs*, Gugong, Beijing.

Mi Fu (1051–1107), b. Hubei province. An intellectual as well as a painter and calligrapher, and also known for his critical connoisseurship of paintings and calligraphy. He was the author of *Huashi (The History of Painting)*. He painted foliage with large, wet dots and rocks with soft modelling. Only *Verdant Mountains with Pine Trees*, NPM, Taipei, is extant; more works survive by his son **Mi Youren** (1086–1165).

Zhao Danian/Zhao Lingrang (*fl. c.*1080–1100). Descendant of the Song royal family and collector of ancient paintings. His paintings are more intimate than those of most of his Northern Song contemporaries, being on a small scale, with a simplicity of design and a new realism. *River Village in Clear Summer*, Museum of Fine Arts, Boston.

Huizong (1082–1135). Effectively the last Northern Song emperor (r. 1101–25) before both he and his successor were captured and exiled. He was an aesthete and eminent calligrapher and painter, specialising in birds and flowers. He surrounded himself with the court artists of the Academy of painting (Painting glossary) and took an active part in supervising them, neglecting state affairs. Paintings include *Ladies Preparing Newly Woven Silk*, Museum of Fine Arts, Boston (copied from the Tang dynasty artist Zhang Xuan); *Listening to the Qin*, Gugong, Beijing; *Gardenia and Lichi with Birds*, British Museum [OA 1926.4–10.01, Add 32], a handscroll, attributed to him but probably by a court artist, showing the colourful and close description of nature so valued at his court, and signed with the imperial cipher.

Ma Hezhi (*fl. c.*1131–62), from Zhejiang province. Official at the court of the Southern Song Emperor Gao-

zong, who commissioned him to illustrate the Confucian classic *Shijing* (*Book of Songs*) as part of a series of paintings with themes proving the legitimacy of his rule, in the face of the occupation of north China by the Jin. *Illustrations to the Odes of Chen,* British Museum [OA 1964.4–11.01, Add 338], is one of the finest surviving examples of this series with ten scenes accompanied by the appropriate odes in the calligraphy of Emperor Gaozong. Two of the odes from this scroll were reproduced by Dong Qichang (q.v.) as models of Gaozong's writing; on some of the series the calligraphy was actually written by a court calligrapher (though attributed to the emperor himself). Ma used the so-called 'orchid leaf' and 'grasshopper-waist' style of fluctuating brushwork to depict the reverence necessary for such a canonised work of literature, transforming the fluctuating drapery lines of the Tang painter Wu Daozi (q.v.).

Zhang Zeduan (*fl. c.* early twelfth century), Shandong province. A colophon on his sole surviving work informs us that he was a member of the Hanlin Academy, specialising in buildings, boats, carriages and bridges, etc. His extant masterpiece is the handscroll *Going up the River on Qingming Day,* Gugong, Beijing, a celebration of the varied and busy scenes in and around the capital of the Northern Song, painted shortly before the city was captured by the Jin in 1126.

Xia Gui (*fl. c.*1180–1224). Painter, at the Hangzhou Academy, of landscapes, and Buddhist and Daoist figures. He later retired from court life to a Chan (Zen) Buddhist temple. He was a younger contemporary of Ma Yuan (q.v.). *Twelve Views from a Thatched Cottage,* handscroll, Nelson-Atkins Museum, Kansas City; *River Landscape in Rain and Wind,* fan painting, Museum of Fine Arts, Boston.

Ma Yuan (*fl.* 1190–after 1225). Fourth generation of a famous family at the Academy of painting (Painting glossary) and himself a foremost Southern Song painter, strongly influenced by Li Tang (q.v.). The soft scenery around Hangzhou, conducive to intimate landscape scenes, encouraged painters to turn away from the monumental Northern Song landscape style. The Academy painters Ma Yuan and Xia Gui (qq.v.), often referred to as the Ma-Xia school, used ink washes to create effects of light and mist, employing a 'one-corner' type of composition. Their style was to influence the court painters of the early Ming dynasty, such as Li Zai, when Chinese rule was re-established after the fall of the Mongol Yuan dynasty. *Banquet by Lantern Light,* NPM, Taipei; *Bare Willows and Distant Mountains,* fan painting, Museum of Fine Arts, Boston; *Composing Poetry on a Spring Outing,* handscroll, Nelson-Atkins Museum, Kansas City.

Liang Kai (early thirteenth century), from Shandong province. Painter of figures, landscapes, and Daoist and Buddhist subjects. 'Painter in attendance' at Hangzhou (Southern Song capital) painting academy, from 1201. *Sākyamuni Leaving the Mountains,* Shima Euiuichi collection, Tokyo; *The Supreme Daoist Master Holding Court,* Wango Weng collection, a detailed outline sketch for a wall painting in a Daoist temple; *The Sixth Patriarch Chopping Bamboo,* Tokyo National Museum, a fine example of Chan subjects that became popular in Japan as Zen painting; *The Poet Li Taibo,* NPM, Taipei, a masterpiece of economy in brushwork.

Yuan dynasty (1279–1368)

Qian Xuan (1235–after 1301), b. Wuxing, Zhejiang province. Gained the *jinshi* (doctoral) degree in the Jingding reign (1260–4) and was learned in literature and music; he never served the Mongol regime. Closely followed by Zhao Mengfu (q.v.), he was the first to practise a deliberate archaism, especially in landscape. *Dwelling in the Mountains,* Gugong, Beijing, is in the 'blue and green' style. His flower paintings are finely detailed but with a certain blandness, shared by his calligraphy, usually inscribed on the same paper as the painting itself. *Young Noble on a Horse,* British Museum [OA 1954.12–11.05, Add 286]; *Pear Blossoms* (formerly Sir Percival David collection), Metropolitan Museum of Art, New York; *Early Autumn,* Detroit Institute of Art, Michigan.

Zhao Mengfu (1254–1322). Relation of the Song dynastic royal family who nevertheless took office under the Yuan dynasty, for which he was much criticised. He was the foremost calligrapher, painter and statesman of his day. In painting he followed the lead of Qian Xuan (q.v.) in cultivating the 'spirit of antiquity', but his art could only have been possible at this time. For instance, *Autumn Colours at the Qiao and Hua Mountains,* NPM, Taipei, was painted for a friend who, because of the Jin rule of north China in the Southern Song period, had never been able to travel to his native district. *The Mind Landscape of Xie Youyu,* Princeton Art Museum, New Jersey, reflects Zhao's own ambivalent position by portraying a fourth-century scholar-recluse who served at court yet preserved the purity of his mind. *The Water Village,* dated 1302, Gugong, Beijing, exhibits the unified ground plane and simplified brushwork that would be emulated by late Yuan masters of landscape.

Ren Renfa (1255–1328), from Songjiang, Jiangsu province. Bureaucrat and painter of horses and landscapes. His inscription on *Fat and Lean Horses,* Gugong, Beijing, likens the two horses to different types of official, one who grows fat in office, the other who gives his all to serve the people.

Huang Gongwang (1269–1354), b. Jiangsu province. One of the four masters of the late Yuan. Along with Wu Zhen, Ni Zan and Wang Meng (qq.v.), he pioneered a landscape style that was to inspire countless variations by later painters, bringing landscape wholly within the repertoire of the scholar-painter or *wenren. Dwelling in the Fuchun Mountains,* dated 1350, NPM, Taipei, is his most famous work, displaying a limited range of motifs to create a monumental composition of rivers, forests and mountain ranges of unlimited scope.

Wu Zhen (1280–1354). Another of the four masters of the late Yuan. His landscape paintings are, like those of Huang Gongwang, in the tradition of Juran and Dong Yuan (qq.v.). They show the use of a well-soaked brush and deliberate, rounded strokes and dots. The NPM, Taipei, has a number of his paintings including *Twin Junipers*, *The Central Mountain* and *Stalks of Bamboo beside a Rock*.

Ni Zan (1301–74). Third of the four masters of the late Yuan. Also a poet, calligrapher and landscape painter. From a wealthy family in Jiangsu province, he gave up his fortune to lead a simple life on a boat. He is famous for his dry ink brushwork executed with a slanted brush, and for his sparse dots of intense black. *The Rongxi Studio*, dated 1372, NPM, Taipei, and *Autumn Clearing over a Fishing Lodge*, Shanghai Museum, both exhibit his favourite subject, a small pavilion with bare trees, and favourite compositional scheme, with foreground rocks, a stretch of water and distant hills.

Wang Meng (1308–85). Grandson of Zhao Mengfu (q.v.), from Zhejiang province, surviving briefly into the Ming dynasty and dying in prison. A landscape painter in the style of Dong Yuan and Juran (qq.v.), and one of the four masters of the late Yuan, his main contribution to Yuan painting is the portrayal of mountains as colossal features, exuberant, executed with an extremely varied and rich repertoire of brush techniques, in contrast to the spare and dry style of Ni Zan (q.v.). *The Qingbian Mountains*, dated 1366, Shanghai Museum; *Dwelling in Summer Mountains*, Gugong, Beijing.

Ming dynasty (1368–1644)

Dai Jin (1388–1462), from Qiantang (Hangzhou). Modelled his landscape style on that of Ma Yuan and Xia Gui (qq.v.) of the Southern Song. In the Xuande reign (1426–35) he served for a short time at court. Despite the overtones of the Academy style, his brushwork is distinctively free and lively. *Fishermen on a River*, Freer Gallery, Washington DC; *Returning Late from a Springtime Walk*, NPM, Taipei.

Shen Zhou (1427–1509). Earliest and leading master of the Wu school. He preferred to live in retirement in Suzhou than to serve at the Ming court. A talented calligrapher and poet, as well as a painter, he used the brush styles of the late Yuan landscape painters as vehicles for his own expression, being especially at home with that of Wu Zhen, while also striving to emulate the economy of Ni Zan's brushwork (qq.v.). Besides landscapes, he is known for drawings from life, such as the *Album of Plants, Animals and Insects* (sixteen leaves), dated 1494, NPM, Taipei. *Misty River and Layered Ranges*, Liaoning Museum, is a handscroll in the grand Song manner; *Lofty Mount Lu*, 1467, NPM, Taipei, has all the density and richness of texture associated with Wang Meng (q.v.). At other times, Shen Zhou's depiction of actual places has a refreshing simplicity, capturing essential features with a minimum of detail. *Peach Blossom Valley* (attributed), British Museum [OA 1956.5–12.012, Add 288], provides some idea of his brushwork and large calligraphy modelled on the style of the Northern Song calligrapher Huang Tingjian.

Wu Wei (1459–1508), Jiangxia, Hubei province (where he may have moved from Hunan). His patron in Nanjing, the Duke of Chengguo, was a great collector in whose collections Wu studied the refined *baimiao* ink monochrome, linear figure style of Li Gonglin (q.v.) which is apparent in many of Wu's early paintings such as the handscroll, *The Iron Flute*, 1484, Shanghai Museum. Serving at court in the Hongzhi reign (1488–1505), his version of the Ma-Xia style of landscape painting found favour, and became popular, making him a leading master of the Zhe school. His mature style was characterised by swift, even brash, brushwork later much criticised by Dong Qichang (q.v.). *The Pleasures of Fishing*, Gugong, Beijing, is a fine example of his mature style. The British Museum has several paintings acquired when Wu Wei's work was not highly regarded by Chinese collectors, the most important being the handscroll, *Strolling Entertainers* [OA 1929.11–6.02–08, Add 67], and *Lady Laoyu with the Luan Phoenix* [OA 1913.5–1.010, Painting 84].

Tang Yin (1470–1523), from Suzhou, Jiangsu province. Pupil of Zhou Chen (d. c.1536) who also taught Qiu Ying (q.v.). Tang Yin was befriended by the father of Wen Zhengming (q.v.) and moved among Suzhou's literary circles. He was renowned for his portraits of women and for impressive landscapes inscribed with poems in his distinctive hand. *Thatched Cottage at West Mountain*, British Museum [OA 1965.7–24.07, Add 345].

Wen Zhengming (1470–1559), from Suzhou, Jiangsu province. One of the greatest Ming painters and calligraphers, and the most important painter of the Wu school after his teacher Shen Zhou (q.v.). He served briefly at court after unsuccessfully attempting the tightly constrained state examinations ten times. As a calligrapher, he was equally at home with running script in large or over-sized characters and with precise small regular script. In painting he was equally versatile, bringing finer detailing and a lyrical use of colour to Shen Zhou's landscape style and depicting also figures, ink bamboo and other literati subjects. His followers of the Wu school in the sixteenth century included several members of his own family. *Washing the Feet in the Sword [Jian] Pool*, British Museum [OA 1979.6–25.01, Add 416]; *Wintry Trees*, British Museum [OA 1965.10–11.01, Add 351]; *A Thousand Cliffs Vying in Splendour*, NPM, Taipei; *A Myriad Valleys Competing in Flow*, Nanjing Museum.

Qiu Ying (c.1494–c.1552), b. Taicang, Jiangsu province, and lived in Suzhou. Named with Shen Zhou, Wen Zhengming and Tang Yin (qq.v.) as one of the Four Masters of Suzhou, he was a professional painter and pupil of Zhou Chen, as well as being at home with literati painters. He was a brilliant figure painter and equally skilled in landscapes in the archaic 'blue and green' manner, on account of which many later imitations of

this style are signed with his name. The different aspects of his art are illustrated by *Zhao Mengfu Writing the Sutra in Exchange for a Cup of Tea*, Cleveland Museum of Art, Ohio; *Passing a Summer Day in the Shade of Banana Palms*, NPM, Taipei; and *Saying Farewell at Xunyang*, Nelson-Atkins Museum, Kansas City.

Lu Zhi (1496–1576), b. Suzhou, Jiangsu province. Landscape painter and poet, follower of Wen Zhengming (q.v.). He apparently never held office and eventually retired to a mountain retreat on Mount Zhixing, near Suzhou, where he continued to paint. In his landscapes of the Suzhou region, Ni Zan (q.v.) was evidently an inspiration to Lu Zhi who emulated his angular, faceted forms and dry brushwork, often adding a pale vermilion or pale green. *Huqiu Shan Tu* (*Tiger Hill*), Gugong, Beijing; *Landscape in the Style of Ni Zan*, British Museum [OA 1977.2–28.01, Add 393].

Jiang Song (*fl. c*.1500), from Nanjing. Zhe school painter who captured in his landscape paintings 'all the mists of Jiangnan'. Like other Zhe school painters, he was out of favour with collectors in the Qing dynasty and *Taking a Lute to Visit a Friend*, British Museum [OA 1947.7–12.04, Add 228] had the original signature and seals removed, and a label added attributing it to Xu Daoning (q.v.) of the Song dynasty; but the ink wash foliage of the foreground trees, and other details, are unmistakably those of Jiang Song.

Xu Wei (1521–93), from Shanyin, Zhejiang province. Poet and calligrapher who excelled at plants and flowers in a free or even wild ink wash manner, which was to be a major influence on the painting of Bada Shanren (q.v.). *Ink Flowers*, long handscroll on paper, Nanjing Museum, is one of his major works, culminating in a magnificent stand of banana palms.

Ding Yunpeng (1547–*c*.1621), b. Xiuning, Anhui province. Ding was a professional painter of landscapes, figures and particularly Buddhist and Daoist subjects. *The God of Literature*, 1596, British Museum [OA 1936.10–9.0129, Add 170], is an example of his refined and detailed figure painting in ink monochrome; his paintings in colour are equally accomplished. The woodblock-printed book, *Chengshi Moyuan*, contains some notable designs for ink cakes. Imitations of his work are fairly common among Buddhist and Daoist figure subjects.

Dong Qichang (1555–1636), b. Jiangsu province. The dominant figure of Chinese painting in the late Ming and thereafter. Beginning with the study of calligraphy, he went on to search for and analyse the surviving masterpieces of Song and Yuan painting, with the aim of restoring ancient values to the painting of his own day. Clarity of composition, clear outlines and appropriate motifs were of the greatest importance to him. In the course of authenticating old paintings, he wrote extensively and proposed the theory of the Northern and Southern schools (Painting glossary). According to his theory, literati painters should follow the Southern school exclusively, relying on brushwork and eschewing excessive detail or painterly

effects. He was followed by Wang Shimin (q.v.), who executed a large album of reduced copies of Song and Yuan paintings in his own collection under Dong's guidance, and by other painters of the Orthodox school, such as Wang Jian, Wang Hui and Wang Yuanqi (qq.v.). The short handscroll, *Rivers and Mountains on a Clear Autumn Day*, after the Yuan painter Huang Gongwang (q.v.), Cleveland Museum of Art, Ohio, is a fine example of his style and approach to past masters. The British Museum has a *Landscape* [OA 1963.5–20.04, Add 332] and a handscroll (attributed) of studies of rocks and trees, with notes written beside them [OA 1972.12–11.01, Add 386].

Cui Zizhong (*c*.1594–*c*.1644). Major figure painter of the late Ming dynasty, usually paired with Chen Hongshou (q.v.) – ('Cui in the north and Chen in the south'). Cui was an independent artist following no particular school; a solitary and aloof character, somewhat of a recluse who eventually starved himself to death rather than ask for help. He was probably a member of a Daoist sect and painted many scenes from Buddhist and Daoist literature and legends. His figures often refer to antique models and he concentrated on eccentric archaisms in an original way. *Xu Jingyang Ascending to Heaven*, NPM, Taipei.

Xiao Yuncong (1596–1673), from Anhui province. The first of the Masters of Xin-an (in Anhui), and an *yimin* or 'left-over' subject (Painting glossary) after the fall of the Ming dynasty. The early Qing monk painter Hongren (q.v.), another of the Anhui masters, was his pupil. *Reading in Snowy Mountains*, Gugong, Beijing; *Frosty Woods*, handscroll, British Museum [OA 1963.10–14.02, Add 334].

Xiang Shengmo (1597–1658), b. Jiaxing, Zhejiang province. Son of the great collector Xiang Yuanbian (1525–90), his paintings exhibit rather precisely delineated features and elegant colour in both landscapes and flower paintings. *Reading in the Autumn Woods*, dated 1623–4, British Museum [OA 1960.5–14.01, Add 309].

Chen Hongshou (1599–1652), from Zhuji, near Shaoxing in Zhejiang province. On failing the official examinations, he began to concentrate on his painting in order to earn a living. Early on he developed a distinctive style and a creative transformation of the past that would identify him as an artist worthy of notice. His figure paintings were based on archaistic paintings of historical or Buddhist subjects. He was paired from his stay in Beijing (1640–3) with the artist Cui Zizhong (q.v.) ('Cui in the north and Chen in the south'). He was best known as a painter of figures working in the fine linear style of the fourth-century master Gu Kaizhi (q.v.), but he also painted landscapes and designed woodblock illustrations and playing cards. *Female Immortals*, Gugong, Beijing. In the British Museum, besides several attributed works, there is a fine album leaf, *Landscape*, datable to 1647 [OA 1965.7–24.010, Add 348], and a large hanging scroll, *Chrysanthemums* [OA 1978.10–9.01, Add 408].

Qing dynasty (1644–1911)

Wang Shimin (1592–1680), b. Jiangsu province. Because he himself had a large collection of old masters, Wang Shimin was the best placed of the Orthodox masters to put the theories of Dong Qichang (q.v.) into practice. He did so in a famous album of exact copies, in reduced size, entitled *Within the Small See the Large*, NPM, Taipei, for which Dong wrote the title and inscriptions. In his own landscape paintings, Wang Shimin's preferred style is derived from that of the Yuan master Wang Meng (q.v.). The British Museum's *Landscape*, dated 1654 [OA 1960.10–8.01, Add 311], is inspired by the brush manner of another Yuan master, Huang Gongwang (q.v.). (Painting glossary: Four Wangs, Yun and Wu)

Wang Jian (1598–1677), b. Jiangsu province. The second of the Four Wangs in the group of six Orthodox masters, specialising like Wang Shimin (q.v.) in landscapes after Song and Yuan masters. *Landscape after Juran*, British Museum [OA 1978.6–26.02, Add 402], exemplifies how the Orthodox masters used ancient styles and motifs (here those of the tenth-century master Juran, q.v.), to produce variations in their own distinctive hands (Painting glossary: Four Wangs, Yun and Wu).

Hongren (1610–64), from Anhui province. One of the Four Monk painters (with Bada Shanren, Kuncan and Daoji, qq.v.), a Ming loyalist who became a monk when the Ming dynasty collapsed. He was the first painter to display a distinctive Anhui style, and was especially fond of painting Mount Huang, one of China's most spectacular mountains. The album by him in the Nelson-Atkins Museum, Kansas City, features individual landscape elements each labelled with a single character. *The Coming of Autumn*, Ching Yuan Chai collection, China, shows the same precision in a complete landscape composition.

Kuncan/Shi Qi (1612–73), b. Hunan province. Individualist and one of the Four Monk painters (with Hongren, Bada Shanren and Daoji, qq.v.). He early became a Chan (Zen) Buddhist monk and eventually abbot of a monastery near Nanjing. His paintings are characterised by crowded and restless compositions in which the landscape is broken up into numerous mountain ridges, valleys and rocky outcrops. His brushwork has a dry earthy quality which is frequently enriched by coloured washes. *Autumn* and *Winter*, two album leaves, British Museum [OA 1963.5–20.03, Add 331], were done for a friend, Cheng Zhengkui, in 1666 and are among his finest works. *Spring* and *Summer*, completing the set of four, are now in the Cleveland Museum of Art, Ohio, and the Museum für Ostasiatische Kunst, Berlin, respectively.

Gong Xian (c.1618–89). One of the Eight Masters of Nanjing, and an *yimin* or left-over subject (Painting glossary) of the Ming dynasty, who belonged to a restoration society and subsequently became a recluse. In his rather sombre landscape paintings he merged ink washes with 'piled ink' or layers of brushwork, creating a monumental effect. *A Thousand Peaks and a Myriad Ravines*, c.1670, Drenowatz collection, Rietberg Museum, Zurich, shows him at his most claustrophobic; the British Museum has a more open *Lake View* [OA 1960.10–8.02, Add 312].

Bada Shanren/Zhu Da (1626–1705). Another of the Four Monk painters (see Hongren, q.v.). He was a scion of the Ming royal house and hence another *yimin* or left-over subject (Painting glossary) when the Ming dynasty fell in 1644. His early paintings include albums of flowers and rocks, with recondite poems, and are signed with a variety of obscure names. Later he used quizzical depictions of birds and fish to allude to his distress under Manchu rule, also painting lotuses with broken stems, and ink landscapes. The British Museum has a hanging scroll, *Rocks and Wutong Seeds* [OA 1958.12–13.01, Add 295] and a small *Landscape* [OA 1959.10–10.04, Add 304].

Wang Hui (1632–1717). The most versatile of the Orthodox painters, coached and encouraged, even to the point of passing off his paintings as Song or Yuan originals, by Wang Shimin and Wang Jian (qq.v.). At court in the 1690s he was in charge of producing the series of massive handscrolls describing the Kangxi emperor's *Tours of the South*. The British Museum has only a small fan painting of his, but the anonymous handscroll, *Snow Landscape,* bearing the signature of Fan Kuan (q.v.), is perhaps close to Wang Hui's oeuvre [OA 1913.4–15.03, Painting 17]. (Painting glossary: Four Wangs, Yun and Wu)

Wu Li (1632–1718), b. Jiangsu province. Friend and contemporary of Wang Hui (q.v.) and one of the leading Orthodox painters of the early Qing. Together with Wang Hui he was instructed by Wang Jian and Wang Shimin (qq.v.) and through them became acquainted with and influenced by the landscapes of the Four Masters of the Yuan dynasty, particularly Wang Meng (q.v.). His orthodoxy was shown in his admiration for the ancient masters, yet he believed in manipulating the styles of the Song and Yuan masters to create an intensely personal style. Wu's paintings were much admired by his contemporaries. He eventually became a Jesuit priest in 1688 after which time he apparently painted relatively little. *Pine Wind from Myriad Valleys*, Cleveland Museum of Art, Ohio.

Yun Shouping (1633–90). Flower and landscape painter, friend and near contemporary of Wang Hui (q.v.), and linked with the Four Wangs and Wu Li (qq.v.) as an Orthodox master. Deferring to Wang Hui in landscape, he is known chiefly for his paintings of flowers in the 'boneless' technique. (Painting glossary: Four Wangs, Yun and Wu)

Daoji/Shitao (1642–1707). Descendant of the Ming imperial family. The fall of the Ming dynasty left him a wanderer, and he is known as one of the Four Monk painters (with Hongren, Kuncan and Bada Shanren, qq.v.). His *Huayulu* is one of the most important of Chinese writings on painting, which he discusses from his concept of 'the single brushstroke'. In the same work, he strenuously defends his own originality: 'the beards and eyebrows of the ancients do not grow on my face'. His handscroll painting in the Suzhou Museum, *Ten Thousand Ugly Ink Dots*, bears an inscription in which he declares his purpose to shock the past masters such as Mi Fu

(q.v.). Many of his paintings, such as *Eight Views of the South*, British Museum [OA 1965.7–24.011(1–8), Add 349], are closely linked with his own wanderings in early life; they are frequently complemented with his calligraphy in different styles to match the brushwork of the paintings.

Wang Yuanqi (1642–1715), b. Jiangsu province. Grandson of Wang Shimin (q.v.). Landscape painter, youngest and arguably the most original of the Four Wangs. Perhaps his greatest work is the large coloured recreation of the handscroll, *Wang Chuan Villa*, Metropolitan Museum of Art, New York, a long-lost masterpiece of the Tang poet and painter Wang Wei (q.v.), then, as now, known only from a rubbing and late copies. (Painting glossary: Four Wangs, Yun and Wu)

Shangguan Zhou (1665–c.1750), b. Changting, Fujian province. Primarily a painter of somewhat rustic figures and landscapes, exemplified by the handscroll in the British Museum, *The Fisherman's Paradise* [OA 1965.7–24.012, Add 350]. Huang Shen (q.v.) was his pupil.

Leng Mei (c.1677–1742), Jiaozhou, Shandong province. Professional court painter, specialising in figure painting. He is associated with the Jesuit painter Giuseppe Castiglione (known in China as Lang Shining, q.v.), and introduced him to Chinese painting. *Wutong Shuangtu Tu (Two Rabbits Beneath a Wutong Tree)*, Gugong, Beijing. Paintings in the British Museum: *Portrait of a Lady* [OA 1910.2–12.466, Painting 171]; *Manchu Official at the Door of his Library* [OA 1922.1–19.01, Add 21].

Hua Yan (1682–1765), from Fujian province. Poet and calligrapher as well as painter, noted for his lively and meticulous renderings of birds, but also skilled at figures and landscapes. *The Red Bird*, Elliott collection, Princeton Art Museum, New Jersey; *Mynah Birds and Squirrel*, Freer Gallery, Washington DC.

Gao Fenghan (1683–1748), b. Jiaoxian, Shandong province. Known early on in life for his poetry. He had an official career but never rose very high in rank. His right arm became paralysed in 1737 and thereafter he painted with his left hand. The British Museum has a fine set of fan paintings of landscapes and flowers, all painted before this event [OA 1951.4–7.04–15, Add 260–71], and an album of *Flower Paintings after Designs from the Ten Bamboo Studio* [OA 1951.4–7.03 (1–12), Add 273].

Zou Yigui (1686–1772). Court painter under the Qianlong emperor (r. 1736–96) who commissioned him to paint a pictorial colophon, *Pine and Juniper Trees*, British Museum [OA 1903.4–8.1, Painting 1], at the end of the Gu Kaizhi (q.v.) handscroll, *The Admonitions of the Court Instructress*, regarded as the most valuable painting in the whole of the Palace collection, being installed by the emperor with just three others in a separate pavilion in the Forbidden City. Though now separately mounted, it came to the British Museum with Gu's painting, and also bears the Qianlong emperor's seals.

Huang Shen (1687–1766), b. Yangzhou, Jiangsu province. Pupil of Shangguan Zhou (q.v.), and one of the Yangzhou Eccentrics (Painting glossary). He painted figures and landscapes with lengthy inscriptions in a distinctive cursive hand. *Laozi (Ning Qi) and his Ox*, British Museum [OA 1910.2–12.471, Painting 212], and *The Nine Dragons Rapids* [OA 1960.4–9.01, Add 307].

Lang Shining/Giuseppe Castiglione (1688–1768), b. Milan, Italy. Castiglione became a Jesuit priest in 1707. He arrived in Macao in 1715 and then went to Beijing where he remained until his death. There he became part of the group of Western advisers at the Chinese imperial court. He painted for three emperors, Kangxi, Yongzheng and Qianlong, and also trained Chinese artists in Western techniques. Of all the missionary artists who worked for the Qing emperors, Castiglione was preeminent. His paintings combined traditional Chinese watercolour techniques with the Western use of perspective and chiaroscuro. He excelled in religious painting, portraiture and the painting of animals, flowers and landscapes. *Ten Horses and Nine Dogs*, NPM, Taipei.

Yuan Jiang (c.1690–1724), b. Yangzhou, Jiangsu province. Specialised, like Yuan Yao and Li Yin, in large landscapes, often with prominent architectural features, and composed in a grand manner reminiscent of the monumental landscape style of the Five Dynasties and Song. However, his brushwork, especially in the outlines of rock forms, betrays mannered forms that cannot be mistaken for Song work. *Penglai, Island of the Immortals*, dated 1723, British Museum [OA 1953.5–9.05, Add 283] is a characteristic example of his treatment of legendary subjects.

Zheng Xie (1693–1765), b. Yangzhou. Famous for paintings of subjects such as orchids and bamboo, interspersed with calligraphy in which the characters often display unusual variations. *Orchids on Rocks*, Crawford collection, New York. The British Museum has a handscroll, *Chrysanthemums, Bamboo and Epidendrum*, attributed to him [OA 1951.7–14.037, Add 277].

Luo Ping (1733–99), b. Yangzhou, Jiangsu province. Called himself the 'Monk of the Flowery Temple'. He is regarded as one of the Eight Eccentrics of Yangzhou and became a student of Jin Nong, another of the Eight Eccentrics (Painting glossary). He travelled to Beijing, acquiring many patrons along the way, and was also a good calligrapher and seal carver. He painted many portraits and one of his famous works is *Guiqu Tu* (a series of paintings of ghosts and spirits). Paintings in the British Museum: *Portraits of the Poets Wang Shizhen and Zhu Yizun* [OA 1975.3–3.03, Add 389]; *Monk under a Palm Tree* [OA 1968.10–14.03, Add 365].

Tang Yifen (1778–1853), b. Wujin, Jiangsu province. Tang's style belongs to that of those who in the nineteenth century were still followers of the Orthodox tradition of the seventeenth century. The subject matter of the garden was a popular one in China, where the garden was seen as a microcosm of the larger landscape, and the British Museum has a large handscroll entitled *The Garden of Delight* [OA 1938.12–10.01, Add 177] with many contemporary colophons (Painting glossary: inscriptions and colophons).

Ju Lian (1824–1904), b. Guangdong province. Influenced by the Jiangsu painters such as Song Guangbao and Meng Jinyi who had come to Guangdong to teach painting, Ju Lian and his cousin Ju Chao became masters in the painting of flowers, insects and plants. Ju Lian was especially prolific in painting landscapes and figures. He and his cousin improved on the style of painting known as 'boneless': by sprinkling a white powder on to coloured areas they produced a bright and somewhat glossy surface (*zhuangfen*) and by dripping water on to applied colours while they were still wet they created subtle tonal gradations (*zhuangfei*). *Flowers*, Hong Kong Museum of Art, Hong Kong.

Zhao Zhiqian (1829–84), b. Zhejiang province. Famous seal carver, poet and calligrapher. Also established himself through his flower paintings as one of the foremost painters of the nineteenth century.

The following is a selection of important twentieth-century Chinese artists from the People's Republic of China, Taiwan, Hong Kong and the West.

Qi Baishi (1863–1957), b. Hunan province. Began life as a carpenter, and became a prolific painter of flowers, shrimps, crabs, insects and birds. As he remained in China after 1950 and painted everyday subjects, adding his own calligraphy and seals also carved by himself, he became the best-known painter of the mid twentieth century. The British Museum has a fine study of *Bodhidharma* in a red robe [OA 1967.2–13.03, Add 358], as well as flower paintings from his hand.

Gao Jianfu (1879–1951), b. Panyu, Guangdong province. Together with Gao Qifeng (q.v.) and Chen Shuren (1883–1949), was one of the three founders of the Lingnan school in Guangdong province. They were all influenced by earlier Qing painters such as Ju Lian (q.v.), Ju Chao and Meng Jinyi, and all three also studied in Japan from 1906 to 1911, returning to participate in the revolution. They pioneered a new Chinese movement in painting whereby they advocated the use of Western perspective and chiaroscuro, and Japanese brush techniques, while still employing Chinese traditional ink and colour. Their pupils include Zhao Shao'ang and Li Xiongcai. *Sepia*, Hong Kong Museum of Art, Hong Kong.

Gao Qifeng (1889–1933), b. Panyu, Guangdong province. The brother of Gao Jianfu (q.v.). He studied art in Japan and learned painting from his brother, together with whom he formed part of the Lingnan school. *Cockerel and Hen under a Begonia Tree*, Hong Kong Museum of Art, Hong Kong.

Zhu Qizhan (b. 1892), b. Taicang, Jiangsu province. Member of the Shanghai Painting Academy. As a student Zhu studied Western oil painting and later concentrated on traditional Chinese styles. He paints landscapes and flowers in the bold brush style of Shanghai painters of the nineteenth and twentieth centuries. Many of his landscapes are distinguished by the use of vivid colour.

Xu Beihong (1895–1953), b. Jiangsu province. Major figure in the modernisation of Chinese art. He visited Europe and Japan and held a series of key teaching positions where he advocated the study of realism. The theme for which he is best known in the West is horses, whose spirited movements he captured through rapid and abbreviated brushwork and ink washes. In China, his horses became a symbol of the indomitable national spirit. *Two Horses*, British Museum [OA 1980.5–12.02, Add 425].

Pu Xinyu (1896–1963), b. Beijing. A descendant of the Daoguang emperor, he received a classical education and a traditional training in Chinese painting. His paintings are based on the literati landscape tradition of the late Ming and early Qing but he also studied the work of the Song landscape masters. In 1949 he moved to Taiwan, and during the 1950s was regarded as the leading painter there. He had many students, including Jiang Zhaoshen (b. 1925).

Pan Tianshou (1897–1971), b. Ninghai district, Zhejiang province. Received no formal training in painting or calligraphy but learned from painting manuals such as the Qing dynasty work, the *Mustard Seed Garden Manual of Painting*. In 1923 he went to Shanghai and taught at the Shanghai art college, and his works were influenced by masters of the Shanghai school. His painting followed traditional styles of landscape and bird and flower painting.

Zhang Daqian (1899–1983), b. Sichuan province. Versatile master of painting and assiduous collector, who courted controversy in his personal life through his many forgeries of some of the most famous painters of the past, particularly of the individualist seventeenth-century painter Daoji/Shitao (q.v.). Two years spent at Dunhuang in the 1940s left him with a deep appreciation of bright colour and a lifelong interest in figure painting. One of his best-known forgeries is the large landscape, *Dense Forests and Layered Peaks by the Monk Juran from Zhongling*, signed as Juran (q.v.), in the British Museum [OA 1961.12–9.01, Add 314]. Another *Landscape* [OA 1977.2–28.02, Add 394] illustrates the more abstract style of his late years, when he lived in Brazil and California.

Lin Fengmian (1900–91). Studied in France, returned to China but finally settled in Hong Kong. He wrote extensively on painting, trying to synthesise and harmonise the different qualities of Chinese and Western art. He painted mainly single figures in a square format adapted for framing rather than in the traditional Chinese scroll format.

Fu Baoshi (1904–65), b. Jiangxi province. Educated in China and Japan. He was a calligrapher of note and also cut seals. As a teacher he wrote several books on painting and is regarded as one of the last great literati painters. *Mountain Landscape*, British Museum [OA 1958.12–13.05, Add 299] and *Scholars Suffering from Hardship* [OA 1967.2–13.04, Add 359] were both painted during the war years, when he was living in Sichuan province.

Wang Jiqian/C. C. Wang (b. 1907), b. Jiangsu province. Connoisseur, collector and well-known landscape painter who has lived in New York since 1950. He has formed the extensive Bamboo Studio collection, some of

which is now in the Metropolitan Museum of Art, New York. *Odes of the State of Chen* by Ma Hezhi (q.v.) [OA 1964.4–11.01, Add 338] was acquired from his collection by the British Museum.

Li Keran (1907–89), b. Jiangsu province. Born into rural poverty, he painted water buffalo and herd boys in his early years. His later paintings were generally in black ink, an intensely inked surface becoming one of his trademarks, as well as an innovative use of deeply saturated ink and colour. He was originally a leading exponent of traditional landscape painting, re-establishing the style within the Communist theoretical framework. In the 1960s he developed his own landscape style, adapting Western, conventional perspective. *Landscape in Colours* and *Landscape Based on Chairman Mao's Poem*, both in the Drenowatz collection, Rietberg Museum, Zurich, Switzerland.

Lui Shoukun (1919–75), b. Guangzhou, China, but emigrated to Hong Kong in 1948. He was a Chan (Zen) Buddhist adherent and painted in many styles including those of the classical past. He was influenced by Western art, including Cubism, and had a number of followers such as Irene Chou (b. 1924).

Wu Guanzhong (b.1919), b. Jiangsu province. Studied figure painting in oils in China and then in Paris from 1947 to 1950. On his return to China he took up landscape painting. He sought to find common ground between Chinese and Western techniques, using both line and colour, often with descriptive details, to ensure that a Chinese viewer would recognise the subject matter of more abstract works. In 1990 he turned once more to life studies, with a hint of landscape in the setting. The British Museum has a large horizontal format painting, *Paradise for Small Birds* [OA 1992.5–6.01].

Liu Guosong (b.1932), b. Shandong province. Early on an advocate of anti-traditionalism, aspiring to be a painter in the Western tradition. He attained his maturity in Taiwan and found solutions blending Eastern and Western traditions and incorporating contemporary subjects such as space travel. He modelled his work after Matisse and Picasso, and was also influenced by Klee, De Kooning and Rothko. He has sometimes used a special coarse fibre paper and an ink-laden brush, tearing fibres from the surface after painting to enhance the calligraphic effect.

He Huaishuo (b.1941). Writer, and pupil of Fu Baoshi (q.v.). Studied painting in Guangzhou. He believes in communicating emotion through his paintings, and in covering the whole picture surface, in contrast to traditional Chinese paintings where a balance of solids and voids is sought.

The British Museum has an active acquisition policy in collecting twentieth-century Chinese painting, aiming eventually to assemble a collection representative of all the major twentieth-century movements in the People's Republic of China, Taiwan and elsewhere. Apart from the paintings mentioned above, the British Museum also has works by the following twentieth-century artists: Jia Youfu, Nie Ou, Wu Changshi, Xiong Hai, Yang Yanping and Zhu Xiuli from the People's Republic of China, and Jiang Zhaoshen and Yu Peng from Taiwan.

Alphabetical index of painters

Glossaries

Bronzes

The names of the various vessel and bell shapes are described in the glossary below. Instead of illustrating the main shapes individually, as though they were all equally important and used concurrently, the drawings which follow the definitions illustrate tomb groups of the main periods discussed in chapter 1, showing which vessels were used together and indicating by their numbers and sizes their relative importance to one another.

bo Bell with a flat (as opposed to arched) lip suspended from a loop. The *bo* may have been invented in southern China, enlarging a smaller harness bell called a *ling* (q.v.). *Bo* were introduced to northern metropolitan centres in the second half of the Western Zhou.

ding Ritual vessel for cooked food with a round body and three legs. Used throughout the Shang, Zhou, Qin and Han periods.

dou Ritual vessel for offering food, shaped as a shallow cup on a high foot. Very common in ceramic and lacquer, *dou* were made regularly in bronze from the late Western Zhou.

dui Ritual vessel for offering food, consisting of two matching halves of equal size that make a rounded box when together and two bowls on legs when separated. *Dui* were not used before the Eastern Zhou. They are sometimes called *dun*.

fang ding Rectangular form of *ding* (q.v.), used for cooked food.

fang yi Rectangular ritual vessel for wine, shaped like a box. *Fang yi* were current from about the time of the construction of Fu Hao's tomb in the first half of the Anyang period until the end of the middle Western Zhou.

fou Lidded jar-shaped ritual vessel used from the Eastern Zhou for holding wine.

fu Rectangular ritual vessel for holding food. The lid and body are usually identical in shape. The type was made in bronze from the late Western Zhou, but it seems that earlier bamboo examples had been used. An early Western Zhou bronze that imitates such bamboo items is in the Palace Museum, Beijing. These containers are today known as *hu* or *gu* (qq.v.).

gong Ritual vessel for wine, shaped like a ewer or jug and covered by a lid decorated with animal heads. The type was current from the time of the construction of Fu Hao's tomb in the first half of the Anyang period until the middle Western Zhou.

gu Ritual vessel for wine with a curved profile constricted at the waist. One of the most ancient forms of ritual vessel, ceramic *gu* were used from the Erlitou period.

guan Jar more common in ceramic than bronze; occasionally made in bronze in the Western Zhou, it was used more regularly from the Eastern Zhou, when it was presumably part of the ritual assemblage.

gui Ritual vessel for offering food. For much of the Shang, *gui* seem to have been made without handles and these are sometimes termed *yu* (q.v.); from late Shang and throughout the Zhou most *gui* had two handles, although a few were cast with four.

he Ritual vessel for holding water. In Shang and early Western Zhou times the *he* was used to dilute wine and was therefore classed with wine vessels. During the Western Zhou its function was changed to hold water for ablutions in conjunction with the *pan* (q.v.).

hu Ritual vessel for holding wine. Such vessels were used singly from the Shang period. From the late Western Zhou much larger *hu* were used in pairs.

jia Ritual vessel for wine drinking, with a cup-shaped body supported on three blade-like legs. Some have three lobes. *Jia* also have curved handles and small vertical posts at the lip. Their mouths are circular, not spouted or pointed like those of *jue* (q.v.). The *jia* employed from the Erlitou period was abandoned during the middle Western Zhou.

jian Ritual vessel used from the Eastern Zhou for holding water.

jiao Ritual vessel for wine drinking, with a small cup-shaped body similar to that of a *jue* (q.v.), which opens to a lip in two symmetrical points, without posts. The *jiao* was invented during the Shang and abandoned during the Western Zhou.

jue Ritual vessel used for wine drinking, shaped like a cup supported on three blade-like legs. The mouth has a spout at one end and a point at the other. It can be held by a small curved handle. Invented in the Erlitou period, *jue* went out of use at the end of the middle Western Zhou.

lei Ritual vessel shaped like a tall jar with a constricted neck for holding wine.

li Trilobed ritual vessel for cooking food.

ling Small bell with a clapper; the shape was much enlarged to make the *bo* (q.v.).

nao Bell supported mouth upwards on a tubular handle and struck at two points on the outside. The cross-section is elliptical and the lip is sharply curved.

niu zhong Bell shaped like a *zhong* (q.v.) but suspended from a loop like a *bo* (q.v.).

pan Shallow basin used as a ritual vessel for holding water.

pen Relatively deep basin; in use in bronze from the middle Western Zhou.

pou Ritual vessel of depressed jar shape for holding wine. The *pou* was particularly popular in the period transitional between Erligang and the main Anyang period.

xu Rectangular ritual vessel for food based upon the *gui* (q.v.). Used from the latter part of the Western Zhou.

yan Ritual vessel in the shape of a steamer consisting of the trilobed lower half, resembling a *li* (q.v.), with a basin above, the two portions being divided by a perforated plate through which steam could rise.

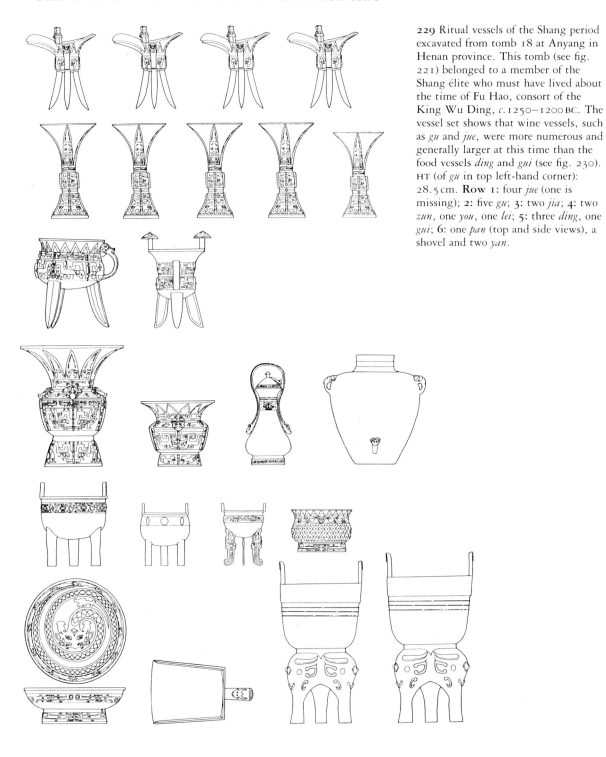

229 Ritual vessels of the Shang period excavated from tomb 18 at Anyang in Henan province. This tomb (see fig. 221) belonged to a member of the Shang élite who must have lived about the time of Fu Hao, consort of the King Wu Ding, *c.*1250–1200 BC. The vessel set shows that wine vessels, such as *gu* and *jue*, were more numerous and generally larger at this time than the food vessels *ding* and *gui* (see fig. 230). HT (of *gu* in top left-hand corner): 28.5 cm. **Row** 1: four *jue* (one is missing); 2: five *gu*; 3: two *jia*; 4: two *zun*, one *you*, one *lei*; 5: three *ding*, one *gui*; 6: one *pan* (top and side views), a shovel and two *yan*.

yi Late Western Zhou vessel, also current in the Eastern Zhou, employed with *pan* and in place of *he* (qq.v.) for washing.

yong zhong See *zhong*

you Ritual wine vessel with an S-shaped profile, a lid and a long U-shaped handle. In use from the late Shang period until the middle Western Zhou.

yu Ritual basin-shaped vessel used for water. The name is also used for a food vessel not unlike a *gui* (q.v.).

zhi Short beaker-shaped ritual wine vessel used from the late Anyang period up until the middle Western Zhou.

zhong Modified form of the *nao* bell (q.v.), suspended by a small loop on its tubular handle. Invented in southern China, such bells were imitated in the north from the early Western Zhou.

zun Ritual wine vessel consisting of a jar with a widely flared lip supported on a tall footring. In the second half of the Shang the shouldered *zun* was replaced by a taller columnar vessel based on the *gu* (q.v.) and often designated as a cylindrical *zun*.

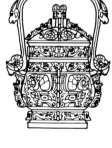
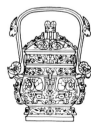
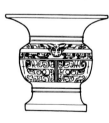
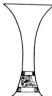

230 Ritual vessels of the early Western Zhou (*c.* 950 BC) period excavated from tomb 7 at Baoji Zhuyuangou in Shaanxi province. This tomb (see fig. 222) belonged to a member of the ruling house of the small Yu state, occupying territory to the west of the Zhou centres in Fufeng and Chang'an (present-day Xi'an). Compared to the earlier set shown in figure 229 (opposite), the food vessels, *ding* and *gui*, have increased in size and therefore probably in importance relative to the wine vessels *gu* and *zhi*. Among the wine vessels of this date, the two *you* and one *zun* were among the most beautifully decorated. The second *zun* is an heirloom handed down from a previous generation. HT (of *ding* in top left-hand corner): 36.8 cm. **Row 1**: three *ding*; **2**: two *gui*; **3**: a *zun* with two matching *you* and a more old-fashioned *zun*; **4**: two *gu* and a *zhi*.

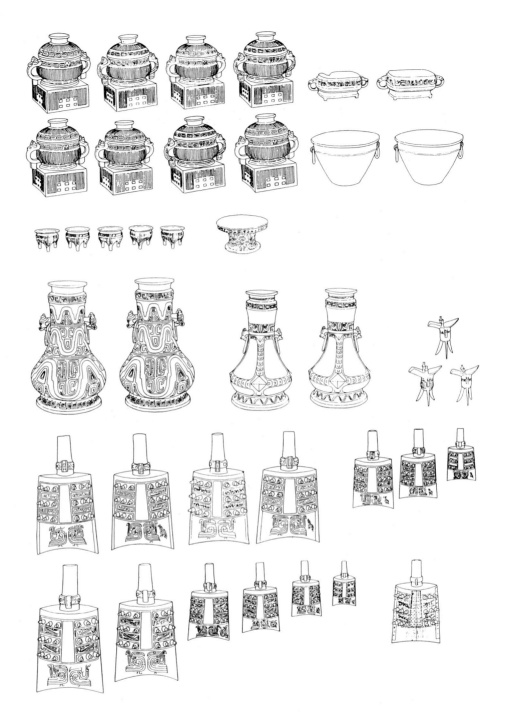

231 Ritual vessels and bells belonging to Wei Bo Xing found with a hoard of 103 bronzes belonging to one family, excavated at Shaanxi Fufeng Zhuangbai, late Western Zhou (*c.* 880 BC). Hoards such as this one were buried when the Zhou were forced to flee from Shaanxi in 771 BC. Their owners obviously hoped to return to collect the bronzes when the danger had passed, but they never did. This set of bronzes illustrates the changes that had taken place in the performance of ritual towards the end of the middle Western Zhou. The use of large numbers of highly decorated wine vessels had given way to substantial sets of rather plain food vessels. *Ding* are missing, but Wei Bo Xing would presumably have owned nine, the appropriate number to go with the eight surviving *gui*. His family may have taken the *ding* with them when they fled. Five *li* still remain from the sets of food vessels. Dramatic additions are large *hu* for wine and sets of bells. Three *jue* are the remnants of an earlier tradition (see fig. 229), soon to disappear. HT (of *gui* in top left-hand corner): 35.7 cm. **Row 1:** four *gui* cast on square bases, two *xu*; **2:** four *gui* cast on square bases, and two *pen*; **3:** five *li*, one *fu* (*dou*); **4:** four *hu*, three *jue*; **5–6:** fourteen bells.

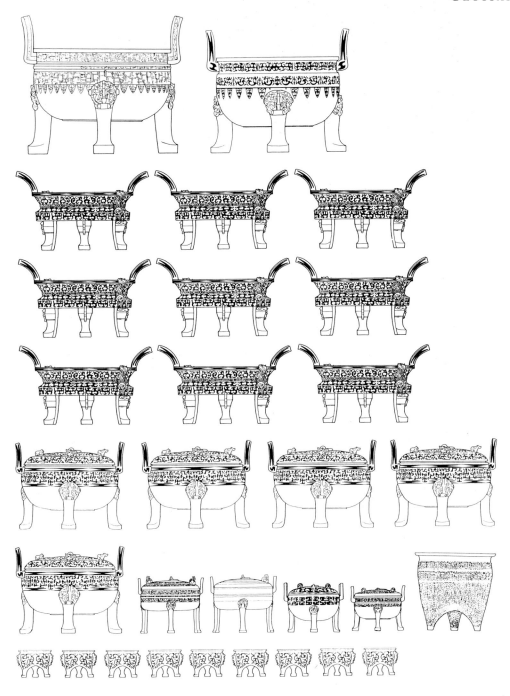

232 Ritual vessels of the late Spring and Autumn period (*c.* 433 BC) from the tomb of the Marquis Yi of Zeng at Sui xian, Leigudun, Hubei province (see also pp. 352–3). The marquis was a ruler of a petty state to the north of the great state of Chu. Sets of bells (ch. 1, fig. 42), materials such as lacquer, jade and gold, and the large number of ritual vessels (*above* and continued overleaf) demonstrate his wealth and status. The vessel set is based on the functions and shapes devised at the time of the ritual changes in the middle Western Zhou (see fig. 231). HT (of *ding* in top left-hand corner): 64.6 cm. **Row 1**: two large *huo ding*; **2–4**: nine *sheng ding*; **5–6**: five matching covered *ding*, four unmatching covered *ding*, one large *li* in pottery form; **7**: nine *li*.

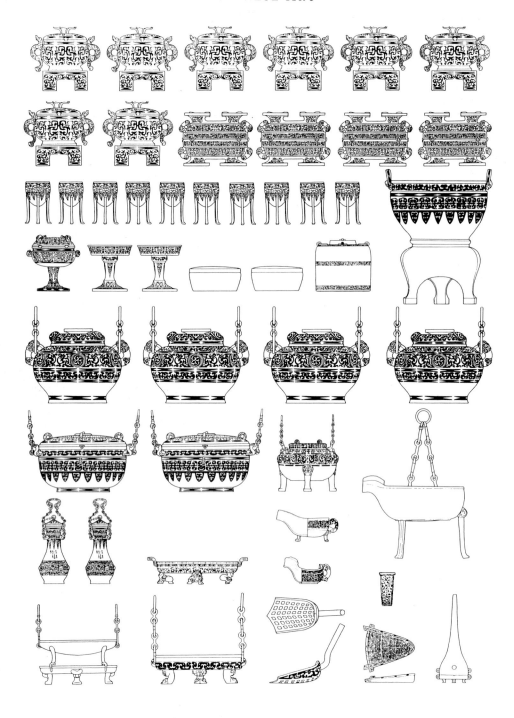

Food vessels are much in evidence in the groups from the tomb of the Marquis Yi of Zeng, as shown in the rows of *ding* (p. 351) and *gui*. By this date bronze incense burners, braziers and shovels were also an essential part of the set. **Rows 1–2**: eight *gui*, four *fu*; **3**: ten egg-shaped cups; **4**: three *dou*, two boxes, one covered jar, one *yan*; **5**: four *fou*; **6**: two covered basins, one narrow-necked *ding*; **7**: two *hu* with chains, one *pan*, two *yi* and one *yi* with a chain; **8**: two *pan* with chains, two shovels, two incense burners.

The sets of vessels found in the tomb of the Marquis Yi of Zeng (opposite and p. 351) also contained a number of highly unusual wine vessels (rows 2–3). **Row 1:** two *hu* on a tray (HT: 99 cm), two large jars; **2–3:** two square *hu* in square buckets, one ladle, one *zun* (HT: 30.1 cm); **4:** one *pan* with lost-wax cast decoration (HT: 33.1 cm). (These illustrations have been drawn to a different scale than those on the preceding two pages.)

Painting and calligraphy

Academy of painting Semi-bureaucratic institution drawing on the Song court painters, competent in a wide variety of painting types and styles. The Song academy, officially founded in AD 984, was modelled on the academies of the tenth century in the minor states of the Former Shu (907–25), Later Shu (934–65) and the Southern Tang (937–75). The early academy was a melting pot for many different styles, but with a particular emphasis on figure painting. The development of the court academy also fostered the ambition of the scholar-artists to free painting from the stigma of its being a minor craft skill, which in turn promoted the development of the so-called literati painting (q.v.). There was no official imperial painting academy between 1350 and 1650. During this time certain painters were officially summoned to court and undertook special commissions. Their paintings owed much to the former Southern Song Academy and other conservative styles practised under the Song. During the Qing dynasty there was an Academy of painting under the Kangxi (1662–1722) and Qianlong (1736–95) emperors.

album paintings Generally circular, oval or rectangular paintings – shapes not suited to scroll mounting (q.v.) – pasted into albums. Such paintings are assembled from stiff leaves which are made by laminating sheets of paper with starch paste. Some are joined at both vertical edges, others are in landscape format. Some albums are like a concertina, allowing the whole to be opened out and all paintings to be viewed simultaneously. Others are adhered in from the edge so only one painting is viewed at a time. There were generally six to twelve paintings in an album, not all necessarily by the same artist but generally related in theme. Often the paintings are on one side of the page, with calligraphy on the other. Although this type of format probably first became popular in the Southern Song period, when an intimate style of painting was favoured, it was not until the Yuan dynasty that paintings appear to have been produced specifically for mounting in album format.

banners Religious paintings on silk or woven textile, hung in temples or carried in procession. Buddhist banners are well illustrated by those from Dunhuang in the British Museum's collection. The form of the vertical scroll is possibly derived from the banner. The painting, usually on textile, was backed by another textile, and mounted in borders, the whole being hung from a triangular headpiece in the case of narrow examples. Larger pieces were suspended from small loops.

Bifaji *Notes on the Art of the Brush*. Famous treatise on painting by Jing Hao (b. *c*.870/80, d. *c*.925/35).

brush See **four treasures**

caoshu 'Grass' or draft script. The oldest style of fully cursive, informal, script. It developed out of *zhuanshu* and *lishu* (qq.v.) in an abbreviated form.

colophons See **inscriptions and colophons**

distance The Chinese term for linear perspective is *jin yuan* (near and distant) and this is further subdivided into three 'distances', which describe the types of scenic view distinguished by the position of a main horizon from which the eye instinctively begins but cannot complete exploring the picture surface; it does not define perspective drawing in the Western sense. According to the Northern Song painter Guo Xi (*c.* 1001–*c.* 1090), a mountain has three dimensions: looking up to the top from below gives the dimension called height, that is high distance; looking toward the back from the front gives the dimension called depth, that is deep distance; looking across at a mountain from an opposite height gives the horizontal dimension, that is level distance.

Eight Eccentrics of Yangzhou The largest aggregate of capital in seventeenth- and eighteenth-century China was concentrated in the city of Yangzhou, in Jiangsu province, where many rich salt merchants patronised the arts. A group of painters, centred in Yangzhou, developed a highly idiosyncratic style, showing unfettered movements of brushwork, e.g. Gao Qipei (*c.* 1672–1734), who painted with his fingers and nails. There were in fact more than eight 'Eccentrics', but they generally include: Hua Yan (1682–1765), Luo Ping (1733–99), Zheng Xie (1693–1765), Huang Shen (1687–1766), Gao Fenghan (1683–1748) (Painters list) and Wang Shishen, Gao Xiang, Min Zhen, Jin Nong, Li Fangying and Gao Qipei.

fan painting In the hot and humid climate of the Far East fans were widely used by men and women. The paper or silk that covered the frame was often decoratively painted. There were three basic types of fan. The *bian mian* (face cover) was a rigid, usually round, fan made of feathers or silk stretched over a frame and decorated with painting or embroidery. A ceremonial fan was mounted on a long pole or handle and used in addition to the banner and umbrella-like canopy for official occasions. Folding fans, the third type, were further subdivided into three: those made from feathers, those made from paper supported by individual sticks, and those made from rigid segments joined at the base by a rivet and at the top by a thread. Fan painting, as a type, was not recognised as an established genre of Chinese painting until the Song dynasty (although painted fans are known to have existed from at least the fifth century). It then became the practice to commission friends or famous artists to produce paintings that could be so used. The fan painting, in either the round or folding arc-shaped format, allowed the artist to show intimate genre and other subjects and to display his expertise in managing a composition in an unusual format.

Four Great Yuan masters Huang Gongwang (1269–1354), Wu Zhen (1280–1354), Ni Zan (1301–74) and Wang Meng (1308–85). (For biographical details see Painters list.)

Four Monk painters Hongren (1610–64), Bada Shanren/ Zhu Da (1626–1705), Daoji/Shitao (1642–1707) and Kuncan/Shi Qi (1612–73). (For biographical details see Painters list.)

four treasures Brush, ink, inkstone or slab and paper:
 brush Chinese *bi*, generally made of goat's hair carefully graded and glued into the end of a bamboo tube. A great variety of animal fibres has been employed in making Chinese brushes, including rabbit hair (a brush made of rabbit hair was excavated from a late Zhou site at Changsha in Hunan province, fourth–third century BC). Other materials include the hair of the wolf, sable, fox, deer and hare, and hog bristle. Sheep and goat hair are more suited to bold work and rabbit hair to more delicate work. After special washing to remove oils, the fibres are tied in a bundle and then glued into the hollow socket of a holder. The holder may be of bamboo or some more precious material, such as lacquer, ivory or porcelain.

 ink Chinese *mo*. Chinese ink is a carbon black pigment produced from soot which is bound with animal glue and moulded in cake form.

 inkstone or slab Often the most treasured item of a calligrapher. The inkstone requires a smooth flat sloping area for rubbing the inkstick with water, and a well or depressed area to collect the ink. The best examples will often be beautifully carved and use the veins and colour variations in the stone to give relief to the motifs of their design. They can be made out of various materials, principally stone, but also ceramic. Among the most prized materials for inkslabs are Duanzhou stone from Guangdong province, Shexian stone from Anhui province and Chengni clay from Jiangzhou in Shanxi province.

 paper The invention of paper is attributed to the eunuch Cai Lun, in the early second century AD. However, excavations from a tomb near Xi'an have produced samples of what is thought to be paper dating from the second century BC. Paper was not at first used for documents and religious texts and was only regularly employed for painting from the Yuan dynasty. Many different papers were developed for the different requirements of writing, painting and printing. From China, paper spread to all parts of the world.

Four Wangs, Yun and Wu The principal painters of the so-called Orthodox school of the seventeenth century. Wang Shimin (1592–1680) was a pupil of Dong Qichang (1555–1636); he and Wang Jian (1598–1677) together coached Wang Hui (1632–1717), who became a successful painter at court in the 1690s. The fourth Wang, Wang Yuanqi (1642–1715), was the grandson of Wang Shimin. Yun Shouping (1633–90) and Wu Li (1632–1718) complete the group of Orthodox masters: the former was a friend and exact contemporary of Wang Hui, but did not enjoy the same social success; the latter was a convert to Christianity, though this left no mark in his painting style. (For biographical details see Painters list.)

handscroll See **scrolls**

hanging scroll See **scrolls**

Huashi *The History of Painting*. Written by Mi Fu (1051–1107).

ink See **four treasures**

inkstone See **four treasures**

inscriptions and colophons Artists, especially scholar-officials, generally signed their work giving such information as the title of the painting, its date and for whom it was painted. Sometimes a poem might also be appended, or comments relevant to the painting. The artist added a seal impression as the equivalent of a signature at the end of the inscription. Many artists used several different names during their careers. Thus a seal may give the artist's given name, his family name, his artistic or studio name, the name of his

home or studio, the date of his birth, a poetic name, or a pictorial symbol.

Subsequently, when collectors acquired works of art, they frequently added their own seals, sometimes with a dedicatory **colophon**. If such a colophon belonged to an eminent collector, it added value to the painting and confirmed its authenticity, becoming itself an important part of the work. The earliest colophons are brief comments added to the end of transcriptions of Buddhist sutras and most of these date from the fifth and sixth centuries. A colophon may be only a signature but often includes a date, place name, explanation as to why it was written and a dedication. The Qing Emperor Qianlong was particularly well known for his dedicatory colophons, some of which are extremely long.

jiaguwen Oldest form of Chinese calligraphic script, first used in the Shang dynasty for writing on oracle bones.

kaishu Regular script. The standard form of script, which replaced *lishu* (q.v.) in the Six Dynasties period (265–589). It is also referred to as *zhengshu*, standard script. It was the last of the calligraphic styles to emerge and was fully developed by the end of the fifth century AD. The characters are clearly defined, stroke by stroke.

Lidai minghuaji A Record of Famous Painters of all the Dynasties (trans. in W. R. B. Acker, *Some T'ang and Pre-T'ang Texts on Chinese Painting*, Leiden, 1954). Compiled by scholar-artist Zhang Yanyuan (Painters list) in AD 845. Zhang expounds some of the traditional views on contemporaneous painting and gives a short history of its early development.

lishu Clerical script. Official or clerical script from which today's regular characters have evolved. *Lishu* flourished in the Han dynasty (206 BC–AD 220) and from the third century AD replaced *zhuanshu* (q.v.) as the most widely used script.

literati painting Chinese *wenrenhua*. Term applied to painting undertaken by scholar-officials as opposed to professional painters. The tradition developed from the reactionary attitude of eleventh-century scholars such as Su Shi (1036–1101) to the practices and aims of the Song academy. Su and his friends were all primarily officials. The aims of such artists included the expression of ideas and feelings rather than the creation of exact depictions. They believed that a painting should not aim to be an exact copy of reality but should reveal something about the artist and his mood, with nature serving as the raw material which the artist transformed into some form of artistic idiom. They often worked in ink rather than in colour, deliberately interpolated archaisms and other eccentric touches, and specifically painted for themselves and their own circle, vehemently refusing any money for their works of art.

Literati painting did not emerge as a distinct category until the Ming dynasty. By this time there was a definite view that literati painting was superior to professional painting, because of its emphasis on ink painting, its spontaneous approach, and its lack of interest in realism, which so concerned the professionals.

Lofty Message of Forests and Streams Valuable source of information about Song attitudes to landscape, and techniques of composition and brushwork, written by the artist Guo Xi (c.1001–c.1090). (Passages of this text are translated by J. Hay in S. Bush and Shih Hsio-yen (eds), *Early Chinese Texts on Painting*, Cambridge, Mass. and London, 1985.)

mounting The mounting of a Chinese painting is not analagous to the framing of a Western picture. A frame is only an incidental and can be changed easily, but the mounting of a Chinese picture is an essential and integral part of the painting, providing a strengthening for the frail silk or paper and an enhancement of the picture's beauty. The art of mounting scrolls probably began in the second century AD, as before then painters worked mostly on wooden and lacquered surfaces or directly on walls. However, when silk and paper gained in popularity as suitable media for painting, mounting became a necessity. The oldest literary source giving a description of the mounting process is the *Lidai minghuaji* (*A Record of Famous Painters of all the Dynasties*, q.v.), compiled in AD 845 by Zhang Yanyuan, a scholar-artist, and most of the processes described are still followed today. Traditionally Chinese paintings of the hanging scroll format were prepared for display with borders of silk brocade. The painting was first lined with paper, the silk brocades attached and a further two layers of paper adhered to the verso of the entire ensemble. It was then pasted on to a board by its edges and allowed to pull flat. On removal from the board, it was burnished on the verso before the attachment of a wooden stave and roller to the top and bottom. The techniques involved dictate a high level of skill and constitute an art form, with very precise rules, which are essential to provide the flexibility required when the painting is unrolled for viewing. It is usual for a painting to be remounted when the original mount becomes damaged or worn.

Northern and Southern schools The division of the principal ancient painting styles by Dong Qichang (1555–1636) into Northern and Southern schools was made by analogy with the Northern and Southern schools of Chan (Zen) Buddhism of the Tang dynasty. Chan rejected the traditional monastic disciplines leading to enlightenment. So in painting, *wenren* or literati painters who rejected the professional methods of the court painters were considered to be in the Southern tradition, while professional painters were dismissed as Northern by Dong and his followers. Nevertheless, rigorous study and practice of such aspects of painting as brushwork and composition remained necessary even for artists of the Southern school. The eventual aim was that they should become second nature so that the hand and brush responded directly to the artist's experience. Dong Qichang also traced the two schools back to the Tang dynasty through his investigations of ancient paintings: the Northern school to Li Sixun (651–716) and Li Zhaodao (fl. c.670–730), famous for their mastery of the 'blue and green' landscape manner; the Southern school to the monochrome landscape style of the poet-painter Wang Wei (699–759).

painting techniques Some of the main ones are:
 bai miao Literally 'white sketch' drawing. Achieved by drawing the outline in one ink tone only and leaving the plain ink drawing uncoloured or coloured only with a flat wash of ink.
 cun Texture strokes which shade and model contour lines. Term may be translated as 'wrinkles'. After a form has been outlined, character and contour are added using *cun*. There are some twenty-five varieties of *cun* strokes, including *yu dian cun*, raindrop *cun*, i.e. the strokes resemble raindrops; *pi ma cun*, brushstrokes like spread-out hemp fibres; *da/xiao fu pi cun*, brushstrokes like big/small axe cuts.
 fei bai Literally 'flying white'. Characters so written that the hairs of the brush separate, leaving blank streaks not

covered with ink. The effect is one of speed and lightness and is primarily associated with writing; in painting it is seen mainly in the depiction of bamboo.

gan bi Literally 'dry brush'. Very sparing use of ink in ink painting, exemplified by Ni Zan (1301–74), of whom it was said 'he was economical of ink as if it were gold'.

gong bi Meticulous brushwork, confined to painting in colours.

lan ye ('orchid leaf') and **ma huang** ('grasshopper-waist'). Two styles of drawing used to depict thick and thin drapery lines in a fluctuating, inflected linear style, particularly associated with the Song artist Ma Hezhi (fl. c. 1131–62).

mo gu 'Boneless painting'. Painting in colour without outline.

pomo Literally 'broken ink'. The defining of the outline and general configuration of rocks to create a sense of modelling and depth. Can be seen in the works of Wang Meng (1308–85) and other Northern Song artists, for example.

qing lu 'Blue and green' painting. Term used with reference to landscape in the Tang tradition.

shui mo 'Ink painting'. Painting without colour.

xie yi 'Free sketch'. The writing of ideas, a term used to suggest that the painting of the scholar-officials was to convey meaning or mood by analogy with the expressiveness of poetry.

zhitouhua Finger painting. The use of fingers and nails for painting instead of, or in addition to, the brush.

paper See **four treasures**

perspective See **distance**

scrolls The most common methods of mounting Chinese paintings were the hanging scroll and handscroll formats. Scrolls, which are so characteristic of Chinese painting, have a long history. Traditionally, before the invention of paper, the Chinese wrote on silk or bamboo strips which were folded up for storage. These, as well as religious textile banners, influenced the development of the mounting of Chinese paintings in scroll format. Other formats were the album and fan paintings (qq.v.).

The **hanging scroll** gives a vertical format which was intended to be hung and viewed by a group of people together. It was used for large-scale landscapes and figure compositions. By the tenth century AD, the hanging scroll format was in popular use and was very well suited to the monumental style of Song dynasty landscapes.

Handscrolls were made by joining sheets of paper or silk. The horizontal continuous scroll, generally measuring between one and nine metres in length and 25–40 cm in height, is gradually wound and rewound to show a picture section by section. The right-hand end of the handscroll would have been tied to a semicircular rod, and the other end to a dowel. The scroll would then be rolled up around the roller from left to right until the rod was reached, whereupon it would be securely tied with ribbons. The roll would then be unrolled from left to right and the painting viewed from right to left. As scrolls can be very long indeed they were never intended to be seen in their entirety at one glance but were to be viewed section by section, as if a text. It was the format of the intimate art form, best viewed by a few people only; the subject matter and the painting style were therefore more delicate than in a hanging scroll. Handscrolls often have narratives with text and paintings interspersed. One of the earliest extant handscrolls combining painting

and calligraphy is the British Museum's *Admonitions of the Court Instructress*, attributed to Gu Kaizhi (c.344–c.406).

Wall scrolls were used for the display of 'horizontal' paintings or calligraphy. They are mounted in similar fashion to hanging scrolls, but horizontally with tabs to support the painting at intervals along its length.

seals Painting and calligraphy are often marked with vermilion seal impressions. These may be affixed by the artist or his friends, or by collectors and connoisseurs.

Six Canons of Painting Formulated by Xie He in about AD 500, since when they have dominated the aesthetics of Chinese painting and formed the basic standards of art criticism. The terms are best understood in a Chinese context and exact translations are therefore very difficult.

The six points Xie He thought should be considered when judging a painting were:

1. **spirit resonance** (qi yun sheng dong), by which he meant the vitality of the painting, the energy generated by the artist through his brush in depicting what he painted.

2. **bone method** (gu fa yong bi), referring to the use of the brush.

3. **reflecting the object** (ying wu xiang xing), referring to the depiction of the forms.

4. **appropriateness to type** (sui lei fu cai), referring to the application of colour.

5. **division and planning** (jing ying wei ji), referring to the placing and arrangement of the composition.

6. **transmission and conveying** (chuan yi mo xie), referring to the established Chinese practice of copying old and famous models.

Southern school See **Northern and Southern schools**

wall scroll See **scrolls**

wenrenhua See **literati painting**

Wu school So called after the Wu district, around Suzhou, a centre of culture and painting which provided the setting for literati, calligraphers and painters during the Ming period. Shen Zhou (1427–1509), Wen Zhengming (1470–1559), Tang Yin (1470–1523) (Painters list) and sixteenth-century followers of Wen Zhengming, such as his second son Wen Jia and nephew Wen Boren, as well as Lu Zhi, Wang Guxiang, Xie Shichen and others, were all Wu school painters. All were literati painters (q.v.) who inscribed their paintings at some length. In contrast, the professional painters of the Zhe (Zhejiang province) school (q.v.) generally added only a brief signature to their works.

xingshu Literally 'running script'. A semi-cursive style of calligraphy but not as fluent or abbreviated as caoshu (q.v.).

Yangzhou eccentrics See **Eight Eccentrics of Yangzhou**

yimin Literally 'left over'. Term used to refer to loyal subjects of the Ming dynasty group of painters who were reluctant to take office under the non-Chinese, Manchu Qing dynasty, and who would not serve the court as members of the academy.

Zhe school So called after Zhejiang province. During the early years of the Ming dynasty, Hangzhou became the centre of this school. The painters, such as Dai Jin (1388–1462), were generally professional and court painters, modelling themselves after the romantic landscape stylists of the Southern Song academy.

zhuanshu Epigraphical or seal script. In use in the Zhou and Qin dynasties (eleventh to third century BC), it comprised two types: the *dazhuan* or great seal script and the *xiaozhuan* or later small seal script.

Clothing and materials

block printed Patterned by the use of one or more carved wooden blocks. Two kinds of block existed: small regularly shaped blocks were used to print repeating designs of scattered motifs, the resist medium or dye (q.v.) being applied directly with the block; pairs of larger 'clamp resist' blocks were clamped around the folded cloth, and dyes were poured through the blocks from the back to create areas of different colour on the cloth, corresponding to the carved hollows in the block. See also **resist-dyed**

brocade Term without a precise English meaning, often used in modern translations of Chinese texts to denote complex multicoloured weaves covered by the Chinese term *jin*, in particular warp-faced compound tabby (q.v.) and weft-faced compound twill (q.v.).

brocaded Where a figured design is partly or wholly created by an additional or pattern weft (q.v.). The movement of a brocaded weft is limited to the width of the area where it is required, and it does not travel from selvedge to selvedge. Brocaded satin (q.v.) was common from the Ming dynasty.

chain stitch Embroidery stitch produced by forming a loop with an embroidery thread so that the resulting pattern resembles a chain. It is one of the oldest techniques in Chinese embroidery (q.v.). There are several variations of the basic stitch.

chaodai Court belts which held the *chaopao* (q.v.) tightly around the waist. The colour of the belt varied according to rank: the emperor wore yellow (although at imperial sacrifices he wore other colours), the crown prince apricot yellow and other royal family members wore golden yellow. The *chaodai* was decorated with four belt-plaques which the Manchus adopted from the Ming courtier's insignia. The plaques differed according to the rank of the wearer. The emperor had two types: the first was round, set with either red, blue or turquoise stones; the second was square with different settings depending on the ceremony to which it was being worn. Other royal family members wore belt-plaques set with different stones. High-ranking officials wore plaques inlaid with a piece of white jade, in the centre of which was set a single red stone, and lower-ranking officials wore plainer ones. Two small purses were suspended from both the left and right sides of the belt, either plain or embroidered (q.v.) depending on the occasion. A small knife and ceremonial kerchiefs were also suspended from the belt.

chaofu Court dress, a term including all types of official dress worn on state and ceremonial occasions by both men and women. The *chaofu* was basically inherited from the Ming Chinese by the Manchu but retailored to suit their own taste. The final form of *chaofu* was regulated in the Qianlong reign when its details were incorporated into the *Huangchao liqi tushi* (q.v.). It would appear that the twelve symbols (q.v.) were added to the design of imperial robes sometime between 1736 and 1759.

chaopao Part of the court robe. A full-length, side-fastening robe. See also **chaodai** and **chaofu**

chaozhu Court necklace, an important adjunct to court dress for both men and women, and possibly originating from the Buddhist rosary. Its use was restricted to imperial nobles and officials down to the fifth rank. Women wore three separate such necklaces with their *chaofu* (q.v.). The stones of which these necklaces could be made were strictly regulated according to rank: for example, a pearl necklace could be worn only by the empress or empress dowager.

damask Figured weave (q.v.), usually monochrome, with one warp and one weft (qq.v.), in which the pattern is formed by a contrast of binding systems. In its classic form it is reversible, and the contrast is produced by the use of the warp and weft faces of the same weave. Twill (q.v.) damask with contrasting warp-faced and weft-faced areas is well represented among the Shōsō-in silks. (The Shōsō-in is an imperial Japanese repository at the Tōdai-ji temple in Nara which was sealed up in the eighth century, its contents including many Chinese imported treasures.) With the development of satin (q.v.) in the twelfth or thirteenth century, satin damask became an important weave. The term damask is also frequently applied to the self-patterned (q.v.) silk cloths with a tabby ground and a twill pattern which occur from the Han period onwards.

dragon robe See *longpao*

dyes and pigments A dye is a colouring matter which is initially soluble in water but which becomes physically or chemically attached to the textile fibre. A pigment, in contrast, is a material applied to a surface by a binding medium. Important Chinese dyes of vegetable origin have been safflower, sappan wood and madder, all producing reds or pinks; magnolia and indigo for blues; *shikonin* for purple; gardenia, turmeric and various other plants for yellow; tannin with iron for brown and black. On early Chinese textiles a number of pigments were applied including cinnabar (mercuric sulphide) and vulcanised lead, as well as powders of gold, silver and mica. Perhaps growing out of the use of pigments, dyes in certain circumstances were also applied to woven silk (q.v.) cloth by brushing rather than by means of a dye bath, these painted dyes being afterwards 'fixed' by steaming and washing. Such methods were particularly associated with printed or stencilled resist designs. See **resist-dyed**

embroidery Decorative sewing. Embroidery on silk fabrics (qq.v.) has been found in China from the Shang period, sometimes with the addition of painting. Early designs were geometric, with patterns of twisted grass, and chain stitch (q.v.) was the only stitch used. Later embroidery techniques included satin stitch (q.v.), straight encroaching stitch, knot stitch, couching, appliqué, gauze (q.v.) embroidery or 'woven-in' designs and *gu* embroidery (q.v).

figured weave Term used to designate weaves in which one or more of the warps (q.v.) is controlled by a figure harness

or patterning mechanism; in other words, a weave where the design has been preselected during the setting up of the loom.

gauze Weave in which warp threads (q.v.) called 'doup ends' are made to cross over other warp threads called 'fixed ends', resulting in an open texture. Figured gauzes are created by altering the direction and complexity of the crossings or by employing contrasting areas of plain or 'tabby' weave (q.v.). Gauze (*luo* in Chinese) is a very important Chinese weave with a continuous history.

Gongbu Ministry of Works. One of the top-grade agencies under, variously, the Department of State Affairs, the Secretariat, and after 1380 directly subordinate to the emperor, though from the early fifteenth century it was also under the supervisory co-ordination of the Grand Secretariat (Neike). The Gongbu was in general charge of building projects, conscription of artisans, maintenance of roadways, etc. In addition it normally supervised a large number of storehouses, supply agencies and factories throughout the empire. The term was used from the Northern and Southern Dynasties period (386–589) till the Qing dynasty.

gu embroidery Style of embroidery (q.v.) which attempts to imitate famous paintings of birds, flowers and landscapes. Some areas may be painted, and the colour shading and layering in the embroidery is very rich. It employs many stitching techniques.

Guangqu si Office of the Privy Purse, a Qing dynasty term for one of seven major units in the Imperial Household Department (Neiwufu, q.v.). The Guangqu si included storehouses for silks, clothing, porcelain and tea, and a silver vault.

Huangchao liqi tushi *Illustrated Precedents for the Ritual Paraphernalia of the Imperial Court.* Title of an illustrated book, commissioned by the Qianlong emperor in 1759, dealing with various appurtenances (clothing, musical instruments, rank insignia, etc.) of the imperial family and its household and the civil service.

jifu Festive dress, a more informal court dress than the *chaofu* (q.v.).

kesi/kossu Fine silk tapestry (qq.v.) weave. The first specific reference in Chinese literature to the technique dates from the Northern Song (960–1126) and it was supposedly introduced to China from the West. The technique was perfected in the Song dynasty when textile artists were able to create pictures, closely following the style of contemporary painters.

lampas Figured weave (q.v.) in which a pattern weave, composed of weft (q.v.) floats bound by a binding warp (q.v.), is added to a ground weave formed by a main warp and a main weft. The ground weave may be in tabby, twill, satin, etc. (qq.v.). The pattern weft is normally bound in tabby or twill. Lampas weaves occur among Chinese textiles from the Song dynasty (960–1279).

longpao Dragon robe, which formed part of the *jifu* (q.v.): a full-length, side-fastening robe embroidered with five-clawed dragons, worn by both emperor and officials at the Qing dynasty court. Most are blue, but brown, turquoise, orange and yellow and red ones do exist. They were worn mainly by men. See also *mangpao*

mangpao Dragon robe which formed part of the *jifu* (q.v.): a full-length, side-fastening robe decorated with four-clawed dragons (*mang*), worn by officials at the Qing court. See also *longpao*

Neiwufu Imperial Household Department, a Qing dynasty term referring to a multi-agency administrative organisation created in 1661. It was responsible for serving the personal needs of the emperor, his immediate family and his intimate attendants in the private residential quarters of the imperial palace.

pigments See **dyes and pigments**

rank badges Badges applied directly to court robes during the Ming period as important indications of rank. In 1652 a decree was promulgated necessitating all hierarchical positions, both civil and military, to be shown by the appropriate rank badge. The Qing badges were smaller than the Ming and applied to plain, three-quarter surcoats. The civil upper ranks had dragon roundels; the number of these roundels and the number of claws on the dragons, as well as the way in which the dragons were shown, all reflected the rank of the wearer. Civil officials had square badges on the front and reverse of their gowns, showing different types of birds, according to strictly laid down rules related to rank. The military also had square badges, portraying animals, the animals again determined by rank. Wives in the Qing period were entitled to the same rank badge as their husband.

resist-dyed Patterned by 'reserved' or undyed areas. In some resist techniques, including tie-dyeing and clamp resist, dye is prohibited from colouring reserved areas by pressure – either by the tight gathering of areas of cloth with a thread or by clamping a wooden block against folded cloth (see block printed). In other techniques a resist medium – wax or vegetable starch, sometimes with the addition of an alkali chemical resist – prevents dye from penetrating the reserved design. The resist medium could be applied to cloth directly by hand, as in batik, by carved wooden block (see block printed) or, particularly in later centuries, through a stencil of stiffened paper.

satin Weave based on a unit of five or more warp threads (q.v.) where the binding points are irregularly distributed within each unit to give the impression of a smooth uninterrupted surface, usually warp-faced. Known in modern Chinese as *duan*, satin was probably invented in China in the twelfth century. Brocaded (q.v.) satins and satin damasks (q.v.) became very common.

satin stitch Embroidery technique (q.v.) where stitches are arranged neatly and regularly in flat rows so that no space is left between them and a gleaming, satin-like surface is achieved. It was often used for those embroideries trying to imitate paintings and was employed on double-faced embroideries as the basic stitch.

self-patterned Patterned by the modification of the regular binding system, without the use of a further warp or weft (qq.v.). Damask (q.v.) is a form of self-patterning.

silk Filaments of the cocoon of a silkworm. It is generally believed that the history of sericulture extends back to the Neolithic period. A small ivory cup from Hemudu in Zhejiang province dating from at least 4000 BC has a silkworm design carved on it, and parts of primitive looms about seven thousand years old have been identified from Hemudu also. The name of the species of silkworm cultivated in China is *Bombyx mori*. In cultivated silk, the silkworm is killed in the

cocoon before it emerges as a moth so that the silk can be reeled from the cocoon as a continuous filament.

tabby The simplest weave, also known as plain weave, in which one warp thread passes over one and under one weft thread (qq.v.).

tapestry Weft-faced weave with one warp and a weft (qq.v.) composed of threads of different colours which do not pass from selvedge to selvedge but which turn back on themselves, interweaving with the warp only so far as they are required by the pattern. The meeting of adjacent areas of colour can be handled in various ways: in Chinese *kesi* (q.v.) short slits are left, parallel to the warp.

twelve symbols Symbols of imperial authority worn by the emperors of every imperial dynasty from the Han dynasty onwards (206 BC). The right to wear these symbols could, however, be granted personally by the emperor to others. Women's robes exist with some of the symbols on them. Probably only an empress or empress dowager would have worn robes with all twelve symbols.

twill Weave based on a unit of three or more warp threads and three or more weft threads (qq.v.), in which each warp thread passes under two or more weft threads and over the next one or more. The binding points are offset by one warp thread for each successive weft thread and so form diagonal lines.

velvet Warp-pile weave in which the pile is produced by a pile warp that is raised in loops above a ground weave through the introduction of rods during weaving. The loops may be left as loops or cut to form tufts. Velvets may be figured (q.v.) or plain. Velvet weaving was probably invented in Turkey or Italy, *c.* AD 1300; Chinese examples are known from the Ming dynasty (1368–1644). The modern Chinese term *rong* is also used for a small group of Han dynasty silks with a looped warp pile found, for example, at Mawangdui.

warp Longitudinal threads of a textile; those that are arranged on the loom. A single thread of warp is called an end.

warp-faced compound tabby Warp-faced weave employing a warp (q.v.) of two or more series of colours and one weft (q.v.). Every other weft thread serves to separate the

series of warp threads so that only one colour appears on the surface at a time, while the threads of the other series are kept to the reverse. The remaining weft threads bind the warp threads in tabby. This is an important early Chinese weave known from the fourth century BC. See also **brocade**

weft Transverse threads of a textile; those that are passed through the sheds. A single weft thread is called a pick.

weft-faced compound twill Weft-faced weave employing a main warp (q.v.), a binding warp and a weft (q.v.) composed of two or more series of threads of different colours. By the action of the main warp threads, only one colour appears on the surface at a time, while the threads of the other series are kept to the reverse. The binding warp threads bind the weft 'passes' in 1:2 twill. It is a Western weave, probably originating in Iran, which became common in China for some centuries from about AD 700, replacing the older warp-faced compound tabby (q.v.).

weft-patterned Patterned or enriched by the use of a pattern weft additional to the main weft (q.v.). See also **brocaded**

Yuyong jian Sub-department of the Neiwufu (q.v.). A term current in the Ming and Qing dynasties, referring to a directorate for Imperial Accoutrements, one of twelve major directorates in which palace eunuchs were organised. In 1661 the directorate was disbanded into various palace storehouses which in 1667 were placed under the jurisdiction of the Office of the Privy Purse (Guangqu si, q.v.) of the Imperial Household Department (Neiwufu).

The textiles in the British Museum are almost all from Dunhuang, Gansu province, from the sealed library of cave 17, where they were once incorporated in the mountings or trimmings of Buddhist paintings. Their intrinsic value is immense as they represent a variety of weaves, mainly from the Tang dynasty, though with a few earlier examples also. For illustrations of the Stein textiles see R. Whitfield, *The Art of Central Asia: The Stein Collection in the British Museum*, vol. 3, *Textiles, sculpture and other arts*, Tokyo, 1982–5. For illustrations and diagrams of various weaves see D. K. Burnham, *Warp and Weft: A Textile Terminology*, Toronto, 1980. For information on Chinese costume see G. Dickinson and L. Wrigglesworth, *Imperial Wardrobe*, London, 1990, on which parts of this glossary have been based.

Decorative metalwork

Canton enamels See **enamelling**

champlevé **enamels** Technique of enamelling (q.v.) in which the surface of the metal is gouged away to create troughs and channels, each separated from the other by a thin ridge. The coloured enamels are laid into the troughs in powdered form and fired. When cool the enamel is polished to form a smooth surface level with the metal ridges. As thick sheet metal is required, copper and other base metals are ideal for this technique.

cloisonné Technique in which a network of cloisons forming the outlines of the decorative pattern of a picture is soldered to a metal surface. The coloured enamels (q.v.) are laid into the cloisons in powdered form and fired. When cool the enamel is polished to form a smooth surface level with the cloisons.

doucai See Ceramics glossary

enamel Coloured glass, or a combination of vitreous glazes, fused on to a metallic surface. The general term 'enamels' is often applied to a class of objects heavily decorated with some form of enamelling (q.v.).

enamelling Technique of painting in enamel (q.v.) on metal over a bronze, copper or sometimes a silver body, which is then coated with a white enamel. The vessel is fired at a low temperature, which matures the enamel but does not bond it to the metal body. Then the decorator paints it with coloured, metallic glazes, sometimes within a fine engraved line. The vessel is fired a second time, also at a low temperature. Any additional decoration of black emphasis or gold is added after this firing and is unfired. The technique originated in Europe and was introduced to the Chinese court by Jesuit missionaries at the end of the seventeenth century. Although there were pieces made specifically for the emperor

and the court in Beijing, Canton became another important centre for the manufacture of such enamels; many were made specifically for the overseas and European market and shipped directly from Canton. The term Canton enamels came to be used in the West for such pieces specifically made for export.

fahua See Ceramics glossary

filigree Decorative pattern made of wires, sometimes soldered to a background but often left as openwork.

granulation Decoration consisting of minute spherical grains of metal soldered to a background, usually in gold.

grisaille Style of painting in greyish tints in imitation of stone carving.

Guyuexuan Literally 'Old Moon Pavilion'. Originally a polychrome enamelled (q.v.) glassware, but from the Yongzheng reign (1723–35) the term was extended to por-celain objects similarly decorated. The characters are quite often applied to certain fine porcelain objects mostly made in the second quarter of the eighteenth century, decorated with delicate overglaze enamels and poetic inscriptions.

Jingtai lan Chinese generic term for cloisonné (q.v.), referring to the Ming Emperor Jingtai, in whose reign (1450–7) some of the best cloisonné was thought to have been made.

kuṇḍikā Tall spouted vessel, a water sprinkler of Indian origin.

penjing Miniature gardens, either of real plants and rocks or of precious stones, set into basins.

repoussé Literally 'embossed'. A technique of working sheet metal from behind with punches to raise the pattern, which stands in relief on the front.

Lacquers

carved lacquer Made by building up a large number of layers of lacquer on to a base that is generally either wooden or textile, and then carving through the various layers to create patterns or landscapes, etc. Sometimes different-coloured lacquers are used and the carving technique reveals the underlying different colours. The earliest recognised carved lacquer examples, made of camel hide covered in alternate layers of red and black lacquer, are the Fort Mirān pieces of armoured lacquer now in the British Museum. This lacquer, much thinner than later, more heavily carved types, was decorated with carved circles, commas and S-shapes. See also **guri lacquer** and **carved marbled lacquer**.

carved marbled lacquer (*tixi* or *xipi*) Multiple layers of different-coloured lacquers carved at an angle, thereby creating a marbled effect along the sides of the cut edges. The design is usually based on the pommel scroll motif, which is a symmetrical pattern resembling ancient sword pommels. This technique was in existence in the eighth century (Tang dynasty).

Coromandel lacquer Term used to describe a type of Chinese lacquer transshipped from the Coromandel coast of southwest India to Europe, where it was a very popular export item. In general it includes screens, chests and panels having the designs cut through three or four layers of lacquer to the raw wood base, which was then painted with brightly coloured lacquered pigments. Polychrome decoration was left unpolished against the glossy black, brown or red polished ground. This type of ware was probably first made for the home market in China but it became so popular overseas that huge quantities were produced, some not of very good quality.

guri lacquer Term taken from the Japanese word meaning a pommel scroll to describe a pattern used on early carved lacquer pieces. *Guri* is a form of carved lacquer where alternate layers of different-coloured lacquers are carved in schematised spiral scrolls. The deeply cut lines are often bevelled.

The technique was in use from the Song dynasty and possibly earlier. See also **carved lacquer** and **carved marbled lacquer**

laque burgauté Technique whereby chips of mother-of-pearl are embedded into the lacquer base and then polished. It is nearly always done against a black background. It is a very time-consuming technique and therefore relatively expensive.

miaojin Gold painting on lacquer.

moxian 'Polish reveal' technique, whereby certain parts of the design outline are built up on the surface and then the ground filled in with different-coloured lacquers until they rise above the level of the outline lacquers. The whole is then polished down to reveal the coloured design. This technique was developed in the Ming dynasty.

qiangjin Technique whereby fine, linear designs are first engraved on the lacquered base. A lacquer adhesive is then applied to the lines, and they are in-filled with gold foil or powdered gold. This style of decoration was begun in the Song dynasty.

tianqi Literally 'filled in' technique (*zonsei* in Japanese). The dry technique, which is more common, involves allowing the background lacquer to set firmly before a design is cut away and then filled in with lacquer of contrasting colours. The piece is finished by polishing. The outlines of the design are subsequently incised and gilded to make the design stand out. In the wet technique, the contrasting lacquer is inlaid into the top layer of the lacquer base while this is still wet and then one layer only is inlaid. This produces a shallow colour and one which does not wear well, which is why the method was not so popular. The technique was used from as early as AD 1200.

tixi See **carved marbled lacquer**

xipi See **carved marbled lacquer**

Ceramics

alkaline glazes Low-fired glazes (q.v.) fluxed with potassia, soda or lithia. In China potassia (potassium oxide), is the favoured flux (q.v.), often derived from saltpetre (potassium nitrate). Alkaline glazes give turquoise blues when coloured with copper oxide (q.v.), aubergine colours from manganese dioxide and royal blues from cobalt oxide.

alkalis To potters (as opposed to chemists, for whom the word has a slightly different meaning) the alkalis are the oxides of potassium, sodium and lithium. The first two (potassia and soda) are important in Chinese ceramics, in both bodies and glazes (qq.v.). In Chinese stoneware clays (q.v.) potassia and soda operate as body fluxes (q.v.), increasing fired strength by causing glass to form in the clays during firing (q.v.). In Chinese porcelain (q.v.), potassia (from potash mica) and soda (from soda feldspar) react with silica (quartz, q.v.) in the clay to produce sufficient body glass to make the material translucent. Potassia is also the main flux in Chinese alkaline earthenware glazes (qq.v.), often used on *fahua* (q.v.) wares, and it is an important secondary flux (to calcium oxide) in all Chinese high-fired glazes.

anhua Secret or hidden decoration, so called because it is generally only possible to see the decoration in transmitted light. It was achieved by applying trails of very fine slip (q.v.) before glazing, using very fine moulded decoration, or engraving with extremely light lines.

bai dunzi Literally 'little white bricks', previously known as *petuntse*. The term refers to bricks of crushed and washed porcelain stones found and worked at Jingdezhen (qq.v.). The raw material for porcelain (q.v.) was transported there from the hills to the kilns (q.v.). The term *cishi* (porcelain stone) is more often used today.

bisc, bisque Hard biscuit (q.v.). Ceramic (especially porcelain, q.v.) that has been fired to maturity (q.v.) with some or all of the object left unglazed. Bisque porcelains are often glazed with lower-firing compositions then refired to give wares that combine high strength with bright colours.

biscuit Low-fired, unglazed ceramic intended for further processing, especially glazing and refiring at higher temperatures.

blanc de Chine Wares made in Dehua, Fujian province, from the late Ming dynasty onwards. A very fine ivory-white porcelain with clear glaze (qq.v.). Many vessels were made of this material but figures of popular gods were also numerous.

body Potter's term for prepared clay (fired or unfired).

bulb bowl Wide shallow bowl on three or four feet made from the Song dynasty onwards and most common in Jun ware, Longquan celadon, Yixing (qq.v.) and Guangdong ware.

calcia See calcium oxide

calcium oxide Calcia (CaO), often referred to loosely as 'lime' (q.v.). Calcium oxide is the most important and most ancient high-temperature glaze flux (qq.v.) in Chinese ceramics. It is cheap, abundant and effective. It gives hard, bright glazes with good 'glaze fit'. Its commonest sources in Chinese ceramics are woodash (q.v.) and limestone. Calcia will not work effectively as a glaze flux at temperatures below $1170°C$.

celadon European term covering a wide range of high-fired green-glazed wares, where the colouring is brought about by iron oxides (q.v.) in glaze solution reacting in a reducing atmosphere (q.v.). The bodies were both grey stonewares and white porcelains (qq.v.). The term is applied particularly to Yue, Yaozhou and Longquan wares (qq.v.).

ceramics Objects made from fired clays. Chinese ceramics include those made for practical, decorative, architectural, ritual and military use.

Chai ware Supposedly an imperial ware of the Five Dynasties period (AD 907–60) which has never been identified although it is mentioned in historical texts.

chicken cups Name given to a style of winecup best known from the Chenghua period (1465–87). Such cups were decorated in *doucai* technique (q.v.) often with hens, cocks and chickens depicted together with foliage and plants. Chicken cups and the Chenghua reign marks (q.v.) were imitated in the sixteenth and again in the eighteenth century.

Cizhou ware Stonewares (q.v.) produced at many kilns throughout the northern provinces of Hebei, Henan and Shaanxi during the Song, Jin, Yuan and Ming dynasties. These utilitarian ceramics carried a wide variety of decoration executed chiefly in black or white slip beneath a transparent glaze (qq.v.). The ornament is either freely painted or carved. Some wares are decorated by the sgraffito technique in which one layer of slip is applied on top of another and then cut away to make a design in contrasting colours. Additional detail may be incised or stamped. Later in the Yuan dynasty a cut glaze technique was introduced, whereby a thick layer of glaze, usually black, was applied and the ornament then cut away to reveal the body (q.v.) rather than an underlying layer of slip. Cizhou-type wares were also made in south China in the Song and Yuan dynasties at the Jizhou kilns, Jiangxi province, where the dark slip was painted directly on to the light porcellaneous stoneware body before it was glazed.

coiling Technique whereby a pottery vessel is built up with successive ropes of clay. Each new rope of clay is thoroughly welded to the rim of the growing vessel, and the joins smoothed inside and out. The final form is achieved by beating, using an anvil inside and a paddle outside. The last stage was usually scraping, sometimes followed by burnishing. Coiling was used for most Neolithic and early Bronze Age Chinese ceramics. The method is still used in China for making large field jars and water cisterns.

Compagnie des Indes Chinese ceramics made specifically to European orders and sometimes designs, for the Dutch, English and other East India companies.

copper oxide, copper metal Copper is second only to iron in importance as a glaze colourant in Chinese ceramics. Copper occurs in Chinese glazes (q.v.) in three forms: cupric oxide (CuO), cuprous oxide (Cu_2O) and colloidal copper metal (Cu). Dissolved cupric oxide supplies greens in Chinese lead glazes and turquoise blues in Chinese alkaline glazes (qq.v.), typically at about 3 per cent concentration. Lead glazes overloaded with cupric oxide (e.g. some Tang *sancai* glazes, q.v.) show the grey-black colour of crystalline cupric oxide. Fine crystalline cuprous oxide may give a reddish colour in some Chinese copper-red glazes but the prime source of the famous Chinese copper-red effect is now thought to be colloidal copper metal, usually at concentrations less than 0.5 per cent Cu.

crackle Crazing (q.v.) in glazes (q.v.) accepted and exploited as an aesthetic effect. Ru ware is sometimes cited as the first Chinese crackle ware, but Guan ware is a slightly later and more obvious candidate (qq.v.). In some Chinese wares the crackle is stained after firing (q.v.), particularly Ge ware (q.v.), where the large primary crackle (hot from the kiln) was often stained black, and the finer secondary crackle, which developed later, was stained golden brown.

crazing Fine cracks in the fired glaze coat. Crazing is caused

by the glaze (q.v.) shrinking more than the clay beneath during the last stages of cooling. Crazing may continue for some time after the wares have been drawn from the kiln (qq.v.).

Ding ware A particular high-firing (1300–1340°C) oxidised porcelain (qq.v.) made in north China from a secondary kaolin material (q.v.). The body fluxes (q.v.) were mostly calcia and magnesia, with a lesser amount of potassia. Ding ware is a thin white porcelain, with transparent ivory-toned glaze (q.v.); the wares were named after kilns in present-day Jiancicun in Quyang county, Hebei province. (In the Song dynasty this area was in Ding prefecture, as distinct from Ding county, also in Hebei.) Ding was made in the mid and late Tang dynasty, but the Song wares were considered the best. Production continued into the Jin and Yuan dynasties. Many of the shapes imitated fine metalwork and were decorated with carved and later moulded patterns. In the eleventh century a new firing technique (q.v.) for this ware was introduced whereby bowls and dishes were fired upside down in stepped saggars (q.v.), which prevented warping of the thin bodies. After firing the rims were often bound with copper, bronze or precious metals. Ding ware may also be black, brown, green, purple or red. In the post-Song period Ding ware was retrospectively named one of the so-called 'five great wares' along with Ru, Jun, Guan and Ge ware (qq.v.).

doucai Literally 'fitted colours', a reference to decoration outlined in blue under the glaze and coloured over the glaze with enamel colours within the blue lines. The technique of producing *doucai* wares was well developed in the Xuande period (1426–35) but is particularly associated with the Chenghua period (1465–87) of the Ming dynasty. *Doucai* wares are typically small, thin-walled porcelains (see **chicken cups**).

drawing The process of unloading a kiln.

earthenware Low-fired, porous ceramic made from many types of clay and usually fired between about 600 and 1150°C. The body colour depends on the type of clay, its impurities such as iron content, and the firing conditions. From the Tang dynasty onwards most Chinese 'earthenware' clays, used with low-fired glazes, were either underfired or bisque-fired stonewares (qq.v.).

earthworm tracks Meandering lines of darker glaze (q.v.) on a lighter background, often seen on thickly glazed Jun wares (q.v.), and reminiscent of earthworm tracks on damp smooth ground. Caused by cracks in the dry glaze filling up with melting glaze at high temperatures. As certain components in a glaze melt before others, these lines are still obvious after firing due to their slightly different chemical compositions.

eggshell Very thin, white porcelain (q.v.).

enamel on bisque Technique employed for wares such as *fahua* and some styles of *sancai* (qq.v.) when after bisque firing (q.v.), generally to porcelain temperatures, a soft lead or alkaline silicate enamel was applied to the unglazed object which was then fired again at a lower temperature.

enamelled porcelain Porcelain decorated over the glaze with coloured glazes applied in a second firing (qq.v.), lower in temperature than the first. The colours derived from metal oxides and the enamel glazes were usually fluxed (q.v.) with lead oxide (50–70 per cent). The technique first appeared in north China on white-slipped stonewares (qq.v.) in the late

twelfth and thirteenth century and at Jingdezhen (q.v.) in the early Ming, but in China enamelled decorated porcelain is best known in the form of *famille verte* and *famille rose* (qq.v.) enamelled porcelain of the eighteenth and nineteenth centuries, which was exported to Europe in large quantities.

fahua Literally 'bounded designs', in which the motifs are outlined in a raised trail of slip (q.v.). The designs were shown off by the use of indigo, turquoise, purple, yellow and green glazes (q.v.) fired at fairly low temperatures of about 1000°C. *Fahua* wares were made from the fourteenth to the sixteenth century, principally in Shanxi and Jiangxi provinces. Chinese *fahua* glazes of the alkaline type (q.v.) used potassia as their main glaze flux, often supplemented by small amounts of lead oxide.

famille rose, jaune, noire, verte Overglaze enamel-decorated porcelains (q.v.) made from the Kangxi period (1662–1722) and later, in which the dominant colour of the decoration is either pink, yellow, black or green. The pink in *famille rose* is colloidal gold (about 0.3 per cent) in a high-lead enamel base. This results in the rose pink of *famille rose*, the technique of which is believed to derive from the West.

feldspar Very abundant mineral in igneous (q.v.) rocks and an important insoluble source of potassium oxide flux in Western glazes and porcelain bodies (qq.v.). To a large extent the role played by potassium feldspar in Western ceramics is taken in Chinese ceramics by potassium mica – a mineral that is a close relation to clay, but which contains potassium oxide as a natural flux. Southern Chinese porcelains including Longquan celadon bodies (q.v.) are largely micaceous. True 'feldspathic' glazes (where feldspar makes up the bulk of the recipe) are widely used in the West and in Japan but are almost unknown in Chinese ceramic history.

fireclay Very refractory clay (q.v.) usually associated with coal seams, where it forms the seat earth or under-clay. It was used extensively in north China for making saggars and building kilns (qq.v.). Lower-grade fireclays were also used in the north for some Chinese stoneware bodies (qq.v.).

firing The transformation of dry clay into fired ceramic through the application of energy from burning fuel. In earthenware clays, fired strength comes from driving away chemically combined water from the various clay crystals (350–800°C), the sintering together of various minerals in the clay body (q.v.), and the production of small amounts of body glass in the fired material. At higher temperatures (1100–1350°C) kaolinitic clays (q.v.) slowly transform into an intergrown mass of needle-shaped mullite crystals. The mullite, together with increasing amounts of body glass, gives the exceptionally high-fired strength typical of both stonewares and porcelains (qq.v.).

flambé Flame-like glaze quality, often seen in later Qing Chinese copper-red glazes (q.v.). It consists of vertical curdled streaks within the glaze, often of blue against red or red against blue. The flambé effect is usually the result of glass-in-glass phase separation (q.v.) occurring during the cooling of the glaze.

fluxes Metal oxides included in glaze or glass recipes to lower the extremely high melting point (1713°C +) of the prime glass-forming oxide silica (q.v.) to temperatures manageable in pottery kilns (q.v.) or glass furnaces. The main glaze flux used in Chinese earthenware glazes is lead oxide (q.v.), with potassium oxide playing a lesser role. In

Chinese stoneware and porcelain glazes calcium oxide (qq.v.) is the prime glaze flux, again supplemented by potassium oxide.

Ge ware Grey-glazed ceramic with a distinctive crackle (q.v.), probably dating only from the Yuan and early Ming periods, although traditionally classed together with the great wares of the Song dynasty. Ge may have been made in kilns in southern Zhejiang or in Jiangxi province. Reproductions of this ware were made at Jingdezhen (q.v.) in both the fifteenth and eighteenth centuries.

glass-in-glass phase separation Phenomenon responsible for the 'optical blue' colours of Jun and *flambé* glazes (qq.v.). It occurs in cooling as the molten glaze separates into spherules of glass of one composition within a glaze matrix of slightly differing composition. The glass spherules are so small that they scatter blue light. This gives a strong blue, violet or milky-white cast to thick Jun glazes, and streaky reds and blues in copper-containing glazes.

glaze Thin coating of powdered rocks, ashes or minerals rich in glass-forming oxides, fluxes (q.v.) and the glass stabiliser alumina which, after firing, closely resembles a sheet of glass. Glaze is continuous and impervious when correctly applied and fired.

Guan ware Literally 'official ware', a Southern Song dynasty celadon ware with a distinctive crackle made at kilns at Hangzhou and imitated at the Longquan kilns (qq.v.). Guan wares were fired both in oxidation and in a reducing atmosphere (qq.v.) and the high iron content of the body (q.v.) resulted in a dark brown or black colour on the unglazed footrings. The thick, bubbly glaze (q.v.) was applied in several layers before firing and this encouraged the crackle. The colour of the glaze varies from a brownish grey through grey to a delicate lavender blue. Many imitations were made in the eighteenth century.

Guyuexuan Literally 'Old Moon Pavilion'. Originally a polychrome enamelled glass ware of the eighteenth century. The name was later applied to certain fine porcelain objects (q.v.) mostly made in the second quarter of the eighteenth century and decorated with delicate overglaze enamels (q.v.) and poetic inscriptions.

hare's fur Dark brown-black glaze (q.v.) with fine streaking which appears on teabowls and other vessels of Jian type (q.v.), made in Fujian province. The effect is produced by the natural unmixing of the glaze into different glasses as it melts and matures.

huashi Literally 'slippery stone'. A fine white powder consisting of a very white-firing kaolin (q.v.) containing a fair content of white mica. *Huashi* was added to porcelain stone (q.v.) in the eighteenth century to provide a body (q.v.) of exceptional smoothness and whiteness. It was also used as a white ground for fine underglaze blue painting (q.v.). *Huashi* wares are known as 'Chinese soft paste' porcelain (q.v.).

igneous rocks Rocks that have been molten at some time in their history. They are usually hard and crystalline.

illite Main clay mineral in loess (q.v.). It contains potassium oxide (potassia) and contributes to the low melting point of loessic clays.

Imari Port in southern Japan, from which porcelain from the Arita kilns was exported on a large scale in the seventeenth and eighteenth centuries. The name is used to refer to a type of Japanese porcelain, usually decorated with underglaze blue and overglaze red and gilding enamels (qq.v.) exported in large quantities from that city. During the period from 1639 to 1854, when all Japanese ports except Nagasaki were closed, the Chinese made their own types of Imari ware to meet the unsatisfied demand.

iron oxide Universal impurity in ceramic materials and the most important colouring oxide in Chinese ceramics in both bodies and glazes (qq.v.). In its higher oxide state (ferric oxide, Fe_2O_3), and in solution, iron gives warm tones to Ding and *blanc de Chine* (qq.v.) glazes, and provides the translucent yellow, amber and chestnut colours seen in Chinese lead glazes and overglaze enamels (qq.v.). In its crystalline state ferric oxide gives rusty-red colours to Chinese iron-red enamels, to reoxidised Longquan celadon bodies (q.v.) and to Han earthenware clays. In its lower oxide state (ferrous oxide, FeO), iron gives cold colours when dissolved in glazes – notably the icy-blue tones of *yingqing* glazes, the duck-egg blue of *kinuta* celadons (qq.v.) and a vast range of cool greens where some titanium dioxide (q.v.) is also present in the raw materials of the glaze. Higher concentrations of iron oxide in glazes give browns and blacks in both its ferric and ferrous states. The presence of crystalline ferrous oxide in clays that have been fired and cooled in a reducing atmosphere (q.v.) gives the ashy-grey colours typical of unglazed Han burial wares.

Jian ware Products of kilns in the southeastern coastal province of Fujian. The Jian kilns are particularly famous for their teabowls, with characteristic dark brown or black body, many of which were decorated with the 'hare's fur' type of glaze (q.v.). The other ware for which the kilns are known is the 'oil spot' (q.v.) type of glaze. Although a somewhat unrefined and coarse ware, with a thick glaze often pooling around the foot, it was favoured by emperors, officials and literati for the drinking of tea and large quantities were exported to Japan.

Jingdezhen City in Jiangxi province which was and still is the most important centre for porcelain (q.v.) manufacture in China. Porcelain making began at Jingdezhen in the tenth century AD and ceramics made for imperial use were manufactured here from the beginning of the Ming dynasty, continuing into the Qing. In addition to kilns (q.v.) dedicated to such high-quality porcelains, there were many other kilns making more ordinary ceramics.

Jun ware Ware produced mainly at Linru in central Henan province. Excellent raw materials in this region led to the making of ceramics from at least the tenth century. Jun wares are rather heavy and are thickly glazed in green, lavender blue, lavender blue with purple splashes, and purple with blue streaks. Although some Jun was probably made in the Song period, the majority of examples belong to the Jin, Yuan and early Ming periods.

kaolin White-firing and refractory clay (q.v.) that is unusually low in the earthy colouring oxides of iron and titanium (qq.v.). A useful (though not indispensable) ingredient in porcelain bodies (qq.v.). Kaolin is the anglicised form of the Chinese name Gaoling (High Ridge), given to a mountain range in Jiangxi from which the Chinese derived high-quality porcelain-making materials. Two major types of kaolin were used in Chinese porcelain. For southern porcelains, mainly Jingdezhen (q.v.) wares, primary kaolins were favoured – that is, kaolins washed out from the crumbly

granite rocks from which they derived, either by the potters or clay miners. These primary kaolins were purified, dried and transported to the porcelain workshops in the form of bricks, where they were added to porcelain stones (q.v.) in varying amounts. In north China secondary or sedimentary kaolins were the major ingredients for porcelain production, and porcelain stone was not used. These secondary kaolins had already been washed by rain from their rocks of origin millions of years ago, and deposited in sedimentary strata often associated with coal seams.

kaolinite One of the purest and most refractory (q.v.) of the large family of clay minerals; kaolinite is the basis of most north Chinese high-firing clays. South Chinese kaolin (q.v.) is rich in a close relation of kaolinite known as halloysite.

kaolinitic Containing large amounts of the clay mineral kaolinite (q.v.).

kiln System usually consisting of firebox, chamber and chimney, all connected by flues. The fuel burns in the firebox and the insulated chamber containing the wares allows the heat to build up and bring about the ceramic changes associated with firing (q.v.). The chamber also protects the wares from cold draughts in cooling. The chimney provides the draught. Kilns (figs 233–6) are of three main types: updraught, where the firebox is beneath the kiln chamber and the flames travel upwards through the wares; crossdraught, where the firebox, kiln chamber and exit flues are more or less level and the flames travel horizontally; and downdraught, where the exit flues are in the floor of the kiln, causing the flames to travel downwards through the wares on their way to the chimney. High-temperature kilns are usually of the second and third types. See also *long* kiln, *mantou* kiln, *zhenyao* kiln

kinuta celadon Japanese name for a particularly fine type of Longquan celadon ware (q.v.), probably made at Dayao, Zhejiang province, with a pale blue celadon glaze and a very light-coloured body (qq.v.). '*Kinuta*' is Japanese for a fuller's mallet and is the shape of a famous Longquan vase in a Japanese temple collection.

kraak *Kraakporselein* was a term coined by the Dutch for a type of blue-and-white ware produced in Wanli's reign (1573–1619), of which large quantities were exported to Europe. Kraak porcelain is distinguished by the prevalent arrangement of its underglaze blue ornament (q.v.) into panels which usually radiate to a bracketed rim notorious for its liability to chip, a feature particularly common in mid seventeenth-century ceramics. Many of the motifs within the panels are similar to those on late Ming polychrome wares.

lead glazes First introduced in the Warring States period in China, but not used extensively there until the first century BC, and then almost entirely on burial wares. Most Chinese lead glazes contain at least 50 per cent lead oxide and are therefore of the high-lead type. They may have originated from Chinese high-lead glass. Lead glazes have a rich depth due to the high refractive index of lead oxide, and a smooth and even melt. Han lead glazes were usually coloured green with copper oxide (q.v.), which made them poisonous after firing and prone to deterioration in burial. Essentially similar lead-rich glazes were used later for Tang, Liao and Song *sancai* (q.v.) wares, and Ming and Qing architectural glazes. Their colours were mainly pale straw, copper green, iron yellow and a dark iron brown. The firing temperatures for these glazes were between 900 and 1000°C. High-lead

compositions have also been used for Chinese overglaze enamels (q.v.) from the late twelfth century AD to the present day, firing between about 700 and 800°C. Lead glazes turn black and boil in reduction, so are always given oxidising firings (qq.v.).

leatherhard Term used to describe the state of clay which has been worked and has partially dried.

lime Broad term for calcium oxide (q.v.), quicklime, or calcia – all different names for CaO. The term is also used to describe slaked lime, $Ca(OH)_2$. The main sources of lime (CaO) in Chinese glazes (q.v.) are woodash (q.v.) and limestone (calcium carbonate, $CaCO_3$). The lime-rich material in 'glaze-ash' was made by burning limestone to quicklime (CaO), then burning it again to calcium carbonate ($CaCO_3$) to make it less caustic. This produced an ultra-fine powder that turned to calcium oxide (CaO) in the kiln (q.v.).

lime-alkali glazes Types of stoneware and porcelain glazes (qq.v.), first used at Gong xian in the Tang dynasty, but more typical of Song ceramics such as Jun wares, Yaozhou wares and Longquan celadons (qq.v.). Lime-alkali glazes have a smooth, translucent richness that has been compared to jade or to 'congealed lard'. Lime-alkali glazes are also the standard glazes used on blue-and-white Jingdezhen porcelain (q.v.) from the mid fourteenth to the mid twentieth century. They contain about twice as much calcia ('lime', q.v.) as potassia and soda (the 'alkalis') and fire to between about 1230 and 1300°C.

lime glazes The earliest type of Chinese glaze, first used in the Shang dynasty. Glazes substantially similar to Shang lime glazes are still in use in Chinese country potteries. Lime glazes are high firing (*c.* 1170–1250°C) with calcia (q.v.) as their main glaze flux (q.v.), usually supplied by woodash (q.v.) or limestone. They tend to be unsuitable for underglaze decoration (q.v.) but show any engraving or stamping of the clay body (q.v.) to good effect. They are usually greeny yellow or grey green in colour and often have a finely frosted surface due to the growth of micro-crystalline lime-rich minerals in the cooling glaze. Lime glazes developed into lime-alkali glazes (q.v.) at a number of kiln sites.

loess Fine rockdust, stripped from igneous rocks (q.v.) in the deserts of Inner Mongolia by alternate freezing and thawing, and by the action of salt and winds. The material has been blowing southeast across the northern provinces of Gansu, Shaanxi, Shanxi, Hebei and Henan for nearly two and a half million years. North Chinese loess (*huangtu*, 'yellow earth') has buried much of north China's original landscape in a loosely compacted blanket of rock flour, in some places up to 300 metres deep. Much of this primary loess has since been redistributed by wind and water and the total area of north China's loess country now approaches one million square kilometres. Loess is a fertile material and has also seen many uses in Chinese ceramics: it was the main raw material for Shang bronze-casting moulds, the terracotta warriors of Lintong, and Han burial wares, both glazed and unglazed. Its low melting point (*c.* 1100°C) makes it unsuitable as a body material for high-fired ceramics, although it was occasionally used in northern stoneware glazes (qq.v.).

long kiln Literally 'dragon kiln' (fig. 233). A highly efficient type of wood-burning kiln (q.v.), first developed in south China in the Warring States period, and in widespread use in Zhejiang province by the Han dynasty. *Long* kilns became the main high-firing kiln type in south China in the Tang,

Song and Yuan dynasties. The *long* kiln consists of a long brick tunnel built up a hillside with the wares set on shallow steps inside, originally on thrown columns but later packed in saggars (q.v.). *Long* kilns have a large firebox at the bottom end for bringing the lower part of the kiln to temperature. Once this is achieved, firing (q.v.) is continued by side-stoking through ports along the kiln's length. The full heat gradually travels along the kiln to the top. This system made enormous lengths of kiln possible and the design reached 60 metres or more in the Longquan area of Zhejiang. Southern *long* kilns tended to fire between about 1200 and 1300°C and were used for both oxidation and reduction (qq.v.).

Longquan ware Green-glazed porcelain or porcellaneous stoneware made at kilns (qq.v.) sited in the southern part of Zhejiang province which began operation in the tenth century. The characteristic blue-green, thickly glazed ceramic was made from the Southern Song period when output more than doubled. The body is pale grey or almost white which shows the glaze to full advantage, and burns to a brick red where exposed in the firing (qq.v.). Many Southern Song pieces were made as altar vessels in ancient bronze shapes. From the Yuan and Ming periods large quantities were exported to Southeast Asia and the Middle East.

luting Method of joining the components of an unfired vessel or sculpture using a slip (q.v.).

mantou kiln Main north Chinese high-temperature kiln design (fig. 234). A rather compact (usually 2–3 metres internally) kiln (q.v.) of crossdraught or downdraught design, usually with a dome of bread roll (*mantou*) shape. Originally fired with wood, the *mantou* design adapted well to coal in the Northern Song, with a smaller firebox and a deeper pit for the embers. *Mantou* kilns reached some of the highest temperatures used in Chinese ceramics (1370°C), particularly when firing northern porcelains.

marbled wares Wares in which clays are combined in alternate layers, often in complex patterns or swirls. Thin slabs were cut from a solid block of laminated clays and pressed into moulds to produce vessels and models with 'marbled' surfaces. Marbling was popular in burial wares of the Tang dynasty and later.

maturity The temperatures at which clays and glazes show their best qualities.

meiping Literally 'plum blossom vase', a tall vase with a wide shoulder and small mouth. The shape was first made in the Song dynasty and became a standard form in the Yuan and Ming periods.

mise Reserved or 'secret colour' ware. The term is used to describe green-glazed wares of the Tang and Five Dynasties periods. Examples have been found in the pagoda deposit at the Famensi Buddhist temple at Fufeng, Shaanxi province.

monochrome glazes Single colour glazes, particularly those used on porcelain (qq.v.). The earliest porcelain monochrome glazes were the ultra-rare coloured Ding wares (black, brown, green, purple and red Ding, q.v.). However, Chinese monochrome porcelain glazes achieved their greatest status in the late fourteenth and early fifteenth century when porcelains with red, yellow and blue monochrome glazes were used in imperial rites.

northern celadon General term for ceramics with grey or brownish bodies and a green glaze (qq.v.), made at many north Chinese kilns in the Northern Song and Jin dynasties. The principal type was made at the Yaozhou kilns (q.v.) in Huangbaozhen, Tongchuan xian, Shaanxi province. Yaozhou wares are notable for their deeply carved ornament. Moulds were used at an early stage for both shaping and decorating the Yaozhou wares. Some other northern kilns making greenwares were at Linru and Baofeng in Henan province.

oil spot So called after spots resembling oil droplets found on some northern teabowls, and on a few rare examples of Jian ware (q.v.) from Fujian province. The northern oil-spot glazes were applied over an iron-rich slip (q.v.), on a light-firing clay. Oil-spot effects are occasionally seen on the thick *temmoku* glazes (q.v.) applied to the dark-firing Jian clays. The oil spots are rich in magnetite and change to the more common hare's fur type of decoration (q.v.) at a slightly higher temperature. Jian wares were particularly prized by the Japanese for the tea ceremony.

overglaze enamels Term used to describe decoration, in enamels, on top of a glaze (q.v.) which has already been fired. Once painted, the vessel would be given a second firing (q.v.), usually at a lower temperature.

overglaze painting Term used to describe pigments or glazes (q.v.) applied to unfired glazes before the main firing (q.v.), such as copper pigments on Jun glazes (q.v.), or iron pigments on some northern black ware glazes.

oxidising conditions Term used to describe the firing of a kiln (qq.v.) when abundant air is allowed to enter the kiln during the firing. Oxidising conditions encourage warm colours from glazes and bodies containing iron oxides (qq.v.), and create greens and turquoise blues from glazes containing cupric oxide. Oxidising firings are essential for lead-glazed wares (q.v.).

peachbloom Pinkish-red, high-fired copper glaze developed in the Qing dynasty at Jingdezhen (qq.v.). Peachbloom glazes have a smooth but variegated cloudy quality reminiscent of blushing skin or ripening fruit. The peachbloom effect may have been achieved by sandwiching a copper-lime pigment (applied by spraying) between layers of clear porcelain glaze. Peachbloom wares were of the finest Jingdezhen materials and craftsmanship and were made in a limited range of forms 'for the scholar's table'.

porcelain In the West this term is generally used for high-fired white ceramics, whose bodies (q.v.) transmit light and make a ringing sound when struck. Modern Western porcelains are generally made from kaolin, quartz (silica) and feldspar (qq.v.) and fired to temperatures in excess of 1300°C. In China several different white ceramics were made, several of which might be termed porcelain. The northern porcelains, such as Ding ware (q.v.), were made predominantly of kaolin-rich clay. At Jingdezhen primary kaolin was added to porcelain stone (qq.v.) from the Yuan dynasty onwards, but in Fujian province porcelain stone was usually used alone. Southern porcelains were fluxed (q.v.) with hydro-mica, an abundant mineral in the porcelain stone rock. Porcelains from southern China are generally distinguished from northern ones by the bluish tinge in their glazes caused by reduced firings (qq.v.). The southern *blanc de Chine* porcelains (q.v.) made at Dehua in Fujian province are exceptions; they show a warm ivory tinge from their oxidising firings (q.v.).

porcelain stone Abundant volcanic rock found in the south-eastern coastal provinces of China, and in some parts of Jiangxi province, near Jingdezhen (q.v.). Porcelain stone consists mainly of quartz, together with large amounts of the plastic mineral hydro-mica. Some varieties also contain lesser amounts of feldspars and/or true clay minerals, mainly kaolinite (qq.v.). The varieties richest in micas and clays could be made into porcelains without further additions. Those with lower plasticity and greater fusibility were more usually mixed with kaolins.

potter's wheel Turning disc on which a lump of clay can be thrown (q.v.) into the shape of a pot or bowl. It allows constant pressure to be applied to the spinning clay, with water used to prevent the clay dragging excessively or sticking to the potter's fingers. A distinction is usually made between the slow wheel, which was an aid to coiling (q.v.), and the fast wheel on which the wares could be thrown direct. Most Chinese potter's wheels ran anticlockwise.

protoporcelain Discontinued term for early Yue ware (q.v.), originally adopted because of genuine compositional similarities discovered between this material and the true porcelains (q.v.) made much later in south China.

qingbai Literally 'blue-white'. The term is used to describe the glaze colour of southern porcelains (qq.v.) produced from the tenth to the fourteenth century, which have a transparent glaze with a blue tinge as a result of slightly less than 1 per cent ferrous oxide dissolved in the glaze, and an almost total lack of titanium dioxide (q.v.) in the raw materials. (The presence of titanium makes reduction-fired glazes containing small amounts of ferrous oxide fire green.) The term *yingqing* ('shadow blue') is sometimes used to denote the same type. See also **reducing conditions**

reducing conditions The opposite of oxidising conditions (q.v.). Air entering the firebox for burning the fuel is restricted somewhat, causing the combustion products to contain carbon monoxide and hydrogen – both 'oxygen-hungry' (reducing) gases. Inside the kiln chamber (q.v.) these gases attack iron oxide (q.v.) in its higher (ferric) oxide state and 'reduce' it to its lower (ferrous) state. Reduction should be carried out before the glazes melt and it is responsible for the blues, greens, greys and lavender tones of Song stoneware and porcelain glazes (qq.v.). Reduction of copper compounds (q.v.) can produce copper-red colours, which have been made in China since the ninth or tenth century.

refractory clay Clay that is particularly resistant to high temperatures, and often found beneath seams of coal. Refractory clays were valuable for building kilns and making saggars, especially for northern porcelain production (qq.v.). Refractory clays were also used for the bodies of some northern stonewares, e.g. Yuan and Jun wares (qq.v.).

reign marks Marks consisting of either four of six characters, giving the title of the emperor and the corresponding regnal period. They were first applied in the reign of the Ming dynasty Yongle emperor (1403–25). The marks are generally on underglaze blue wares but are also on overglaze red or blue enamel wares (qq.v.).

resist Substance such as a wax or a clay flour paste applied to the surface of any material in order to prevent the action of a colouring agent. On Chinese ceramics, resists were used principally to execute ornament on Tang *sancai* ware (q.v.), but they also played a part in the decoration of certain types of Ming dynasty enamelled wares (q.v.). Paper resists were used at the Jizhou kilns in Jiangxi in the thirteenth century.

robin's egg glaze Low-fired decorative glaze developed at Jingdezhen (q.v.) in the early eighteenth century. It is usually an opaque turquoise blue, suffused with fine reddish or darker blue spots or streaks. One analysis of a Jingdezhen robin's egg glaze showed it to be a lead-containing composition opacified with arsenic and coloured with copper. Similar, but higher-firing, glazes were made at Yixing (q.v.) in Jiangsu province and Shiwan in Guangdong province in the eighteenth and nineteenth centuries.

Ru ware Grey-blue glazed ceramic made in Henan province, the kiln site recently having been identified at Qingliangsi village, Baofeng county. It has a fine, closely knit greyish or buff body, a thick blue-grey glaze with a small regular crackle (qq.v.), and is generally fired on three or five spurs. This ceramic is thought to have been made for the Northern Song court for a very short time from *c*.1107 to 1125. Very few pieces survive today. It was later much praised by Chinese connoisseurs for its beauty and rarity and taken to represent the epitome of court taste, particularly favoured by Emperor Huizong of the Northern Song.

saggar Box-like container of a coarse refractory clay (q.v.) used for encasing ceramics in the kiln (q.v.), to prevent impurities in the kiln atmosphere from blemishing the ceramics and to ensure even temperature during firing. Saggars also permitted stacking within the kiln, thus making more efficient use of the space.

sancai Literally 'three colours'. This term refers to the green, amber and cream glazes (q.v.) used on burial ceramics of the Tang dynasty and is the name by which such wares are known. The term is somewhat inexact as the Tang *sancai* palette also included blue and black glazes. Similar glazing techniques were used in architectural ceramics and on later wares employed in the Song and Ming periods.

setters Supports for ceramics designed to fit inside saggars (q.v.) and hold the wares in place during firings (q.v.). They were made from the same (or similar) materials as the wares they supported, and also in the same condition – either raw or bisque fired (q.v.). They shrank at the same rate as the wares during firing, thereby minimising distortion. Stepped setters allowed 'nests' of bowls to be fired rim-down within larger saggars, and ring setters with ledges were used to support columns of bowls of the same size by their rims, with setters and bowls alternating in the setting. Setters (unlike saggars) could only be used once.

shufu Two Chinese characters which have been interpreted as 'privy council'. The term '*shufu*' denotes a class of white ware probably made for the Shu Mi Yuan, a central government agency, on which these two characters are moulded. A further distinguishing feature is the opacity of the thick, bluish-white glaze (q.v.). '*Shufu*' type is also a term used for thick-glazed wares inscribed with other characters or none at all.

silica Main constituent of glaze (q.v.) and glass which occurs naturally in a pure state as flint and quartz. Igneous rocks (q.v.) and clays are also rich in silica. Silica begins to melt when heated to 1713°C but does not become liquid until even higher temperatures are reached. Molten silica cools to form a true glass. However, as most clays can only withstand temperatures of about 1300°C or lower, silica cannot be used

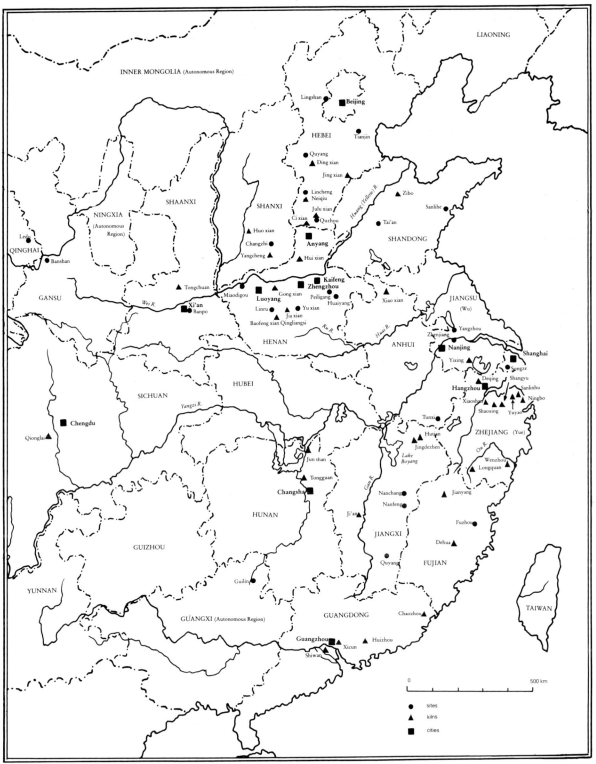

MAP VII Kilns and other ceramic sites.

alone as a ceramic glaze and a flux (q.v.) must be added so that glassy materials can be formed at lower temperatures.

slip Dilute clay mixture sometimes applied to the surface of a pot before glazing, often to enhance smoothness or to disguise an unsuitable clay body colour (q.v.). Slip was used for many purposes in Chinese ceramics including luting (q.v.) separate parts, outlining motifs and creating relief decoration.

soft paste Term used to denote *huashi* wares (q.v.) of the eighteenth century, but otherwise not applicable to Chinese ceramics. Hard paste porcelain is the name given to European porcelains whose consistency and chemistry approach those of Chinese porcelains (q.v.). European soft pastes were made mainly from mixtures of white-firing clays with crushed glass. Although they were often very white and highly translucent, European soft paste porcelains were soft and fragile with poor resistance to thermal shock, e.g. from boiling water.

spur marks Small circular or elliptical marks of rough whitish or blackish clay in a glaze (q.v.), usually on the base, caused when the spurred stands on which the vessels were fired, which were made of refractory clay (q.v.), were broken away. Spurs were used particularly to allow the feet of bowls or dishes to be glazed overall, with the spurs supporting the wares inside the foot rings during firing.

stoneware Tough and non-translucent ceramic (q.v.) varying in colour from black to light grey or dirty white. It is usually glazed (q.v.), the glaze being different from that used on earthenware (q.v.) and fired to between about 1150 and 1300°C.

Swatow Name of the port from which ceramics from Fujian province were exported to Japan, Southeast Asia, Indonesia and India in the sixteenth and seventeenth centuries. The pieces were generally large, rough and decorated in turquoise, red and black enamels (q.v.).

teadust Iron-rich Chinese stoneware glaze (qq.v.), usually showing a dusting of greenish crystals on a much darker background. Teadust effects are often seen on underfired Song, Jin and Yuan *temmoku* wares (q.v.), but an intentional teadust glaze was also used on later Jingdezhen porcelains (qq.v.), particularly in the eighteenth century. The green crystals are believed to be the mineral pyroxene, formed during cooling.

temmoku Japanese term for black wares known to the Chinese as Jian ware (q.v.).

terracotta Very broad term for unglazed earthenware (q.v.). Chinese loess (q.v.) proved to be one of the most versatile terracotta materials in the world and was used for the enormous army of over 7000 life-size warriors made to guard the first Qin emperor's mausoleum in the third century BC. Reduction firing (q.v.) and cooling produced the characteristic grey colour in the terracotta warriors, but the oxidised firings (q.v.) used for Han lead-glazed wares (q.v.) gave the more familiar terracotta red from the same raw material.

throwing Efficient and expressive technique for forming ceramic objects by the use of the potter's wheel (q.v.) under the control of the potter's hands. Like virtually all ceramic-making methods, throwing is essentially compressive (a gradual thinning of a stout spinning cylinder of clay by pressure), but to the observer it appears as though the pot or bowl is gradually growing beneath the potter's hands.

titanium dioxide Common impurity in ceramic clays and glazes (q.v.). In combination with iron oxide, and in reduction firings (qq.v.), titanium dioxide is responsible for the huge range of greens seen in Chinese celadon (q.v.) glazes. South Chinese porcelain materials are virtually titanium free, which accounts for their cool bluish tones (the natural colour of small amounts of ferrous oxide in solution).

turning The paring down of half-dry thrown wares, usually managed by returning the wares to the potter's wheel (q.v.) and turning away any excessive thickness of clay using metal or bamboo turning tools. Footrings are also produced by turning. 'Turning' is sometimes used (inaccurately) as a synonym for throwing (q.v.).

underglaze blue Cobalt-blue pigment applied for decorative purposes directly to the ceramic body before glazing and firing (qq.v.). Cobalt was first imported into China from the Near East but native sources were used later.

underglaze painting Decoration applied to the body of a ceramic before it is glazed (qq.v.). Underglaze painting may also be applied to a piece which has been covered with slip (q.v.) but not yet glazed.

woodash, vegetable ash Inorganic residue left from burning woody or plant material. Woodash is rich in glaze-forming oxides, particularly calcia (q.v.). The earliest Chinese glazes (q.v.) are believed to have consisted largely of woodash, and the use of this material in some Chinese glazes has survived to the present day. Different woodashes tend to be rich in different glaze oxides and this effect was exploited by Chinese potters. For example, ordinary woodash (hearth ash) is rich in calcia while rice-straw ash contains much silica (q.v.). Pine-needle ash is rich in potassia and was used as a source of K_2O in Longquan celadon glazes (q.v.).

wucai Literally 'five colours', a reference to the late Ming ceramics decorated in underglaze blue and overglaze enamels (qq.v.). The blue is used for specific elements rather than in the outline manner as on *doucai* wares (q.v.).

Xing ware White porcelain produced from the late Sui dynasty at kilns (qq.v.) in Neiqiu and Lincheng counties in Hebei province. Xing ware was the whitest and purest of early northern porcelains with a composition similar to Ding ware (q.v.), although usually lower in magnesia. In 1989 two sherds of a highly feldspathic (q.v.) translucent Xing ware, from late Sui levels in Neiqiu and supposedly of that date, were exhibited at a conference in Shanghai, but no complete examples of this remarkable ware are known.

Xiuneisi Palace Works Department. It is stated in Southern Song texts that when the Southern Song dynasty established itself in 1127 at its new capital in Hangzhou in Zhejiang province, wares for the exclusive use of the court were to be made on the orders of the Xiuneisi, which was close to Phoenix Hill within the palace grounds. However, despite frequent searches, the Xiuneisi's kiln has never been positively identified.

Yaozhou Kiln site in the city of Tongchuan, Shaanxi province. The kilns at Yaozhou began production in the Tang dynasty, reached their peak in the Northern Song and finished production in the Yuan. They made a variety of different wares, the best known of which is a greenware, with carved and moulded decoration, often called northern celadon (q.v.).

yingqing See *qingbai*

Yixing One of China's most ancient ceramic centres, sited on the shore of Lake Tai in Jiangsu province. Yixing ceramics date back to the Shang dynasty, but the area is most famous for its unglazed brown, red and yellow buff pottery tea wares made from the local *zisha* (purple sand) clays (q.v.). These were first celebrated in the early sixteenth century and have been popular in China ever since. Yixing teapots (modelled and moulded by hand) are endlessly inventive in design and include some of the few Chinese ceramics signed by their makers. Besides the *zisha* wares, more recent Yixing stonewares include those with thick Jun and *flambé*-style glazes (qq.v.).

Yue Small state near the Yangzi River mouth which has given its name to a grey-bodied ceramic with an olive-green or grey glaze (qq.v.). Such greenwares were first made in the fourth or third century BC and continued to be made down to the tenth or eleventh century AD. In the late Tang period Yue ceramics were made at a group of kilns (q.v.) in the neighbourhood of Shanglinhu in Yuyao xian, Zhejiang province, where several separate kiln sites have been found. These ceramics were exceptionally fine and were often offered as tribute to the Tang court. Yue ware continued into the Song dynasty but was gradually displaced by the northern celadon and southern celadon wares of Longquan (qq.v.). Yue wares were exported to the Far East, Southeast Asia and the Near East.

zhenyao kiln Literally 'egg-shaped' kiln (fig. 236). A wood-fired, single chambered kiln (q.v.) with a large single firebox which also acted as a door for setting and drawing (qq.v.) the wares. The *zhenyao* kiln was developed at Jingdezhen (q.v.) in the late Ming. It looked like half an egg lying on its side, with a tapering chimney as tall as the kiln was long (10–15 metres inside). The *zhenyao* kiln became the main Jingdezhen porcelain-producing kiln until the 1950s. A peculiarity of this kiln was the great fall-off in heat from the firebox end (1300°C) to the chimney end (*c.*1000°C). However, this temperature difference was exploited by the Jingdezhen potters, who were able to fire a great range of glazes and porcelain bodies in the same kiln in one firing (qq.v.).

zisha Literally 'purple sand', a reference to the brown stonewares produced at Yixing (qq.v.) in Jiangsu province.

233 The *long* (dragon) kiln is the principal kiln design of south China, named after the resemblance of its long, narrow shape to a dragon. Dragon kilns, designed in the late Warring States period, are wood-fuelled and fire to high temperatures (1200–1300°C). At the Longquan kiln complex in southern Zhejiang province, dragon kilns of up to 60m in length are known.

234 (*right*) The *mantou* (bread roll) kiln is the principal kiln type of north China, named after the local bread roll of comparable shape. *Mantou* kilns are small and high, well-suited both to the short flame length of the coal with which they were fuelled and to achieving the high temperatures (up to 1370°C) required for high-firing northern clays.

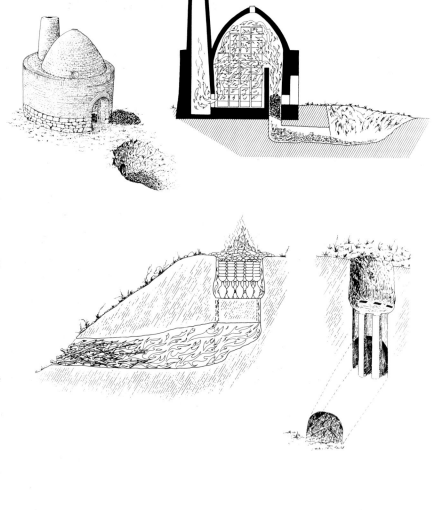

235 (*right*) Yangshao Neolithic kiln. Kilns with the firebox placed below the firing chamber are known as updraught kilns. The pierced floor of the Yangshao design allowed an even temperature throughout the firing chamber; the kiln atmosphere was oxygen-rich, accounting for the red colour of the earthenwares produced.

236 (*below*) The *zhenyao* (egg-shaped) kiln is peculiar to Jingdezhen, where it was developed in the late Ming period, and is named after its resemblance to half an egg lying on its side. Egg-shaped kilns were wood-fuelled, and the variation in temperature between 1000 and 1300°C within the kiln allowed a range of glazes and porcelain bodies to be achieved within a single firing.

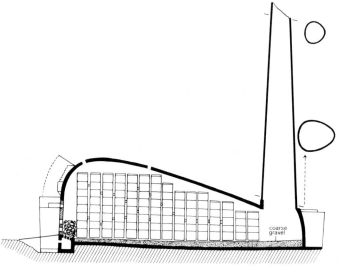

Select bibliographies

The following series of bibliographies is not meant to be exhaustive, but simply to offer a selection of books relevant to each chapter of the text. This is prefaced by a list of more general references. The bibliographies of individual books can also be consulted for further assistance.

General

JOURNALS AND PERIODICALS
English language
Artibus Asiae, Ascona, Switzerland, monographs published irregularly
Asia Major, new series, 1949 –
Bulletin of the Museum of Far Eastern Antiquities, Stockholm
Bulletin of the School of Oriental and African Studies, London University
Early China, Berkeley, California
Harvard Journal of Asiatic Studies, Cambridge, Mass.
Journal of American Oriental Society
Journal of Asian Studies, 1941 – (pre-1956 entitled *The Far Eastern Quarterly*)
Monumenta Serica, published irregularly by the Catholic University of Beijing until 1948 and thereafter by the Society of the Divine Word in Tokyo and Nagoya, Japan
Oriental Art, London
Oriental Ceramic Society Translations, series of important articles from Chinese published at irregular intervals
Orientations, Hong Kong
T'oung Pao, published irregularly by E. J. Brill, Leiden
Transactions of the Oriental Ceramic Society, London

Chinese language
Gugong bowuyuan yuankan (The Palace Museum Journal), Beijing
Jiang Han kaogu
Kaogu
Kaogu xuebao
Kaogu yu wenwu
Wenbo
Wenwu and *Wenwu cankao ziliao*
Wenwu ziliao congkan
Zhongyuan wenwu
(All the above are Chinese mainland publications)
Bulletin of The National Museum of History, Taipei, Taiwan (in Chinese)
The National Palace Museum Research Quarterly, National Palace Museum, Taipei, Taiwan (in Chinese)

EXHIBITION CATALOGUES
This is a very large field and the following list of exhibition catalogues is only a small selection, but each is important for its comprehensiveness.
Arte Cinese (Chinese Art), catalogue of an exhibition in Venice, 1954, published Venice, 1954, reprinted London, 1981
Genius of China, an exhibition of archaeological finds of the People's Republic of China held at the Royal Academy, London, September 1973–January 1974, London, 1973
Palastmuseum Peking: Schätze aus der Verbotenen Stadt, exhibition held in Berlin, May–August 1985, Frankfurt, 1985
The Chinese Exhibition: A Commemorative Catalogue of the International Exhibition of Chinese Art, Royal Academy of Arts, November 1935–March 1936, London, 1936

REFERENCE, LITERATURE, PHILOSOPHY, ETC.
Cao Xueqin (trans. D. Hawke and J. Minford), *The Story of the Stone*, 5 vols, London, 1973–86
Chang, K. C. (ed.), *Food in Chinese Culture: Anthropological and Historical Perspectives*, New Haven, 1977
Christie, A., *Chinese Mythology*, London, 1975 (new edition, New York, 1985)
Ch'u, T-T., *Law and Society in Traditional China*, The Hague and Paris, 1961
Franke, H., *Sung Biographies*, 2 vols (entries in French, German and English), Wiesbaden, 1976
Fung Yu-lan (trans. D. Bodde), *A History of Chinese Philosophy*, 2 vols, Princeton, 1st paperback printing, 1983
Giles, H., *A Chinese Biographical Dictionary*, London and Shanghai, 1898
Goodrich, L. C. and Fang Chaoying (eds), *Dictionary of Ming Biography*, 2 vols, New York and London, 1976
Hawkes, D. (trans.), *The Songs of the South: An Anthology of Ancient Chinese Poems by Qu Yuan and Other Poets*, Harmondsworth, England, 1985
Herrmann, A., *An Historical Atlas of China*, 1935 (revised new edition, N. Ginsburg (ed.), Edinburgh, 1966)
Hook, B. (ed.), *The Cambridge Encyclopedia of China*, Cambridge, 1982
Hucker, C., *A Dictionary of Official Titles in Imperial China*, Stanford, 1985
Hummel, A. W. (ed.), *Eminent Chinese of The Ch'ing Period*, Washington DC, 1943
Legge, J., *The Chinese Classics*, with a translation, critical and exegetical notes, prolegomena and copious indexes, 5 vols in 4, reprinted Hong Kong, 1961
Needham, J. et al., *Science and Civilisation in China*, Cambridge, 1954– (15 vols published to date with a projected 19 to follow)
Nienhauser, W. H. (ed.), *The Indiana Companion to Traditional Chinese Literature*, Bloomington, 1986
Schwartz, B. I., *The World of Thought in Ancient China*, Cambridge, Mass., 1985
Shi Nai'an and Luo Guanzhong (trans. S. Shapiro), *Shui Hu Zhuan (Outlaws of the Marsh)*, 3 vols, Beijing, 1980

Tan Qixiang (chief ed.), *Zhongguo Lishi Ditu Ji (Historical Atlas of China)*, vols 1–8 (divided dynastically), Shanghai, 1982

The Times Atlas of China, London, 1974

Tregear, T. R., *A Geography of China*, London, 1965

Waley, A., *Three Ways of Thought in Ancient China*, London, 1939

—— (trans.), *The Book of Songs*, London, 1937 (2nd edition, 1960)

Werner, E. T. C., *A Dictionary of Chinese Mythology*, Shanghai, 1932 (reprinted New York, 1961)

Wright, A., *Buddhism in Chinese History*, Stanford, 1959

Wu Cheng'en (trans. A. Yu), *Journey to the West*, 3 vols, Chicago, 1977

Wu Jingzi (trans. G. and Hsien-yi Yang), *The Scholars*, Beijing, 1957

HISTORY, SOCIOLOGY, ETC.

The Cambridge Histories of China (volumes published to date):

Vol. 1: Twitchett, D. and Loewe, M. (eds), *The Ch'in and Han Empires, 221 BC–AD 220*, Cambridge, 1986

Vol. 7: Mote, F. W. and Twitchett, D. (eds), *The Ming Dynasty, 1368–1644*, Part 1, 1987

Vol. 10: Fairbank, J. K. (ed.), *Late Ch'ing, 1800–1911*, Part 1, 1978

Vol. 11: Fairbank, J. K. and Liu Kwang-ching (eds), *Late Ch'ing, 1800–1911*, Part 2, 1980

Vol. 12: Fairbank, J. K. (ed.), *Republican China, 1912–1949*, Part 1, 1983

Vol. 13: Fairbank, J. K. and Feuerwerker, A. (eds), *Republican China, 1912–1949*, Part 2, 1986

Vol. 14: MacFarquhar, R. and Fairbank, J. K. (eds), *The People's Republic, Part 1: The Emergence of Revolutionary China, 1949–1965*, 1987

Ahern, E. M., *The Cult of the Dead in a Chinese Village*, Stanford, 1973

Anderson, M. M., *Hidden Power: The Palace Eunuchs of Imperial China*, New York, 1990

Baker, H. D. R., *Chinese Family and Kinship*, London and Basingstoke, 1979

Balaz, E. (ed. with introduction by A. F. Wright, trans. H. M. Wright), *Chinese Civilisation and Bureaucracy*, New Haven and London, 1964

Chan, A., *The Glory and Fall of the Ming Dynasty*, Norman, Oklahoma, 1982

Chang, K. C., *Shang Civilization*, New Haven and London, 1980

——, *The Archaeology of Ancient China*, New Haven and London, 4th edition, 1986

Ch'en, K. K. S., *Buddhism in China: A Historical Survey*, Princeton, 1964 (reprinted 1973)

Chow, T-t., *The May Fourth Movement: Intellectual Revolution in Modern China*, Cambridge, Mass., 1960

Creel, H., *The Origins of Statecraft in China*, Chicago, 1970

Dardess, J. W., *Conquerors and Confucians*, New York, 1973

Dubs, H. H., *History of the Former Han Dynasty*, vols 1–3, Baltimore, 1938–55

Elvin, M., *Pattern of the Chinese Past*, Stanford, 1973

Fairbank, J. K. (ed.), *The Chinese World Order: Traditional China's Foreign Relations*, Cambridge, Mass., 1968

Fang, A. (trans.), *The Chronicle of the Three Kingdoms (220–265)*, Cambridge, Mass., 1952

Freedman, M., *Family and Kinship in Chinese Society*, Stanford, 1970

Gernet, J. (trans. H. M. Wright), *Daily Life in China on the Eve of the Mongol Invasion: 1250–1276*, Stanford, 1962

—— (trans. J. R. Foster), *A History of Chinese Civilization*, Cambridge, 1982

Guisso, R. W. L., *Wu Tse-T'ien and the Politics of Legitimation in T'ang China*, Washington DC, 1978

Haeger, J. W. (ed.), *Crisis and Prosperity in Sung China*, Phoenix, Arizona, 1975

Ho Ping-ti, *The Ladder of Success in Imperial China: Aspects of Social Mobility, 1368–1911*, New York, 1962

Hsu Cho-yun and Linduff, K. M., *Western Chou Civilization*, New Haven, 1988

Huang, R., *1587, A Year of No Significance: The Ming Dynasty in Decline*, New Haven, 1981

Hucker, C. O., *The Traditional Chinese State in Ming Times (1368–1644)*, Tucson, Arizona, 1961

——, *The Censorial System of Ming China*, Stanford, 1966

—— (ed.), *Chinese Government in Ming Times: Seven Studies*, New York, 1969

Hulsewé, A. F. P. (with introduction by M. Loewe), *China in Central Asia: The Early Stage: 125 BC–AD 23*, Leiden, 1979

Jenner, W. J. F., *Memories of Loyang: Yang Hsuan-chih and the lost capital (493–534)*, Oxford, 1981

Karmay, H., *Early Sino-Tibetan Art*, Warminster, 1975

Keightley, D. N., *Sources of Shang History: The Oracle Bone Inscriptions of Bronze Age China*, Berkeley, 1978

Kierman, F. (translated from *La Chine Antique* by H. Maspero), *China in Antiquity*, Amherst, Mass., 1978

Kuhn, D., *Die Song Dynastie (960 bis 1279): Eine Neue Gesellschaft im Spiegel Ihrer Kultur*, Acta Humaniora, UCH Weinheim, 1987

Langlois, J. D. (ed.), *China Under Mongol Rule*, Princeton, 1981

Latham, R. (trans.), *Marco Polo, The Travels*, London, 1958

Ledderose, L. and Schlombs, A., *Jenseits der Grossen Mauer: Der Erste Kaiser von China und Seine Terrakotta Armee*, Munich, 1990

Lee, S. E. and Ho Wai-kam, *Chinese Art under the Mongols: The Yuan Dynasty 1279–1368*, Cleveland, 1968

Levinson, J. R., *Liang Ch'i-Chao and The Mind of Modern China*, Cambridge, Mass., 1953

Lewis, M., *Sanctioned Violence in Early China*, Albany, 1990

Li Xueqin (trans. K. C. Chang), *Eastern Zhou and Qin Civilizations*, New Haven and London, 1985

Liu, James T. C., *Reform in Sung China: Wang An-shih (1021–1086) and his new policies*, Cambridge, Mass., 1959

Loewe, M., *Everyday Life in Early Imperial China during the Han Period, 202 BC–AD 220*, London, 1968

——, *Ways to Paradise: The Chinese Quest for Immortality*, London, 1979

——, *The Pride that was China*, London and New York, 1990

Overmeyer, D., *Folk Buddhist Religion: Dissenting Sects in Late Traditional China*, Cambridge, Mass., 1976

Pirazzoli-t'Serstevens, M. (trans. J. Seligman), *The Han Civilization of China*, Oxford, 1982

Rawson, J., *Ancient China: Art and Archaeology*, London, 1980

Rossabi, M., *China and Inner Asia from 1368 to the Present Day*, London, 1975

—— (ed.), *China Among Equals: The Middle Kingdom and its Neighbors, 10th-14th Centuries*, Berkeley, 1983

——, *Khubilai Khan: His Life and Times*, Berkeley, Los Angeles and London, 1988

Schafer, E. H., *The Golden Peaches of Samarkand: A Study of T'ang Exotics*, Berkeley, Los Angeles and London, 1963

——, *The Vermilion Bird: T'ang Images of the South*, Berkeley and Los Angeles, 1967

——, *Pacing the Void: T'ang Approaches to the Stars*, Berkeley, 1977

Schram, S., *Mao Tse-Tung*, Harmondsworth, 1967

Schurmann, H. F., *Economic Structure of the Yuan Dynasty*, Cambridge, Mass., 1956

Shaughnessy, E. L., *Sources of Western Zhou History, Inscribed Bronze Vessels*, Berkeley, Los Angeles and Oxford, 1991

Sinor, D. (ed.), *The Cambridge History of Early Inner Asia*, Cambridge, 1990

Smith, R. J., *China's Cultural Heritage: The Ch'ing Dynasty, 1644–1912*, Boulder, Colorado and London, 1983

Spence, J. D., *Emperor of China: Self-Portrait of K'ang-hsi*, London, 1974

——, *The Gate of Heavenly Peace: The Chinese and their Revolution 1895–1980*, London, 1982

Stein, A., *Ancient Khotan: Detailed report of archaeological explorations in Chinese Turkestan*, 2 vols, Oxford, 1907

——, *Serindia: Detailed report of explorations in Central Asia and Westernmost China*, 5 vols, Oxford, 1921

——, *Innermost Asia: Detailed report of explorations in Central Asia, Kansu and Eastern Iran*, 4 vols, Oxford, 1928

Steinhardt Shatzman, N. (ed.), *Chinese Traditional Architecture*, New York, 1984

Wang Gungwu, *The Structure of Power in North China during the Five Dynasties*, Malaya, 1967

Wang Zhongshu (trans. K. C. Chang and collaborators), *Han Civilization*, New Haven and London, 1982

Watson, B., *Ssu-Ma Ch'ien: Grand Historian of China*, New York, 1958

——, *Records of the Grand Historian* (translated from the *Shiji* of Sima Qian), 2 vols, New York, 1971

Watson, W., *Art of Dynastic China*, New York, 1981

Wilson, D., *Mao Tse-Tung in the Scales of History*, Cambridge, 1977

Wolf, A. P. (ed.), *Religion and Ritual in Chinese Society*, Stanford, 1974

—— and Huang Chieh-shan, *Marriage and Adoption in China, 1845–1945*, Stanford, 1980

Wolf, M., *The House of Lim: A Study of a Chinese Farm Family*, New York, 1968

Wright, A. F. and Twitchett, D., *Perspectives on the T'ang*, New Haven and London, 1973

——, *The Sui Dynasty: The Unification of China, 581–617*, New York, 1978

Yu, Y. S., *Trade and Expansion in Han China*, Berkeley and Los Angeles, 1967

Zhongguo shehui kexueyuan kaogu yanjiusuo, *Xin Zhongguo de kaogu faxian he yanjiu*, Beijing, 1984

Zurcher, E., *The Buddhist Conquest of China*, 2 vols, Leiden, 1959

Zwalf, W. (ed.), *Buddhism: Art and Faith*, London, 1985

LITERATURE ON THE CHINESE AND RELATED COLLECTIONS OF THE DEPARTMENT OF ORIENTAL ANTIQUITIES, BRITISH MUSEUM

Addis, Sir J., *Chinese Porcelain from the Addis Collection: Twenty two pieces of Chingtechen porcelain presented to the British Museum*, London, 1979

Anderson, W., *Descriptive and Historical Catalogue of a Collection of Japanese and Chinese Paintings in the British Museum*, London, 1886

Binyon, L., *A Catalogue of Japanese and Chinese Woodcuts preserved in the Sub-department of Oriental Prints and Drawings in the British Museum*, London, 1916

——, *The Catalogue of the George Eumorfopoulos Collection of Chinese, Corean and Siamese Paintings*, London, 1928

Farrer, A., *The Brush Dances and the Ink Sings: Chinese Paintings and Calligraphy from the British Museum*, London, 1990

Franks, A. W., *Catalogue of a Collection of Oriental Porcelain and Pottery, lent for exhibition by A. W. Franks*, London, 1876

Garner, Sir H., *Chinese Lacquer*, London and Boston, 1979

Hobson, R. L., *Handbook of the Pottery and Porcelain of the Far East in the Department of Oriental Antiquities*, London, 1948

——, *The Catalogue of the George Eumorfopoulos Collection of Chinese, Corean and Persian Pottery and Porcelain*, 6 vols, London, 1925–8

Jenyns, R. S., *Chinese Archaic Jades in the British Museum*, London, 1951

Rawson, J., *British Museum Keys to the Past, Chinese Pots 7th–13th Century AD*, London, 1977

——, *Ancient China: Art and Archaeology*, London, 1980

——, *Chinese Ornament: The Lotus and the Dragon*, London, 1984 (2nd edition, 1990)

——, *Chinese Bronzes: Art and Ritual*, London, 1987

Smith, L., Rawson, J., Whitfield, R. and Pinder-Wilson, R., *The World's Great Collections, Oriental Ceramics*, vol. 5, *The British Museum, London*, Tokyo, New York and San Francisco, 1974 (new edition, 1981)

Tait, H. (ed.), *Jewellery through 7000 Years*, exhibition catalogue, London, 1976

—— (ed.), *7000 Years of Jewellery*, London, 1986 (reprinted 1989)

—— (ed.), *5000 Years of Glass*, London, 1991

Vainker, S., *Chinese Pottery and Porcelain: From Prehistory to the Present*, London, 1991

Waley, A., *Artists represented in the subordinate department of Oriental Prints and Drawings, British Museum*, London, 1922

——, *An Introduction to the Study of Chinese Painting*, London, 1923

——, *A Catalogue of Paintings Recovered from Tun-Huang by Sir Aurel Stein*, London, 1931

Watson, W., *Handbook to the Collections of Early Chinese Antiquities*, London, 1963

Whitfield, R., *The Art of Central Asia: The Stein Collection in the British Museum*, 3 vols, Tokyo, 1982–5

—— and Farrer, A., *Caves of the Thousand Buddhas: Chinese Art from the Silk Route*, London, 1990

Wood, F., *Chinese Illustration*, London, 1985

Yetts, W. P., *The Catalogue of the George Eumorfopoulos Collection of Chinese and Corean Bronzes, Sculptures, Jades, Jewellery and Miscellaneous Objects*, 2 vols, London, 1929–30

——, *The Cull Chinese Bronzes*, London, 1939

Zwalf, W. (ed.), *Buddhism: Art and Faith*, London, 1985

Jades and bronzes

JADES

d'Argencé, R-Y. Lefebvre, *Chinese Jades in the Avery Brundage Collection*, San Francisco, 1972 (revised edition, 1977)

Childs-Johnson, E., *Ritual and Power: Jades of Ancient China*, New York, 1988

Dohrenwend, D., *Chinese Jades in the Royal Ontario Museum*, Toronto, 1971

Hansford, S. H., *Chinese Jade Carving*, London, 1950

——, *Chinese Carved Jades*, London, 1968

Lam, P. Y. K. (ed.), *Jades from the Tomb of the King of Nanyue*, Hong Kong, 1991

Loehr, M., *Ancient Chinese Jades from the Grenville L. Winthrop Collection in the Fogg Art Museum, Harvard University*, Cambridge, Mass., 1975

Na Chih-liang, *Chinese Jades, Archaic and Modern, from the Minneapolis Institute of Art*, Rutland, Vermont and Tokyo, 1977

Rawson, J., 'The Surface Decoration on Jades of the Chou and Han Dynasties', *Oriental Art*, vol. XXI, no. 1, 1975, pp. 36–52

—— and Ayers, J., *Chinese Jade throughout the Ages*, London, 1975

Salmony, A., *Archaic Chinese Jades from the Edward and Louise B. Sonnenschein Collection*, Chicago, 1932

——, *Chinese Jade Through the Wei Dynasty*, New York, 1963

Watt, J. C. Y., *Chinese Jades from the Collection of the Seattle Art Museum*, Seattle, 1989

Yeung Kin-Fong, *Jade Carving in Chinese Archaeology*, vol. 1, Hong Kong, 1987

BRONZES

d'Argencé, R-Y. Lefebvre, *Bronze Vessels of Ancient China in the Avery Brundage Collection*, San Francisco, 1977

Bachhofer, L., 'The Evolution of Shang and Early Chou Bronzes', *The Art Bulletin*, vol. XXVI, 1944, pp. 107–16 (see Maenchen-Helfen)

Bagley, R., *Shang Ritual Bronzes in the Arthur M. Sackler Collections*, Washington DC and Cambridge, Mass., 1987

Barnard, N., *Bronze Casting and Bronze Alloys in Ancient China*, Monumenta Serica Monograph, XIV, Canberra, 1961

Chase, W. T. (with assistance of Jung May Lee), *Ancient Chinese Bronze Art: Casting the Precious Sacral Vessel*, New York, 1991

Fong Wen (ed.), *The Great Bronze Age of China*, exhibition catalogue, New York, 1980

Guo Moruo, *Liang Zhou jinwenci daxi tulu kaoshi*, Tokyo, 1935

Hayashi Minao, 'In Seishū kan no seidō yōki no hennen', in *Tōhō gakuhō*, 50 (A Chronology of Bronze Vessels from the Yin to Western Zhou Dynasty), 1978, pp. 1–55

——, *In Shū jidai seidōki no kenkyū (In Shū seidōki sōran ichi)*, A Study of Bronze Vessels of the Yin and Zhou Dynasties (A General Survey of Bronze Vessels of the Yin and Zhou), vol. 1, Tokyo, 1984

——, *In Shū jidai seidōki no kenkyū (In Shū seidōki sōran ni)*, A Study of Bronze Vessels of the Yin and Zhou Dynasties (A General Survey of Bronze Vessels of the Yin and Zhou), vol. 2, Tokyo, 1986

——, *Shunjū Sengoku jidai seidōki no kenkyū (In Shū seidōki sōran san)*, A Study of Bronze Vessels of the Spring and Autumn and Warring States' period (A General Survey of Bronze Vessels of the Yin and Zhou), vol. 3, Tokyo, 1989

Kerr, R., *Later Chinese Bronzes*, London, 1990

Kuwayama, G., *Ancient Ritual Bronzes of China*, Los Angeles, 1976

—— (ed.), *The Great Bronze Age of China. A Symposium*, Los Angeles, 1983

Lawton, T. (ed.), *New Perspectives on Chu Culture during the Eastern Zhou Period*, Princeton and Washington DC, 1991

——, 'An Imperial Legacy Revisited: Bronze Vessels from the Qing Palace Collection', *Asian Art*, vol. 1, no. 1 (Fall/Winter 1987), pp. 51–79

Loehr, M., 'The Bronze Styles of the Anyang Period', *Archives of the Chinese Art Society of America*, vol. VII, 1953, pp. 42–53

——, *Ritual Vessels of Bronze Age China*, New York, 1968

Maenchen-Helfen, O., 'Some Remarks on Ancient Chinese Bronzes', *The Art Bulletin*, vol. XXVII, 1945, pp. 238–43 (comments on Bachhofer (q.v.), followed by Bachhofer's reply, pp. 243–6: Bachhofer 1945)

Pope, J. A. et al., *The Freer Chinese Bronzes*, vol. 1, *Catalogue*, Washington DC, 1967 (see Rutherford)

Rawson, J., *Ancient China: Art and Archaeology*, London, 1980

——, 'Eccentric Bronzes of the Early Western Zhou', *Transactions of the Oriental Ceramic Society*, vol. 47,

1982–3, pp. 11–32

——, *Chinese Bronzes: Art and Ritual*, London, 1987

——, 'Western Zhou Sources of Interlaced Motifs', in R. Scott and G. Hutt (eds), *Style in the East Asian Tradition, Colloquies on Art and Archaeology in Asia*, no. 14, Percival David Foundation of Art, London, 1987, pp. 38–64

——, *Western Zhou Ritual Bronzes from the Arthur M. Sackler Collections*, 2 vols, Cambridge, Mass., 1990

—— and Bunker, E., *Ancient Chinese and Ordos Bronzes*, Hong Kong, 1990

Rutherford, J. G., *The Freer Chinese Bronzes*, vol. 2, *Technical Studies*, Washington DC, 1969 (see Pope)

Shanghai Bowuguan cang qingtongqi, 2 vols, Shanghai, 1964

Soper, A., 'Early, Middle and Late Shang: A Note', *Artibus Asiae*, vol. XXVIII, 1966, pp. 5–38

Watson, W., *Ancient Chinese Bronzes*, London, 1962, reissued 1977

Weber, G. W. Jr, *The Ornaments of Late Chou Bronzes: A Method of Analysis*, New Brunswick, 1973

Yetts, W. P., *The Catalogue of the George Eumorfopoulos Collection of the Chinese and Corean Bronzes, Sculptures, Jades, Jewellery and Miscellaneous Objects*, 2 vols, London, 1929–30

——, *The Cull Chinese Bronzes*, London, 1939

Painting, calligraphy and printing

PAINTING

Acker, W. R. B., *Some T'ang and Pre-T'ang Texts on Chinese Painting*, Leiden, 1954

Bickford, M. et al., *Bones of Jade, Souls of Ice: The Flowering Plum in Chinese Art*, New Haven, 1985

Binyon, L., *Painting in the Far East*, London, 4th edition, 1934

Bush, S., *The Chinese Literati on Painting: Su Shih (1037–1101) to Tung Ch'i-Ch'ang (1555–1636)*, Harvard Yenching Studies, no. 27, Cambridge, Mass., 1971

—— and Shih Hsio-yen (eds), *Early Chinese Texts on Painting*, Cambridge, Mass. and London, 1985

Cahill, J., *Chinese Painting*, Lausanne, 1960

——, *Fantastics and Eccentrics in Chinese Painting*, New York, 1967

—— (ed.), *The Restless Landscape: Chinese Painting of the Late Ming Period*, exhibition catalogue, University Art Museum, Berkeley, 1971

——, *Hills Beyond a River: Chinese Painting of the Yuan Dynasty, 1279–1368*, New York and Tokyo, 1976

——, *Parting at the Shore: Chinese Painting of the Early and Middle Ming Dynasty, 1368–1580*, New York and Tokyo, 1978

——, *The Compelling Image: Nature and Style in Seventeenth Century Chinese Painting*, Cambridge, Mass., 1982

Chen Shih-hsiang, *Biography of Ku K'ai-Chih*, Institute of East Asiatic Studies, University of California, Chinese Dynastic Histories Translations, no. 2, Berkeley and Los Angeles, 1953

Clapp, A. de Coursey, *Wen Cheng-Ming: The Ming Artist and Antiquity*, Ascona, 1975

——, *The Painting of Tang Yin*, Chicago and London, 1991

Cohen, J. Lebold, *The New Chinese Painting 1949–1986*, New York, 1987

Contag, V. (trans. M. Bullock), *Chinese Masters of the 17th Century*, Rutland, Vermont and Tokyo, 1967

—— and Wang Chi-Ch'ien, *Seals of Chinese Painters and Collectors of the Ming and Ch'ing Periods*, revised edition, with supplement, Hong Kong, 1965

Edwards, R., *The Field of Stones: A Study of the Art of Shen Chou*, Washington DC, 1962

Ellsworth, R. H., *Later Chinese Painting and Calligraphy, 1800–1950*, 3 vols, New York, 1987

Farrer, A., *The Brush Dances and the Ink Sings: Chinese Paintings and Calligraphy from the British Museum*, exhibition catalogue, London, 1990

Fong Wen, 'The Problems of Forgeries in Chinese Painting', *Artibus Asiae*, vol. XXV, 1962, pp. 95–140

——, 'Tung Ch'i ch'ang yü cheng-tsung-p'ai hui-hua li lun' ('Tung Ch'i ch'ang and the Orthodox Theory of Painting'), *National Palace Museum Research Quarterly*, no. II, 1968, pp. 1–26

—— and Fu, M., *Song and Yuan Paintings*, New York, 1973

—— (ed.), *Images of the Mind*, Princeton, 1984

Fontein, J. and Hickman, M. L., *Zen Painting and Calligraphy*, Boston, 1970

Fu Shen and Stuart, J., *Challenging the Past: The Paintings of Chang Dai-Chien*, exhibition catalogue, Washington DC, 1991

Group for the authentication of ancient works of Chinese Painting and Calligraphy, *Zhongguo gudai huihua tu mu (Illustrated Catalogue of Selected Works of Ancient Chinese Painting and Calligraphy)*, vols 1–8, Beijing, 1986–90

Gulik, R. van, *Chinese Pictorial Art as Viewed by the Connoisseur*, Rome, 1958

Ho Wai-kam, Lee, S. E., Sickman, L. and Wilson, M. F., *Eight Dynasties of Chinese Painting: The Collections of the Nelson Gallery-Atkins Museum, Kansas City, and The Cleveland Museum of Art*, Cleveland, Ohio, 1980

Kao Mayching, *Twentieth Century Chinese Painting*, Oxford, 1988

Lawton, T., *Chinese Figure Painting*, Washington DC, 1973

Lee, S. E., *Chinese Landscape Painting*, New York, 1962

Li Chu-tsing, *Trends in Modern Chinese Painting: The C.A. Drenowatz Collection*, Artibus Asiae, vol. XXXVI, Ascona, 1979

Loehr, M., *Chinese Landscape Woodcuts: From an Imperial Commentary to the Tenth Century Printed Edition of the Buddhist Canon*, Cambridge, Mass., 1968

——, *The Great Painters of China*, Oxford, 1980

Ma Chengyuan (ed.), *The Four Monks Painters: Paintings from the Shanghai Museum Collection*, Hong Kong and Shanghai, 1990

March, B., *Some Technical Terms of Chinese Painting*, Baltimore, 1935

Murck, A. and Fong Wen (eds), *Words and Images: Chinese Poetry, Calligraphy and Painting*, New York and Princeton, 1991

Murray, J., *Last of the Mandarins: Chinese Calligraphy and Paintings from the F. Y. Chang Collection*, Cambridge, Mass., 1987

———, *Ma Hezhi and The Book of Odes*, Cambridge, forthcoming

Rogers, H., *Masterworks of Ming and Qing Painting from the Forbidden City*, catalogue of an American museum tour of paintings from the Palace Museum in Beijing, Lansdale, Pennsylvania, 1988

Rowley, G., *Principles of Chinese Painting*, Princeton, 1947

Silbergeld, J., *Mind Landscapes: The Paintings of C. C. Wang*, Washington DC, 1991

Sirén, O., *The Chinese on the Art of Painting*, Beijing, 1936 (reprinted New York and Hong Kong, 1963)

———, *A History of Later Chinese Painting*, 2 vols, London, 1938

———, *Chinese Painting: Leading Masters and Principles*, 7 vols, London and New York, 1956–8

Stein, Sir A., *The Thousand Buddhas: Ancient Buddhist Paintings from the Cave Temples of Tun-Huang, on the Western Frontier of China*, 3 vols, London, 1921

Sullivan, M., *Chinese Art in the Twentieth Century*, London, 1959

———, *The Birth of Landscape Painting in China*, Berkeley and Los Angeles, 1962

Suzuki Kei, *Comprehensive Illustrated Catalogue of Chinese Painting*, 5 vols, Tokyo, 1982

Sze Mai-mai (trans., ed.), *The Mustard Seed Garden Manual of Painting* (paperback reprint), Princeton, 1977

Waley, A., *A Catalogue of Paintings Recovered from Tun-Huang by Sir Aurel Stein*, London, 1931

———, *An Introduction to the Study of Chinese Painting*, London, 1923

Whitfield, R., *In Pursuit of Antiquity: Chinese Paintings of the Ming and Ch'ing Dynasties from the Collection of Mr and Mrs Earl Morse*, Princeton, 1969

———, 'Che School Paintings in the British Museum', *The Burlington Magazine*, vol. CXIV, no. 830, May 1972, pp. 285–94

———, *The Art of Central Asia: The Stein Collection in The British Museum*, 3 vols, Tokyo and London, 1983

——— and Farrer, A., *Caves of the Thousand Buddhas: Chinese Art from the Silk Route*, exhibition catalogue, London, 1990

CALLIGRAPHY AND PRINTING

Billeter, J. F., *The Chinese Art of Writing*, New York and Geneva, 1990

Carter, T. F., *The Invention of Printing in China and its Spread Westward*, New York, 1925 (revised 1955 by L. C. Goodrich)

Chiang Yee, *Chinese Calligraphy: An Introduction to its Aesthetic and Technique*, Cambridge, Mass., 1973

Cinquante Ans de Gravures sur Bois Chinoises, 1930–1980, exhibition catalogue, Grenoble, 1981

Edgren, S., *Chinese Rare Books in American Collections*, New York, 1984

———, 'Southern Song Printing at Hangzhou', *Bulletin of the Museum of Far Eastern Antiquities*, no. 61, Stockholm, 1989

Fu Shen et al., *Traces of the Brush: Studies in Chinese Calligraphy*, exhibition catalogue, New Haven, 1977

———, Lowry, G. and Yonemura, A., *From Concept to Context: Approaches to Asian and Islamic Calligraphy*, Washington DC, 1986

Ledderose, L., *Die Siegelschrift (Chuan-Shu) in der Ch'ing Zeit. Ein Beitrag zur Geschichte der Chinesischen Schriftkunst*, Wiesbaden, 1970

———, *Mi Fu and the Classical Tradition of Chinese Calligraphy*, Princeton, 1979

Mote, F. W. and Chu Hung-lam (ed. Goodman, H. L.), *Calligraphy and the East Asian Book*, Boston and Shaftesbury, 1989

Needham, J. and Tsien Tsuen-hsuin, *Science and Civilisation in China*, vol. 5, *Chemistry and Chemical Technology: Part 1: Paper and Printing*, Cambridge, 1985

Sun, S., *Modern Chinese Woodcuts*, exhibition catalogue, San Francisco, 1979

Tseng Yu-ho Ecke, *Chinese Calligraphy*, exhibition catalogue, Philadelphia, 1971

Tsien Tsuen-hsuin, *Written on Bamboo and Silk: The Beginnings of Chinese Books and Inscriptions*, Chicago and London, 1962

Twitchett, D., *Printing and Publishing in Medieval China*, London, 1983

Wood, F., *Chinese Illustration*, London, 1985

Zheng Zhenduo, *Zhongguo banhuashi tulu (The History of Chinese Woodblock Illustration)*, Shanghai, 1940–42

Zhongguo meishu quanji (A Conspectus of Chinese Art), Chinese Painting, vol. 21, New York and Beijing, 1985

Sculpture

d'Argencé, R-Y. Lefebvre (ed. with D. Turner), *Chinese, Korean and Japanese Sculpture in the Avery Brundage Collection*, San Francisco, 1974

Ashton, L., *An Introduction to the Study of Chinese Sculpture*, London, 1924

Bagley, R., 'Sacrificial Pits of the Shang Period at Sanxingdui in Guanghan County, Sichuan Province', *Arts Asiatiques*, vol. 43, 1988, pp. 78–86

———, 'A Shang City in Sichuan Province', *Orientations*, November 1990, pp. 52–67

Chavannes, E., *La Sculpture sur Pierre en Chine au Temps des Deux Dynasties Han*, Paris, 1893

———, *Les Mémoires Historiques De Se-Ma Ts'ien*, 6 vols, reprinted Paris, 1969

Chen De'an and Chen Xiandan, 'Guanghan Sanxingdui yizhi yihao jisikeng fajue jianbao', *Wenwu* 1987.10, pp. 1–15

Chen De'an, 'Guanghan Sanxingdui yizhi erhao jisikeng fajue jianbao', *Wenwu* 1989.5, pp. 1–20

Cotterell, A., *The First Emperor of China*, London, 1981

Gansusheng wenwu gongzuodui, *Longdong shiku*, Beijing, 1987

Gansusheng wenwu gongzuodui *and* Qingyang beishikusi wenguansuo, *Qingyang beishikusi*, Beijing, 1985

Gansusheng wenwu kaogu yanjiusuo, *Hexi shiku*, Beijing, 1987

Getty, A., *The Gods of Northern Buddhism*, 2nd edition, Oxford, 1928

Gillman, D., 'A New Image in Chinese Buddhist Sculpture of the Tenth to Thirteenth Century', *Transactions of the Oriental Ceramic Society*, vol. 47, 1982–3, pp. 33–44

Hackin, J. et al., *Studies in Chinese Art and Some Indian Influences*, London, 1937

Hearn, M. K., 'The Terracotta Army of the First Emperor of Qin (221–206 BC)', in Wen Fong (ed.), *The Great Bronze Age of China*, New York, 1980

Heibonshe/Wenwu (eds), *Chūgoku sekkutsu: Tōnkō Mokō kutsu (Stone Caves of China: Mogau Caves of Dunhuang)*, 5 vols, Tokyo, 1982

——, *Chūgoku sekkutsu: Kyōken sekkutsu-ji (Stone Caves of China: Cave Temples of Gongxian)*, Tokyo, 1983

——, *Chūgoku sekkutsu: Kijiru sekkutsu (Stone Caves of China: Stone Caves of Kizil)*, 3 vols, Tokyo, 1983–5

——, *Chūgoku sekkutsu: Kumutora sekkutsu (Stone Caves of China: Stone Caves of Kumtura)*, Tokyo, 1985

——, *Chūgoku sekkutsu: Bakusekizan sekkutsu (Stone Caves of China: Stone Caves of Maijishan)*, Tokyo, 1987

Hildebrand, J., *Das Ausländerbild in der Kunst Chinas als Spiegel Kultureller Beziehungen (Han–Tang)*, Stuttgart, 1987

Howard, A. F., 'Tang Buddhist Sculpture of Sichuan: Unknown and Forgotten', *Bulletin of the Museum of Far Eastern Antiquities*, no. 60, Stockholm, 1988, pp. 1–164

——, 'A Gilt Bronze Guanyin from the Nanzhao Kingdom of Yunnan, Hybrid Art from the Southwestern Frontier', *The Journal of the Walters Art Gallery*, no. 47, 1990, pp. 1–12

——, 'In support of a new chronology for the Kizil mural paintings', *Archives of Asian Art*, vol. 44, 1991, pp. 68–83

——, Li Kunsheng and Qiu Xuanchong, 'Nanzhao and Dali Buddhist Sculpture in Yunnan', *Orientations*, February 1992, pp. 51–60

Hunan Provincial Museum and Institute of Archaeology, *Changsha Mawangdui yihao Han mu (The Han Tomb no. 1 at Mawangdui, Changsha)*, in Chinese with English abstract, Beijing, 1973

Institute of Archaeology and Hebei CPAM, *Mancheng Hanmu fajue baogao (Report on the excavation of the Han tombs at Mancheng)*, Beijing, 1980

Klimburg-Salter, D., *The Kingdom of Bamiyan*, Naples, 1989

Kuwayama, G. (ed.), *Ancient Mortuary Traditions of China: Papers on Chinese Ceramic Funerary Sculptures*, Los Angeles, 1991

Laing, E. J., 'Chin "Tartar" Dynasty (1115–1234) Material Culture', *Artibus Asiae*, vol. XLIX, 1/2, 1988–9, pp. 73–126

Ledderose, L. and Schlombs, A., *Jenseits der Grossen Mauer:*

Der Erste Kaiser von China und Seine Terrakotta Armee, Munich, 1990

Lim, L. (ed.), *Stories from China's Past: Han Dynasty Pictorial Tomb Reliefs and Archaeological Objects from Sichuan Province, People's Republic of China*, San Francisco, 1987

Loewe, M., *Chinese Ideas of Life and Death: Faith, Myth and Reason in the Han period 202 BC to AD 220*, London, 1982

Los Angeles County Museum of Art, *The Quest for Eternity: Chinese Ceramic Sculptures from the People's Republic of China*, Los Angeles and London, 1987

Lutz, A. (ed.), *Der Goldschatz der Drei Pagoden: Buddhistische Kunst des Nanzhao-und-Dali Königreichs in Yunnan, China*, Zürich, 1991

Mahler, J. G., *The Westerners among the Figurines of the T'ang Dynasty of China*, Istituto Italiano per il Medio ed Estremo Oriente, Rome, 1959

Mathieu, R., *Etude sur la Mythologie et l'Ethnologie de la Chine Ancienne: Traduction Annotée du Shanhai Jing*, 2 vols, Paris, 1983

Mizuno Seiichi, *Chinese Stone Sculpture*, Tokyo, 1950

—— and Nagahiro Toshio, *Unkō sekkutsu (Yungang: The Buddhist Cave temples of the fifth century AD in North China)*, 32 vols, Kyoto, 1951–6

Munsterberg, H., *Chinese Buddhist Bronzes*, Rutland, Vermont and Tokyo, 1967

Murray, J., 'The Ladies' Classic of Filial Piety and Sung Textual Illustration: Problems of reconstruction and artistic context', *Ars Orientalis*, vol. XVIII, 1988, pp. 95–129

Ningxia huizu zizhiqu wenwu guanli weiyuanhui *and* Zhong yang meishu xueyuan meishu shixi, *Xumishan shiku*, Beijing, 1988

Paludan, A., *The Imperial Ming Tombs*, New Haven and London, 1981

——, 'Two Early Ming Mausolea', *Orientations*, January 1988, pp. 28–37

——, 'The Chinese Spirit Road', *Orientations*, September 1988, pp. 56–65; April 1989, pp. 64–73; March 1990, pp. 56–66

——, *The Chinese Spirit Road: The Classical Tradition of Stone Tomb Statuary*, New Haven and London, 1991

Priest, A., *Chinese Sculpture in the Metropolitan Museum of Art*, New York, 1944

Prip-Moller, J., *Chinese Buddhist Monasteries*, Copenhagen, 1937, reprinted Hong Kong, 1967

Rudolph, R. C., *Han Tomb Art of West China*, Berkeley and Los Angeles, 1951

Salmony, A., *Chinese Sculpture*, New York, 1944

——, *Antler and Tongue, an essay on ancient Chinese symbolism and its implications*, Artibus Asiae Supplement 13, Ascona, Switzerland, 1954

Segalen, V. (trans. E. Levieux), *The Great Statuary of China*, Chicago and London, 1978

Shaanxisheng kaogu yanjiusuo, *Qin Shihuang ling bingmayong keng yihaokeng fajue baogao, 1974–84*, 2 vols, Beijing, 1988

Shu Zhimei (ed.), *The Unearthed Cultural Relics from Leigudun, Suizhou, Hubei*, Hubei, 1984

Sirén, O., *Chinese Sculpture from the Fifth to the Fourteenth Century*, 4 vols, London, 1925

Smithies, R., 'The Search for the Lohans of I-Chou (Yixian)', *Oriental Art*, vol. XXX, 1984, pp. 260–74

Soothill, W. E. and Hodous, L., *A Dictionary of Chinese Buddhist Terms*, London, 1937

Soper, A. C., *Literary Evidence for Early Buddhist Art in China*, Ascona, Switzerland, 1959

Sullivan, M., *The Cave Temples of Maichishan*, Berkeley and Los Angeles, 1969

Taiyuanshi wenwu guanli weiyuanhui *and* Shanxi Jinci wenwu baoguansuo, *Jinci*, Beijing, 1981

Till, B., 'Some observations on stone winged chimeras at ancient Chinese tomb sites', *Artibus Asiae*, vol. XLII, 4, 1980, pp. 261–81

Tokiwa, Daijo and Sekino, Tadashi, *Buddhist Monuments in China*, vols 1–5, Bukkyo shiseki, Kenkyu-kwai, Tokyo, 1926–38

Wang Ziyun (ed.), *Shaanxi gudai shi diaoke*, Shaanxi, 1985

Watson, W. (ed.), *Mahayanist Art after 900: Colloquies on Art and Archaeology in Asia No. 2*, Percival David Foundation of Chinese Art, London, 1971

Whitfield, R., *The Art of Central Asia: The Stein Collection in the British Museum*, 3 vols, Tokyo and London, 1982–5

——, 'Buddhist Monuments in China: Some Recent Finds of Śarīra Deposits', *Buddhica Britannica, Series Continua 1, The Buddhist Heritage* (ed. T. Skorupski), vol. 1, Tring, Hertfordshire, 1989, pp. 129–41

——, 'Esoteric Buddhist Elements in the Famensi Reliquary Deposit', *Asiatische Studien*, vol. XLIV.2, 1990, pp. 247–66

——, 'Kizil and Dunhuang', (unpublished) paper presented at the symposium, Central Asia: Tradition and Change, 7–10 April, School of Oriental and African Studies, University of London, 1987

Wu Hung, 'Buddhist Elements in Early Chinese Art', *Artibus Asiae*, vol. XLVII, 1986, pp. 263–376

——, 'From Temple to Tomb, Ancient Chinese Art and Religion in Transition', *Early China*, vol. 13, Berkeley, 1988, pp. 78–115

——, *The Wu Liang Shrine: The Ideology of Early Chinese Pictorial Art*, Stanford, 1989

Yan'an diqu qunzhong yishuguan, *Yan'an Songdai shiku yishu*, Shaanxi, 1983

Yang Hsuan-ch'ih (trans. Yi-t'ung Wang), *A Record of Buddhist Monasteries in Lo-Yang*, Princeton, 1984

Yuan Zhongyi, *Qin Shi Huang ling bingmayong yanjiu*, Beijing, 1990

Zwalf, W. (ed.), *Buddhism: Art and Faith*, London, 1985

Decorative arts

SILK AND DRESS

Becker, J., *Pattern and Loom*, Copenhagen, 1987

Cammann, S., *China's Dragon Robes*, New York, 1952

Chung, Y. Y., *The Art of Oriental Embroidery*, New York, 1980

Dickinson, G. and Wrigglesworth, L., *Imperial Wardrobe*, London, 1990

Medley, M., *The Illustrated Regulations for Ceremonial Paraphernalia of the Ch'ing Dynasty*, London, 1982

Needham, J. and Kuhn, D., *Science and Civilization in China*, vol. V:9, *Textile Technology: Spinning and Reeling*, London, 1988

Priest, A., *Costumes from the Forbidden City*, exhibition catalogue, New York, 1945

Vollmer, J. E., *In the Presence of the Dragon Throne: Ch'ing Dynasty Costume in the Royal Ontario Museum*, Toronto, 1977

——, *Five Colours of the Universe: Clothes and Fabrics from the Ch'ing Dynasty*, exhibition catalogue, Edmonton, 1980

——, *Decoding Dragons: Status Garments in Ch'ing Dynasty China*, exhibition catalogue, Eugene, Oregon, 1983

Wang, L. H., *The Chinese Purse: Embroidered Purses of the Ch'ing Dynasty*, Taiwan, 1986

Wilson, V., *Chinese Dress*, London, 1986

Wrigglesworth, L., 'The Badge of Rank', *China*, London, 1990

Zhou Xibao, *Zhongguo gudai fushi shi (History of Ancient Chinese Costume)*, Beijing, 1984

Zhou Xun and Gao Chunming, *Zhongguo fushi wu nian qian (5000 Years of Chinese Dress)*, Hong Kong, 1984

LACQUER

Bluett & Sons and Krahl, R., *From Innovation to Conformity: Chinese Lacquer from the 13th to 16th Centuries*, London, 1989

Bourne, J. et al., *Lacquer: An International History and Illustrated Survey*, New York, 1984

Figgess, Sir J., 'A Group of Decorated Lacquer Caskets of the Yuan dynasty', *Transactions of the Oriental Ceramic Society*, vol. 34, 1962–3, pp. 97–100

——, 'Ming and Pre-Ming Lacquer in the Japanese Tea Ceremony', *Transactions of the Oriental Ceramic Society*, vol. 37, 1967–9, pp. 37–51

Garner, Sir H., *Chinese Lacquer*, London, 1979

Herberts, K., *Oriental Lacquer: Art and Technique*, London, 1962

Kuwayama, G., *Far Eastern Lacquer*, Los Angeles, 1982

Lee King Tsi and Hu Shih Chang, *Dragon and Phoenix: Chinese Lacquerware, The Lee Family Collection, Tokyo/Drache und Phoenix, Lackarbeiten aus China, Sammlung der Familie Lee, Tokyo*, Cologne, 1990

Lee Yu-kuan, *Oriental Lacquer Art*, New York and Tokyo, 1972

Nishioka Yasuhiro, *Chūgoku no Raden*, Tokyo, 1981

Palace Museum, *Gugong Bowuyuan Cang Diaoqi (Carved Lacquer in the Collection of the Palace Museum)*, Beijing, 1985

Waley-Cohen, J. (trans.), *The Lacquers of the Mawangdui Tomb* (translated from the sections dealing with the lacquer finds in *Changsha Mawangdui yihao Han mu*, Beijing, 1973), *Oriental Ceramic Society Translations Number*

11, London, 1984

Wang Shixiang, *Xiushilu jieshuo (The Annotated 'Lacquer Decoration')*, Beijing, 1983

——, *Ancient Chinese Lacquerware*, Beijing, 1987

—— and Zhu Jiajin (eds), *Zhongguo meishu quanji, gongyi meishu, bian 8, Qiqi (Anthology of Chinese Art: Decorative Arts, vol. 8, Lacquer)*, Beijing, 1989

Watt, J. C. Y., *The Sumptuous Basket: Chinese Lacquer with Basketry Panels*, New York, 1985

——, *East Asian Lacquer: The Florence and Herbert Irving Collection*, New York, 1991

IVORY AND CARVINGS

Cox, W., *Chinese Ivory Sculpture*, New York, 1946

Ip Yee and Tam, L. C. S., *Chinese Bamboo Carving*, 2 vols, Hong Kong, 1978 and 1982

Jenyns, R. S., *Chinese Art III*, revised edition, New York, 1982

Kadoorie, H., *The Art of Ivory Sculpture in Cathay* (incorporating a catalogue of the Kadoorie collections), 3 vols, Hong Kong, 1988

Kao Mayching (ed.), *Chinese Ivories from the Kwan Collection*, Hong Kong, 1990

Laufer, B., *Ivory in China*, Chicago, 1925

Lucas, S. E., *The Catalogue of Sassoon Chinese Ivories*, 3 vols, London, 1950

Na Chih-liang, 'Chinese Ivory Carving', *The National Palace Museum Bulletin*, vol. IV, no. 5, 1969, pp. 1–13

Tsang, G. and Moss, H., *Art from the Scholar's Studio*, Hong Kong, 1986

Watson, W. (ed.), *Chinese Ivories from the Shang to the Qing*, London, 1984

JADE

d'Argencé, R-Y. Lefebvre, *Chinese Jades in the Avery Brundage Collection*, San Francisco, 1972, (revised edition, 1977)

Cheng Te K'un, 'Jade Flowers and Floral Patterns in Chinese Decorative Art', *Journal of the Institute of Chinese Studies*, Hong Kong, 1969

Dohrenwend, D., *Chinese Jades in the Royal Ontario Museum*, Toronto, 1971

Gure, D., 'Jades of the Sung Group', *Transactions of the Oriental Ceramic Society*, vol. 32, 1959–60, pp. 39–50

Hansford, S. H., *Chinese Carved Jades*, London, 1968

Ip Yee, *Chinese Jade Carving*, exhibition catalogue, Hong Kong, 1983

Li Chu-tsing and Watt, J. C. Y., *The Chinese Scholar's Studio: Artistic Life in the Late Ming Period*, London and New York, 1987

Na Chih-liang, *Chinese Jades, Archaic and Modern, from the Minneapolis Institute of Art*, Rutland, Vermont and Tokyo, 1977

——, *Guyu jiancai (Connoisseurship of Archaic Jades)*, Taipei, 1981

——, *Yuqi tongshi (History of Jade)*, 2 vols, Taipei, 1979

National Palace Museum, *Masterworks of Chinese Jade in the National Palace Museum*, Taipei, 1969

——, *Catalogue of a Special Exhibition of Hindustan Jade in the National Palace Museum*, Taipei, 1983

Rawson, J. and Ayers, J., *Chinese Jade throughout the Ages*, London, 1975

Skelton, R., 'The Relations between the Chinese and the Indian Jade Carving Traditions', *Westward Influence of the Chinese Arts from the 14th to the 18th century*, Colloquies on Art and Archaeology in Asia, Percival David Foundation, no. 3, London, 1973, pp. 98–110

Watt, J. C. Y., *Chinese Jades from Han to Ch'ing*, New York, 1980

Xia Nai (trans. and ed. Chu-tsing Li), *Jade and Silk of Han China*, Kansas City, 1983

Yang Boda, 'Qing dai gongting yuqi' ('Jade Ware Carving of the Qing Court'), *Palace Museum Journal*, no. 1, Beijing, 1982

GOLD, SILVER AND JEWELLERY

Gyllensvärd, B., *Chinese Gold and Silver in the Carl Kempe Collection*, Stockholm, 1953

——, *Chinese Gold, Silver and Porcelain, the Kempe Collection*, New York, 1971

Jenyns, R. S. and Watson, W., *Chinese Art II*, revised edition, New York, 1980

Rawson, J., 'The Ornament of Chinese Silver of the Tang Dynasty (AD 618–906)', *British Museum Occasional Paper*, no. 40, Department of Oriental Antiquities, 1982

——, 'Tombs or Hoards: The Survival of Chinese Silver of the Tang and Song Periods, Seventh to Thirteenth Centuries A.D.', in Vickers, M. (ed.), *Pots and Pans, A Colloquium on Precious Metals and Ceramics*, Oxford Studies in Islamic Art, III, Oxford, 1988, pp. 31–56

Tait, H. (ed.), *Seven Thousand Years of Jewellery*, London, 1986 (reprinted 1989)

POLYCHROME, CLOISONNÉ AND ENAMELLED WARES

Arapova, T., *Catalogue of the Hermitage Museum Painted Enamels Collection* (in Russian), Moscow, 1988

Ayers, J., *The Baur Collection*, vol. 4, *Painted and Polychrome Porcelains of the Ch'ing Dynasty*, Geneva, 1974

Brinker, H. and Lutz, A. (trans. S. Swoboda), *Chinese Cloisonné: The Pierre Uldry Collection*, New York and London, 1989

Brown, C., *Chinese Cloisonné: The Clague Collection*, Phoenix, Arizona, 1980

Chang Linsheng, 'The Dragon Motif in Cloisonné Enamels', *The National Palace Museum Bulletin*, vol. XI, no. 4, 1976

——, 'Ching-t'ai lan' ('Early Ming Dynasty Cloisonné'), *The National Palace Museum Bulletin*, vol. XXIV, nos 1–3, 1989, pp. 1–21; 1–16; 1–18

Garner, Sir H., *Chinese and Japanese Cloisonné Enamels*, London, 1962 (2nd edition, London, 1970)

Getz, J., *Catalogue of the Avery Collection of Ancient Chinese Cloisonnés*, New York, 1912

Gillingham, M., *Chinese Painted Enamels*, exhibition catalogue, Oxford, 1978

Gray, B., 'The Influence of Near Eastern Metalwork on Chinese Ceramics', *Transactions of the Oriental Ceramic Society*, vol. 18, 1940–41, pp. 47–60

Jenyns, R. S., 'Chinese Cloisonné Vase and Cover of the Hsuan-Te Period, 1426–35', *The British Museum*

Quarterly, vol. XXVI, 1962–3, pp. 113–17

——, Watson, W., Lion-Goldschmidt, D. and Moreau-Gobard, J-C., *Chinese Art: The Minor Arts*, vols 1–3, London and Fribourg, 1965 (revised edition 1980–2)

Leary, R. H., 'Cloisonné: The Ching-T'ai Myth', *Arts of Asia*, no. 1, 1975, pp. 25–34

Moss, H., *By Imperial Command: An Introduction to Ch'ing Imperial Painted Enamels*, Hong Kong, 1976

National Palace Museum, *Masterpieces of Chinese Enamel Ware in the National Palace Museum*, Taipei, 1971

Till, B. and Swart, P., *Antique Chinese Cloisonné*, Greater Victoria, British Columbia, 1983

Yang Boda, 'A Short Account of Cloisonné', *Recent Discoveries in Chinese Archaeology* (28 articles by Chinese archaeologists describing their excavations), Beijing, 1984

GLASS

An Jiayao (trans. M. Henderson), *Early Chinese Glassware*, Oriental Ceramic Society Translations Number 12, London, 1987

——, 'Zhongguo de zaoqi boli qimin' ('Early Glass Vessels of China'), *Kaogu xuebao*, no. 4, 1984, pp. 413–48

Brown, C. and Rabiner, D. (eds), *Chinese Glass of the Qing Dynasty, 1644–1911, The Robert H. Clague Collection*, Phoenix, Arizona, 1987

——, *Clear as Crystal, Red as Flame: Later Chinese Glass*, exhibition catalogue, New York, 1990

Chang Linsheng, 'Qing Enamelled Glass', in Brown, C. and Rabiner, D. (eds), *Chinese Glass of the Qing Dynasty, 1644–1911, The Robert H. Clague Collection*, Phoenix, Arizona, 1987, pp. 87–93

Yang Boda, 'A Brief Account of Qing Dynasty Glass', in Brown, C. and Rabiner, D. (eds), *Chinese Glass of the Qing Dynasty, 1644–1911, The Robert H. Clague Collection*, Phoenix, Arizona, 1987, pp. 71–86

SNUFF BOTTLES

Hall, R., *Chinese Snuff Bottles*, 4 vols, Hong Kong, 1987–91

Kleiner, R. W. L., *Chinese Snuff Bottles from the Collection of Mary and George Bloch*, Hong Kong, 1987

——, *Chinese Snuff Bottles from the Burghley House Collection*, Stamford and Hong Kong, 1989

Moss, H., *Chinese Snuff Bottles of the Silica or Quartz Group*, London, 1971

——, *Snuff Bottles of China*, London, 1971

Stevens, R. C., *The Collector's Book of Snuff Bottles*, New York, 1976

White, H., *Snuff Bottles from China: The Victoria and Albert Museum Collection*, London, 1991

MISCELLANEOUS

Anderson, E. N., *The Food of China*, New Haven, 1988

Ayers, J. et al., *Chinese Ceramic Tea Vessels: The K. S. Lo Collection*, Hong Kong, 1991

Boyd, A., *Chinese Architecture and Town Planning: 1500 BC–AD 1911*, Chicago, 1962

Chang, H. C., *Chinese Literature 2: Nature Poetry*, Edinburgh, 1977

Chang, K. C. (ed.), *Food in Chinese Culture: Anthropological and Historical Perspectives*, New Haven and London, 1977

Chinese Academy of Architecture, *Ancient Chinese Architecture*, Hong Kong and Beijing, 1982

Clunas, C., *Chinese Furniture*, London, 1988

Feuchtwang, S. D. R., *An Anthropological Analysis of Chinese Geomancy*, Vientiane, 1974

Fitzgerald, C. P., *Barbarian Beds: The Origin of the Chair in China*, London, 1965

Hay, J., *Kernels of Energy, Bones of Earth: The Rock in Chinese Art*, New York, 1986

Iröns, N. J., *Fans of Imperial China*, Hong Kong and London, 1982

Keswick, M., *The Chinese Garden*, London, 1978

Ledderose, L., 'The Earthly Paradise: Religious Elements in Chinese Landscape Art', in Bush, S. and Murck, C. (eds), *Theories of the Arts in China*, Princeton, 1983, pp. 165–83

Stein, R. A. (trans. P. Brooks), *The World in Miniature: Container Gardens and Dwellings in Far Eastern Religious Thought*, Paris, 1987, and Stanford, 1990

Wang Shixiang, *Classic Chinese Furniture*, Hong Kong and London, 1986

Yang Boda, *Tributes from Guangdong to the Qing Court*, Beijing and Hong Kong, 1987

Ceramics

Addis, Sir J., *Chinese Ceramics from Datable Tombs and Some Other Dated Material*, London and New York, 1978

——, *Chinese Porcelain from the Addis Collection: Twenty Two Pieces of Chingtechen Porcelain Presented to the British Museum*, London, 1979

Ayers, J., *The Baur Collection*, 4 vols, Geneva, 1968–74

Carswell, J., Maser, E. A. and Mudge, J. McClure, *Blue and White: Chinese Porcelain and its Impact on the Western World*, Chicago, 1985

David, Sir P. (trans. and ed.), *Chinese Connoisseurship: The Ko Ku Yao Lun, The Essential Criteria of Antiquities*, London, 1971

Donnelly, P. S., *Blanc De Chine: The Porcelain of Tehua in Fukien*, London, 1969

Gray, B., *Sung Porcelain and Stoneware*, London, 1984

Hong Kong Museum of Art, *Imperial Porcelain of the Yongle and Xuande Periods Excavated from the Site of the Ming Imperial Factory at Jingdezhen*, Hong Kong, 1989

——, *The Art of the Yixing Potter: The K. S. Lo Collection, Flagstaff House Museum of Tea Ware*, Hong Kong, 1990

——, *Brush and Clay: Chinese Porcelain of the Early 20th Century*, Hong Kong, 1990

Howard, D. S., *Chinese Armorial Porcelain*, London, 1974

—— and Ayers, J., *China for the West: Chinese Porcelain and*

other Decorative Arts for Export, Illustrated from the Mottahadeh Collection, 2 vols, London and New York, 1978

Hughes-Stanton, P. and Kerr, R., *Kiln Sites of Ancient China*, London, 1982

Jenyns, R. S., *Ming Pottery and Porcelain*, London, 1953

——, *Later Chinese Porcelain*, London, 1965

Jörg, C. J. A., *Porcelain and the Dutch China Trade*, The Hague, 1982

——, *The Geldermalsen: History and Porcelain*, Groningen, 1986

Kerr, R., *Chinese Ceramics: Porcelain of the Qing Dynasty 1644–1911*, London, 1986

Kilburn, R., *Transitional Wares and Their Forerunners*, Hong Kong, 1981

Kingery, W. D. and Vandiver, P. B., *Ceramic Masterpieces: Art, Structure, Technology*, New York, 1986

Krahl, R. (ed. J. Ayers), *Chinese Ceramics in the Topkapi Saray Museum, Istanbul*, 3 vols, London, 1986

——, 'Glazed roofs and other tiles', *Orientations*, March 1991, pp. 47–61

Lan Pu (ed. Zheng Tinggui), *Jingdezhen taolu (The Potteries of Jingdezhen)*, 1815, reprinted as *Ching-te-chen t'ao lu*, trans. G. R. Sayer, London, 1951

Lion-Goldschmidt, D., *Ming Porcelain*, London, 1978

Little, S., *Chinese Ceramics of the Transitional Period: 1620–1683*, New York, 1983

Los Angeles County Museum of Art, *The Quest for Eternity*, Los Angeles, 1987

Medley, M., *Yuan Porcelain and Stoneware*, London, 1974

——, *The Chinese Potter: A Practical History of Chinese Ceramics*, Oxford, 1976

——, *Tang Pottery and Porcelain*, London, 1981

Mino Yutaka, *Freedom of Clay and Brush through Seven Centuries in Northern China: Tz'u-chou type wares* AD 960–1600, Indianapolis, 1980

—— and Tsiang, K., *Ice and Green Clouds: Traditions of Chinese Celadon*, Indianapolis, 1986

Oriental Ceramic Society, *Iron in the Fire: The Chinese Potters' Exploration of Iron Oxide Glazes*, London, 1988

Oriental Ceramic Society of Hong Kong, *Jingdezhen Wares: The Yuan Evolution*, Hong Kong, 1984

Pijl-Ketel, C. L. van der (ed.), *The Ceramic Load of the 'Witte Leeuw' (1613)*, Amsterdam, 1982

Pope, J. A., *Chinese Porcelains from the Ardebil Shrine*, Washington DC, 1956 (reprinted with corrections, London, 1986)

Portal, J., 'A Tang dynasty tile in the British Museum', *Orientations*, March 1990, pp. 67–71

Rawson, J., *Chinese Ornament: The Lotus and the Dragon*, London, 1984 (2nd edition, 1990)

Rinaldi, M., *Kraak Porcelain: A Moment in the History of Trade*, London, 1989

Sato Masahiko (trans. Kiyoko Hanaoka and S. Barberi), *Chinese Ceramics: A Short History*, New York and Tokyo, 1981

Scheurleer, D. F. L., *Chinese Export Porcelain: Chine De Commande*, London, 1974

Scott, R. (ed.), *Imperial Taste: Chinese Ceramics from the Percival David Foundation*, Los Angeles and London, 1989

Shangraw, C., *Origins of Chinese Ceramics*, New York, 1978

Sheaf, C. and Kilburn, R., *The Hatcher Porcelain Cargoes: The Complete Record*, Oxford, 1988

Southeast Asian Ceramic Society (Singapore), *Chinese Celadons and other Related Wares in Southeast Asia*, Singapore, 1979

Southeast Asian Ceramic Society (West Malaysia Chapter), *A Ceramic Legacy of Asia's Maritime Trade: Song Dynasty Guangdong Wares and Other 11th-19th Century Trade Ceramics*, Kuala Lumpur, 1985

Taoci shihua, in series *Zhongguo keji shihua congshu*, Shanghai, 1982

Tichane, R., *Ching-te-chen: Views of a Porcelain City*, New York, 1983

——, *Reds, Reds, Copper Reds*, London, 1985

——, *Ash Glazes*, New York, 1987

Tregear, M., *Catalogue of Chinese Greenware in the Ashmolean Museum*, Oxford, 1976

——, *Song Ceramics*, London, 1982

Vainker, S., *Chinese Pottery and Porcelain: From Prehistory to the Present*, London, 1991

Valenstein, S. G., *A Handbook of Chinese Ceramics*, New York and London, 1975 (revised 2nd edition, 1989)

van Oort, H. A., *Chinese Porcelain of the 19th and 20th Centuries*, Lochem, The Netherlands, 1977

Wang Qing-zheng, Fan Dong-qing and Zhou Li-li (trans. L. Chin and Xu Jie), *The Discovery of Ru Kiln: A Famous Song Ware Kiln of China*, Hong Kong, 1991

Watson, W., *Tang and Liao Ceramics*, London, 1984

——, *Pre-Tang Ceramics of China: Chinese Pottery from 4000 BC to AD 600*, London, 1991

Wirgin, J., *Sung Ceramic Designs*, London, 1979

Wood, N., *Oriental Glazes, Their Chemistry, Origins and Re-creation*, London, 1978

——, 'Some Implications of Recent Analyses of Song Yingqing Ware from Jingdezhen', in Shanghai Institute of Ceramics, Academia Sinica (ed.), *Scientific and Technological Insights on Ancient Chinese Pottery and Porcelain*, Beijing, 1986, pp. 261–4

——, Tregear, M. and Henderson, J., 'An Examination of Chinese Fahua Glazes', in Li Jiazhi and Chen Xianqiu (eds), *Proceedings of the 1989 International Symposium on Ancient Ceramics*, Shanghai, 1989, pp. 172–82

Wu Renjing and Xin Anhu, *Zhongguo taoci shi (History of Chinese Ceramics)*, Shanghai, 1954 (reprint of 1936 original)

Ye Pei-lan (ed.), *Qing Porcelain of Kangxi, Yongzheng and Qianlong Periods from the Palace Museum Collection*, Hong Kong, 1989

A separate bibliography of kiln site reports and articles on ceramics in Chinese periodicals can be found on p. 383.

Trade

Atwell, W. S., 'International Bullion Flows and the Chinese Economy circa 1530–1650', *Past and Present*, no. 95, May 1982, pp. 68–89

Ayers, Sir J., 'The Discovery of a Yuan Ship at Sinan, South-West Korea. A First Report', *Oriental Art*, vol. XXIV, no. 1, 1978, pp. 79–85

——, 'Chinese Porcelain of the Sultans in Istanbul', *Transactions of the Oriental Ceramic Society*, vol. 47, 1982–3, pp. 77–104

Clunas, C. (ed.), *Chinese Export Art and Design*, London, 1987

——, *Chinese Export Watercolours*, London, 1984

Conner, P., *Oriental Architecture in the West*, London, 1979

——, *The China Trade, 1600–1860: Exhibition Catalogue at the Royal Pavilion*, Brighton, 1986

Cranmer-Byng, J. L. (ed.), *An Embassy to China: Lord Macartney's Journal 1793–1794*, London, 1962

Crossman, C., *The Decorative Arts of the China Trade: Paintings, Furnishings and Exotic Curiosities*, London, 1991

Gray, B., 'The Export of Chinese Porcelain to India', *Transactions of the Oriental Ceramic Society*, vol. 36, 1964–6, pp. 21–37

Guy, J. S., *Oriental Trade Ceramics in South-east Asia, Ninth to Sixteenth Centuries*, Oxford, 1986

Hall, J., 'Notes on the Early Ch'ing Copper Trade with Japan', *Harvard Journal of Asiatic Studies*, vol. 12, 1949, pp. 444–61

Hardie, P., 'China's Ceramic Trade with India', *Transactions of the Oriental Ceramic Society*, vol. 48, 1983–4, pp. 15–32

Harrisson, B., *Swatow in het Princessehof: The Analysis of a Museum Collection of Chinese Trade Wares from Indonesia*, Leeuwarden, The Netherlands, 1979

Hirth, F. and Rockhill, W. W., *Chau Ju-Kua: His Work on the Chinese and Arab Trade in the 12th and 13th Centuries, entitled Chu Fan Chi*, reprinted Taipei, 1970

Honour, H., *Chinoiserie: The Vision of Cathay*, London, 1961

Hourani, G. F., *Arab Seafaring in the Indian Ocean in Ancient and Early Medieval Times*, Princeton, 1951

Howard, D. S. and Ayers, J., *China for the West: Chinese Porcelain and other Decorative Arts for Export, Illustrated from the Mottahedeh Collection*, 2 vols, London and New York, 1978

Hunter, W. C., *The Fan Kwae in Canton before the Treaty Days*, London, 1882

Impey, O., *Chinoiserie, The Impact of Oriental Styles on Western Art and Decoration*, Oxford, 1977

Jörg, C. J. A., *Porcelain and the Dutch China Trade*, The Hague, 1982

——, *The Geldermalsen: History and Porcelain*, Groningen, 1986

Jourdain, M. and Jenyns, R. S., *Chinese Export Art in the Eighteenth Century*, London, 1967 (reprint of 1950 edition)

Kim Hongnam, 'China's Earliest Datable White Stonewares from the Tomb of King Muryong (d. AD 523), Paekche, Korea', *Oriental Art*, vol. XXXVII, no. 1, Spring 1991, pp. 17–34

Krahl, R. (ed. J. Ayers), *Chinese Ceramics in the Topkapi Saray Museum, Istanbul*, 3 vols, London, 1986

Lach, D. F., *Asia in the Making of Europe*, 5 vols, Chicago, 1965–78

Lion-Goldschmidt, D., 'Ming Porcelains in the Santos Palace Collection, Lisbon', *Transactions of the Oriental Ceramic Society*, vol. 49, 1984–5, pp. 79–93

McNeil, W., *The Pursuit of Power*, Chicago, 1982

Maitra, K. M. (trans.), *A Persian Embassy to China: An Extract from Zubdatu't Tawarikh of Hafiz Abru*, Lahore, 1934 (reprinted New York, 1970)

Morse, H. B., *The Chronicles of the East India Company Trading to China, 1635–1834*, 5 vols, Oxford, 1926–9

National Museum of Korea, *Special Exhibition of Cultural Relics found off Sinan Coast*, Seoul, 1977

Needham, J., *Science and Civilisation in China*, vol. IV:3, Cambridge, 1971

Palace Museum Beijing and The Art Gallery, The Chinese University of Hong Kong, *Tributes from Guangdong to the Qing Court*, exhibition catalogue, Hong Kong, 1987

Pope, J., *Chinese Porcelains from the Ardebil Shrine*, Washington DC, 1956 (reprinted with corrections, London, 1986)

Quanzhou Yisilanjiao yanjiu lunwenxuan, Fujian, 1983

Rawson, J., *Chinese Ornament: The Lotus and the Dragon*, London, 1984 (2nd edition, 1990)

——, Tite, M. and Hughes, M. J., 'The export of Tang sancai wares: some recent research', *Transactions of the Oriental Ceramic Society*, vol. 52, 1987–8, pp. 39–62

Sheaf, C. and Kilburn, R., *The Hatcher Porcelain Cargoes: The Complete Record*, Oxford, 1988

Shiba Yoshinobu (trans. M. Elvin), *Commerce and Society in Sung China*, Michigan Abstracts of Chinese and Japanese Works on Chinese History, no. 2, Ann Arbor, 1970

Vollmer, J. E., Keall, E. J. and Nagai-Berthrong, E., *Silk Roads, China Ships*, exhibition catalogue, Toronto, 1983

Watson, W. (ed.), *Chinese Ivories from the Shang to the Qing*, London, 1984

Whitfield, R. and Farrer, A., *Caves of the Thousand Buddhas: Chinese Art from the Silk Route*, London, 1990

Wood, F., *Blue Guide: China*, London, 1992

Yang Boda, *Tribute from Canton to the Qing Court*, Beijing and Hong Kong, 1987

Kiln site reports and articles
on ceramics in Chinese periodicals

Abbreviations

GGBWYYK	Gugong bowuyuan yuankan
JHKG	Jianghan kaogu
KG	Kaogu
KGTX	Kaogu tongxun
KGXB	Kaogu xuebao
KGXJK	Kaogu xuejikan
KGYWW	Kaogu yu wenwu
WW	Wenwu
WWCKZL	Wenwu cankao ziliao
ZYWW	Zhongyuan wenwu

NEOLITHIC

Peiligang KG 1978.2, p. 73; KG 1979.3, p. 197; KG 1983.12, pp. 1057–65; KGXB 1984.1, p. 23

Yangshao ZYWW 1984.1, pp. 53–9; KGTX 1956.6, p. 9; WW 1979.11, pp. 52–5. Banshan: KG 1980.1, pp. 7–10; KGXJK 1982. Majiayao: KG 1983.12, p. 1066. Machang: KGXB 1983.2, p. 191; KG 1965.7, p. 321

Qijia KGXB 1975.2, p. 57; KGXB 1974.2, p. 29; KGXB 1980.2, p. 187

Longshan KGXB 1954.8, p. 65. Teng xian Beixin: KGXB 1984.2, p. 159. Weifang Yaoguanzhuang: KG 1963.7, p. 347. Rizhao Liangchengzhen: KGXB 1958.1, p. 25; KG 1960.9, p. 10. Jiao xian Sanlihe: KG 1977.4, p. 262; WW 1981.7, p. 64

Dawenkou WW 1960.2, p. 61. Wangyan: KG 1979.1, p. 5

Hemudu WW 1976.8, p. 6; WW 1980.5, p. 1; WW 1982.7, pp. 61–9; KGXB 1978.1, p. 39

Songze KGXB 1962.2, p. 1; KGXB 1980.1, p. 29

Daxi WW 1961.11, pp. 15–22; KGXB 1981.4, p. 461; JHKG 1982.2, pp. 13–19

Xinle KGXB 1985.2, p. 209

SHANG AND ZHOU DYNASTIES

White ware WWCKZL 1954.1, pp. 103–7

High-fired wares WW 1960.8/9, pp. 68–70; WW 1972.10, p. 20; WW 1973.2, pp. 38–45; WW 1975.7, pp. 77–83; WW 1979.3, pp. 56–7; WW 1982.4, pp. 53–7; WW 1985.8, pp. 66–72; KG 1984.2, pp. 130–4; KG 1985.7, pp. 608–13; KG 1985.11, p. 985

HAN DYNASTY

Architecture and hollow bricks KG 1964.4, pp. 180–81; WW 1981.4, pp. 107–10; WW 1978.8, pp. 46–50; KGYWW 1983.4, pp. 94–9; KG 1962.9, pp. 484–92; ZYWW 1982.1, pp. 24–5; KG 1964.2, pp. 90–3; WW 1980.2, pp. 56–7

High-fired wares KGYWW 1984.2, pp. 91–5; KGXB 1958.1, p. 111; WW 1960.2, pp. 37–8; KG 1980.4, pp. 343–6; WWCKZL 1956.11, pp. 1–7; WW 1981.10, pp. 33–5; WW 1984.11, p. 62

Burial pottery KGYWW 1983.3, pp. 80–3; KG 1966.2, p. 66; ZYWW 1981.1, p. 62; WW 1985.1, p. 8; KGYWW 1982.1, p. 40; KG 1966.1, p. 14

SIX DYNASTIES

Greenwares North China: KG 1991.12, pp. 1090–5; WW 1984.12, pp. 64–7. Southeast China: KG 1963.2, p. 108; WW 1976.3, p. 55; KG 1983.4, pp. 347–53;

WW 1975.2, pp. 92–4; KGXB 1957.4, pp. 83–106; KG 1974.1, p. 27; KG 1966.3, p. 152; WW 1959.6, pp. 18–19

Burial wares KG 1973.4, p. 218; KG 1983.7, p. 612; WW 1977.5, p. 38; WW 1975.4, p. 64; KG 1972.5, p. 33; KG 1966.4, p. 197; KG 1965.4, p. 176; KGXB 1959.3, p. 75

TANG DYNASTY

White wares WW 1959.3, p. 58; WW 1981.9, pp. 37–50; WW 1984.12, pp. 51–7 & 58–63; WWCKZL 1953.9; KG 1959.10; GGBWYYK 1981.4; KGYWW 1984.3

Greenwares Zhejiang: WWCKZL 1953.9; WWCKZL 1955.3; WWCKZL 1958.8; KGXB 1959.3; WW 1963.1; WW 1981.10, pp. 43–7; KGYWW 1982.4. Northern: KG 1962.6

Black wares GGBWYYK no. 2; WW 1965.11; WW 1966.11; WW 1978.6; WW 1980.5, pp. 52–60

Sancai WW 1959.3; WW 1961.3; WW 1979.2; KG 1964.4; KG 1972.3; KG 1983.5; KG 1985.5; KG 1985.9; KGYWW 1985.2; ZYWW 1981.3; ZYWW 1984.2

Changsha WW 1960.3; WW 1972.1; KGXB 1980.1, pp. 67–96

Qionglai WWCKZL 1958.2; WWCKZL 1955.10

Yangzhou blue-and-white WW 1977.9, p. 94

Liao KG 1973.7; KGXB 1984.3, p. 361; WW 1978.5, pp. 26–32; WW 1981.8, pp. 65–70; WWCKZL 1958.2, pp. 10–22

SONG DYNASTY

Ding ware KG 1965.8, pp. 394–412; WW 1980.10, pp. 95–6; GGBWYYK 1983.3, pp. 70–7; WW 1984.5, pp. 86–8; KG 1985.7, pp. 623–6; WW 1985.8, pp. 93–4

Fang ding Anhui: KG 1962.3, pp. 134–8; KG 1963.12, pp. 662–7

Ru ware WW 1964.8, pp. 15–27

Jun ware WW 1964.8, pp. 27–37; WW 1974.12; WW 1975.6, pp. 57–64; GGBWYYK no. 2

Guan ware KGYWW 1985.6, pp. 105–6

Ge ware GGBWYYK 1981.3, pp. 33–5 & 36–9

Longquan ware KG 1962.10, pp. 535–8; WW 1963.1, pp. 27–43; KGXB 1973.1, pp. 131–56; WW 1981.10, pp. 36–42; KG 1981.6, pp. 504–10; GGBWYYK 1982.2, pp. 59–61

Cizhou ware Cizhou: WW 1959.6, pp. 159–61; WW 1964.8, pp. 37–49; ZYWW 1983.2, p. 86. Dangyangyu: WWCKZL 1952.1; WWCKZL 1952.4. Dengfeng: WW 1964.2, pp. 154–62; WW 1964.3, pp. 47–55

Jianyang WWCKZL 1953.9; WWCKZL 1955.9; KG 1964.4, pp. 191–4

Jingdezhen WWCKZL 1953.9; WW 1984.8, pp. 94–6; WW 1981.6, p. 87; GGBWYYK 1979.2, pp. 74–5

Dehua WWCKZL 1957.9; WWCKZL 1954.5; WWCKZL 1955.4, pp. 55–71; WW 1965.2, pp. 26–35; WW 1979.5, pp. 62–5

Guangdong Chaozhou: WWCKZL 1957.3; KG 1964.4. Huizhou: WWCKZL 1955.2, p. 157; KG 1964.4, pp. 196–200; WW 1977.8, pp. 46–56. Xicun: KGTX 1957.3, pp. 70–71

List of illustrations

Illustrations are by courtesy of the Trustees of the British Museum except where otherwise noted.

234 After Shui Jisheng and Wang Taian, 'A study on the traditional kilns in Shanxi', 2nd International Conference on Ancient Chinese Pottery and Porcelain, Beijing, 1985

235 After Banpo Museum, near Xi'an; and photographs by N. Wood

236 After Liu Zhen, Zheng Naizhang and Hu Youzhi, 'A study of the structural characteristics of Jingdezhen kiln', 2nd International Conference on Ancient Chinese Pottery and Porcelain, Beijing, 1985; and Museum of Chinese History, Beijing

Maps Drawings A. Searight; IV After J. Needham, *Science and Civilisation in China*, IV/3, Cambridge, 1971, fig. 989

front cover OA 1959.5–1.1
back cover OA 1926.4–10.01, Chinese painting Add 32, given by Mrs W. Bateson

Index